ROMAN SCULPTURE
IN THE ART MUSEUM
PRINCETON UNIVERSITY

ROMAN

SCULPTURE

IN THE ART MUSEUM
PRINCETON UNIVERSITY

Edited by J. Michael Padgett

With contributions by Michaela Fuchs, Hugo Meyer, Robert Wenning, Michal Gawlikowski, Tina Najbjerg, Robert G. A. Weir, Robert J. Cro, Margaret L. Laird, J. Michael Padgett, Nassos Papalexandrou, Christopher Moss, Nadja Aksamija, Blake de Maria, John Pollini, Kyriaki Karoglou, Michael Marton

THE ART MUSEUM, PRINCETON UNIVERSITY

DISTRIBUTED BY PRINCETON UNIVERSITY PRESS

Paper and cloth editions published by The Art Museum, Princeton
University, Princeton, New Jersey 08544-1018
Distributed by Princeton University Press, Princeton, New Jersey

This publication has been supported with funds from the Publications
Committee of the Department of Art and Archaeology, Princeton
University; the Andrew W. Mellon Foundation; the Joseph L. Shulman
Publications Fund; and an anonymous donor.

Managing Editor: Jill Guthrie
Editor: J. Michael Padgett
Copy Editor: Sharon R. Herson
Designer: Bruce Campbell
Photographer: Bruce M. White
Typesetter: Barbara Sturman
Indexer: Kathleen M. Friello
Printer: Arnoldo Mondadori Editore Publishing Ltd., Verona, Italy

Library of Congress Catalog Card Number: 2001087428
ISBN 0-943012-34-1 (paper); 0-943012-35-x (cloth)

The book was typeset in Centaur and Perpetua and printed on
150 gsm. R4 matte satin

Cover illustration: *Funerary Monument to a Charioteer*, detail (cat. no. 12)

Frontispiece: *Front Panel of a Sarcophagus with Scenes from the Childhood of
Dionysos*, detail (cat. no. 42)

Printed and bound in Italy

Contents

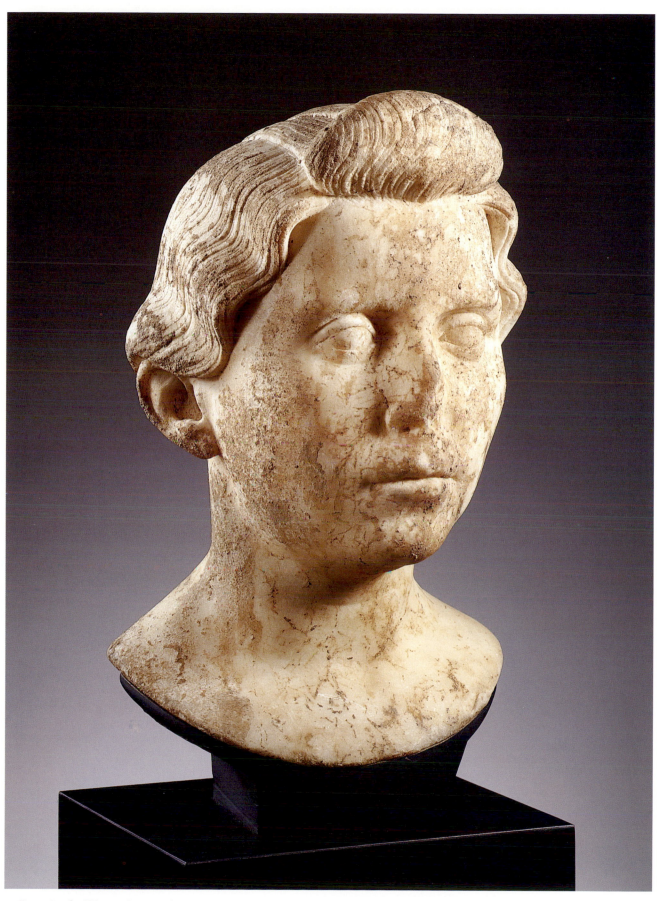

1. Portrait of a Woman (cat. no. 1).

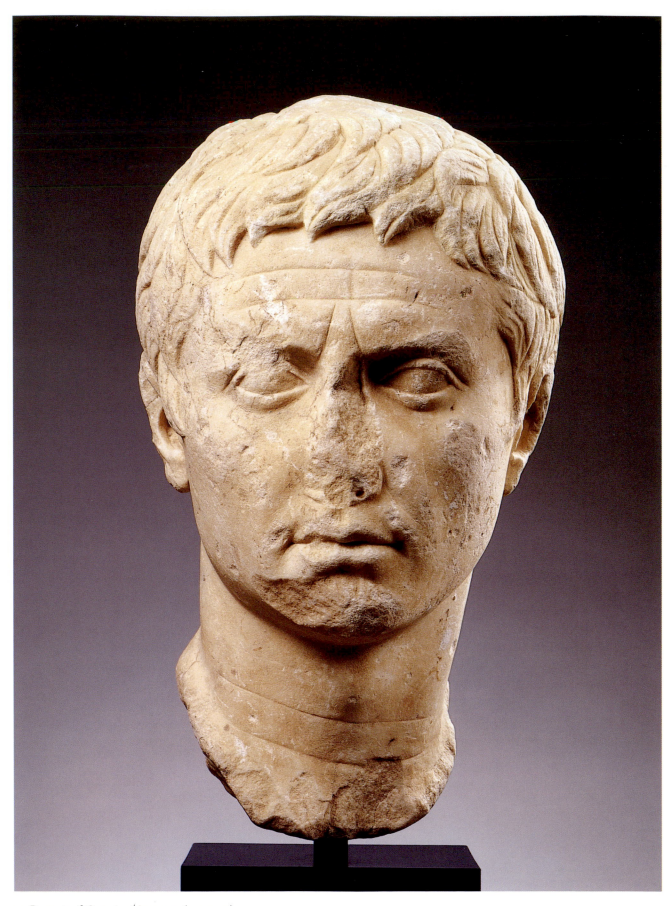

2. Portrait of Octavian/Augustus (cat. no. 2)

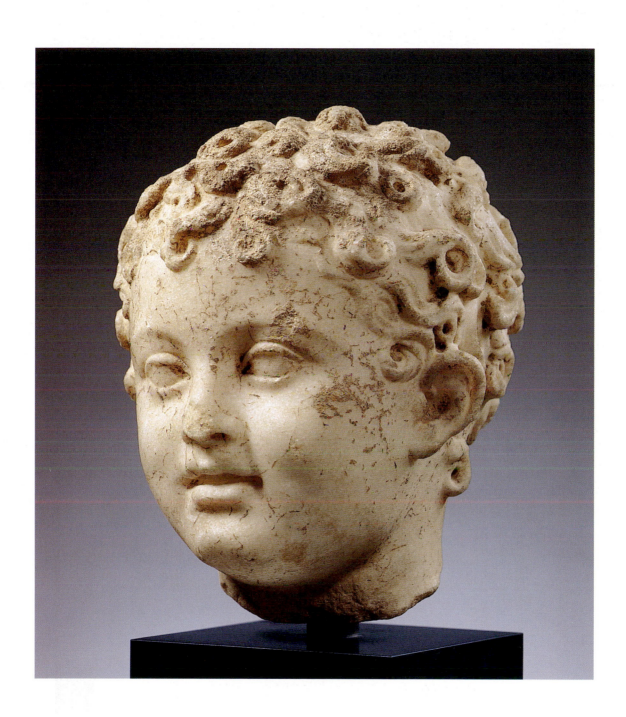

3. Head of a Child (cat. no. 4)

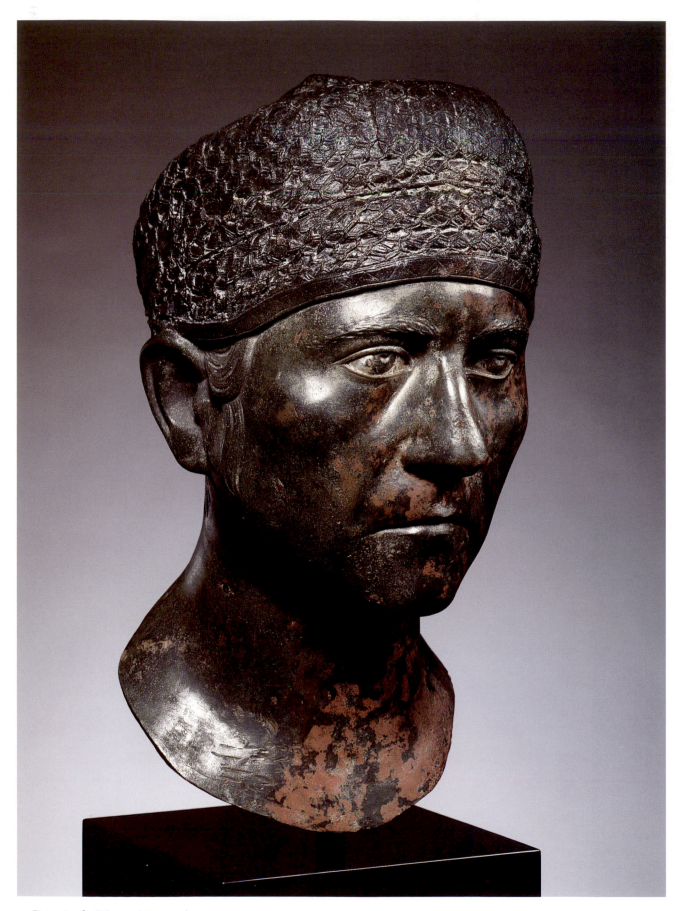

4. Portrait of a Woman (cat. no. 9)

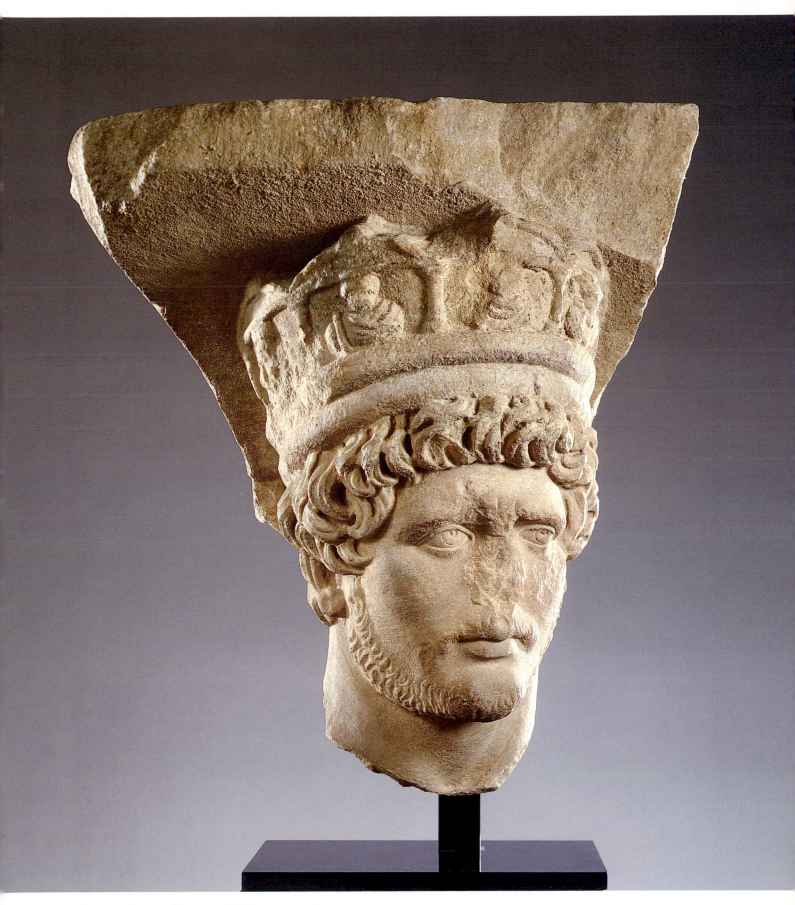

5. Head of a Priest of the Imperial Cult (cat. no. 13)

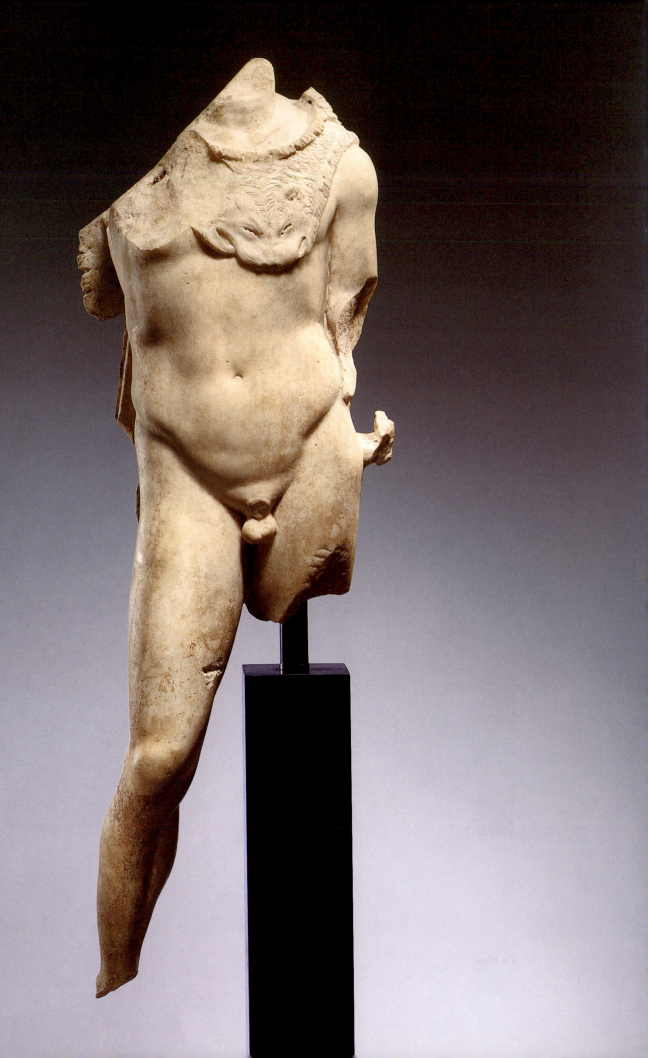

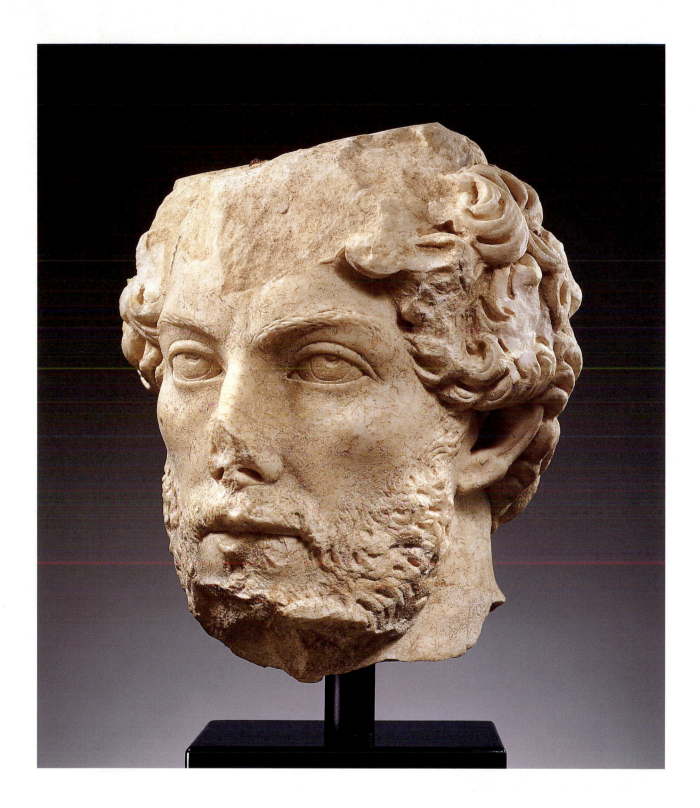

6. Statue of Dionysos (cat. no. 24)

7. Portrait of a Man (cat. no. 16)

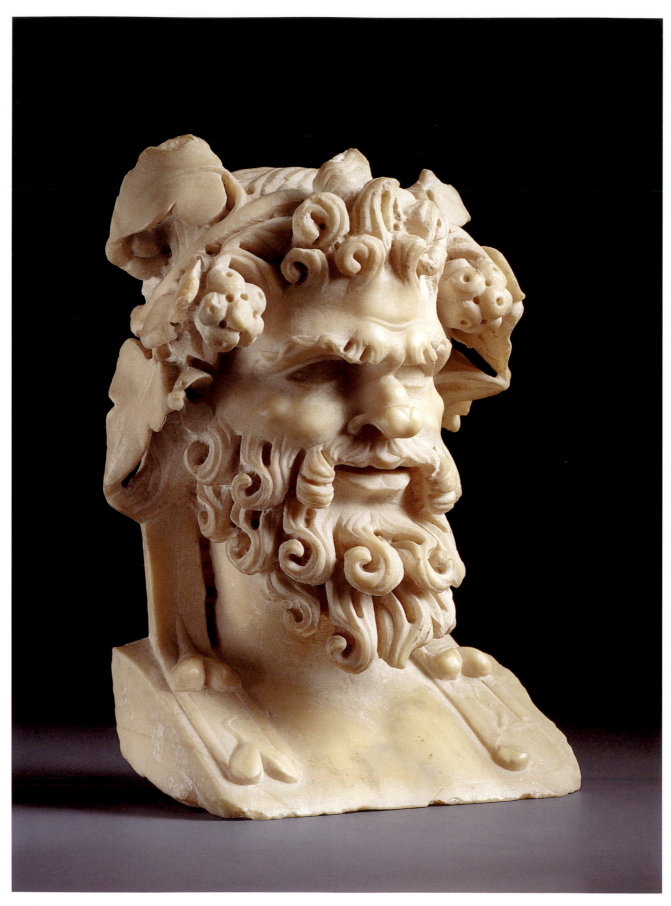

8. Herm Bust of Pan (cat. no. 28)

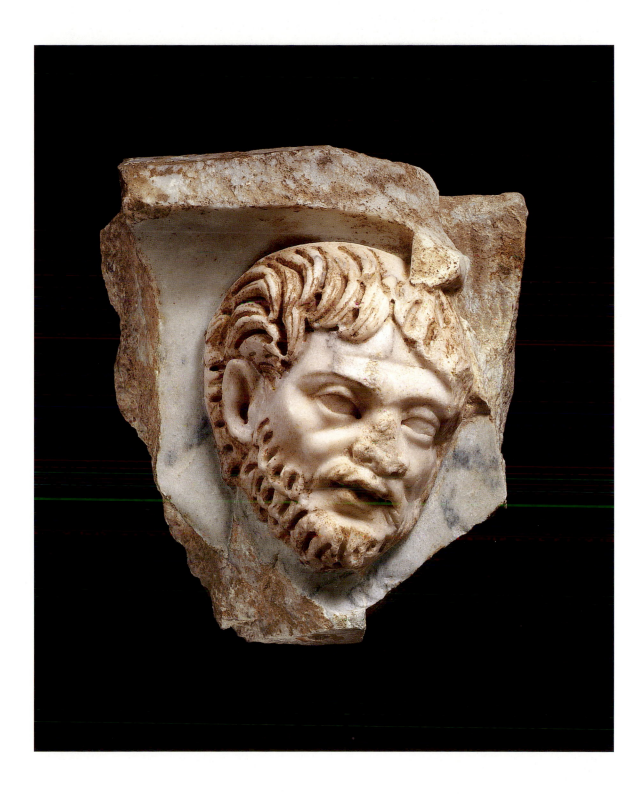

9. Fragment of a Hunt Sarcophagus (cat. no. 45)

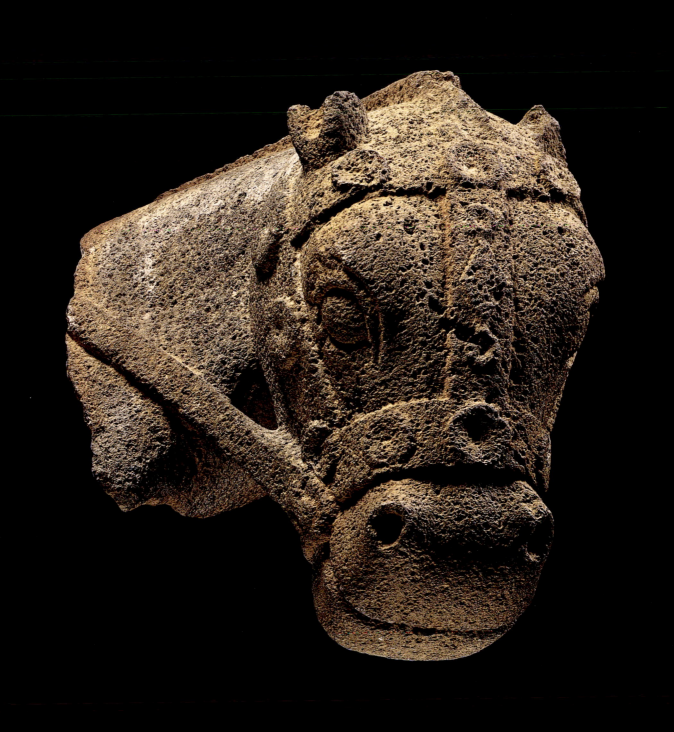

10. Head of a Horse in High Relief (cat. no. 137)

11. Head of a Lion (cat. no. 159)

12. Fragmentary Portrait of a Greek King (cat. no. 162)

Foreword

It is uncertain when the first Roman sculpture entered The Art Museum's collection, and the difficulty is more than one of incomplete records. The basalt sculptures brought back from Syria nearly a hundred years ago by Howard Crosby Butler (cat. nos. 134–149), although postdating the Roman annexation of the Hauran region, are in a distinctly provincial style that some would hesitate to characterize as "Roman." The marble torso of Dionysos donated in 1909 by Robert Garrett, Class of 1897, while undoubtedly Roman in date, is not included in this catalogue, having already been published in Brunilde Ridgway et al., *Greek Sculpture in The Art Museum, Princeton University* (Princeton 1994), 56–59, where it is said to have been "generally inspired by fifth- and fourth-centuries B.C. Greek renderings." Many of the works in this catalogue of Roman sculpture, including at least one torso of Dionysos (cat. no. 24), also are said to reflect earlier Greek works. The question of why some sculptures of this type should be catalogued as Greek and others as Roman leads to the larger and more vexing question, What is a Roman sculpture? There are many possible answers, since Rome's empire encompassed so many diverse cultural traditions, but it is safe to say that the current trend, at least in this country, is away from the almost automatic assumption that most sculptures of ideal type produced in Roman times are copies or variants of Greek originals and that it is a principal task of the art historian to identify these prototypes. The excesses of this methodology are now rightly questioned by many scholars who believe that discussions—and catalogues—of Greek sculpture are better limited to works produced before the Roman conquest and that sculptures of Roman date, even those clearly based on Greek originals, ought to be analyzed within the context of Roman society, with suitable attention paid to the particular region in which they were produced. This viewpoint, too, can be held with excessive rigidity: the truth, as usual, lies somewhere in between. Considering the diversity of influences that contributed to its early development and later evolution, pure Greek sculpture may be as much an illusion as pure Roman. I cannot say what factors led to the inclusion of Roman copies and variants in the earlier catalogue of Greek sculptures at Princeton, but the result is a fait accompli. Those who wish to know all of the Roman sculpture in Princeton will have to consult both volumes. Some rank among the finest classical sculptures in America, while others are the merest fragments, like the limbs and digits found in a sculptor's workshop at Antioch (cat. nos. 92–93). All are included and receive as much analysis as their preservation and the limitations of the catalogue format permit.

This catalogue completes the publication of The Art Museum's collection of Roman sculpture, but just as everything Roman is not in it, not everything in it is Roman. The addenda of three Greek works omitted from or acquired since the publication of the Greek sculpture catalogue need no explanation. Two Etruscan pieces are included because they are the Italian predecessors of Roman sculpture, and one of them, the Volterran *cinerarium* (cat. no. 160), was made after the Roman annexation of Etruria. Cypriote sculptures of every date have been excluded from both the Greek and Roman catalogues because it is anticipated that they eventually will be published in a fascicle of the *Corpus of Cypriote Antiquities.* Most of the Byzantine sculpture in The Art Museum was published in the exhibition catalogue *Byzantium at Princeton: Byzantine Art and Archaeology at Princeton University,* edited by Slobodan Ćurčić and Archer St. Clair (Princeton 1986), including the best of the marble reliefs from the late-fifth- and early-sixth-century phases of the

so-called Martyrion of Seleuceia in Pieria. These early Byzantine sculptures stand outside the scope of the present volume, but the early Christian sarcophagus reliefs of Jonah and the Good Shepherd (cat. nos. 47–48) are pre-Constantinian and are best studied alongside other Roman sarcophagi. Purely ornamental architectural moldings and fragments— mostly from Antioch and Sardis—also are excluded, as are modern fakes and *dubitanda*. Among these is a portrait of Caracalla long believed to be an authentic work of the early third century A.D. (F. Jones, *Ancient Art in The Art Museum, Princeton University* [Princeton 1960], 64–65), but now recognized as a product of the eighteenth century. A miniature chalcedony statuette of Herakles, although technically a sculpture in stone, is of a material normally catalogued with gems and semiprecious stones. For the same reason, carvings in ivory, bone, and amber are excluded, as are terracotta sculptures and small-scale bronzes. On the other hand, three bronze portraits are included, since it would make no sense to catalogue them separately from the portraits in stone. One fragmentary piece from Antioch is in the fragile—but surprisingly durable— medium of plaster (cat. no. 67). The rest are of stone: primarily white marble, but also yellow and gray marbles, basalt, limestone, and a single work in chalk.

In excluding inscriptions and architectural ornament, the word "sculpture" has been strictly interpreted, but the widest meaning is accorded to "Roman," with works from three separate areas of Roman Syria: the Hauran, Palmyra, and Antioch. The Hauran region of southern Syria was explored by the Princeton University Expeditions to Syria in 1904–5, and 1909, directed by Howard Crosby Butler. The majority of the basalt sculptures are from Butler's excavations at the site of Seeia, but we lack specific information about some pieces. At least three frag-

mentary Palmyrene reliefs (cat. nos. 152, 156, 158) entered the Museum at the same time as the Hauranite sculptures, and it is likely that Butler acquired them during one of his expeditions. A single sarcophagus fragment from Sardis (cat. no. 43), where Butler directed excavations in 1921–22, also is otherwise undocumented. Antioch-on-the-Orontes, in what is now southern Turkey, was the focus of Princeton-sponsored excavations from 1932 to 1939, yielding a wealth of information about the great Hellenistic and Roman metropolis, the elegant villas of its suburb Daphne (Harbie), and its great port city of Seleuceia in Pieria, at the mouth of the Orontes. The best-known finds from these sites are the splendid mosaics that today adorn The Art Museum, the Hatay Archaeological Museum in Antakya, Turkey, and many other museums in America and France. Of the over eighty-five sculptures from Antioch now in Princeton, most are fragmentary, and in many cases the subject can only be tentatively identified. Many pieces were published in the reports of the excavation, edited by Richard Stillwell, but with only small photographs and brief descriptions (see the Concordance of Antioch Sculpture); others are published here for the first time. Several pieces said by Stillwell to be in Princeton are, in fact, not here. One of these, a male torso (Stillwell 1938, 170, no. 101), was sold to a graduate student in 1951 for one hundred dollars and is now at the Art Museum of the Culver Military Academy, in Indiana. Other pieces also may have been sold or disposed of at the discretion of the American Committee for the Excavation of Antioch and Vicinity. The essays by Tina Najbjerg and Robert Weir provide more information about the history of Antioch and its excavation, and the discussion by Robert Wenning of the Hauranite sculptures sheds new light on Butler's activities in Syria.

Many of the finest sculptures in this catalogue were purchased for the collection with endowments established by Fowler McCormick, Class of 1921, Carl Otto von Kienbusch, Class of 1906, Henry Marquand, Edward Harkness, John Maclean Magie and Gertrude Magie. In addition, the Friends of The Art Museum have been consistently generous benefactors, from the "Good Shepherd" relief they purchased in 1952 (cat. no. 48) to the centauromachy sarcophagus of 1996 (cat. no. 41), the latter also partially underwritten by an anonymous friend. In addition to purchases, a nearly equal number of Roman sculptures have come into the Museum as gifts or bequests from alumni and friends such as Junius S. Morgan, Class of 1888, Moses Taylor Pyne, Class of 1908, Edward Sampson, Class of 1914, John B. Elliott, Class of 1951, David G. Carter, Class of 1945, Harris S. Colt, Class of 1957, Margaretta Colt, Josepha Weitzmann-Fiedler, and Elias S. David.

The production of this catalogue has been a cooperative venture involving many individuals. Originally conceived by Robert Guy, associate curator of ancient art from 1984 to 1991, the project enjoyed enthusiastic support from the director of The Art Museum, Allen Rosenbaum, who retired in 1998. Peter C. Bunnell, acting director from 1998 to 2000, also endorsed the project, as did Susan M. Taylor, who became director in August 2000. The final publication has been supported with funds from the Publications Committee of the Department of Art and Archaeology, Princeton University; the Andrew W. Mellon Foundation; the Joseph L. Shulman Publications Fund; and an anonymous donor. To celebrate the publication of the catalogue, the Museum organized the exhibition "Empire of Stone: Roman Sculpture from The Art Museum, Princeton University," from October 13, 2001, to January 20, 2002. The exhibition featured some forty-eight works from the catalogue and an innovative design by Craig Konyk.

Like the earlier catalogue of Greek sculpture, the present volume is multi-authored. Many of the entries have been written by Princeton graduate students, several of whom have now graduated and begun teaching careers. The principal faculty contributor, Professor Hugo Meyer, of the Department of Art and Archaeology, enlisted four of his graduate students and helped to edit their contributions. Professor Meyer was an active collaborator in nearly every phase of the project and deserves special thanks for much more than his own written contributions, which are significant. It was he who suggested that two distinguished visiting fellows at the Institute of Advanced Study—Professor Michal Gawlikowski, of the University of Warsaw, and Professor Robert Wenning, of the University of Münster—be invited to catalogue the sculptures from Palmyra and the Hauran. More than half of the non-Syrian sculptures have been catalogued by Michaela Fuchs, a renowned authority on classical sculpture and, not incidentally, Professor Meyer's wife. The translation of Dr. Fuchs's entries from the German was undertaken by Howard Fine, with editorial assistance from Professor Meyer. Christopher Moss, editor of publications in the Department of Art and Archaeology, provided several key entries, and Professor John Pollini, of the University of Southern California, came to our rescue with a contribution on a newly acquired portrait of the emperor Augustus (cat. no. 2). In 1995, Professor Brunilde Ridgway traveled from Bryn Mawr to Princeton to discuss with the students the often puzzling fragments from Antioch, providing numerous insights and infecting her rapt audience with her own enthusiasm. Cornelius Vermeule, the distinguished former Curator of Classical Art at the Museum of

Fine Arts, Boston, was an ardent supporter of the project from the beginning, also offering many helpful suggestions about the Antioch fragments. The anonymous outside reader of the catalogue made a great many useful observations, and I personally benefited from my discussions with Jasper Gaunt about the Archaic Etruscan lion's head (cat. no. 159).

With 163 entries, the present catalogue is four times as large as its predecessor and contains features lacking in the earlier volume, including maps, concordances, and short essays. Throughout the production process, oversight was provided by Jill Guthrie, managing editor, whose patient professionalism is largely responsible for the success of the project. The manuscript was meticulously copyedited by Sharon Herson, and the final formats of the notes and bibliography owe much to her sage advice. We are happy again to have had the services of designer Bruce Campbell, who is responsible for the elegant appearance and rational layout of the photos and text, and are grateful to the typesetter, Barbara Sturman, the printers Sergio Brunelli and Peter Garlid of Arnoldo Mondadori Editore, and Kathleen M. Friello, who prepared the index, for their excellent work. New photographs of every sculpture were made by the museum's photographer, Bruce M. White, working closely with Karen Richter, assistant registrar, who supervised this massive project with patience and diplomacy. The photographs were printed by Chris Schwer. When we learned we needed two new photographs of a marble portrait on loan to Emory University, they were swiftly provided by Kay Hinton and Melody Hanlon, photographer and assistant registrar at the Michael C. Carlos Museum. A photograph showing the original location of a head from the Princeton excavations at Seeia was kindly provided by Jean-Marie Dentzer. Several sculptures were cleaned or repaired by the Museum's conservator, Norman Muller, and new bases were provided by Bill Stender. The constant movement of pieces within the Museum was ably attended to by preparators Gerrit Meaker and Brian Kamen, under the supervision of registrar Maureen McCormick. Eliza Frecon, assistant registrar, oversaw the accessioning and numbering of all the Antioch material. Shari Kenfield, curator, research photograph collection and archive, Department of Art and Archaeology, provided valuable assistance to authors researching the findspots of pieces from Antioch and Seleuceia. Jill Mazeika, graphic designer in the Educational Technologies Center, Princeton University, designed the detailed maps. Tina Najbjerg (Graduate School Class of 1997), while working as my research assistant, oversaw the division of the Antioch material among herself and her fellow graduate students and acted as general project coordinator during her tenure at the Museum. Her successor, Glenda Swan, formatted the draft Antioch entries and began the process of turning a group of disparate submissions into a rough manuscript. The concordances and list of emperors were prepared by James Woolard, Zoullas Research Intern and a graduate student in classics. Finally, to Elfriede Knauer goes the credit for first identifying the nondescript objects held by Silvanus on the Museum's relief as the entrails of a sacrificial animal (cat. no. 32); I did not believe it, and neither did many other distinguished visiting scholars, but "Kit" Moss has proven her right.

J. Michael Padgett

Notes on the Use of the Catalogue

The subdivisions of the catalogue are set forth in the Contents and discussed briefly in the Foreword. The initial section is divided into portraits; deities, ideal types, and animals; and sarcophagi, each arranged chronologically. The next section, which begins with an introductory essay, presents the fragmentary sculptures from the Princeton excavations at Antioch, which, with their more tenuous identifications, are divided into females, males, body parts, animals, attributes, and sarcophagi, again in order of date. These are followed by the catalogue of funerary stelai from Antioch and by a section devoted to the Hauranite sculptures from Syria, both arranged chronologically and prefaced by brief essays. The next section covers Palmyrene sculpture, followed by another comprising two Etruscan works. An addendum presents three Greek works not included in the earlier catalogue of Greek sculpture.

Two concordances allow the user to find individual works using either the Museum accession number or, in the case of works from Antioch, the catalogue number in the excavation reports (Stillwell 1938 and Stillwell 1941). Most of the sculptures from Antioch were only accessioned in 2000. The excavators assigned "Antioch numbers" to many of the sculptures they brought back, and these are given both in the concordance and in the individual catalogue entries, either following the Stillwell reference in the entry bibliography or, in the case of previously unpublished works, in the heading under "provenance." Many pieces were not excavated but were acquired by gift or purchase; these have Antioch numbers preceded by "P": e.g., Pa315-396, the "a" indicating it was catalogued in 1937 ("b" stands for 1938, "c" for 1939). The sector coordinates of pieces excavated in Antioch, given in the entry under "provenance," match the grid on the map of Ancient Antioch.

The Abbreviations are based on those of the *American Journal of Archaeology.* With few exceptions, all references in the Notes are in short title form—author and year of publication—and can be found by consulting the Bibliography of Works Cited. In the latter, authors are listed alphabetically, so that, for instance, "Bol 1984," by R. Bol, follows "Bol 1994," by P. Bol. Essay bibliographies are not abbreviated and, like the bibliographies that follow each entry, are arranged chronologically. Greek titles are transliterated into English. In the transliteration of ancient names, consistency yields to custom and clarity. The Greek gods portrayed have retained their names (e.g., Herakles), but some Greek names are Latinized (e.g., Socrates), while others are anglicized (e.g., Rome).

In describing relief compositions, directions are given from the spectator's point of view. For figures in the round, however, *left* and *right* mean *proper left* and *proper right.* All measurements are expressed metrically and, unless otherwise stated, are the maximum of a given dimension, abbreviated as (h.)eight, (l.)ength, (w.)idth, (d.)epth, (th.)ickness, and (diam.)eter. Initials at the end of the main text of each entry credit the individual authors, as follows:

NA	Nadja Aksamija
RJC	Robert J. Cro
BDM	Blake de Maria
MF	Michaela Fuchs
MG	Michal Gawlikowski
KK	Kyriaki Karoglou
MLL	Margaret L. Laird
MM	Michael Marton
HM	Hugo Meyer
CM	Christopher Moss
TN	Tina Najbjerg
JMP	J. Michael Padgett
NP	Nassos Papalexandrou
JP	John Pollini
RGAW	Robert G. A. Weir
RW	Robert Wenning

Abbreviations

AA	Archäologischer Anzeiger	ARV²	J. D. Beazley, Attic Red-figure Vase-painters, 2d ed. (Oxford 1963)
AAS	Annales archéologiques arabes syriennes	ASR	C. Robert et al., Die antiken Sarkophagreliefs (Berlin 1890–)
ABr	P. Arndt, H. Brunn, and F. Bruckmann, Griechischer und römischer Porträts (Munich 1891–1935)	AvP	Altertümer von Pergmamon
ADAJ	Annual of the Department of Antiquities of Jordan	AZ	Archäologische Zeitung
AÉpigr	L'Année épigraphique	BABesch	Bulletin antieke Beschaving. Annual Papers on Classical Archaeology
AF	Archäologische Forschungen	BAH	Bibliothèque archéologique et historique, Institut français d'archéologie du Proche Orient
AIRRS	Acta Instituti Romani Regni Sueciae		
AJA	American Journal of Archaeology	BAR-IS	British Archaeological Reports. International Series
AM	Mitteilungen des Deutschen Archäologischen Instituts, Athenische Abteilung	BCH	Bulletin de correspondance hellénique
AncSoc	Ancient Society	BClevMus	The Bulletin of the Cleveland Museum of Art
AncW	The Ancient World		
AnnArchBrux	Annales de la Société royale d'archéologie de Bruxelles	BdA	Bollettino d'arte
		BÉFAR	Bibliothèque des Écoles françaises d'Athènes et de Rome
ANRW	H. Temporini, ed., Aufstieg und Niedergang der römischen Welt (Berlin 1972–)	BJb	Bonner Jahrbücher des Rheinischen Landesmuseums in Bonn und des Vereins von Altertumsfreunden im Rheinlande
AntCl	L'Antiquité classique		
AntK	Antike Kunst	BMFA	Bulletin of the Museum of Fine Arts, Boston
AntP	Antike Plastik		
AntW	Antike Welt. Zeitschrift für Archäologie und Kulturgeschichte	BMQ	British Museum Quarterly
		BMusBeyr	Bulletin du Musée de Beyrouth
ArchCl	Archeologia classica	BollMC	Bolletino dei Musei comunali di Roma
ArchDelt	Archaiologikon Deltion	BullCom	Bullettino della Commissione archeologica comunale di Roma

CAH	Cambridge Ancient History, 2d ed. 1961–; 1st ed. 1923–39	IGLSyr	Inscriptions grecques et latines de la Syrie
CII	Corpus inscriptionum iudicarum	IGRR	Inscriptiones graecae ad res romanas pertinentes
CIL	Corpus inscriptionum latinarum	IstMitt	Istanbuler Mitteilungen
CIS	Corpus inscriptionum semiticarum	JdI	Jahrbuch des Deutschen Archäologischen Instituts
Clarac	F. de Clarac, Musée de sculpture antique et moderne (Paris 1841–53)	JMFA	Journal of the Museum of Fine Arts, Boston
CollLatomus	Collection Latomus	JRA	Journal of Roman Archaeology
CSIR	Corpus signorum imperii romani	JRGZM	Jahrbuch des Römisch-germanischen Zentralmuseums, Mainz
DialArch	Dialoghi di archeologia	JWalt	Journal of the Walters Art Gallery
DissPontAcc	Atti della Pontificia Accademia romana di archeologia. Dissertazioni	Latomus	Latomus. Revue d'études latines
DM	Damaszener Mitteilungen	LIMC	Lexicon Iconographicum Mythologiae Classicae, vols. 1–8 (Zürich and Munich 1981–97)
EA	P. Arndt and W. Amelung, Photographische Einzelaufnahmen antiker Skulpturen (Munich 1893–1940)		
		LTUR	E. M. Steinby, ed., Lexicon Topographicum Urbis Romae (Rome 1933–2000)
Espérandieu	E. Espérandieu, Recueil général des bas-reliefs, statues, et bustes de la Gaule romaine (Paris 1907–)		
		MAAR	Memoirs of the American Academy in Rome
FA	Fasti archaeologici	MarbWPr	Marburger Winckelmann-Programm
GettyMusJ	The J. Paul Getty Museum Journal	MDIK	Mitteilungen des Deutschen Archäologischen Instituts, Abteilung Kairo
GGA	Göttingische gelehrte Anzeiger		
Helbig⁴	W. Helbig, Führer durch die öffentlichen Sammlungen klassischer Altertümer in Rom, 4th ed., supervised by H. Speier (Tübingen 1963–72)	MedMusB	Medelhavsmuseet, Bulletin [Stockholm]
		MÉFRA	Mélanges de l'École française de Rome, Antiquité
		MemPontAcc	Memorie. Atti della Pontificia Accademia romana di archeologia
HSCP	Harvard Studies in Classical Philology		
HTR	Harvard Theological Review	Mon. Anc.	Monumentum Ancyranum

MüJb	*Münchener Jahrbuch der bildenden Kunst*
NSc	*Notizie degli scavi di antichità*
OCD²	*The Oxford Classical Dictionary,* 2d ed. (Oxford 1970)
ÖJh	*Jahreshefte des Österreichischen archäologischen Instituts in Wien*
PAAES	H. C. Butler, ed., *Publications of an American Archaeological Expedition to Syria in 1899–1900* (New York 1903–8)
PAPS	*Proceedings of the American Philosophical Society*
PEQ	*Palestine Exploration Quarterly*
PPUAES	H. C. Butler, ed., *Publications of the Princeton University Archaeological Expeditions to Syria in 1904–5 and 1909* (Leiden 1907–20)
RA	*Revue archéologique*
RBibl	*Revue biblique*
RdA	*Rivista di archeologia*
RE	A. von Pauly, G. Wissowa, and W. Kroll, *Real-Encyclopädie der klassischen Altertumswissenschaft* (1893–)
Record	*Record of The Art Museum, Princeton University*
RendPontAcc	*Atti della Pontificia Accademia romana di archeologia. Rendiconti*
RepES	*Répertoire d'épigraphie sémitique*
RM	*Mitteilungen des Deutschen Archäologischen Instituts, Römische Abteilung*
Roscher	W. H. Roscher, ed., *Griechischen und römischen Mythologie* (Leipzig 1897–1902)
RSGR	S. Reinach, *Répertoire de la statuaire grecque et romaine* (Paris 1897–1924)
Selections	*Selections from The Art Museum, Princeton University.* Princeton 1986
StädelJb	*Städel-Jahrbuch*
StIt	*Studi italiani di filologia classica*
Syria	*Syria. Revue d'art oriental et d'archéologie*
TrWPr	*Trierer Winckelmannsprogramme*
TrZ	*Trierer Zeitschrift für Geschichte und Kunst des Trierer Landes und seiner Nachbargebiete*
WissZBerlin	*Wissenschaftliche Zeitschrift der Humboldt-Universität zu Berlin, Gesellschafts- und sprachwissenschaftliche Reihe*
ZPE	*Zeitschrift für Papyrologie und Epigraphik*

Roman Emperors

Augustus	27 B.C.–A.D. 14	Trebonianus Gallus	251–253
Tiberius	14–37	Aemilian	253
Gaius (Caligula)	37–41	Valerian	253–260
Claudius	41–54	Gallienus	253–268
Nero	54–68	Postumus	260–268
Galba	68–69	Claudius II Gothicus	268–270
Otho	69	Quintillus	270
Vitellius	69	Aurelian	270–275
Vespasian	69–79	Tacitus	275–276
Titus	79–81	Florian	276
Domitian	81–96	Probus	276–282
Nerva	96–98	Carus	282–283
Trajan	98–117	Carinus	283–285
Hadrian	117–138	Numerian	283–284
Antoninus Pius	138–161	Diocletian	284–305
Marcus Aurelius	161–180	Maximian	286–305; 307–308
Lucius Verus	161–169	Carausius	286/7–293
Commodus	180–192	Constantius I Chlorus	305–306
Pertinax	193	Galerius	305–311
Didius Julianus	193	Severus II	306–307
Septimius Severus	193–211	Maxentius	306–312
Pescennius Niger	193–195	Constantine I the Great	306–337
Clodius Albinus	195–197	Licinius	308–324
Caracalla	211–217	Maximinus II Daia	310–313
Geta	211	Constantine II	337–340
Macrinus	217–218	Constantius II	337–361
Elagabalus	218–222	Constans I	337–350
Severus Alexander	222–235	Magnentius	350–353
Maximinus I	235–238	Julian the Apostate	361–363
Gordian I	238	Jovian	363–364
Gordian II	238	Valentinian I	364–375
Balbinus	238	Valens	364–378
Pupienus	238	Gratian	367–383
Gordian III	238–244	Valentinian II	375–392
Philip the Arab	244–249	Theodosius I the Great	379–395
Trajanus Decius	249–251	Magnus Maximus	383–388

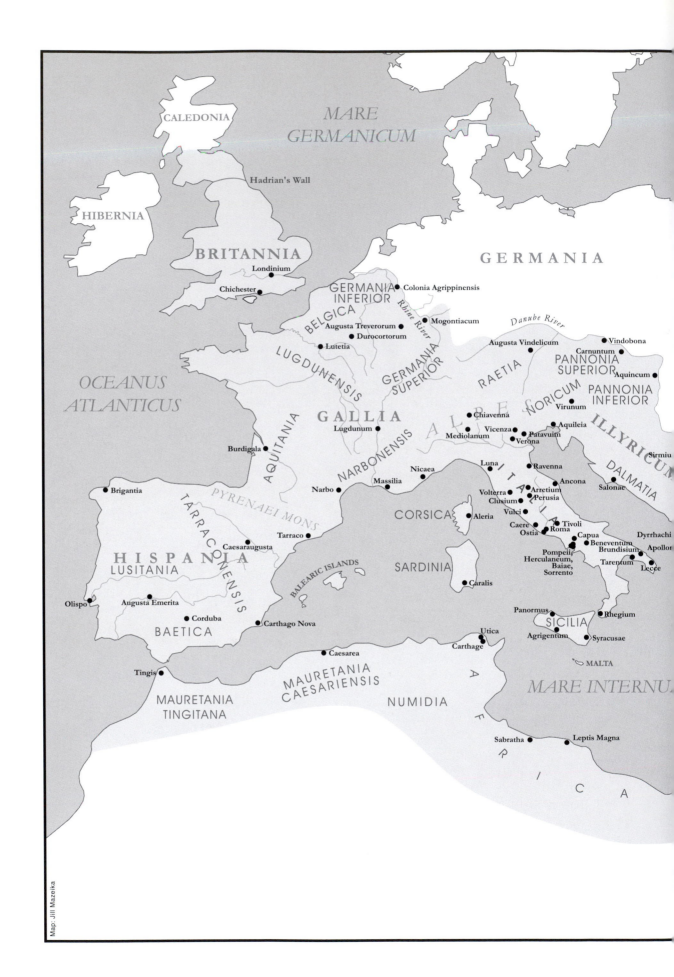

CALEDONIA

MARE
GERMANICUM

Hadrian's Wall

HIBERNIA

BRITANNIA

Londinium

Chichester

GERMANIA

GERMANIA
INFERIOR

Colonia Agrippinensis

BELGICA

Rhine River

Mogontiacum

Danube River

Augusta Treverorum

Durocortorum

Lutetia

LUGDUNENSIS

GERMANIA
SUPERIOR

Augusta Vindelicum

Vindobona

Carnuntum

PANNONIA
SUPERIOR

Aquincum

OCEANUS
ATLANTICUS

GALLIA

RAETIA

NORICUM

PANNONIA
INFERIOR

AQUITANIA

Lugdunum

Chiavenna

Virunum

ALPES

Vicenza

Patavuim

Aquileia

ILLYRICUM

Mediolanum

Verona

Sirmiu

Burdigala

NARBONENSIS

Luna

Ravenna

DALMATIA

Nicaea

ITALIA

Ancona

Brigantia

Narbo

Massilia

Volterra

Arretium

Salonae

PYRENAEI MONS

CORSICA

Clusium

Perusia

Vulci

TARRACONENSIS

Aleria

Caere

Tivoli

Tarraco

Ostia

Roma

Capua

Dyrrhachi

Caesaraugusta

Beneventum

Brundisium

Apollor

HISPANIA

BALEARIC ISLANDS

Pompeii

Tarentum

LUSITANIA

SARDINIA

Herculaneum,
Baiae,
Sorrento

Lecce

Olispo

Augusta Emerita

Caralis

Corduba

Rhegium

Carthago Nova

Panormus

BAETICA

SICILIA

Utica

Agrigentum

Syracusae

Caesarea

Carthage

MALTA

Tingis

MAURETANIA
CAESARIENSIS

A
F
R
I
C
A

MARE INTERNU

MAURETANIA
TINGITANA

NUMIDIA

Sabratha

Leptis Magna

THE ROMAN EMPIRE

0 500 1000

MILES

Miller Cylindrical Projection

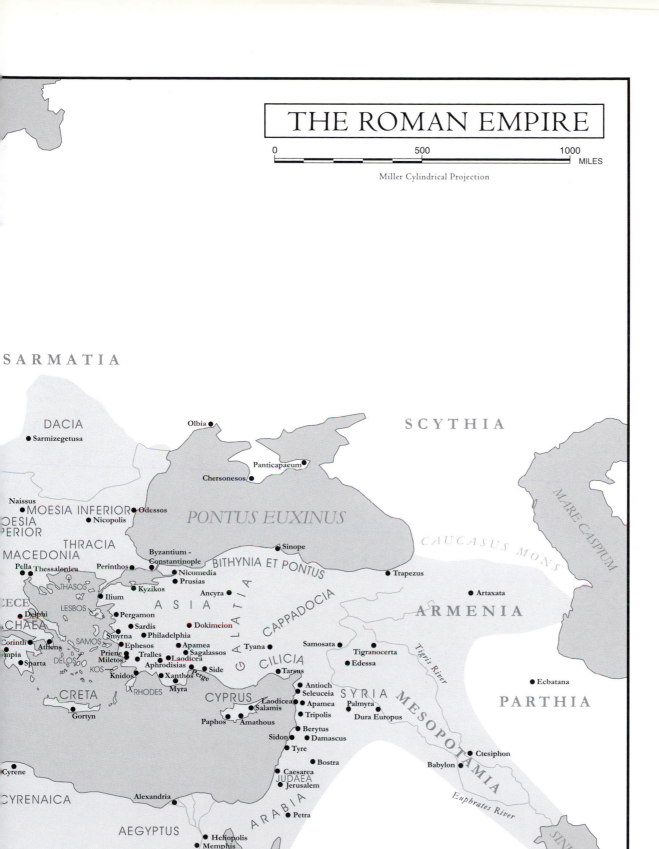

SARMATIA

DACIA

Sarmizegetusa

Olbia

SCYTHIA

Panticapaeum

Chersonesos

Naissus

MOESIA INFERIOR

Odessos

OESIA
ERIOR

Nicopolis

PONTUS EUXINUS

THRACIA

MACEDONIA

Byzantium -
Constantinople

Sinope

Pella

Thessalonica

Perinthos

BITHYNIA ET PONTUS

THASOS

Nicomedia

Prusias

Trapezus

CAUCASUS MONS

MARE CASPIUM

ECE

Kyzikos

Ilium

ASIA

Ancyra

Artaxata

LESBOS

Pergamon

ARMENIA

Delphi

CHAEA

Sardis

Dokimeion

GALATIA

CAPPADOCIA

SAMOS

Smyrna

Philadelphia

Corinth

Athens

Ephesos

Apamea

Tyana

Samosata

Tigranocerta

Tigris River

Ecbatana

mpia

Priene

Tralles

Sagalassos

Edessa

Sparta

DELOS

Miletos

Laodicea

CILICIA

KOS

Aphrodisias

Side

Tarsus

PARTHIA

Knidos

Xanthos

Perge

CRETA

RHODES

Myra

CYPRUS

Antioch

Seleuceia

SYRIA

MESOPOTAMIA

Laodicea

Palmyra

Gortyn

Salamis

Apamea

Dura Europus

Ctesiphon

Paphos

Amathous

Tripolis

Babylon

Cyrene

Sidon

Berytus

Damascus

Tyre

Bostra

Caesarea

Euphrates River

CYRENAICA

Alexandria

JUDAEA

Jerusalem

ARABIA

SINUS PERSICUS

Petra

AEGYPTUS

Heliopolis

Memphis

Fayum

Nile River

SINUS ARABICUS

Thebes

Syene

Berenike

xxix

PORTRAITS

I.
PORTRAIT OF A WOMAN

Late Republican, ca. 40–30 B.C.
Provenance: unknown
Material: Carrara (Luna) marble
Dimensions: h. 31.3 cm., h. of face 16.7 cm., w. of bust
19.4 cm., w. of head 18.6 cm., d. 22.2 cm.
Museum purchase, Fowler McCormick, Class of 1921, Fund
(y1984-77)

CONDITION: *Part of the nose is missing; the entire surface is heavily encrusted and covered with root marks. Smaller damaged sites of modern date are found on the back of the head.*

The head was made for insertion into a statue, bust, or herm in which it was anchored by means of a rectangular dowel on the underside of the bust segment.[1] In its original position, the head must have been inclined slightly toward its left side, as can be supposed because the edge of the chest segment rises more steeply on this side and because the left half of the face is more voluminous than the right half. The face of this no longer very young woman is characterized by broad cheeks and deeply set eyes. Extrapolating from the remains of the nose suggests that it may have been somewhat curved. On the crown of the head, her hair is parted along two lines and gathered into a bulge above her forehead, then collected into a narrow, tapering strand and combed backward to the nape knot, underneath which it has been pinned into place. The remaining hair falls over her temples in soft waves; elsewhere it hangs straight

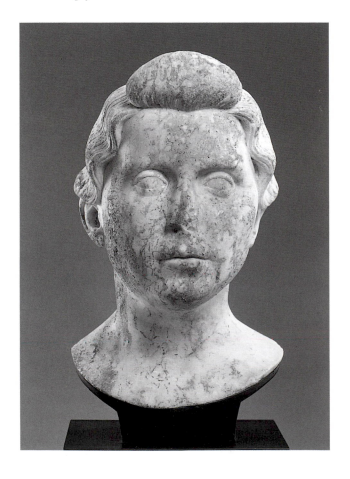 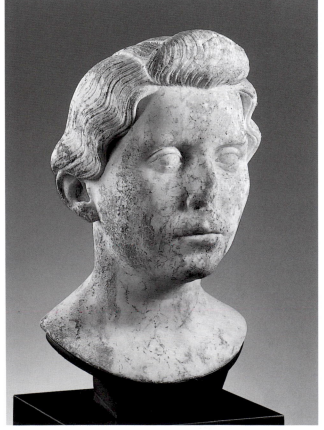

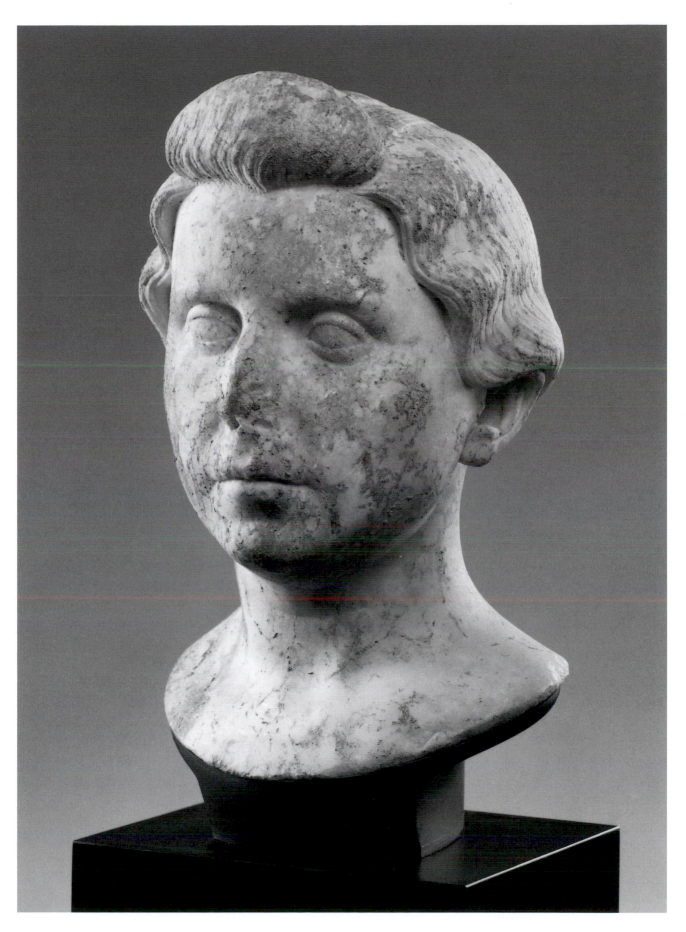

3

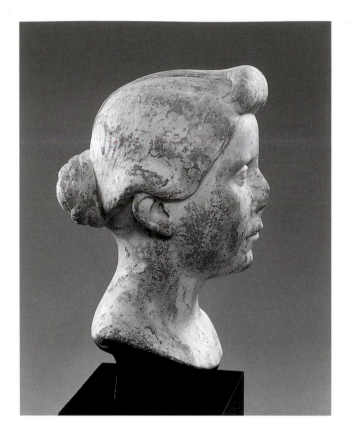
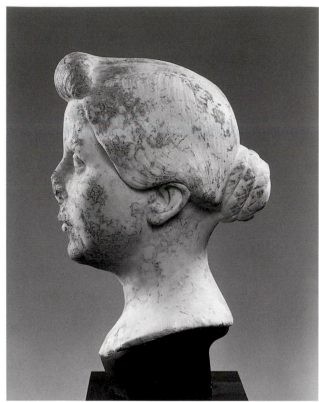

down. Behind the ears, which are not covered by hair, her locks have been gathered into three slender braids which are arranged around the oval knot, whose surfaces have remained unstructured.

This coiffure identifies the portrait as having been sculpted in the 30s of the first century B.C.; close comparisons can been found among the early portraits of Livia,[2] as well as in the portrait of Octavia Minor on the van Quelen *aureus* in Berlin,[3] which was likely struck on the occasion of her marriage to Marc Antony in 40/39 B.C. Unlike the portrait in Princeton, the hair at Octavia Minor's temples is worn in rolled curls. The locks are thus carried as a twisted strand across the upper edge of the ear and down to the nape. The arrangement of this coiffure corresponds to one of the two girls' heads from the tomb of the Licinii[4] preserved in Copenhagen.[5] The two heads, which might represent sisters, have recently been hypothesized to represent the two Scriboniae, the wives of Sextus Pompeius and Octavian.[6] However, the way the hair at the temples is coiffed in second of the girls' busts[7] is closer to the coiffure

in the Princeton portrait. The second girl's hair is combed laterally downward in a flat arc and is not rolled into a curl until after it has been carried behind her ears; these are left uncovered.

All the portraits mentioned here share the characteristically broad and full bulge of hair above the forehead, and all have their nape knots tied in a compact shape and at a relatively high position on the nape. Typologically, these characteristics predate the *nodus*-type of Livia's images which can be dated to the 20s B.C. and which is documented by the well-known head from the Fayum in Copenhagen and associated images.[8] The construction and design of the Princeton head likewise suggest that it was carved somewhat earlier, probably in the decade between 40 and 30 B.C. The outline of the face, which widens considerably as it descends from the forehead to the cheekbones, bears strong similarities to the form of the face in a portrait of an older lady, which is likewise preserved in Copenhagen.[9] The elements of the coiffure on the back of the Princeton head indicate that it was more likely carved during the earlier portion

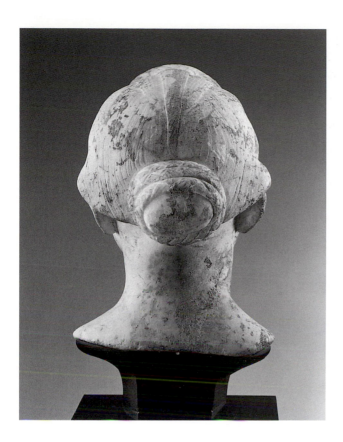

of this time interval.[10] The bust of a woman at the Capitoline Museum also seems to have been carved around 40 B.C.[11] The strongly convex eyes, surrounded by broad lids, and the lively modeling of the mouth zone seem quite comparable to the corresponding features on the Princeton head.

MF

BIBLIOGRAPHY

Selections, 39 (illus.).
Record 44.1 (1985): 45, 47 (illus.).

NOTES

1. For comparable treatment of the chest portion, see, e.g., Felletti Maj 1953, 56, no. 88; 52, no. 81; Fittschen and Zanker 1983–85, 3:40–41, no. 45, pls. 57–58.

2. According to D. Boschung (1993b, 46–47), the group surrounding the basalt head in the Villa Albani and the head in Bonn, which probably dates from around 35 B.C. (see Fittschen and Zanker 1983–85, 3:1, n. 3), may be a simplification or variant of the type represented by the head from the Fayum; E. Bartman (1999, 219–20) shares this view. That the group represents an independent type is an opinion recently expressed by R. Winkes (1995, 35); for the date of the piece, see Winkes 1995, 35. For Livia's portrait types in general, in addition to the studies by Bartman and Winkes, see Fittschen and Zanker 1983–85, 3:1–5, nos. 1–3; Boschung 1993b, 46–47; Winkes 1988, 555–61; Kleiner and Matheson 1996, 53, no. 1.

3. Kent, Overbeck, and Stylow 1973, no. 109, pl. III; Toynbee 1978, 48–50, fig. 54; Hofter 1988, 305–6, no. 142 (illus.) (with additional literature); Winkes 1995, 68–71; Bartman 1999, 59, 213, and fig. 47.

4. On the provenance of the portrait, see Boschung 1986, 257–87, especially 283–84.

5. Poulsen 1962–74, 1:108, no. 69, pls. 118–19; Boschung 1986, 265–68, figs. 3–5; Hofter 1988, 319–20, no. 159 (illus.); Johansen 1994, 166–67, no. 71.

6. Boschung 1986, 285–86.

7. Poulsen 1962–74, 1:109, no. 70, pls. 120–21; Boschung 1986, 265–68, figs. 1–2; Hofter 1988, 319, no. 158 (illus.); Johansen 1994, 168–69, no. 72. In this detail, the Princeton head is also quite closely related to the group of portraits of Livia mentioned above (n. 2).

8. Poulsen 1962–74, 1:65–71, no. 34, pls. 52–54; Johansen 1994, 96, no. 36; Boschung 1993b, 45–47.

9. Poulsen 1962–74, 1:126, no. 98, pl. 174; Johansen 1994, 226, no. 101.

10. See Fittschen and Zanker 1983–85, 3:41, esp. no. 45, n. 4.

11. Fittschen and Zanker 1983–85, 3: no. 46, pls. 59–60.

2.

PORTRAIT OF OCTAVIAN/AUGUSTUS

Augustan period (early to middle), ca. 27–1 B.C.
Provenance: unknown
Material: Carrara (Luna) Marble
Dimensions: h. 40.5 cm., w. 23.2 cm., d. 24.0 cm.
Museum purchase, Fowler McCormick, Class of 1921, Fund
(2000-308)

CONDITION: *Except for some breaks, chips, pits, abrasions, and weathering, the head is fairly well preserved. The nose, broken off to its roots, is weathered. Besides the nose, the most evident areas of wear are the right eyebrow and brow, the upper right eyelid, the upper part of the right eye, the outer edge of the left eyebrow, around the right and left cheekbones, the right side of the upper and lower lips, the chin (especially on the right side), both rims of the ears, along the lower part of the front of the neck, the left side and middle of the nape of the neck, and the back of the tenon. There are some minor chips on the left side of the neck and abrasions on the hair, especially on the fringe of locks over the left side of the forehead.*

Root marks, incrustations, and sinter remains are evident here and there, especially on the lower left cheek, upper part of the left and right side of the neck, and the break on the back of the tenon. The bottom of the tenon was roughly finished with a hand pick. The surface finish of the entire head and hair is dry and rough in places. The patina is a light beige color except for some brownish mottling here and there over the face and neck. Fresh minor chips, especially on the forehead over the right eyebrow and on the left side of the neck, reveal a fine-grained white marble that appears to be from the ancient

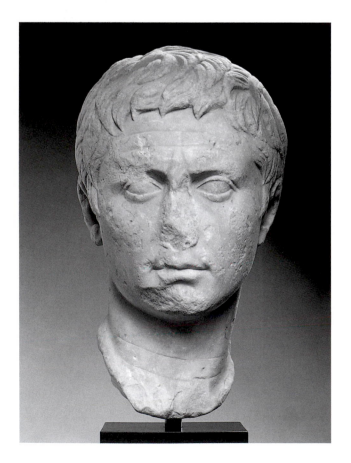

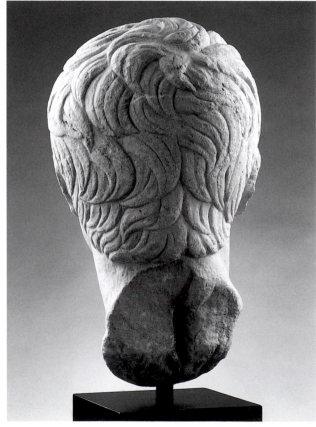

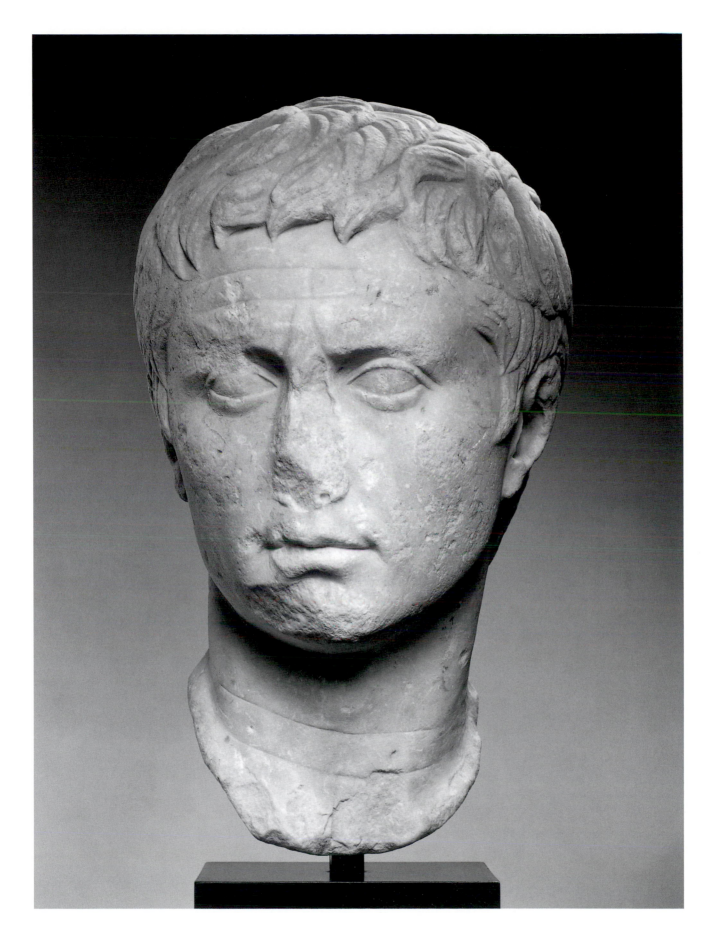

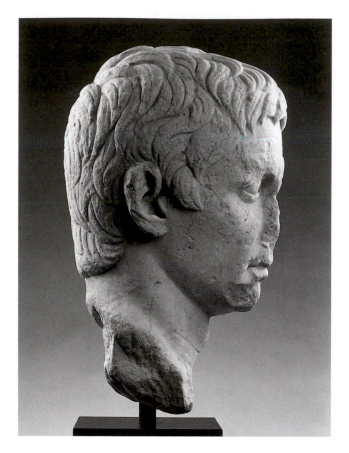
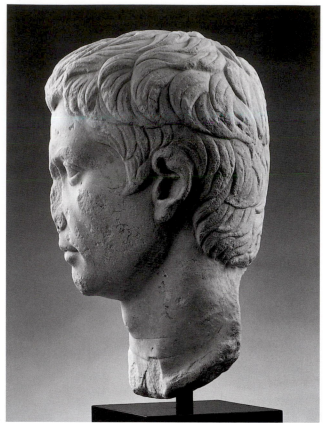

quarries at Luna, more specifically from the so-called Colonnata quarries (Carrara, Italy).[1]

Preserved in the tenon is a vertical drill channel (ca. 6.8 cm. long) with dark iron oxide incrustation. The iron oxide on the broken area surrounding this rusted drill channel indicates that expansion from iron oxidation over a long period caused the marble to fracture and split off from the back of the tenon. That there are the same root marks and patina around the tenon and the nape of the neck as on the rest of the head would be consistent with the iron dowel's being ancient, although bronze was the usual metal employed in antiquity to join marble body parts.[2] A metal dowel to join the head to the now-missing statue body would have provided greater stability than would a fixative, especially since the tenon is so shallow.[3]

This good quality, overlife-sized marble portrait of a Roman is carved fully in the round. The head is turned to its right side. The face is youthful-looking and lean. The cheekbones and Adam's apple are prominent, with skin tautly drawn over the bony structure of the face. Two horizontal furrows line the forehead, and two short diagonal creases above the bridge of the nose accentuate the knitting of the eyebrows. The eyes and chin are somewhat small, while the mouth is of average size with slight creases at the corners. Shallow naso-labial furrows are barely visible by the sides of the nostrils. Remains of a hole in the root of the left side of the nose indicate that the nostrils were drilled.

The hair is conceived as a mass of locks carved compactly in low relief. The fringe of locks is worn high up on the forehead, with a forking over the left eye. From the fork the locks are brushed continuously toward the left side of the head. On the right side of the forehead the hair is formed into five distinct locks. The three over the middle of the forehead are widely spaced, with short tips turning down; the two locks over the outer corner of the right eye

are closer together and more distinctly reverse comma-shaped. The hair locks at the crown of the head form into a whorl pattern that radiates counterclockwise. Below this whorl, along a central vertical axis, the hair is brushed to both sides of the head in three rows of locks, with a forking of the lowermost bank of locks at the nape, just to the right of the middle of the neck.

The base of the neck has a rounded rim (flange) and is roughly worked into a shallow tenon for insertion into a now-missing statue body that was most likely togate or cuirassed. The join where the head would have met the body would have once been masked with a fine marble stucco cement, with the edge of the tunic or breastplate further concealing the join. Such joins were also masked by painting or tinting the marble.

With furrowed forehead, knitted brows, and face averted sharply to the right side, this youthful-looking portrait captures the power, determination, and emotional state of the individual represented. The facial features and iconographic hairstyle clearly identify this emotionally-charged image (*Pathosbild*) as a portrait of Octavian/Augustus Caesar (63 B.C.–A.D. 14).[4] Of the thousands of portraits of Augustus set up throughout the vast Roman empire, considerably more than two hundred have come down to us, with still more remaining to be discovered. There are in fact more extant portraits of Augustus than of any other Roman—or, for that matter, of any other known historical personage of the ancient world—an indication in itself of Augustus's popularity throughout the empire and of his importance as a leader.

The division of Roman portraits into types is primarily based on iconographic hairstyles, especially, in the case of male portraits, the configuration of locks over the forehead. For known historical figures of the Roman period whose portraits have survived in replicas, it is often possible to work out a typological framework that can be useful in dating. In the case of Augustus, five principal types and two subtypes have been established.[5] The original models for the first four principal types (Types I–IV) were created during the Second Triumviral period (44 B.C.–29 B.C.), when he was still known as Octavian and was contending with others for power and hegemony over the Roman world. Only one principal type (Type V) and two subtypes (IV.A and IV.B) go back to prototypes produced after he founded the Principate in 27 B.C.

Based on the iconographic hairstyle and other features, the Princeton head most closely resembles portraits belonging to Type IV. The original model for this type appears to have been created to commemorate Octavian's triple triumph in 29 B.C., the same year in which he closed the doors of the Temple of Janus, heralding a new age of peace and prosperity.[6] Type IV might be called, secondarily, the Triumphator type.[7] One of the best replicas of this type is a marble head, probably originally from Rome, now in the Louvre (MA 1280).[8] In the shape of the face, the proportions of the facial features, and the general age of the individual, the Louvre head compares well with the Princeton portrait. One noticeable difference between the two, however, is the configuration of locks over the forehead: in the Princeton head three widely-spaced locks turn down distinctly, while in the Louvre portrait the central locks are brushed continuously to the right side of the head, except for one lock over the right eye which turns down slightly. The two coupled locks over the outer corner of the right eye of the Louvre head are also significantly smaller than those of the Princeton sculpture. Moreover, the arrangement of hair at the back of the head is only vaguely similar in the two portraits.

The nearest parallel for the Princeton head is another marble replica of Type IV in Mantua.[9] Despite the reworking of the Mantua head in modern times, the important comparative elements are still discernible. In the number and arrangement of locks over the forehead, the Mantua portrait is very like the Princeton head, except that the locks over the outer corner of the right eye are smaller in the Mantua sculpture.[10] Both portraits are alike in the comma-shaped locks in front of the left ear, the bank of large reverse comma-shaped locks extending from the left temple toward the back of the head, the reverse comma-shaped locks fanning down in front of the right ear, the forking of locks high above the right temple, and the forward-brushed locks on the neck behind the ears. The tips of these locks turn down on the left side of the neck and toward the ear on

the right side of the neck. Moreover, in both portraits the configuration of locks behind the right ear is very similar, with one lock at the level of the middle of the ear, a coupled pair of locks at the level of the earlobe, and several locks bunched together at the nape. In both portraits the hair whorl at the back of the head radiates in a counterclockwise manner, with a sweep of long comma-shaped locks down the middle of the right side of the back of the head. On the lower part of the back, the hair locks that fork along a vertical axis in three successive rows are simplified into two rows in the Mantua head, as in another portrait head of the same type in a private collection in Lora del Rio, near Seville.[11]

In the arrangement of locks on the forehead, the Princeton head is also somewhat similar to Type IV.A, a redaction of Type IV that was probably created ca. 17 B.C. under the influence of Type V.[12] The Princeton head, however, lacks the fullness of the classicizing facial features of IV.A, which is best represented by a marble replica in Stuttgart.[13] The Princeton sculpture also differs from Type IV.A, in the arrangement of hair at the sides, back, and top of the head.

Interestingly, the forking of hair locks at the back into three rows along a more or less central axis, including the lowermost row's forking to the right of the middle of the neck, finds its closest parallel in the statue of Augustus from Prima Porta, which is among the finest replicas of Type V.[14] The Princeton head and the Prima Porta portrait are also very close in the configuration of the locks at the top of the head, and to a lesser extent those at the sides. Type V, by far the best known and most widely replicated of Octavian's portrait types, was undoubtedly created to celebrate his becoming *princeps* in 27 B.C. and taking the name "Augustus." For this reason, Type V might also be called, secondarily, the Princeps Augustus type.[15] In Type V the features have been ennobled, projecting a more classicized image of Augustus as everlastingly youthful, an image that was consonant with the concept of a Rome reborn during his Principate. Under this new system of government, the leader of state was neither a king nor a dictator, but a *princeps*, or first citizen (cf. Tacitus, *Annales* 1.9).

In replicas of Type V the planes of the face are generally smooth and the face less angular than in Type IV. The very similar arrangement of hair at the back and top of the head of the Princeton and Prima Porta portraits[16] suggests that the sculptor of the Princeton head may have picked up these features from a replica or clay/plaster model of Type V. Such a mixing or "contamination" (*Typenklitterung*) of features from two different iconographical hairstyles is an indication that the Princeton head dates sometime after the creation of the prototype of Type V in 27 B.C. The modeling and dryness of facial features, the accentuated linear furrows in the forehead, and the form and treatment of the hair locks of the Princeton head would all be in accord with an early to middle Augustan date, essentially the same period as the stylistically similar replicas of Type IV in Mantua and Lora del Rio. JP

BIBLIOGRAPHY

Art of the Ancient World—Volume XI—January 2001 (Royal Athena Galleries, New York 2000), 15, no. 26 (illus.).
Gazette des beaux-arts, 6ᵉ periode, vol. 137 (March 2001).
 La Chronique des arts, 38, no. 158 (illus.).

NOTES

1. I thank Michael Padgett for inviting me to publish this splendid head and for providing me with photos, technical details, and other assistance. This includes supplying me with Professor Norman Herz's report on the analysis of the marble of the head based on a stable isotopic ratio analysis performed at the Center for Archaeological Sciences at the University of Georgia. The isotopic analysis revealed an 80 percent probability that the marble is Carrara (Luna). The fine grain size also supports this provenance, with the Roman Colonnata quarries being the most probable source within the larger Carrara quarries. For the ancient quarries at Carrara, see Dolci 1980; Dworakowska 1983; Dolci 1988, 77–84.

2. Iron dowels were more commonly used for repairs in the 18th and 19th centuries: La Rocca 1983, 66–68, figs. 19, 24.

3. To provide for greater stability of the head cradled in its mortise, ancient tenons were generally made more conical in shape.

4. For the portraiture of Augustus, see Boschung 1993a and the review in Pollini 1999, 723–35. For general histories of Augustus, see *RE* 10:275–381, no. 132 (F. Kizler); Kienast 1982; and Southern 1998.

5. See Boschung 1993a and Pollini 1999 for the typology of Octavian/Augustus.

6. In his *Res Gestae* (*Monumentum Ancyranum* 13), Augustus heralded his bringing peace to the Roman world with the phrase "terra marique . . . parta victoriis pax" [peace brought forth through victories on land and on sea].

7. This was formerly called the Forbes Type after a portrait in the Museum of Fine Arts, Boston: Boschung 1993a, 124–25, no. 34, pl. 46; Pollini 1999, 730.

8. Boschung 1993a, 27–37, 60–65, 129, no. 44, pls. 36–37; Pollini 1999, 723, 727–28, 730, 732, fig. 4.

9. Galleria e Museo di Palazzo Ducale (inv. 6812): Boschung (1993a, 127–28, no. 40, pls. 42.4, 43) dates this head in the early to middle Augustan period.

10. The tip of the lock directly over the inner corner of the right eye also does not turn down as distinctively in the Mantua sculpture as in the Princeton portrait, but this lock in the Mantua head appears to have been slightly damaged and reworked.

11. Boschung (1993a, 126–27, no. 38, pl. 41) dates this portrait in the early to middle Augustan period.

12. Type IV.A was probably created in connection with the *ludi saeculares* [secular games] of 17 B.C. This subtype first appeared a year later on the coins of the moneyer L. Vinicius (Boschung 1993a, 60–61, pl. 239.2–3 [16 B.C.]; Pollini 1999, 727–28). The second and apparently last subtype (Type IV.B) could have been produced either during Augustus's lifetime (probably after ca. 13 B.C.) or shortly after his death in A.D. 14. In either case, this last subtype, which does not closely resemble the Princeton portrait, seems never to have been popular, judging from the very small number of replicas that have come down to us.

13. For the Stuttgart Replica Group: Boschung 1993a, 32–37, 63, 135–36, no. 58, pls. 52–53; Pollini 1999, 728–31, fig. 6.

14. Boschung 1993a, 38–59, 60–65, 179–81 (cat. 171), pls. 69–70, 82.1 (top of head); Pollini 1999, fig. 5. For the Prima Porta statue of Augustus and the ideology embodied in it, see Pollini 1995, 262–82.

15. Pollini 1999, 730.

16. See, e.g., one of the best replicas of Type V, a portrait head of Augustus in the Kunsthistorisches Museum in Vienna: Boschung 1993a, 193, no. 206, pl. 71. Cf., however, a replica of Type V in Syracuse (Boschung 1993a, 188, no. 195, pl. 72), in which the forking of the hair at the back is found in two instead of three rows, a feature also found on the two replicas of Type IV mentioned above (Mantua [above n. 9] and Lora del Rio [above n. 11]).

3.

HEAD OF A WOMAN, RECARVED FROM AN EARLIER HEAD

Tiberian, ca. A.D. 14–37
Provenance: unknown
Material: fine-grained white marble
Dimensions: h. 29.5 cm., w. 17.5 cm., d. 17.8 cm.
Museum purchase, gift of John B. Elliott, Class of 1951
(y1989-55)

CONDITION: *The head is in a relatively poor overall condition. A small section of the front of the neck is broken off. The tip of the nose is missing. There is a shallow groove arching over the back of the head from side to side. The surface of the head is very eroded and grainy, indicating that it probably stood outside. Details of the face and coiffure are worn away or flattened. The surface of the earlier face is in better condition, confirming that*

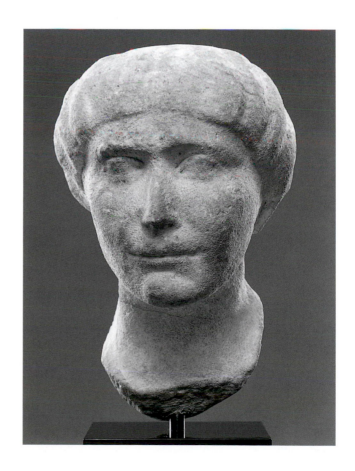

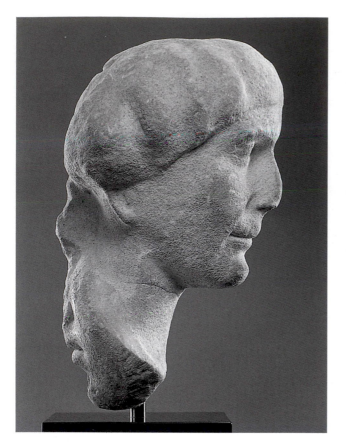 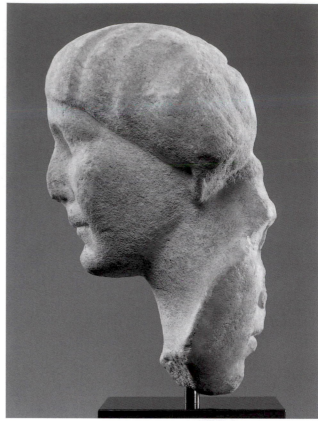

it was protected through insertion into a body, but the face itself is extremely damaged: lost are the forehead, ears, nose, left eye, and left eyebrow. A deep hole in the chin of this face was drilled beneath the lower lip for the metal pin that secured the later head within the statue. Reddish stains in the hole were caused by rust from this pin.

Recarved from an earlier work, this nearly life-sized female head is shaped at the base of the neck in a manner suggesting that it had been inserted into a separately wrought body. The earlier head, whose face is preserved at the bottom of the bust, facing backward, seems to have worn a helmet or a crown, thus providing ample material for recarving. By virtue of its very shape, the earlier face lent itself to be used as a tenon matching a mortise in the body. The face of the later, recarved head is broad and oval-shaped. The eyes are large and not deeply set, and the pupils are not incised. The brows follow the shape of the eyes from the outer corner inward but

then nearly merge above the woman's nose. The forehead is short because it is covered by hair, which also partially covers the ears. The woman wears a typical Tiberian hairstyle: wavy, parted in the middle, and loosely gathered into a short, braided chignon below the nape. The nose is thin, and although somewhat damaged, still rather prominent. The mouth is closed and has fine, protruding lips delicately carved in a gentle smile. The naso-labial lines are not very pronounced. The profile views reveal smooth, fleshy cheeks, a strong chin, and a pouting upper lip. There is little emphasis on the cheekbones. In these views the flatness of the top of the head, which is the result of the insufficient amount of carving material available from the earlier head, is apparent. The head was probably intended for frontal viewing.

The gender of the earlier head is unclear, but female seems the likelier possibility. Its face is wide, with a small chin and full, fleshy lips. It has been suggested that this could have been the head of an

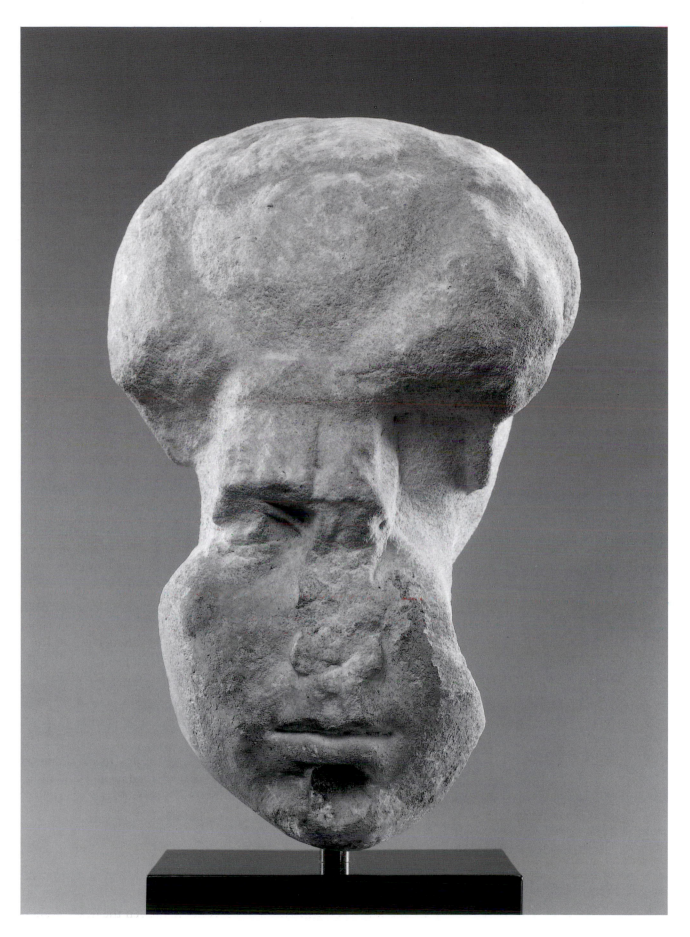

Athena wearing her helmet far up on her head, or, should the piece hail from Egypt (see below), a head with a wig or crown.[1] However, the extensive damage it suffered does not allow for a conclusive dating or identification.

The later portrait is of a private individual and reveals similarities with several male and female heads from the Tiberian era. A portrait of Tiberius himself, in the Ny Carlsberg Glyptotek, Copenhagen, shares certain characteristics with the Princeton head.[2] In both portraits the eyes are large and rounded in a comparable fashion, and there are commonalities in the treatment of the eyebrows and the smoothness of the cheeks. The softly incised naso-labial lines are similar, as are the prominent chins, the relation of upper to lower lip, and the indication of a slight double chin.

A female portrait in the Capitoline Museum displays numerous Tiberian characteristics that compare well.[3] The most obvious are the wavy, parted coiffure tied in the back, the large shallow eyes, the smooth cheeks, the long thin lips, the small forehead covered with hair, and the partial covering of the ears. A head of a Roman lady in the Ny Carlsberg Glyptotek is close to the Princeton portrait in the treatment of the eyes and eyebrows, the shape of the nose, the thinness of the lips, and the emphasis put on the chin.[4] The cheeks are smooth in both instances, and only a small portion of the forehead remains uncovered. This portrait best confirms the Tiberian date of the Princeton head. A Claudian date can be completely rejected if one observes the development of female hairstyles, which become much more elaborate and curly.[5]

While the way in which the earlier head was reused seems quite unique, there are several male and female portraits that have been recarved from earlier heads or architectural members.[6] Two additional examples can be found in the Princeton collection: a Flavian male head recarved from an anta capital (cat. no. 6) and another Flavian male recarved from a portrait of Nero (cat. no. 5). The more radical recarvings might be indicative of a shortage of marble in their areas of origin. For the Princeton woman, this may suggest Egypt as a possible provenance.[7]

NA

BIBLIOGRAPHY
Varner 2000, 220–23, no. 58.

NOTES
1. For an example of a helmeted head of Athena, cf. another Julio-Claudian head at Princeton (y178), described in Ridgway et al. 1994, 53–56, no. 15. Varner (2000, 220) suggested that the original head might have represented Minerva or Mars. For an example of a suitable Egyptian crown, cf. Meyer 2000a, figs. 126–27.
2. Inv. 1750; Johansen 1994, 118–19, no. 47.
3. Inv. 373; see Fittschen and Zanker 1983–85, 3:45, no. 55, pls. 70–71.
4. Inv. 742; Johansen 1994, 178–79, no. 77.
5. One example is a portrait in the Ny Carlsberg Glyptotek (inv. 755); Johansen 1994, 150–51, no. 63. On the development of Julio-Claudian hairstyles, cf. Polaschek 1972; Boschung 1993b.
6. For a discussion of some of the reasons behind the reuse of earlier works, see Kinney 1997. Cf. also Meyer 1991, kat. I 27, 60; Meyer 2000a passim.
7. See Antonaccio 1992, 444–45.

4.
HEAD OF A CHILD

Caligulan or Claudian, ca. A.D. 37–54
Provenance: unknown
Material: white marble with a yellowish patina, perhaps
Carrara (Luna)
Dimensions: h. 17.6 cm., w. 13.9 cm., d. 14.6 cm.
Museum purchase, John Maclean Magie and Gertrude Magie
Fund (y1952-63)

CONDITION: *The fracture runs through the neck just below the chin. The tip of the nose, the left eyebrow, and the edge of the right ear are damaged; the head is covered with root marks and has thick crusts of sinter on the upper side of the crown.*

This little head represents a two- or three-year-old child with short curly hair. Because the statue or bust to which the head once belonged has been lost, it is impossible to determine the gender of the child.[1] Ever since the first discussion of this head, scholarly literature has repeatedly claimed that it represents a boy, but there are no unambiguous reasons to support this claim: children of both genders are depicted with short hair. Likewise without indubitable justification is the supposition that the head is a portrait. Most recently, it has been suggested that the

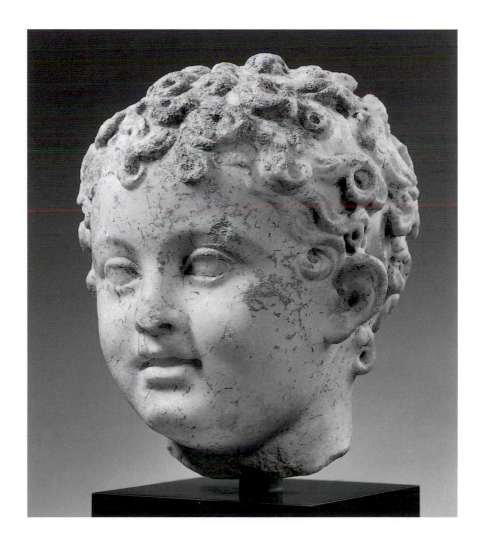

15

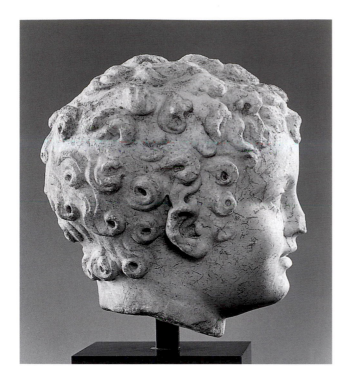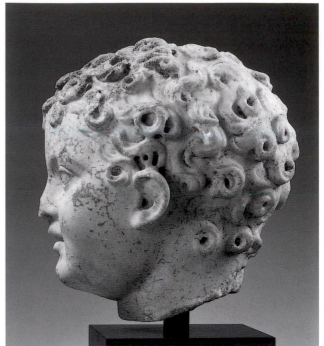

head is the portrait of a boy from the Julio-Claudian period.[2] The proposed reasoning was that although curly hair is seldom seen in depictions of children from this period,[3] the two curls which lie somewhat low on the forehead and which curl in opposite directions can be derived from the "fork-and-pincer" motifs that characterize the portraits of Augustus's grandsons, Gaius and Lucius Caesar.[4]

The majority of boys depicted in portraits from the Julio-Claudian period have straight hair which has been cut in steps or at least an individual physiognomy.[5] Neither is present in the Princeton head: the idealized features are entirely without any suggestion of individualized portraiture of the sort that can be clearly seen, for instance, in the portrait type that allegedly depicts the two- or three-year-old Britannicus.[6] The two conspicuous ringlets on the forehead are not necessarily indicative of a portrait, since strands of hair which have freed themselves from the coiffure are especially characteristic of generic depictions of children.[7] It can therefore be asserted that the little Princeton head is an "ideal" representation of a child whose identity can no longer be determined.[8]

Within the context of the stylistic evolution of depictions of children, the most evident connection seems to be with certain late Hellenistic examples.[9] The round and pudgy cheeks, the comparatively small eyes, and the lack of tension in the composition of the forms are well paralleled by a small head from Amathous, on the island of Cyprus.[10] It seems more likely that the Amathous head was created in the first century A.D. rather than in the late fourth.[11] Another head in Geneva seems to be extraordinarily closely related,[12] but its poor condition precludes the possibility of knowing whether it is a replica of the Princeton child's head and also makes the date of its creation impossible to determine.

The pointedly accentuated, rolled curls on the little Princeton head indicate that it was carved during the Caligulan-Claudian period.[13] M F

BIBLIOGRAPHY
Jones 1960, 61 (illus.).
Record 12.1 (1953): 38.
J. Allen in: Kleiner and Matheson 1996, 143, no. 76.

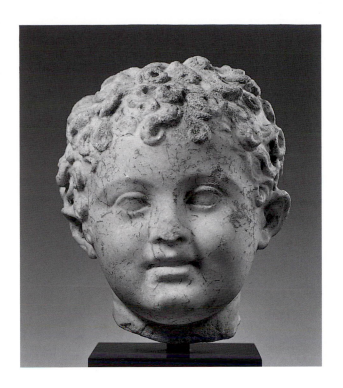

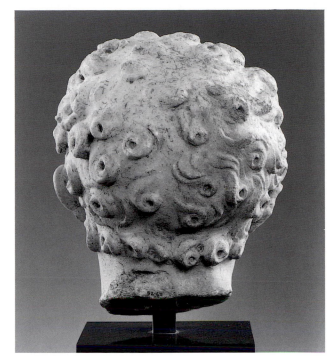

Notes

1. In most cases, the gender is evident only when a body is combined with the head. The gender of a child's head is certain only when the hair is long and tied upward, a hairstyle limited to girls. See Vorster 1983, 87; Amedick 1991, 381–82.

2. J. Allen in: Kleiner and Matheson 1996, 143, no. 76.

3. Ibid. The reference to the curly coiffure of the boy on the arm of the statue in the Louvre that has been associated with Messalina (Kersauson 1986, 1:200–201, no. 94) should be ignored because the head has been restored in modern times.

4. See Fittschen 1977a, 34–40, no. 12; Pollini 1987; Boschung 1993b, 52–54.

5. Despite its unusual coiffure, the curly-haired head of a boy from Tralles in Berlin (Özgan 1995, 80–86, no. TR.35, pl. 20.1–2), for example, is recognizable as a portrait from this era because of its physiognomy; the suggested identification with Nero as a small boy is entirely hypothetical. The portrait of an infant in Petworth (Amedick 1991, 382, 392–93, pl. 103) is also unambiguously characterized as such, as are other portraits of small children (Amedick 1991, 393–94, pl. 104); also see Mlasowsky 1992, 112–21, no. 11 and Gercke 1968, 151–57.

6. Amedick 1991, 373–95, pls. 95–104; on this, see Boschung 1993b, 75.

7. Cf., for example, the wrestling boy in the Lateran: *EA*, 2197; Klein 1921, 34–35, fig. 10; Vorster 1983, 165–66; 234–35; Söldner 1986, 49–52, 142. Boy carrying pitcher: Söldner 1986, 132–62 (with literature). Boy strangling goose: Vorster 1983, 166, 237 (with literature). Girl from Fethiye: Özgan 1979, 39–45, pls. 6–9; on this, see Vorster 1983, 242–43.

8. In this context, it should be noted that Suetonius (Caligula 7) mentions that, after an early death, a child of Germanicus and Agrippina was depicted as Cupid. On the phenomenon of the deification of children, see Wrede 1981, 105–16.

9. For more, see Vorster 1983, esp. 242–43.

10. Hermary 1983, 292–99, figs. 5–8.

11. Hermary's dating (1983, 298) in the late fourth century is not convincing. As far as composition and plasticity are concerned, cf., e.g., Vorster 1983, 386, no. 165; 392, no. 185 and a head in Cambridge: Budde and Nicholls 1967, 38–39, no. 66, pl. 20; also cf. Vorster 1983, 243. The hair design is comparable to that found on portraits dating from the middle of the first century B.C.; see, e.g., Berger 1980, pl. 20.2,4; 21.2–4; also Fuchs 1999a, 65–66, with additional examples.

12. Chamay and Maier 1989, 2:53–54, no. 65, pl. 70.

13. See, above all, the portraits of Agrippina Major (Fittschen and Zanker 1983–83, 3:5–6, no. 4, pls. 4–5; Beilagen 1–2, 3a-b) and Antonia Minor (Fittschen 1977a, 61–62, no. 19, pl. 21).

5.

Portrait of a Man, Recarved from a Portrait of Nero

Flavian, ca. A.D. 69–96
Provenance: unknown
Material: white marble with yellow patina.
Dimensions: h. 33.8 cm., w. 18.2 cm., d. 27.0 cm.
Museum purchase, gift of the Friends of The Art Museum
(y1963-30).

CONDITION: *Old damage is found on the tip of the nose, the edges of the ears, and the right eyeball; new damage is present on the bridge of the nose, right eyebrow, left cheek, right ear, and in the hair behind the right ear. Traces of incrustation are found on the face and on the hair on the forehead; root marks are present on the back of the head.*

Carved for insertion into a statue, this head depicts a young man whose hair is curled into bulging ringlets. These have been carved, albeit only imprecisely, on the forehead and temples; the mass of hair on the crown of the head and adjoining the left side of the profile is not subdivided and has been left in a coarsely carved state. The coiffure on the right half of the back of the head, by contrast, consists of tiered strands of hair that obviously correspond to an earlier condition of the portrait. In that state the hair grew far down the neck and was shortened in the process of recutting. A blunt attempt has been made to create the impression of a backward-bulging cranium, which is not uncommon in heads with a hairstyle of this type, fashionable during the head's second phase of existence. The results of the recutting are particularly crude behind the left ear and at the nape of the neck. Only in the area to the left of the right ear did the artist bother to smooth the surface of the skin after recarving had removed hairtips belonging to the original coiffure.

The rendering of the hair on the crown gives rise to the supposition that the sketchily indicated, bulging locks of hair on the front may have been completed in plaster.[1] The resultant suspicion that this piece might be of Egyptian origin is supported by the individual's curly-haired coiffure and facial features—emphatic cheekbones, broad nose bridge, and upturned upper lip. This slightly exotic-looking physiognomy probably has its best parallels in two painted portraits on a tondo in Cairo.[2] The angular course of the hairline next to the temples is another characteristic that suggests a link to a North African ethnic group.[3] This feature is very similar to the corresponding detail on an almost completely intact statue of a man clad in a mantle, also preserved in Cairo.[4] The gaunt, bony face of the man in the latter portrait not only shares the same phenotype as the Princeton head,[5] but also has a strikingly similar facial expression.

P. Graindor's suggested dating for the mantle statue in Cairo—the latter years of the Trajanic era[6]—seems to be too late. The firm rendition of the figure's flesh and muscles, the design of the eyelids, and the severe, careworn facial expression are indicative of portraits dating from the latter years of the first century A.D.[7] The Princeton head will have been carved somewhat earlier.[8] A *post quem* dating is provided by the remnants of the original coiffure on the right half of the back of the head. The arrangement of the strands, which alternate their direction in stepwise fashion, directly corresponds to the pattern in the last portrait type of Nero:[9] in the uppermost of the still-recognizable zones, the hair points toward the left half of the head, followed by a row pointing in the opposite direction, which, in turn, is succeeded by a narrower row that again points the other way; the central portion of the long hair on the nape, at the point where the forward-combed, sickle-shaped locks separate, is marked by a curvaceous lock.[10]

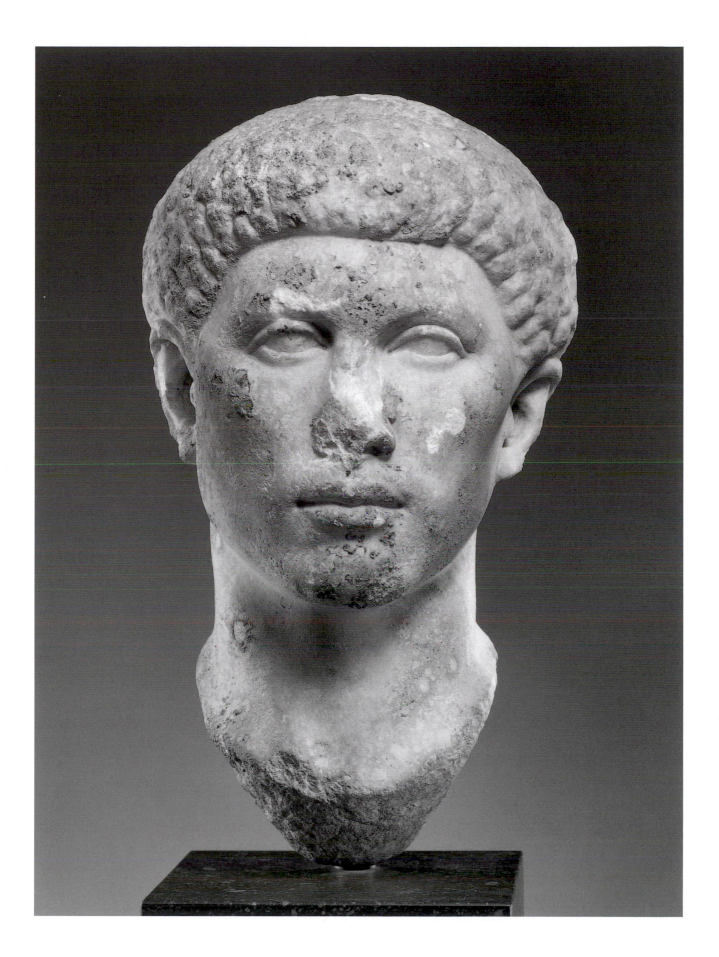

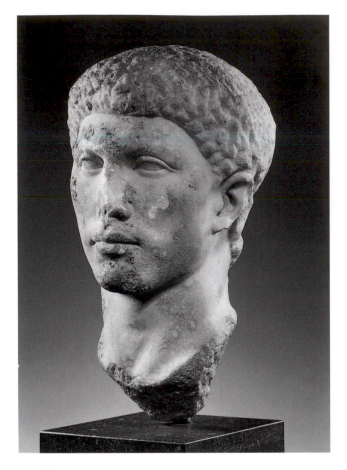

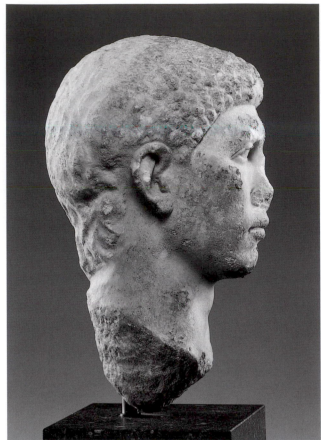

The Princeton portrait thus has been reworked from a portrait of Nero, and more precisely, a replica of the emperor's last portrait type, created in A.D. 64. The death of the *princeps* in the year A.D. 68 thus provides a *terminus post quem* for the creation of the sculpture. Stylistic considerations argue for a date in the Flavian era. The design of the eyes, with the upper lids extending far outward to the sides, and the flat, disklike eyeballs can be compared to portraits of Domitian[11] and Titus.[12] The structure of the skull, too, with a forehead that narrows as it rises and curves in a convex arc toward its center, evinces parallels with likenesses of these emperors, as well as with contemporary portraits of private individuals.[13]

MF

BIBLIOGRAPHY

Hesperia Art Bulletin 24 (no year given), no. A4.
Kelleher 1963, 46, fig. 2.
Record 23.1 (1964): 30; 23.2 (1964): 35.
Cain 1993, 71–72; 196–97, no. 75, pls. 15–16.

NOTES

1. Similar sketchlike treatment of the hair is evident on a portrait head from Alexandria, now preserved in the British Museum (Smith 1904, 3:154, no. 1888, pl. 15; Jucker 1983, 147–48, pl. 18.1–2), and on another head, likewise of Egyptian provenance, now in Berlin (Blümel 1933, 16 R 36, pl. 26; *ABr* 1137/38; Kiss 1984, 150, figs. 106–7; Trillmich 1982, 297–300, figs. 185–86).

2. Parlasca 1966, 70–71, pl. 19.1.

3. For more on this, see Trillmich 1982, 297, with additional examples.

4. Graindor 1938, 93–95, no. 42, pls. 35–36; Grimm 1975, 20, no. 20, pls. 29, 31, 34, and 35. For more on this kind of coiffure, see also NFA Classical Auctions: *Egyptian, Near Eastern, Greek and Roman Antiquities* (New York, Dec. 11, 1991), no. 160 (illus.).

5. For portraits of "foreigners," see also Balty 1993, 17–18.

6. Graindor (1938, n. 369) mentions a portrait in the Capitoline Museum (Stuart Jones 1912, 210, no. 73, pl. 51), but this portrait's style suggests a later origin, probably late Hadrianic (see Daltrop 1958, 59–60, 61–62, 90–91, 121).

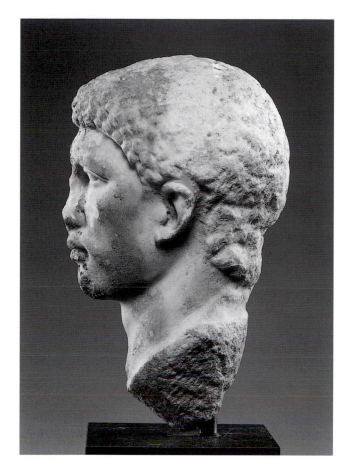

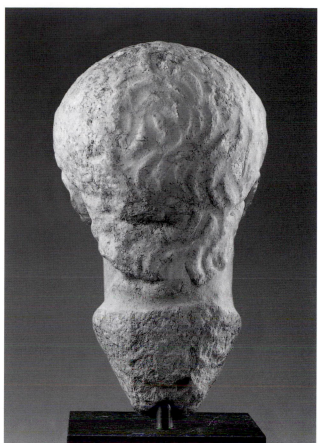

7. Cf., e.g., Cain 1993, 172–73, no. 54, pl. 39; 182–83, no. 63, pls. 43–44; 213–14, no. 88, pls. 35–36; see also Amelung 1903–56, 2:537, no. 350, pl. 70; Daltrop 1958, 128.

8. Cain (1993, 71–72, 197) dates the portrait in the Neronian period. She includes it in the series of portraits with *anuli* coiffures without, however, mentioning the ethnic peculiarities. It is difficult to understand the reasoning behind her evaluation of the high-quality head of a young man with a curly-haired coiffure in Boston (Comstock and Vermeule 1976, 214–15, no. 339; Vermeule 1990, 39–41, fig. 2), to whom she denies any and all Negroid features, which Balty (1991, 17) again confirmed. Cain assigns this portrait to the precursors of the *anuli* coiffure portraits and compares it to a portrait from the tomb of the Licinii (Poulsen 1962–74, 1:110, no. 73, pls. 126–27).

9. In general, see Hiesinger 1975, 113–24. On the last type, see Bergmann and Zanker 1981, 326–32 (illus.); Fuchs 1997, 83–96, pls. 6–11.

10. Cf. esp. the Nero in Munich (Bergmann and Zanker 1981, fig. 9d). The head in Worcester (Bergmann and Zanker 1981, fig. 10a–d) shows the same arrangement in the three lower zones, which could be significant for the evolution of the individual phases of its reworking; for more information on this point, see Bergmann and Zanker 1981, 330–31.

11. Daltrop, Hausmann, and Wegner 1966a, 36–37, 103, pl. 32a–b; Bergmann and Zanker 1981, 369–70, fig. 40; Daltrop, Hausmann, and Wegner 1966a, 33–34, 107, pl. 28a–b; Bergmann and Zanker 1981, 354–56, fig. 28a–d; see also Bergmann and Zanker 1981, 350–52, fig. 25a–d.

12. Fittschen 1977a, 63–67, no. 21, pls. 23, 24.4; Daltrop, Hausmann, and Wegner 1966a, 85–86, pl. 13; 20–21, 94, pl. 16d; 24, 29, 89–90, pl. 17a–b.

13. Cf., e.g., a portrait bust in the Louvre (Cain 1993, 194–95, no. 72, pl. 23; Kersauson 1996, 2:24–25, no. 3), or another in Budapest (Daltrop 1958, 84, 113, fig. 4).

6.

PORTRAIT OF A MAN, RECARVED FROM AN ANTA CAPITAL

Late Flavian, ca. A.D. 79–96
Provenance: formerly in the Morgan Collection, Pullborough
(Essex)[1]
Material: grayish brown, coarsely crystalline marble
Dimensions: h. 37.7 cm., h. of face 20.7 cm., w. 22.6 cm.,
d. 22.2 cm.
Museum purchase, Carl Otto von Kienbusch, Jr., Memorial
Collection Fund (y1953-25)

CONDITION: *The head has been recarved from an anta capital whose original surface is still preserved on the back side, on the crown of the head and, in part, on the underside. The underside, which has been slightly hollowed, has a large, four-sided dowel hole and remnants of plaster. Material has been lost from the front edge of the bust; one portion has been broken off and later pasted onto the remaining stump of the right shoulder. With the exception of the anta capital, the surface is severely weathered. Brownish deposits are present on the upper and lower sides of the head and on the left half of the back of the head.*

Crafted for insertion into a sculpture, this head of a middle-aged man has been worked from an anta capital whose appearance can be inferred from the remnants of the original surface still present on the back side and, in part, on the upper and lower sides. The middle of the front was occupied by a double volute above a broad acanthus leaf; the corners were ornamented with winged creatures[2] whose lower portions were likewise covered by acanthus leaves. Wings also framed the (no longer preserved) central motif on the narrower sides, but it cannot be determined whether or not they were part of single-headed, double-bodied creatures whose heads occupied the front corners.[3] The sole clue, and a vague one at that, to the dating of this anta capital lies in the design of these wings:[4] the sculpturally rounded cover feathers, arranged serially opposite one another, are also found in depictions of eagles on altars[5] and urns[6] dating from the late Neronian to the Flavian period.

The marble surface of the anta capital is much less weathered than the surface of the portrait, which

was carved subsequently. This can be interpreted as an indication that parts made of stucco or plaster were affixed at these places. Further evidence in favor of this supposition is provided by the coarsely pecked indentations on the crown of the head, which were probably incised here so that the malleable added material would cling more firmly to its marble substrate.[7] This detail of the craftsmanship suggests that the head originated in a region poor in marble and is characteristic, for example, of Cyrenaïca, and especially of Egypt.[8] Although the head shows no typically Egyptian phenotypic characteristics, the portrait's emphatically realistic depiction and its somewhat coarse execution both suggest that it may indeed be of provincial Egyptian origin.[9]

The head, which must have been anchored in a bust or statue by means of a strong dowel,[10] has been comprehensively discussed by C. M. Antonaccio, who dated it to the middle or third quarter of the first century A.D. She compared it with portraits of Vespasian[11] and, indeed, a strong physiognomic resemblance exists between this individual and the first Flavian emperor, especially in the deep wrinkles above the root of the nose and around the mouth, and in the hollowed cheeks. All these traits are conspicuous in a portrait of Vespasian from Ostia, now preserved in the Museo delle Terme.[12] The curving, arc-shaped eyebrows, too, are oriented according to the iconography associated with Vespasian,[13] although the eyes themselves refer back to the Julio-Claudian style.[14]

The Princeton portrait, whose execution is somewhat coarse, most closely resembles a colossal head

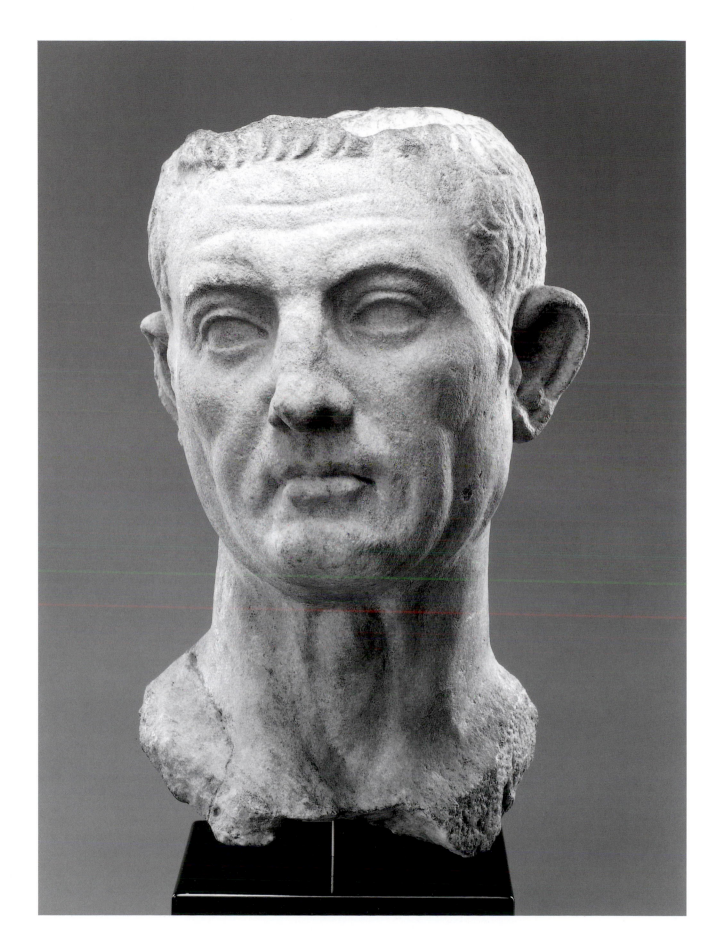

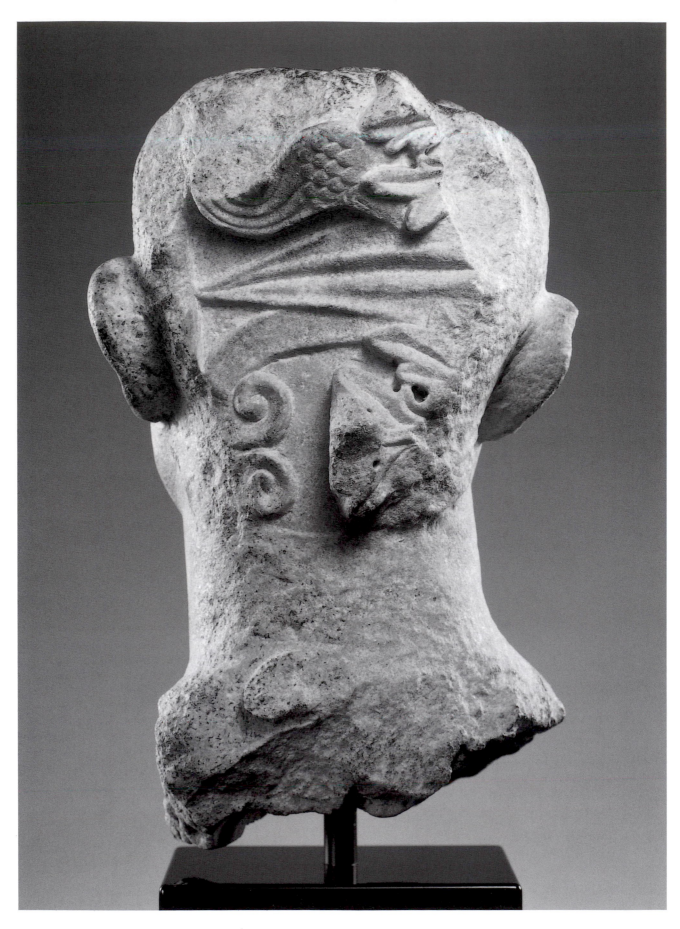

24

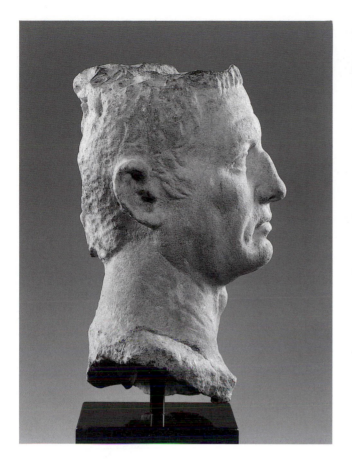

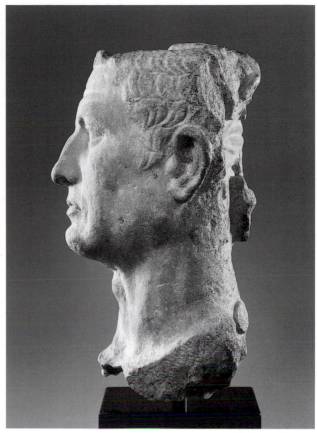

of Vespasian in Alexandria.[15] Like the comparable head of Vespasian on Cancelleria relief B, which was recarved from a portrait of Nero,[16] and the portrait in the Museo delle Terme,[17] discussed above, the Princeton head, too, was very likely crafted after Vespasian's death.[18] This would mean that the late Flavian era would be the most likely date for the creation of the Princeton head.[19]

Antonaccio argued that the Princeton head originally served a funerary function, pointing to the use of Corinthian capitals of the same dimensions—and of sphinxes and griffins—in Alexandrian tomb contexts, the discovery of reworked portraits in the necropoleis of Alexandria, and the "conservative stylistic tendencies" in Egyptian funerary sculptures,[20] but her arguments are unconvincing. Although this portrait undoubtedly depicts an important and admired private individual of the Flavian period, the question of where it was originally exhibited will have to remain unanswered. MF

BIBLIOGRAPHY

Antiquités égyptiennes, 73, no. 472 (illus.).

Record 13.2 (1954): 62.

Vermeule 1955, 350.

The Carl Otto von Kienbusch, Jr., Memorial Collection, exhib. cat., The Art Museum, Princeton University (Princeton 1956), 26 (illus.).

Vermeule 1964a, 111–12.

Antonaccio 1992, 441–52.

Kinney 1997, 117–48, figs. 1–2.

Varner 2000, 224–27, no. 59.

NOTES

1. The head was acquired for the Morgan Collection in 1905, when the P. Philip collection was auctioned in Paris (see *Antiquités égyptiennes*, 73, no. 472).

2. Whether or not these were sphinxes cannot be determined with certainty (see Antonaccio 1992, 443–44). For more information on such *spolia*, see Kinney 1997.

3. Albeit in greatly simplified form, the composition corresponds to that found on the capital of the small

Top

Bottom

propylaia of Eleusis; see Mercklin 1962, 251–52, figs. 1171–74; Antonaccio 1992, 445, fig. 7. On capitals with double sphinxes, see Mercklin 1962, 256–59.

4. A comprehensive discussion of this is found in Jung 1986, 16–28.

5. Cf., e.g., an altar (probably carved during the Flavian period) in the garden of the Villa Mattei in Rome: Boschung 1987, 43, series 7; 85, no. 248, pl. 5; or a late Neronian/early Flavian altar in the Uffizi in Florence: Boschung 1987, 66 I 89; 97, no. 651, pl. 17.

6. Sinn 1991, 79–82, nos. 46–48, figs. 133–39; 105, no. 91, fig. 225; Sinn 1987, 147, no. 221, pl. 42e–f; 155–56, no. 258, pl. 46e–f.

7. So also Antonaccio 1992, 443.

8. Rosenbaum 1960, e.g., 37, no. 5; 40, no. 10. On augmentations on Egyptian pieces, see Kyrieleis 1975, 130–36; examples are cited by Strocka (1967, 123–25) and by Hoffmann (1969, 329, fig. 10a-b); also see Jucker 1983, 139–49 and 1981a, 667–724; Delivorrias 1993, 214–15, figs. 21–22; Antonaccio 1992, 444–45.

9. See Trillmich 1982.

10. See the description of the condition.

11. See Wegner 1966a, 9–17; Bergmann and Zanker 1981, 332–49.

12. Wegner 1966a, pl. 4. Bergmann and Zanker (1981, 334) regard the portrait as a variant of the second type of the emperor; see also Cambi 1984, 82–88, pl. 3.

13. In addition to the previous note, also compare, for example, the head cited in Wegner 1966a, pls. 5, 6a–b.

14. Rather small, slightly squinting eyes, deeply set in the wrinkled face are characteristic of the portrait of Vespasian. Lively surface design, seemingly not unlike that found in the Princeton portrait, is also evident on some heads of Claudius, e.g., the one in the Palazzo dei Conservatori (Jucker 1981b, 274–77, figs. 44–47), or another in the Kestner Museum, Hannover (Jucker 1981b, 277–81, figs. 48–52; Mlasowsky 1992, 90–91, fig. 14). For the treatment of the mouth, cf. also a portrait of Tiberius from Lower Egypt in Toronto: Jucker 1981a, 689–90, fig. 18a–b; Antonaccio (1992, 448) also sees affinities to portraits of Tiberius and Claudius.

15. Graindor ca. 1938, 47–48, no. 7, pl. 7; Grimm 1976, 101–3, pl. 20.1; Jucker 1981a, 698–702, fig. 25a-d.

16. Wegner 1966a, pl. 5; Meyer 2000a, 131–32, figs. 243, 245–46.

17. Above n. 12.

18. Jucker 1981a, 699.

19. Antonaccio (1992, 448–52) compares portraits from the first century B.C. to the Flavian period and, after some hesitation, decides in favor of the above-mentioned date which, however, seems to be somewhat too early.

20. Antonaccio 1992, 445–46; 451–52.

7.

Torso of a Man in Armor

Neronian, mid-first century A.D.
Provenance: unknown
Material: white, fine-grained marble with gray veining,
probably from Asia Minor
Dimensions: h. 125.7 cm., w. 64.8 cm., d. 47.5 cm.
Museum purchase, Caroline G. Mather Fund (y1984-2)

CONDITION: *A horizontal break across the width of the lower torso was neatly repaired in ancient times with three iron pins, now lost, which were set within deeply carved, vertical, rectangular channels, not visible from the front. The break through the thighs was at the juncture with the undergarment. No trace remains of the limbs or neck. The shoulders are roughly broken, although the right arm's dowel hole and part of the chiseled surface next to it are preserved. The break in the right shoulder extends onto the cuirass, taking with it the right shoulder flap and much of the back right quadrant. The* paludamentum *that draped the left shoulder and hung in folds down the back of the left side was added as a separate piece, at least in part: a square section on the back of the left shoulder was flattened with a claw chisel to accommodate it. Most of this garment is lost, along with large chunks of the adjacent cuirass. Some of the breaks in the left shoulder seem relatively fresh, and one is pierced with a modern drill hole. A second drill hole on the opposite side is in the same position, along the juncture of the front and back plates of the cuirass. These holes and the modern breaks on the left shoulder indicate that the missing arms and drapery were once restored. The leather flaps in front are chipped, as are many of the animals and faces decorating the lappets above. The* gorgoneion, *floral ornament, and central scene on the cuirass are worn and scratched, with extensive damage to the defeated barbarian and the heads of the Victories. A longitudinal break down the left side of the leather skirt, possibly from the hanging folds of the* paludamentum, *might instead be the remains of a strut, such as a tree stump.*

Despite its incomplete state of preservation, this monumental statue is impressive—not only because of its rich iconographic program, but also on account of its exceptional, almost uncanny, naturalism. A military man in full armor stands before the viewer. He is dressed in four layers of clothing. A wool tunic is visible on the thighs, covered by a curtain of leather straps with stitching on their edges and tassels at their lower ends. These straps protect the groin and, at the same time, guarantee mobility to the wearer of the rigid cuirass that is worn on top of the leather jacket, of which the straps are an integral part. The metallic nature of the cuirass is immediately graspable through the hinges on the right side of the thorax—the protective device basically is an openable shell—and the flaring rim which delineates the lower abdomen and hips and continues across the figure's back. The cuirass consists of three parts: (a) the hinged breast- and backplates; (b) an intermediary frieze showing booty of war—shields, helmets, flags, swords, etc.—that loosely follows the line of the flaring rim mentioned above; and (c) a double row of tabs or lappets (*pteryges*) attached to the intermediary frieze by hinges indicated as round horizontal bars with tapering ends. These lappets are decorated with a variety of motifs which include human or humanoid and animal heads, as well as beasts of prey and their victims.

The decoration of the breastplate is worthy of closer scrutiny. At the top of the composition is a grimacing *gorgoneion*—the decapitated head of the Gorgon Medusa—with a collar of snakes tied into a knot under her chin. The *gorgoneion* is an apotropaic symbol: the hero Perseus had cut it off and, on more than one occasion, employed its eerie power of petrifying unsuspecting beholders. To the left of the *gorgoneion,* a bow secures the missing right shoulder flap of the curirass, while to the right, a portion of a military cloak (*paludamentum*) is preserved. In its unfolded state, the cloak would have been fastened on the man's right shoulder with a pin. Here, however, as in many

other instances, it has been folded up and placed in a bunch on the left shoulder, whence it fell down the back and, most likely, wound around the left forearm.

At the lower end of the cuirass proper there is a symmetrically organized, foliate ornament (acanthus), out of which two symmetrical tendrils emerge to undulate upward toward the armpits. In combination with iconography signifying victory or triumph, this motif commonly refers to prosperity, which, according to Roman thinking, presupposed military resolve and success. References to the force of arms, to victory, and to soldierly valor are, indeed, abundant. The intermediary frieze above the groin and loins symbolizes total conquest of the enemy through heaping amounts of captured weaponry. On the lappets, the predatory animals—wolves attacking stags, eagles disemboweling hares, additional Gorgon's heads, rams' heads (an allusion to battering rams)—are, by and large, self-explanatory; the same goes for elephant heads with awe-inspiring tusks and stylized male heads that refer to barbarian nations, whether conquered or to be conquered.[1]

The cynosure proper, however, is the figural group in the center of the breastplate. There, two winged Victory goddesses are setting up a trophy (*tropaion / tropaeum*), a marker indicating where the disheartened enemy turned around to seek safety in flight. (The term is derived from the Greek word

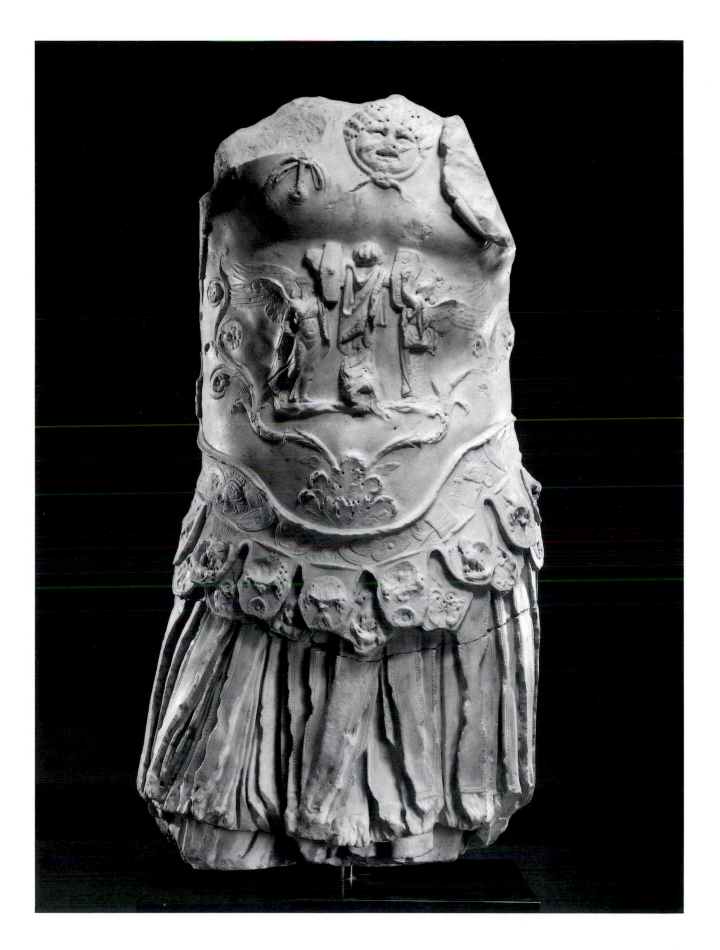

the warrior Amazons, but also of Venus Victrix, likewise alluded to in the luscious body forms and diaphanous drapery. In comparison, the other Victory is more chastely dressed in an outfit made of thicker fabric.

An intriguing naturalism pervades the heavily armored figure, as a consequence whereof it appears light and agile. The man stands on his left leg, which was firmly locked, allowing the right leg to move freely to the side: it is likely that only the ball of the right foot touched the ground. It appears as though the man has just assumed this posture, for the tassled leather straps have not yet swung back into their steady position: one almost hears them rubbing against one another. Following the rules of the contrapposto originating from Polykleitos's *Doryphoros*, or Spear-bearer,[3] the right hip is sagging while the right chest muscle, following the motion of the elevated right arm, is being pulled upward while the left one is tilted toward the pushed-up hip. Here, art imitates nature: a true metal breastplate would not have done anything of the sort. Judging from the break surfaces on the torso's left side, the left upper arm was pulled backward but close to the rib cage, while the lower arm was freestanding and, probably, wrought separately, like the right arm, which was attached at the armpit by a dowel. It has been astutely argued that this torso is Flavian in date and that the sitter is most likely the emperor Domitian (r. A.D. 81–96).[4] Such an ascription certainly would account for much of the damage the piece has undergone, a lot of which seems to have been willfully wreaked. However, it seems difficult to ascertain that the badly bruised barbarian at the foot of the trophy is, indeed, a German and, possibly, one of the Chatti vanquished by Domitian in A.D. 83.[5] It is not at all clear why and how the heads of the Victories and several of the blazons on the lappets of the cuirass were mutilated.[6] Some of the damage may not have been inflicted on the original statue but later, on a repaired version of unknown date (see below). In the absence of the soldier's head one cannot, generally speaking, be sure whether the piece eulogized an emperor[7] or a private individual of importance. However, the statue's destruction makes an emperor visited with *damnatio memoriae*[8] (or, perhaps, better: *mortuorum persecutio*[9]) a

trepein, "to turn around.") The trophy itself consists of a lopped tree trunk with an attached crossbar upon which military paraphernalia are displayed. There is a cloak, a helmet on top, and polygonal shields of non-Roman type. Sitting at the base of the trophy, a trousered barbarian, largely destroyed, shares the same ground line with the two Victories; its uneven surface suggests a rocky terrain. The goddess on the right wields a hammer in her right hand and seems to be nailing the ornamented shield in front of her to the crossbar of the trophy. (Equally likely, she may be incising an inscription commemorating victory upon the already affixed shield.[2]) Her counterpart seems to have finished her job already, for her right arm and hand (which possibly also held a hammer) are down, while with her left hand she seems to be checking the hexagonal shield's fit. One of her breasts is bare, recalling the iconography of

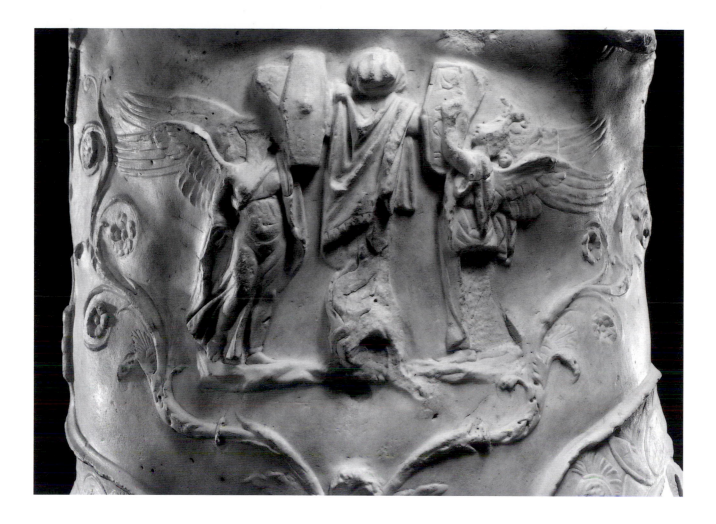

more than likely possibility. But while the figure's lively plasticity and its elaborate iconography exclude a date beyond the Flavian era, there are still two alternatives to Domitian in the first century A.D., namely Nero and Caligula.

With the portrait head missing, the best point of departure for an attempt at dating the torso is the vegetal ornament that frames the main scene on the breastplate. The foliate cup of acanthus at the base is remarkably flat, and in parts even sketchy. Randomly placed drill holes are relied on to enhance the impression of a three-dimensional plant with zigzagging leaves. The tendrils issuing from the central cup are not just stalks with spiraling ramifications terminating in blossoms: they are enveloped in foliage that is in the process of detaching itself from the stalk. To emphasize the independent nature of the sprouting leaves, further drilled dots have been employed. These

scrolls of vegetation stand in contrast to the flat acanthus: they look tender and juicy. A good comparison is found on the legs of a marble imitation of a portable bronze altar (*foculus*) in Palermo, which, in a comprehensive study of marble bases and altars with elaborate relief decoration, has been persuasively attributed to the Claudio-Neronian period.[10] In addition, a Claudian date has been suggested for a marble urn in Patras, where the basic flatness and subdued plasticity of the ivy leaves seem comparable to the acanthus on the Princeton torso.[11] The tendrils and more-or-less closely encircled buds in the urn's pediment and acroteria also compare quite well. Again, this dating, which is established against the background of almost the whole body of comparable monuments,[12] seems convincing.

The best comparison for the swaying straps of the leather jacket may be those on a fragmentary piece

in Dresden, which, in a study of a large quantity of cuirassed statues, was assigned a "late Claudian to early Flavian" date: that is, Neronian.[13] An additional reason to attribute the Princeton torso to the reigns of the last two Julio-Claudian emperors can be found in the somewhat uneven weighting of the decorative units on the breastplate: the tendrils and the *gorgoneion*, by virtue of their size, make the figural scene appear to be a miniature, while, conversely, the latter affords the former the semblance of larger-than-life proportions. O. Dräger noted similar disproportions among the elements on the bronze altar in Palermo, mentioned above.[14] One may add that the Victories and the trophy may also be compared with the famous Ravenna relief, a Neronian frieze recarved to honor the short-lived emperor Vitellius in A.D. 68/69,[15] in that the folds of drapery, with a somewhat stiffening effect, are used as markers of a frontal picture plane.[16]

The definition of the musculature on the breastplate recalls a headless, cuirassed statue which M. Fuchs has identified as Nero for a compelling reason: the depiction of the sun god (Sol) on the figure's chest bears a clear facial resemblance to portraits of that emperor.[17] This statue, from the theater of Caere/Cerveteri, is also worth noting for its similar juxtaposition of flat and bulgy sculptural components, as well as the use of pinpoint *chiaroscuro* drill work. In the frontal view, even the realistic treatment of the leather straps with their stitched seams is comparable, although the right thigh is not pushed forward and sideways as vigorously as in the Princeton and Dresden pieces. The statue in Cerveteri also displays an intermediary zone between breastplate and lappets, which in this case, however, is decorated with a running wave pattern.

In the wake of his fall, several cuirassed statues of Nero were reused for the representation of private individuals.[18] This may also have been true of the Princeton torso, for the nature of the repair work seems to indicate that the decision to patch up a broken statue was made on the basis of a thrifty budget.

Summing up, the stylistic analysis points toward a Neronian date for the Princeton torso. The original figure probably was toppled over and broken, and that makes Nero a prime candidate for identification.[19]

This, of course, would presuppose human involvement in the effigy's destruction, but it also should be noted that the nature of the marble may indicate an origin in the Roman East, where earthquakes were a frequent cause of sculptural collapse. Whatever the cause, the broken original underwent repair and was set up again. The facial disfigurations of the Victories and some heads on the lappets have the ring of post-pagan antiquity to them. In the heathen period, these personifications and symbols were so generic that no one would have connected them to a specific person once the portrait head was gone or had been substituted. HM with contributions by KK

BIBLIOGRAPHY
Sotheby's, London, July 15, 1980, no. 207.
Record 44.1 (1985): 45, fig. p. 46.
Gergel 1986, 2–15, figs. 1–4.
Selections, 40 (illus.).
Gergel 1987, 30, n. 2.
Varner 2000, 162–63, no. 36.

NOTES
1. See Fittschen 1976, 196, fig. 16; H. Meyer, in Steuben 1999, 193 n. 17.
2. See, for example, Kleiner 1992, 219, fig. 184; Hölscher 1967, pls. 11, 14 passim.
3. Lorenz 1972; Steuben 1973; Steuben 1990; Borbein 1996; Himmelmann 1998, 159–62; Meyer 1995.
4. Gergel 1986; Varner 2000.
5. Gergel 1986, 9–10: "The figure is bare-chested, wears trousers, and has his hands tied behind his back." The presence of trousers surely cannot be disputed.
6. Varner (2000, 162) says the following: "The heads of both victory figures have been attacked and obliterated with chisels as a way of symbolically disparaging or even canceling Domitian's military triumphs and prowess."
7. Gergel's reasoning with regard to possible allusions to legionary emblems and references to the Rhine River seem somewhat stretched.
8. *Damnatio memoriae* is a modern coinage: see H. Flower, in Varner 2000, 58: "Damnatio memoriae is the collective term used by modern historians to describe a variety of penalties employed by the Romans to limit or destroy the memory of a citizen who was deemed unworthy of being a member of the community." The inauthentic nature of the term was established by F. Vittinghoff (1936).

9. Seneca (*Apocolocyntosis* 11) says about Claudius: "*C. Cae-sarem non desiit mortuum persequi*"; cf. Ramage 1983, 201–14.

10. Dräger 1994, 210–11, no. 38, pl. 64.2, 3.

11. Sinn 1987, 108, no. 70, pl. 21d, e.

12. For additional material see Fuchs 2001.

13. Stemmer 1978, 78, VII 6, pl. 51, 5. For research on cuirassed statues, cf. also C. C. Vermeule's pioneering articles on "Hellenistic and Roman Cuirassed Statues," *Berytus* 13 (1959), 1–82; 15 (1964), 95–110; 16 (1966), 49–59; 23 (1974), 5–26; 26 (1978), 85–123.

14. Cf. Dräger 1994, 211, no. 38.

15. See Meyer 2000a, 35–48.

16. Cf. Meyer 2000a, 142.

17. Fuchs 1989, 68–70, no. 5, figs. 49–55; Fuchs 1987, 81, DM I 1, pl. 32.1; 33.1.

18. Take, for instance, the statue of Holconius Rufus from Pompeii: Meyer 2000a, 41–45; see also a statue in Parma: Curtius 1932, 242–44, fig. 17, pls. 66, 67 (he was not aware of the recarving and believed the statue represented Otho).

19. On Nero, see Griffin 1984; Champlin 1998, 333–44; Fuchs 1997, 83–96; Meyer 2000a.

8.

STATUE OF A WOMAN

Trajanic, ca. A.D. 98–117
Provenance: unknown
Materials: body, Pentelic marble; head probably Parian marble
Dimensions: h. with plinth 1.89 m., h. of plinth 10 cm., w. of plinth 55.8 cm., d. of plinth 30.5 cm., w. of head 21.0 cm., d. of head 21.9 cm.
Museum purchase (y1980-34)

CONDITION: *The head and its statue were worked separately, the latter together with the plinth. The statue is missing its left hand and right forearm, both of which were subsequently replaced in modern times (note the round dowel holes); however, the remainder of the plane upon which the forearm was added shows that the forearm also had originally been worked separately. The front half of the left foot, tip of the right foot, front edge of the plinth, and numerous ridges in the garment folds are also broken off. Fairly extensive damaged portions are found on the statue's right hip as well as between and somewhat above its knees.*

The woman's head is missing its nose, and the edge of the left ear has been broken off. The eyelids, right eye orbit, and lips are damaged; above the seam where parts were added, portions of the mantle have been broken off at the point where the garment was drawn up over the back of the head. The entire surface of the head is severely weathered. The back side of the statue was carved only coarsely.

The statue depicts a richly clad, older woman. The strap on her right shoulder indicates that she has donned a *stola* over her undergarment.[1] Above it, she wears a wide mantle wrapped around her outstretched left forearm and draped over her chest and shoulder and over the back of her head. On her right, the mantle falls down to frame her upper body, then returns to the front under her right elbow, where it is folded back and stretched tautly across her body. This creates excess fabric which is folded over from the top and whose upper edge is rolled into a twist, which rises slightly toward her left breast. Beneath her left arm, the fabric is pressed against her body, from where it hangs down in a loose bundle of folds.

The austere and energetic lineaments of the face are emphasized by the mouth, whose lips are firmly pressed together, and by the depth of the wrinkles,

especially above the root of the nose. Not much of the coiffure can be seen because the mantle is drawn upward, but the hair is obviously parted in the middle and combed toward the sides. A separate head covering lies over the hair and beneath the mantle. It is apparently a kerchief, which seems to have been folded double, for it falls into folds at the point where it is pulled backward. Its middle part is adorned with three stripes in raised relief; these stripes converge toward the rear and then disappear beneath the *velatio capitis.* One must imagine that the stripes represent embroidered decorations, which stiffen the central swath of the cloth. Two cordlike forms lie atop the cloth, where they run irregularly, cross over one another, and are largely concealed beneath the mantle. These probably represent bands that could be used, under normal circumstances, to tie the cloth in place. The most likely interpretation of the purpose of this cloth is that it represents a veil for the woman's face, since such veils were worn folded back in a very similar manner. When worn hanging in front of the face, it was held in position by bands like those on the head in Princeton.[2] It is not clear whether what hangs down in back of the head, behind the woman's left ear, is a portion of the veil or hair taken upward in a flat loop.

The statuary design chosen as the bearer of the woman's portrait head goes back to a model that has survived in numerous repetitions, the best-known of which is the so-called Spinner in Munich.[3] The original has been related to the *Catagusa* (Woman Spinning) of Praxiteles, which is mentioned by Pliny (*Natural History* 34.69).[4] The motif of the movement of the arms, best preserved on the bronze statue in Munich, has led researchers to conclude that "her left hand originally held a distaff, while her right hand pulled the thread."[5] Not without its critics,[6] this interpretation has been joined by other alternative interpretations,[7] all of which must remain hypothetical on account of the incomplete condition of the statues. Regarding the question of the position of the arms in the original sculpture upon which all the copies are based, the Munich Spinner surely does not deserve to be given primary consideration because, as a product of the art of Etruscan bronze molding,[8] this statue varies in several details[9]—one of which

is the posture of the arms—from the more dependable transmissions of the type. Consideration of the majority of surviving replicas suggests that the original statue probably stretched its left forearm forward in a nearly horizontal line. The position of the right hand can no longer be determined, so it is impossible to know for certain what activity originally occupied the woman's attention.

In the three marble replicas that are believed to be most nearly identical with the original, the position of the left arm is the same as that of the statue in Princeton.[10] Unlike these three sculptures, however, the Princeton woman wears a *stola* and has pulled her mantle up over the back of her head.[11] She also differs from the other three sculptures in that her upper body is slightly elongated above the transversely rising bulge of the garment. For these reasons, one can suggest that the Princeton version represents a redesign of the original, adapted to serve as a portrait sculpture. This sort of "privatization" of an idealized type seems to have taken place in several statues from this series. Although all other repetitions are headless (with the exception of one offered for sale in the art trade in 1976[12]) and would seem to have had their heads carved separately,[13] the public site where two other such statues originally stood would suggest that they were intended as honorary statues.[14] The original and as yet unknown meaning of the Greek original, which was probably carved in the latter years of the fourth century B.C.,[15] was relegated to the background and assumed lesser importance in the Roman copies.

A unique feature of the statue in Princeton, however, is that its use as a portrait led to a change being made in the clothing. While the veil alludes to the elegance of an upper-class lady,[16] the addition of a *stola*[17] identifies the woman as a Roman matron, that is, a married woman who possessed Roman citizenship and its associated rights, and who may have even belonged to the senatorial order.[18] The notions of moral value associated with this article of clothing[19] are emphasized by the hardness of the facial expression, which is rendered by the sculptor without any attempt to prettify it. Her expression recalls men's portraits from the Trajanic era: the head of Trajan in the Piraeus;[20] or Trajanic private portraits, for example,

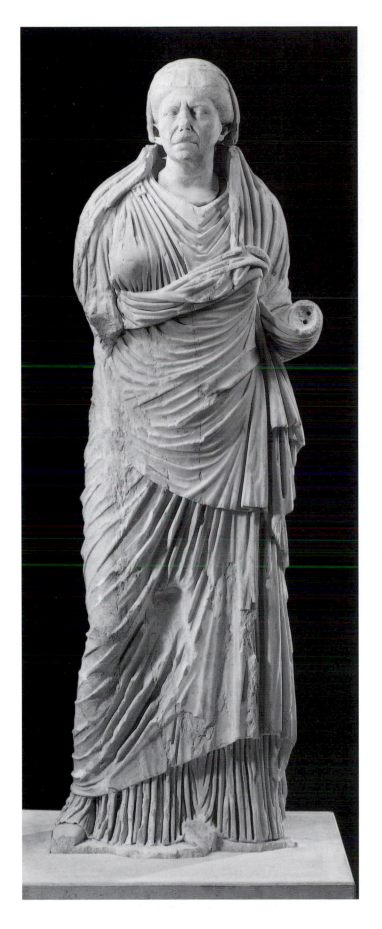
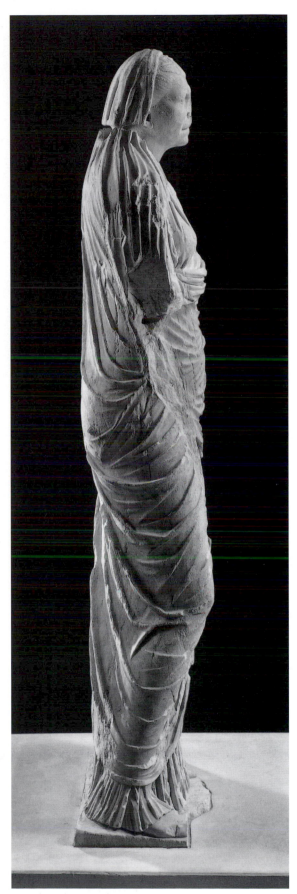

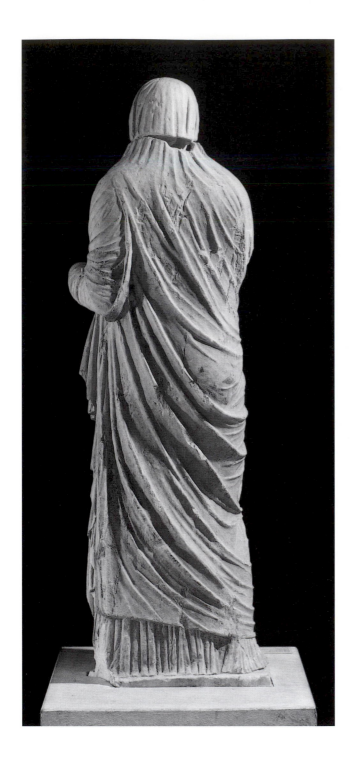
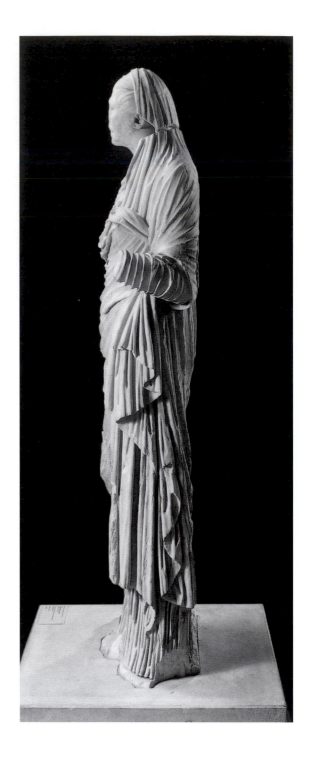

in the Palazzo dei Conservatori[21] and the Museo delle Terme[22] in Rome, along with the latter's replica in Copenhagen.[23] These heads define the temporal limits within which the Princeton portrait statue belongs. The motifs of the mouth zone—the deeply furrowed naso-labial lines and lips firmly pressed together—are closely related to the portraiture of

Trajan. Other details, such as the shading of the upper eyelids, the bulging and energetic brow, the form of the tearducts,[24] and, in general, the articulation of sculptural volume, all evince unmistakable stylistic relationship to Trajanic portraiture. The arrangement of the coiffure, insofar as it can be seen, does not argue against this temporal assignation. A

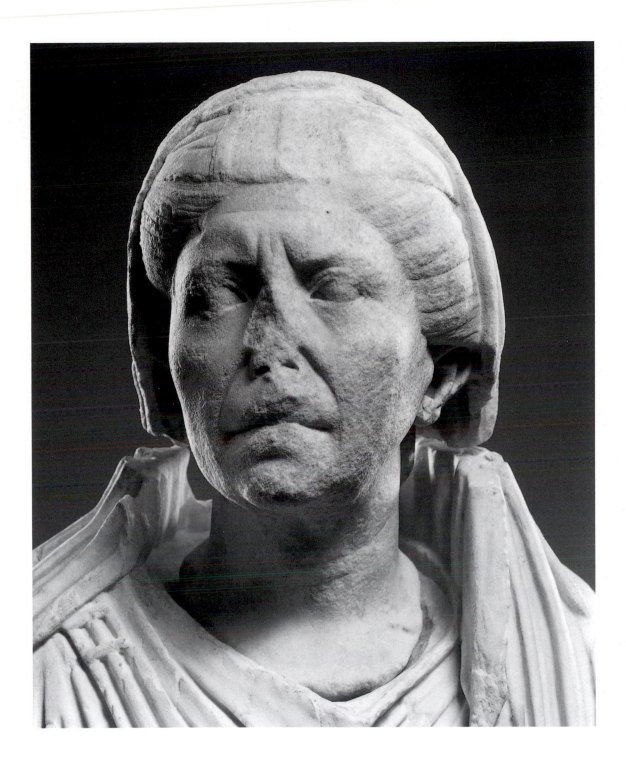

Trajanic lady in the Uffizi in Florence[25] and another female statue from the same period in the Capitoline Museum in Rome[26] both wear their hair parted above the center of the forehead and drawn straight back to the rear of the head. The latter sculpture, however, is similar to a relief in Geneva[27] in that the coiffure is enriched by the presence of a braided bow over the parting. A head made originally for insertion into a statue and now preserved in Boston[28] is also very similar in style to the portrait of the lady in Princeton.

The treatment of the garments worn by the Princeton statue likewise indicates that it was carved during the Trajanic era. Almost undifferentiated in

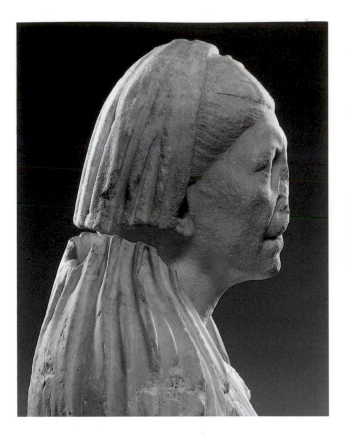
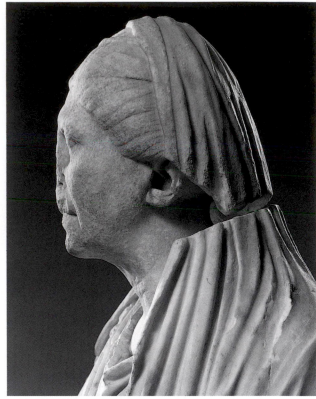

terms of the textures of their fabrics, the chiton and mantle both seem thick and heavy, two attributes which they share with a Trajanic portrait statue in the Vatican;[29] also similar are the partly parallel, narrow ridges of the folded fabric, between which broad and flat "valleys" intervene.[30] Furthermore, the notched edges on the mantle are similar to those on numerous examples from this same era.[31]

MF

BIBLIOGRAPHY
Selections 1986, 38 (illus.).

NOTES
1. On the *stola*, see: *RE* 7A.2:56–62, s.v. Stola (M. Bieber). Newer literature includes Kockel 1993, 51–52 and Scholz 1992.
2. Examples, especially of terracotta statuettes, are found in Thompson 1963, 50–52, pls. 42–46. Pfisterer-Haas (1991, 99–110) calls such veils luxury accessories to the outfits of a woman of noble standing.
3. The following repetitions are involved:
 a. Formerly Villa Borghese: Matz 1891, no. 1534; *RSGR* 3:192, no. 8; Flasch 1901, 126–27, fig. p. 124; Linfert-

Reich 1971, 48, n. 6, no. 1 = no. 4; Moreno 1975–76, 136, pl. 21, fig. 26; Di Castro and Fox 1983, 104, no. 47a (illus.).
 b. Pollena, Villa Santangelo: De Koehne 1853, 16–17, no. 4, pl. 5; *RSGR* 2:303, no. 9; Loeschke 1880, 102; Flasch 1901, 126; Lippold 1923, 208, n. 174; Linfert-Reich 1971, no. 2.
 c. Rome, Museo delle Terme, inv. 91409: Sgubini Moretti 1982–84, 71–109, esp. 79–85, figs. 8, 9.
 d. Munich, Staatl. Antikensammlungen und Glyptothek, Gl. 444: Hekler 1909, 228, pl. XIX; Furtwängler and Wolters 1910, 392–93, no. 444; *EA*, 2945–48; Lippold 1923, 208; Rizzo 1932, 90–91, pl. 134b; Lippold 1959, 266, n. 2; Kabus-Jahn 1962, 31, n. 31; Linfert-Reich 1971, 48–52; Palagia 1980, 31, fig. 55; Haynes 1985, 318–19, no. 191, figs. pp. 236–37.
 e. Seville, Casa de Pilatos: *RSGR* 5:375, no. 7; *EA* 1827; Horn 1931, n. 1; Linfert-Reich 1971, no. 3.
 f. Location unknown: Sotheby's, London, July 12–13, 1976, addendum.
4. Loeschke 1880, 102; Amelung 1895, 51; Klein 1898, 360–61; Furtwängler and Wolters 1910, 392–93; Rizzo 1932, 90–91. On the question of the word's meaning and the possibility of postulating a statue of a spinning woman, see Corso 1988, 78–79.

5. Furtwängler and Wolters 1910, 393.

6. Flasch 1901, 120, 134–37.

7. See Linfert-Reich 1971, 48.

8. For information about Vulci as the find-spot and the subsequent fate of the statute, see Roncalli 1973, 21, n. 23; Buranelli 1991, 320–25; Haynes 1985, 318–19, no. 191.

9. The rings and shoes should be regarded as having been added by the copyist; replica nos. 1, 3, and 6 are wearing sandals. The way the chiton is draped over the non-weight-bearing leg also differs from the other repetitions.

10. Above n. 3 a–c.

11. Above n. 3f (formerly art market) likewise was depicted *capite velato*, as can be seen by examining the break on the neck.

12. Above n. 3f. The head currently matched with the body rests atop a smoothed breakage plane and does not seem to belong with it.

13. Based on old drawings, Moreno (1975–76, 136) assigned a head (Amelung 1925, 199–201, figs. 12–15) to the statue that disappeared from the Villa Borghese (above n. 3a). If this head were in fact to be associated with the body, it does not need to have been the original head. The head of the statue in Seville (above n. 3e) does not belong to it (*EA*, 1827).

14. This is certainly the case for the statue in the Museo delle Terme and for the Spinner in Munich (above n. 3c, d). For the circumstances surrounding their discovery, see the literature mentioned above (above nn. 3 and 8).

15. The dating of the original model upon which these repetitions are based in the fourth century B.C.—and perhaps in the later years of that century (see, e.g., Kabus-Jahn 1962, 31–32; Heiderich 1966, 74–75; Linfert-Reich 1971, 48–49)—is not accepted by T. Dohrn (review of Kabus-Jahn 1962 in *Gnomon* 39 [1967]: 214; also see Horn 1931, 75), who asserts that the Spinner in Munich is a classicistic creation. That the original model was, in fact, created in the late fourth century B.C. is made plausible not only by Heiderich's comparison of it with a statue of Asklepios in Eleusis that was carved around 320 B.C., but also by comparison with a group of draped female figures from Thasos (Macridy 1912, 1–19, pls. 1–4), which, like a series of closely related draped statues in Cyrene (Rosenbaum 1960, 56–57, no. 45, pl. 32.2, 4; 89–90, nos. 148–149, pl. 71; cf. also a relief from the fourth century B.C.: Paribeni 1959, 34–35 no. 49) and a statue from the theater of Miletos (Linfert 1973, 81, fig. 3) are all based on models dating from this time (see also Horn 1931, 60, 91; Kleiner 1942, 236). Also worthy of mention is a statuette of Hades from Kos, which must rely on a creation of the same sort as the model upon which the so-called Spinner is based and which bears an inscription dating it to the third century B.C. (Kabus-Jahn 1975, 52, 56–63, pls. 27–28).

16. Pfisterer-Haas 1991, 103–4.

17. A comparable situation exists with the torso of a *peplophoros* in Frankfurt. Parallel to its use as a portrait statue, it was also embellished with an undergarment. See Tölle-Kastenbein 1986, 67–68.

18. Scholz 1992, 13–32; see Kockel 1993, 30, 50–51. The source also includes information on the *velatio*, likewise a characteristic garment of married women.

19. Scholz 1992, 13–32.

20. Gross 1940, 128, no. 34, pl. 20, and 130, no. 54, pl. 27b; Felletti Maj 1953, 91, no. 167.

21. Daltrop 1958, 37, 39, 122, fig. 42; Zanker 1980, 196–202, pl. 68.3.

22. Felletti Maj 1953, 92, no. 168; Grimm 1989, 350–52, pls. 87.2 and 89.

23. Poulsen 1962–74, 1:41–42, no. 2, pls. 3–5; Grimm 1989, 350–52, pls. 86.2 and 88; Johansen 1994, 1:26–27, no. 2. Concerning the replica in Munich, see Ohly 1971, 227–29, figs. 1–2; Grimm 1989, 350–52, pls. 86.1 and 87.1; see also Zanker 1980, 196–202.

24. Also cf., e.g., De Luca 1976, 65, no. 28, pls. 55–56; 65–66, no. 29, pl. 57.

25. Mansuelli 1958, 85, no. 88.

26. Fittschen and Zanker 1983–85, 3:61, no. 81, pls. 101–2.

27. Chamay and Maier 1989, 80–81, no. 104, pls. 97–98.

28. Comstock and Vermeule 1976, 206, no. 326, where the head is dated ca. 30 B.C.–A.D. 50.

29. Giuliano 1957, 45, no. 49, pls. 31–32; Kruse 1975, 113–14; 325–26, no. D2, pl. 42.

30. Cf. a statue at the Poggio Imperiale, Florence: V. Saladino, in Capecchi et al. 1979, 110–12, no. 56, pls. 66–67.

31. E.g., the fragment of a draped statue from the theater of Lecce (Fuchs 1987, 52, no. DW I 1, pl. 10.5), and also the other sculptures from this complex (51–54, pl. 10–15).

9.

PORTRAIT OF A WOMAN

Trajanic, ca. A.D. 98–117
Provenance: reputedly found at Chiavenna near Lake Como in 1879[1]
Material: bronze
Dimensions: h. 32.8 cm., w. 17.4 cm., d. 20.4 cm. th. of bronze 0.18-0.37 cm.[2]
Museum purchase, Fowler McCormick, Class of 1921, Fund (y 1980-10)

CONDITION: *The portrait has survived nearly undamaged; only parts of the hairnet are corroded on the left side; other parts of the net, especially on the back of the head, are missing entirely, either because they did not materialize when the bronze was cast or because they were broken off when the clay mold was removed.[3] Green patina with black and red spots.*

This impressive portrait, which probably derives from a clothed statue,[4] depicts an older woman with realistic facial features: the somewhat surly look in her eyes is a good match for the narrow mouth with its frowning, downwardly curving corners; the aquiline nose juts forward directly beneath the pursed forehead. Clearly defined wrinkles beneath the eyes and around the mouth and nose further emphasize her earnest and energetic expression. She wears her hair bound up in a sort of turban coiffure: five braids originate at the back of the head and wrap themselves around it, forming a kind of wall around the hair on the crown. One portion of the hair at the nape has been combed upward and folded over these braids. The coiffure is covered by a hairnet, which has been rendered in an appealingly accurate manner: the method used to tie this type of net (a technique known today as "sprang"[5]) makes use of a wooden frame with threads affixed in parallel lines. These threads are then knotted to one another to create a hexagonal pattern like the cells in a beehive. The edge of the net is reinforced above the forehead. A drawstring, which was used to affix the net to the head, is visible at the nape; a second drawstring on the top of the head was used to bind together the remainder of the net, thus stretching it

tautly across the coiffure. The liveliness and immediacy of this portrait are primarily due to the well-preserved condition of the eyes. The eyeballs, outline of the irises, and indented, half-moon-shaped pupils were poured simultaneously and in a single casting with the remainder of the head. After the head had been poured and had cooled, the whites of the eyes were highlighted through the addition of a thin layer of silver.[6] The realistic impression is further enhanced by the exactness with which the hairnet has been depicted. It seems likely that the artist who poured this bronze did not take the trouble to model all of the net's details on the model for the casting,[7] but instead affixed an actual hairnet to the wax model. This supposition is corroborated by the sculptor's use of a piece of wax to affix the tip of the tied-off net's upper portion to the crown of the head.[8] When the negative form was poured, the slender threads failed to leave their impressions at a few points on the crown of the head and above the right ear; these had to be added "cold," that is, after the casting had cooled and hardened.

It has been surmised that, in analogy to the realistic model used for the hairnet, the sculptor might also have used a realistic model for the face of the depicted woman, namely, a death mask.[9] However, neither the unembellished rendering of this not very attractive physiognomy nor the arguments based on molding techniques, which claim to prove the modern origins of this sculpture,[10] provide credible justification for this assumption.[11] Recent technical research leaves no doubt that this sculpture was indeed crafted in ancient times.[12] Furthermore, the realism of the bronze head is wholly in accord with the approach to portraiture that was common at the time when this head was cast (see below). An additional argument in favor of the authenticity of the head is that textile historians did not rediscover the "sprang" technique until the end of the nineteenth century, after examination of archaeological finds in Denmark and Egypt[13]—after this bronze head had already come to

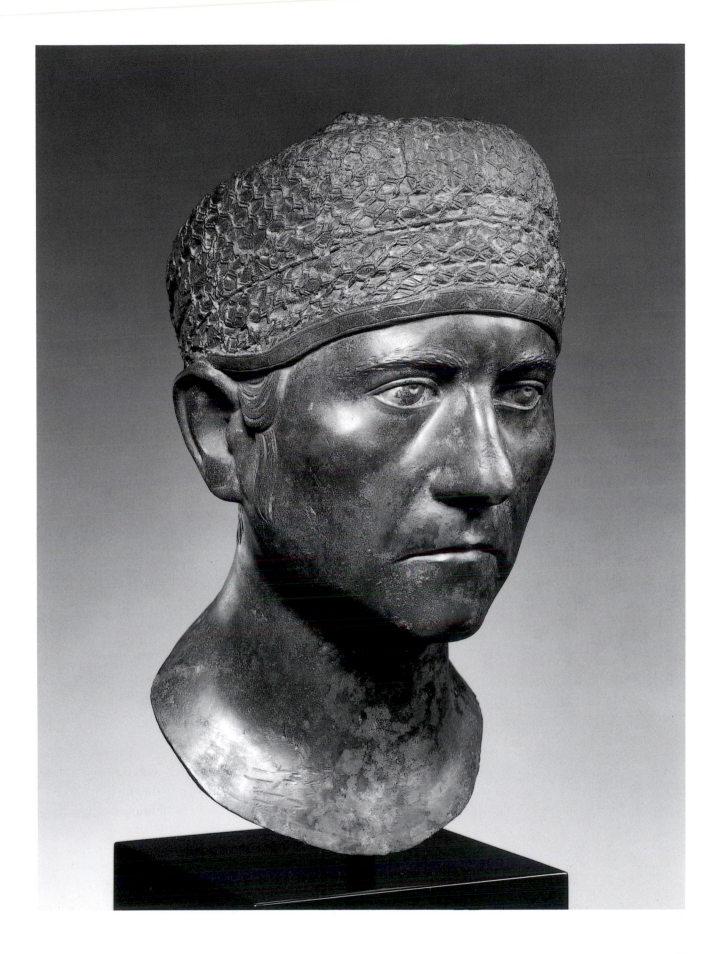

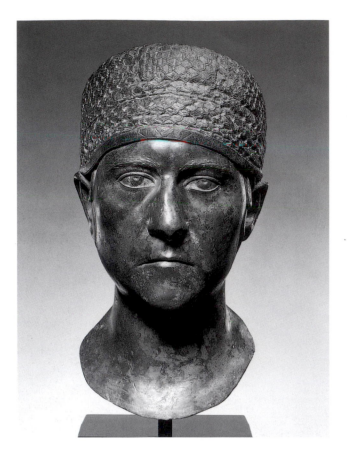
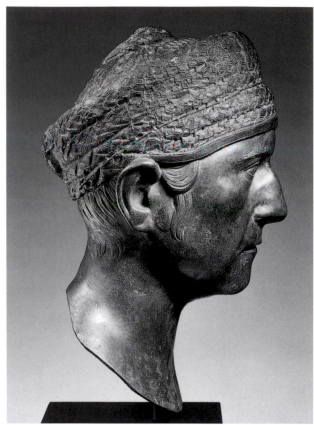

light. A nineteenth-century counterfeiter could not possibly have had access to a hairnet of this sort.

Clues upon which to date this bronze head are provided above all by the "turban" coiffure. This hairstyle evolved from a Flavian/Trajanic hair fashion and was common into the Hadrianic, perhaps even into the early Antonine period.[14] Characteristic features of this coiffure are the cylindrical braids layered one atop the other to reach their greatest elevation above the forehead, ringlets of hair in front of the ears (in the Princeton portrait, some strands have also been painstakingly arranged over the cheek), and the separate bundle of hair at the nape which is combed upward and laid over the braids that begin there. Although this style of hairdressing enjoyed renewed popularity during the fourth century A.D., detailed analysis makes it possible to distinguish later portraits from earlier ones.[15] The Princeton head doubtlessly belongs to this earlier group. The severe physiognomy and the earnest, determined facial expression, which recalls the look of portraits of women from Trajan's court,[16] make it possible to

date this sculpture even more accurately to the reign of this emperor. MF

BIBLIOGRAPHY
Lanciani, Hermanin, and Paribeni 1919, 123–38.
Albizzati 1921, 291–307.
Kluge and Lehmann-Hartleben 1927, 240–41.
Comstock 1953, 68–69, (illus.).
Milkovich 1961, 44–45, no. 18.
Sotheby's, London, July 1, 1969, no. 81, and frontispiece.
Sotheby's, New York, December 14, 1978, no. 274.
Record 40.1 (1981): 19, fig. p. 18 and cover.
Erhart Mottahedeh 1984, 193–210, pls. 29–30.
Selections 1986, 43, (illus.).
Jenkins and Williams 1987, 9–19.
Meyers 1990, 238–40 (illus.).
Mattusch 1996, 58, 293–96, no. 39 (illus.); pl. 7 (color).
Bartman 2001, 14, 16, pl. 2 (color).

NOTES
1. For the circumstances surrounding the discovery, see Lanciani, Hermanin, and Paribeni 1919, 123–38; on the subsequent fate of the head, see Erhart Mottahedeh 1984, 194–210.

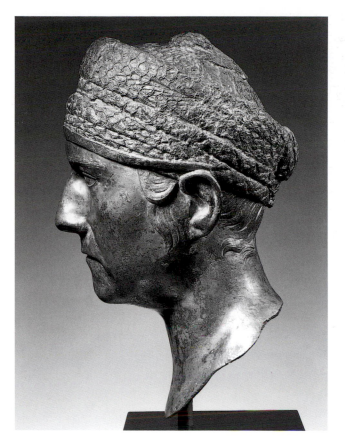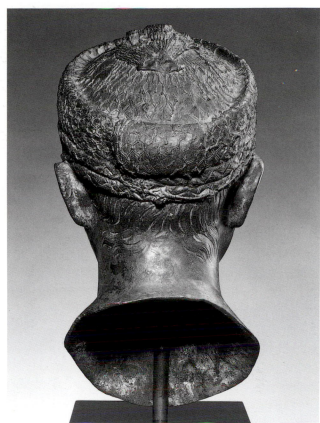

2. Mattusch 1996, 58, 293–96, no. 39 with illus.; pl. 7 (color).

3. Mattusch 1996, 296.

4. Mattusch 1996, 293, 296.

5. On this technique, see Collingwood 1974; Jenkins and Williams 1985, 411–18; see also Jenkins and Williams 1987, 9–19; Rutschowscaya 1990, 55–59, fig. p. 59.

6. Mattusch 1996, fig. 39d.

7. This was the opinion of Lanciani, Hermanin, and Paribeni 1919, 132–33; Kluge and Lehmann-Hartleben 1927, 240; Erhart Mottahedeh 1984, 196; Jenkins and Williams 1987, 9.

8. Mattusch 1996, 296, fig. 39e; additional examples of female heads with molded hairnets are found in Jenkins and Williams 1987, 11, figs. 6–7.

9. Lanciani, Hermanin, and Paribeni 1919, 133–34; Kluge and Lehmann-Hartleben 1927, 240–41; Erhart Mottahedeh 1984, 198.

10. Ever since its discovery, the authenticity of the head has been questioned: see Lanciani, Hermanin, and Paribeni 1919, 123–38; Albizzati 1921, 291–307; Kluge and Lehmann-Hartleben 1927, 240–41. Cf. also Erhart Mottahedeh 1984, 193–210, esp. 196–200; Jenkins and Williams 1987, 9.

11. Neither is anything gained by alluding to the popularity of death masks among the Romans (Lanciani, Hermanin, and Paribeni 1919, 133; Jenkins and Williams 1987, 13–14): because evidence is lacking, the question to what extent death masks were used in the creation of public honorific portraits of venerated citizens—especially during the high imperial period, in which Pliny expressly laments the decline in verisimilitude of portraits (Pliny, *Natural History* 35.4)—must remain unanswered. Comprehensive information about death masks among the Romans can be found in Drerup 1980, 81–129; see also Meyer 2000b, 25–26.

12. Mattusch 1996, 293–96; see Erhart Mottahedeh 1984, 199, n. 25.

13. Collingwood 1974; Jenkins and Williams 1987, 9.

14. Fittschen and Zanker 1983–85, 3:62–64, nos. 84–85, with a list of portraits having this coiffure. On the Princeton head, see Fittschen and Zanker 1983–85, 3:63, n. 7.

15. Fittschen and Zanker 1983–85, 3:64; Fittschen 1973, 59, no. 91. See also Erhart Mottahedeh 1984, 200–203; Jenkins and Williams 1987, 13.

16. Cf., e.g., Fittschen and Zanker 1983–85, 3:8–9, no. 7, pl. 9. On this phenomenon, see Fittschen and Zanker 1983–85, 3: 62.

10.

PORTRAIT BUST OF A WOMAN

Hadrianic, ca. A.D. 135
Provenance: purchased by the donor from M. Komor,
New York, 1959
Material: bronze
Dimensions: h. 21.2 cm., h. of head 9.5 cm., w. 14.8 cm.,
d. 9.9 cm.
Bequest of John B. Elliott, Class of 1951 (1998-419)

CONDITION: *Largely intact. Small pieces of the right ear are missing. Scratches on nose (old), nape of neck, and right shoulder (modern). Surface of face partly flaky. Patina uneven and of different colors. Suface touched up. Thick layers of corrosion on the inside.*

The bust that is placed on an acanthus leaf or foliate "cup" shows a young to middle-aged woman who is dressed in a buttoned chiton and a mantle. She has pulled up some of the chiton's cloth by the side of her right breast so that it hangs down over the rolled-up portion of her mantle. The latter's fabric

seems to be relatively thin and covers her left shoulder and arm in a rich display of interacting folds. The woman's face is long and slender with emphasis on cheekbones and chin, her nose slightly aquiline and turned downward at the tip. Her narrow mouth is full-lipped and almost puckered, and her small but wide eyes show a pensive expression.

The woman's high forehead is partly covered by her long, centrally parted hair, which has been combed over to the temples. From behind the ears it issues as thin braids that disappear under the "turban" of sturdier braids that constitute the most conspicuous

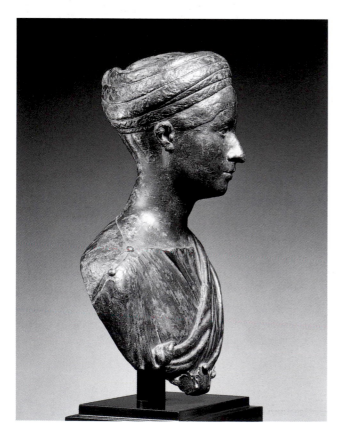
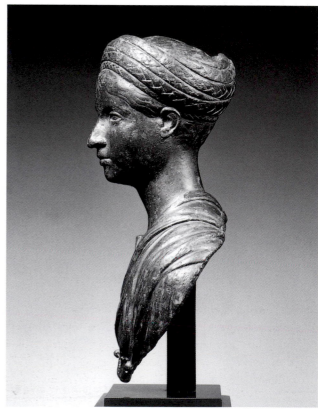

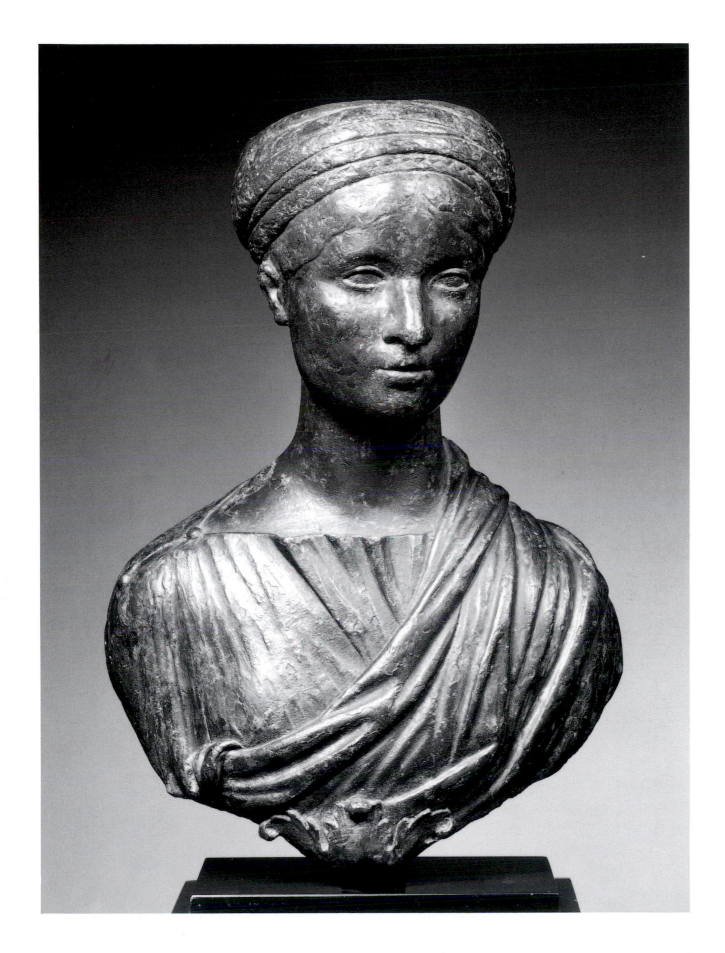

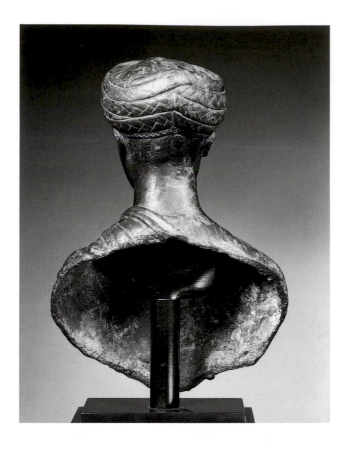

the time of Trajan, when the incorporation of racial traits had often obfuscated the Roman "private" portrait's predominant mode of closely emulating official or court portraiture.[4] (The latter had social and political reasons: the portraits of the rulers were not accurate depictions of the quick in power, but statements about time-specific concerns and intended styles of government written in art forms. They were *auctoritas* portraits to which the subjects reacted, by way of imitation, with *consensus* portraits.) One would not say, however, that the bronze bust flaunts ethnicity; rather, it intimates it.

H. Jucker's speculations on the set of meanings about the afterlife, which he attached to the foliated "cup" at the bottom of the chest segment and which would make any portrait so mounted a representation of someone deceased,[5] can nowadays be called obsolete. Jucker was coerced by his hypothesis to declare as posthumous acanthus-borne images of Caligula and Domitian, emperors whose memory had been officially condemned.[6] The sprouting leaves are but a playful, decorative element.

HM

BIBLIOGRAPHY
Mitten and Doeringer 1968, no. 231.

NOTES
1. Mattingly and Sydenham 1923, 1: no. 1019; Kent, Overbeck, and Stylow 1973, no. 288, pl. 73.
2. Cf. Fittschen and Zanker 1983–85, 1: no. 46, pl. 50; no. 55, pls. 61, 62; Meyer 1991, Kat. 1 17, pl. 16 and passim; H. Meyer, in Steuben 1999, 194–96, pls. 46, 47.
3. Trillmich 1982; Balty 1993, 17–18; H. Meyer, in Steuben 1999, 191–94.
4. Cf. Zanker 1982, 307–12; Meyer 1989, 121–22; see also Meyer 2000b, 24 with n. 85.
5. Jucker 1961; Mitten and Doeringer 1968; see below n. 6.
6. For the fate of portraiture of emperors whose memory had been condemned, see Jucker 1981, 236–316; Bergmann and Zanker 1981, 317–412; Varner 2000. See Meyer 1991, 127, and n. 120 for further reading.

component of the hairstyle as a whole. Three of these braids originate on the top of the head while others set out from a middle part that all but cleaves the back of the head. Between the nape of the neck and the thin braids the hair has been subdivided into six compartments and treated with a curling iron.

The hairstyle of the bronze bust echoes a fashion inaugurated by Hadrian's wife Sabina[1] and is thus datable to the 130s A.D. That is also confirmed by the time-typical *habitus* of the bust, its calm pensiveness underscored by the gentle turn and slight tilt of the head. One finds these characteristics not only in female portraits of the period, but also in images of Hadrian and his friend Antinous.[2] The almond-shaped eyes, the aquiline nose, and, probably, also the fleeing chin could be interpreted as indications of the sitter's ethnicity[3]—and thus as a carryover from

II.

FRAGMENTARY PEDIMENT FROM A FUNERARY MONUMENT WITH PORTRAIT OF A MAN

Hadrianic, ca. A.D. 130–140
Provenance: Colle Tasso, near Tivoli
Material: white marble with a brownish patina, also evident on the broken surfaces
Dimensions: h. 47 cm., w. 70 cm., d. 17 cm.
Museum purchase, Carl Otto von Kienbusch, Jr., Memorial Collection Fund, and funds given by Shelby White and Leon Levy (y1985-34)

CONDITION: *It appears that repairs were attempted in antiquity on the smooth surface of the break by the right-hand corner of the pediment. The break, which rises toward the left, contains a round dowel hole, which runs diagonally toward the right. The remnants of a marble dowel can be seen inside this hole. The shorter breakage surface beneath it also contains a dowel hole, although this one is four-sided and directed downward. A third dowel hole, which was drilled immediately beside the break into the front plane of the pediment, completely pierced the slab. The upper edge of the cornice is chipped. The portrait lacks its nose; a piece of the beard is missing from the chin. With the exception of the portrait's head, all other surfaces show tool marks; only the face has been cleaned of the layer of incrustation that coats the tool marks. A small round pinhole in the lower cornice was probably drilled in modern times.*

Only the right half of the inscription is preserved:

....QVADRATILLA
....APTHONETI: PATRIS
....ET:AQVA:HABITATIONE:SVPER
....CLVSA:ET:HORTVM:CONSACRATVM
....CELLA:LATERICIA:LIBERIS:MEIS
....POSTERISQ:EORVM:CVSTODIAM
....NOMINE:SERVIAT:NEDE:NOMINE
....MANVS:INFERRE:NOLI:SACRILEGE
....LOCVM:DEDI

Most of the right half of a pediment has survived, together with its diagonal, thrice-framed cornice. A round shield decorated with the bust of a bearded man occupies the center. At first glance, the tondo does not seem to be centrally placed within the

pedimental field; one would expect to find the gable's peak at the upper end of a line that runs through the middle of the portrayed individual's face. If one completes the composition by adding the missing part of the tondo, however, one sees that the portrait bust is not centered but has been shifted toward the right. Therefore the middle of the gable must indeed have been situated beyond the break.

The inscription has not survived in its entirety. The beginning of each line, as well as the left-hand portion of the fragment, has been lost. Nonetheless, enough of the text survives to surmise that a woman named Quadratilla arranged to have the monument built in memory of her father Apthonetus. What remains of the inscription suffices to show its kinship with the formula that is familiar in inscriptions from so-called *horti sepulcrales*.[1] These funerary gardens, of which Trimalchio's will gives a vivid picture (Petronius 71.6ff.), consisted of a surrounding wall on the main axis (*maceria/murus*), an entry area (*aedificium*), and the grave monument (*monumentum/memoria*) itself, which was surrounded by trees and flowers.[2] Since lavish plantings were one of the salient features of these sites, there is no lack of allusions to water (*aqua*), cisterns, basins, and canals. According to the inscription, Quadratilla too arranged to have water diverted into the walled area (*[maceria] clusa*). This water was no doubt used to irrigate the consecrated garden (*hortus consecratus*) she also established there. The mention of living quarters (*habitatio*), which were most likely situated above a room not mentioned in the

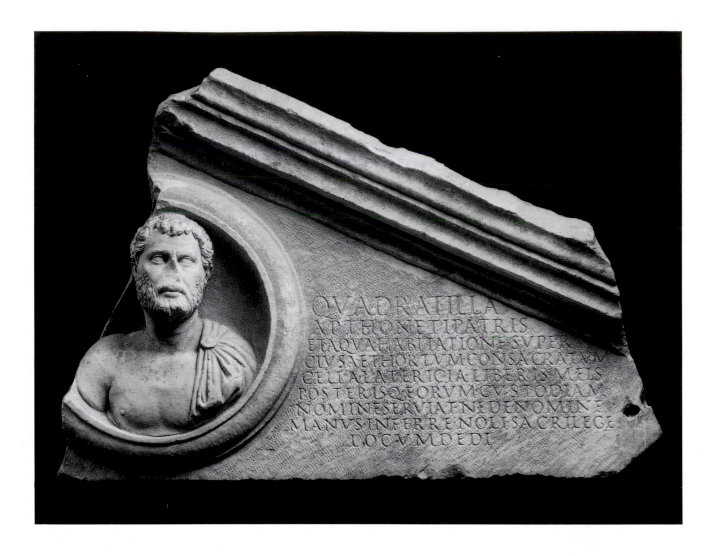

surviving text, is likely to have been a reference to a *habitatio super tabernas*,[3] living quarters for a custodian charged with the task of protecting and caring for the *hortus*. Opinions differ about what function the *tabernae* may have served. Their use has been variously interpreted as dwelling spaces, function rooms, or shops which sold flowers, wreaths, groceries, and other items related to the cult of the dead.[4] In most cases, the *horti sepulcrales* also had banquet rooms for the people participating in the cult of the dead *(diaetae)*, as well as *stabula* (shelters) and *meritoria* (spaces for rent).[5] Regarding the funerary monument itself, the inscription tells us only that it had a central structure built of bricks *(cella latericia)*. The tympanum fragment in Princeton, which surely belonged to this

structure, proves that the cella was elaborately decorated with marble.

The name Quadratilla is found several times in extant inscriptions.[6] The name Apthonetus, on the other hand, occurs only twice:[7] mention is made of a slave who lived in the first or second century[8] and of a person named Larcius Apthonetus,[9] about whom nothing else is known. Whether or not a connection exists between the latter and a certain Larcia Quadratilla, who appears together with her husband, Ti. Claudius Gratus, on the sarcophagus for her son, who died at an early age,[10] must remain an unanswered question.[11] For this reason, the question of a relationship between this Larcius Apthonetus and the Apthonetus mentioned in the inscription on the

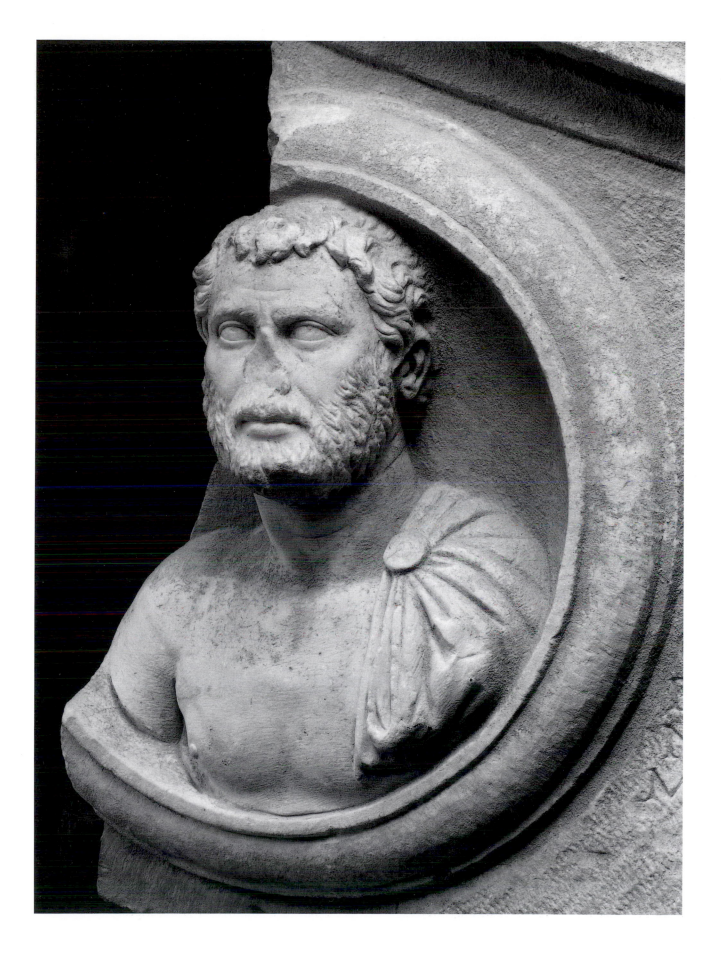

tympanum fragment must likewise remain unanswered. The Greek name of the father, Apthonetus, does suggest unfree origins and/or the status of a manumitted freedman.[12] Nevertheless, it seems that the family had attained a fairly high rank in society, as the elaborate tomb facility and its accompanying grounds suggest. Despite this obvious prosperity, the manner in which the deceased is depicted is nonetheless remarkable: the placement of a bust in the middle of the tympanum is not as surprising[13] as are the shield (*clipeus*) and the military cloak (*paludamentum*), which in this combination must be understood as alluding to the military prowess of the deceased.[14] As a rule, freedmen were excluded from military service,[15] although beginning in the late Republican period, there were some cases of "social climbers" who had been accepted into the knightly class and attained the rank of *tribunus militum*.[16]

The portrait makes it possible to identify the date when the tomb monument was built. It is extraordinarily similar to a bust, now in the Museo delle Terme,[17] that is closely modeled after portraits of Hadrian. The similarity of the Terme bust and the tympanum portrait to the emperor's "rolled ringlet type"[18] (*Rollöckchen-Typus*) suggests a date for this artwork in the later years of Hadrian's reign, the decade between A.D. 130 and 140. MF

BIBLIOGRAPHY
Record 45.1 (1986): 38–39 (illus.).
Mari 1991, 279, no. 210, 315–16, no. 15 (illus.).
AÉpigr 1991, 596.
Bodel and Tracy 1997, 148.

NOTES

1. On this, see Altmann 1905, 260–62; Toynbee 1971, 94–100; Jashemski 1979, 141–53; Gassner 1985, 165–69; Gregori 1987/88, 172–88; Hesberg 1992, 57–72; 229–230.
2. On the following, see Gregori 1987/88, 182–85, and Toynbee 1971, 95–100.
3. Cf., e.g., *CIL* VI, 31852, and Gassner 1985, 167.
4. Gassner 1985, 167–68; Gregori 1987/88, 182.
5. Cf. Gregori 1987/88, 182–83, and Toynbee 1971, 97.
6. Cf., e.g., *CIL* VI, 17823, 18573, 18937, 28526, 28729, 29758 (on the inscription, see below n. 11), and 33688 (below n. 10); On the mention in Pliny, *Letters* 7.24, of Ummidia Quadratilla, see *RE* 9A:600–603, s.v. Ummidius, no. 3 (M. Schuster); Syme 1979, 287–310.
7. Solin 1982, 747 and 1996, 417.
8. Solin 1996, 417.
9. *CIL* VI, 7724; on the proper reading of the name, see Solin 1972, 199, no. 2; also Solin 1982, 747.
10. *CIL* VI, 33688.
11. The marble tablet discovered near the gate of S. Sebastiano on the Via Appia, *CIL* VI, 29759 (*CII* 1:201, no. 285), upon which mention is made of a certain Larcia Quadratilla and a certain Pthonetus Securu[s?], cannot be regarded as evidence in this context because the names are assembled from two inscriptions not carved at the same time. Furthermore, the augmentation of the male name as "Apthonetus" can no longer be verified. I am indebted to K. Dietz for valuable criticism of my thoughts on this epigraphic problem.
12. Solin 1971.
13. Wrede 1978, 416; 414, pl. 135.1; Sinn and Freyberger 1996, 54.
14. Wrede 1978, 420; Sinn and Freyberger 1996, 54–55; Sinn 1987, 65.
15. See *RE* 2.6:2445–46, s.v. Tribunus (Lengle); Treggiari 1969, 51, 67–68.
16. Zanker 1975, 304–6, figs. 43–44, 46; Kockel 1993, 24–25; 108–109, no. D 1; 109, no. D 2, pl. 21 a–b; 182–183, no. L 9, pl. 95. See also Devijver and van Wontgerhem 1990, 59–98.
17. Felletti Maj 1953, 100, no. 190 (illus.).
18. Wegner 1956, 56–57; Fittschen and Zanker 1983–85, 1:49–51, no. 49, pls. 54–55; see also Schröder 1993, 198–200, no. 52.

12.

FUNERARY MONUMENT TO A CHARIOTEER

Hadrianic or early Antonine, ca. A.D. 130—140
Provenance: unknown
Dimensions: h. 57.6 cm., w. 63.0 cm., d. 51.2 cm.
Material: fine-grained marble
Museum purchase, gift of John B. Elliott, Class of 1951
(y1989-41)

CONDITION: *The top and left half of the front niche are broken away, including the entire palm tree on the left side. The break continues around the left corner: as a result, most of the rim of the left niche around the horse is missing, as well as the horse's forehooves and most of its head. The lower moldings of the left niche are also broken away, along with the entire upper back left corner. The front left corner is broken off, with consequent damage to the adjacent chest of the charioteer. On the portrait, the hair is abraded, the nose is missing, and the eyebrows, tip of beard, and mustache are chipped. The head and left foreleg of the horse in the right niche are damaged.*

This upper section of a freestanding funerary monument in the form of an altar features a portrait of a bearded man in high relief.[1] The top and back have been roughly smoothed with a claw chisel. Three of the altar's four sides are carved. On both the left and right sides, arched niches are decorated with horses carved in shallow relief. The horse on the right is depicted in a lively posture, head bowed and left foreleg raised, as though stamping the earth. The horse's open mouth also indicates movement. The mane is full and gracefully articulated with undulating curves. The horse on the left is depicted in the same stance, as if seen from the other side, but it is not the same horse: the mane is clipped, indicated by small straight parallel lines, and the tail is raised.

A frontal, life-sized, half-length relief sculpture of a bearded man faces out from the deep, apsidal niche on the front of the altar. The thick, wavy hair shows evidence of incision and deep drill work. The mid-length locks form an arc along the forehead. The eyes and lids are boldly carved below sharp bridges. The incised, C-shaped pupils give the impression of

looking off into the distance. The fleshiness of the face is partially offset by the high cheekbones and the medium-length beard, which is slightly longer beneath the chin. The ears are asymmetrical, the left being smaller and more recessed. The man wears an amulet around his neck and is clothed in a tunic with shallow folds. Over this garment, the man wears a harness of leather strap bands (*fasciae*) to protect his ribs, an accoutrement that instantly identifies him as a charioteer.

The Princeton charioteer shares a number of traits with portraits of the emperor Hadrian, during whose reign (A.D. 117–138) at least six different imperial portrait types were promulgated.[2] The Princeton portrait corresponds most closely to the later examples, especially Type 5, the Cuirass-Bust Imperatori 32.[3] This resemblance is particularly evident in the fuller, fleshier treatment of the face and the prominent beard. Despite these affinities with Hadrianic portraiture, however, there is one major deviation: Hadrian's hair is consistently rendered with pronounced curls, but the charioteer's hair is wavy and lacks the burgeoning ringlets that characterize many portraits of the emperor.

It was precisely during the Hadrianic/Antonine period that Roman funerary practices began to change. Since Etruscan times, inhabitants of the Italian peninsula had cremated bodily remains. During Hadrian's reign, however, burial began to gain increased social acceptance.[4] The Princeton charioteer probably would have been placed on the outskirts of town, perhaps alongside other similar monuments lining a road or within an officially sanctioned funerary precinct, or necropolis. It would not,

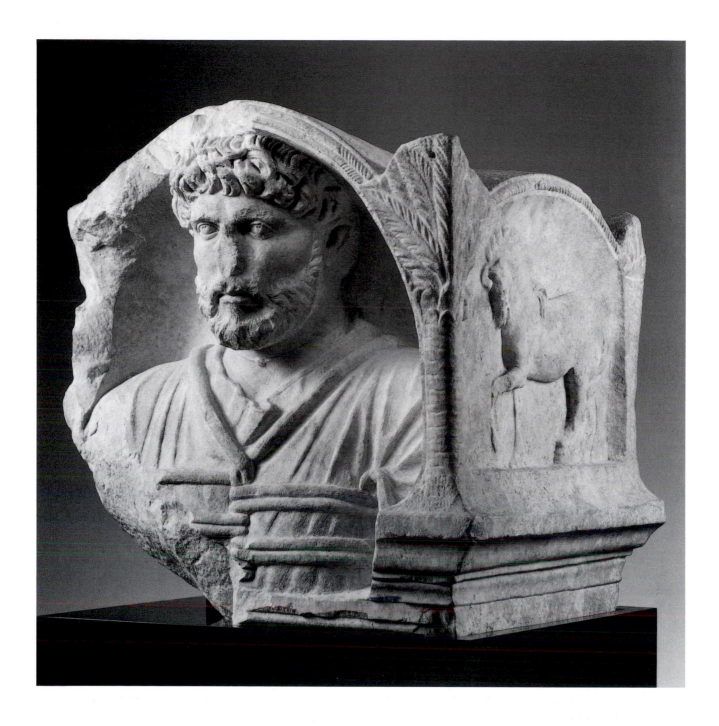

however, have provided an actual site for ritual sacrifice.[5] Rather, the monument would have functioned as a symbol and memorial to the deceased. The charioteer's family would have journeyed to this spot regularly to celebrate birthdays and other important events. During these visits, guests would leave food, gifts, and tokens for the enjoyment of the deceased.[6]

Roman beliefs concerning the afterlife may also explain the unusual relationship between the figure of the charioteer and his sculpted frame. The life-sized portrait is barely contained by the marble niche. This dynamic treatment creates considerable tension between the figure and his surroundings: the charioteer appears ready to break free from his architectural constraints. Assisted by the horses that flank

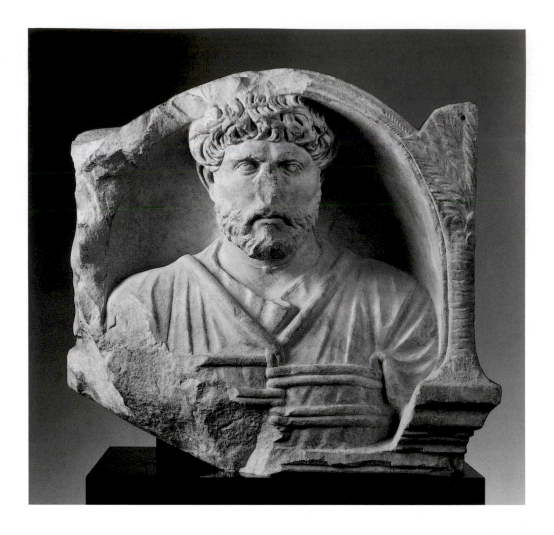

him on either side, he stands poised to charge forth from his starting gate to the ultimate victorious finish, an outcome symbolized by the palms that decorate the carved aedicula.[7]

It is important to note that funerary altars of this type were not commissioned by or for members of the Roman patriciate. Rather, the majority of these monuments commemorated the lives and accomplishments of former slaves.[8] These emancipated slaves, or freedmen, used the visual arts, specifically the sculpted funerary altar, as a means by which to celebrate their elevated social status.[9] In addition, the Princeton monument celebrates the prestigious and popular profession of its subject, a charioteer.

Public projects and events such as chariot racing served a dual civic purpose.[10] Not only did they provide entertainment for a given population, they also bolstered public opinion which, in turn, enhanced and secured the position of the person or group who supported them. Both Hadrian and his successor, Antoninus Pius, were well aware of the goodwill that could be engendered via public games and they often sponsored such events. By associating himself visually with both his profession and the emperor, the Princeton charioteer commemorates his social and professional triumphs as well as the important role that he and his fellow drivers played in society at that time.

BDM

BIBLIOGRAPHY
Record 49.1 (1990): 53 (illus.).

NOTES
1. For more on funerary altars, see Altmann 1905; Bowerman 1913; Candida 1979; Koch and Sichtermann 1982; Koch 1988; Sinn 1991; and Koch 1993. For altars with sculpted portraits, see Kleiner 1987.
2. For a description of the six types and their distinguishing

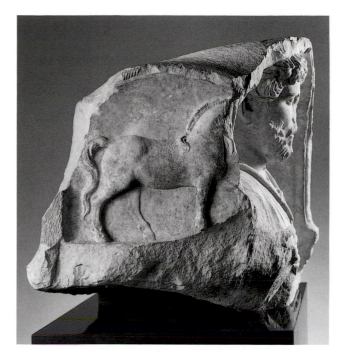

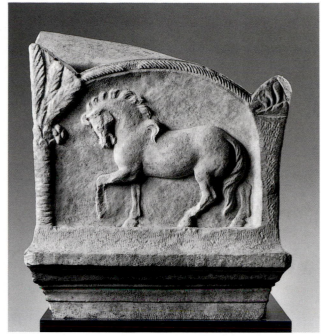

characteristics, see Kleiner 1992, 238–41. For more on Hadrianic portraiture, see also Wegner 1956; Fittschen and Zanker 1983–85, vol. 1; and Evers 1994.

3. Cf., for example, Athens, National Archaeological Museum 3739: Wegner 1956, 40–41, pl. 35.

4. Nock 1932, 323, 357; Toynbee 1971, 40, 73–74; Kleiner 1987, 17, 21.

5. Kleiner 1987, 89.

6. Toynbee 1971, 51; Kleiner 1987, 89.

7. Toynbee 1971, 38–39.

8. Toynbee 1971, 17.

9. Cf., for example, an unpublished funerary altar of similar date in the Tampa Museum of Art (91–1), which also features a portrait of the deceased within an apsidal niche. The monument was erected for L. Caltilius Diadumenus by his former owner in memory of his "best freedman" (liberto optimo).

10. On chariot racing and its importance in ancient cultures, see Manodori 1982; Humphrey 1986; and Landes 1990. Although more general in scope, Pisani Sartorio et al. 1990, and Golvin and Landes 1990 also contain useful information concerning the social ramifications of public sporting events.

13.

HEAD OF A PRIEST OF THE IMPERIAL CULT

Probably late Hadrianic, second quarter of the second century A.D.
Provenance: unknown
Material: bluish marble
Dimensions: h. 48.5 cm., w. 40.5 cm., d. 36 cm.
Museum purchase, gift of John B. Elliott, Class of 1951
(y1990-3)

CONDITION: *The head is broken off diagonally through the base of the neck. The nose is missing and the surface of the face has sustained some chipping and abrasions, most notably on the nose bridge and under the left eye. All the busts on the crown are worn down or chipped beyond recognition (if they were ever finished), and small sections from the front of the crown and right side of the headband (strophion) are damaged. The left edge and front corners of the plinth above the crown are broken off, as is much of its rear portion, particularly on the left side.*

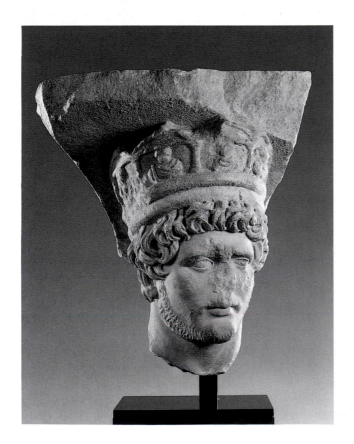

The man's long, oval face tapers to a rounded point at the strongly protruding chin. A series of deeply carved and drilled curls define the tight, semicircular coiffure above the slightly bulging brow. The eyebrows are prominent, and the wide, almond-shaped eyes terminate in sharp points at the outer corners. The eyelids are thin, sharply defined folds, while the pupils are in the form of drilled, U-shaped crescents. The man's youthful face is nearly devoid of wrinkles save the firmly sculpted caliper lines and the creases denoting crow's feet. The surface is unpolished, and, indeed, exhibits noticeable rasp marks. Protuberant cheekbones coupled with a long, narrow face give the man a somewhat gaunt countenance. A thin beard composed of S-shaped chisel marks follows the firm contours of the jawline; a mustache, similarly treated though separated from the beard, lightly covers the upper lip of a full, curvaceous mouth. The lips are closed together gently and framed by deep dimples. The fleshiness of the lower lip creates a noticeable dip between itself and the prominent chin below. The head is turned approximately 45 degrees to its left, and the more summary treatment of the far left side suggests that the intended view was from the figure's right. The twist of the neck indicates that the body probably stood frontally.

The man wears a tall crown atop a thick, cylindrical headband. The crown consists of a *strophion*-like base and an arcade, with four bays topped by triangular pediments and separated by squat columns. A small male bust occupies each bay, each wearing a miltary cloak (*paludamentum*) fastened over the right shoulder. Looming above the crown is a flat, rectilinear

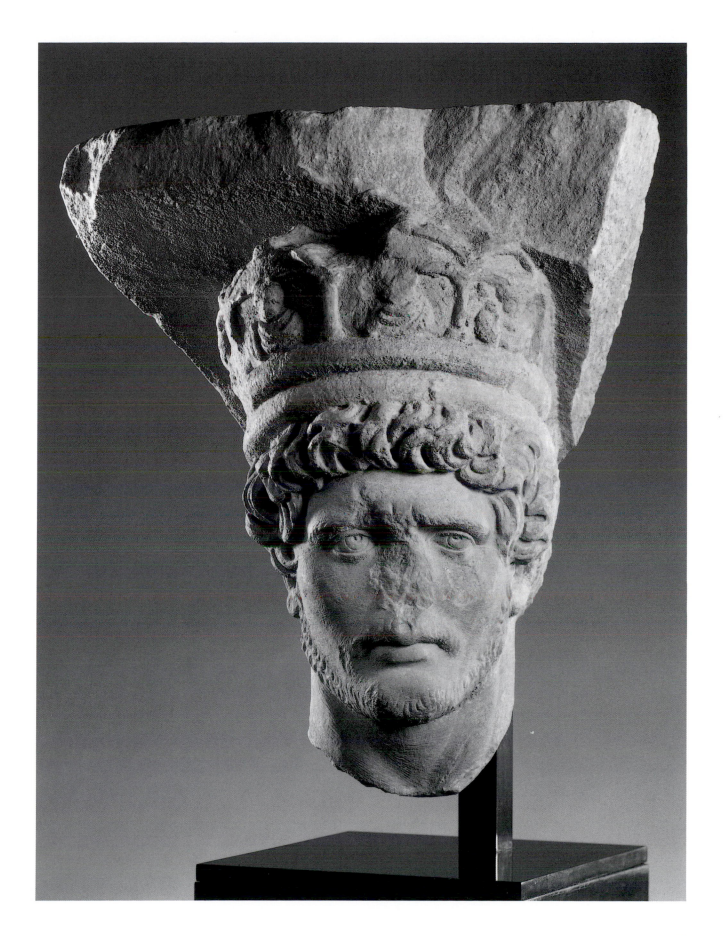

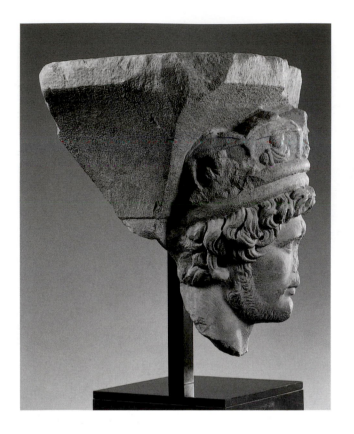 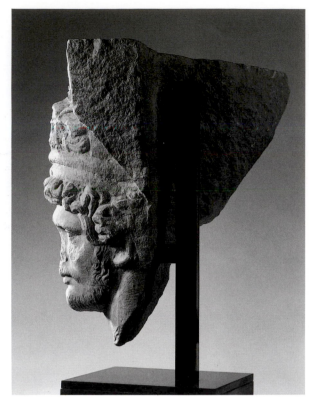

plinth, which tapers as it slopes down the back of
the head. The sloping taper is repeated on the proper
right side, and remnants of the damaged left side
indicate that this section was similarly sculpted, so
that the plinth takes on the rough form of a column
capital. Though largely lost, the back of the piece
appears to be undecorated, suggesting that this figure
would have been viewed solely from the front.

Firm parallels for the portrait of the priest may be
found in the portrait types of the emperor Hadrian,
most notably Types 5 and 6, exemplified by busts in
Athens and Copenhagen.[1] Among other congruent
features, these portraits share similarly thin eyelids
and a slim face, although the emperor's chin appears
less prominent and tapered. The gaze of the Prince-
ton portrait, slightly upward and to the left, recalls
that of the emperor' bust in Athens. One also might
compare the gaze of later emperors, such as Marcus
Aurelius, in which a similar feature is employed to
evoke the sensation of intellectuality and introspec-
tion; a bust of a young man, also in Copenhagen,
offers another fine comparison.[2] Lastly, the many por-
traits of Antinous in the so-called Main Type, firmly

attest the attribution of the Princeton portrait to the
late Hadrianic period.[3] The beard and overly promi-
nent eyebrows aside, many of the aforementioned
features are present in the Antinous portraits. Particu-
larly notable is the coiffure by the right temple, which
resembles an abridged form of Antinous's own.[4]

The identification of this portrait as an imperial
priest is based primarily on literary and epigraphical
sources. Inscriptions dating to the second century B.C.
testify to the Hellenistic origins of crown-busts as
well as to their iconographic association with the
office of the priesthood.[5] That such a tradition actu-
ally existed is confirmed by Athenaeus (*Deipnosophistae*
211b), who recalls a certain visit by the Epicurean
Diogenes to the court of Alexander, during which
the philosopher sought permission to wear a crown
"bearing in the middle the face of Virtue."[6] A pas-
sage from Suetonius (*Life of Domitian* 8.4) document-
ing the contests held in honor of Jupiter Capitolinus
attests the Roman adaptation of this tradition, as do
certain Syrian variants on the apocryphal acts of Paul
and Thekla. Though he is not expressly named in the
acts as an imperial priest, the antagonist, Alexander,

is described as wearing a crown (wreath) bearing the face of Caesar. Finally, some figures wearing such crowns are actually accompanied by inscriptions naming them as *archiereis*, high priests.[7]

Once the man's priestly standing has been established as probable, one may address the issue of the identities of the busts in his crown. As all of the figures are worn down or chipped beyond recognition, identification is dependent upon their raiment. In this case, all figures appear to wear *paludamenta*, divulging their likely standings as members of the imperial household. In light of the late Hadrianic attribution, one might postulate Nerva, Trajan, Hadrian, and Lucius Aelius or Antoninus Pius—the latter being heirs apparent—for the four figures, although imprecise dating and possible inclusion of deified emperors render these identifications tenuous at best.

Only twenty-three or so bust-crowns in the round are known, the overwhelming majority of which have been found in Asia Minor. Regardless of contemporaneous construction or geographical proximity, these crowns vary widely in their decoration and composition. The numbers of busts can range anywhere from one to fifteen. Bust-crowns are worn by both men and women, with the decorative elements occasionally modified to suit the gender of their owner. Some priestesses have been found with pearl diadems, while their male counterparts occasionally sport rolled fillets in the manner of athletes.[8]

The number of high priests who operated in Asia Minor concurrently is an issue of some dispute. Most likely, there was only one high priest for every polis possessing a provincial cult, regardless of the number of cults contained within the limits of the polis. The specifics of the high priest's position were largely of an economic nature, cultic responsibilities being almost an afterthought. An appointment to the position was based upon one's socio-economic status among the provincial elite; the number of times and degree of lavishness with which one held the position was a constant source of competition for advancement within the community. Overwhelmed by the financial burdens of the post, some even sought to avoid appointment. Whether erected by themselves or in their honor (or memory), only the most successful

and popular of the imperial priests were worthy of having their image placed in a public setting.[9]

There are two additional manifestations of bust-crown iconography in addition to its appearance in Asia Minor. In Palmyra, reliefs and paintings found within the tombs of priests often depict the deceased wearing a modius crown featuring a sculpted image of the deity whom he served (e.g., cat. nos. 154, 155).[10] The few examples of bust-crown iconography that have been discovered in Italy, including an image of Antinous himself, are all associated with the eastern goddess Cybele, otherwise known as Ma Bellona or Magna Mater.[11] All three occurrences of bust-crown imagery, then, are interconnected in terms of function and place of origin, preserving the stable transmission of this iconographic element from Hellenistic times.

The construction of the piece indicates that the intact figure originally served in an architectural capacity, most likely as a votive column. It should be mentioned, however, that this is the only extant portrait to integrate architectural elements directly into the crown itself, perhaps suggesting a more involved architectural function. In particular, it recalls the figural pillars of eastern barbarian captives arrayed on the upper storey of an ornamental façade bordering the Roman agora in Corinth.[12] MM

BIBLIOGRAPHY
Record 50.1 (1991): 60 (illus.).

NOTES
1. Athens, National Archaeological Museum, Imperatori 32; Wegner 1956, 40, pl. 25a. Copenhagen, Ny Carlsberg Glyptotek, *paludamentum* bust 283:1. Johansen 1995, 112.
2. Copenhagen, Ny Carlsberg Glyptotek: Johansen 1995, 146. In addition, the shape and execution of the lightly chiseled beard is also well matched.
3. Meyer 1991, pl. 63. Among the many portraits of Antinous, one in particular might point to the example in Ostia: in addition to bearing a particularly strong resemblance to the Princeton piece, this portrait features a bust-crown by virtue of Antinous's incarnation as Attis, the lover of Cybele.
4. One additional comparison is worthy of note. Curiously, the Princeton portrait resembles Caryatid 2233

from Hadrian's villa at Tivoli. The two works possess similarly firm profiles, long necks, and general treatment of facial features; see Schmidt 1973, 22–24, VH 3, pls. 19–25.

5. Robert 1930, 262–63.

6. Athenaeus, *Deipnosophistae*, trans. C. B. Gulick, Loeb Classical Library (London 1928), 455.

7. Inan and Alföldi-Rosenbaum 1979, 42. Three crowns from Aphrodisias, each featuring an image of Aphrodite, the patron goddess of the city, are often cited as proof that all bust-crown priests were not necessarily associated with the imperial cult. Much of the evidence for cults in Asia Minor suggests, however, that the different cults within the polis were often interrelated. Therefore, dissociation from the imperial cult may not be determined solely by the absence of imperial busts from a particular crown.

8. For a general overview on bust-crowns and their iconography, see Inan and Alföldi-Rosenbaum 1979, 38–47. For a splendid new example in bronze, see Rumscheid 2000, no. 64, pls. 28–30.

9. For an overview of the imperial cult in Asia Minor, see Price 1984 and Friesen 1993, 76–113.

10. Ingholt 1935, 68–69, pl. 28.

11. Inan and Alföldi-Rosenbaum 1979, 44–45.

12. Vermeule 1986, 71–73, figs. 1–2. For the plainness of the tapering plinth, cf. another figural pillar with a barbarian, in the Louvre (MA 1695), from El Kantara, Tunisia (Brouillet 1994, 100, no. 68).

14.
PORTRAIT OF A BOY

Antonine, ca. A.D. 160–180
Provenance: unknown
Material: white marble with yellow patina
Dimensions: h. 12.6 cm., w. 6.3 cm., d. 9.2 cm.
Museum purchase, gift of the family and friends in memory
of Mathias Komor (y1984-15)

CONDITION: *In very good condition. The ears are battered, the chin slightly abraded. The tip of the nose is missing and both nostrils chipped. The edge of the bust is broken away on the sides and front, and part of the support post is broken off at bottom. The polished flesh areas have a slightly yellow patina. The head is lightly speckled with brown incrustation, most noticeable on the nose, chin, right cheekbone, and hair. Traces of (modern?) plaster are discernable on the edge of the bust and around the modern drill hole in the base.*

This unusual head belonged to a miniature bust, as can be seen from the tapering support post on the back. At the nape of the neck is a section of garment whose exact nature can no longer be determined with certainty. However, it was probably a Greek mantle (himation), for the posture of the boy's long, thin neck suggests that this bust should be envisaged as an abbreviated version of a seated statue. In that case, the sitter might be credited with philosophical or

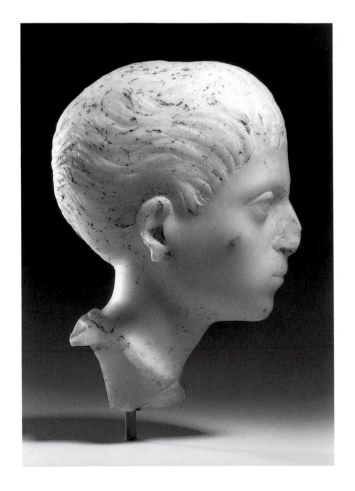

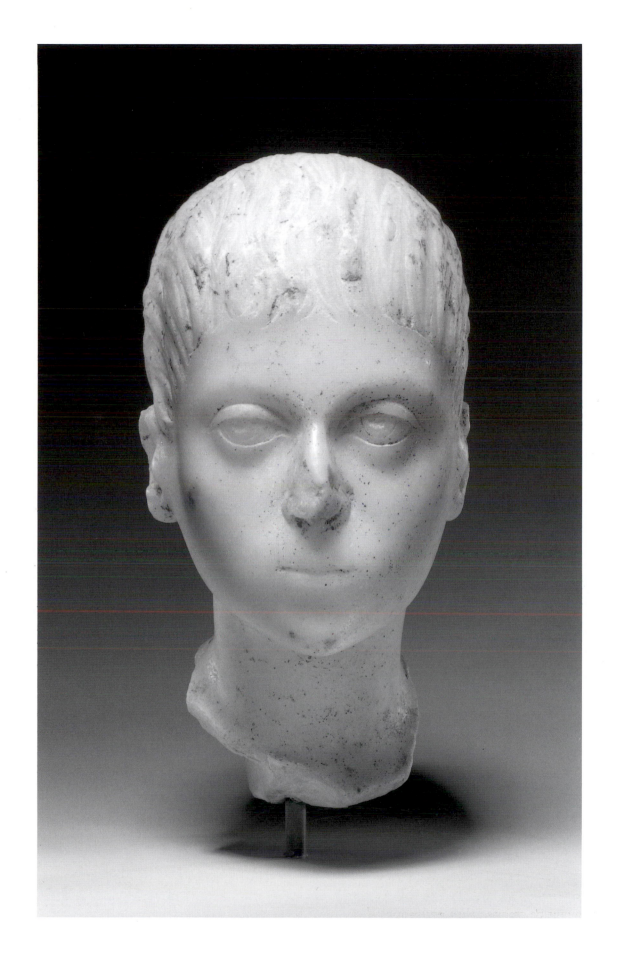

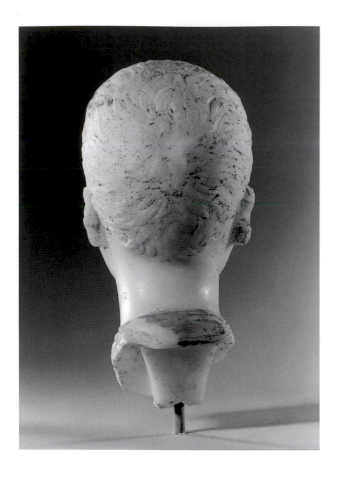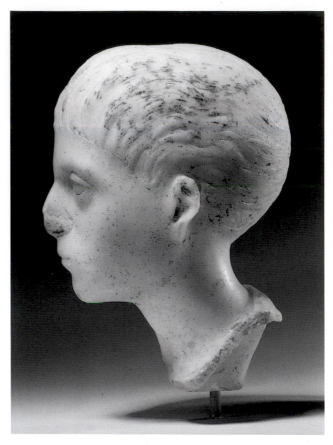

poetic propensities, which is neither unheard of[1] nor contradicted by the delicate facial features and the long, slender skull. The eyes are huge, and the wide upper lids add a touch of weariness to the pensive upward gaze. The C-shaped pupils are set within incised irises. The aquiline nose projected far outward, overarching the small, soft mouth that, nevertheless, stands out quite prominently against the background of the hollow cheeks. The small but weighty chin points downward. Emphasis on the cheekbones and jaws further underscores the almost emaciated appearance of this youth, under whose eyes bags have begun to form. In the lateral views, the enormous bulge of the back of the head contributes to the sense of human frailty. The contrast between the high polish on face and neck, as opposed to the coarser treatment of the hair, further amplifies this impression.

A portrait of a girl in a private collection seems closely related at first sight.[2] Her expression is thoughtful, her face slim and elongated, and her braided hairstyle juts out at the back of the head forming a more than sizeable bulge. The suggested early-third-century date for this masterfully carved piece seems convincing. That, however, does not clinch the date for the Princeton youth, because the girl's head, overall, is much firmer and, as it were, less otherworldly. The Princeton bust is earlier: it belongs to the reign of Marcus Aurelius.

The eyelids with their downward-turned inner corners most closely resemble those of Lucilla Augusta, daughter of Marcus Aurelius, in her portrait in the Braccio Nuovo of the Palazzo dei Conservatori (Type 1, A.D. 165–169).[3] Portraits of Lucilla's brother Commodus sometimes show a similarly delicate surface treatment of flesh and skin.[4] In spite of Commodus's young age, his eyes show a tendency to become baggy, and the area of the mouth is soft and slightly protruding. In the latter regard, however, the Princeton boy may be influenced by portraits of Lucilla's husband, Lucius Verus.[5] In this emperor's images, the mouth often seems pursed or puckered. Lucius Verus died in A.D. 169. For the finely incised

but irregular lines of the Princeton youth's hair one may find comparisons among the portraits of Faustina the Younger, mother of both Commodus and Lucilla, specifically in her eighth portrait type.[6] It thus appears safe to say that the Princeton portrait was crafted in the sixties or early seventies of the second century A.D.

<div style="text-align: right">HM</div>

BIBLIOGRAPHY
Record 44.1 (1985): 45 (illus.).

NOTES
1. Cf. Meyer 1991, 260 with further references.
2. Fittschen 1991, 302–3, pl. 70, 1–3.
3. Fittschen and Zanker 1983–85, 3: no. 24, pl. 33; on Lucilla's portrait types, see Fittschen 1982, 69–81.
4. Fittschen and Zanker 1983–85,1: nos. 74 and 75, pls. 88, 89; cf. Fittschen 1999, 53–62, pls. 85, 91, 92, and passim.
5. Fittschen and Zanker 1983–85, 1: no. 73, pls. 84, 85, and Beilage 50–54.
6. Fittschen 1982, 60–63, pls. 36, 38. For a correction regarding Fittschen's Type 6, see M. Fuchs's review of Bol 1986, in *BJb* 186 (1986): 856.

15.

PORTRAIT OF MARCUS AURELIUS

Antonine, ca. A.D. 170–180
Provenance: said to be from an English private collection
Material: Carrara (Luna) marble with a brownish patina
Dimensions: h. 34.1 cm., h. of face 19.5 cm., w. 27.9 cm., d. with restored nose 26.8 cm.
Museum purchase, Carl Otto von Kienbusch, Jr., Memorial Collection Fund (y1958-1)

CONDITION: *The tip of the beard and several strands of hair have broken off. The locks of hair on a nearly palm-sized area on the top of the head have flaked off. Chip marks are evident on the hair and beard, eyelids, forehead, and eyeballs. The nose is restored; the face has been smoothed. A layer of incrustation covers the hair, especially on the back of the head.*

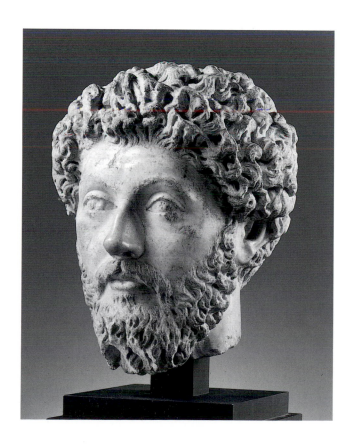

This slightly larger than life-sized head belongs to a series of portraits of Marcus Aurelius at an advanced age, but it is not immediately apparent to which type it belongs.[1] The hair is combed radially away from the face; deeply drilled channels subdivide it into individual strands. This style of coiffure characterizes the fourth and last version of Marcus's portraits.[2] However, a rudimentary remainder of the previous portrait type has survived above the right temple:

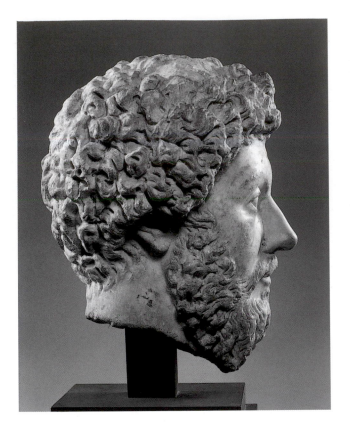

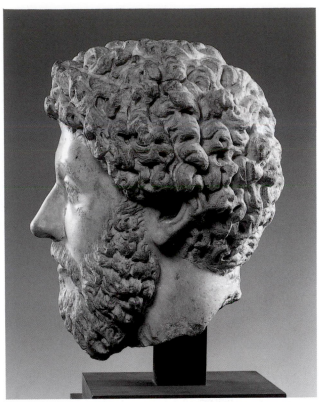

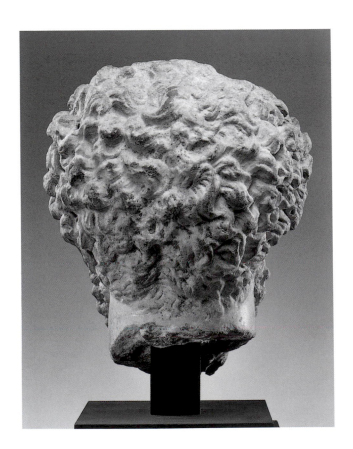

despite the chipping, one can discern the beginning of a loop-shaped lock of hair that would have hung over the face and joined an S-shaped one winding its way toward the center of the forehead. These are components of a forehead hair motif consisting of a loosely curled, forwardly falling arrangement of hair, which seems to be characteristic of the third type of portrait.[3] Likewise characteristic of the third type is the physiognomy, which shows neither the dramatized traces of age (there are no wrinkles on the forehead or above the root of the nose[4]) nor the abundant growth of beard[5] that are typical of the fourth type.

The Princeton portrait of Marcus Aurelius is thus apparently a hybrid type *(Klitterung)*. It combines the third version of the emperor's portraits, created on the occasion of the emperor's ascent to power in A.D. 160–61,[6] with the fourth version, which probably dates from A.D. 169.[7] In this year, following the demise of Lucius Verus, Marcus became sole emperor. It would therefore seem to have been carved between the last-mentioned date and the death of Marcus in A.D. 180.[8]

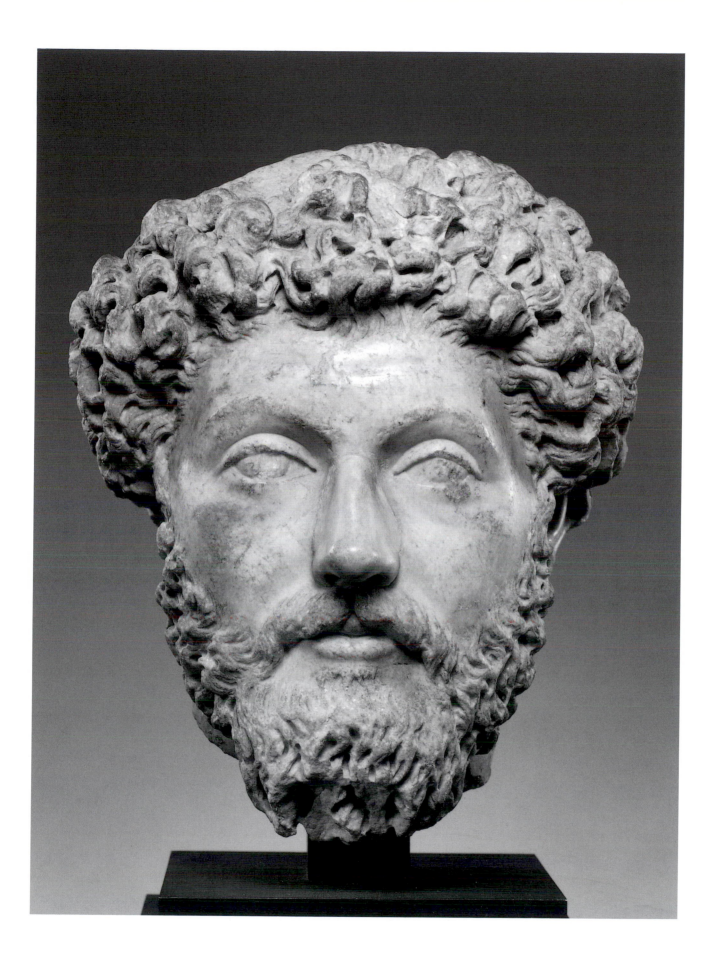

While conflation of types is by no means unusual in the portraiture of Roman emperors,[9] the Princeton head differs from most of the other extant portraits of Marcus Aurelius in a number of noteworthy ways. It is characterized by an uncannily calm air of superiority, or severity, which resides in the even-handed treatment of both halves of the face: only on close inspection does one notice that the right half is more drawn out than the left. In its frontality, this portrait foreshadows the artistic conventions of late antiquity and the Byzantine era. The rationalization of form is discovered in minute details: the arc of the eyebrows is echoed twofold by the upper lids, and then repeated in reverse order by the upper rim of the lower lids and the depression that separates the latter from the bags under the eyes—hinting of advanced age and unsparing dedication to the imperial office. The sagging, lower demarcation of the bags is antithetical to the naso-labial "caliper lines," whose curve is reiterated by the emperor's mustache. The latter hides the upper lip, but the fleshy lower lip is fully relaxed, for the mouth is slightly opened without being occupied with speech. Great care has been taken to make the curly strands in both the beard and the hair radiate away from the highly polished surfaces that make the skin and eyes of this portrait almost seem to glisten.

Following the unperturbed reigns of the emperors from Trajan through Antoninus Pius (A.D. 98–160), the empire and its inhabitants were bound to be upset and threatened when the borders started to crumble simultaneously before barbarian incursions on the northeastern frontier and Parthian invasion in the East. Against this backdrop, the Princeton portrait features Marcus as an almost Christ-like savior. His hair and beard speak of energy and resolve, while certain indications of physical decay intimate concern and awareness, as well as that kind of experience which is conducive to the resolution of problems. It should be remembered that Marcus, at the time when this image was carved (i.e., after the death of Verus), had been left to shoulder the responsibilities of empire on his own.

MF

BIBLIOGRAPHY

Record 17.2 (1958): 50–51, cover illus.
Record 18.1 (1959): 40.
Art Quarterly 21 (1958): 216, fig. p. 217.
Vaughan 1959, 134 (illus.).
Vermeule 1961a, 8–9, fig. 18.
De Franciscis 1972, 332–33.
Selections 1986, 45 (illus.).
Wegner 1979b, 162.

NOTES
1. See Wegner 1979b, 162; see also De Franciscis 1972, 333.
2. Bergmann 1978, 26; cf. 41–42.
3. For the motif of the hair on the forehead, see Fittschen and Zanker 1983–85, 1:70, no. 65, pl. 75.
4. Bergmann 1978, 26, figs. 34–39; Fittschen and Zanker 1983–85, 1:70, no. 65, pl. 75.
5. Bergmann 1978, 26; Fittschen and Zanker 1983–85, 1:75, no. 68.
6. Bergmann 1978, 23–26; Fittschen and Zanker 1983–85, 1:70, no. 65.
7. Fittschen and Zanker 1983–85, 1:75, no. 68.
8. Thus far, no stylistic proof of posthumous portraits has been forthcoming (Fittschen and Zanker 1983–85, 1:75).
9. Cf. Bergmann and Zanker 1981, 317–412. For Domitian's portrait on Cancellaria frieze B, see Meyer 2000a, 124–40.

16.

PORTRAIT OF A MAN

Antonine, ca. A.D. 180
Provenance: unknown
Material: white, finely crystalline marble
Dimensions: h. 27.6 cm., w. 24.2 cm., d. 24.0 cm.
Museum purchase, anonymous gift in memory of Mathias
Komor (y1989-26)

CONDITION: *The head is broken off below the chin at the upper end of the neck. The crown of the head was added on as a separate piece (an iron pin is still inserted in the pecked area on top of which the additional piece was once added) and is missing today. The tip of the beard, tip of the nose, part of the lower lip, locks of hair at the temples, and the upper half of the forehead have all been broken off. Some fresh damage is evident on the right half of the face and on the rows of locks above the temples and ears. The hair directly above the nape has not been fully sculpted; remnants of incrustation are evident here and on the parts immediately above; traces of root marks can be seen on the entire surface.*

The man wears his hair and beard in a style reminiscent of Antoninus Pius.[1] As in that emperor's portraits, the hair is combed forward from the whorl at the cowlick in clearly defined groups of locks. It is likely that the hair arrangement on the now-missing portions of the crown and above the forehead[2] would have been similar to that in Antoninus's portrait. Likewise closely related, it seems, are the short, cropped beard and the shape of the mustache, which leaves the *philtrum* free of hair and frames the shaved portion of the lower lip in a curving arc that begins at the corners of the mouth. The physiognomy, especially the comparatively large eyes, emphatic cheekbones, and youthful appearance leave no doubt that

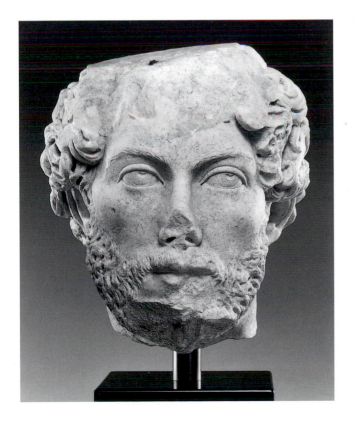

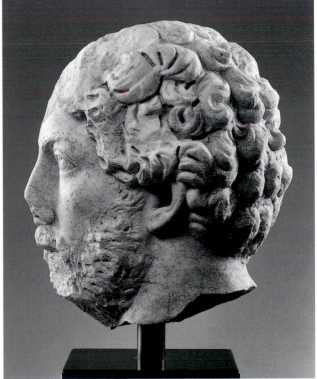

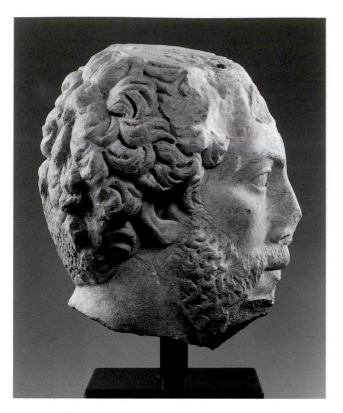 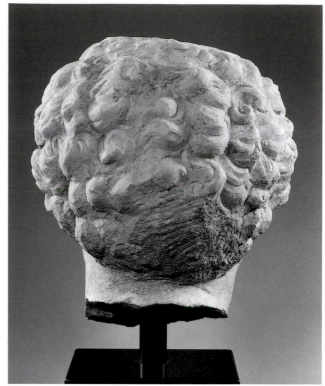

the sculpture represents a clearly individualized person who had lived under Antoninus Pius and not the emperor himself.

In addition, the man's face betrays the influence of yet another imperial image postdating that of Antoninus. The arched eyebrows, high cheekbones, and hollowed cheeks, as well as the gaze, which is directed diagonally upward, all reveal the influence of portraits of Marcus Aurelius.[3] The contemplative eyes, seemingly focused on no tangible object, especially connect this portrait with the facial expression seen in later portraits of this emperor.[4] The expression, which may suggest that this individual is contemplating profound and recondite thoughts, is similar to the facial expression in the latest portraits of Marcus Aurelius, where it emphasizes the emperor's philosophical proclivities. The Princeton head, therefore, was carved during the later years of the emperor's reign, although the sitter elected to refer back to the hairstyle and beard fashions of his halcyon years.

Observations of certain technical details corroborate such a later dating of the portrait. A characteristic feature of the sculpting is the neglect of the back of the head. Unlike the hair, which is visible from the front and in which the sculptor made frequent use of his drill, the back of the head shows no traces of drilled lines beyond the caesura, which runs just behind the ears. This peculiarity in the craftsmanship[5] first appears during the mid-Antonine period and is a characteristic feature of portraits of Marcus Aurelius. It still occurs in portraits of Septimius Severus.[6] Its presence lends support to the supposition that the sculpture was created during the later years of the Antonine period. One can do little more than speculate about the possible location of the workshop where the piece was carved: the organic build of the face and the rather minimal attention to detail in the rendition of the hair both suggest that the Princeton head may have Attic origins;[7] excellent comparative examples exist to support this supposition.[8]

According to these considerations, it seems likely that the private individual depicted in the Princeton portrait would have commissioned or received the sculpture around A.D. 180. M F

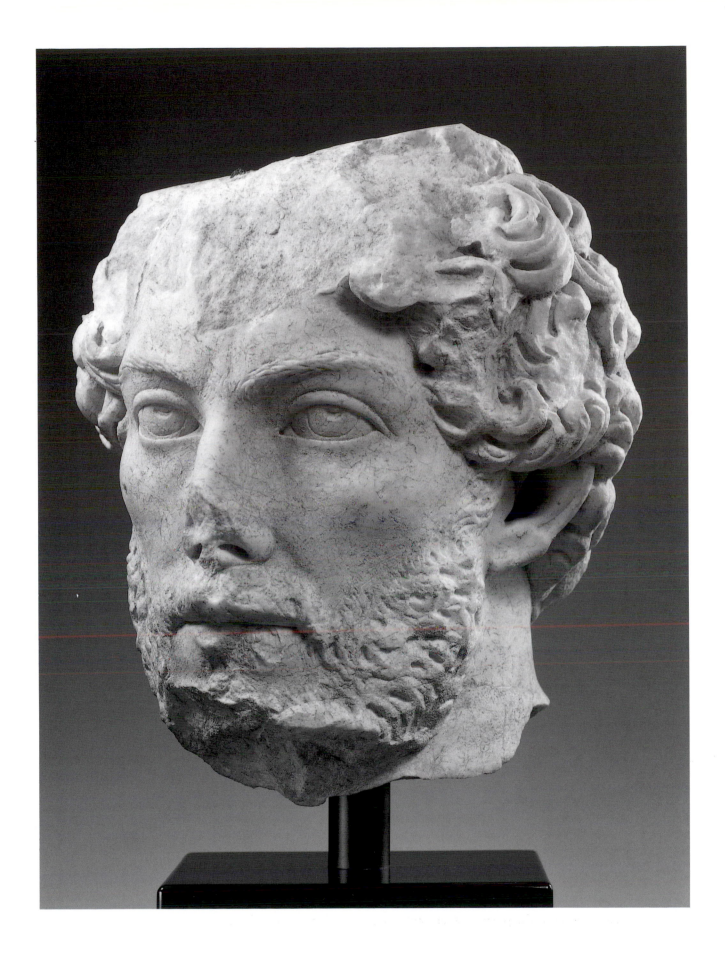

BIBLIOGRAPHY
Record 49.1 (1990): 52 (illus.).

NOTES

1. Wegner 1939, 15–25, pls. 1–9; Fittschen and Zanker 1983–85, 1:63–66, no. 59, pls. 67–68.
2. The hair is more tightly curled than it is on heads of Antoninus Pius. The two symmetrical remnants on the edge of the break suggest that the hair originally hung down over the forehead.
3. See Bergmann 1978, 22–28; Fittschen and Zanker 1983–85, 1:67–69, nos. 61–63.
4. Fittschen and Zanker 1983–85, 1:29–31 on the statement associated with this.
5. Fittschen and Zanker 1983–85, 1:70, 71.
6. Cf., e.g., Fittschen and Zanker 1983–85, 1:70–71, nos. 65–66, pl. 75; 74–78, nos. 68–71, pls. 78–82; 91–98, nos. 80–85, pls. 97–104; Datsouli-Stavridi 1987, figs. 28–29, 30–31 and 1985, figs. 75–76, 87–90. The portrait in Sparta (Datsouli-Stavridi 1987, figs. 30–31) and the one in Athens (Datsouli-Stavridi 1985, figs. 75–76) can also be included as far as the facial expression is concerned; also see Datsouli-Stavridi 1989, 135–36, pls. 34–35.
7. For the peculiarities of Attic portraits, see Fittschen 1971, 228–30; Bergmann 1977, 80–88; Bol 1984, 21.
8. Cf. above n. 6 and the examples cited by Fittschen 1971, nos. 53–63.

17.

PORTRAIT OF A GIRL

Severan, beginning of the third century A.D.
Provenance: unknown
Material: white marble with a yellow patina, possibly Carrara (Luna)
Dimensions: h. 21.4 cm., w. 16.4 cm., d. 17.9 cm.
Museum purchase (y1955-3228)

CONDITION: *The head and part of the neck have survived. Chipping can be seen on the tip of the nose, both eyebrows, the forehead, the lips, and the wreath, as well as on both ears; another damaged site on the chin has been patched. A modern rectangular incision is found on the back of the head directly above the flat knot of hair. Severe surface abrasion is evident on the hair, especially above the forehead, and on the wreath. Remnants of incrustation are visible on the left half of the head; traces left by tool marks are visible on the entire surface.*

The head, which is inclined slightly to its left, depicts a young girl whose youthful age is suggested by her plump round cheeks, high convex forehead, and "melon" coiffure.[1] The hair on the crown is subdivided into several ribs on both sides of the middle parting; these ribs continue nearly horizontally toward the back of the head, where they are gathered into a flat, nestlike bundle. Small, sickle-shaped strands frame the forehead and temples. Except for the design of these little locks of hair, the arrangement of the coiffure corresponds to that worn by Plautilla as shown in her first portrait type, which was probably created on the occasion of her marriage to Caracalla in A.D. 202.[2] In this type, one flatly-carved, sickle-shaped lock breaks away from each of the ridges of the "melon" coiffure. In the girl's head in Princeton, by contrast, pairs of locks have freed themselves to fall vertically over the maiden's face. The physiognomy, too, betrays the intention to assimilate this piece to the portrait of the empress: the convexity of the forehead, the uncommonly large extent of the back of the head, the small mouth, and the strikingly large ears[3] are all characteristic of this resemblance. These details place the little Princeton head

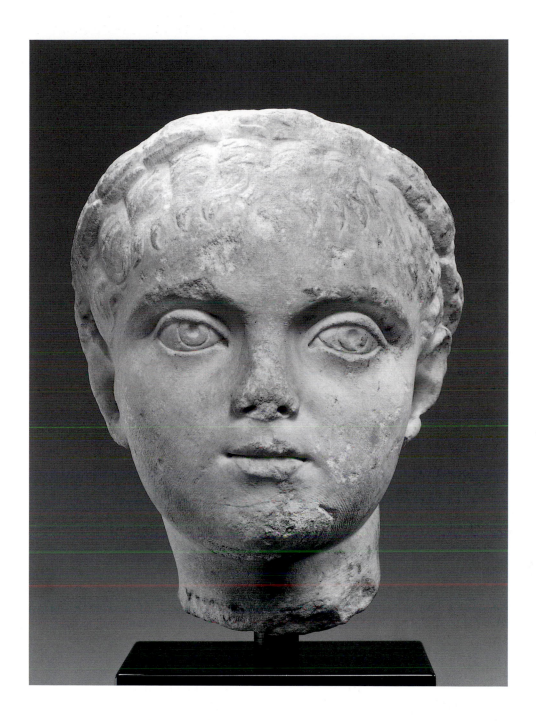

among a series of girls' portraits which date from the beginning of the third century A.D. and are relatively closely related to the earliest portrait of the empress, who was fourteen or sixteen years of age when she was married.[4]

This interpretation is by no means contradicted by the attribute worn by the maiden: she wears a wreath whose surface, though severely abraded, nonetheless reveals the characteristic shapes of laurel leaves

at some points. Laurel wreaths are not restricted to the emperor and the imperial family; they frequently adorn the heads of private individuals, including children.[5] In most cases, the wreath is indicative of priestly status. This interpretation can also be considered for laurel-wreathed children.[6] The rectangular indentation directly above the nestlike bunch of hair on the back of the Princeton head has prompted the suspicion that the depicted girl could be either a

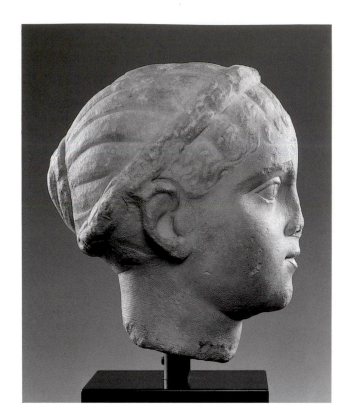

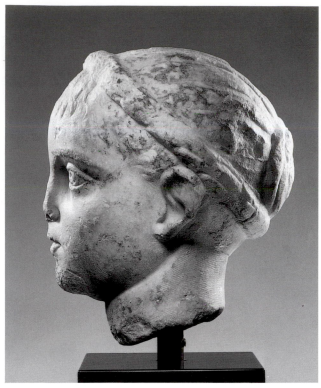

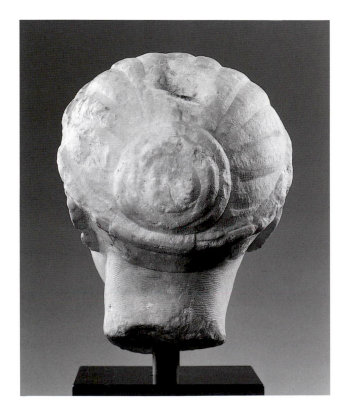

member of the imperial family[7] or a priestess of Isis.[8] Neither identification can be sustained, however, on account of the indentation's position and its modern origins. MF

BIBLIOGRAPHY

Art Quarterly 18 (1955): 301, fig. p. 303.
Record 15.1 (1956): 26.
Parke-Bernet, April 9, 1953, 19, no. 117.
Vermeule 1981, 361, no. 312.
Fittschen and Zanker 1983–85, 3:86, no. III, n. 6, no. f.
E. R. La Rocco, in Kleiner and Matheson 1996, 141–42, no. 74 (illus.).

NOTES

 1. See Fittschen and Zanker 1983–85, 3:86, n. 3, on the preferences for this kind of coiffure on the part of young girls.
 2. Wiggers and Wegner 1971, 115–21, pls. 28–29; Vermeule 1981, no. 41. On the first portrait type, see Wiggers and Wegner 1971, 117–18, pl. 29a-b.

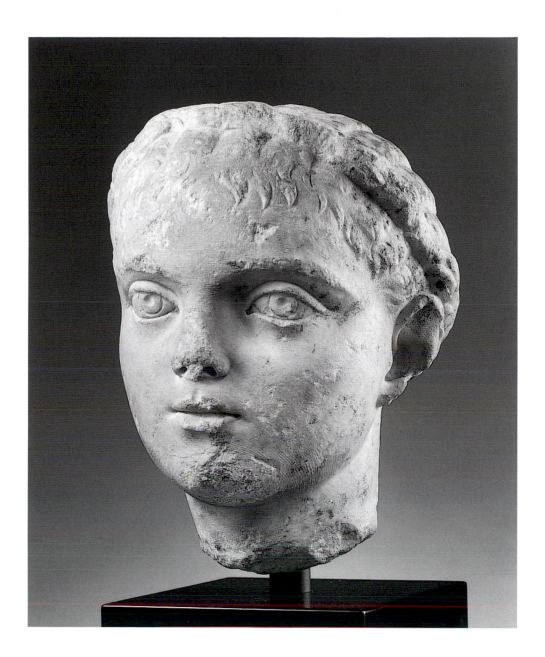

3. Large ears are present on the portrait in the Vatican (Wiggers and Wegner 1971, pl. 29 a-b; Varner 2000, 176–79, cat. 41), as well as on the second example of this type in Naples (Paribeni 1934, pl. 282; Sestieri 1940, 92–94, pl. 32.1–2; Scrinari 1953–55, 125, fig. 9).

4. Additional examples can be added to those cited by Fittschen and Zanker 1983–85, 3:86, n. 6; e.g., Adriani 1938, 213–15, no. 65, figs. 35–36. For the special difficulties of dating children's portraits from the Hadrianic to the Severan period, see Fittschen 1991, 304; Meyer 1985, 393–404.

5. E.g., Athens, National Archaeological Museum 456: Datsouli-Stavridi 1985, 76–77, figs. 101–2. On the laurel wreath, see Wegner 1939, 97–99, 284; Gercke 1968, 204–6; Oberleitner 1973, 127–40; Fittschen 1977b, 222–23; Fittschen 1979, 591. On the *corona civica* in portraits of private individuals, see Massner 1988, 239–50.

6. Fittschen 1977b, 223.

7. E. R. La Rocco, in Kleiner and Matheson 1996, 141–42, no. 74.

8. La Rocco (ibid.) suggests that this indentation may have helped to affix the locks which are characteristic of Isis and her priestesses.

18.

HEAD OF A WOMAN

Gallenic, ca. A.D. 253–268
Provenance: unknown
Material: grayish white marble
Dimensions: h. 36.0 cm., w. 25.6 cm., d. 25.4 cm.
Museum purchase, Carl Otto von Kienbusch, Jr., Memorial
Collection Fund (y1981-34)

CONDITION: *The overall condition of the portrait is poor. It is broken off at the base of the neck, most of the nose is missing, the lips are greatly damaged, and the right side of the veil is missing. The face has numerous surface abrasions, particularly on the right cheek; it is weathered and has probably been cleaned with acid as evidenced by pitting and a reflective quality of the surface.*

The veiled head is turned to its proper left and is somewhat tilted. The top and back are roughly picked and the left ear is unfinished, suggesting that it was intended for viewing from the proper right. The surplus material at the back of the head was not removed, again confirming the intended viewing point. There is a rectangular dowel hole in the back of the head close to the top, partially lined with lead to narrow the aperture used for the insertion of a securing rod or, less likely, a *meniskos*. The head was probably broken from a life-sized statue that stood in a niche or next to a wall to which it was secured with the rod. The elevated placement of the veil on the top of the head suggests an abundance of hair underneath. The veil completely covers the back of the head. The hair is arranged in tight waves on either side of the central division and has little

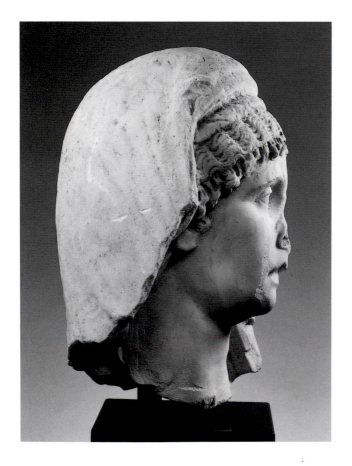 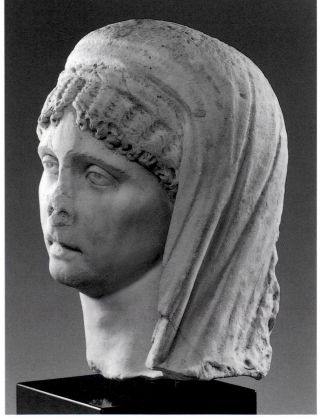

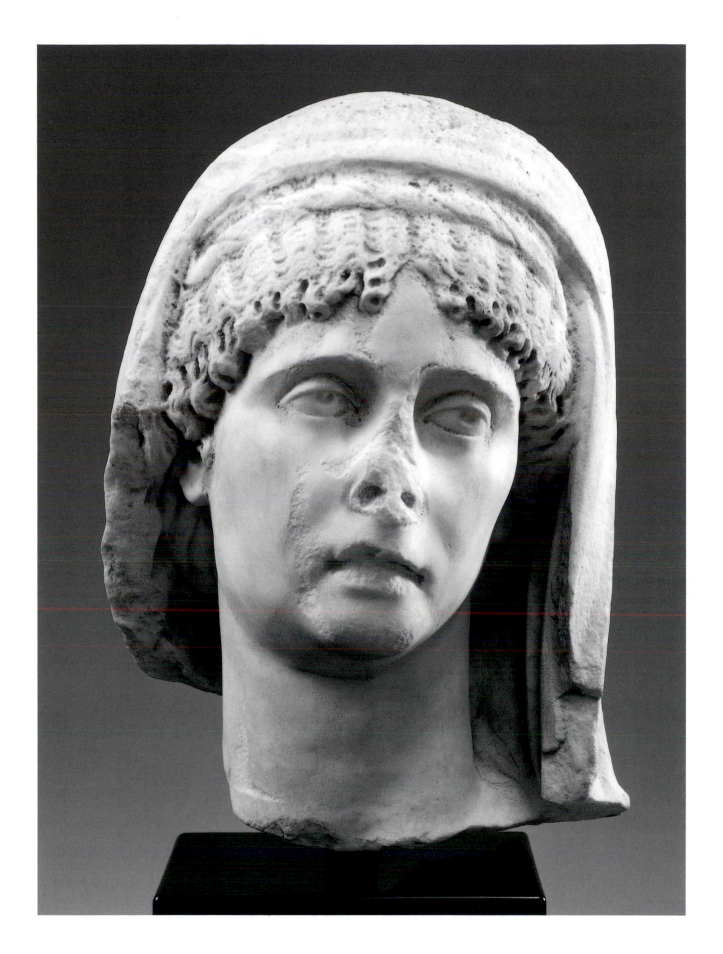

drilled curls dangling onto the forehead, which is only partly visible. The hair loops over the top of the ears and is drawn loosely to the nape of the neck under the veil. A twisted cord placed laterally on top of the coiffure disappears underneath the veil. The sharply drawn, linear eyebrows are badly abraded but preserve nicks indicating hair that converges above the nose in a V-shaped pattern. The deep-set eyes possess heavy upper lids and separate tear ducts that are marked with drilled dots. The eyes, which are incised with crescent-shaped pupils, gaze sideways and upward. The woman's lips are parted slightly, with deep dimples at both ends. The overall treatment of the flesh is soft, with no sharp naso-labial lines or wrinkles, and there is an incipient double chin. Surface abrasions give the head a ghostly and tired look.

The twisted cord in the woman's hair may point to a priestly status.[1] If so, the veiling of her head could be understood as a further sign of her piety. In conjunction with the double chin (not an unpopular feature in mid-third-century portraiture[2]) and the heavy upper eyelids, it also gives the head a somewhat matronly air.

A female portrait type comprising twelve copies depicts either Furia Sabina Tranquillina, the wife of Gordian III (A.D. 238–244), or Otacilia Severa, the spouse of Philip the Arab (A.D. 244–249).[3] Its hairstyle helps to visualize those parts of the Princeton head's coiffure that are hidden under the veil. From a part in the center, the hair descends laterally in dense waves. Just below the ears, it is folded over and attached to the top of the head. Such a hairstyle would certainly explain why the veil sits so high up on the Princeton head. However, the bearing of the Otacilia-Tranquillina type is clearly much stiffer than that of the Princeton head, whose turn, tilt, and yearning gaze are reminiscent of Hellenistic *pathos*. Two male busts—one in the Palazzo dei Conservatori, the other in Ostia—are quite comparable in this respect, and so is Gallienus's portrait in that type which is named for the copy in the Museo delle Terme (*Typus Thermenmuseum*).[4] The latter emulates the iconography of Alexander the Great and dates to the time of Gallienus's sole rulership (A.D. 260–268).[5] In female portraiture, two heads in Copenhagen are similar to the Princeton portrait in the softness of

their flesh and their pensive mood.[6] Both have long hair gathered at the nape and affixed to the top of their heads. The one with the straight hair provides a direct comparison for the hair on the neck of the woman in Princeton. The other one offers a parallel for the wavy hair with a central part and the fringe of locks invading the forehead.

The portrait in Princeton is strongly idealized and may, for that matter, be viewed as an example of Gallienic classicism. Other works worth mentioning in this context are the statue of the so-called *Cacciatore*, whose body is a copy of a Severe Style original;[7] the cycle of portrait statues with Polykleitan propensities in Villa Doria Pamphilj;[8] and the sarcophagus of the emperor Balbinus, who had been killed in A.D. 238 but received a proper burial only under Gallienus.[9] The portrait of Balbinus's wife from the casket's lid also compares well to the Princeton and Copenhagen heads.[10]

Finally, it may be pointed out that the Princeton woman's shaftlike neck, which does not seem to be organically connected to the head, is a Gallienic trait.[11]

HM/NA

BIBLIOGRAPHY
Record 41.1 (1982): 20–21 (illus.).

NOTES
1. Cf. Meyer 2000a, 27, figs. 1, 8, 10; see also 48–50, figs. 85–86.
2. Inan and Rosenbaum 1966; Inan and Alföldi-Rosenbaum 1979; Bergmann 1977; Meischner 1984; Wood 1986; Kleiner 1992, 376–81.
3. Johansen 1985, 112–13, no. 45 (Copenhagen); Fittschen and Zanker 1983–85, 3: no. 36, pl. 44; Bergmann 1977, 39–41.
4. Conservatori: Wood 1986, 111, fig. 81. Ostia: ibid., fig. 78. Terme: Fittschen and Zanker 1983–85, 1: nos. 114, 115, pl. 142, Beilagen 91–93; Fittschen 1993, 213, 226, pl. 26.
5. Fittschen 1993, pl. 26d; cf. Wood 1986, fig. 13.
6. Johansen 1995, nos. 54 and 69; Wood 1986, 112–14, figs. 82, 85; Kleiner 1992, 381, fig. 350 (no. 54).
7. Wood 1986, 111, figs. 79, 80; Meyer 1991, 66–70, no. 1 48.
8. Calza et al. 1977, nos. 372–74; Kleiner 1992, 381, figs. 351–53.
9. On the date of the Balbinus sarcophagus see Meyer 1986b, with bibliography. See also Gütschow 1938.
10. Kleiner 1992, fig. 346.
11. Cf. Fittschen 1993, pls. 26b, 30a, b.

19.

PORTRAIT OF A MAN

Middle of the third century A.D.
Provenance: unknown[1]
*Material: yellowish, finely crystalline marble, possibly from
Asia Minor*
Dimensions: h. 28.1 cm., w. 21.7 cm., d. 28.0 cm.
*Museum purchase, Wilmer Hoffmann, Class of 1913, Fund
(y1970-1)*

CONDITION: *The break runs diagonally downward from
immediately below the chin to the nape, where a coarsely hewn
boss is found.*[2] *Chip marks are evident on the tip of the nose, the
left eyebrow, and the edges of the ears, as well as on the forehead,
chin, and beard. The surface of the left side of the face is slightly
weathered. Tool marks are visible on the plane of the break
through the neck.*

Asymmetries in this well-preserved head of an older
man indicate that it must have been turned slightly
to its right: the right half of the face is broader and

flatter than the left half; the situation is reversed on
the back side. Here, the neck support has been shifted
toward the right, where it would have been concealed
in the main view. The man wears his receding hair
cut very short. It is structured by short, scratched
lines (see below), and its roughened surface stands
out only minimally against the polished surfaces of
the fleshy parts. From the ears, the hair of the head
continues in an uninterrupted transition into the
short, cropped beard, which covers the entire chin
and upper lip. The face is strikingly angular and has

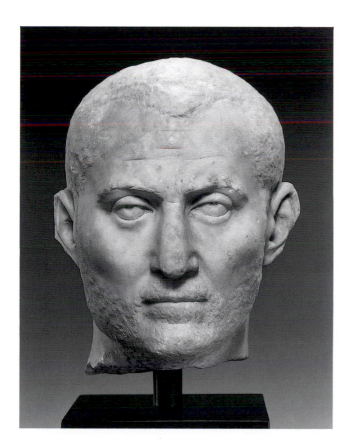
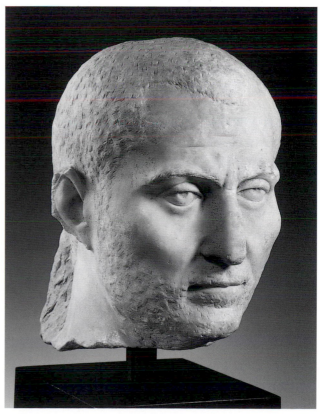

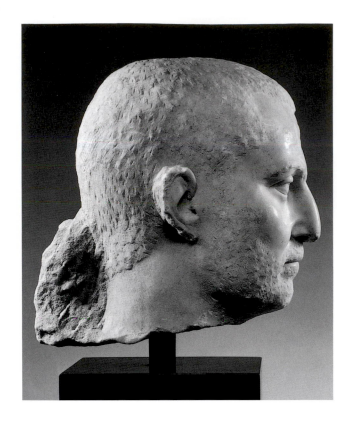

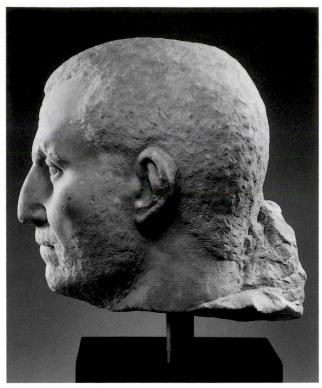

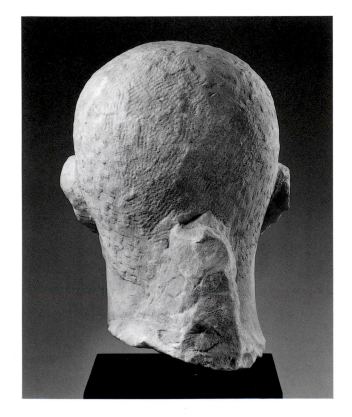

very prominent cheekbones. The man's eyebrows, pursed together above his bent nose, bespeak an energetic nature, and his forehead is traversed by three horizontal wrinkles of varying lengths.

E. Alföldi-Rosenbaum, who included the head in her corpus of Roman and early Byzantine portrait sculptures from Asia Minor,[3] concluded that the piece was created in the fifth decade of the third century A.D. and compared a contemporaneous piece from Side.[4] The portrait from Side, however, differs from the Princeton head in that it has a longer, curly beard and hair depicted with very few scratch marks; its expression, especially in the mouth, is also different. The representation of hair in the Princeton portrait uses individual, seemingly randomly distributed, short notched lines,[5] indicating that this piece dates from the forties of the third century.[6] The closest comparisons are found in some portraits of Gordian III,[7] and above all, of Philip the Arab.[8] Reliably identified portraits of the latter[9] are related to the Princeton

head not only in their physiognomic similarities, which include deep naso-labial furrows, a surly gaze from underneath knitted eyebrows, an aquiline nose, and a hairline over the forehead and temples,[10] but also in large degree the shape of the beard, which, however, extends beneath the lower lip. All these features indicate that the head was intended to emulate the portrait of the soldier-emperor. Stylistic parallels with this and with private portraits[11] that depend on it are evident in the design of the hair[12] and eyebrows, as well as in the contrast between the underlying bony structure and the fleshy portions of the face.

This portrait, perhaps of a soldier, thus seems to have been created either during or soon after the reign of Philip the Arab (244–249 A.D.).[13] MF

BIBLIOGRAPHY
Record 30.1 (1971): 24.
Inan and Alföldi-Rosenbaum 1979, 3; 336, no. 336, pl. 244.
Ćurčić and St. Clair 1986, 42, no. 1.
Selections, 45 (illus.).

NOTES

1. Inan and Alföldi-Rosenbaum 1979, 336, no. 336.
2. This technical detail makes it likely that the portrait was carved in Asia Minor (Inan and Alföldi-Rosenbaum 1979, 3), although such "neck supports" are also sometimes found in artworks that demonstrably were not carved in Asia Minor: cf., e.g., Bol 1984.
3. Bol 1984, 336, no. 336, pl. 244.
4. Inan and Rosenbaum 1966, 194, no. 268, pl. 146.1–2. On the head, see also Bergmann 1977, 79: A.D. 235–250. The combination of scratched short hair and woolly beard covering only the jaw zone characterizes the portrait of Volusian. For more on this, see Balty 1980, 49–56, pls. 14.1, 16.1–2.
5. In this respect, the Princeton head is closely related to a portrait from Bursa (Inan and Rosenbaum 1966, 186, no. 252, pl. 139.1–2; Bergmann 1977, 79), which also seems to be related because of the hatched lines used to render the eyebrows. It was probably carved in the fourth decade of the third century.
6. For the rendering of hair in portraits from this time period, see Fittschen 1969, 206–11, esp. 211; Fittschen and Zanker 1983–85, 1:130.
7. For the breadth of variations in the rendering of hair in portraits of Gordian III, see Fittschen and Zanker 1983–85, 1:206 and 3:128–29, no. 108, pl. 133.
8. Wegner 1979, 30–41, pls. 11–14; Fittschen 1977c, 93–99, pls. 28–29.
9. See Fittschen 1977c, 93–94, n. 3.
10. Also comparable is the direction in which the hair is combed, represented by incised lines.
11. Physiognomically and stylistically related artworks are mentioned, e.g., by Fittschen 1977c, 94, n. 3.
12. Even the direction in which the hair is combed, as evidenced in the incised lines, is comparable.
13. The possibility cannot be ruled out that the work was created during the reign of Trajanus Decius, A.D. 249–251 (cf., e.g., the portrait of the emperor with a mustache: Kent, Overbeck, and Stylow 1973, pls. 107, 469), or Trebonianus Gallus, A.D. 251–253 (Balty 1980, 49–56, pls. 14.1, 3; 15.1, 3).

20.

BUST OF A MAN IN A TOGA

Probably late fourth century A.D.
Provenance: Chichester, southern England[1]
Material: Chalk[2]
Dimensions: h. 40.1 cm., w. 31.2 cm., d. 15.7 cm.
Museum purchase (y1943-90)

CONDITION: *Tip of nose missing. The entire surface is abraded and weathered, particularly the knuckle area of the right hand. Incrustation on left side of neck and left cheek, as well as on the lower right torso. Back of neck and lower portion of back side broken off. The back shows evidence of perfunctory carving. There are two mounting holes on the back and an additional drill hole at the base.*

The almost life-sized bust depicts a bearded man. The head is quite large and oval-shaped. The oval motif repeats throughout, most noticeably in the brow line, which forms a thick, slightly wavy arc along the forehead. The hair is closely cropped and made visible with wavy parallel lines that converge into sideburns. The prominent eyes are set in shallow sockets and have hollowed pupils framed by incised rings indicating the irises. The corners of the deeply carved mouth turn down slightly. The ears are prominent and show evidence of extensive drill work. The downward arc is again reiterated in the sloping shoulders. Clad in a toga, the figure's right arm rests in the folds of the garment, the hand emerging to grasp the

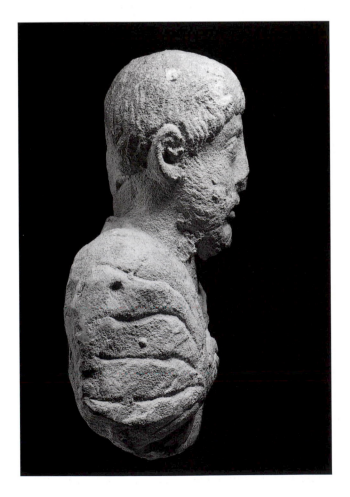

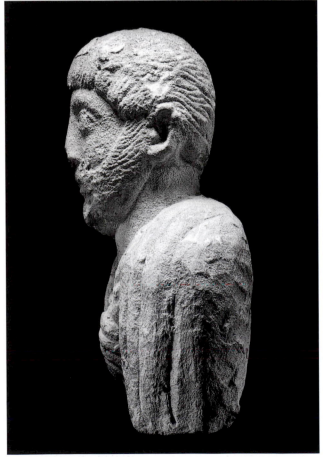

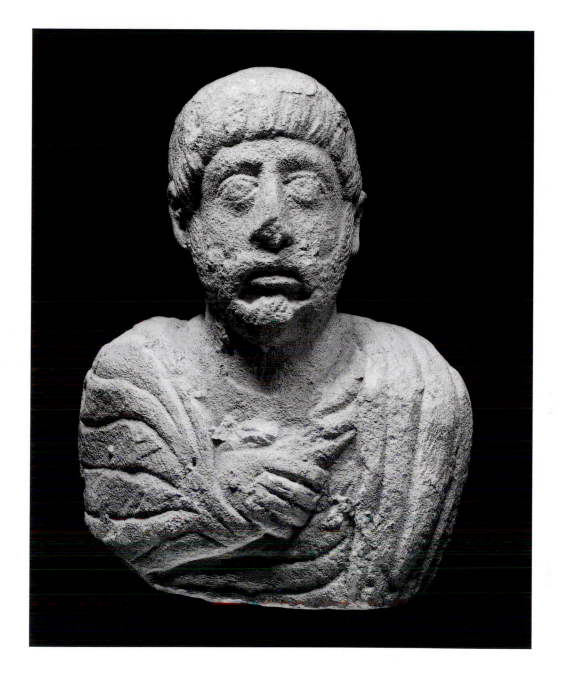

roll extending over the left shoulder. The shoulders are scored with vertical folds of drapery, which continue in crude fashion on the back in the form of parallel chisel marks.

The representation as a togatus defines the sitter as a Roman citizen.[3] The Romans understood the value of visual imagery as a means by which to establish and reinforce political authority. Art, particularly the sculpted portrait, provided a visual alliance between the emperor and the far reaches of his dominion. A marble portrait of the emperor Gratianus, in Trier,[4] dating to ca. A.D. 380, exhibits some of the

same distinctive elements as the Princeton bust: beard, large shallow eyes, arching brow reiterated by the hairline.

Archaeological evidence indicates that the Romans established themselves in Chichester and its environs by the middle of the first century A.D.[5] Given its strategic location on the southern coast of England, Chichester proved a valuable defensive post for the empire. However, as imperial fortunes waned, outlying provinces became increasingly susceptible to invasion and internal turmoil. Such was the case when Gratian and Valentinian II became co-emperors in

A.D. 375. In 383, Magnus Maximus, a military official in Britain, was named emperor by his troops. Faced with such turmoil, a civic official like the man portrayed in the Princeton bust might commission a portrait recalling Gratian's forceful gaze and imposing *persona* as a means of reinforcing both his own political authority and that of the emperor. Epigraphical evidence may even provide a clue to his identity: a certain Flavius Sanctus held the post of *praeses* under Gratian[6] and was related by marriage to Ausonius, the famous man of letters and Christian poet who was Gratian's trusted advisor.[7] These connections, and the troubled times, would have provided ample inducement for Flavius Sanctus to have his own image cast in the imperial mold; neverthless, the identification must remain speculative. BDM

BIBLIOGRAPHY
Levi 1944.
Winkes 1969, 204–5.

NOTES

1. The bust was excavated in the early 1900s in the garden of Wycombe House, outside of Chichester.
2. Professor Richard M. Field of the Geology Department, Princeton University, conducted research on the material. He concluded that the source was not of Mediterranean origin but rather made of Cretaceous chalk found on either side of the English Channel: see *Record* 3.2 (1944): 19.
3. *OCD²*, 1080.
4. For a discussion of this portrait, see Delbrueck 1933, 193–95, pl. 90.
5. Excavations indicate that Chichester was initially founded as a military outpost. The city itself began to develop ca. A.D. 50. The history of the settlement and its archaeological evidence have been analyzed in Holmes 1965.
6. Jones, Martindale, and Morris 1971, 801.
7. The poet Ausonius (d. ca. A.D. 395), tutor of Gratian, emerged as a key figure in the imperial court. He was a prolific writer, best known for his *Mosella*. He also enjoyed considerable political power, attaining the post of *praefectus Galliarum*, joint governor of Illyricum, Italy, and Africa. His sister-in-law, Namia Pudentilla, was married to Flavius Sanctus. For more on Ausonius's life and literary output, see Sivan 1993.

DEITIES, IDEAL TYPES, ANIMALS

21.

HEAD OF A YOUTH

Third quarter of the first century B.C.
Provenance: unknown
Material: white marble with a reddish brown patina
Dimensions: h. 28.2 cm., w. 15.1 cm., d. 18.3 cm.
Gift of John B. Elliott, Class of 1951 (y1991-43)

CONDITION: *The neck is battered, and nearly the entire surface on its left side is lost. The nose and parts of the lips are missing, as are the rolled strands of hair above the right eye. Parts of the hair-band above the right and left ears are broken off, along with the locks that covered the left ear and the ends of the locks on the right cheek. A piece has splintered away from the chin, and the knot of hair that was originally doweled onto the nape is missing. All surfaces, including the breaks, show various degrees of abrasion, and there are modern scratches on the nape, neck, and back of the head.*

The bulge at the base of the nape, where a separate knot was once attached by a dowel, seems to suggest that the head was originally mounted on a separately sculpted body. The ends of the dangling strands of hair, however, extend further onto the roughened and diagonally cut plane than one would expect, and the breaks in the neck and its smoothed lower surface (a modern recutting?) exacerbate the difficulty of proving this supposition.

A noteworthy feature of this youth's head is its complex coiffure: long strands of hair begin in the cowlick at the upper back of the head and stretch forward in a regular pattern to cover the crown. They are held in place by a bulging hair-band around which they are wrapped diagonally in three separate portions above the forehead and temples. From there, they fall onto the youth's cheeks in wavy S-curved locks. The same motif was apparently repeated above the ears: although the rolled portions of the locks are missing, the better-preserved strands on the right side of the head support this assumption. Below the hair-band, the hair at the nape is combed smoothly backward and collected in a knot, from which three symmetrically arranged pairs of locks hang downward. This last-mentioned detail makes it clear that

the design of the coiffure is unrealistic and illogical, as though the sculptor placed less emphasis on logic than on the feeling of refinement conveyed by an artful and complicated arrangement of the hair. This "inconsistent coiffure"[1] suggests that the piece is the product of an artistic trend that, in an eclectic manner, harkened back to the various forms and models of classic Greek sculptures and combined these to create new compositions. Similarly elaborate coiffures are encountered in sculptures of the so-called School of Pasiteles. The coiffure on the Princeton head corresponds rather closely to that of the so-called Pylades, a statue which has been assigned to this circle and which survives in a number of copies.[2] Inspiration for the individual motifs is derived primarily from the Early Classical period. The facial proportions of the Princeton head are also oriented according to these models: the elongated outlines of the face, the large planes of the cheeks, the heavy chin, and the eyelids that enclose the eyeballs like thick borders are characteristic.

While the head probably was designed for insertion into a separately carved body,[3] it is impossible to extrapolate from this to form an impression of what the youth's body may have looked like. Nonetheless, the strong asymmetries of the head suggest that it was turned toward the right, that is, the main view of the piece was intended to be diagonally from its right. Consequently, the right half of the face is wider, and the missing nape knot would have been shifted toward the left so that it would also be visible to an observer viewing the statue from the front.

No attributes have survived to offer clues to the youth's identity. Similar coiffures, which recall the Severe Style, are found in some Roman sculptures of Apollo, such as the so-called Citarista from Pompeii.[4]

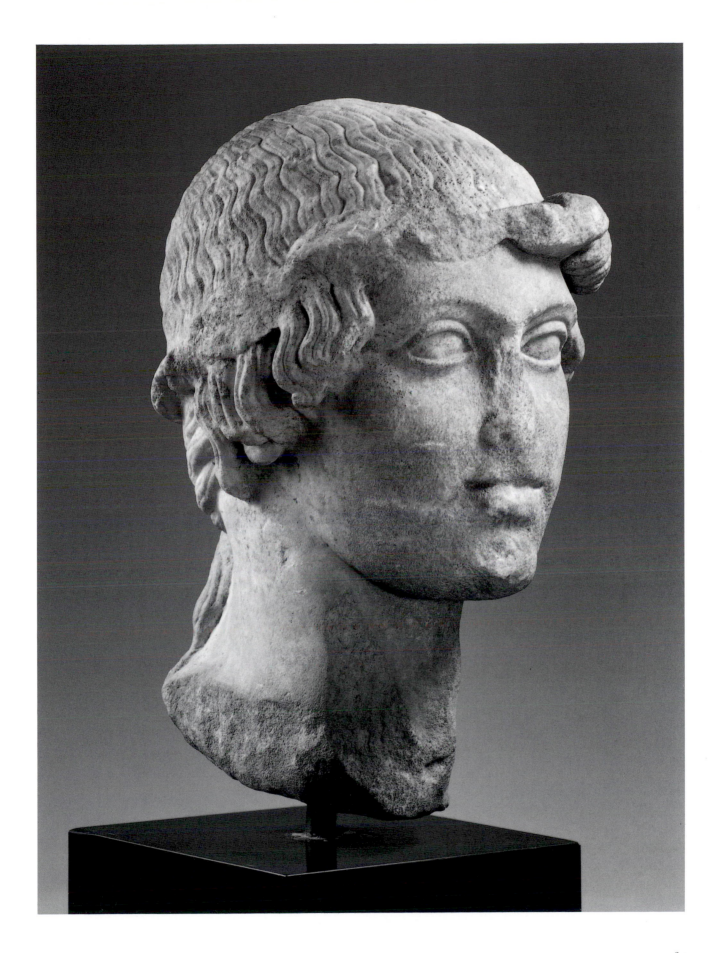

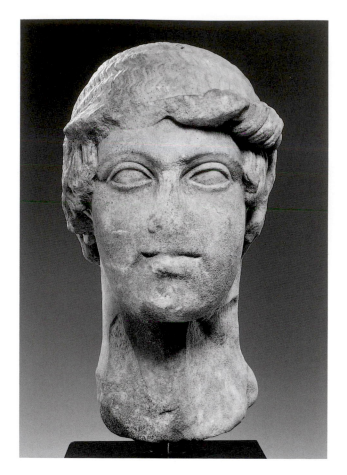

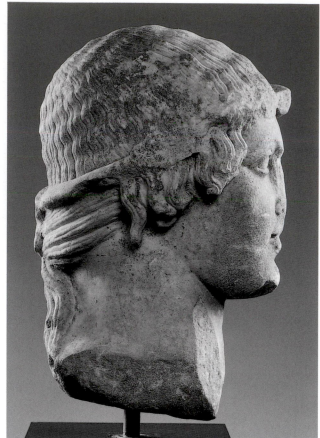

However, in the absence of any unambiguous clues upon which to base a reliable identification, it would be advisable to continue using the neutral appellation "head of a youth" to describe the sculpture.

The eclectic style and the similarities between this head and the head of the so-called Pylades both offer initial clues for a provisional dating of the Princeton sculpture. The original of the Pylades type was carved around or soon after 50 B.C.;[5] the nearest stylistic parallels to the Princeton head likewise date from this era. Above all, worthy of mention is a head of Apollo in Frankfurt,[6] where short, sickle-shaped locks on the crown identify it as having been carved during the late Republican period.[7] The modeling of the area around the eyes is very similar to the corresponding facial features in the Princeton youth, as is the tenderness evident in the representation of the fleshy portions around the mouth. This last detail is similar to the two replicas of the portrait of Cleopatra;[8] related details can also be seen on terracotta

sculptures from the Palatine,[9] which were produced around the middle of the first century A.D. It therefore seems justifiable to date the Princeton head to the third quarter of the first century B.C.

MF

BIBLIOGRAPHY
Record 51.1 (1992): 71 (illus.).

NOTES
1. For more on this, see Steuben and Zanker 1966, 68–75; Zanker 1974, 56–58; Röwer 1976–77, 501–2.
2. Zanker 1974, 54–58. In the so-called Pylades, too, the hair that has been combed forward is rolled over a bulging band before it falls in twisted locks onto the cheeks. There, however, braids that cross over one another originate behind the ears; and the hair at the nape (which is transmitted in quite different versions) is in every case unlike the hair on the Princeton head; see also Fuchs 1992, 60–61.

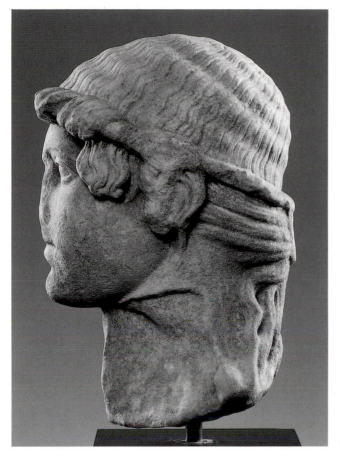

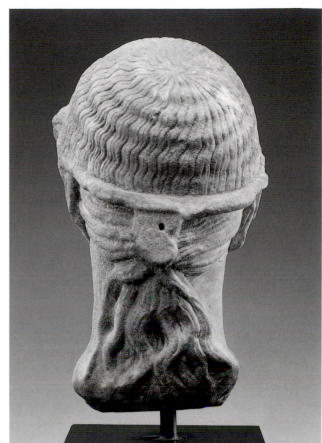

3. In the absence of convincing examples, one would not want to assume that there originally had been a bust or herm.

4. Zanker 1974, 61, no. 7.1 and 62–64; *LIMC* 2:372–73, no. 35, fig., s. v. Apollon/Apollo (E. Simon).

5. Zanker 1974, 56–57, also 52–54. On Pasiteles' pupil Stephanos and the latter's followers, see Fuchs 1999a, 59–64.

6. Hafner 1961.

7. A tousled head of hair with thick, sculpturally subdivided, sickle-shaped locks is characteristic, e.g., in portraits of Agrippa: Johansen 1994, 1:38–39, no. 7; Kersauson 1986, 54–55, no. 22. Comparisons also can be drawn to portraits dating from the third quarter of

the first century B.C.; cf., e.g., a statue from Cassino in Naples (Fuchs 1987, 25, C II 1; Himmelmann 1989, 222–25, no. 13); see Johansen 1994, 1:84–85, no. 30.

8. Musei Vaticano, Museo Gregoriano Profano 179; Berlin, Antikenmuseum 1976.10: see Fuchs 1999a, 61 (on their dating), pl. 50 (both heads illustrated). Cf. especially the indented and upwardly curving corners of the mouth and the little "pillows" adjacent to them.

9. Fuchs 1999a, 69–72, pls. 64–66; Meyer 2000a, 64–65. The female head in San Antonio seems to have been carved somewhat later (Hoffmann 1970, 97–99, no. 28). Its mouth and eyes seem related, and the design of the eyes even seems to allude to early portraits of Livia.

22.

STATUETTE OF A SILENOS

Augustan, ca. 31 B.C.–A.D. 14
Provenance: unknown
Material: fine-grained, possibly Greek marble
Dimensions: h. 28.9 cm., w. 21.5 cm., d. 13.5 cm.
Gift of Junius S. Morgan, Class of 1888 (y180)

CONDITION: *The torso, left arm, and both thighs, as well as the upper half of the tree trunk and the wineskin lying atop it have all survived. The presence of round dowel holes on the corresponding breakage planes indicates that the right arm beginning below the shoulder, both lower legs, and the lower portion of the tree trunk were once restored in modern times. A nearly square breakage plane on the outside of the right thigh testifies to the erstwhile presence of some object here. The upper part of the chest and the right shoulder are largely broken away; there is also minor damage below the navel and a gash on the wineskin below its spout. The entire surface is covered with root marks and patches of dark incrustation, the latter especially prevalent on the back. A shallow circle, cut into the back of the wineskin in modern times, is probably the marking for a planned hole which, if it had been bored, would have permitted the Silenos to be used as a fountain sculpture.*

This corpulent and much smaller than life-sized figure has adopted a leisurely pose as he supports himself with his left hand propped against a wineskin, which has been laid atop a tree trunk. The figure's hand grasps the tied-off spout of the wineskin, around which has been wound a twig of ivy. This attribute identifies the figure as a Silenos, a companion of the wine god Dionysos. A corpulent physique, the consequence of his good living and indulgence in wine, is the premier characteristic of a Silenos. What remains of the shoulder suggests that this Silenos held his right hand in a downward position. Whether it held an attribute, such as a drinking vessel, cannot be determined, nor is it possible to know what sort of object was originally present beside the figure and connected to his right thigh. A small, elevated site along the edge of the break above the left side of the chest, however, makes it possible to conclude that the Silenos originally had a long beard.

The pose and the supporting motif put the statuette into the same context as a series of depictions of Silenoi derived from the seldom-considered Munich-Dresden type.[1] Only five slightly smaller than life-sized statues[2] can be described as faithful replicas of this type, although the theme and the composition were treated in numerous variants and a number of sizes. The much miniaturized and, in comparison to the type, mirror-image variant in Princeton most closely corresponds to a Silenos of similar size in the Villa Albani,[3] although the latter variant has been provided with a skin; and to another statue in Genoa,[4] in which, however, the sculptor varied the supporting motif: rather than leaning against a tree trunk, the Silenos in Genoa, whose left hand may in antiquity have held a drinking vessel, wears a mantle whose broad, pendant folds serve as supports for the figure.[5]

The wide spectrum of variations within this genre suggests that these statues and statuettes belonged to "a great throng of sculptures which formerly adorned parks and fountains and which resemble one another in many respects, although they are rather seldom identical with one another in the sense of faithful replicas."[6] The connection with the Munich-Dresden type,[7] however, which has not been overlooked, seems to indicate that this type was the inspiration leading to the creation of these decorative Roman artworks. This supposition is especially corroborated by the head, which recurs unchanged in most examples from the group. (Where variations occur at all, they mostly involve the nature of the wreath.) The type of the "contemplative Silenos," whose vacant eyes gaze downward, obviously challenged Roman sculptors to devise many new variations.

In older research, the original behind the Munich-Dresden type was dated to the fourth century B.C.

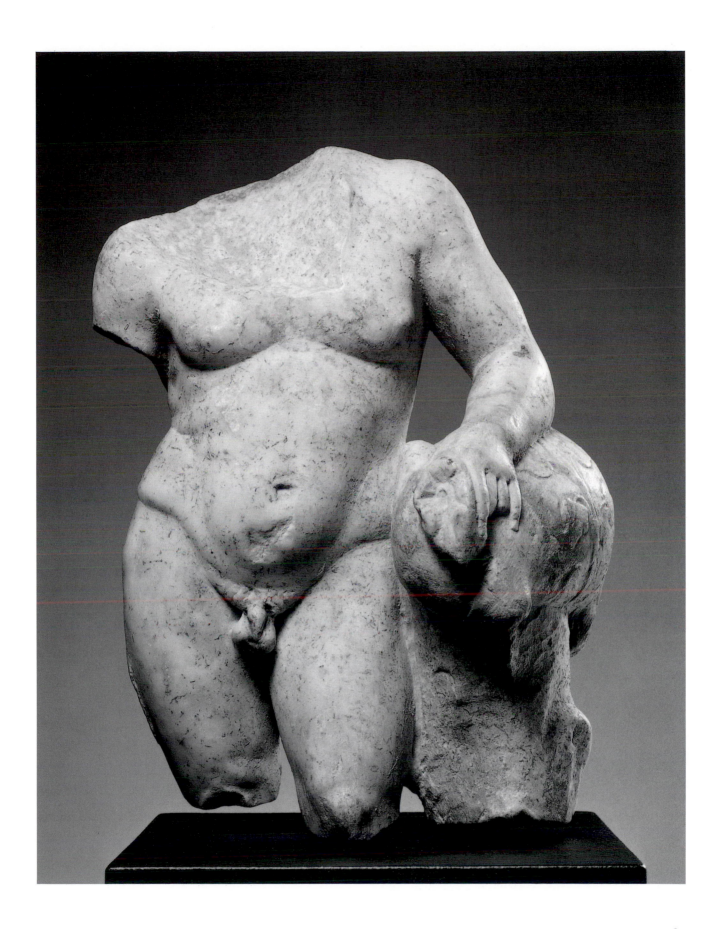

and connected with Lysippos or, rather, a master from his circle, the Farnese Herakles serving as a source of inspiration.[8] A more realistic appraisal, however, would separate the original sculpture of a contemplative Silenos from the school of Lysippos and link it to a series of other statues that date from the middle and/or second half of the second century B.C. Although all of these are related to older models, they modify these in a characteristic manner, with compositions suggesting their primary view was intended to be from the front.[9] An important element in this is the support, which, together with the attributes, forms a vertical boundary. This rigid vertical axis stands in distinct contrast to the right half of the Silenos's body, which is given a lively accentuation through the shortened torso, the twist in the

upper body, and the forceful inclination of the head toward this side.

In better-preserved examples, the gaze is directed toward the attribute in the left hand (in the mirror-image Princeton example, the right hand), imparting a transitory air, as if the Silenos were captured in a fleeting moment between drinks. A composition of this sort, as well as the narrative, ephemeral element, are characteristic of works like the Cyrene Apollo, which developed from Praxiteles' *Lykeios* and has been attributed to Timarchides, who was active around the middle of the second century B.C.[10] It also characterizes the so-called Leiden Pan[11]—(a derivation of the so-called Dresden Youth)—and the Aphrodite of Melos,[12] which are likewise derived from earlier models. The original model upon which the Munich-

Dresden type of Silenos is based must be included among these "creative imitations."[13]

What remains of the Princeton variant offers little clue to its date of creation: the rendering of the pubes, with its vertical subdivisions and clearly distinct upper edge, is quite similar to the corresponding portion of the anatomy on a sleeping Silenos from Caere, now preserved in the Vatican.[14] This similarity, as well as the rendering of the chest muscles, which are clearly defined despite the figure's corpulence, suggests that the Princeton statuette might likewise date from the Augustan era. Further support for this dating is evident in the clear demarcation between torso and legs. A technical detail which supports this conjecture is that the tool marks have been allowed to remain visible, a practice also seen on the Ara Pacis.[15] MF

BIBLIOGRAPHY

The Greco-Roman World as Seen in Its Crafts, exhib. cat., St. Peter's College Art Gallery (Jersey City 1974), no. 3.

NOTES
1. Furtwängler and Wolters 1910, 221–22, no. 221; Roscher 4:483, s.v. Satyros (Kuhnert); *EA* 4332; Lippold 1950, 284, n. 9; Arnold 1969, 197, n. 675; R. M. Schneider, in Bol 1994, 282, n. 4.
2. This involves the following repetitions:
 a. Munich, Staatliche Antikensammlungen und Glyptothek 221: Clarac 732, 1760; Lützow 1869, pl. 21; Brunn 1887, no. 98; *Einhundert Tafeln nach Bildwerken der Kgl. Glyptothek zu München* (Munich 1903), pl. 39; Furtwängler and Wolters 1910, 221–23, no. 221; I. Scheibler, in *Sokrates* 1989, 59, no. 9.4.

b. Dresden, Staatliche Kunstsammlungen, Skulpturen-sammlung: Clarac 731, 1762; *RSGR* 1:420.3; Hettner 1881, 56–57, no. 15; Herrmann 1925, 75, no. 316.

c. Formerly in the art market: Sotheby's, New York, Dec. 14, 1993, no. 77, and June 1955, no. 84.

d. Narbonne, Musée Archéologique: *RSGR* 2:53.7; Espérandieu 9 (1925), 183, no. 6882.

e. Rhodes, Archaeological Museum, inv. BE 780: Dontas 1966, figs. 91–92, pl. 39e; Konstantinopoulos 1977, 85–86, no. 161, fig. 139; Merker 1973, 29, no. 59.

f. Another statue in Paris, Louvre MA 291: Clarac 334, 1749; Fröhner 1878, 267, no. 251; Charbonneaux 1963, 70, no. 291. This type corresponds to the aforementioned replicas, except for its right arm (restored from the elbow downward), which is not used as a prop to lean upon, but is raised into a horizontal position at shoulder height.

3. Bol, "Silen," in Bol 1989, 1:444–45, no. 141, pls. 255–56.

4. *RSGR* 3:17.5; Bettini et al. 1998, 27, fig. 13; 45–46, no. 1 (illus.).

5. Bettini et al. 1998, 45. As was the case with the statuette in the Villa Albani and probably also for the one in Princeton, the head was inclined and turned toward the right shoulder.

6. Bol 1989, 1:445.

7. E.g., Amelung 1903, 671–00, no. 544; Ghedini 1980, 66; Schneider, in Bol 1994, 280.

8. Furtwängler and Wolters 1910, 222–23; Roscher 4:483, s.v. Satyros (Kuhnert); *EA* 4332; Amelung 1903, 672; Lippold 1950, 284, n. 9; Arnold 1969, 197, n. 675. See also Krull 1985; Meyer 1996, 133–35, fig. 22, with n. 60. For literature on the school of Lysippos, see Meyer 1996, 115–18, 144–46.

9. See the discussion by A. H. Borbein on the post-classical manner of design in *GGA* 234 (1982): 215–16; 221–222; Fuchs 1999a, 67–69.

10. For the chronology of the Timarchides family of sculptors, see Habicht 1982, 178–84; Martin 1987, 58–59; E. La Rocca 1990, 427–28.

11. Most recently, Fuchs 1999a, 68.

12. Most recently, Hamiaux 1998, 2:41–44.

13. Fuchs 1999a, 68.

14. Fuchs 1989, 94–96, no. 15 (inv. 9994).

15. Cf. Simon 1967, pls. 20–23; Conlin 1997.

23.

HEAD OF A GOAT

Late Augustan-Tiberian, ca. A.D. 1–37
Provenance: possibly from the Horti Maecenatis on the Esquiline, Rome
Material: Greek marble with a yellowish gray patina
Dimensions: h. 26.5 cm., w. 11.6 cm., d. 23.3 cm.
Museum purchase, John Maclean Magie and Gertrude Magie Fund (y1948-58)

CONDITION: *The tip of the beard, the right ear near the place where it joined the head, and the pendant wart on the right side of the chin (the one on the left side was not carved) have all been broken off. There is a conical tapering hole (7 cm. deep and a maximum of 4–5 cm. wide) in the back of the head; a metal pin is inserted into the bottom of this hole. Further toward the side of the head, there is an elliptical depression (2 cm. deep and 4 cm. wide; a circular hole of ca. 3.6 cm. in diameter corresponds to that concavity.*

The goat's head was originally in the Palazzo dei Conservatori in Rome,[1] from which it disappeared during the Second World War. No one knows how it found its way to the United States, where it was purchased for the Princeton University Art Museum in 1948.[2] After its identity was determined, the piece was restored to the Italian museum. In 1953 the Roman authorities returned the head to Princeton "in memory of the outstanding work of American scholars in protecting works of art in Italy during the tragic

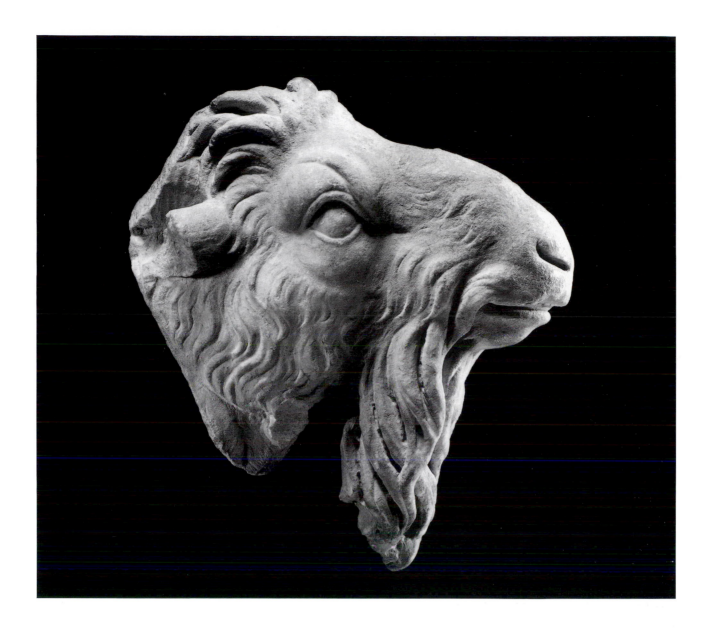

days of war, and in token of friendship for an institution of learning in which the memory of Rome is rightly honored."[3]

The catalogue of the Palazzo dei Conservatori describes the origins of the goat's head as "unknown,"[4] but more recent research has offered plausible reasons to believe that the piece was unearthed during the excavations conducted after 1870 on the Esquiline.[5] The piece is believed to be related to the statues of two goat riders which were found there in the Diaeta Apollinis of the Horti Maecenatis (Gardens of Maecenas).[6] The better-preserved rider is mounted upon a goat whose head has been lost; however, the position of the remainder of the neck indicates that the animal's head was turned toward the left and thus visible in the main view.[7] The asymmetries evident in the Princeton goat's head likewise suggest that the missing head was turned in this direction: the left half of the animal's skull is foreshortened and its left eye is positioned higher than its right eye. A deep, round hole, most likely for the insertion of the left horn, is also situated unusually high atop the head. On the body of the goat in the Palazzo dei Conservatori, the end of the horn is situated directly forward of the strut which supports the rider's outstretched right arm, and this suggests a similar reconstruction

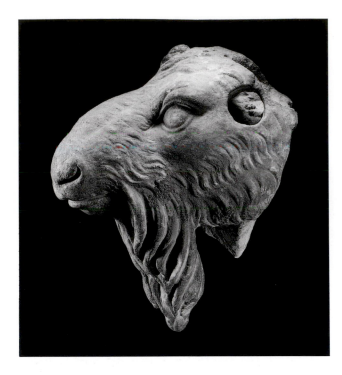

similarities with the way hair is rendered in portraits dating from the late Augustan and Tiberian periods.[10] It can therefore be assumed that the goat's head in Princeton was carved at about the same time.[11]

MF

BIBLIOGRAPHY
Stuart Jones 1912, 104, no. 48, pl. 39.
Record 8.1 (1949): 15.
Jones 1954a, 22–23 (illus.).
Häuber 1986, 180, n. 101.
Häuber 1991, 134–35, no. 108.

NOTES

1. Stuart Jones 1912, 104, no. 48, pl. 39.

2. *Record* 8.1 (1949): 15.

3. Jones 1954a, 23.

4. Stuart Jones 1912. In the list published by R. Lanciani on the occasion of the opening of the Sala Ottogona in the Palazzo dei Conservatori, the provenance is described as "Esquilino, Orti Vezziani"; cf. also Häuber 1986, 180, n. 101.

5. Häuber 1991, 134–35, no. 108 f.

6. See Häuber 1990, 92–96, maps 3 and 4, fig. 67; *BullCom* 12 (1884): 257, no. 2; Stuart Jones 1912, 103, no. 46, pl. 40. For the site where the second goat rider was discovered, see Häuber 1991, 134–35.

7. Hesberg 1979, 297–317, pls. 62–63. The second, matching sculpture likewise shows the same twist (Hesberg 1969, pls. 60–61).

8. Hesberg 1979, 301. To augment the material collected by Hesberg, it should be noted that, in addition to the goat's head in Princeton, there is another, from Fondi: Mustilli 1937, 66, no. 5, fig. 4. Its iconography and style are very similar to those evident in the Neronian/Flavian specimen in Castle Howard (Hesberg 1979, 303, pl. 70.1).

9. See Hesberg 1979, pl. 68.1: for dating, see p. 302. Deeply drilled lines also characterize the twisted shoulder locks in some portraits of the elder Agrippina that date from the Tiberian/Caligulan period; see Fittschen and Zanker 1983–85, 3: Beilagen 1a–b, 2a–d, and 5–6.

10. Cf., e.g., Fittschen and Zanker 1983–85, 1: 25–26, no. 21, pl. 23; 14, n. 9: suppl. 14c-d; Fittschen and Zanker 1983–85, 3:5, n. 3b, Beilagen 1a–b.

11. Stuart Jones (1912, 104, no. 48) calls the head a Hellenistic work of the Augustan period.

for the statue to which the Princeton goat's head originally belonged. Hence, it is worth considering the possibility that the lateral, circular cavity may have served to support a thyrsos of the sort carried by the boy in the group in the Palazzo dei Conservatori. The accuracy of this suggestion can be neither confirmed nor disproved owing to the incomplete condition of the Princeton head. Whether or not the piece in fact belongs to the Roman goat-rider group must likewise remain an open question.

Certain stylistic similarities are evident which support the head's connection with the fragmentary group of statues at the Palazzo dei Conservatori: the tufts of fur in the Princeton piece are not rendered three-dimensionally but rather are incised into the surface of the marble; only the creature's beard has been enlivened with wide, drilled grooves. The Conservatori riders have been dated to the post-Augustan period and compared with the sculptures from Sperlonga.[8] The strongly drilled goat's beard in the Princeton fragment would by no means contradict a suggestion of this sort because such a detail, which renders the tufts of fur more apparent, is also found in pieces dating from the late Republican period.[9] In fact, the way the stone is carved to depict the animal's fur evinces

24.

STATUE OF DIONYSOS

Tiberian—early Claudian, ca. A.D. 14–45
Provenance: unknown
Material: white marble, finely crystalline
Dimensions: h. 99.6 cm., w. 31.6 cm., d. 25.9 cm.
Museum purchase, gift of John B. Elliott, Class of 1951
(y1989-24)

CONDITION: *The head is missing, as is the left forearm. The position of the remaining elbow indicates that the missing forearm was pointed forward. The left leg has been broken off and lost; the break runs upward and rearward through the thigh. Chisel marks above the break suggest later manipulation. Also missing are the right arm and shoulder, which seem to have been restored in ancient times: the plane upon which the restored parts were attached, which runs from the base of the neck to the armpit, bears remnants of incrustation and patina. The attached body parts were affixed to the back of the figure by means of a large clamp whose embedding is still present on the skin, at the lower end of which a dowel hole is visible. A second dowel hole is partly preserved at the upper edge of the break. Above the chest, bordering on the attachment plane, there is an obliquely drilled hole with a corroded metal dowel still within it. A large portion of the skin and chest has broken off in this area; also broken off are the right foot, the genitals, and the edges of the animal's pelt both above and below. The remnants of a large rectangular strut which once stretched diagonally outward are visible on the right calf; a deep, horizontal cut mars the inside of the right thigh. Root marks cover the surface of the sculpture in numerous places, but they appear to have been cleaned away from the front.*

This youthful male figure wears an animal skin draped over his back. The animal's head rests on the left half of the young man's chest. The position of the animal's skin seems to suggest that a rudimentary preserved portion, which is connected with the left thigh by means of a short strut, belongs to the left front paw, which was pulled toward the front. This supposition, however, is contradicted by the folds produced by stretching the pelt across the back and, in fact, it is the left hind paw that, rising diagonally from the inside toward the outside, was wrapped around the (now missing) extended left forearm of

the youth before falling downward. The position of the front paw remains uncertain, as do the positions of the two paws on the right side of the figure: the right front paw could possibly have rested in the vicinity of the (now missing) shoulder; the rear paw probably lay to the side of the gluteus, where the skin displays a broken edge. The paw might have begun here and depended downward along the youth's right thigh.

The uncommonly large size of the pelt, its tufted surface, and its rolled edges might prompt one to identify it as the skin of a goat,[1] but the surviving scalp of the animal permits no other identification than with the pelt of a panther.[2] There can thus be no doubt that the youthful figure represents Dionysos,[3] even though no other attributes characteristic of this god have survived. It is certain, however, that the god wore a band in his hair because its wrinkled end can still be seen on the skin covering the figure's left shoulder. Furthermore, the remnants of a rectangular strut that led diagonally outward from the right calf suggest that there once was an object or second figure at this point—most likely, the accompanying figure was a panther since, as the god's companion, this animal is frequently depicted together with him.[4] The statue's support, on the other hand, will have been located beside the figure's weight-bearing leg. This support might have stretched behind the left thigh upward to the location of the break, the upper edge of which seems to suggest that a protruding portion once was situated here.[5]

The sculptor of the Princeton statue of young Dionysos relied on a famous model. The so-called Westmacott Ephebe, a statue of a boy carved by Polykleitos[6] that has been the subject of much discussion

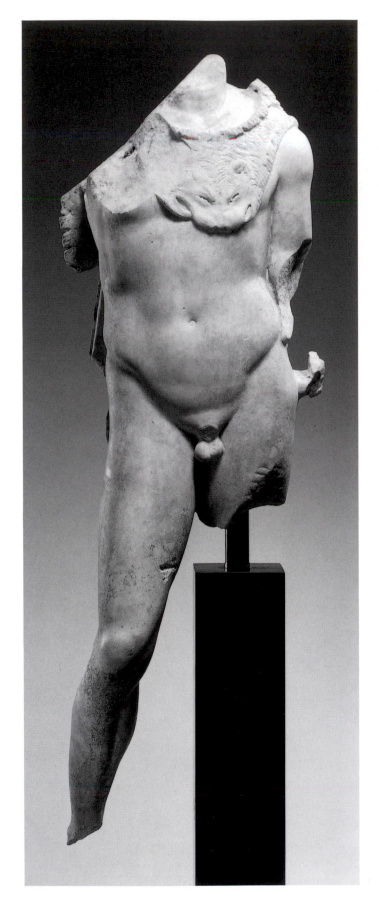
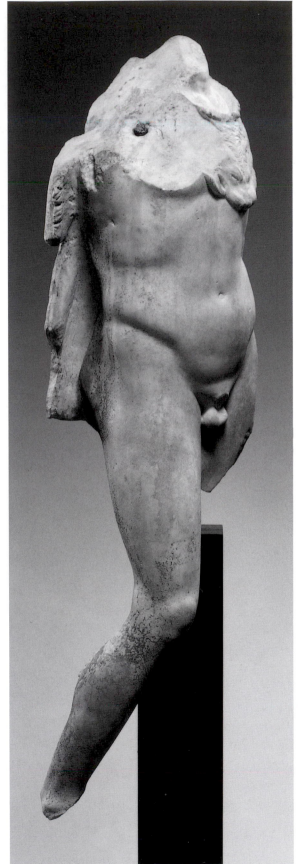

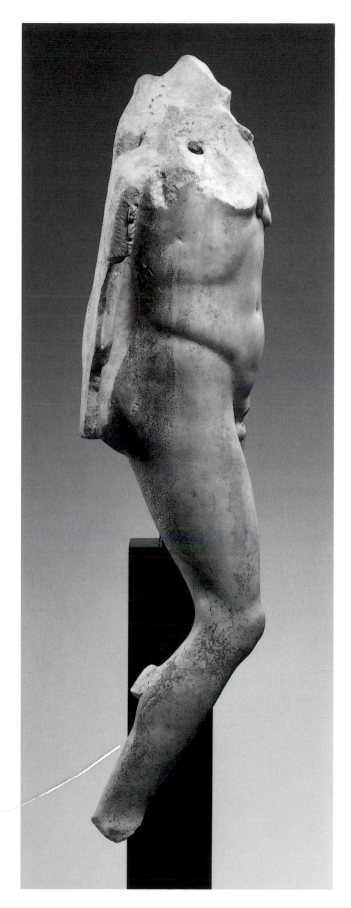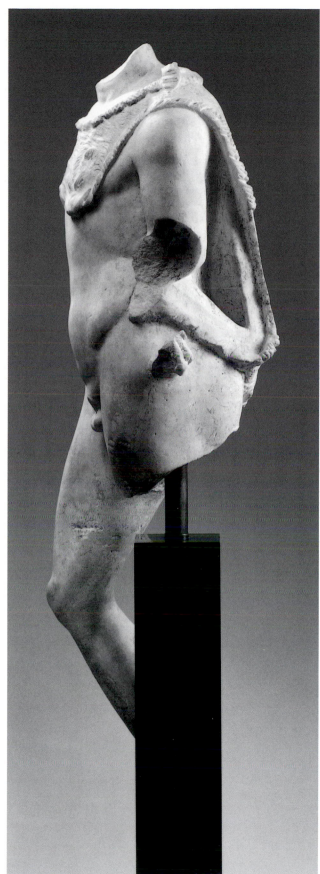

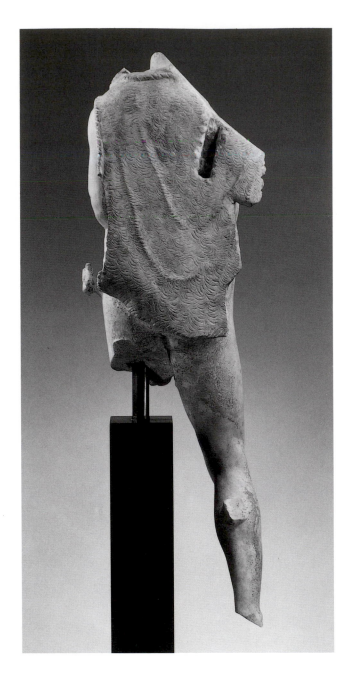

the Princeton statue, as well as in several others,[12] although the pelts, which for that purpose have been added to all the figures, are hung and designed in widely differing manners. In the examples known to date, it is a panther's pelt that is worn by the god, either draped across his back[13] or knotted over his left shoulder.[14] In a statue from the Ludovisi Collection, now in Brussels,[15] the panther's scalp falls on the figure's chest much the same way as it does in the Princeton statue, while the long stretch of pelt falling down the back is held in place by a narrow band tied with a knot above the navel. This sculpture also differs from the Princeton Dionysos in that the figure in Brussels wears fur boots and has a more slender physique. The figure in Princeton, like the other examples cited here, must therefore be regarded as an independent Roman recreation, loosely based on the Westmacott Ephebe.

The soft modeling of the flesh, the almost chubby bodily forms, and the porcelain-like surface all suggest that the Princeton statue was carved during the Tiberian to early Claudian period.[16] This supposition is further supported by the graphically structured rendering of the fur, which evinces close parallels to the rendering used in a figure of a herdsman with a kid goat and fur pouch in Geneva.[17] However, the drilled holes in the rolled-up edges of the panther's skin, which find comparisons in portrait hairstyles from the late Tiberian period onward,[18] suggest that the Princeton statue was carved at a slightly later date.

MF

BIBLIOGRAPHY
Record 49.1 (1990): 50, 51 (illus.).

NOTES
1. Cf., e.g., the depictions of goats collected in Hesberg 1979, 297–317, pls. 60–76.
2. The rendering of the surface also seems unusual in the panther pelt worn by a statue of Dionysos in San Antonio: Hoffmann 1970, 66–70, no. 20 (illus.); Fullerton 1990, 140–41; 152, no. C 5, illus. 71.
3. The (black) goat's skin also could be an attribute of Dionysos, and this would identify the god specifically as Dionysos *melanaigis*; for more on this, see Roscher 1.1:1070, s.v. Dionysos (E. Thraemer); Himmelmann 1986, 43–54; cf. also *LIMC* 3:418, s.v. Dionysos (A. Veneri).

in the archaeological literature, was frequently copied during Roman times, when it also inspired many variations.[7] In the last-mentioned cases, the addition of attributes to the Polykleitan model itself, whose activity has not been convincingly explained,[8] has clarified their secondary identifications. In several cases, the presence of a caduceus or wings on the head identify the figure as the god Hermes;[9] a lion's pelt identifies him as Herakles;[10] and a boar's head identifies him as Meleager or Adonis.[11] Reinterpretation of the figure as Dionysos is graspable in

4. For depictions of the youthful Dionysos with a panther, see, e.g., *LIMC* 3:433, no. 102; 435, no. 119a; 437, no. 128b.

5. It could have been a strut whose position and height were similar to that on the Westmacott Ephebe in Castel Gandolfo: see P. Liverani, in Beck and Bol 1993, 117–140; see also A. Linfert, in Beck and Bol 1993, 161, no. G, fig. 80.

6. In the catalogue accompanying the exhibition *Polyklet* (Beck, Bol, and Bückling 1990, 240–48; 585–87, no. 103 [A. Linfert]), the Polykleitan figures of boys (the Westmacott Ephebe, the Dresden Youth, and the Narcissus) were attributed to one or more of the master's students; for comments on this, see Lorenz 1993, 10–12. See also Linfert 1993; and Gauer 1998, 53–67.

7. Most recently collected by Linfert (1993, 156–62). The list, however, is incomplete: e.g., add a torso in Rome, Giardino Colonna (Inst. Neg. DAI Rome 78.542). Linfert (1993, 160, no. F) erroneously identifies the torso in Cyrene (Paribeni 1959, 156, no. 452, pl. 196) as Hermes. Different from these, the statuette in Villa Albani (Linfert 1993, 158, no. 23; below n. 11) and the Torlonia 22 statue (Linfert 1993, 157, no. 20; below n. 12) are reinterpretations rather than replicas. In addition to the Princeton statue discussed here, other variants and reinterpretations include a torso of Hermes in the Museo Nazionale in Rome (below n. 9) and statues of Herakles in Oxford, Munich, Copenhagen, and Dresden (for all of these, below n. 10).

8. The latest suggestions about this are found in Linfert 1993, 147–55, and Gauer 1998.

9. Rome, Museo Nazionale Romano 681: D. Candilio, in Giuliano 1982, 158–59, no. VI.24 (illus.); Cyrene 14.110: Paribeni 1959, 128, no. 361, pl. 162.

10. Oxford, Ashmolean Museum: Vermeule 1957, 287–89, figs. 3–4; Moreno 1978–80, 72, fig. 3. Munich, Staatliche Antikensammlungen und Glyptothek 230: Fuchs 1992, 81–85, no. 12, figs. 62–67. Copenhagen, Ny Carlsberg Glyptotek 253: Arndt 1912, 149, pls. 102–3; Poulsen 1951, 190–91, no. 253, pl. 18. Dresden, Staatliche Kunstsammlungen, Skulpturensammlung: Hettner 1881, 76, no. 79; Herrmann 1925, 46, no. 159.

11. Rome, Villa Albani 222: *EA*, 3611; Maderna-Lauter, in Beck, Bol, and Bückling 1990, 354–55, fig. 219. As E. Berger correctly remarks (1978, 60), the age of the figure would suggest Adonis rather than Meleager. A statue in Copenhagen (Ny Carlsberg Glyptotek 397) might be interpreted as a rendering of Adonis: Arndt 1912, 86–87, pl. 55; Poulsen 1951, 266, no. 397, pl. 27. An unambiguous identification is no longer possible for the replicas that wear mantles on their backs: in the Albertinum in Dresden (Hettner 1881, 118, no. 256; Arndt 1912, fig. 46; Herrmann 1925, 65, no. 248); in Paris, Louvre MA 3067 (Hamiaux 1992, 1:208–9, no. 214) and Sotheby's, London, Dec. 8, 1994, 86, no. 135.

12. Brussels, Musées Royaux du Cinquantenaire, inv. B 4535: B. Palma, in Giuliano 1986, 76–78, pl. II.37. Rome, Museo Nazionale Romano 113203: Maderna-Lauter, in Beck, Bol, and Bückling 1990, 635–36, no. 165 (illus.); Linfert, in Beck and Bol 1993, 161, no. G, fig. 80. Rome, Museo Torlonia 22: Visconti 1884, 16, no. 22, pl. 6.

13. In the Torlonia statue (above n. 12), the head, arms, and legs (except for the right thigh) have all been added at later dates; the pelt on the back side of the torso has survived.

14. As on the statue in Museo Nazionale in Rome (above n. 12).

15. Above n. 12.

16. The Princeton statue is very similar to a repetition of the Stephanos Athlete, which has been redesigned to represent Hermes in the Museo Nuovo Capitolino in Rome (Helbig[4] 2: no. 1693 [von Steuben]; Zanker 1974, 49, no. 4; 52, pl. 42.4). Cf., e.g., another statue in Basel (Zanker 1974, 5–6, no. 1, pls.1.2, 2.1–2, 2.4–5; Kreikenbom 1990, 165, no. III.8, pl. 128) and a torsetto in the Museo Nuovo Capitolino (Kreikenbom 1990, 186, no. IV.a.5, pl. 244; Beck, Bol, and Bückling 1990, 554–55, no. 65).

17. Chamay and Maier 1989, 59–60, no. 75, pl. 78. For more on this type, see Laubscher 1982, 22–25. His dating of the statue in the pre-Augustan period, for which he provides no justification (Laubscher, 24), seems to be too early: the carefully designed, finely moving modeling of the surfaces calls to mind the Grimani fountain reliefs (Strocka 1965, 87–102; cf. esp. pl. 54), and above all the piece in Palestrina, which belongs to the same monument (Palma 1976, 46–49). This suggests a dating in the late Augustan/Tiberian period (see Zevi 1976, 38–41; also Coarelli 1978, vii–ix; Zevi 1979, 21–22). Most recently, A. Giuliano (1985a, 41–46) argued in favor of a date in the early Augustan period.

18. Cf., e.g., Chamay and Maier 1989, 8–9, no. 8, pls. 14–15.

25.

MALE HEAD FROM AN HISTORICAL RELIEF

Neronian, third quarter of the first century A.D.
Provenance: formerly in a British private collection, for which
it was allegedly acquired in Hamburg during the 1930s[1]
Material: Carrara (Luna) marble
Dimensions: h. 15.5 cm., w. 14.5 cm., d. 8.8 cm.
Museum purchase, gift of Harry A. Brooks, Class of 1935
(y1987-1)[2]

CONDITION: *The head must have been lifted or wedged directly off the relief plane. With the sole exception of the edge of the ear, the head is completely preserved above the break, which runs through the neck, along the underside of the chin, and across the left cheek. Shallow chipping, some of which is of modern date, is evident on the neck; the berries on the wreath are slightly damaged. A dark patina covers most of the surface but has been removed from the face, which has also been subject to additional smoothing. Remnants of the patina persist in the eyes, nose, mouth, and ear.*

This fragment is undoubtedly taken from a relief: evidence for this comes not only from the perfectly smooth, vertical cleavage plane, but also from the blurred forms at the inner corner of the left eye and the drilled line that has been left at this point. It is obvious that the sculptor had difficulty reaching this point with his tools.

The fragment is a strict profile view of a young man wearing a laurel wreath. It seems clear on typological grounds that he was a servant at a sacrifice, part of a procession progressing toward the right on an historical relief. His precise function within the procession could probably have been determined by an accompanying attribute,[3] but the state of preservation precludes this.

The coiffure, with its straight strands of hair combed toward the face, exhibits the typical hairstyle of the Julio-Claudian period. The downy beard, which forms a sort of extended sideburn that covers the upper part of the jawbone, suggests that this head was not carved at a particularly early date within this period.[4] Examples with a similarly extensive growth

of beard are found on the altar of the Vicomagistri[5] and especially on the sacrificial frieze of the della Valle-Medici reliefs.[6] There, a youthful head situated directly beside the right acroterion of the eight-pillared temple[7] is especially closely related: the vertically divided forehead, which bulges forward above the root of the nose, the elongated orbital crease above the upper lid, and the callous mouth with the short vertical dent *(philtrum)* above the lip all match one another very closely. A Neronian date for the much-discussed Medici frieze[8] is suggested for a number of reasons.[9] That the Princeton relief head, too, was carved during Neronian times is further evidenced by its resemblance to portraits of Nero of the Cagliari type,[10] to which the Princeton head relates in both physiognomy and hairstyle. From a stylistic standpoint, clear similarities exist to connect it with fragments of an indisputably Neronian frieze from the theater of Vicenza.[11] This fragment can thus be assigned to the third quarter of the first century A.D. MF

BIBLIOGRAPHY
Sotheby's, London, December 8–9, 1986, no. 534.
Record 47.1 (1988): 47, 49 (illus.).

NOTES
1. According to the museum's files.
2. Purchased at Sotheby's, 1986, 150, no. 534, with funds provided by Mr. Brooks.
3. For the iconography of the sacrificial personnel, see Fless 1995.

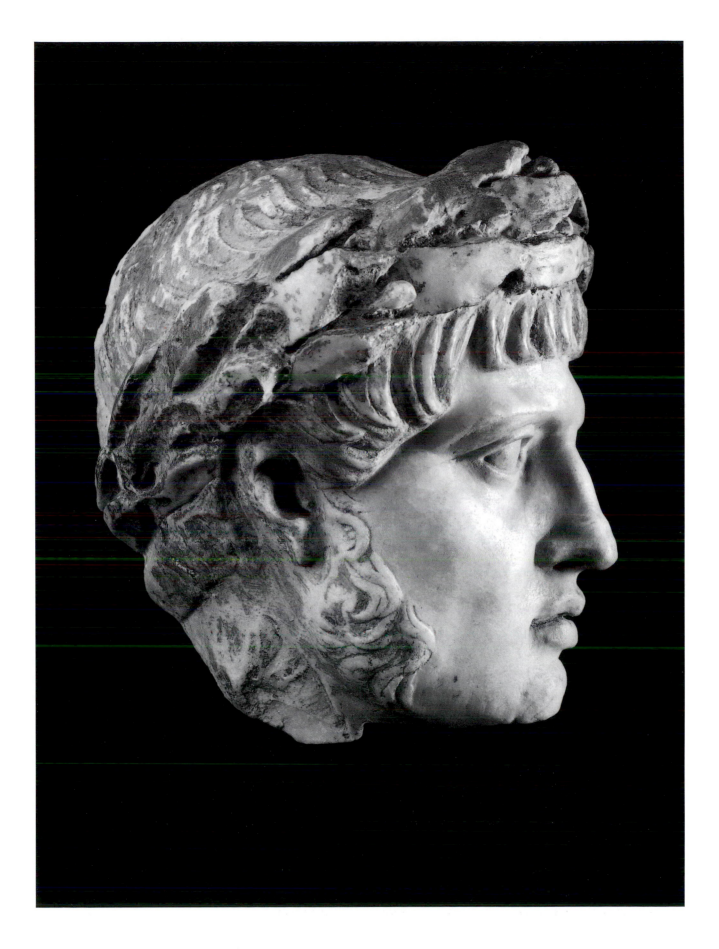

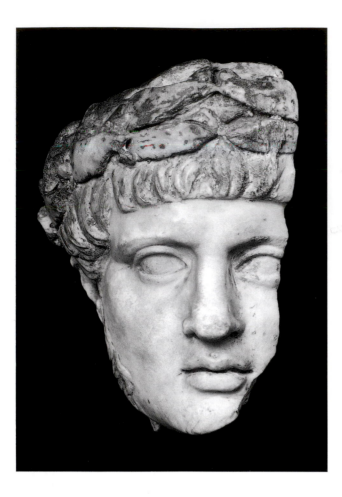

Bonanno 1988, 157–64. Cf. also Cain 1993, 102–4; Bergmann 1982, 144–45.

5. Bonanno 1976, pls. 105–15.

6. Bonanno 1976, pls. 81–88; better illustrations are found in Cagiano de Azevedo 1951, pls. 1–9.

7. Cagiano de Azevedo 1951, 37–38, no. 3, pl. 3.3.

8. Recently summarized by E. La Rocca 1994, 273–78.

9. La Rocca (1994, 277–78) again emphasizes the stylistic difference between these reliefs and the series with depictions of personifications that has justifiably been attributed to the Claudian period. But his interpretation of the sacrificial relief, which he relates to Claudius's *reditus* of A.D. 44 and attributes to an *Ara reditus Claudii*, fails to persuade. If a set of fragments which came to light during the 1930s on the slopes of the Capitol really do belong with the other slabs (La Rocca 1994, 282–89), then it can be said with certainty that the frieze should not be dated to the Claudian period. The identification of the boy who resembles Nero (La Rocca 1994, 284–86, 289) with the six-year-old Nero himself is mistaken because a portrait of Nero as a small child—if ever there were such a portrait—cannot possibly have had Neronian stylistic characteristics. It seems, therefore, that the fragment proves that the Valle-Medici monument was created during the Neronian period. Consequently, the depicted sacrifice may be related to the ceremonies reported in the records of the Arval Brethren as having taken place on the occasion of Nero's *reditus* in June or September of the year A.D. 59. (For more on this, see La Rocca, 280.)

10. Hiesinger 1975, 113–24; Bergmann and Zanker 1981, 321–22.

11. Galliazzo 1976, 141–43, no. 37; 155, no. 43; Fuchs 1987, 119–20, no. A II a.

4. Sparingly elongated sideburns are found among cult personnel as early as the Ara Pacis, but their size and density are not readily comparable; cf. Simon 1967, fig. 22; Conlin 1997, fig. 95, 160; Bonanno 1976, pls. 69–70. For beards on historical reliefs, see

26.
Fragmentary Double Herm with Heads of Old and Young Dionysos

Probably first century A.D.
Provenance: unknown
Material: opaque, fine-grained white marble with slight bluish cast, possibly Carrara (Luna)
Dimensions: h. 9.5 cm., w. 7.5 cm., d. 8.3 cm.
Gift of Edward Sampson, Class of 1914, for the Alden Sampson Collection (y1962-137)

CONDITION: *Missing the shoulders of both busts, the tip of the old Dionysos's beard, and the face of the young Dionysos from the eyes to the base of the neck. The ivy leaves, nose, mustache, lower lip, and beard of the old face are chipped; the upper row of curls above his forehead has been broken or worn away, and the top surface cut with an oblique pattern of shallow striations. The young Dionysos's forehead is chipped, and the hanging curls at the left side of his head are missing, as is a large chip at the center of his fillet; the top of the hair above the right temple is broken away. Most surfaces are worn and lightly abraded; the top of the head is particularly weathered.*

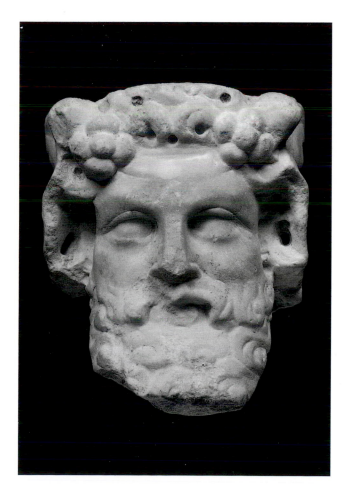

The old Dionysos wears a *taenia* that extends across the top of his forehead between two large ivy berries. Two rows of drilled curls rise above the *taenia*, and ivy leaves hang over his ears. His slightly convex eyes are fairly shallow and have heavy, linear lids. The nose is straight, the thick mustache slightly curled, and the lower lip full. His projecting beard, which consists of rows of snail curls in low relief, was shovel-like in form. The young Dionysos wears a broad *sphendone*; a V-shaped panel runs from its peak back across the top of his head.[1] His thick, wavy hair is pulled straight back, with doughy curls falling along both sides of his head. The shallow almond-shaped eyes are slightly convex. A round mortise (ca. 1.2 cm. in diameter and 3 cm. deep) is drilled into the base of the neck.[2]

This small piece is carved in a rather superficial manner, although some of the modeling—for example, of the old Dionysos's cheeks—is nicely executed. The style of neither head is clearly definable,

but the projecting beard and schematic curls of the old Dionysos's beard identify it as archaizing, and the young face shows some traits of the so-called Trieste type.[3]

True double herms, with addorsed busts on a single shaft, are a creation of the Roman imperial period, with the earliest datable examples coming from Pompeii.[4] The first-century date of the Princeton piece is suggested in part by the use of the drill, which was employed only to pick out the centers of some locks of hair and to undercut the ivy leaves. A similar technique is frequently seen in small-scale white marble sculpture from the area buried by Vesuvius in A.D. 79.[5]

The combination of a hirsute old Dionysos and a younger, almost effeminate version in the same herm is especially appropriate for the god who was thought to have a dual, contradictory nature. This may have contributed to the popularity of the type: a number of old and young Dionysos double herms, in both large and small scale, survive.[6]

Finds at Pompeii and other areas buried by the eruption of Vesuvius show that small-scale double herms like this one functioned almost exclusively as garden and peristyle decorations, and that they were generally displayed on slender columns or pillars.[7]

CM

BIBLIOGRAPHY
Unpublished.

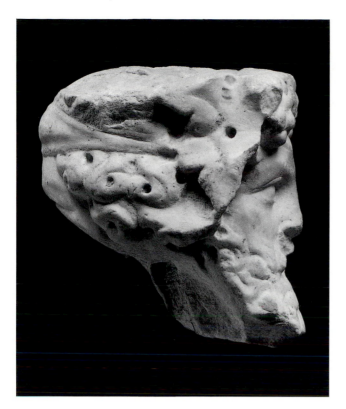 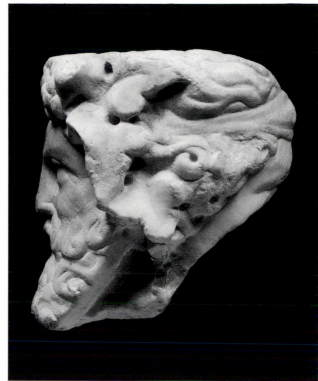

NOTES

1. The straight lines of this feature are unlike the wavy hair that appears elsewhere on the head, and it probably represents an unusual type of hair binding. Nothing comparable appears in Krug 1968; see especially 114–18 on Dionysiac fillets. It is weathered like the adjacent areas of the head, suggesting that it is ancient.

2. The rusty stain around the mortise suggests that it once held an ancient iron pin that corroded and expanded, fracturing the young face.

3. In particular, the soft waves of hair falling at the sides of the head and the hair pulled straight back from the *sphendone* over the top of the head; on the type, see *LIMC* 3: no. 199, pl. 319, s.v. Dionysos.

4. Seiler 1969, 11–12, 62; A. Giumlia 1983, 20–24; Wrede 1985, 53.

5. Some examples are: Watt 1897, pl. 39; Tran Tam Tinh 1975, 286, fig. 250; Dwyer 1982, 67, fig. 84; Strocka 1984, 31–32, figs. 130, 131; De Caro 1987, 92–94, no. 8, figs. 10a, 10b; Moss 1988, 585–86, 601–2, nos. A234, A249; Seiler 1992, 121, no. 50, fig. 625.

6. For a list of double herms of an old and young Dionysos, see Giumlia 1983, 74–83, 218–22, nos. 69–85. Additional examples include Waldhauer 1928, pt. 1:67–68, no. 52, pl. 33; Frel 1967, 28–34, figs. 3–5; Giuliano 1979, 31–32, no. 30 (D. Candilio); Ghedini 1980, 186–87; Dwyer 1982, 43–44, 47–48, 91, figs. 36–41, 52–54; Vermeule and Comstock 1988, 48–51, no. 41; Fuchs 1992, 163–65, no. 23; Giuliano 1995, 62–66, nos. s64–s66 (A. Ambrogi); and Mikocki 1999, 85–86, no. 72, pls. 64, 65.

7. For double herms found in gardens or peristyles, see Dwyer 1982, 43–44, 47–48, 91, figs. 36–41, 52–54; Vermeule and Comstock 1988, 48–51, no. 41; Orto and Varone 1990, 260–61, nos. 181, 182; Seiler 1969, 117, 118, 122, 128, 129, 131, 132, nos. 4 and 12, figs. 537–40, 562–65; and Jashemski 1993, 130, 132, 147, 150, 169, 171, 232, 233, 239, figs. 204, 270.

27.

HERM BUST OF SILENOS

Probably first century A.D.
Provenance: unknown
Material: fine-grained, opaque, white marble, almost certainly
Carrara (Luna)
Dimensions: h. 14.6 cm., w. 9.1 cm., d. 5.9 cm.
Gift of Harris S. Colt, Class of 1957, and Margaretta B. Colt
(y1994-32)

CONDITION: *Weathered surface with areas of dark incrusta-tion, especially on the right side. Damage to the area around the left ear, the taenia above the left forehead, the taenia that falls over the left shoulder, and the front of the base. The right eye is chipped. A diagonal saw-cut groove on the back retains traces of mortar with crushed brick. There are a number of minor abrasions.*

The bald-pated Silenos has an asymmetrical face with furrowed forehead, prominent brows and cheek-bones, pug nose, and full lower lip. The ropey locks of his long beard are indistinct and lack detail. His ears appear to slant forward and may have been goat-like, but they are not fully carved. A thick rolled fillet is draped over his forehead; its plain, flat ends fall down the front of the bust. There may have been a few ivy leaves or berries in low relief over the ears, but that area is damaged on the left and very indis-tinct on the right. The back is flat and smoothly fin-ished; the base is roughly claw-chiseled and has no mortise or tenon.

Despite its small scale and rather superficial exe-cution, this herm bust is a fairly successful rendition of the Silenos type with furrowed brow. The most striking aspect of the face is its asymmetry. Its right eye and cheek are noticeably higher than their coun-terparts on the left, the brows at divergent angles, the mustache slightly askew, and the left side of the face sunken. While this might be dismissed as the hasty work of a less than competent craftsman, the asym-metry in fact gives the piece a certain animation. The blank, convex eyes, which give the impression of closed eyelids, as well as the distortion of the face, suggest that the Princeton head may be related to the sleeping Silenos type which was often used

for fountain figures.[1] These drunken Silens typically rest their heads on a wineskin or jar, pushing one cheek higher and skewing their facial features, much as in this bust.

Large-scale Silenos herms are rare,[2] but Silenos was one of the more popular subjects for miniature, flat-backed busts of this type.[3] The Princeton piece, like other small-scale herm busts of this genre, was intended for attachment—for example, to a free-standing shaft or a table support in the form of a miniature herm[4]—or for insertion into a niche.[5]

CM

BIBLIOGRAPHY
Unpublished.

NOTES

1. See especially Fuchs 1987, 77–78, nos. AV 1–2, pl. 29: 1–2 (two examples from Caere, now in the Vatican), and 89, nos. AV 1–2, pl. 33.3–4 (two examples from Falerii, now in the Louvre). On the Caere statues, dated to the first half of the first century A.D., see also Fuchs 1989, 94–96, nos. 15 and 16, figs. 93, 94, with a list of copies in n. 2, p. 96. For drunken Silenos fountain fig-ures with a wine jar, see Kapossy 1969, 35, figs. 21, 22.
2. Wrede 1986, 29–30.
3. Other small-scale Silenos herm busts include Schöne 1878, 154, no. 653; García y Bellido 1949, 434–36, 438, nos. 445, 448, 449, 451, 460, pls. 315–17, 321; Mansuelli 1958, 1:194–96, nos. 186, 190, figs. 186, 190; Collins 1970, 171–72, 283, no. 27, fig. 68 (fragmentary); Goethert 1972, 4, no. 27, pl. 17; Equini Schneider 1979, 40–41, no. 32, pl. 31; *Sammlung Wallmoden* 1979, 61–62, no. 22 (H. Döhl); Bastet and Brunsting 1982, 1:220–21, nos. 411, 412, and 2: pls. 121, 122; Winkes 1985, 86,

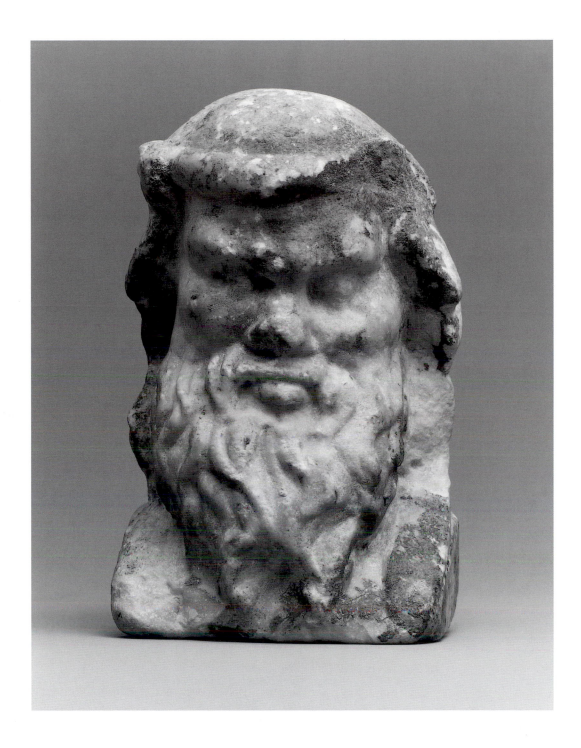

no. 66; Nieddu 1986, 161–65; Moss 1988, 595–97, nos. A244, A245; Neudecker 1988, 237, no. 68.15 (now lost, probably miniature); Pensabene 1989, 92, no. 34, pl. 85.3–4; Goethert 1992, 97, pl. 12.4; Mikocki 1999, 107, no. 99, pl. 89; Toronto, Royal Ontario Museum, acc. no. 926.20.33 (unpublished).

4. Two marble table supports with separately carved Silenos herm busts were excavated at Pompeii. One was found in the Casa del Criptoportico (I 6, 2), and is now Pompeii, Antiquarium, inv. 1176–4 (3605): Della Corte 1914, 104–5. The second, from the shop at IX 8, 4, is now lost: Fiorelli 1879, 242. See Moss 1988, 595–97, nos. A244, A245.

5. On the various uses of these miniature herm busts, see cat. no. 28, n. 8.

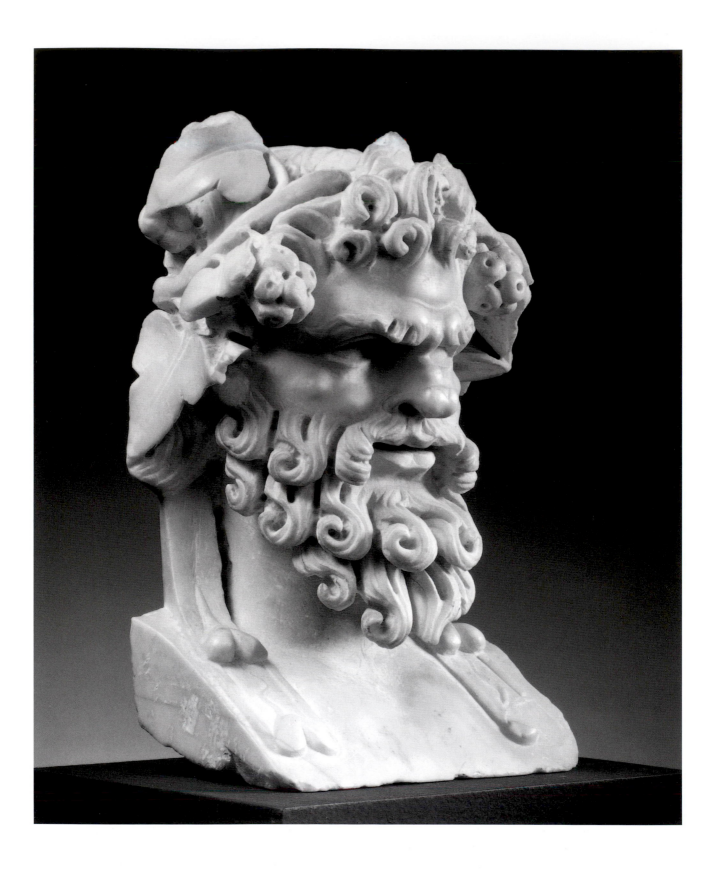

28.
HERM BUST OF PAN

Probably second half of the first century A.D.
Provenance: said to be from Hadrian's Villa, Tivoli
*Material: pale, creamy yellow marble (giallo antico) with
faint veining[1]*
Dimensions: h. 17.8 cm., w. 11.5 cm., d. 7.0 cm.
Museum purchase, Caroline G. Mather Fund (y1963-44)

CONDITION: *The leaf above the left forehead, almost all of
the horns, most of the leaf over the right ear, and the tips of other
leaves are missing; three locks of hair over the forehead and the
lowest curls of the beard at the left are chipped. The lower part of
the back is broken away, along with the left front corner of the
base and the lobed decoration of the left fillet.*

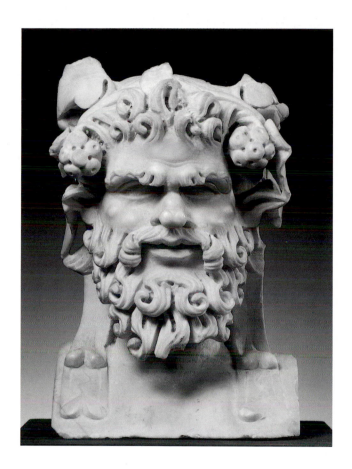

The face of this shoulder bust of Pan has knobby
protrusions on the brows, cheeks, and tip of the nose.
His forehead is furrowed, and his beetling brow with
extravagant eyebrows projects strongly over deeply
recessed eyes. The eyelids have linear rims, and the
eye sockets are flat and keyed for insets, probably of
glass paste. A series of rigid, curled locks of hair
stands up over his forehead, with the stumps of two
striated horns sprouting just behind. The luxuriant
mustache ends in corkscrew curls that fall into a
beard made up of stiff, hooklike locks separated by
deep drilling. The open mouth has a thin upper lip
that curls into the shape of compound bow. His ears
are distinctly goatlike: long, pointed, and projecting
forward. Around his head he wears a fillet of ivy
leaves and berries; the berries are disproportionately
large. The broad ends of the fillet, which fall down
the fronts of his shoulders, are decorated with two
double-lobed ornaments connected by a wavy tendril.
The back is flat and shows traces of claw-chiseling
except in some smooth, slightly concave areas, partic-
ularly along the base. The base was finished with a
flat chisel and shows no trace of a pin or mortise.

The lumpy flesh, hirsute brows, and pointed ears
of this slightly malevolent little sculpture create an
impression that falls somewhere between the human
and the animal, entirely appropriate for a depiction
of the goat-god Pan. Although the Pan herm is an

ancient type, attested as early as the fifth century B.C.,
few full-sized examples survive from any period, and
this piece is not related to any of them.[2] It seems
instead to be loosely based on a late Hellenistic
statue type, but the interpretation here is wilder and
more exaggerated.[3]

This example is one of a small group of very
similar herm busts depicting satyrs and other Dio-
nysiac attendants.[4] All of these have the exaggerated,
gnarled features and wild, thick-stranded hair and

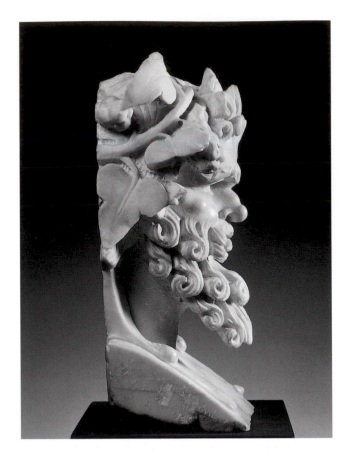
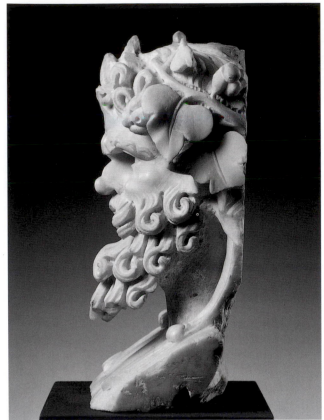

beard seen here. They are also uniformly carved from the very fine-grained colored marbles *giallo antico* and *rosso antico,* and all are very similar in execution, with sharply cut, heavily drilled features; some of the drill work was characteristically done with extremely small drills. The Princeton piece is one of the finer examples of this group, and its execution is superb, with deeply undercut elements, skillful use of the drill, and finely finished surfaces. A strikingly close parallel found at Pompeii provides the best indication of date.[5]

Small herm busts of this sort survive in large numbers and in a variety of styles and stones; they are especially well documented in the western Mediterranean.[6] These busts were sometimes incorporated into marble table supports in the form of herms, and they are often identified exclusively as components of tables.[7] But they are so frequently found used in other ways—set into niches in walls and altars, displayed in *lararia,* placed on the rims of fountain basins, fixed atop small shafts in gardens— that they were clearly not produced specifically for tables but as multipurpose decorative pieces.[8]

Although herms were originally public monuments, often with sacred connotations, by the Roman period they had been thoroughly appropriated as domestic decoration.[9] The villas of wealthy Romans were often enough ornamented with large-scale herms,[10] and the many Pompeian finds of smaller versions like this one make it clear that they were intended to provide similar decor for more modest houses.[11]

CM

BIBLIOGRAPHY
Unpublished.

NOTES

1. This is the variety of *giallo antico* usually called *giallo dorato*. The color and veining of this piece fall just between two specimens published in Mielsch 1985, nos. 529 and 531.

2. The earliest depiction of a Pan herm appears on an Attic bell-krater of ca. 420 B.C. (*ARV*² 1156, 11), illustrated and discussed by C. Bérard (1982, 137–50, figs. 1, 2). For full-sized Pan herms, see Marquardt 1995, 18–20, 21–22, 59, nos. 17, 18, 22, 73.

3. A Pan head in the Cyrene museum (inv. 14263) is a good example of the type (see Marquardt 1995, 36–37, no. 42, pl. 5:2), but the date proposed by Boardman (*LIMC* 8: pl. 619, no. 81, s.v. Pan) seems preferable.

4. Other examples are:
 Agrigento, Museo Archeologico (from Caltabellotta): Griffo 1987, 242, 244, fig. 207.
 Bologna, Museo Archeologico, inv. G1088 (unpublished).
 Córdoba, Heredia Espinosa collection (from Porcuna): Trillmich et al. 1993, 379, pl. 172a–c (H.-G. Niemeyer).
 New York, private collection.
 Saint Petersburg, Hermitage, inv. nos. 299 and 8551: Waldhauer 1928, 1:80, nos. 70 and 71, pl. 45.
 Sorrento, Museo Correale: Mingazzini and Pfister 1946, 179, no. 101, pl. 31.
 Troyes, private collection: Espérandieu 4:264, no. 3218.
 Vienna, Kunsthistorisches Museum: Giumlia 1983, 229, no. 110, fig. 9.
 Wilanow: Mikocki 1999, 91–92, no. 80, pl. 75.
 This group also includes the two examples cited in n. 5 below.

5. Naples, Museo Archeologico Nazionale, inv. 126252, from Pompeii (*notamento* of January 17, 1902) but with no find-spot recorded. See Ward-Perkins and Claridge 1978, 139, no. 63; Moss 1988, 71, 93, 162, 563–64, no. A214. A second bust, also very similar, is Naples, Museo Archeologico Nazionale, inv. 6526, probably from Pompeii: *Pictorial Catalogue of the Archaeological Museum [sic], Naples* (Bath 1987), fiche no. 233.

6. Some published examples are García y Bellido 1949, 434–38, nos. 444–61, pls. 315–21; Goethert 1972, 4–6, nos. 22, 27–29, 31, 32, 34, 35, pls. 15–18; Bonanno 1977, 399–410, with general bibliography on the subject; Wrede 1986, 68–70; *San Severo* 1989, 166 (erroneously dated to the Hellenistic period); Rodriguez Oliva 1988, 215–29; Pensabene 1989, 92, no. 34, pl. 85.3–4; and Linfert 1992, 17–19, nos. 9–11, pls. 14, 15. For some eastern examples, see Hepding 1907, 397–99; and Winter 1908, 357, nos. 456, 457. See also n. 7 below.

7. For example, by H.-G. Niemeyer, in Trillmich et al. 1993, 379; and Boschung, Hesberg, and Linfert 1997, 33–34, no. 25. Thirty-three examples of table supports which incorporate separately carved herm busts are known; see Moss 1988, 540–600, nos. A190, A191, A196–A198, A200, A202, A203, A206–A209, A213–A224, A226, A234, A237, A238, A240–A242, A244, A248.

8. Set into niches: Becatti 1954, 2:14–15, pl. 1.1; Vermaseren 1978, 19, no. 42, pls. 11–13; Jashemski 1993, 52–53, figs. 61, 62; *Pompei* 1999, 772–73, figs. 6, 7.
 In *lararia*: Ricard 1923, 77–79, nos. 78, 79, and 89, pl. 52 (three examples said to have been found in a *lararium* in Pompeii); Boyce 1937, 22–23, no. 13; De Caro 1994, 85, 217, pl. 13:a–b.
 In gardens: F. Seiler 1992, 39, 122, 123, 128, 129, 131, 132, figs. 205–8, 541–44, 547, 548, 576, 577; Jashemski 1993, 40, 87, 109, 116, 150, 159–62, 218, 238, figs. 44, 62, 182, 186, 188.
 On fountain basins: Niccolini and Niccolini 1896, 2:pl. 10; Jashemski 1993, 238.
 In peristyle: Dwyer 1982, 77–78, figs. 117, 118.
 In garden *triclinia*: Maiuri 1927, 61, 73–74, figs. 37–40, pl. 5; Jashemski 1993, 40, fig. 44.

9. See Wrede 1986, 32, 34–44, 49, for public herms; and 58–62, 78, 82, on herms as domestic ornaments. The popularity of decorative herms in domestic contexts as early as the late Hellenistic period can be seen on Delos, where dozens of herms were found in houses (Kreeb 1988, 115–321, passim).

10. For large-scale herms from Roman villas, see Raeder 1983, 59, 110–11, 117–18, 154–55, 158, nos. I 41, I 130–I 132, I 140, III 36, III 43; Wojcik 1986, 51–85, 171–75; De Caro 1987, 102–4, figs. 17, 18; Neudecker 1988, 15, 65–68, 73, 133, 148–49, 157, 159, 163, 169, 179, 186, 193–95, 198, 201, 202, 204, 218, 222, 225–27, 230–34, 236–38, 242–43, pls. 16–19; Palma Venetucci 1992; Sinn and Freyberger 1993, 131–42, nos. 57–62, figs. 258–74; Schädler 1998, 110–12, 136–38, 144, nos. 86–94, 195, 198, 199, 218, pls. 14–16, 19, 20; Vorster 1998, 40–42, 57, 68, no. 12, pls. 23, 24.

11. For some herms in Pompeian houses, and on the phenomenon of townhouses at Pompeii as "miniature villas," see Zanker 1998, 135–203, esp. 156, 169, 178.

29.
STATUETTE OF APHRODITE

First century B.C.—second century A.D.
Provenance: unknown
Material: small-grained white marble
Dimensions: h. 21.3 cm., w. at elbows 8.3 cm., w. at shoulders
6 cm., d. 4.73 cm.
Gift of Josepha Weitzmann-Fiedler (y1994-140)

CONDITION: *The head and left arm, most of the Eros figure, and the bottom right and left corners are broken off. The statuette is worn smooth and covered with white and brown incrustations, especially on the back.*

The statuette depicts a female figure. Standing with the weight on her left leg, the right leg bent (and probably placed on the base of the pillar), she leans on a slender column with her right arm, elbow locked. A himation hangs diagonally across her abdomen and is draped over her left arm. Underneath the himation, the figure wears a thin chiton whose sleeves have slid down both shoulders and which is tied with a belt underneath the breasts. Remains of a small figure are visible above and behind her right shoulder. The back of the statuette is almost flat, the contours of the body and the drapery folds barely indicated.

The statuette, which represents a draped Aphrodite leaning on a pillar with Eros perched on her shoulder, is a probably a Roman copy or adaptation of a Hellenistic variant of what was either a fifth-century Greek or an early Hellenistic original.[1] Numerous adaptations of this type are known.[2] A Hellenistic variant of the common Aphrodite Tiepolo type shows the goddess leaning on a pillar with her right arm, elbow locked, and right leg bent and placed on the base of the column as in the Princeton example. Her left hand, however, is on her left hip and the himation is draped over the left shoulder, behind the back, and across the bent right leg.[3] A second Hellenistic adaptation is an exact mirror composition of the Tiepolo type.[4] A third variant is similar to the second, with the exception that Aphrodite's left arm, with which she leans on the pillar, is bent.[5] While the Princeton statuette probably is a Roman copy, its slender, elongated features,

the addition of the Eros figure, and its stylistic and compositional quotations from these three variants suggest that its prototype was a Hellenistic creation.[6] An early Hellenistic statuette from Cyprus in the FitzWilliam Museum in Cambridge, that shares almost all of the characteristics of the Princeton piece, may be closely related to the prototype.[7] TN

BIBLIOGRAPHY
Unpublished.

NOTES
1. See Bieber 1977, 93, for discussion of the attribution of the original to Pheidias.
2. Bieber 1977, 95–96. The changes in body type and drapery folds are common for the Hellenistic adaptations of the leaning Aphrodite. The harmonious classical body was transformed into an elongated figure with broad hips and narrow upper body. Vertical lines

replaced the variated chiton folds of the classical original, and a tight belt was placed under the breasts.

3. For examples of the Tiepolo type, see Gualandi 1969, 233–72, figs. 1–21. For examples of the variant where Aphrodite leans on pillar, see *LIMC* 2:42, pl. 31, nos. 300, 303, s.v. Aphrodite (A. Delivorrias); Gualandi 1969, figs. 23–25; and Horn 1931, pl. 36, figs. 2 and 3.

4. See *LIMC* 2:43, pl. 32, no. 318, s.v. Aphrodite (Eros on left shoulder); Horn 1931, pl. 37, fig. 2; Pedley 1990, 159, fig. 119.

5. For this variant, see *LIMC* 2:43–44, pls. 31–32, nos. 309, 314, 324, s.v. Aphrodite; Horn 1931, pl. 30, fig. 2.

6. Horn (1931, 160) suggests that the numerous variants of the Leaning Aphrodite type are Roman adaptations rather than Hellenistic creations.

7. *LIMC* 2:40, pl. 30, no. 268, s.v. Aphrodite. The Cyprus statuette differs from the one in Princeton in two ways only: the Eros is larger and the chiton has not slid from the shoulders.

30.

MALE TORSO

First–second century A.D.
Provenance: unknown
Material: medium-grained white marble, highly crystalline
Dimensions: h. 11.3 cm., w. 12.1 cm., d. 6.8 cm.
Gift of Josepha Weitzmann-Fiedler (y1994-141)

CONDITION: *The head, both arms, and lower body are broken off. All breaks are slightly worn, and the entire surface is covered with nicks. In the back, large parts of the shoulder blades, especially the right one, have been chipped off. A modern fracture appears in the remains of the left upper arm.*

The fragment represents the nude torso of a heavy-set male figure. Both arms are held close to the body, the right arm moved slightly forward, the left back. The thrust of the hips to the right has caused a slight curve of the torso. A dowel hole for the attachment of the head is visible in the neck.

The figure probably represented a nude or semi-nude god or mythical creature. The curve of the torso and the thrust of the hips to the right suggest that he was standing with the weight on his right leg or, possibly, that he was seated. The broad torso with its soft musculature and bulging abdomen is similar to that of a seated Hermes figure from Rhodes and of a standing Silenos figure from Ephesos in the British Museum.[1] TN

BIBLIOGRAPHY
Unpublished.

NOTE
1. For the Hermes from Rhodes (Archaeological Museum E 416), who holds the infant Dionysos, see *LIMC* 3:479, pl. 377, no. 676, s.v. Dionysos (G. Gasparri). For the Silenos in London (British Museum 1257), which dates to the mid-second century A.D., see Aurenhammer 1990, 75–76, pl. 37, no. 56.

31.
HEAD OF A DIOSKOUROS

Ca. A.D. 130
Provenance: unknown
Material: fine-grained white marble with a pale patina
Dimensions: h. 38.2 cm., h. of face 19.2 cm., w. 26.6 cm.,
d. 26.9 cm.
Museum purchase, Fowler McCormick, Class of 1921, Fund
(y1988-10)

CONDITION: *The head and approximately half of the neck*
have survived; the break runs diagonally toward the nape and
shows several smaller damaged sites of modern date on its edge.
The greater portions of the nose and chin have been lost; a few
tips of locks of hair and some leaves in the wreath are missing.
Larger damaged sites are evident on the lips, the right eyebrow, on
the surviving portions of the wreath, and beneath the rectangular
indentation incised in the center of the forehead on the edge of
the pilos.

The head, which is inclined slightly toward its left,
represents a young man with lush, curly hair. He wears
a round, conically tapering head covering called a
pilos, which was usually made of felt.[1] The sculptor
only roughed out the surface of the cap so as to give
the texture semblance of that particular material.
Paint would have further added to the illusion. The
edge of the headdress was originally bounded by a
wreath, which, though mostly damaged, still has
enough leaves and berries to identify it as laurel. In

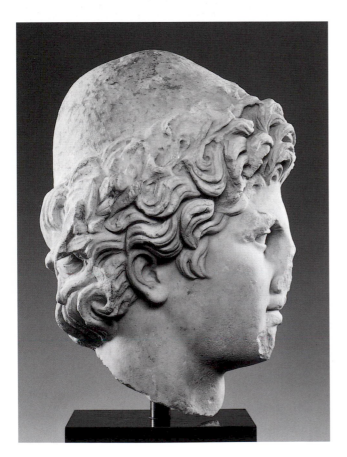

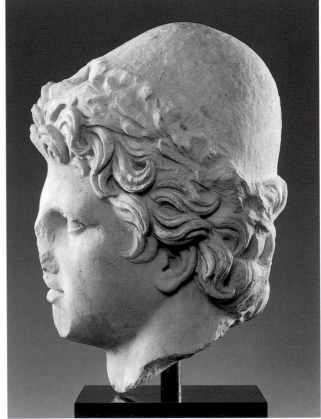

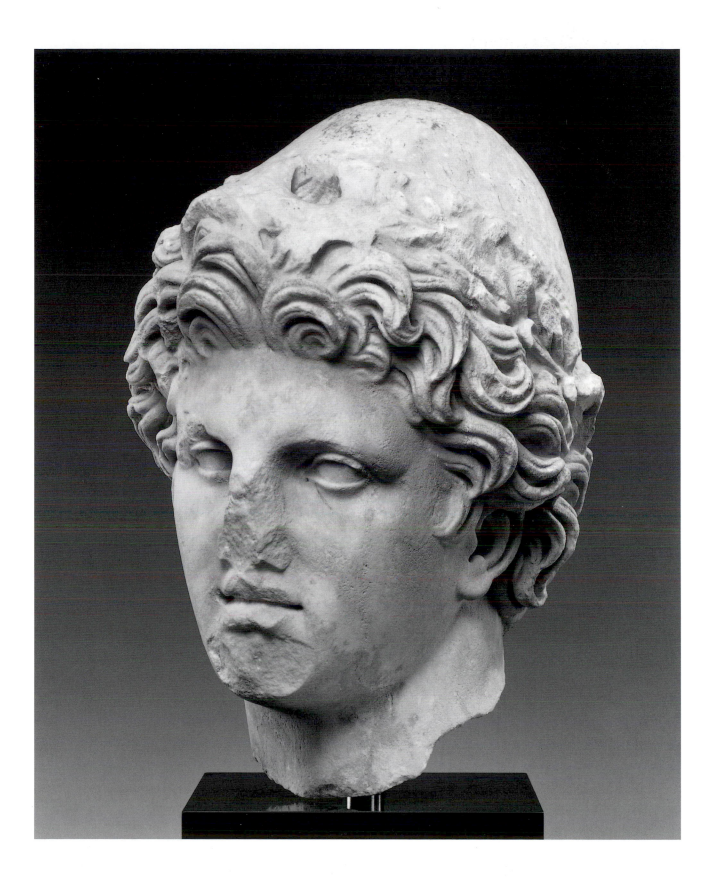

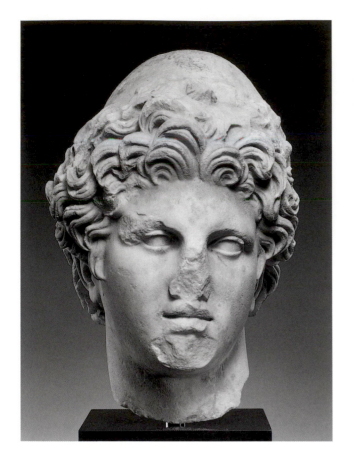
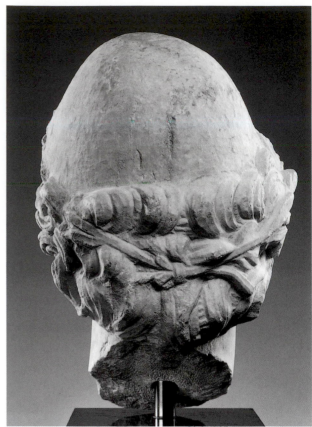

the back, the ends of the wreath are fastened with a fillet whose ends dangle down toward the nape.

The laurel wreath around the edge of the *pilos*[2] permits identification of the youth as a Dioskouros: Castor or Pollux, the equestrian sons of Zeus [Gk. genitive: Dios], who, among other things, were revered by ancient mariners as guardian deities.[3] This, in turn, makes it possible to reconstruct the object whose rectangular insertion hole is located above the part in the hair on the lower edge of the *pilos:* the object was almost certainly a star—an attribute associated with the Dioskouroi since the fifth century B.C.[4] No certain statements, however, can be made about the appearance of the statue[5] to which the Princeton head once belonged: the surviving sculptures of the Dioskouroi allow no groupings in clearly defined types according to confirmable models, but offer only schemata which can be more or less strongly varied.[6] Hence, all that can be said is that the statue would likely have been nude, with a chlamys over its shoulders, and probably would have had other attributes, possibly a horse, a lance, and a sword.[7]

A similar situation exists with respect to representing the heads of Dioskouroi. Specific Greek artworks[8] have been cited as inspirations for groups of works thought to constitute discrete types, but comparisons hardly provide more than general reference points. The Princeton head belongs to the most comprehensive group, whose conception is related to the idealizing portraiture of Alexander.[9]

For the date of the head, reference has been made to portraits of Antinous, especially the equally high-quality portrait in Delphi.[10] Among idealized sculptures, an extraordinarily closely related head-replica of the Kassel Apollo in Athens[11] is also worthy of mention: the correspondences are particularly striking in the design of the area around the eyes with the narrow orbital, the high and ridgelike eyebrows, the lively modeling of the naso-labial area, and the slightly opened mouth with indentations at its corners. Not only do these comparisons make it possible to date the Princeton head to ca. A.D. 130, they also suggest that the piece may well have been carved in Greece (see also the type of marble).[12] M F

BIBLIOGRAPHY
Record 48.1 (1989): 53, 56 (illus.).
Geppert 1996, 51–52, 105, 155, no. P 30, fig. 88.

NOTES

1. *RE* 20.2:1330–33, s.v. pílos (R. Kreis-von Schaewen); Dintsis 1986, 58–59, n. 12.
2. For more on this, see Roscher 1:1172, s.v. Dioskuren (A. Furtwängler). Without going into detail about the significance with regard to the Dioskouroi, the laurel wreath is mentioned several times in Geppert 1996. Cf. Festus, *Glossaria Latina* 225 (ed. W. M. Lindsay).
3. For the Dioskouroi, see Nista 1994.
4. On the symbol's origin and significance, see Roscher 1:1171–72; 1175–76; *LIMC* 3:592 and passim, s.v. Dioskouroi (A. Harmary); Kyrieleis 1986, 58–67. See Geppert 1996, 121–22.
5. Busts of Dioskouroi are very rare. There is only one genuine example (Geppert 1996, 147, no. P 1); in four other cases, the busts are modern additions (Geppert 1996, 19, 22, 49, 51).
6. See Geppert 1996, 86 and passim.
7. On these attributes, see Geppert 1996, 123–25.
8. Geppert 1996, 102–3.
9. Geppert 1996, 104–5, 128–30. The interaction between idealized sculpture and portrait sculpture is interesting in this context; the topic is also treated by Kyrieleis (1986, 60–62); for more on the subject, see Fuchs 1992, 97, n. 11; Meyer 1991, 239–42.
10. Geppert 1996. On the statue of Antinous, see Meyer 1991, e.g., 36–38, no. I 15, pls. 13–15; also see 29–30, no. I 7, pl. 5; 51, no. I 29, pl. 31; 88–90, no. I 67, pls. 77–78; 116, no. III 5, pl. 103.5–6. Cf. also the private portrait in Florence, which likewise probably dates from ca. A.D. 130, as discussed in Daltrop 1958 (see fig. 56).
11. Schmidt 1966, 20–22, pls. 20–22.
12. Greek provenance is not only certain for the two sculptures mentioned here, but also for one other: see the comparison cited above in n. 11.

32.

RELIEF WITH SILVANUS

First half of the second century A.D.
Provenance: unknown
Material: fine-grained, fairly opaque white marble
Dimensions: h. 70.5 cm., original h. ca. 92 cm.,[1] w. 50.3 cm., th. at left thigh ca. 9 cm.
Museum purchase, gift of Dorothy Willard and Henry White Cannon, Jr., Class of 1910 (y1991-21)

CONDITION: *Assembled from at least seven fragments. The original edge survives only at the right. The top of the panel, including the figure's head, and the entire left side are missing. The surface of these breaks is corroded and encrusted, indicating that they are ancient. Irregular pieces are lost from the right leg of the figure, the background between the figure's arms, and around the top of the tree. All these breaks are modern, as are chips in his left hand, his right leg and boot, the tree, the altar, and the garland. There is ancient damage to the figure's cloak, the bottom of his tunic, his feet, the base of the tree, the garland, and the altar. The surface is well preserved but has an incrustation that ranges from reddish gray to brownish gray. On the bottom surface, about 3 cm. from the right side, is the rust stain from an ancient iron pin. A channel (l. 6 cm.) cut into the underside just to the left of center may also have been part of an ancient mount. The right side has a rust-stained dowel hole about 18 cm. above the base.*

The sturdy, bearded figure stands with his left leg forward and his shoulders turned slightly toward the viewer in an ambiguous pose somewhere between standing and walking. He wears a sleeved undergarment and a heavy knee-length tunic with short sleeves,

a tasseled fringe along the bottom hem, and a thick, ropelike belt knotted at the waist. The tassels have oblique hatching running in alternating directions. A long cloak, mostly missing, is draped over his shoulders and reappears between his legs. His muscular legs are bare, and his crude animal-skin boots have rolled or twisted tops; the ragged edges of the skins hang around his ankles. With his right hand he raises a broad-bladed implement to the level of his chest. In his left hand he carries a set of animal organs, grasping the hollow windpipe with his thumb and two fingers; below it dangle two lungs, an ovoid heart, and a multilobed liver. At the right stands a twisted tree trunk with the stumps of three limbs. The rustic altar at its foot consists of a round plate atop a stack of stones, with a garland looped over the rocky base. The mound of indistinctly carved, rounded objects on the altar may represent fruit but is more likely to be a heap of coals.

Silvanus is a rustic divinity whose domain embraced forests and other wild land; he oversaw the activities that took place there, including herding and hunting, and protected the boundaries of cultivated areas. Also viewed as a guardian of the household, he was in fact more popular in cities than in the countryside.[2] Silvanus had neither a place in the state religion nor truly public places of worship. His shrines, which for the most part seem to have been fairly modest, were erected privately by followers of his cult, who dedicated statues, reliefs, inscriptions, and altars to him.[3]

The Princeton panel is one of the largest and finest extant reliefs of Silvanus, remarkable for the high quality of its carving as well as for its unusual details and iconography. Most of the surfaces are highly finished, but traces of fine claw chiseling were left on the figure's tunic, probably to give the impression of rough material. A bullnose chisel was used to carve the uneven bark of the tree. The tunic shows a number of unusually fine details, including seams running down the sleeve and the front of the skirt, a hem around the opening of the sleeve, and two decorative bands above the fringed border. The edges of the boot overfolds are cut with fine incisions that give them the look of crinkled leather.

The primary difficulty with this piece lies in deter-

mining its subject: is it Silvanus in his usual setting, a grove of trees, or a rustic figure like a hunter offering a sacrifice? His identity is obscured by the fact that he is not accompanied by a dog and holds neither pine bough nor fruit, all regular if variable attributes of the god Silvanus.[4] However, the beard, the rustic clothing, and the animal-skin boots seen here are standard traits of Silvanus,[5] and animal sacrifice was a regular feature of his cult.[6] Altars heaped with coals also appear consistently in Silvanus reliefs.[7]

The key to the identification of the figure as Silvanus is the object he raises in his right hand. If he were a rustic making a sacrifice, he would very likely hold the implement he had just used to dispatch or gut the animal. But the surviving portion of the tool, with its straight blade, centered handle, and broad pommel, shows that it is not a knife used to slaughter or butcher animals. The knife that appears in scenes of Roman animal sacrifice always has a triangular shape, sometimes with a curved cutting edge, and a strongly off-center handle.[8] The various knives and cleavers used by Roman butchers also had offset handles.[9] Since the triangular sacrificial knife appears even in rustic scenes comparable to the Princeton relief,[10] it is clear that the implement held by this figure was not used to sacrifice or gut an animal. In fact, the part of the tool that remains is identical to Silvanus's most characteristic attribute, the pruning hook or billhook (*falx*).[11] The large pommel and the lack of a hilt guard indicate that it was to be used with a pulling motion, like a pruning hook, rather than with the pressing or pushing action of a meat knife.[12] In the great majority of Silvanus reliefs, the god holds a *falx* in front of his body at chest level, exactly as the figure in the Princeton panel does.

Two features of this sculpture, the animal organs in the figure's left hand and the rough stone altar at the foot of the tree, appear in no other depiction of Silvanus. The dangling objects he carries are clearly a cluster of innards depicted rather graphically—even the fissure of the lung is indicated. The same configuration of organs, from windpipe to liver, sometimes with the addition of intestines beneath, appears in anatomical terracotta votives[13] and hanging from meat racks in reliefs showing the interiors of Roman butcher shops.[14] Even though this attribute does not

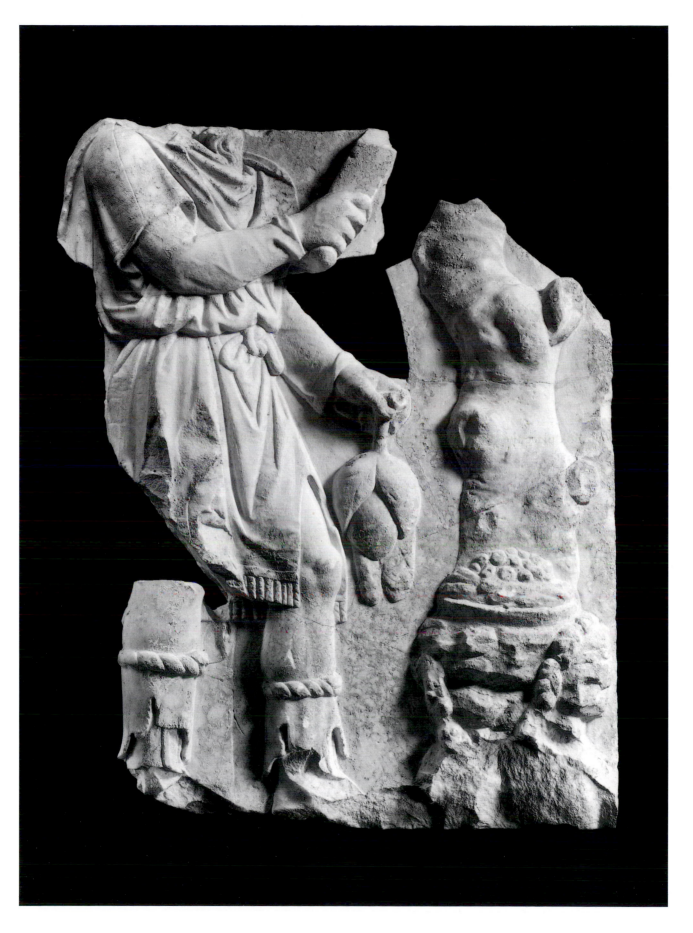

appear in other depictions of Silvanus, it is entirely in keeping with his cult, which involved the sacrifice of various animals. The stacked stone altar serves to enhance the impression of the rural setting in which Silvanus was usually portrayed. A passage in Martial (10.92.5–6) suggests that altars dedicated to Silvanus were often crudely built, but similar rough stone altars at the foot of a tree indicate a rustic locale in a variety of ancient reliefs.[15]

The Princeton relief appeared on the art market with a second marble panel of very similar size, style, and state of preservation.[16] That relief shows an elderly bearded man holding a walking stick while an eagle perches on the ovoid stone (the *omphalos*) that stood in the temple of Apollo at Delphi. This must be a depiction of the legendary sage Aesop, who was lame and was said to have visited Delphi in his old age, where he told the Delphians a fable about an eagle and a beetle.[17] Aesop, a former slave who told stories about wily animals, and Silvanus, a deity of herding and the wilderness who was widely worshiped by slaves and freedmen, were both rustic, homespun figures.[18] The shared theme of these two panels may be their focus on humble "outsiders" with special links to the natural world.

The scale and quality of the Princeton panel seem appropriate to a public monument, and its original height of about 92 cm. would be suitable for a podium. The difficulty with this supposition is that Silvanus, who was never admitted to the state religion, makes very few appearances on public monuments.[19] Most Silvanus reliefs are on fairly modest altars or plaques dedicated by individuals and made primarily for the shrines devoted to him. Dedications to Silvanus are also frequently found in the clubhouses erected by associations of tradesmen or the boards of freedmen (*augustales*) who maintained the cult of the Roman emperor.[20] The great majority of these votive reliefs and altars, however, show Silvanus nude except for a cloak and boots, and in the starkly frontal pose appropriate for a deity receiving his worshipers. The clothing and the profile pose of the figure in the Princeton panel give it a more secular and narrative quality.[21] Since the presumed companion relief of Aesop has nothing to do with the worship of Silvanus, it is tempting to conclude that both of these

sculptures had a decorative rather than a religious function. The subject of the Aesop relief is so unusual, in fact, that both panels may have been commissioned for a house or villa by an owner with fairly cultivated literary tastes.[22]

Although the absence of the head makes this relief more difficult to date, the subject provides an important clue: Silvanus in fully human form is not documented until the beginning of the second century A.D., when his cult expanded dramatically.[23] The technique of the Princeton panel is consistent with reliefs of that period: all traces of drill work were removed, and a variety of tools was used to suggest various textures. The sturdy proportions of the figure, the simple but deep cutting of the drapery folds, and the detailed representation of clothing also appear on relief sculpture dating to the early second century.[24] In addition to being one of the finest Silvanus reliefs, the Princeton panel is thus probably also one of the earliest. CM

BIBLIOGRAPHY
Record 51.1 (1992): 70 (illus.), 71.

NOTES
1. The estimated original height is based on the height of the companion piece that appeared on the market with the Princeton relief and which is discussed above. The height of that panel was given as 92 cm.; extrapolation from the published photographs indicates that the width was identical to that of the Princeton piece, suggesting that the height was also the same. The missing head would fit comfortably in a panel about 90 cm. high.
2. On Silvanus in general, see Dorcey 1992; for his character, epithets, and powers, 16–32; on his popularity in urban areas, 28, 32. On Silvanus worship in the city of Rome, see n. 3 below.
3. Over 200 inscriptions and other objects found in the city of Rome document the locations of Silvanus shrines there and the numerous dedications made in them: *LTUR* 4:312–24, s.v. Silvanus (L. Chioffi); for references to more substantial "temples" to Silvanus, see 316, and 324, s.v. Silvanus, Templum (J. Aronen).
4. The iconography of Silvanus is not fixed, and none of these attributes occurs universally. Statues of Silvanus, for example, often show him without a dog, and the dog is absent even in some reliefs, for example, *LIMC*

7, pls. 553–54, nos. 41, 49, 55, 58, 60, s.v. Silvanus (A. M. Nagy).

5. Compare the Silvanus on the attic of the Arch of Trajan in Benevento, who has identical boots and a similar tunic but wears an even more rustic fleece in place of a cloak: Simon 1979, 9, pl. 15. The rolled skin boots are a typical feature of Silvanus iconography: see Schraudolph 1993, 176–77, no. s16, pl. 16; *LIMC* 7: pls. 551, 552, 557, nos. 4, 11, 17–20, 23, 33, 106, s.v. Silvanus. If the figure on the Princeton relief were a "barbarian," he would very likely have leggings and a belt fastened above the waist, and would not wear animal-skin boots. A barbarian would also not conduct a Roman-style sacrifice.

6. Literary sources and reliefs record that pigs, rams, lambs, goats, and boars were sacrificed to Silvanus: Juvenal 6.447; Martial 10.92.6–7; Cerulli Irelli 1961–62, 103–11, esp. 106–8, figs. 3, 4; Schraudolph 1993, 171–73, 177–78, 186, nos. S6, S7, S17, S27, pls. 14, 16, 18; *LIMC* 7: pls. 551, 553, nos. 6, 38, s.v. Silvanus; Andreae 1995, pl. 443, no. 630, and pl. 802, no. 636a; Sinn and Freyberger 1996, 81–83, no. 11, pl. 31. See also Dorcey 1992, 27.

7. Although the objects on the altar are not clearly depicted, the fact that the figure carries animal organs suggests that the altar would be prepared to burn his offering. On reliefs that are indisputably dedicated to Silvanus, the altars are clearly flaming, not loaded with fruit or other offerings. See, for example, Schraudolph 1993 172–73, nos. S7, S8, pls. 14, 15; *LIMC* 7: pls. 551, 553, 554, 557, nos. 2, 6, 38, 47, 48, 51, 106, s.v. Silvanus.

8. This knife, usually called a *culter*, was used in the rites of formal religion and is often depicted with other official implements, most familiarly in the frieze of the temple of Vespasian; see De Angeli 1992, 94–95, figs. 89–91. The triangular ritual knife also appears on altars dedicated to gods who received animal sacrifices; for an example dedicated to Diana, see Galliazzo 1976, 146–48, no. 40.

9. These knives appear in reliefs showing the interiors of butcher shops or simply a collection of butcher's tools: see Zimmer 1982, 94–96, 98–105, nos. 2–6, 8, 9, 11–14; Chioffi 1999, 34–37, 54–55, 71–72, 76, 80–85, nos. 24, 26, 27, 53, 89, 97, 104–9, figs. 13, 15, 16, 40, 47–50.

10. For example, on a relief in Padua showing a satyr gutting a sacrificial animal that is suspended from a branch in a grove of trees; the triangular knife lies on the ground beneath the victim (Ghedini 1980, 195–98, no. 88).

11. The term *falx* was actually applied to a wide variety of pruning and cutting tools, and the implement commonly carried by Silvanus is more accurately called a *falx arboraria*, a straighter, smaller form very much like the modern billhook (White 1967, 85–88, fig. 58, pl. 8b).

12. A billhook found at Pompeii is very similar in both size and form to the implement depicted here: both have a centered handle and a large knoblike pommel (White 1967, 85, fig. 58, 183, no. 58).

13. See Tabanelli 1962, 45–59, esp. figs. 16, 17, 20, 22; Comella 1982, 154–57, pl. 92, esp. no. D20III; Unge Sörling 1994, 50–51, fig. 3; and Costantini 1995, 100–103, nos. E121–E12fr3, pl. 45, especially 45c and 45d. Even though these dedications are intended to depict the afflicted organs of the human donors, the multilobed form of the liver is more characteristic of animals.

14. Zimmer 1982, 94–97, nos. 2, 4, 5; Chioffi 1999, 34–37, 54–55, nos. 24, 26, 53, figs. 13, 15. For better illustrations of the shop scene with the closest parallel to the organs of the Princeton relief, a plaque in the Museo Ostiense (inv. 133), see Calza and Nash 1959, fig. 102; and Blanc and Nercessian 1992, 140, fig. 78.

15. For example, in the so-called Aeneas panel of the Ara Pacis (Zanker 1988, 203–4, fig. 157); in the Grimani relief in Vienna (Strocka 1965, 89, pls. 53, 56a); and in Dionysiac reliefs in Berlin and Cambridge, Mass. (Hanfmann 1966, 371–73, pl. 94).

16. Atlantis Antiquities, *Greek and Roman Art* (New York 1989), no. 14; Hesperia Arts Auction, *Egyptian, Near Eastern, and Classical Greek and Roman Antiquities*, pt. 2, *November 27, 1990*, no. 57; Sotheby's, *Antiquities and Islamic Works of Art, 14 December 1993*, no. 51.

17. On this presumably fictional episode, see Weichers 1961; for the fable, 11–13. Another, though less compelling, reason for identifying the figure in the panel as Aesop is the similarity of his hair and beard to the only other extant depiction of Aesop, on a red-figure kylix in the Vatican (Richter 1984, 80, fig. 44).

18. On the status of Silvanus's adherents, see Dorcey 1992, 105–34; on the nature of his powers, 14–32.

19. He is mostly hidden by a group of other gods on an attic panel of the Arch of Trajan at Benevento (Simon 1979, 9, pl. 15). Elsewhere he appears on public monuments only as a statue: on the Severan arch at Leptis Magna (Parra 1978, 807–28) and on a Hadrianic roundel reused on the Arch of Constantine in Rome (Dorcey 1988, 107–20).

20. The buildings of these *collegia*, which could be lavishly ornamented, have produced more dedications to Silvanus than to any other deity. For Silvanus dedications found in *collegia* in Italy, see Bollmann 1998, 147, 233, 242, 266–67, 271, 298–99, 320, 468 (nos. C9 and C13).

Collegia dedicated specifically to Silvanus are discussed by Dorcey (1992, 84–90); see also Bollmann 1998, 266–68, no. A19.

21. Silvanus appears clothed on altars dedicated to him primarily in Germany, Pannonia, and Illyricum, but nothing about the Princeton relief connects it with any of these areas; see *LIMC* 7: pls. 554–57, nos. 64–96, s.v. Silvanus. Schraudolph (1993) catalogues sixteen altars with a nude Silvanus (nos. S1–S3, S6, S9–S11, S13, S16, S22, S24–S27, S35, G10) and only three (nos. S8, S12, and S28) on which he is clothed, but two of these are very late, probably fourth or fifth century A.D.

22. The Delphi episode is mentioned only in three lines of Aristophanes' *Wasps* (*Aristophanes*, ed. J. Henderson, Loeb ed. [Cambridge, Mass. 1998], vol. 2, lines 1145–47), and in a passage of a Life of Aesop preserved in a manuscript in Moscow (Perry 1936, 60–65, 67–68, 172). A group of five mythological reliefs comparable in size to the Princeton Silvanus was found in the ruins of a villa at Capo di Massa near Sorrento, showing that marble panels of this sort were considered appropriate decor for a private residence: see Neudecker 1988, 37, 220, no. 61.1, pl. 6.2.

23. On the change from an animal-like to a fully human Silvanus, see *LIMC* 7:771, s.v. Silvanus (A. M. Nagy). The earliest datable anthropomorphic Silvanus appears on a coin struck by the emperor Trajan between A.D. 104 and 111: *LIMC* 7: pl. 553, nos. 40–41, s.v. Silvanus. Schraudolph (1993) catalogues four first-century A.D. altars dedicated to Silvanus (nos. S7, S15, S17, and S20), but interestingly none of these has a depiction of the god, another indication that his iconography was not established until the second century, when he consistently appears in human guise (e.g., Schraudolph 1993, nos. S6, S13, S16, S22, S24).

24. A relief showing the burning of tax records, now at Chatsworth House, is particularly close in style and execution. Note especially the plain but deeply cut V-shaped folds and the details such as sleeve hems in the tunics of the leftmost and rightmost figures, as well as the attention to texture. The Chatsworth relief, however, is not precisely datable. The most recent publication places it in the reign of Hadrian (Boschung, Hesberg, and Linfert 1997, 77–79, no. 76, pls. 67–70 [Boschung]). Others prefer a Trajanic date (Koeppel 1985, 171–72, no. 8, figs. 10–12).

33.

MITHRAS SLAYING THE BULL

Early Antonine, ca. A.D. *140–160*
Provenance: "found in France" [1]
Material: grayish marble
Dimensions: h. 60.5 cm., w. 58.0 cm., d. 22.7 cm.
Gift of Mrs. Moses Taylor Pyne in memory of Allan Marquand, Class of 1874 (y342)

CONDITION: *The tip of the Phrygian cap is broken off. There is minor wear, and traces of cement (ancient) are visible on the lower edge. The carving on the back is shallow and the drapery simplified.*

The youthful god is wearing a long-sleeved, girded oriental dress with leggings, a short cloak, a Phrygian cap, and soft shoes. Attacking a bull from behind and holding it down with the weight of his body, he is pulling back its head by the muzzle and thrusting his knife into the animal's neck. The order for the sacrifice had come to Mithras from the Sun god, and it is toward the latter that his gaze is directed: he had complied only with hesitation. A forceful stream of blood issuing from the bull's wound has caught the attention of a dog and a snake, which are lapping at it, while a scorpion is attacking the victim's genitals. These animals represent the powers of darkness and evil.

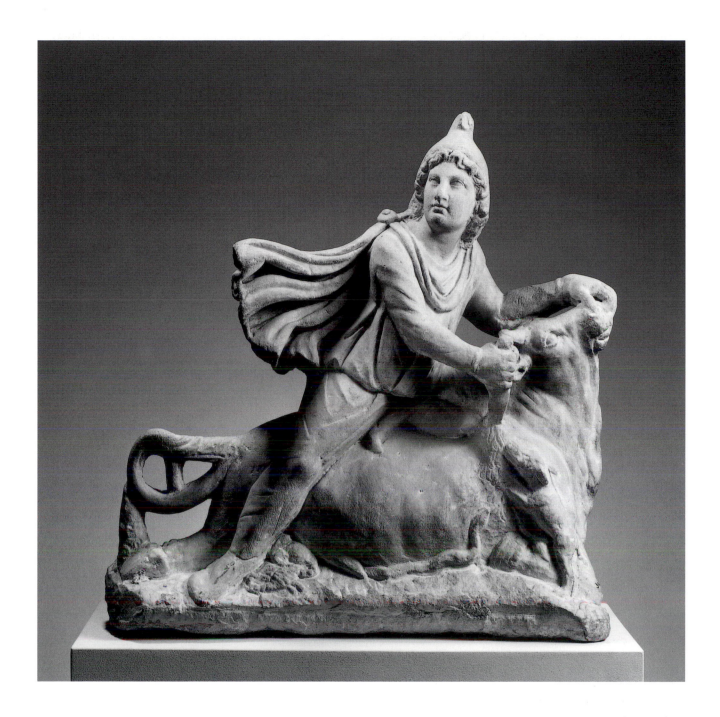

The slaying of the bull resulted in a sequence of miraculous events. Mithras' cloak became the heavenly vault. From the animal's tail there sprouted the first grain, which is why the sculptor has actually given the strut connecting the tip of the tail to the rear the shape of an ear of corn; from the bull's blood grew the first grape, and the creatures inhabiting earth sprang from the holy seed. The bull itself turned into the moon, day and night were separated, and time began, but likewise the eternal strife between Good and Evil. With creation unfolding, Mithras joined the Sun god in his chariot, and the two of them drove off across the sky.

The strictly male cult of Mithras[2] originated in ancient Iran and did not reach the Roman world prior to the early 2nd century A.D. "Roman Mithraism was practically a new creation" which "gave the old traditional Persian ceremonies a new Platonic

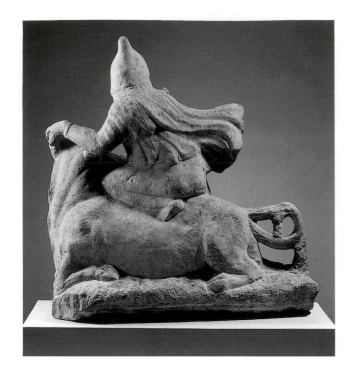

In terms of composition, the images of Mithras slaying the bull are derivatives of Classical Greek types showing sacrificing Victory goddesses.[4] Moreover, Mithras' hairstyle and facial expression in the present group have been modeled on portraits of Alexander the Great, a trait that further underscores the god's glory and inability to be conquered.[5] As comparisons with sarcophagi show, the Princeton Mithras was carved in the early Antonine period.[6]

HM

BIBLIOGRAPHY
Elderkin 1925, 118.
RSGR 6:107, no. 6.
Espérandieu 10:133–34, no. 7457.
Vermaseren 1956, no. 605.
Turcan 1972, 5, 12, pl. VI.
Walters 1974, 146 i.

interpretation that enabled Mithraism to become acceptable" in its new environment.[3] At the center of both the Iranian and the Roman cult stood the notion of loyalty to the ruler, and this made it attractive to soldiers, imperial administrators, and members of the imperial household. The mysteries of Mithras, celebrated in subterranean cult rooms, rapidly spread in the empire's metropolitan areas and the frontier provinces. The Princeton statuette must have served as the central cult image in one of those chapels, and the spatial restrictions of the cavern explain its modest proportions. For understandable reasons, the early Church fathers showed a good deal of concern about Mithraism, but when Constantine in 312 defeated Maxentius under the sign of the cross, its fate was sealed. At the end of the fourth century Mithraism was dead.

The Princeton statuette's quality of workmanship is above average, as can best be seen from the rich detail in the rendering of the bull's head and neck. Surprisingly, some elements, for instance, the scorpion and the snake, did not receive the final touch, but certainly color will have helped to bring them out more clearly.

NOTES

1. According to Joseph Brummer, from whom it was purchased in 1925, the sculpture was "found in France." George Elderkin said it came from the general area of Vienne, but apparently Franz Cumont believed he had seen the group at Jandolo's gallery in Rome in 1919. (The reference to Cumont is in Vermaseren.) There is a lot of confusion regarding the history of the piece: suffice it to say that, contrary to assertions by Espérandieu, it never belonged to the Metropolitan Museum or to Allan Marquand. However, Edmund Wilson, in his amusing essay "Mr. More and the Mithraic Bull" (in *The Triple Thinkers* [New York 1948], 8), relates the following: Frank Jewett Mather "explained in detail the symbolism of Mithraic art. There was a Mithraic bull in the Museum, he said, which he had bought and brought back from Europe and which was one of the best things the Museum had." It seems safe to assume, though, that Wilson, who was writing from memory, unintentionally misrepresented Mather's statement: it would seem to imply that Mather had obtained the group and sold it to Brummer who, in turn, sold it to Moses Pyne.

2. For the exclusion of women from the cult of Mithras, see Clauss 1992, 25 n. 94, 264.

3. *Encyclopaedia Britannica*, 15th ed., s.v. Mithraism. This entry is very clearly structured and highly informative. See also Vermaseren 1965; Merkelbach 1984; Stucky 1987, 17–19, with additional bibliography in n. 8; Clauss 1990 and 1992; Turcan 1993; Mastrocinque 1998.

4. Cf. Bol 1990a, no. 230, pl. 196 (R. M. Schneider), with bibliography.

5. See the entry on the head of a Dioskouros, Princeton y1988–10 (cat. no. 31).

6. The best comparisons for the rendering of the fabric in the god's dress and cloak—and even the somewhat squinty eyes—are found on a Dionysiac sarcophagus in Cambridge, England: cf. Matz 1968, no. 129, pl. 152, and passim; with an attribution to A.D. 145–160 and further references. Likewise, the Princeton sarcophagus with scenes from the life of Dionysos is comparable (see cat. no. 42).

34.
GROUP OF HERMES AND RAM

Early Antonine, mid-second century A.D.
Provenance: unknown
Material: white marble, coarse-grained and highly crystalline, probably Pentelic
Dimensions: h. 17.4 cm., w. 12.6 cm., d. 5.4 cm.
Museum purchase (y1945-247)

CONDITION: *The head is now missing but was recorded in an old inventory. The patina on the break surface, however, does not suggest that the head came off recently. (There are some scratches that may have been caused by an attempt to fit it on.) The left leg is missing from the knee down, the right one from below the middle of the shin. Thumb, index and middle fingers of the right hand, and most of the fingers of the left hand are lost. The animal's head is chipped. A sizable drill hole below the left armpit has not been smoothed out. The figure was broken into two pieces diagonally through the hips and the right elbow. The honey-yellow patina is visible everywhere but is more uniform on the figure's back. Incrustations and heavy discolorations in places.*

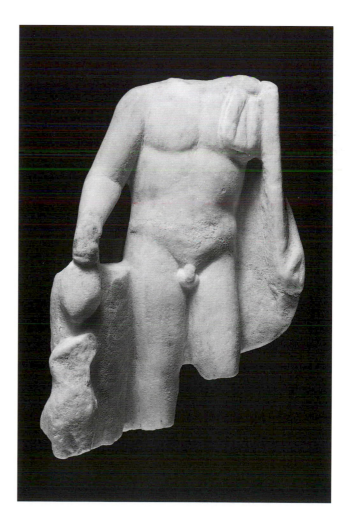

Hermes-Mercury is recognizable by the moneybag in his right hand, his nudity, and the characteristic way in which his cloak (the chlamys) is gathered on his left shoulder. Hermes is accompanied by an animal that sits to his right and looks up. The creature is only roughed out, and its shape may at first glance resemble a dog. However, links between the messenger god and the dog are difficult to establish.[1] The animal will be a goat or—as may seem more plausible in the lateral view—a ram. Both these creatures are well-attested attributes of the god.[2] The boardlike object on Hermes' left arm can only be explained as

on which the telltale prop of the *caduceus*, or Mercury's staff, was added in paint. Here, as elsewhere, the sculptor was eager to limit the risk of fracturing.[3]

The small sculpture is not quite as unassuming as it may first appear. The god stands on his right leg while the foot of the free left leg was set back and a little to the side. The contrapposto stance occasions the slant from left to right in the hip area. Rib cage, chest, and shoulders are leaning slightly toward the side of the free leg.

The figure is intended to be viewed from a vantage point to the right of it. In this view, the painted *caduceus* or *kerykeion* would become fully visible, as would the arm that holds it. The right arm creates a sense of three-dimensional depth, and the moneybag and animal become semifreestanding components of the group. Also, in the suggested view the musculature of the god's body displays a lively interaction between bulging and receding units. (Note also how

the wide groove by the side of the left leg enhances that impression.)

The marble and its patina make it likely that this is an Attic work. The abundance of attributes— animal, moneybag, staff, cape and, probably, cap and winged feet—suggest a Roman date of the mid-second century, as does the generally classicizing appearance of the godly figure. HM

BIBLIOGRAPHY
Unpublished.

NOTES
1. See Roscher 1.2:2404 and 2430, s.v. Hermes (C. Scherer).
2. See, e.g., the plates in *LIMC* 5:310–11, nos. 254–259, pl. 222, s.v. Hermes (G. Siebert); or Wrede 1981, pls. 32–33.
3. For a comparison see, e.g., a statuette from Thasos: *LIMC* 5:364, no. 918a.

35.
HEAD OF ISIS

Early Antonine, ca. A.D. *140–60*
Provenance: unknown
Material: translucent, alabaster-like marble
Dimensions: h. 4.9 cm., w. 4.6 cm., d. 4.8 cm.
Gift of Edward Sampson, Class of 1914, for the Alden Sampson Collection (y1964-140)

CONDITION: *Broken through the neck, a part of which is preserved at the head's proper right. The tips of the corkscrew locks on the left side are missing. A deep, squarish hole on the top of the head is surrounded by abrasions. The better part of the nose is destroyed, the right cheekbone chipped, and the first corkscrew lock on the right side is damaged. The face seems to have been slightly cleaned, and also an area on the back of the head. Otherwise, there is an even coat of patina with some light incrustations in the grooved lines. The black stains seem to be tar.*

That the diademed head depicts the goddess Isis can be seen by the characteristic corkscrew locks[1] on either side and the idealized facial features. The goddess's long hair is parted in the center and waved back under the diadem.[2] At the back of the head, a bun seems to have been composed from several rolled-up strands of long hair. From underneath the bun, long corkscrew locks that are almost completely lost flowed down onto the shoulders. Behind the diadem a large hole was crafted for the insertion

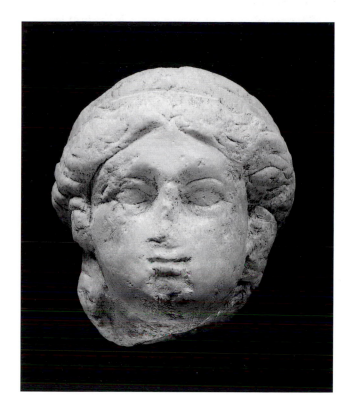

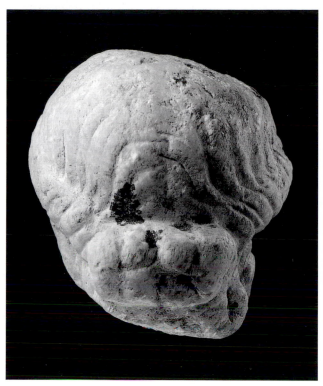

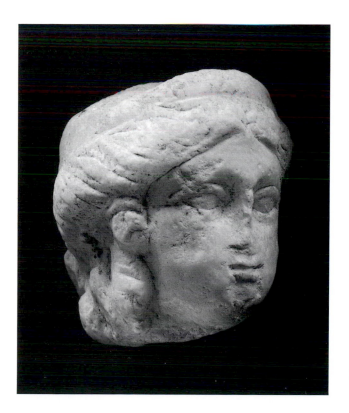

127

of Isis's conspicuous prop, the *basileion*, or crown of Hathor-Aphrodite.[3] It consisted of the solar disc surrounded by cow's horns as well as feathers and, probably, ears of corn. In all likelihood, the attribute was made of bronze.

The goddess's face is soft and fleshy, her eyes are big: these are traits that can be traced back to the Hellenistic tradition.[4] But the treatment of the hair with its multitude of fine lines suggests a Roman rather than a Hellenistic origin of the piece at hand. More precisely, the delicate striations in conjunction with the heavy eyelids seem to favor a date in the early Antonine period.[5]

For a full appreciation of the head, it is necessary to take into account a number of asymmetries and differences in finish between the left and right sides. On the right, one distinguishes three corkscrew locks, but on the left only two. The hair on the left temple bulges out more than that on the right one

which, however, is more carefully structured. The same is true of the hair above the wave, whereas it is but summarily treated on the opposite side. Thus, it is clear that the three-quarter, right-profile view, which also makes the face appear somewhat less pudgy, was the intended vantage point.　　　HM

BIBLIOGRAPHY
Unpublished.

NOTES
1. Cf. *LIMC* 5:761–96, s.v. Isis, passim (T. T. Tinh).
2. Cf. *LIMC* 5:761–96; Budischovsky 1977, 1:135, no. 54, pl. 72b.
3. Cf. *LIMC* 5:793.
4. Cf., e.g., Le Corsu 1977, 88, pl. 9.
5. Wegner 1939, pls. 10–12 and passim; Anderson and Nista 1988, no. 20. On Isis in the Graeco-Roman world, see Witt 1997; Eingartner 1991.

36.

SMALL HEAD OF HERAKLES

Antonine, second half of the second century A.D.
Provenance: unknown
Material: Fine-grained white marble
Dimensions: h. 6.6 cm., w. 5.0 cm., d. 5.7 cm.
Unrecorded acquisition (y1938-10)

CONDITION: *The break runs diagonally through the neck from the beginning of the right shoulder upward to the left jaw. The tip of the nose is missing. The lower leaves in the wreath on the right side of the head are only partly preserved; the other leaves are abraded in some places. The right eyebrow and beard have suffered minor damage. The surfaces of the face's fleshy parts have been smoothed. A deep crack of modern date runs across the surface of the break.*

The beard, the wreath of grape leaves, the age of the individual, and the highly expressive facial features all identify the depicted person as Herakles. The right portion of the neck protrudes significantly, thus

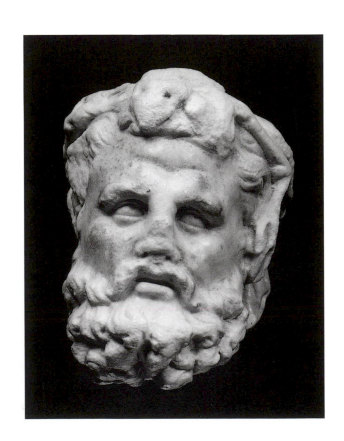

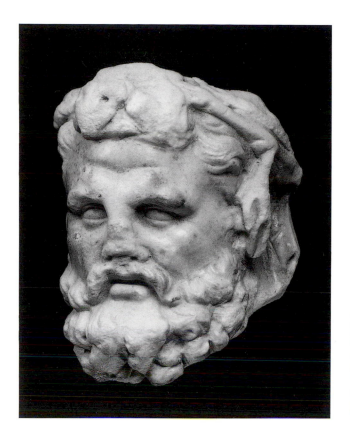

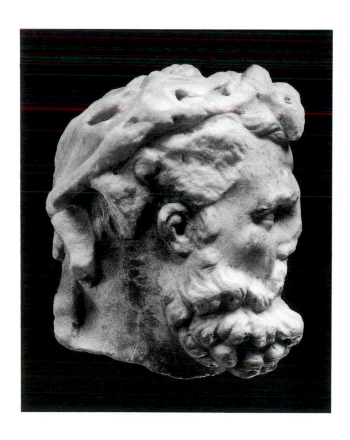

showing that the hero must have held his head turned far to his left. At the same time, the head was also inclined laterally and lifted slightly, as can be inferred from examination of the direction of the gaze in the drilled eyes. The eyes themselves lie deeply embedded beneath the protruding brow ridge. The forehead and cheeks are carved in vital and lively relief.

This posture of the head and the features of the face put the Princeton fragment into very close relationship with a smaller than life-sized statue in the Museo delle Terme in Rome,[1] where Herakles is depicted with a cornucopia. The hero supports himself with his right hand, which grasps a club that stands parallel to his leg and with one of its ends resting upon the ground. The figure's left hand, which lies atop a tree trunk, clasps the fecund horn, around which the Nemean lion's skin has been wrapped. The other end of this pelt lies atop a tree trunk. The turn and inclination of the head direct it toward the cornucopia, but the gaze is focused into the distance beyond. On his head, the hero wears a wreath whose leaves have been identified as belonging to the white poplar.[2]

It seems quite probable that the small head in Princeton once belonged to a typologically related statue. Of course, despite the aforementioned similarities, the condition of the Princeton head makes it impossible to verify or disprove this conjecture.

The date of the head's creation, however, can be determined from examination of certain details. The modeling of the forehead, which retreats stepwise toward the temples; the broad cheekbones with the hollowed cheeks below them; and the eye orbits, the flesh of which hangs over the outer corners of the eyes: all these details are closely related to the corresponding features on a statuette of Herakles in the Glyptothek in Munich.[3] The Munich statuette evinces strong similarities with portraits of Marcus Aurelius, suggesting that it dates from the Antonine era. The way the face is smoothed and the drilled dots marking the pupils are two additional details of the small head in Princeton that further corroborate the likelihood of an Antonine date.

MF

BIBLIOGRAPHY
Unpublished.

NOTES
1. Michaelis 1882, 623–24, no. 3 a; Strong 1908, 9, pl. 5; Becatti 1968, 1–11, figs. 1–4; Curto 1972, 255; D. Bonanome, in Giuliano 1985b, 515–18, no. x.7; *LIMC* 4:757, pl. 483, no. 574, s.v. Herakles (J. Boardman, O. Palagia, and S. Woodford).
2. Becatti 1968, 4, 9.
3. Fuchs 1992, 157–63 no. 22.

37.

HEAD OF HERAKLES WITH VINE WREATH

Antonine, ca. A.D. 170–180
Provenance: unknown; acquired before 1922
Material: white marble, finely grained
Dimensions: h. 12.3 cm., w. 8.9 cm., d. 10.4 cm.
Unrecorded acquisition, before 1922 (y1938-6)

CONDITION: *On the whole, the head is well preserved. Whether it originally belonged to a standing figure or a seated one is impossible to determine. The surface is evenly covered with a brownish gray patina, but there is considerable discoloration in some areas. The fracturing that detached head from body has almost completely eliminated the right half of the neck. The main break surface that stretches diagonally from below the beard to the nape of the neck is almost plane, and the area extending above it to the*

top edge of the wreath displays unmistakable chisel marks. Thus, the head seems to have literally been cut out of its original context. A herm is unlikely; a decorative table leg (trapezophoron) is a distinct possibility. The nose is damaged in its entire length, but the right nostril survives. The left eyebrow is chipped off, and there are scratches in the beard and mustache as well as the hair above the forehead and on the back of the head. Much of the damage is apparently modern. Above the left eye and behind the right ear portions of hair were flaked off in antiquity; the lower part of the right ear is also an early loss. The hole in the neck underneath the beard is modern and was drilled for the purpose of mounting the piece.

The impressive, symmetrized beard, the knitted and bulging brow, and the bristling hair speak of great energy on the part of the man portrayed here. The vine wreath confirms what seems apparent at once, namely, that he is Herakles-Hercules who was closely associated with his half-brother Dionysos-Bacchus, in whose cortège he appears on sarcophagi and in whose military exploits he was said to have participated.[1]

The head's sculptural qualities are best appreciated if it is not viewed frontally, but a little from the left so that the right ear and the bottom row of beard curls by the right jowl are in sight. This ear and row of curls were carefully executed, whereas their counterparts on the other side of the head seem rather sketchy. In the preferred view, the imbalance between the eyes that is quite noticeable in the frontal view is leveled out, and the forehead appears in lively relief.

Very similar is a head of Herakles in a double herm in Leiden,[2] although doubtless the quality of workmanship in the Princeton head is superior. Nevertheless, both heads share the sketchiness in the treatment of hair and beard. This alone would point toward an eastern origin, confirmed by the Leiden herm's ascertained provenance from the Smyrna art market. Portrait heads from the Greek-speaking half

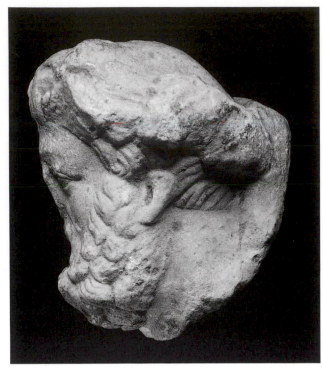

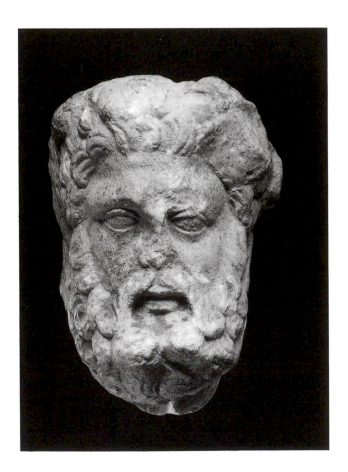

of the Roman empire often show similar characteristics. Suffice it here to point to two heads of Marcus Aurelius (reigned 161–80 A.D.) in Cyrene, Libya, and in Frankfurt (from Asia Minor).[3] Both these heads belong to the emperor's fourth portrait type, which shows Marcus with clear signs of aging.[4] Their faces with the characteristic eyebrows and lower eyelids, as well as the gently closed mouth with its conspicuous lower lip, compare well to the Princeton Herakles. The fourth portrait type of Marcus was created about 175 A.D. The Princeton Herakles and the Leiden herm must be dated accordingly. HM

BIBLIOGRAPHY
Unpublished.

NOTES
1. Roscher 1.2:2249, s.v. Herakles (A. Furtwängler); cf. Vermeule and Comstock 1988, no. 45; *LIMC* 4: no. 1173 and passim, s.v. Herakles (O. Palagia).
2. Bastet and Brunsting 1982, no. 419, pl. 124; Giumlia 1983, cat. no. 170; *LIMC* 4: no. 1203.
3. Bergmann 1978, 16, fig. 54.
4. Bergmann 1978, 22–33.

38.
STATUETTE OF APHRODITE

Severan, ca. A.D. 190–200
Provenance: unknown; formerly in the collection of H. Larrain,
New York
Material: alabaster
Dimensions: h. 11.2 cm., w. 6.7 cm., d. 2.8 cm.
Museum purchase (y1954-146)

CONDITION: *Both legs are missing from above the knees. The lower right arm and hand stood clear of the body and have broken off. On the fold of drapery below the break the inception of a relatively sizable strut is visible: it must have supported the hand. The left hand and the better part of the tendril of hair it seems to have clasped are lost. A strand of hair on the right shoulder is badly worn. The head and almost the whole neck are missing. The right shoulder, the left elbow, and the belly area are damaged. There are discolorations and incrustation in various places.*

The figure seems to date from the Severan period of the late second or early third century A.D. This is suggested by the piece's high polish, a predilection of that era, although forerunners existed in Hadrianic times.[1] Another indication is the soft treatment of the flesh with its propensity to form somewhat isolated bulges. Comparisons are furnished by the figures of Ganymede and two cupids on the front of a strigilated sarcophagus in the Vatican, which H. Sichtermann

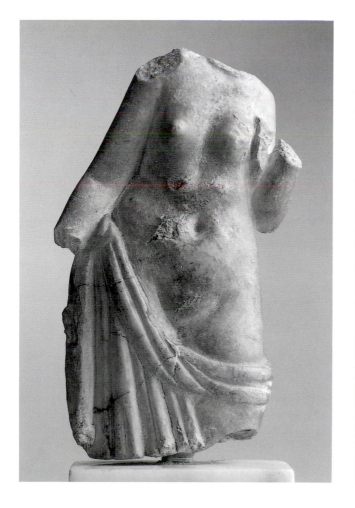
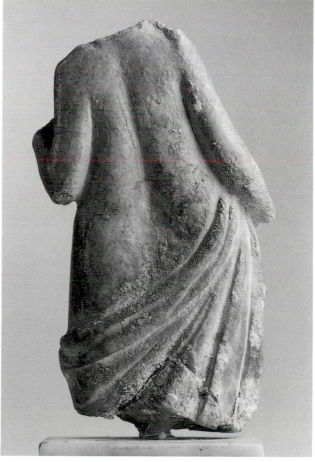

and G. Koch dated to the very end of the second century.[2] The simple folds of the goddess's mantle, which obscures the body but does not stand in striking contrast to it, may be said to resemble the drapery wrapped around the arms of the fighting giants on another sarcophagus in the Vatican, datable to ca. A.D. 170–180.[3] On the other hand, the rendering of the drapery on the Munich caryatids, which M. Fuchs has dated to the first decades of the third century,[4] is noticeably drier than on the Princeton Aphrodite.[5] And finally, on a sarcophagus of about A.D. 230 in Villa Doria Pamfilj, whose sides are less carefully rendered than the front and, for that reason, lend themselves to a comparison with the modest statuette of Aphrodite in Princeton, body and garment have begun to lead almost separate lives.[6] (Note also the avoidance of twists in rolled-up or gathered pieces of cloth, where they might easily have been inserted.)

While not a great work of art, the statuette claims attention for the emphasis put on the display less of female beauty in an abstract sense than on womankind's fertility and ability to give life. Hence the prominent treatment of the pelvic zone, the pudendum, and the breasts with their conspicuous nipples. These features stand out most clearly when the goddess is seen in three-quarter view from her proper left, and the arms now serve as markers of spatial depth. The tilt in the shoulders and what is left of the neck, and also the bunch of hair flowing down between left arm and chest, indicate that Aphrodite's head was turned in the viewer's direction. Typologically, the figure is akin to the Venus of Agen.[7]

HM

BIBLIOGRAPHY
Parke-Bernet, New York, December 1, 1954, no. 108.

NOTES

1. Meyer 1991, 80–81, no. 59, with further references.
2. Sichtermann and Koch 1975, no. 20, pls. 44–45.
3. Sichtermann and Koch 1975, no. 21, pls. 44 and 47; Cf. Helbig[4] 4:382, no. 145.
4. Fuchs 1992, no. 15, figs. 89–125.
5. One might also compare the two Giustiniani caryatids in Copenhagen: Schmidt 1973, 27–30, no. 3, pls. 33–37.
6. Sichtermann and Koch 1975, no. 36, pl. 89.
7. *RSGR* 1:370–76, pl. II; 2:295–303, figs. 1–2; Horn 1931, 89–90, n. 9, group III, no. 2; *LIMC* 2:79–80, no. 707, s.v. Aphrodite (A. Delivorrias). With regard to the steeply raised left arm and its relationship to the hair, cf. a marble statue in Cyrene: Paribeni 1959, no. 257, pl. 134; *LIMC* 2:157, no. 58, pl. 160 (M.-O. Jentel).

39.

HEAD OF A WARRIOR

Late second–early third century A.D.
Provenance: unknown
Material: fine-grained white marble
Dimensions: h. 9.5 cm., w. 6.8 cm., d. 9.1 cm.
Gift of Harris S. Colt, Class of 1957, and
Margaretta B. Colt (y1994-33)

CONDITION: *Ancient breaks through center of neck and strut on helmet; modern chip in hair on nape; most of nose lost; gouge on right cheek; many small scratches; light wear; yellowish patina.*

This head of a bearded warrior evidently was broken from a statuette; the even polish of the surface, front and back, argues against its having been part of a relief. The stump of a slender strut is preserved on the back of the helmet, the latter a Hellenistic type with a ridged bowl, visor, nape guard, chin strap, and no cheek-pieces. The deep drill hole on top of the helmet and the flattened area immediately in front of it indicate there likely was a separately-made crest. The warrior's wavy hair is parted in the middle and

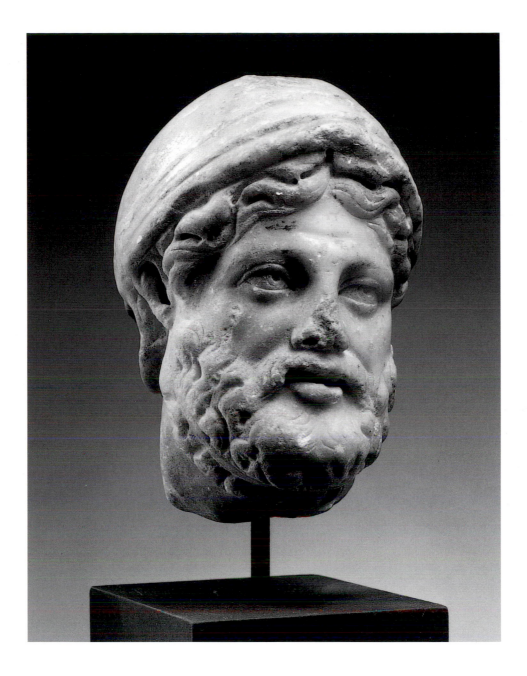

brushed back to the ears, which, like the hair, are deeply drilled. The beard is short, with shallow, rounded curls and only a few drill marks. The sculptor took pains to render the indention in the beard made by the chin strap. The man's brow is creased, and there are distinct naso-labial lines above the drooping mustache. The brows are softly modeled, as are the cheeks. The lips are full and parted, with a deep drill line between them; the line of the upper teeth is clearly represented. The eyes are carefully carved, with heavy lids and bulging lower orbits; the irises are carved, the pupils and tear ducts drilled.

The warrior turns his head up and to the left, his eyes following.

There is no decisive clue to the warrior's identity. His old-fashioned helmet is not that of a contemporary Roman soldier, and he is more likely a god, such as Mars,[1] or a figure from Greek mythology. The upward gaze and idealized features recall early Hellenistic prototypes, and the high polish and fine drill work —exceedingly fine for a piece of this scale—along with such details as the treatment of the eyes, point to a late Antonine or an early Severan date.[2]

JMP

135

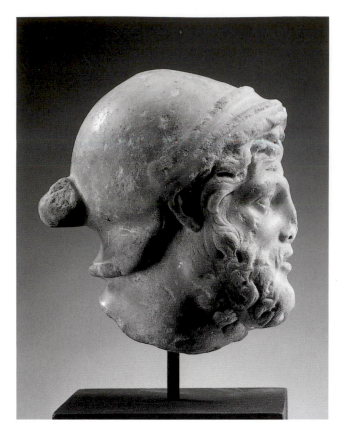

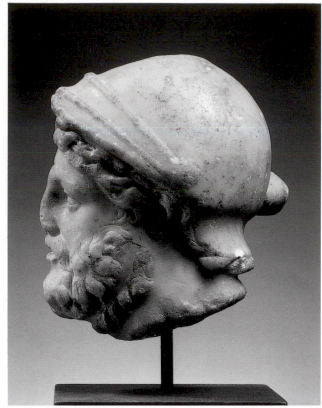

BIBLIOGRAPHY
Record 54.1 (1995): 72 (illus.).

NOTES
1. Mars was not infrequently represented as bearded and wearing a helmet of this general type; for some examples see *LIMC* 2: pl. 381, no. 21b; pl. 394, no. 143a and c; pl 403, nos. 285 and 287; pl. 404, no. 288, s.v. Ares (E. Simon and G. Bauchhenss).
2. For example, cf. the treatment of a helmeted Greek warrior on an Amazonomachy sarcophagus in Paris, Louvre MA 1785 (Baratte and Metzgër 1985, 263–64, no. 169).

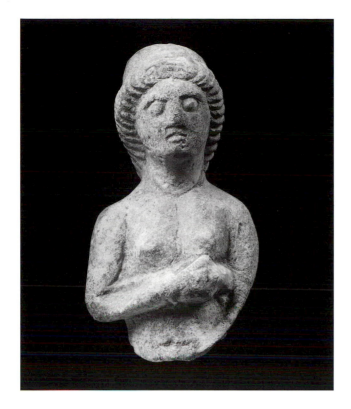
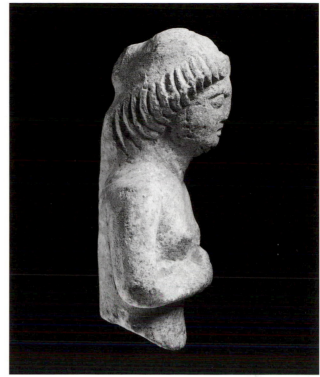

40.

STATUETTE OF APHRODITE

Second—third century A.D.
Provenance: unknown
Material: limestone
Dimensions: h. 8.75 cm., w. 4.9 cm., d. 3.5 cm.
Unrecorded acquisition (y1940-326)

CONDITION: *Broken across the belly, the lower half lost, the upper half largely complete. Damage to right forearm; sloping break through upper left arm; nose missing. Surface worn and flecked with brown incrustation.*

The fragment preserves the upper half of a statuette of Aphrodite carved from soft limestone, light beige in color, fine-grained and chalky in texture. Aphrodite stands erect, her right arm crossing her torso beneath her breasts, her left arm lowered to cover her pudendum. The nude goddess has a large head, sloping shoulders, round protruding eyes, and an elaborate coiffure. Her long hair is parted in the middle and arranged in two sections, with the hair at top pulled back in a chignon and trailing down the nape, and the lower tresses dressed in curving, vertical

waves, which apparently are rolled over a diadem (visible in front, above the forehead). She was either represented completely nude or had her legs covered by a gown, held up with her left hand.

A provincial variation on the standard Pudica type, this small Aphrodite finds her best parallels in statuettes from Syria.[1] She was probably painted originally, although no traces of color survive, and may have occupied a humble household shrine.

JMP

BIBLIOGRAPHY
Unpublished.

NOTE
1. Cf. two similar statuettes-the first in ivory, the second in alabaster-in the National Museum, Damascus, inv. 10326 and 1993 (4321): *LIMC* 2:156, pls. 157–58, nos. 27 and 37, s.v. Aphrodite in peripheria orientalia (M.-O. Jentel).

SARCOPHAGI

41.

CHILD'S SARCOPHAGUS WITH HERAKLES AND CENTAURS

Early Antonine, ca. A.D. 140–150
Provenance: probably Rome[1]
Material: fine-grained white marble
Dimensions: h. 32.7 cm., l. 146 cm., d. 52.2 cm., th. front panel 5.8–6.4 cm.
Gift of the Friends of The Art Museum and an anonymous friend (y1996-10)

CONDITION: *Front panel: The upper left corner and the tip of the lower left are broken off, and the lower frame is chipped in the center and damaged at far right. The right front leg of the centaur at far left is broken off, and his equine body was pierced by a drain hole, now concealed by restoration. The three centaurs on the right half of the relief are all missing various limbs: the right front leg and lower left arm of the centaur above the fallen kantharos; the left front leg and part of the left shoulder of the centaur with bound arms; the left front leg, lower left arm, and parts of the left shoulder, left upper arm, and left hind leg of the centaur at far right. The sarcophagus was once broken into two pieces near its right end: the restored join runs through the lion skin of Herakles and the left foreleg of the centaur at far right. Various minor blemishes and cracks occur throughout (e.g., the*

thighs of the Herakles at far left), and most of the surfaces are quite worn, with a grainy texture.

Left side panel: The young centaur's left knee is broken off, as is most of his right front leg; his nose and chin are also damaged. All the surfaces are worn. A thin, grayish incrustation covers much of the lower half of the background.

Right side panel: The face of the centaur is badly damaged below the eyes. All the surfaces are worn to the same degree as the other two reliefs. Below the centaur's left front leg is a drainage hole plugged with lead. This is one of seventeen holes which were cut through all four panels and the base of the sarcophagus when it was used as a planter, perhaps as early as the Renaissance. Most of the holes were placed carefully to avoid damaging the figures, emerging between and around their legs. At some later

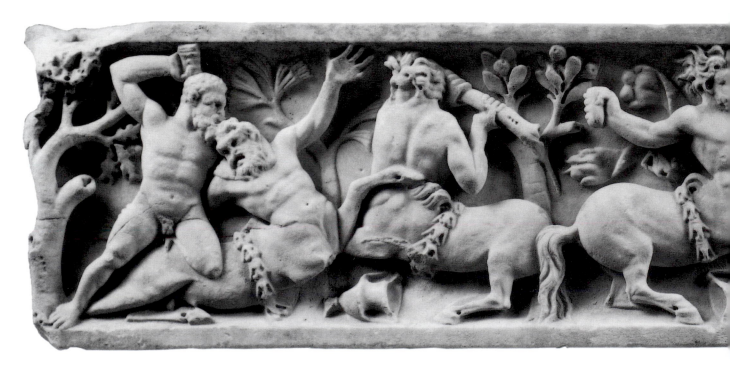

date, the holes were plugged with lead, and thereafter, in a much later restoration, the exteriors of all but one of the holes were completely concealed.

The (now missing) lid was articulated with a shallow groove on top of the coffin rim and was fastened in place by four clamps, one at each corner; two of the four clamp holes still retain traces of metal. The right end of the interior is rounded, and the floor slopes gently upward at the same end. The inner walls of the coffin and the back of the exterior were smoothed with a claw chisel.

Front panel: The relief on the front shows Herakles fighting against centaurs in two separate scenes. At either end, the relief is framed by trees: to the left an oak tree, to the right a fig tree. A pine and a laurel tree, rendered in low relief, provide the background of the scene at the left. There the nude hero is shown with his left knee bent over the trunk of a centaur, around whose neck he has entwined his left arm in an asphyxiating grip. Herakles' right arm is raised above his head as he prepares to strike a final blow to his opponent with his club. The centaur extends his right arm behind Herakles' torso to grip the hero's right thigh; his left arm is raised in the air denoting pain and exhaustion, the same state indicated by his gaping mouth and raised forelegs. Below the combat-

ants is a wine cup, a kantharos, which lies overturned on the ground, hinting at the event that occasioned the struggle. The scene is completed at right by a second centaur, who prepares to strike Herakles with a heavy branch, which he holds with both hands. His equine body is shown in profile to the left, while his human torso is contorted by his gesture, so that we see only his tense, well-muscled back and the upper half of his left profile. Both centaurs have ivy garlands wrapped around their equine bodies, which also bear little manes at the juncture with the human torso. The same garlands and manes characterize the centaurs in the scene to the right.

This scene is in many ways a mirror image of the one described above, but here the composition is enriched by the addition of a third centaur to the right of Herakles. In the middle, the hero is shown wearing his lion skin and holding his club in his right hand. He extends his left arm to grab at his opponent's hair while raising the club in his right hand above and behind his head, preparing to strike. His right leg is bent over the back of his opponent's equine trunk, which has already been forced to the ground. This centaur has already been subdued, for his hands are tied behind his back, the latter shown in three-quarter view. The pathos of the centaur is evident in his head, which features a gaping mouth,

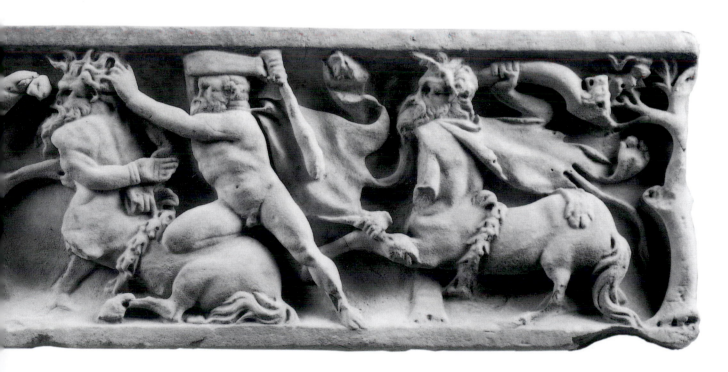

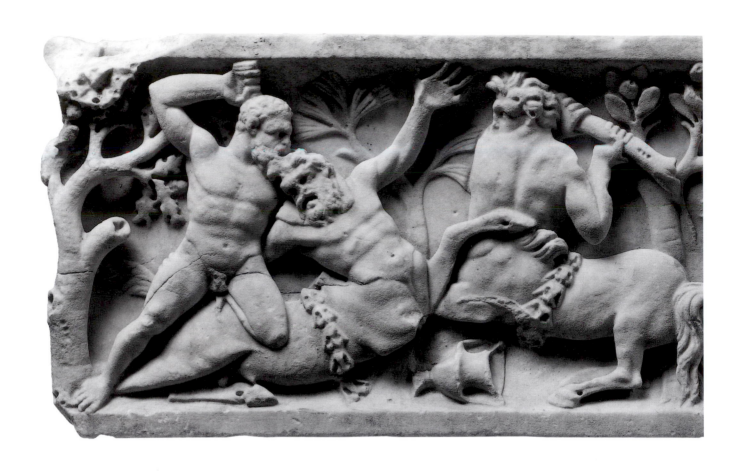

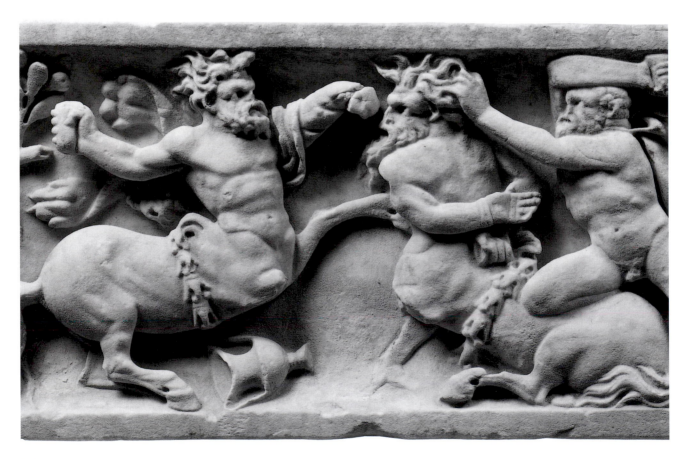

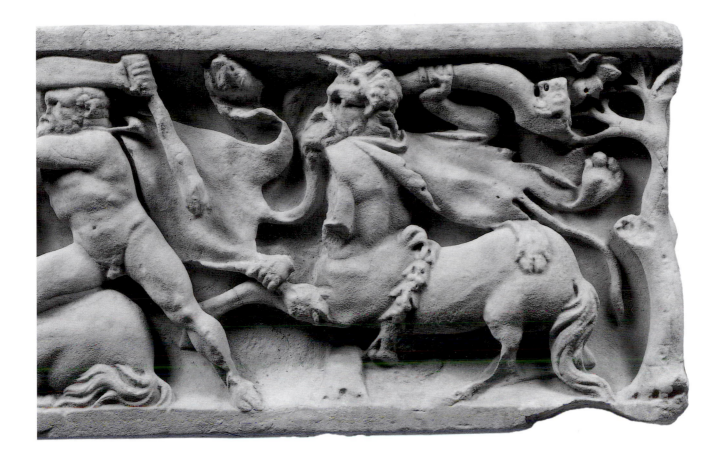

deep-set eyes, a furrowed forehead, and long wavy hair and beard. To the left, an agitated centaur rushes to the rescue of his peer. He holds a stone in his right hand and has a panther skin draped around his extended right arm. His equine body is shown in profile, but his finely muscled torso is turned in three-quarter view as he rears back to throw the stone at Herakles. The propulsive force of his gesture is underlined by his raised forelegs, his long wavy hair, and the panther skin wrapped around his left arm, its head and paws fluttering behind his back. The overturned kantharos on the ground below his trunk contributes to the sense of violent action.

The centaur to the right of Herakles is shown in profile view. With his left hand, he grabs Herakles' billowing lion skin, and with his right hand raises a table leg topped with a leonine head, ready to strike the hero from behind.[2] The panther skin tied around his neck flutters behind him. In the background, below the centaur's chest, is the stump of a tree, rendered in low relief.

Left side panel: In a much quieter scene, two sober centaurs walk briskly to the right, apparently engaged in conversation. They are framed by a pine tree on the left and, on the right, by the trunk of the same oak tree that stands at the left end of the front panel. Their steps are coordinated but falsely rendered, as horses cannot walk with a foreleg forward and a hind leg backward simultaneously on the same side. The centaur at left is mature, a civilized version of his peers on the front panel. This is suggested not only by his well-trimmed beard but also by his orderly hair, which is held in place by a fillet. On his left shoulder he carries a large, double-bladed axe. His torso, in three-quarter view, shows a firm musculature, quite unlike that of his youthful companion. The latter turns his head to meet the gaze of his elder, gesticulating toward him with an upraised right arm, perhaps trying to emphasize a point in an ongoing discussion. On his left shoulder he carries a thick branch or log. His unbearded face is smooth and rather plump; his long hair is secured by a fillet.

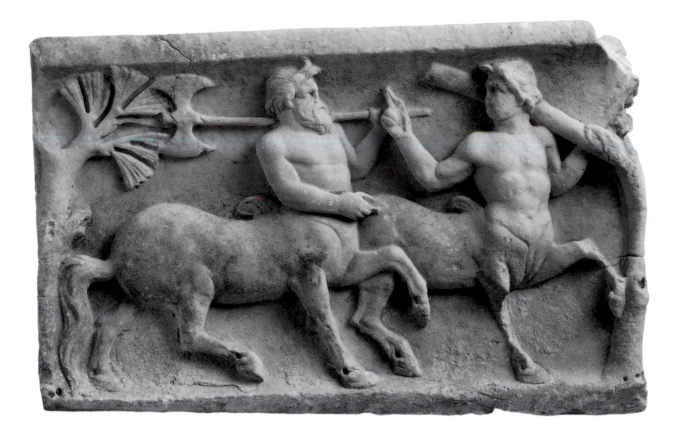

Right side panel: A young centaur is represented attacking a lioness, who half emerges from a rocky cave at left. Her adversary resembles the youthful centaur on the other end of the coffin, but this centaur is shown in violent action, his arms raised above his head to hold a stone aimed at the lioness. Below his forelegs, in low relief, is a tree trunk. At right, the scene is framed by a laurel tree, while the space above the lioness is filled by the branches of a pine tree.

The centauromachy on the front panel has been variously interpreted as an unspecified episode motivated by the funerary symbolism of centaurs (Saladino), as the fight of Herakles against the centaurs of Mt. Pholoe (Dütschke), as the struggle of Herakles against the centaur Eurytion at the wedding of the daughter of King Dexamenos at Olenos in the western Peloponnese (Robert), and as a lost myth about the taming of the centaurs by Herakles (Sengelin). That the iconographic theme cannot have been unspecified is indicated by its unconventional character, its unparalleled usage on a child's sarcophagus, and its richness of attributive elements. Even if

the trees indicate that the fight takes place in a rustic environment, such as Mt. Pholoe, the presence of objects pertinent to the furnishings of a household, such as the kantharoi and the table leg, suggest the proximity of the domestic realm. Moreover, the garlands borne by the centaurs' equine bodies point to a festive event during which wine was consumed in the kantharoi shown overturned on the ground.[3] It is, therefore, reasonable to accept Robert's identification of this episode as the struggle of Herakles against the centaurs at Olenos: during the wedding the centaur Eurytion attempts to rape the bride and Herakles intervenes to save the day.[4] The core theme of this story is in accordance with that of the Thessalian centauromachy: a wedding occasions the attempted rape of the bride and her attendants. The same theme also underlies the struggle of Herakles against Nessos (the centaur attempts to rape the bride of Herakles), but also other Herculean episodes attested only in classical vase-painting.[5] Articulate as it is in its combination of pathos and salvation, this theme could provide a metaphor for death celebrated as a wedding, which would be appropriate in this particular context,

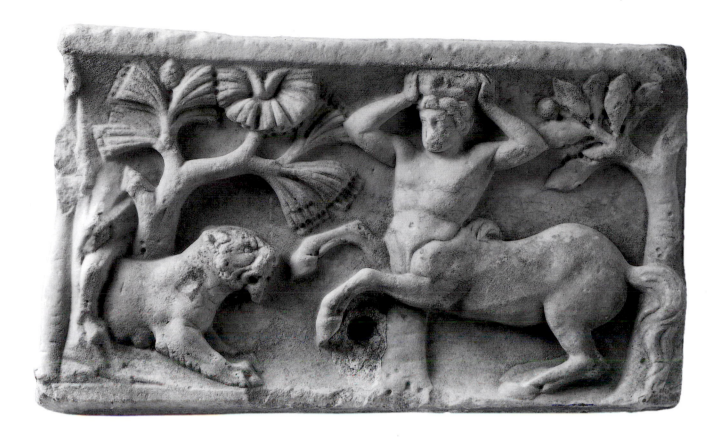

if we surmise that the dead in this sarcophagus was a young, unwedded female.[6]

In contrast to the representation of the Twelve Labors, Herculean centauromachies rarely appear on Roman sarcophagi from Italic workshops.[7] The episode at Olenos has been securely identified on a sarcophagus formerly in the Palazzo Salviati al Corso, Rome,[8] which depicted the moment of the rape in combination with the ensuing struggle. Two more sarcophagi (Robert nos. 132 and 133) feature the same episode. These concentrate only on the fighting, which involves other protagonists besides Herakles. The Princeton sarcophagus is unique in that it depicts Herakles as the sole opponent of the centaurs.[9] Herakles and the centaurs on the front panel are presented in conventional types. The type of the aged-yet-vigorous hero was common in Greece from the fourth century B.C. onward, while certain characteristics of the centaurs, such as the masklike faces and the little pseudo-mane at the base of the spine, can be traced back to the Classical period.[10] With the exception of the centaur with the table leg, the two fighting scenes are so arranged that each protagonist

in the scene at left mirrors a corresponding one in the scene to the right. Robert sought to explain this symmetrical composition by surmising that it copies decorative patterns on Roman silver plate. Interestingly enough, the fighting motifs on the Princeton sarcophagus, which are also found on other sarcophagi as well, find their closest parallels on Roman silver plate and ceramic terra sigillata. For example, the fighting schema of Herakles and the centaur to the left is nearly identical to that on a silver jug from Pompeii in Munich.[11] Likewise the fighting motif to the right appears on Arretine pottery.[12] It repeats the same schema of Herakles (who, however, is here shown grabbing his opponent's hair) but substitutes a centaur seen from behind with arms tied behind his back for the struggling, gesticulating centaur in the scene to the left.[13] Both versions of this essential schema emphasize the suppression of the bestial nature of the centaurs, and they undoubtedly echo the influence on Roman art of fifth-century Greek prototypes: the scene to the left repeats with some variation the fighting motif of the south metope II of the Parthenon or that on the slab H4–524 of the Bassae

frieze;[14] likewise, the scene to the right reflects a similar motif on the slab H7–526 of the Bassae frieze.[15]

The peaceful scene on the left panel of the sarcophagus lacks close parallels, but its constituent elements are in accordance with the visual narratives of centaurs' lives in Roman art. Paired centaurs, usually an old and a young one, often appear in Greek and Roman art, but the precise significance of this combination now eludes us.[16] The club and the double axe in their hands allude to the wild habitat of these composite monsters since elsewhere they are used as weapons against wild beasts such as lions.[17] Thus, the confrontation of a youthful centaur with a lioness in the opposite side panel is thematically associated with the pair of tame centaurs on the left panel.[18] In the former, however, the youthful centaur is ready to launch a stone against his opponent. Centaurs fighting against wild beasts, usually lions, are frequent in Roman art;[19] often their weapon is a stone or boulder.[20] When this theme is used in funerary contexts, such as the stucco reliefs on the vaults of the Tomb of the Pancratii in Via Latina outside Rome, or on numerous Roman sarcophagi,[21] it is laden with a particular symbolism.[22] The confrontation of the young centaur with a lion, a symbol of death, conjures up the theme of struggle against premature death, which is also prevalent in the Herculean iconography on the front panel.

The distinctly classicizing character of the component motifs on the front panel is also evident in the style and composition of the relief, which is imbued with the rhythm, balance, and clarity of a classical frieze. The drill was used with moderation, mainly for the rendering of the hair and some facial details of the centaurs, where the sculptor of the front panel is at his best: note, for example, the effective combination of bestiality, pain, and surrender in the head of the centaur with hands tied behind his back. The classicizing elements on the Princeton sarcophagus certainly reflect the culture, taste, and sensitivities of a learned and cultivated client, probably one living in the fifth decade of the second century A.D.

NP

BIBLIOGRAPHY

Dütschke 1875, 146–48, no. 349.
Robert 1897, 157–58, no. 135.
Capecchi et al. 1980, 29–32, no. 10 (V. Saladino).
LIMC 8:713–14, no. 423a (illus.), s.v. Kentauroi and Kentaurides (T. Sengelin).
Huskinson 1996, 27, cat. no. 2.8.

NOTES

1. This fragmentary sarcophagus has been known since the sixteenth century, when it belonged to the Doni family. Around 1750 it was sold to Bindo Simone Peruzzi, of Florence, and at some point in the late nineteenth century it was sold again to the Florentine dealer Bardini. According to Saladino, a plaster cast of the front panel is still in the Palazzo Peruzzi in Florence. Its location thereafter was unknown to scholars until its rediscovery in the 1990s, in a Connecticut garden.

2. Legs with leonine heads usually belonged to three-legged tables, in either bronze or marble, which were used in banquets. For first-century table legs of this type in marble, see Budde and Nicholls 1967, no. 181; Spinazzola 1928, T. 35. For a bronze three-legged table with leonine feet, see Kleiner and Matheson 1996, no. 88.

3. These garlands are composed of stylized ivy leaves. They are usually worn by centaurs pulling the chariot of Dionysos in triumphal processions of the god and his thiasos on Roman sarcophagi; see, e.g., Matz 1968, no. 59, pls. 24, 69. Garlanded centaurs in this manner appear as early as the fourth century B.C. on South Italian (Campanian and Paestan) vases; see Schauenburg 1976/77, 31, fig. 25.

4. Bacchylides fr. 44; Diodorus 4.33; Apollodorus, Bibliotheca 2 (91) 5.5; Hyginus, Fabulae, no. 33.

5. Brommer 1984, 58–57; Matheson 1996, 217–19; LIMC 3:359–61, s.v. Deianeira II (R. Vollkommer).

6. On the chthonic character of the centaurs in Greece, Rome, and Etruria, see Fittschen 1969, 109–11. He associates the chthonic character of centaurs with the equine part of their body. In Virgil, Aeneid 6.285–89, centaurs are pictured along with other composite monsters as guardians of the entrance to the Underworld (cf. Statius, Thebais 4.533–35; Silvae 5.3. 279–81). The rape of women by centaurs is prevalent in Etruscan art (LIMC 8:725, pl. 488, nos. 49–53, s.v. Kentauroi

in Etruria [C. Weber-Lehman]), and Roman art (*LIMC* 8:713–14, nos. 406, 407, 424 [illus.], s.v. Kentauroi and Kentaurides [T. Sengelin]). On funerals celebrated as weddings in Greek antiquity, see Alexiou 1974, 120–22. On the role of mythological imagery in funereal commemoration, see Koortbojian 1995, 114–26, and Huskinson 1996, 101–4.

7. Jongste (1992) lists thirty-two examples (cat. A1–H2) with representations of the Twelve Labors. Equally rare is the Thessalian centauromachy (two examples cited by Koch and Sichtermann 1982, 155–56), which was, however, widely used on Attic sarcophagi (Koch and Sichtermann 1982, 398). Herakles engaged in battle with one centaur appears on the side panels of two sarcophagi (Robert 1897, nos. 112 and 116), the front panels of which depict the Labors of Herakles (Jongste 1992, cat. B2 and B9). The left half of the front panel of the Princeton sarcophagus is closely paralleled in terms of both composition and individual motifs by a sarcophagus in the Art Institute of Chicago (1984.1338); see Berge 1989, 42–45. The authenticity of this piece is not accepted by Sengelin in *LIMC* 8:714, no. 424.

8. *ASR* 3.1: no. 136; *LIMC* 8:714, no. 424.

9. Robert thought that the figure in the left-hand group is Iolaus. This cannot be the case, however, since the iconographic type used for this figure is identical with Herakles in the group to the right; see Saladino, in Capecchi et al. 1980, 30.

10. Herakles: *LIMC* 4:791, s.v. Herakles (O. Palagia). Centaurs: Schiffler 1976, 46 and passim.

11. Künzl 1975, 62–80, pl. 16. The same motif appears on a bronze medallion of Antoninus Pius and M. Aurelius, dated to ca. 140 A.D.: *LIMC* 8: 713, pl. 465, no. 413a; Toynbee 1944, pl. xxv.3.

12. Dragendorff 1895/96, T. 5, nos. 30, 31; Dragendorff and Watzinger 1948, 97–99, Types 1 and 1a, pl. 10, nos. 135, 136; see also *LIMC* 8:712, no. 400; 713, no. 415. For the same motif on Roman gems, see *LIMC* 8:713, pl. 465, nos. 411a, 414a.

13. Centaurs with hands tied together behind their back appear in the late fifth century B.C.: in this manner they are shown harnessed in the chariot of Herakles on a red-figure oinochoe (Louvre N 3408; *LIMC* 8:696, pl. 451, no. 299), a motif also found on terra sigillata (*LIMC* 8:718, pl. 478, no. 479a, s.v. Herakles-Omphale). For centaurs with hands tied behind their back in other contexts, see Pollitt 1986, 133–35 (on the famous pair from Tivoli) and *LIMC* 8:714, pl. 466, no. 425 (an oscillum from Pompeii). On the motif of the centaurs with tied arms and its development in Greek and Roman art, see also Saladino 1998, 379–95, esp. 382–84.

14. Parthenon: Brommer 1967, T. 165–67; Bassae: Hofkes-Brukker and Mallwitz 1975, 55. Note that the motif of the centaur with the branch first appears as such in the west frieze of the Hephaisteion: see Bockelberg 1979, pl. 40a.

15. Hofkes-Brukker and Mallwitz 1975, 60.

16. Pairs of an old and a young centaur often pull the chariot of Dionysos on Dionysiac sarcophagi. On the pair from the Villa Adriana in Tivoli see Pollitt 1986, 133–35. Pairs of centaurs, symmetrically arranged, fight against lions on Roman sarcophagi: *LIMC* 8:715, pl. 469, no. 436a-d. See also Koch and Sichtermann 1982, pl. 280, for a pair of heraldic centaurs (young and old) flanking a medallion centrally placed on the front panel of a sarcophagus.

17. Two centaurs fight against lions with these weapons on a sarcophagus in Thessaloniki: *LIMC* 8:715, no. 436.

18. It is possible that the subject of the conversation between the two centaurs on the left panel is the episode illustrated on the right side panel. This is indicated by the young centaur's gesture, the oratorical character of which was well known in antiquity; see, e.g., Apuleius, *Asinus Aureus* 2.21 and Fulgentius, *Virgiliana Continentia* 143.

19. *LIMC* 8:715, pls. 467–69, nos. 430–36.

20. *LIMC* 8:715, pl. 468, no. 431b: centaur ready to attack a tiger with a boulder held above his head (mosaic from Villa Adriana, in Berlin); cf. the same motif on the sarcophagus *LIMC* 8:715, pl. 469, no. 436b.

21. Tomb of the Pancratii: *MAAR* 4 (1924): 73–78, pls. 25–35; Roman sarcophagi: *LIMC* 8:715, pl. 469, no. 436a–e.

22. See Cumont 1942, 455 on the lion as a representation of "la Mort hostile" or "l'Esprit du Mal."

42.

FRONT PANEL OF A SARCOPHAGUS WITH SCENES FROM THE CHILDHOOD OF DIONYSOS

Early Antonine, ca. A.D. 140–160
Provenance: purchased in Rome, formerly in the collections of
Giorgio Sangiorgi and Mario Barsanti; possibly from Tuscany[1]
Material: fine-grained, opaque white marble with faint dark
veining, probably Proconnesian
Dimensions: h. 38.5 cm., l. 150.5 cm.,[2] th. ca. 5 cm.
(top molding) to ca. 2 cm. (lower right), th. of floor ca. 4.5 cm.
Museum purchase, John Maclean Magie and Gertrude Magie
Fund (y1949-110)

CONDITION: *The right end of the panel has been sawed off.*
Some areas have been broken away: the left hand of the Dionysos
herm, the lower edge of the bowl in the central scene, the lower
left leg of the figure seated at the left of the right-hand group,
and the forearm of the figure standing at the left of that group.
A crack 1.05 m. in length, partly patched with plaster, runs from
the right edge along the bottom of the panel. Breaks between the
satyr and the tree at the left, and beneath the leftmost figure of
the central scene have been repaired with plaster. The features
in highest relief, particularly faces and hair, are weathered and
chipped. The upper lip and the base of the panel are chipped
and broken away in several places.

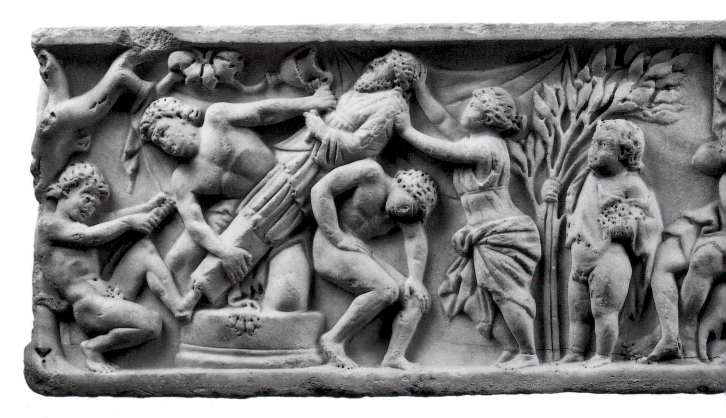

The sarcophagus has been identified as that of a child, primarily on the basis of its size, but also because the same themes are found on a small group of other mid-second-century children's sarcophagi.[3] Both J. Huskinson and S. Dimas conclude, however, that the upper limit of length for children's sarcophagi falls in the range of 1.6 to 1.7 m.[4] That this example was probably originally about 1.9 m. long (see n. 2 below) suggests that it was instead the sarcophagus of an adult.

The present relief is the almost complete front of a sarcophagus whose lateral sides are preserved at Woburn Abbey and Arezzo. The discovery that the right lateral side, in Woburn Abbey, originally belonged to this piece occurred when the relief was acquired by The Art Museum.[5] A few years later, consideration of the dimensions and style made it possible to identify the left lateral side in Arezzo as likewise having belonged to the same sarcophagus.[6] The front side originally included four scenes, of which the scene on the right-hand end is now missing, although part of a figure of Pan still survives against the background of a stretched cloth, in front of which some event which can now no longer be reconstructed must have transpired. It may be that the forest god was originally depicted dancing, similar to the way he is shown on a fragment of a lid in the Vatican, which depicts the birth of Dionysos.[7] To the left of this is a depiction of the child Dionysos, together with his attributes: four persons are caring for the boy, who stands on top of a stony outcrop and already wears a short *nebris* (fawn skin). With his right hand he leans against the head of a satyr, who sits on a boulder and occupies himself with the little god's *cothurni* (boots). A nymph binds a ribbon around his head while he accepts a twig of narthex[8] from a seated Silenos. This Silenos is assisted by a second nymph, who is shown bending forward from behind him and is occupied with the task of adorning the twig with a decorative band.

In what is now the middle scene, the structure seems to be similar; the attention of the participants is focused upon a central point: two satyrs are seated, facing in opposite directions, atop a boulder upon

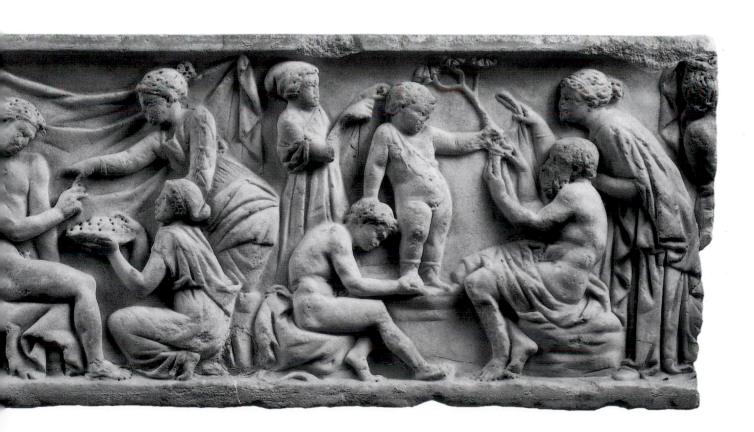

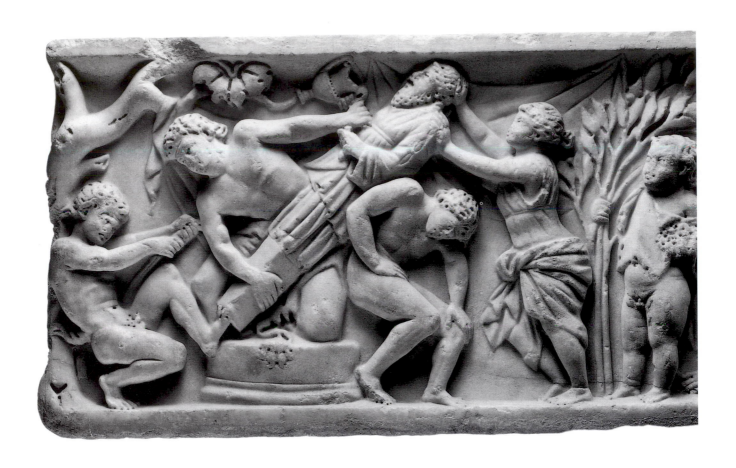

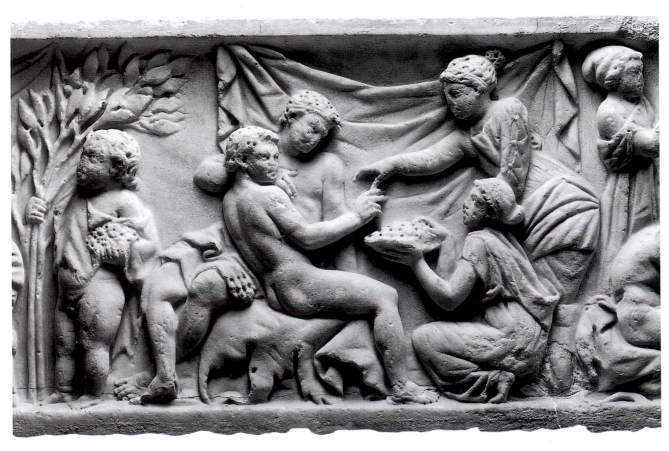

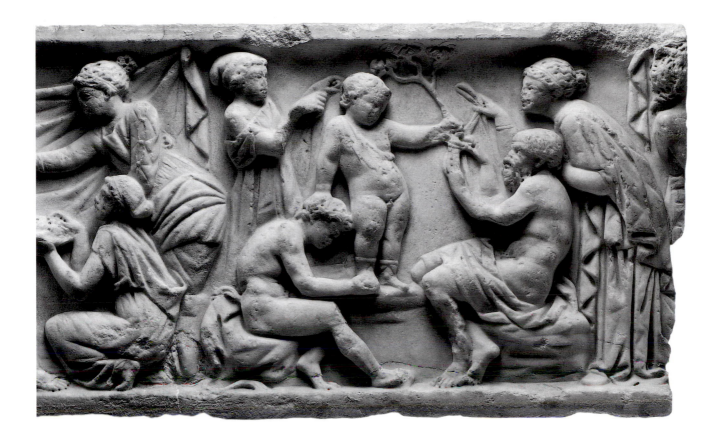

which a pelt[9] has been spread. The hindmost satyr places his right forearm on the shoulder of his companion, who supports himself on his left hand and leans lightly against him;[10] the near satyr stretches his right hand toward a standing woman, who offers him an object which has not survived. A second girl crouches in front of her, offering a bowl to the two satyrs[11] while she removes something from it with her right hand. Depending on one's interpretation of this scene, the standing woman has variously been supposed to have held either a laurel twig, some fruit, or pastry in her hand. If she in fact held a laurel twig, this would indicate that the scene depicted a cultic event that preceded the initiation into the Dionysian mysteries.[12] If, however, she merely offered fruit or baked goods, then this scene would represent "nothing more than an image of the mood at a Dionysian festival."[13] The profane interpretation is supported not only by the atmosphere captured in the scene, but also by a (now lost) fragmentary repetition in which survive the torsos of the two satyrs and, behind their heads, a similarly broad-bellied vessel like the one on the sarcophagus's right-hand lateral side in Woburn

Abbey.[14] Neither this fragment nor the fact that the two women in the scene, divorced from the context, appear again on a sarcophagus in the Capitoline Museum in Rome[15] offers any help in reconstructing the event depicted. Here, too, the hand of the standing woman is empty.[16] The position of the hand with its down-turned palm and widely spread thumb suggests a connection with the process of pouring liquid into a drinking vessel,[17] but on the Princeton relief both the giving figure and the recipient seem never to have held any carved marble vessel in their hands. It has been suggested that some attributes may have been rendered in paint,[18] but it is likewise conceivable that gilt plaster may have been added as attachments.[19]

The most impressive scene on the front side of the sarcophagus is the setting up of a bearded cult statue, depicted on the left-hand end. Three satyrs are occupied with the task of erecting the terminus of a bearded Dionysos[20] atop a round base, and even a nymph[21] helps them by supporting the shoulder and head of the god with her hands. The left-hand satyr is squatting and pulls with all his strength on

a rope that must be imagined as wrapped around the chest of the cult statue. Only a small portion of this is actually carved alongside the left thigh of the young satyr, but its (now lost) continuation can be unambiguously reconstructed by reference to a lamp on which this scene is repeated.[22] The sculptor obviously avoided carving from marble the more difficult, projecting portions; here again it is conceivable that plaster additions may have been added. The same is true of the object in the god's left hand: the surviving fragments do not suffice to indicate what its identity may have been, nor does the repetition on the lamp offer sufficient clues for a positive identification.[23] Whatever it was, it must have covered the left hand of the rearmost satyr who tugs energetically on the rope in front of the chest of the terminus while his right hand grasps the lower part of the shaft. Finally, another satyr assists in this difficult operation by pressing his back against the cult sculpture.[24]

The arrangement of the figures around a central point represents the same compositional principle that has been suggested for the other two groups. This symmetrical structure is disturbed only by the childlike figure with long twigs of laurel in its right arm and fruits[25] in its left arm; L. Curtius suggested that these fruits were intended to decorate the cult sculpture.[26] E. Simon recognized that this detail was added by the Roman stonemason who carved this sarcophagus.[27] In her opinion, the comparatively oversized boy represents Dionysos, the god of the mysteries, as a child who observes the erection of his own herm. This interpretation has rightly been contradicted.[28] Relying on the iconographic relationship between the boy and seasonal *geniuses* observed by F. Matz, H. Meyer suggested that the youth can be interpreted as "a proxy for a whole cycle of seasons indicating the perennial bliss of the reign of Dionysos."[29] Whatever the figure's precise meaning, its inclusion on the Princeton/Woburn Abbey/Arezzo sarcophagus expanded the Dionysian imagery in a certain sense, reinterpreting the underlying Dionysian cycle. It therefore must be included in the series of sarcophagi in which the influence of the individual

who commissioned them is evident, not only in the choice of the theme, but also in the details of the design, which are in accord with the ideas and wishes of the deceased.[30]

The individual images from the "life of Dionysos"[31] and/or the childhood of the god as seen on this sarcophagus are also recorded on a series of other examples from the Hadrianic–early Antonine era.[32] The composition and style support the conjecture that they are all based on a unified underlying cycle,[33] one that probably survives more completely on the Princeton/Woburn Abbey/Arezzo piece than anywhere else.[34] According to Matz, this model included at least the five scenes depicted on the components of this sarcophagus,[35] which, however, are freely combined and augmented through the addition of complementary images on other Dionysian sarcophagi. The (now lost) depiction with Pan on the right-hand end of the Princeton front side would seem to have been one example of an augmentation of this sort, because this most obviously does not belong to the original cycle.

Whereas Simon assumed that the original model for this cycle was taken from a Pergamene painted frieze dating from the late third century B.C.,[36] Matz thought of toreutic models of Ptolemaic provenance which he connected with the historical situation in Egypt during the end of the third century and the first quarter of the second century century B.C., an era when child-monarchs may have provided the basis for an analogy between god-kings and the child Dionysos.[37]

The Hellenistic model seems to have been followed first in the workshop that produced the Princeton/Woburn Abbey/Arezzo sarcophagus, which Matz even supposes to be the archetype of this series.[38] The same workshop seems to have produced the fragment in Zagreb[39] that repeats the scene preserved on the right lateral side of the sarcophagus, now in Woburn Abbey, and also to have been responsible for other important Dionysian sarcophagi. All these place its activity in the late Hadrianic–early Antonine era.[40]

MF with contributions by CM

BIBLIOGRAPHY

Curtius 1946, 62–76, figs. 7, 9, 10, 11.

FA 1 (1946): 157, no. 1228.

Record 8.2 (1949): 12.

Van Hoorn 1951, 28.

Jones 1954a, 242 (illus.).

Janson 1963, 216 n. 7.

Held 1959, vol. 1, 129, fig. 39.

Vermeule and Bothmer 1959, 347–48.

Jones 1960, 62–63 (illus.).

Bieber 1961a, 26–27, fig. 93.

Simon 1961, 161 n. 130.

Simon 1962, 136–58, pls. 43.1, 44.2, 45.

Vermeule 1962, 105, no. 1.

Matz 1963, 54 no. 9, 60–69 (1444–53), pl. 38, top.

Turcan 1965, 118–19.

Helbig⁴ 2:220 (B. Andreae).

Turcan 1966, 51–52, 164, 167–68, 357 no. 1-B-5, 381, 384, 407, 412–18, 524.

"The Art Museum at Princeton University: A Selection from the Collections," *Art Journal* 26 (1967): 172, fig. 2.

Martin 1969, 49, fig. 34.

Matz 1969, 354–56, no. 202, pls. 218–19.

Stuveras 1969, 22–24, fig. 134.

Copies 1974, 98–101, fig. 1 (S. Muenzer).

Matz 1975, 519, no. 202.

Kerényi 1976, 379–81, fig. 140.

Sturgeon 1977, 36 n. 20, 52, no. 5.

Sheard 1978, no. 15 (unpaginated).

Schefold 1981, 40–41, fig. 42.

Vermeule 1981, 242, no. 202.

Bocci Pacini and Nocentini Sbolci 1983, 42.

Chiarlo 1983, 127, 128, fig. 8.

LIMC 3:351, no. 11, pl. 262 (left half), s.v. Daphnis (G. Berger-Doer).

LIMC 3:554, 565, no. 178 (erroneously numbered 177), s.v. Dionysos/Bacchus (C. Gasparri).

Selections 1986, 42 (illus.).

White 1987, 90–91, pl. 104.

Angelicoussis 1992, 96.

Meyer 1993, 51–53, fig. 1.

Herdejürgen 1996, 51–53, 58, 64, 229, fig. 3.

Huskinson 1996, 30–31, 33 no. 3.15, 101.

Dimas 1998, 71, 75 n. 400, 76, 225 no. 18.

LIMC 8:1123, no. 145, pl. 769 (detail), s.v. Silenoi (E. Simon).

Freke and Gandy 1999, fig. 4.

NOTES

1. A Tuscan provenance for this piece is suggested by Donatello's adaptation of two of its scenes for an altar in San Lorenzo completed ca. 1465 (Janson 1963, 216 n. 7; Sheard 1978). Held (1959, 129), Martin (1969, 49), and White (1987, 90) conclude that Rubens also saw the Princeton panel, and Sheard (1978) points out that Rubens was in Florence in the autumn of 1600. The end panel now at Woburn Abbey provides a final Tuscan connection: it is documented in the Peruzzi collection in Florence as early as 1752 (Angelicoussis 1996, 96 n. 2). Matz's proposal (1969, 354) that the sarcophagus was found in Arezzo is hypothetical. The group at the far right of the Princeton sarcophagus appears on a gem inscribed with the name of Lorenzo the Magnificent and attested in a Medici inventory of 1457 (Dacos, Giuliani, and Pannuti 1973, 62, no. 34, fig. 27). L. Curtius (1944–45, 1–3) concluded that the gem was a Renaissance creation and that the gem carver had misunderstood the scene on a sarcophagus. Curtius cites the example in the Capitoline (Matz 1969, no. 200) as a possible model, but that sarcophagus was in Nepi until 1740 (Helbig⁴ 218) and was thus not likely to have been seen by fifteenth-century Tuscan artists. The Medici gem was long known only in a gesso copy (now in the Deutsches Archäologisches Institut in Rome) and in several manuscript drawings, but it is now in the Beverley collection at Alnwick Castle, Northumberland (Yuen 1997, 140–43, 153–54 nn. 24 and 26, figs. 12 and 13.33). D. Scarisbrick, who has examined the Beverley gem, sees no reason to doubt that it is ancient (personal communication). The Medici gem therefore does not contribute to the Tuscan provenance of the Princeton sarcophagus.

2. The central pin, which held the lid in place, is 0.094 m. from the left side of the panel, suggesting that the original length was about 1.9 m.

3. Huskinson 1996, 33, cat. nos. 3.12–3.15; Dimas 1998, 225, cat nos. 16–19.

4. Huskinson 1996, 2; Dimas 1998, 12.

5. Jones 1954a, 242; see Vermeule and Bothmer 1959, 348, pl. 85, illus. 36; Matz 1969, 356, no. 202 a. The Woburn Abbey relief shows two nymphs bathing the infant god.

6. Matz 1969, 356–57, no. 202 b. Which is the left and which the right lateral side is made clear by the tree on the relief in Woburn Abbey; if this tree belonged on the left side of the sarcophagus, it would have stood beside the one on the front side.

7. Matz 1969, 347–48, no. 195, pl. 212, 1. The assumption that this fourth scene must have been narrower is based on the presumption that this is a child's sarcophagus; Simon (1962, 138) noted that what survives is already uncommonly long.

8. Recognized as such by M. Bieber (1917, 17); see also Matz 1969, 352.

9. According to E. Simon (1962, 141), it is the pelt of a ram which was used in purification ceremonies. Her interpretation of the satyr in the foreground as a youthful Dionysos (suggested by Curtius 1946, 68–69) was contradicted by Matz (1969, 355), who called attention to the repetition of the figure mentioned in n. 14 below.

10. The arm does not reach "around the body of the other," as assumed by Matz (1969, 355).

11. According to Matz (1969, 355–56), fruits or baked goods could be inside. The latter commodity was first suggested by Simon (1962, 140), who correctly recognized that the bowl held by the crouching female figure does not contain grapes, thus precluding the interpretation of the scene as a "blessing of the wine," as had been suggested by Curtius (1946, 68–70).

12. Simon 1962, 140–41.

13. Matz 1969, 355–56; see also Matz 1963, 62–63.

14. Matz 1969, 357, no. 204, pl. 209, 4.

15. Matz 1969, 351–53, no. 200, pls. 214–215.1.

16. In this case, the empty hand could be explained by assuming that the nymph was separated from the original context; the bowl held by the crouching female figures contains fruits and a cake. See Matz 1969, 353.

17. For example, cf. the frieze in the Villa of the Mysteries: Simon 1961, 121, fig. 7.

18. Simon 1962, 140, 143; for this subject in general, see Koch and Sichtermann 1982, 86–88.

19. For more on this subject, see Gütschow 1938, 213–22.

20. For more about this, see Curtius 1946, 71–72; Matz 1963, 44–50, 54–59.

21. For an interpretation of the figure, see Curtius 1946, 70.

22. Curtius 1946, 70; Simon 1962, 143, 155, pl. 44, 1. Matz (1969, 355) echoes Simon's conjecture that the rope may have been wrapped around the back of the satyr, but

the depiction on the lamp ought to be given greater priority on this point. Bellori's drawing of this lamp (P. Santi Bartoli and J. P. Bellori, *Le antiche lucerne sepolcrali figurate* II [1691], pl. 28) obviously served as the model for a visiting card from the late seventeenth or early eighteenth century in The Art Museum, Princeton: see Meyer 1993, 53 n. 16, illus. 2, and Muenzer 1974, 99, fig. 2.

23. Curtius (1946, 71–72) and Simon (1962, 143) suppose it may have been a twig from a grapevine, but Matz (1969, 355) believes it was a grapevine.

24. This figure is of interest for the ancient afterlife of the Belvedere torso, to be discussed by H. Meyer in a forthcoming article.

25. For more about this, see Meyer 1993, 51–52.

26. Curtius 1946, 72.

27. Simon 1962, 154–55; see also 138–39. Matz (1969, 355) also agrees.

28. Matz 1963, 61; see also Matz 1969, 355. The young satyr on a sarcophagus in Naples (Matz 1969, 323–35, no. 176, pls. 198–99), which Matz mentions in support of his interpretation of this figure, differs in its stance, clothing, and attributes. Hackländer (1996, 52 n. 165) returns to Simon's interpretation, without addressing Meyer's comments (Meyer 1993, 53 n.16.).

29. Meyer 1993, 52.

30. On this phenomenon, in addition to the literature referred to by Meyer 1993, n. 27, see also Brilliant 1992; Fittschen 1992; Blome 1992; and Meyer (forthcoming).

31. So-called by Curtius 1946, 73.

32. Matz 1969, 345–59, nos. 200–206.

33. So Curtius 1946, 73–; see Simon 1961, 161–62; Simon 1962, 154, 157; Matz 1963, 69; Matz 1969, 346–47.

34. Matz 1969, 346.

35. Simon (1962, 154–55) assigns to the original only the three scenes on the Princeton relief.

36. Simon 1962, 154, 157; see also Simon 1961, 162.

37. Matz 1969, 346–47; Matz 1963, 69. On the relationship of the Ptolemies to Dionysos, see Fraser 1972, 201–7.

38. Matz 1969, 346–47.

39. Matz 1969, 357, no. 203, pl. 213, 1.

40. Matz 1969, 347; see also 267, no. 129.

43.
FRAGMENT OF A PHRYGIAN COLUMN-SARCOPHAGUS

Antonine, ca. A.D. 160–165
Provenance: Sardis, Turkey
Material: fine-grained, fairly translucent white marble
(Dokimeion)[1]
Dimensions: h. 22.6 cm., w. 57.7 cm., th. 16.3 cm.
Gift of the Sardis Excavation Society (y1929-62)

CONDITION: *Most of the uppermost arcade molding is broken away, and only two small stumps of the spandrel decoration survive at the right. Almost all of the projecting surfaces are chipped, and the stone has a tan incrustation. The raised flange on the top is battered along its entire length.*

The arcade is decorated with four moldings: a Lesbian cymatium at the bottom, then egg-and-dart, dentil frieze, and finally a palmette frieze at the top; the last survives only under the mostly missing pediment at the right. A narrow strut connects the ovolos of the egg-and-dart to the fillet below. Three of the dentils on the right side of the arch were never cut free. Just to the left of the arch's center is the broken attachment

for the head of a missing figure. The area under the arch, which on some examples is decorated with a shell motif, is plain and flat. To the right are the projecting impost block and moldings which crowned a column. The right face of this projecting cornice is decorated with three fascias. Running along the front of the top surface is a claw-chiseled ledge (d. 7.8 cm.), on which the lid rested. Behind this is a raised flange (d. ca. 4.8 cm.) which held the lid securely in place.[2]

The Princeton fragment is one of the earliest examples of the most common type of Asiatic columnar sarcophagus, with elaborately decorated arcades framing figures on the body. The missing lid would have had the form of a bed (*kline*) with reclining

portrait(s) of the deceased.[3] The form and style of the moldings of this piece place it near the beginning of the series, close to an example in Melfi, which is dated by the portrait of its lid figure to ca. A.D. 165–170.[4] The drill work on the entablature is deep (almost 2 cm. in places), producing a very black-and-white effect, and the Lesbian leaf pattern is schematic.

The figures beneath the arches of these column-sarcophagi, often placed off-center as here, include a wide range of divinities and mythological figures as well as more generic types, some of which must have been meant to represent the deceased.[5] The forms of the arcades and their decoration seem to have been based, however loosely, on large-scale Anatolian architecture of roughly the same period.[6] This combination must have created the striking impression of gods and heroes posing in front of familiar buildings.

The spandrel figures are usually animals, fantastic creatures, or vignettes such as a lion devouring a stag or an infant playing with a panther.[7] The two oblique stumps on the spandrel of the Princeton piece do not correspond to any of these types. They resemble the attachment points for wings of a sphinx, for example, but there is no trace of a body below: the area beneath the broken stubs is completely flat-chiseled.

Asiatic column-sarcophagi of this type were produced by workshops in the vicinity of the marble quarries at Dokimeion.[8] The Princeton piece is just one of a number of examples that have been found at Sardis, hardly surprising since the site lies on the ancient route leading from Dokimeion to the coast at Smyrna (modern İzmir), whence the sarcophagi may have been shipped to the west.[9] CM

BIBLIOGRAPHY
Lawrence 1928, 428, n. 1, fig. 10.
Lawrence 1951, 146–47, fig. 33.
Wiegartz 1965, 33, 47, 168.
Ferrari 1966, 40 (Sardis C).
Waelkens 1982, 74, no. 19.

NOTES

1. This variety of marble was extracted from quarries in the vicinity of the ancient site of Dokimeion, near modern İscehisar in the region of Afyon in western Anatolia. On the varieties of marble from these quarries, see Röder 1971, 255–56; the marble of the Princeton piece falls somewhere between the specimens illustrated in his pl. 2.4 and 2.6. On the use of this marble for sarcophagi, see Waelkens 1986, 661–68.

2. This flange has a very shallow rectangular recess, measuring ca. 3.2 x 2.5 cm., about 3.5 cm. from the right edge. This may be the base of a mortise for a pin that further secured the lid.

3. Asiatic *kline* sarcophagus lids have been catalogued and studied by V. M. Strocka (1971, 62–86).

4. On the date of the Melfi sarcophagus, which is now in the Museo Archeologico Nazionale at Melfi, see Wiegartz 1965, 27–29, 165; Waelkens 1982, 68–69; and Ghiandoni 1995, 10–12, suggesting that the head was modeled quite closely on a portrait of Faustina the Younger (d. A.D. 175).

5. Discussed by Wiegartz 1965, 119–39; for off-center figures with heads that overlap arch moldings, see his pls. 16i, 18b, 18c, 18g, 19c, 19g, 23a.

6. For a recent examination of the architectural sources of the arcades of the Melfi sarcophagus, which is quite close in both date and style to the Princeton piece, see Ghiandoni 1995, 14–17.

7. For some examples, see Walker 1990, 53, pls. 28, 29 (lion and stag, infant [Dionysos?] and panther); Ghiandoni 1995, 14, figs. 26, 32, 38, 52–54 (dolphins, lions, and fantastic sea creatures); Bothmer 1990, 232–34, no. 169 (sphinxes and sea monsters).

8. See n. 1 above. Waelkens (1982, 105–23) has demonstrated conclusively that the workshops were near Dokimeion.

9. For other examples found at Sardis, see Hanfmann and Ramage 1978, 134–37, nos. 180–87, figs. 328–37 (some of these are now in the museum at Manisa; others are in storerooms at the site); Waelkens 1982, 82 no. 77 (Istanbul 4027); and Baratte and Metzger 1985, 286–87, no. 189 (Louvre MA 3199). For the ancient road, see Waelkens 1982, pl. 31. Ferrari (1966, 77) cites nine examples of this type found at İzmir (as of 1966) as evidence that it was the shipping point.

44.
SARCOPHAGUS WITH SEA CREATURES

Antonine, third quarter of the second century A.D.
Provenance: probably Italy. It was in the Palazzo Colonna in Rome during the sixteenth century, then in the Palazzo Chigi, Rome, in the seventeenth century[1]
Material: Carrara (Luna) marble with a gray patina
Dimensions: l. 179 cm., h. 43 cm., d. 53 cm.
Museum purchase, Carl Otto von Kienbusch, Jr., Memorial Collection Fund (y9)

CONDITION: *Minor damage is evident on the lower edge strip on the front and on the frame of the inscription panel; restorations are found on nearly the entire upper edge strip to the left of the tablet, as well as between the right shoulder of the Triton and the face of the Nereid. The rear upper left corner and patches on the right end are also more recent additions. The box of the sarcophagus has been cut with a saw at the left and right to shorten its length, hence the crossed shields in the inset fields on the ends*

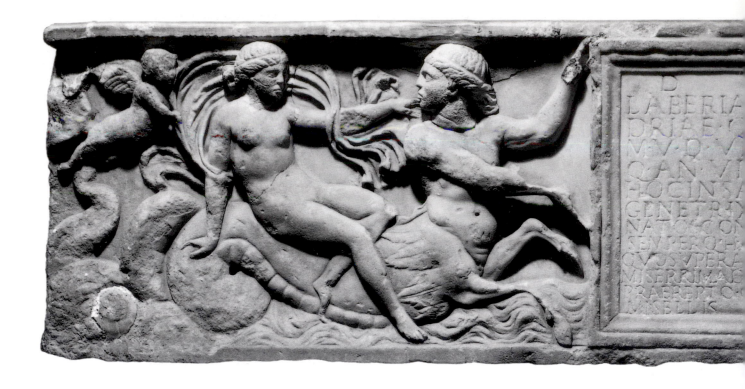

are modern. On the front side, the heads of the figures at the left are modern and the face of the Nereid at the right has been re-worked and, like the restored parts, pecked. The figure of Eros at the right has lost a large portion of its left arm, as well as its shoulder and a part of its chest; minor damage is also evident on the hands of both Tritons, on the arms and knees of the Nereids, and on the wing of the Eros at the left. A drainage hole, stopped in modern times, has been bored in the lower left corner of the coffin. The remnants of a metal pin can be seen on the rear inner wall.

INSCRIPTION:

 D M

 LABERIAE:ALEXAN

 DRIAE:QVAE:(vixit):ANN(is):X

 M(ensibus):V:D(iebus):VII:ET:SILVANO

 Q(ui):(vixit):AN(nis):VI:M(ensibus):V:D(iebus):XIIII

 HOC:IN:SARCOPHAGO

 GENETRIX:DVO:CORPORA

 NATOS:CONDIDIT:INFELIX

 SEMPERQ(ue):HABITVRA[2]:DOLOREM

 QVO(s)SVPEREATVIVET:VITANQ(ue)

 MISERRIMA DVCETCONIVGE

 PRAEREPTO:GENITORQVIBVSIPSE

 MISELLIS:

 (*CIL* VI 3, 20987)

[To the shades of Laberia Alexandria, who lived 10 years, 5 months, 7 days, and of Silvanus, who lived 6 years, 5 months, 14 days. In this sarcophagus the unhappy mother, forever to live in sorrow, laid as corpses the two children that she survives; she leads a most unhappy life, her husband gone, the father of these poor little ones.]

On the rectangular panel which fills the middle portion of the sarcophagus's front side, a grieving mother bemoans the loss of her children, ten-year-old Laberia Alexandria and six-year-old Silvanus, both of whom she arranged to have laid to rest within the stone coffin.[3] On either side of the inscription is a relief of a youthful sea-centaur, who together hold up the tablet, each turning its head to look at the Nereid seated on its back. Each Nereid has placed the fingertips of one hand on her centaur's shoulder; she supports herself by placing her other hand against the first winding of the creature's upwardly undulating tail. A figure of Eros hovers above each group, grasping the sea nymph's billowing veil. Waves are sculpted beneath each ensemble.

The interpretation of the sarcophagi with sea creatures has been the subject of lively debate among scholars.[4] Although there are no indications to suggest

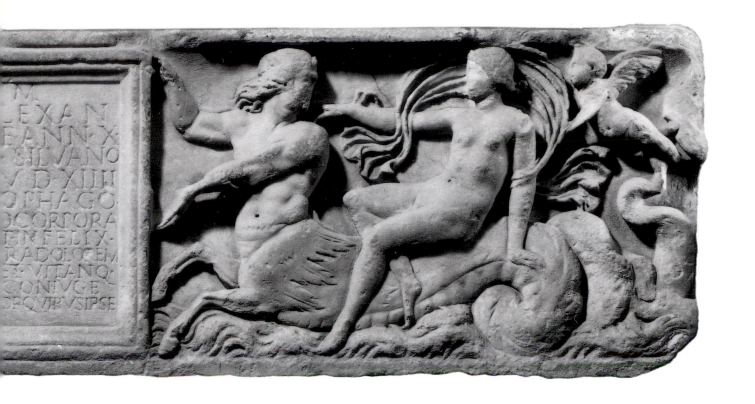

that the carvings symbolize the journey of the soul toward the Isles of the Blessed or its sojourn there,[5] neither is there any justification for the contrary position, which claims that the depictions include no symbolic references to the afterlife.[6] Another suggested interpretation, that the marine cortège expresses the hope of the deceased for a mythical "apotheosis,"[7] is not supported by the funerary poems.[8] Nor do these texts corroborate another theory—based on the observation that sarcophagi depicting this theme were preferably used for the burial of young females[9]

—that the marine cortège represents a wedding procession, which, translated to the funerary sphere, allegedly symbolized the union of the all-too-youthful deceased with Death.[10]

The iconographic evolution of this genre of sarcophagus leads from specimens carved with garlands in whose lunettes sea creatures appear, to straightforward thiasos scenes which, even before the middle of the second century, become organized around a central motif, usually a mask of Oceanus. Soon thereafter, examples with central shields appear, followed

by versions with rectangular panels.[11] Among the examples of this last-mentioned type, the composition on a sarcophagus in the Fassini Collection in Rome[12] is quite similar to the Princeton example, although the Fassini specimen lacks the figures of erotes above the Tritons' fish tails. A casket in Ostia[13] does have this feature, although here a mask of Oceanus occupies the middle portion.[14] Stylistically, however, the Princeton sarcophagus predates the one in Ostia.[15] The Princeton specimen bears strong similarities to a second one in Ostia[16] and to one in the Galleria Borghese in Rome,[17] both of which must have been carved in the Antonine era.[18] The Princeton specimen in all likelihood dates from the third quarter of the second century.[19] MF

BIBLIOGRAPHY

Bücheler 1895, 241, no. 504.
Elderkin 1925, 114 (illus.), 117.
F. Jewett Mather, Jr., *Princeton Alumni Weekly* 25 (1925), 419 (illus.).
Elderkin 1938, 229, fig. 2.
Rumpf 1939, 8, no. 23, pl, 8.
The Carl Otto von Kienbusch, Jr., Memorial Collection (exhib. cat., The Art Museum, Princeton University (Princeton 1956), no. 30.
Record 25.1–2 (1966): p. 46 (illus.).
Turcan 1966, 183, n. 6.

NOTES

1. According to Rumpf 1939, 8, no. 23. In the early years of The Art Museum, the sarcophagus was a favorite with Princeton scholars trained in the classical tradition, one of whom, Edward Forrester Sutton, Class of 1895, penned the poem "Sylvanus and Laberia," which appeared in the *Princeton Alumni Weekly* (Oct. 21, 1925, 80).
2. Erroneously given in *CIL* as *"semper subitura."*
3. For general information about epitaphs for people who died young, see Lattimore 1962, 184–87.
4. See Brandenburg 1967, 195–245; Sichtermann 1970a, 224–38 and 1970b, 214–41; Engemann 1973, 60–69.
5. Engemann 1973, 60–62.
6. Engemann 1973, 62–65.
7. Engemann 1973, 63–65.
8. See, e.g., Geist and Pfohl 1976, 155–63. For a general interpretation of mythological imagery on Roman sarcophagi, see also Fittschen 1992, 1046–59; Blome 1978; Blome 1983, 209.
9. Quartino 1987, 52.
10. Quartino 1987, 53–56.
11. H. Sichtermann, "Meerwesen," in Koch and Sichtermann 1982, 196.
12. Rumpf 1939, 8, no. 24.
13. Rumpf 1939, 13, no. 37, pl. 11; Wrede 1976, 151, pl. 32.3.
14. The erotes are adorned with fragrant wreaths of flowers; the Nereids wear cloaks around their hips.
15. Rumpf dates the sarcophagus in Ostia to the end of the second century A.D.; Wrede (1976) dates it to the ninth decade of that century.
16. Wünsche 1998, 13, no. 36, pl. 13.
17. Wünsche 1998, 15–16, no. 42, pl. 48.
18. Cf. Rumpf 1939.
19. Likewise, cf. Rumpf 1939, 8.

45.
FRAGMENT OF A HUNT SARCOPHAGUS

Ca. A.D. 270–280
Provenance: unknown
Material: Proconnesian marble, bluish with dark veins
Dimensions: h. 26.5 cm., w. 25.8 cm., d. at top 12.3 cm.,
h. of head 18.2 cm., h. of face 13.6 cm.
Museum purchase, Carl Otto von Kienbusch, Jr., Memorial
Collection Fund (y1993-38)

CONDITION: *With the exception of the upper edge of the sarcophagus rim, which is largely intact, the piece is broken on all sides. The face and the background of the relief have been cleaned, but the other surfaces are covered with a yellowish incrustation layer. The man's nose is broken off, as are parts of a strut extending forward on the crown. Minor damage is evident above the right eyebrow and on the left temple, where the remnant of a strut indicates that another element had been connected there. A vertical mortise (w. 2.5 cm.) in the top of the coffin rim originally served to affix its cover. The mortise extends approximately 10.5 cm. into the relief, directly to the right of the head; parts of its right front edge have broken away.*

The fragment derives from the upper part of a sarcophagus, as demonstrated by the lid socket in the preserved upper edge, the back side of which has an *anathyrosis* strip (w. 4.5 cm.) along the top. All that has survived of the relief is the head of a man; because this head has been carved in high relief, it can be assumed that it adorned the front side of the sarcophagus. The man has a beard and mustache, and his hair has been combed toward the forehead in long, sickle-shaped strands. His head is inclined and turned toward his left, and he seems to be devoting his full attention to some event that is taking place

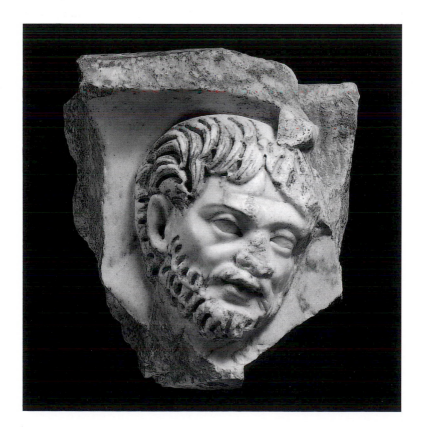

lower down in the composition. The man seems to have been a party to that event, and the object that attached to his head by way of two struts must find its explanation from this context. The tensely expectant expression, the accompanying activity, the portrait-like representation of the head, and the presumed date of its carving all suggest that this fragment belonged to a battle[1] or lion-hunt[2] sarcophagus. The head on the Princeton fragment is very closely related to the head of an unmounted beater accompanying the hunt on a very high-quality sarcophagus in Reims.[3] This attendant holds his right arm bent at the elbow in front of his upper body; he obviously has been caught in the act of raising his sword, the tip of which survives behind his head.[4] This figure does not belong to the fixed iconographic inventory of typical lion-hunt sarcophagi,[5] but should be understood as a unique addition which is without parallel among known examples of this genre.[6] It seems unlikely that the figure on the Princeton fragment would have carried a sword: rather, the strut and the breakage site on the left temple suggest a spear, and the man's gaze no doubt parallels the direction in which the weapon was pointed. An interpretation of the figure as a beater accompanying the hunt seems more than merely likely: the basis for this conjecture is that the spear was the weapon typically carried by these functionaries and that the latter often assume a similar posture. In a poorly preserved sarcophagus relief at the Villa Medici in Rome,[7] the beater stands behind the lion in a pose which is very nearly identical to the posture of the figure on the Princeton relief, as reconstructed above, although the latter must have held his weapon at a slightly steeper angle.

The sarcophagus in the Villa Medici and a monumental example in the Palazzo Mattei[8] (which depicts two scenes) represent a typological variant within the otherwise relatively fixed iconography of lion-hunt sarcophagi: rather than depicting the lion as leaping into the composition from the right, the beast is represented as rushing out of the picture, its head turned back to keep its gaze fixed upon its pursuers.[9] In parallel with the Medici sarcophagus, on which the aforementioned beater strives to intercept the lion and spear it in the chest, one is tempted to assume that the sarcophagus front to which the Princeton

fragment originally belonged featured a similar composition. If this were the case, it would explain the turn of the head and its inclination

It has been suggested that a fragment from a lion-hunt sarcophagus preserved in Munich,[10] an adjoining fragment of which is in Chapel Hill,[11] also derives from a scene where the lord of the hunt has just caught up with a fleeing lion.[12] For a variety of reasons,[13] it seems that an interpretation of this sort is more likely than that proposed by B. Andreae, who suggests that another fragment be added, namely, one which depicts a mighty lion leaping toward the left.[14] The Princeton fragment seems to confirm the supposition that the original composition featured a desperate lion striving to escape toward the right. The stylistic proximity of the Princeton fragment and the head of the attendant[15] which has survived on the right corner fragment in Munich is very striking indeed. The modeling of the flesh of the face, which below the cheekbone heaps flaccidly against the naso-labial furrow and which shows very similar furrows and folds at the root of the nose and on the forehead, is very close, as are the ridge-shaped eyebrows and the forms of the eyelids. The similarities are so great that one can reasonably assume that both pieces were carved by the same artist. Likewise identical is the way the stone is worked, as can readily be seen in the short drill channels and the ridgelike bars that have been left standing in the hair and beard. Also identical are the design of the sideburns and mustache, and the superficially worked ears with the characteristically deep drill hole in the middle. With a head height of 18.2 cm., the Princeton figure is very nearly the same size as the huntsman in Munich, whose head measures 18.5 cm.; the lengths of the faces are nearly identical too, with deviations of only a very few millimeters. Further proof that the fragment in Princeton belongs to the same sarcophagus as the pieces in Munich and Chapel Hill is provided by the height and depth of the sarcophagus's upper edges: the height of the surviving portions varies between 5 and 6.5 cm. in Munich; the height increases from 5 cm. at the left to 5.5 cm. at the right in Princeton; the depth measures about 13 cm. in Munich and 12.3 cm. in Princeton. Furthermore, the Princeton fragment has the same rectangular struts or *puntelli*

which are so characteristic of the fragments in Munich and Chapel Hill. In addition, all three fragments are of the same sort of blue-veined Proconnesian marble and have similar incrustation. A final and truly convincing proof is the identical width (4.5 cm.) in both Munich and Princeton of the *anathyrosis* strip along the inside of the upper edge. It can therefore be concluded with certainty that the fragment in Princeton is part of the same sarcophagus whose fragments are also preserved in Munich and Chapel Hill. Based on the iconography, it can further be concluded that the Princeton beater was originally situated at the right end of the sarcophagus, directly beside the nude attendant in Munich, together with whom he was shown attacking the escaping lion.

On the basis of typological and stylistic criteria, it has been suggested that the Munich-Chapel Hill sarcophagus fragments were carved in the decade between 270 and 280.[16] The head on the fragment in Princeton shows parallels to other artworks surviving from this same period. In the rendering of the beard, it most closely resembles the unfortunately shattered portrait of the deceased adult with contabulated toga on the sarcophagus from Acilia:[17] the beard of the latter is subdivided into two steps and furrowed with short drill channels, between which narrow ridges have been left standing; at the same time, zones of less abundant beard growth are indicated by shallow grooves in the marble. The tensed flesh and sharp lines on the cheeks of the Princeton beater find close comparisons in the attendant figure to the left of the deceased occupant of the Acilia sarcophagus.[18] The long strands of hair on the head in Princeton are nearly identical with those found on the figure depicted behind the youthful togate portrait figure at the left end of the Acilia sarcophagus,[19] and there are several other features which the Princeton head shares with the figures in Acilia: for example, deep drilling in the inner corners of the eyes, ridge-shaped eyebrows, and thick upper eyelids.[20]

It can thus be concluded with certainty that the fragment of a sarcophagus in Princeton, like its sister pieces in Munich and Chapel Hill, dates from A.D. 270–280, most likely toward the end of that decade. M F

BIBLIOGRAPHY
Sotheby's, London, May 6, 1982, no. 313.
Record 53.1 (1994): 82 (illus.), 83.

NOTES

1. Andreae 1956 and 1992, 41–64.
2. Andreae 1980 and 1992, 61–63.
3. Andreae 1980, 46–49, 157–58, no. 75, pls. 13.2, etc.
4. Andreae 1980, 46, 63, pl. 17.8–9.
5. Andreae 1980, 25–47, esp. 46; Andreae 1971, 119–22, fig. p. 118.
6. According to Andreae (1980, 63–64), the right edge of the fragmentary lion-hunt sarcophagus in Munich (Andreae 1980, 151–52, no. 50; Fuchs 2001, 113–17, no. 32) shows a figure which is a synthesis between this hunter's companion and the spear-bearing comrade who preceded him.
7. Andreae 1980, 56–57, 175, no. 192, pl. 22.3.
8. Andreae 1980, 44–46, 167, no. 128, pls. 13.1, etc.
9. Andreae 1980, 45, 57.
10. Andreae 1980, 62–65; 151–52, no. 50, pl. 34.1 a-c.
11. Andreae 1980, 63–65; 147, no. 23, pl. 35.2; Andreae 1985, 14–22, pl. 3.
12. Ohly 1970, 188–90 and 1972, 97, fig. 28; Ohly-Dumm 1973, 239–40, fig. 2; Andreae 1980, 63–64.
13. Fuchs 2001, 113–17.
14. Andreae 1985, 6–8, pl. 41 and passim.
15. Andreae 1980, pls. 34.4–5, 115.4.
16. Andreae and Jung 1977, table p. 434; Andreae 1980, 64–65; Andreae 1992, 62–63, figs. 62–68, with a dating between A.D. 280 and 290, which seems to be too late; a dating between A.D. 270 and 280 is also proposed by G. Koch in Koch and Sichtermann 1982, 257.
17. Bianchi Bandinelli 1954, 200–220, fig. 5; Fittschen 1979, 584–85, figs. 8–9; M. Sapelli, in Giuliano 1979, 298–304, no. 182; Koch and Sichtermann 1982, 102–3, 257 and most recently Reinsberg 1995, 360, 362–63, pls. 90.1, 93.2.
18. Bianchi Bandinelli 1954, fig. 5 right.
19. Bianchi Bandinelli 1954, figs. 7, 10, and esp. 15 right. Hanfmann (1975, no. 137) says: "Being so clearly a product of the highest skill available in Rome, the sarcophagus from Acilia has attracted much speculation concerning the identity of the boy, presumably the son of the couple who appeared in the center of the composition."
20. On this, see Bianchi Bandinelli 1954, fig. 6; and Himmelmann 1973, pl. 12.

46.

FRAGMENT OF A SARCOPHAGUS WITH A SEATED MAN

Late third century A.D.
Provenance: unknown; once owned by J. J. Klejman, New York
Material: fine-grained white marble, probably Italian
Dimensions: h. 31.5 cm., w. 27 cm., d. 5.9 cm.
Museum purchase (1995-124)

CONDITION: *There are straight, sawn edges along the sides and bottom, and at upper left; a slanting break extends from the man's head to the upper right corner. The back is sawn flat. The surfaces are very worn, particularly the scroll and the man's face, beard, and hands. Chips in upper right corner and lower right molding. Yellowish patina. Traces of colored plaster on all four sides attest a previous modern installation.*

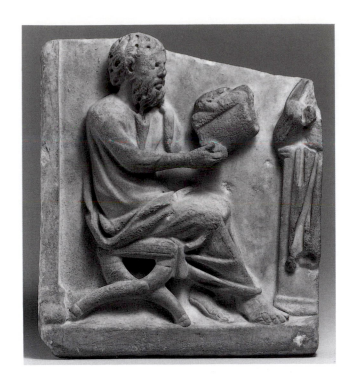

The fragmentary relief is from a sarcophagus, most likely the central panel of a strigilated sarcophagus, originally flanked by rows of wavy vertical fluting (strigils). A man of letters is seated to the right on a curule chair. He wears sandals, a sleeved tunic, and a cloak (himation). There are deep drill holes in the hair and beard, the nostrils, and the corners of the mouth and eyes. With both hands, the man holds up a scroll, partially unrolled and folded in the middle. At the right are the remains—right arm, drapery— of a woman resting her arm on a pillar with a molded base.

The theme of a seated man reading a scroll in the presence of a woman leaning on a pillar was common on Roman sarcophagi of the third and fourth centuries, originating in scenes of one or more poets, musicians, or philosophers seated among the Muses.[1] In the scenes with only one seated man, the latter may read from the scroll or gesture with gratitude toward his Muse, who is often represented leaning on a pillar with her legs crossed, a posture traditionally identified with the Muse Polyhymnia.[2] By the fourth century, the female figure lost her attributes as a Muse, just as the poet became a generic "wise man" or the deceased himself, and the attentive woman his wife.[3] On some late examples, the seated man is making the gesture of Christ, with paired fingers, or

there is some other Early Christian iconography, leading some scholars to interpret the scene as a Christian "praelectio," with the woman receiving instruction in the Christian faith.[4] JMP

BIBLIOGRAPHY
Christie's, New York, June 2, 1995, lot 113.

NOTES
1. For Muse sarcophagi, see Wegner 1966b.
2. For strigilated sarcophagi with reliefs of this type, see Wegner 1966b, 135–38, pls. 75–76, 79–81, 119, 123–124b; Deichmann 1967, 1: pl. 159, no. 994; *LIMC* 7:1044, pl. 746, s.v. Mousa/Mousai/Musae (L. Faedo). For depictions of Polyhymnia, see Wegner 1966b, Beilage 4.
3. On a sarcophagus in Marseilles, e.g., the faces of the poet and his muse are clearly portraits: 1966, 27, pls. 75a, 77a. On some examples, the faces of the man and woman have been left blank in expectation of commissioned portraits: cf. Wilpert 1929, 1: pl. 1.2; pl. 2.2; pl. 3.1.
4. Wilpert 1929, 3–13, pls. 1–3; pl. 5.3–6. For additional examples, see Wegner 1966b, pls. 80b, 121a, 124b, 145b. Wilpert reconstructs some fragmentary examples in which the man raises his right hand as the sign of Christ (pl. 5.4 and 6), but this need not be so: cf. Christie's, London, February 23, 1981, lot 146.

47.

FRAGMENT OF A CHRISTIAN SARCOPHAGUS WITH JONAH

End of the third century A.D.
Provenance: unknown
Material: Proconnesian marble
Dimensions: h. 35.0 cm., l. 115 cm., d. 45.5 cm.
Museum purchase, Carl Otto von Kienbusch, Jr., Memorial Collection Fund (y1994-1)

CONDITION: *Most break surfaces are old, but the one along the lower edge of the back side is more recent. When the bottom of the sarcophagus was knocked out, the fragment broke into two pieces (crack through body of the* ketos*), the molding beneath Jonah's right foot was damaged, and the top of the ancient break was chipped. Chips and scratches are found on the draped figure, the sheep, and the old break surface.*

With its rounded ends, this sarcophagus is a derivative of the wine-trough and tub sacophagi *(lenos)* that originated in the mid-second century A.D. The center of the front is held by the *tabula inscriptionis*, which is basically rectangular but has lateral *ansae* (ears, or tabs). The rhombic space between the remaining *ansa* and the bottom molding is filled with a rosette. To the right of the tablet a sea monster *(ketos)* is seen riding across the waves. Of its head only the lower jaw with some teeth, a small beard, and a triangular fin are preserved. To the left of it, the long neck curves down to the chest, from which a pair of feline legs emerge. In the area where the chest transcends into the spiraling fish's tail, stylized fins smooth the transition.

Here, as in comparable scenes, the *ketos*, whose image had been invented for the purposes of Greek mythological representation, stands in for the "fish" that had swallowed Jonah, whom we find resting under the gourd tree to the right of the monster. Although his eyes are not completely closed, the gesture of his raised right arm tells us that he is asleep. His nudity probably underscores the severity of the ordeal he has endured.[1] Behind Jonah, two trunks of gourd vine with grooves indicating bark are visible. In the full depiction, these developed into a roof above the sleeper, with gourds hanging down from it.

The Jonah scene in its pictorial form is unbiblical, for it conflates two events which in the scriptural account are separated by time and space: Jonah is debouched by the sea monster at the shore near Joppe,

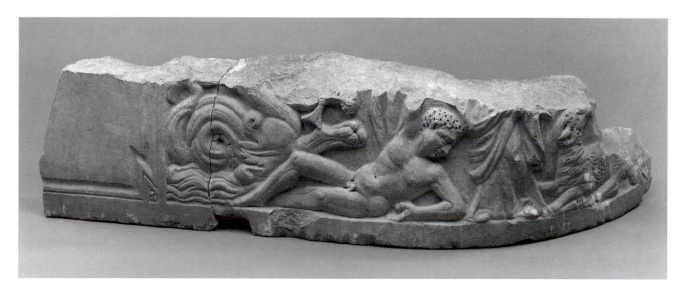

then goes inland to Nineveh to fulfill his mission, and only afterward repairs to the shelter of the gourd vine. But Early Christian art often follows its own logic, and manipulations like this are by no means uncommon.

Following on Jonah to the right there remains the lower half of a standing figure, who from the length of dress must be female. She is wearing a long thin undergarment (chiton) and a mantle (himation) that is partly rolled up.[2] The woman clasps the mantle with her left hand, of which four fingers survive. To the right, a sheep or ram is lying on the ground looking back and up, presumably at a shepherd, whose foot may be preserved in the battered hub to the side of the sheep's tail (cf. cat. no. 48, the "Good Shepherd" relief). This and the evidence from other contexts suggest the identification of the female figure as an orant, and although praying women are normally depicted with both arms raised, a handful of praying figures shows only the right arm elevated.[3] Therefore, the extant part of this sarcophagus combines three independent pictorial elements in what has been termed "staccato" style.

Early Christian sarcophagi of the lenos type are rare: the Princeton fragment represents one of three examples. Another, with the same combination of Jonah under the gourd tree with *ketos, orans,* and "Good Shepherd" on a sarcophagus of the *lenos* type, is the casket at (and from) Santa Maria Antiqua al Foro Romano in Rome.[4]

The Princeton piece is the product of a metropolitan Roman workshop and has been dated to the third quarter of the third century[5] and the time around A.D. 300,[6] respectively. The rendition of Jonah's face possesses Gallienic reminiscences,[7] but the workmanship of his hairstyle points to the later date,[8] as do the treatment of his body (crisp compartmentalization of the musculature)[9] and the lack of spatial recession in the sea monster's coiling tail.[10] The flatness of the relief, the short drill lines in the coiffure, as well as drilled dots by the eye, the mouth, and genitals, and also the groove enhancing the eyebrow, permit attribution of the Princeton *lenos* to the

"pointillistic" style that originates around A.D. 270.[11] The placement of the *tabula ansata* on the casket, not the lid, is unusual, but not completely without parallels, in Early Christian sarcophagi.[12]

HM

BIBLIOGRAPHY
Record 54.1 (1995): 71 (illus.), 74.
Koch 1997, 191–206.
Dresken-Weiland 1998, 1, 70. 1, pl. 1.1.

NOTES
1. In the biblical account Jonah, strangely, is fast asleep in the hull of the ship during the storm sent by Jehovah. See the quote from Koch (n. 12 below).
2. The garment has also been referred to as a *palla*. However: "De la palla employée comme manteau, nous possédons grace à Apulée, une description minutieuse, d'ou il ressort qu'elle etait identique a l'himation des Grecs" (*DarSag* 4:292, s.v. Pallium [G. Leroux]).
3. See, e.g., Wilpert 1929, 82, pl. 65.4 (Arles): "Matrona con la *dextra precans.*" An overview of the occurrences of *orantes* on Christian sarcophagi can be found in Lange 1996, 75–79.
4. Deichmann, Bovini, and Brandenburg 1967, no. 747.
5. Dresken-Weiland 1998, no. 1, pl. 1.1.
6. Koch 1997, 194.
7. See Gerke 1940, 267, n. 2, pl. 20.2; Wilpert 1932, 2:281, pl. 221.3.
8. Deichmann, Bovini, and Brandenburg 1967, nos. 181, 304, 768, 867.
9. Klauser 1966, 24–25, no. 4, pl. 7.
10. Deichmann, Bovini, and Brandenburg 1967, no. 162.
11. Koch and Sichtermann 1982, 257–58, with bibliography.
12. Koch (1997, 194) remarks: "Das Fragment in Princeton gibt gewisse Aufschlüsse über den Vorgang der Herstellung von vorkonstantinischen Sarkophagen mit christlichen Themen. Offensichtlich hatte ein Christ für den Meerwurf des Jonas in die Werkstatt Vorlagen von Abbildungen mitgebracht, wie sie sich als Einzelszenen in den Malereien der Katakomben finden. Der Bildhauer, der die Geschichte von Jonas nicht kannte, hat versucht, mit diesen beiden Szenen und einigen Versatzstücken die Fläche der Wanne zu füllen. In die Mitte setzte er, wie es auf Deckeln geläufig ist, eine Tabula."

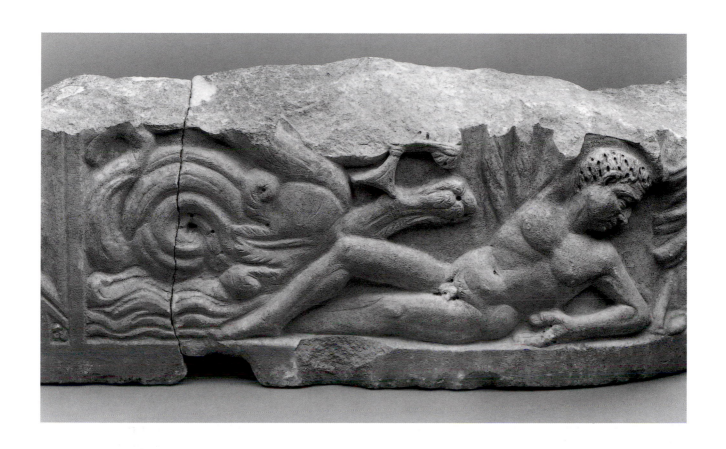

48.

FRAGMENT OF A SARCOPHAGUS WITH A SHEPHERD CARRYING A RAM

Tetrarchic, ca. A.D. 300
Provenance: unknown
Material: white marble
Dimensions: h. 36.3 cm., w. 30.5 cm., th. (at top) 6.4 cm.
Museum purchase, gift of the Friends of The Art Museum
(y1952-169)

CONDITION: *Slightly chipped on edges and back. Back roughly picked. Lateral sides smoothly cut. Lower edge of back recessed to right and left, perhaps for subsequent insertion in wall. Small secondary attachment hole in center of top. Narrow groove along inner edge of top surface for lid.*

An architectural structure (*aedicula*), consisting of fluted Corinthian columns and a pediment with finials on it, serves as a frame for a scene set in open nature. Flanked by two sheep and two trees, and a bird roosting in one of the latter, a young shepherd with thick, curly hair and a pudgy face occupies the center of the composition. Carrying a sheep or ram on his shoulders—its horns are not necessarily indicative of male sex[1]—he is dressed in the outfit typical of his profession: a girded, long-sleeved tunic with a scarf-like collar (*alicula*), laced boots, and puttees (*fasciae crurales*) for protection against thorny underbrush.

The slab was probably part of a child's sarcophagus of the strigilated type, in which picture panels on either end of the front and in its center were separated by zones of wavy ornament.[2] In the past, the image of the herder carrying the animal has often been understood as the Good Shepherd, and lastly Christ, but there are very few cases where that identification can be made with certainty.[3] Similarly, a suggestion according to which the figure would be read as an allegory of philanthropy is not borne out by the factual evidence.[4] Rather, both the heathen and the Christian contexts in which the shepherd appears recommend understanding him as one of a variety of generic allegories pertaining to desired states of bliss and felicity, and stemming from the bucolic tradition.

With regard to the Princeton slab, which has been lifted from its context, this is as far as the interpretation can go.

The date of ca. A.D. 300 is suggested by the typology of the sheep with their flaky fleece, long tails, and the "collar" around their necks.[5] It is confirmed by the figure of Adonis on a certain Orfitus's altar to Cybele, that by way of inscription is dated to 295.[6] The face of Adonis is similarly chubby, his head of hair likewise interspersed with drill holes, and his dress shows the same treatment reminiscent of woodcarving as that of the herder. Typologically, the latter finds a close comparison of more finished quality in a statuette in the Museo delle Terme, Rome.[7]

HM

BIBLIOGRAPHY
Record 12.1 (1953): 38.
Jones 1954b, 243.
Calkins 1968, 102, fig. 4.
Art of the Late Antique 1968, 52, no. 30, pl. XVII.
Weitzmann 1977, 519, no. 463.

NOTES
1. Cf. Himmelmann 1980, 141.
2. Himmelmann 1980, 121–24, pls. 58–59; Vermeule 1981, no. 219. The Princeton relief may also have come from a reduced version of this basic type; cf., e.g., Carli and Arias 1937, fig. p. 67 (shepherd in aedicula flanked by strigilated panels).
3. Himmelmann 1980, 166–68.

4. Himmelmann 1980, 142–44.

5. See Gerke 1940, 257, n. 1.5 (group around the Tacitus fragment).

6. Gerke 1940, 99–100, pl. 44; Bol 1992, 3:234–36, nos. 336–37, pls. 152–53 (G. Lahusen).

7. Gerke 1940, 252, n. 1; 381 (Tetrarchic); illustrated without the restorations in Wilpert 1929, pl. 52.8. For the rendition of the shepherd's dress, cf. also Deichmann, Bovini, and Brandenburg 1967, no. 966 (late third/early fourth century).

SCULPTURE
FROM ANTIOCH

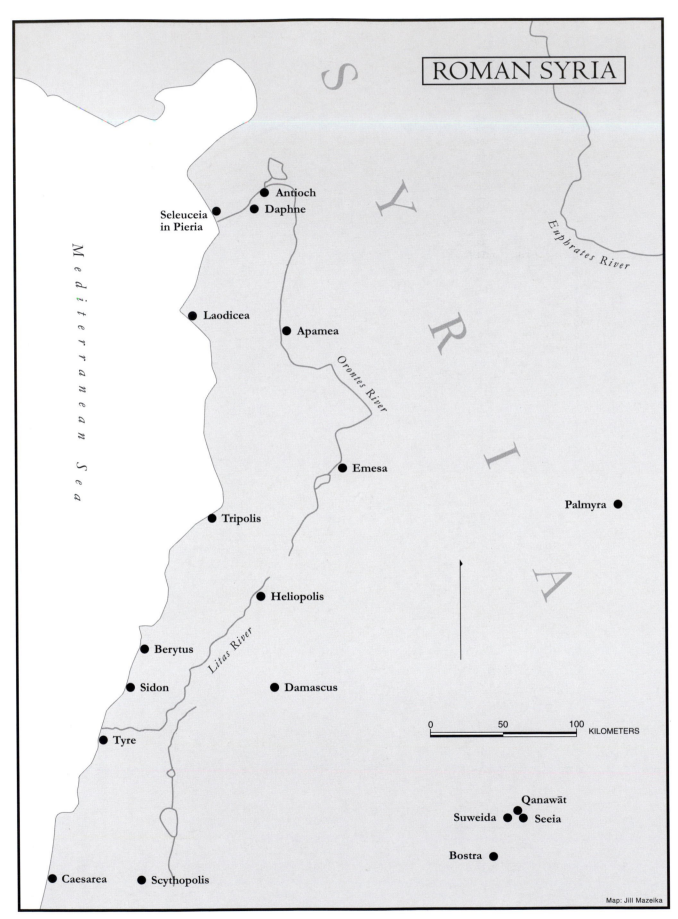

ROMAN SYRIA

S Y R I A

Mediterranean Sea

Euphrates River

Orontes River

Litas River

● Antioch
● Daphne
Seleuceia in Pieria ●
● Laodicea
● Apamea
● Emesa
Palmyra ●
● Tripolis
● Heliopolis
● Berytus
● Sidon
● Damascus
● Tyre
Qanawāt ●
Suweida ● ● Seeia
Bostra ●
● Caesarea
● Scythopolis

0 50 100
KILOMETERS

Map: Jill Mazeika

ANCIENT ANTIOCH

0 500 1000
METERS

1. Bath E
2. Circus
3. Temple
4. Bath B
5. Bath A
6. Atrium House
7. Building
8. Bath D
9. Building
10. Bath C
11. Building
12. Building
13. Byzantine Stadium
14. Tower Area
15. City Wall
16. Church
17. Building
18. Building
19. Building
20. Charonion
21. Theater
22. Iron Gates
23. Street Dig No. 3
24. Cemetery
25. Cemetery
26. Street Dig No. 1
27. Street Dig No. 2
28. Cemetery
29. Cemetery
30. Cemetery
31. Building
32. Cemetery, NE
33. Building
34. Street Dig No. 5
35. Street Dig No. 4
36. Aqueduct
37. Building
38. Building

Present Channel

Orontes River

Imperial Palace

Wall of Tiberius

Wall of Justinian

M.N.

Wall of Seleukos I

Wall of Justinian

Nymphaeum

Wall of Seleucus I

Parmenios River

To Alexandretta

Colonnaded Street of Herod and Tiberius

Citadel

Bridge Gate

To Seleucia

Mount Silpios

Cherubim Gate

Wall of Tiberius

Daphne Gate

Wall of Theodosius II

To Daphne

Wall of Justinian

Phyrminus River

Locations are approximate;
based on Stillwell 1938, 215;
Kondoleon 2000, xv.
Map: Jill Mazeika

173

Antioch-on-the-Orontes

Tina Najbjerg

HISTORY OF THE CITY

Antioch-on-the-Orontes (modern Antakya), named thus in antiquity to distinguish it from three other cities of the same name, was located at the foot of Mount Silpius along the Orontes River in an area that is now part of Turkey (see map 2). Founded in 300 B.C. by Seleucus I Nicator (312–280 B.C.), Antioch grew to become one of the most important political and cultural centers of the Hellenistic East. Seleucus, one of Alexander the Great's older generals, who had received Syria as his share of the Macedonian empire after the death of Alexander in 323 B.C., slowly gained control of northern Syria, Mesopotamia, and Persia. To secure his domination of the newly conquered area, he founded four cities in northwestern Syria: Apamea, Laodicea-on-the-sea, Antioch (named after his father Antiochus), and Seleuceia in Pieria, the latter located on the coast about fifteen miles from Antioch (see map 2). At least two of the cities, Antioch and Laodicea, were laid out on a regular grid plan of the type associated with Hippodamos of Miletos, which was used in the planning of many new cities founded in this period. Seleuceia in Pieria was founded first, and Seleucus chose it as the capital city of his newly established empire.

Several legends associated with the foundation of Antioch were recounted by Libanius, a celebrated rhetorician who lived and wrote in Antioch in the fourth century A.D. One legend involves the story of Io, the beautiful daughter of Inachus, king of Argos, who was seduced and turned into a cow by Zeus, only to be driven from her home by the jealous Hera. In her wanderings, Io came to Mount Silpius and died there. Inachus sent some of his men, led by Triptolemus, to search for her, and they came to the region of the future Antioch. The Argives were so struck by the beauty of the area that they abandoned their task and settled on Mount Silpius, where they founded Iopolis (Libanius, *Antiochikos* 44–52). Similar myths hint at an early Greek settlement on the site, but this has not been confirmed by archaeological evidence.

Libanius also connected the foundation of Antioch to Alexander the Great. Having defeated Darius at the battle of Issus in 333 B.C., Alexander moved south toward Phoenicia and stopped at a site to the east of the future Antioch, where he drank from one of the springs for which the area was famous. Amazed by the sweetness of the water and the beauty of the site, Alexander vowed to build a city on the spot (Libanius, *Antiochikos* 72–77, 87, 250). Although it is possible that Alexander visited the site of Antioch, there is no evidence that he actually planned the city. The story does reflect, however, the fame of the springs around Antioch and its ample water supply, which was one of the principal reasons for Seleucus's decision to build one of his cities here.

In order to assure the cultural as well as the political dominion of his new empire, Seleucus based the administration of the new cities on Hellenic models and institutions and colonized them primarily with Greek-speaking peoples. These consisted of retired Macedonian soldiers from his own army and of Athenian citizens, whom Seleucus moved from Antigonia, the capital of his conquered enemy, Antigonus. Besides Greeks and Macedonians, the populace of Antioch was made up of native Syrians, Jews (mostly retired mercenaries from Seleucus's army), slaves of diverse origin, and a small number of Cretans, Cypriotes, and Argives. Each group was assigned its own quarter in the city, but only the Macedonians and the Athenians were full citizens. The Jews could become full citizens if they

renounced their faith and worshiped the Greek god Zeus, whom Seleucus chose as the patron god of Antioch.

Many of the pieces in this catalogue were discovered in the area of Daphne, a town situated on a plateau five miles south of Antioch (see map 2). According to local tradition, Daphne was the spot in which the mountain nymph Daphne, priestess of Mother Earth, was pursued by the god Apollo. The nymph called upon the mother goddess to save her and she was immediately transformed into a laurel tree, safe from Apollo's desire (Libanius, *Antiochikos* 94). The popularity of this myth is indicated by its frequent depiction on mosaics found in the villas of Daphne and surrounding areas, one of which is preserved in The Art Museum, Princeton University.

The picturesque and fertile area of Daphne acquired a fame of its own, separate from that of Antioch. Libanius relates that Seleucus was led by divine intervention to consecrate the area to Apollo (*Antiochikos* 95–100) and that he proceeded to design a sacred enclosure in which he built the Temple of Apollo and planted the grove of cypress trees sacred to the god. In the temple stood a famous statue of Apollo by the Athenian sculptor Bryaxis, known through representations on coins of Antioch and from Libanius's *Monody on the Temple of Apollo at Daphne* (*Orationes* 50.6.9–11). The numerous natural springs in the area not only supplied water to the beautiful villas, baths, and gardens that lined the road between Daphne and Antioch, but they also provided the latter with a large part of its water supply through aqueducts. Daphne was a favorite resort for local citizens, and with the additions of a theater and an Olympic stadium, it became internationally renowned as a center for pleasure and entertainment, popular with many Roman emperors.

Hardly anything remains of the Antioch of Seleucus. Although there must have been public structures such as temples, baths, and administrative and military installations, there is no physical evidence for any of these. The sources tell of a Temple to Zeus Bottiaios, which Seleucus (or, less likely, Alexander the Great) built when the city was first founded. They also mention some of the many statues that were erected in the first years of the new city,

particularly the famous Tyche (Fortune) of Antioch, by Eutychides of Sicyon, a pupil of Lysippos, which was set up in the city between 296 and 293 B.C. In addition to the cult statue in the Temple of Zeus Bottiaios, Seleucus commissioned a statue of Zeus Keraunios for another temple, and he placed a statue of an eagle, the bird of Zeus, outside the city—a favorite emblem on the coins of Antioch. In honor of the Athenians from Antigonia, whom he had forcefully removed from their city, Seleucus erected bronze statues of Athena Promachos and of the Tyche of Antigonia.

When Seleucus died in 281/280 B.C., he was buried in Seleuceia in Pieria, an indication that the town was still considered the capital of the Seleucid empire. Antioch probably did not become the capital until the reign of his son, Antiochus I Soter (280–261 B.C.).

Under the Seleucid rulers, Antioch continued to prosper and grow, both physically and culturally. Antiochus I followed the trend of other contemporary Hellenistic courts and encouraged intellectual activities. Although the Seleucids never achieved the great wealth of the Ptolemies in Egypt, and therefore could not maintain a great library like the one in Alexandria, they nevertheless kept up the patronage of scholars and scientists, and Antioch soon became famous for its philosophers, astronomers, and historians.

During the reign of Antiochus II Theos (261–247 B.C.), a growing Egyptian influence in Antioch was noticeable, and the marriage between Antiochus and Berenike, daughter of King Ptolemy II Philadelphos of Egypt, signified the attempt to establish close cultural and political ties between the two empires (see cat . no. 163). The alliance broke, however, with the occupation of Antioch by Ptolemy Euergetes in 246–244 B.C. (after the death of Antiochus in 247 B.C.). Seleucus II, the son of Antiochus and his first wife Laodike, managed to reclaim Antioch in 244 B.C., and at this point the city became the principal seat of Seleucid power, as Seleuceia was in Egyptian possession and would remain so until 219 B.C. The consequent population increase in Antioch forced Seleucus II to add a new quarter to the city, which was located on an island in the Orontes, across from

the original settlement. The new island quarter was laid out on a grid plan and connected to the older city with bridges.

The reign of Antiochus III, the Great (223–87 B.C.), was marked by conflicts with the growing power of Rome. Antiochus sided with Rome's arch enemy, Hannibal of Carthage, and in the inevitable confrontation, at the Battle of Magnesia in 190 B.C., Antiochus was defeated by Rome. This prompted a period of political and economic suffering for the Seleucid empire, which lost its military power and, in addition, had to pay a heavy annual tribute to Rome. The immediate effect of the war on Antioch was an influx of veterans from Antiochus's army and supporters from Greece who fled from retaliations of the Romans.

The face of Antioch had hardly been altered since its foundation, but this changed with the accession of Antiochus IV Epiphanes (175–163 B.C.), whose activity as a builder elevated the capital to its place among the most magnificent cities of antiquity. Antiochus added yet another quarter to the city, named Epiphania after its founder. He provided it with a marketplace that was devoted to political and educational activities—an addition to the market built by Seleucus, which was reserved for commercial needs. In the new marketplace, the agora, Antiochus built a council chamber (bouleuterion) and a Temple of Jupiter Capitolinus, as well as an aqueduct to provide the new quarter with water.

After the death of Antiochus IV, the history of the Seleucid empire and, with it, of Antioch, is one of steady decline, marked by bloody struggles for the throne between usurpers and legitimate members of the Seleucid dynasty. With the exception of a museum with a library, built sometime between 114 B.C. and 92 B.C., nothing significant seems to have been added to the city during this long period of growing weakness and dissolution. Finally, in 64 B.C., Pompey the Great brought an end to the Seleucid dynasty by annexing Syria to the Roman empire, and Antioch became the capital of the new Roman province.

With the Roman occupation, Antioch slowly rose to, and even surpassed, its former grandeur. Several of the Roman emperors favored the city, and their building programs gradually changed its face. A series of public buildings that had been begun by Q. Marcius Rex and Pompey the Great were continued by Julius Caesar, whose own buildings included the famous Caesareum, a theater on the slope of Mount Silpius, an amphitheater, an aqueduct, a public bath, and the rebuilding of the Pantheon. After the assassination of Caesar, Antioch became involved in the political struggle between Marc Antony and Octavian, and the city served as Antony's headquarters in the East. It is believed that the wedding between Antony and the Egyptian queen Cleopatra took place there. With the death of Marc Antony in 30 B.C., Antioch, like the rest of the Roman world, entered into a new phase of peace and prosperity, brought about by the victorious Octavian, the later emperor Augustus.

Under Augustus (27 B.C.–A.D. 14), Syria became an imperial province, with Antioch as the seat of the governing imperial legate and the procurator. A major event in this period was the foundation of the local Olympic Games, which would become one of the most famous festivals of the Roman world. The reign of Augustus, however, was notable in Antioch mainly for the erection of numerous public buildings, most of which were connected with the names of Augustus's general Agrippa and his supporter, King Herod of Judaea. Thus we hear of a new quarter with a public bath, a bath outside the city, a new zone of seats added to the theater, a reconstruction of the hippodrome that had been destroyed by an earthquake, and the construction of the great colonnaded street, two Roman miles in length, which became one of Antioch's chief claims to fame (see map 3).

Many of the buildings begun by Augustus were continued by the emperor Tiberius (A.D. 14–37), who built the roofed colonnades that lined the great thoroughfare and erected *tetrapyla*, or covered arches, at each main cross street. Tiberius also completed and improved the Epiphania quarter, and he constructed or restored three temples: the Temple of Jupiter Capitolinus, the Temple of Dionysos, with its statues of the Dioskouroi in front, and a temple to Pan behind the theater. The theater was enlarged again to accommodate the growing population of Antioch. In addition, Tiberius built a gate and a public bath in the eastern part of the city. Two events upset the

peaceful and prosperous period of Antioch under Tiberius: the great fire of A.D. 23/24, which destroyed a great part of the Epiphania agora, and the mysterious death of Germanicus, Tiberius's adoptive son, in Daphne in A.D. 19.

Not much is known about Antioch during the reign of Caligula (A.D. 37–41), the son of Germanicus, except that he was extremely benevolent toward Antioch and immediately sent assistance to the city after a severe earthquake in A.D. 37. Under Claudius (A.D. 41–54), Antioch and its environs suffered from a famine and an earthquake, and the emperor granted relief to all the cities affected. The main event in Antioch during the reign of Nero (A.D. 54–68) was the outbreak of the Jewish rebellion in A.D. 66, sparked by massacres in Palestine and Jerusalem. Nero sent his general Vespasian to suppress the rebellion. A renegade Jew from Antioch, named Antiochus, managed to stir up hatred against his own people, with the result that those who did not agree to offer sacrifices to the Roman gods were massacred.

The death of Nero was followed by a struggle for succession from which Vespasian emerged victorious in A.D. 69. During the year of civil war, Antioch and the province of Syria had played an important role as Vespasian's headquarters in the East, and it continued to do so in the ongoing war against the Jews. Vespasian appointed his son, Titus, to finish the siege of Jerusalem, which was destroyed. On his triumphal tour of the East in A.D. 70, Titus visited Antioch, where he declined to reply to the vehement request of the people to expel the Jews from the city. In order to keep the good will of the non-Jewish population of Antioch, however, the future emperor dedicated part of the spoils from Jerusalem to Antioch as a perpetual memorial of the humiliation of the Jews. He placed a copy of the Cherubim from the Temple by the gate of the road to Daphne, and on the gate itself, facing Jerusalem, Titus set up a bronze figure of the Moon with four bulls, a symbol of the eternity of the Roman empire. In Daphne, a theater was built which bore an inscription stating that it had been financed with the Jewish spoils, and a statue of Vespasian was placed in it.

Antioch did not play a major role in the history of the Roman empire again until the reign of Trajan (A.D. 98–117), who used the city as headquarters for his preparations for the Parthian War. In A.D. 114, the emperor enlarged the theater and ordered the construction of an additional aqueduct from Daphne and of a new bath in connection with it. The following year witnessed one of the most severe earthquakes yet. Trajan and his nephew, the future emperor Hadrian, were both present in Antioch, and the former barely escaped with his life. The surviving denizens of Antioch built a Temple of Zeus Soter in Daphne in gratitude for their preservation. Trajan proceeded to repair the damages made to the major buildings in Antioch, including the famous colonnaded street and the theater. He also constructed the Middle Gate at Antioch and a Temple of Artemis at Daphne. When Trajan died suddenly on his journey back to Rome, Hadrian left Antioch after giving orders for the construction of a Temple to the Deified Trajan.

Hadrian (A.D. 117–138) is well known for his building programs throughout the Roman empire, and Antioch was not excluded from his beneficence. The emperor improved the water supply of the city by building an aqueduct, and at Daphne he constructed an elaborate reservoir in the shape of a theater. At the upper end of the reservoir was a Temple of the Nymphs in which stood a statue of Hadrian as Zeus.

After the reign of Hadrian, Antioch enjoyed the peace and prosperity of the Antonine Age along with the rest of the Roman world. Antoninus Pius (A.D. 138–161) paved the main colonnaded street and all other streets in Antioch with Theban granite. Under Commodus (A.D. 180–192) the city profited from the otherwise worthless emperor's passion for athletics and spectacles when he allowed it to resume the Olympic Games. These had been abolished by his father, Marcus Aurelius (A.D. 161–180), as a punishment for Antioch's support of his enemy, Avidius Cassius, in A.D. 175. To celebrate the restoration of the games, Commodus erected new buildings for use in the festival such as the famous Xystos, a covered running track, as well as a public bath and a Temple of Olympian Zeus, patron of the games; he also restored the Temple of Athena.

In the century that followed the death of Commodus, the peace that had reigned throughout the

Roman empire was upset by constant struggles for power. Syria, and especially Antioch, was affected by the ascension of Septimius Severus to the imperial throne (A.D. 193–211). The governorship of Syria had proven to be a very powerful position from which to claim the throne; once he became emperor, Septimius Severus guarded himself against any such attempt by dividing the province into two: Syria Coele and Syria Phoenice. Antioch was severely punished for its favor to Pescennius Niger, one of the emperor's rivals for the throne, and for its ridicule of Septimius Severus when he was stationed there in A.D. 179. As a result, the emperor deprived the city of its title of metropolis and capital of Syria and reduced it to the status of a "village" of Laodicea, which he made capital. Septimius Severus later restored Antioch to imperial favor and endowed it with two baths. His son, Caracalla (A.D. 211–217), reinstated the Olympic Games which had been abolished by his father.

The period between the Severan dynasty and the reign of Diocletian was one of political and economic instability for the entire Roman empire. Antioch suffered severely from the Persian conquest, which resulted in pillaging, depopulation, and destruction of the city. A long period of Palmyrene domination along with civil and ecclesiastical unrest in the middle of the third century seriously damaged Antioch's civic, economic, and physical structure. The emperor Aurelian managed during his brief reign (A.D. 270–275) to reestablish the stability of the empire, and his successor, Probus (A.D. 276–282), instigated a restoration program for the damaged city.

With the reign of Diocletian (A.D. 284–305), Antioch finally managed to revive some of its former grandeur. His extensive building program in the city included two arms factories, granaries, and five baths; in Daphne, Diocletian rebuilt the Olympic stadium and added shrines of Olympian Zeus and of Nemesis. Most important, a palace was built on the island in Antioch, designed for the use of the emperor on his frequent visits, an act which illustrates Antioch's importance as military and administrative headquarters under Diocletian.

The conversion of the Roman emperor Constantine the Great (A.D. 306–337) signaled the triumph of Christianity and marked a turning point in the history of the Roman empire and of Antioch. Antioch's growing importance as an early Christian community was offset, however, by natural disasters, which so undermined the prosperity of the city that it was gradually abandoned. Despite the efforts of the emperor Justinian to rebuild the city in the sixth century A.D., Antioch never recovered, and its capture by the Arabs in A.D. 638 marked its end as a Graeco-Roman city.

THE PRINCETON EXCAVATION AT ANTIOCH, 1932–39

With the death of Professor Howard Crosby Butler, whose explorations in Syria revolutionized the scholarly notion of Syrian architecture, the desire of his colleagues at Princeton to explore more of this country did not fade. On the contrary, it was felt that Butler's observations could and should be enhanced and confirmed through additional systematic excavations in Syria, especially of its capital, Antioch. A great incentive to excavate this particular site was that of the four great cities of antiquity—Rome, Alexandria, Antioch, and Constantinople—only Antioch offered the opportunity for an excavation of the urban area; whereas the others had been rebuilt extensively over the centuries, modern Antioch (Antakya) had grown only to a fourth of its greatest extent in antiquity.

In 1930, Princeton University finally obtained permission from the Service of Antiquities in Syria to excavate Antioch, and a concession was arranged granting the right of excavation for six years from January 1, 1931. Apart from Princeton, to which were entrusted the direction of the excavation and the subsequent publication, the members of the Committee for the Excavation of Antioch and Its Vicinity were the Musées Nationaux de France, the Baltimore Museum of Art, the Worcester Art Museum, and later Dumbarton Oaks, affiliated with the Fogg Museum of Art. Private support was lent by a group of friends, including Cyrus H. McCormick, Henry J. Patten, Malcolm Lloyd, David Magie, and E. L. Pierce.

The field staff was organized in the fall of 1931 and consisted of Dr. George W. Elderkin as director,

Dr. Clarence Fisher as field director, and Professor William A. Campbell as assistant field director. Dr. Fisher, of the American School for Oriental Research at Jerusalem, did preparatory work at the site.

The results of the eight years of excavation at Antioch were published by Princeton in three volumes: *Antioch-on-the-Orontes I. The Excavations of 1932*, edited by George W. Elderkin (1934); *Antioch-on-the-Orontes II. The Excavations 1933–1936*, edited by Richard Stillwell (1938); *Antioch-on-the-Orontes III. The Excavations 1937–1939*, also edited by Stillwell (1941). This essay represents a brief summary of the excavation history as laid out in these three publications. Works on the ceramics, the coins, and on the Main Street dig of Antioch, by F. O. Waage and D. B. Waage and by J. Lassus, were later additions to the Antioch series.[1] Separate reports and abstracts were published by W. A. Campbell in the *American Journal of Archaeology* in the years between 1934 and 1940 (see Antioch bibliography).

The *sondages* dug during the excavations of 1932 revealed a tower area, three baths (A, B, and C), House A, a Roman villa, a Byzantine stadium, a circus, and a temple (see map 3). At Daphne, a church was exposed, and at Yakto, a small village north of Daphne, a Roman villa with beautiful mosaics was found. This first season yielded many mosaic floors while the marble sculpture amounted to only five pieces, four Roman and one Christian. The paucity of marble was explained by the ubiquitous limekilns, which forewarned the excavators that the chance of finding additional marble sculpture would be slight.

In 1933, Professor W. A. Campbell of Wellesley College was field director, and M. Jean Lassus, representing the Musées Nationaux de France, was assistant field director. The excavation of the Roman villa at Yakto continued, but the activities of the expedition were otherwise confined entirely to the part of the city of Antioch that once had been an island and had been separated from the original settlement by the Orontes River. With time, deposits from Mount Silpius had filled the riverbed, and the island had become one with the rest of the city.

During the campaign of 1934, work was divided between Antioch and Daphne. Antioch 23/24-K turned out to be the site of an ancient cemetery

within the walls built by Justinian. Explorations in Antioch 13-R, which had to be stopped because of the high water table, revealed a large building, and tombs of the fifth and sixth centuries were found adjacent to Antioch 24-K. In Daphne, a Roman theater of unusual design was found; it has been associated with the so-called Theatron built by Hadrian (A.D. 117–138).[2]

While the major effort of the fall season of 1934 concentrated on investigating the line of the famous main street of Antioch, a poor villa of the late fourth or early fifth century A.D. was found by chance just outside the city wall. In it were discovered several fragments of marble statues, apparently collected and buried together in antiquity.

The excavation of the theater at Daphne (Daphne-Harbie, sector 20-N) in 1934–35 is of special interest, since a large percentage of the sculpture in Princeton originated there. The work on the theater came to a halt in 1935 because the expedition failed to obtain the expropriation of the land. Consequently, the theater was thoroughly investigated and then refilled. The excavations revealed no inscriptions by which the building could be identified with any of the theaters known from literary sources and mentioned above. Archaeological evidence indicated that it dated to the end of the first century after Christ; but whether it should be associated with the theater built by Vespasian (A.D. 69–79) or with the enigmatic "Theatron" constructed by Hadrian (A.D. 117–138) is still debated.[3] The theater seems to have had two main periods, the first lasting from its construction in the first century A.D. until 341, when it was destroyed by the severe earthquake of that year. After a short hiatus, the theater was rebuilt and lasted at least through the reign of Justinian (A.D. 527–565). Many broken and mutilated statue fragments were found in the theater, including cat. nos. 52, 59, 68, 97, and 133, indicating that it must have been lavishly decorated with statue groups. It is uncertain, however, where within the theater the statues were placed, as the shallow and flat type of stage and *scenae frons* did not provide a good background for a large number of statue groups. A few pieces had been cut and reused in a high, thin wall that sliced through the building, evidently constructed after the theater

had gone out of use. Among these were two overlife-sized statues of emperors wearing cuirasses.

During the campaigns of 1936–37, work at Antioch centered on topographic exploration along the line of the Main Street. Here, sector 16-P revealed a heavily paved area in front of a small nymphaeum. Following the direction of the pavement underneath a modern road, foundations of shops, a colonnade, a curb, and pavements were found on the east side of the street. A section of this complex lay beneath a burial ground and church of the medieval period, and below the level of the shops were walls and a late Hellenistic pavement. The excavation of this sector was extended and it revealed, among other things, a workshop in the eastern part of the trench. The principal room was paved with pebble mosaics, and a room to the north contained two cement-lined basins and an oven, possibly a limekiln. In the immediate area of the oven were found numerous fragmentary marble sculptures of very small scale (cat. nos. 92 and 93). The building seems to have had a short existence and to have been destroyed in the second half of the first century A.D.

In 1937–38, a splendid villa with mosaics of the third century was excavated in Daphne-Harbie, sector 26/27-0; this sector also yielded a statue of a male figure (cat. no. 84), as well as other pieces (e.g., cat. no. 51).

During the season of 1937, the site of Seleuceia in Pieria was added to the excavation. The area within the city walls was explored and trial trenches were sunk. A section of the marketplace produced a mass of fragments of marble statues broken up in modern times and built into a fence. A long tunnel had been driven through the slope of the mountain toward the harbor by Vespasian and Titus, and around this tunnel the excavators discovered an extensive necropolis. One rock-cut tomb revealed several fragments of relief sculpture from sarcophagi, including cat. no. 107. At the top of the mountain, along the city walls, several buildings were found, tentatively identified as barracks. Further down the slope an Ionic temple and a Doric temple of tufa were explored. The date of the Doric temple is uncertain, but an inspection of the moldings suggested that it may have been built as early as the end of the fourth

century B.C. The only clue to the identification of the temple was a small bronze figure of Isis-Aphrodite found in the fill between the pavement supports of the pronaos. According to Libanius (*Orationes* 10.114), the cult of Isis was introduced to Antioch by Seleucus II (246–226 B.C.), who built an Iseum in the city. On the lower section of the slope, the discovery of an honorary inscription and a marble statue of Isis (cat. no. 58) prompted the digging of a trial trench, which revealed what seemed to be a colonnaded stoa.

In 1939, work continued in sector 15-M in the search for the main east-west cross street of Antioch. A building with several mosaics was found in the process. Along the Aleppo road, a large trench was dug to connect the Roman bath (F) in sector 13-R with the ancient Main Street, and here was found a beautiful marble statue of Hygieia, now in the Worcester Art Museum.[4] In Daphne, part of a large insula in a rich residential district was excavated, and a complete house was cleared, together with sections of four others in sector DH-26-M/N. Some very fine mosaics were uncovered as well as a hoard of silverware and several fragments of statuary, including cat. nos. 49, 77, and 104.

Most of the sculpture found in the excavations remained in Turkey, but a sizeable portion was divided among the Baltimore Museum of Art, the Worcester Art Museum, and Princeton University.[5] A catalogue of the sculpture was published by Stillwell in volumes II and III of the excavation reports. Each piece received only a brief description, and no effort was made to date, interpret, or contextualize the sculpture. The present catalogue is thus the first attempt to gather and properly analyze the Roman sculpture from Antioch located in The Art Museum. While this catalogue is by no means complete (architectural elements and sculpture dating to the Early Christian period have not been included), it does represent a more contemporary approach to the study of ancient sculpture, as the authors have attempted to trace the original context of each object.

Dating the Antioch sculpture in Princeton has been a daunting task. Most of the pieces in this catalogue were discovered out of their original context or were bought by or presented to the expedition; in such cases the authors have relied solely on stylistic

comparisons in their attempt to date the objects. Even the dating of objects that were discovered in situ has proven difficult because of the popular Roman practice of repairing statues and reusing marble. Furthermore, groups of sculpture found in a villa of the fourth or fifth century and in a villa complex at Daphne, which lasted from the second to the sixth century after Christ, illustrate that collecting was popular in Roman Antioch, and that earlier and later works were treasured together.[6] Consequently, one cannot date the sculpture from its archaeological context, and in most cases only a very loosely defined *terminus ante quem* can be inferred.

BIBLIOGRAPHY AND FURTHER READING ON ANTIOCH

C. O. Müller, *Antiquitates Antiochenae* (Göttingen 1839).

R. Förster, "Antiochia am Orontes," *JdI* 12 (1897): 103–49.

E. S. Bouchier, *A Short History of Antioch, 300 B.C.–A.D. 1268* (London 1921).

L. Eufrey, *Antioche* (Paris 1930).

W. A. Campbell, "Excavations at Antioch-on-the-Orontes," *AJA* 38 (1934): 201–6. [report on work during 1932–33]

G. W. Elderkin, ed., *Antioch-on-the-Orontes I. The Excavations of 1932* (Princeton 1934).

W. A. Campbell, "The Third Season of Excavations at Antioch-on-the-Orontes," *AJA* 40 (1936): 1–9. [report on the campaign of 1934]

W. A. Campbell, "The Fourth and Fifth Seasons of Excavations at Antioch-on-the-Orontes, 1935–36," *AJA* 42 (1938): 205–17.

J. Lassus, *La mosaïque du Phénix provenant des fouilles d'Antioche* (Paris 1938).

C. R. Morey, *The Mosaics of Antioch* (New York 1938).

R. Stillwell, ed., *Antioch-on-the-Orontes II. The Excavations 1933–1936* (Princeton 1938).

W. A. Campbell, "The Sixth Season of Excavations at Antioch-on-the-Orontes, 1937," *AJA* 44 (1940): 417–27.

R. Stillwell, ed., *Antioch-on-the-Orontes III. The Excavations 1937–1939* (Princeton 1941).

D. Levi, *Antioch Mosaic Pavements* (Princeton 1947).

F. O. Waage, ed., *Antioch-on-the-Orontes IV, pt. 1. Ceramics and Islamic Coins* (Princeton 1948).

G. Haddad, *Aspects of Social Life in Antioch in the Hellenistic-Roman Period* (New York 1949).

D. B. Waage, *Antioch-on-the-Orontes IV, pt. 2. Greek, Roman, Byzantine, and Crusaders' Coins* (Princeton 1952).

R. S. Chowen, "The Nature of Hadrian's Theatron at Daphne," *AJA* 60 (1956): 275–77.

G. Downey, *A History of Antioch in Syria from Seleucus to the Arab Conquest* (Princeton 1961).

G. Downey, *Antioch in the Age of Theodosius the Great* (Oklahoma 1962).

G. Downey, *Ancient Antioch* (Princeton 1963).

J. Lassus, *Antioch-on-the-Orontes V. Les portiques d'Antioche* (Princeton 1972).

F. Cimok, *Antioch on the Orontes* (Istanbul 1980).

C. Kondoleon, ed., *Antioch: The Lost Ancient City*, exhib. cat., Worcester Art Museum (Princeton 2000).

NOTES

1. F. O. Waage 1948; D. B. Waage 1952; Lassus 1972.
2. See Chowen 1956, 275–77.
3. See D. N. Wilber, in Stillwell 1938, 57–94, especially n. 1. Also Chowen 1956, 273–77.
4. Stillwell 1941, 116–17, no. 241, pl. 1; Kondoleon 2000, 90.
5. Antioch sculpture in the Worcester Art Museum has recently been analyzed by C. Vermeule, in Kondoleon 2000, 91–102.
6. Stillwell 1941, 116.

49.

FEMALE HEAD

Late Hellenistic period, second—first century B.C.
Provenance: Daphne-Harbie, sector 26-M/N (the villa),
April 4, 1939
Material: medium to large-grained white marble
Dimensions: h. 17.6 cm., w. 15.7 cm., d. 15.4 cm.
Gift of the Committee for the Excavation of Antioch to
Princeton University (2000-54)

CONDITION: *Head broken below jawline. Rear portion of head broken off in a flat plane. Break on left side. The nose and the bottom portion of both ears are missing. Surface is badly chipped and weathered, particularly on the right side. Calcium(?) residue encrusts the left side. There is dowel hole (2.2 cm.) cut into the top of the head.*

The round, fleshy contours of this female's head contrast with her relatively small features, giving the face a heavy countenance. The lips, though badly damaged, appear to have been small and full. The eyes are deep-set within delicately carved lids. The original surface of the hair, which is only preserved along the hairline, reveals detailed chisel work delineating wavy strands, which were parted in the middle and pulled straight back, partially covering the ears.

A veil appears to have covered the coiffure. Although no traces of carved drapery are visible, the rear portion of the head, behind the ears, is separated from the hair by an incision running from ear to ear across the top of the head. This area, carved as an unarticulated mass, preserves marks made by a claw chisel. The rough, unfinished workmanship contrasts with the carefully finished technique visible

throughout the hair and face. A veil made of separate material and attached to the head by the square hole could have covered the unworked area.

Several proportional irregularities favoring the right side of the face suggest that this sculpture may have originally been part of a relief. The hair sits higher above the right side of the face, which is given more surface area. On this side, too, the angle between the neck and jawbone is more clearly distinguished. The relative flatness of the rear section of the head and the planar break in this same area further the argument. Nevertheless, the poor preservation of the piece makes this conclusion tentative.

The sculpture was found in Daphne in a large villa dating to the Hellenistic period, with subsequent building phases spanning the second through sixth centuries A.D.[1] Excavators discovered the head in the northwest corner of a nymphaeum on the villa's southeast corner,[2] sealed in a fill of "tightly-packed brown earth" which covered several rooms and apparently accumulated following the destruction of the Hellenistic building by an earthquake. This level was apparently undisturbed by subsequent construction, which began in the second century A.D.[3] Other finds in this stratum dated between the late Hellenistic period and the second century A.D.[4]

The find-spot helps to provide a date for this piece, which should be assigned to the late Hellenistic period. Stylistically, it shares features with a portrait from Cyrenaica in the British Museum.[5] This sculpture or relief originally may have decorated one of the niches in the nymphaeum, which could explain the proportional anomalies found in the face.

MLL

BIBLIOGRAPHY
Stillwell 1941, 119, pl. 8, no. 285 (c89-S563).

NOTES
1. Stillwell 1941, 25.
2. Stillwell 1941, 259, plan VII, no. 1.
3. *Antioch Field Book*, 1939. Daphne 26-M/N. Room 1.
4. *Antioch Field Book*, 1939. Finds, 3–4.
5. Pryce 1937, 57–58, pl. XIXb, c.

50.

FEMALE HEAD

Probably late Hellenistic period, first century B.C.
Provenance: vicinity of Antioch/Seleuceia in Pieria; acquired in 1937 (Pa663-S438)
Material: fine-grained marble with blue veining
Dimensions: h. 22.4 cm., w. 16.8 cm., d. 20.2 cm.
Gift of the Committee for the Excavation of Antioch to Princeton University (2000-53)

CONDITION: *Oblique break through the neck. Face largely obliterated and flattened. Break in right part of hair knot and adjacent veil. Extensive wear, scratches, minor chipping; gray discoloration from burning.*

The statue from which this underlife-sized head of a woman was broken apparently stood in a niche or against a wall, since the back and right side are only roughly worked. The features are badly damaged, but

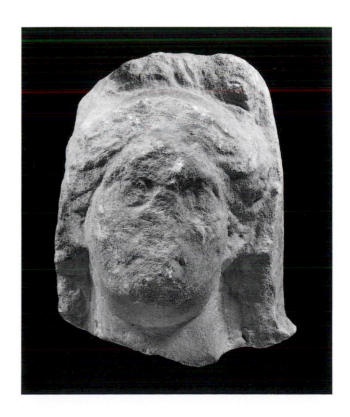

the woman has an oval face with fleshy, rounded chin; her eyes and brows are faintly discernible, as are the dimples at the corners of her mouth. Her long hair is parted in the center and combed back, but two tresses are pulled up and tied in a knot on top of the head. The topknot is separated from the hair over the forehead by a flat bandeau and is surmounted by the woman's mantle, drawn up like a veil. The woman turns to her left, and it is clear that this is the angle from which the statue was viewed, for the mantle on the right side is thicker than on the left and has a rough, unfinished surface. The artist further emphasized the woman's left profile by showing the left ear uncovered while concealing the right ear, when in reality a mantled head so turned would bring the right ear forward from beneath the mantle while moving the left ear back.

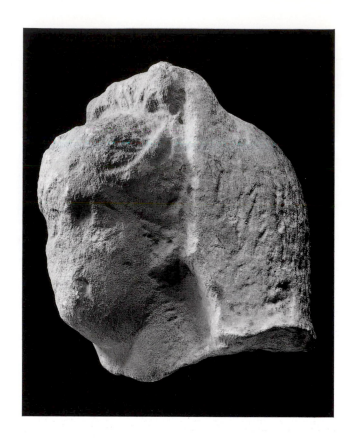

The prominent knot of hair on top of the head is a trait associated with Aphrodite as early as the late fourth century B.C., in statues of the Capitoline and Medici type, when it also appeared in portrayals of mortal women.[1] The mantle, a feature suggestive of matronly modesty, is unexpected in a statue of Aphrodite, but she does adopt such a garment on occasion, most notably in cult images of the Aphrodite of Aphrodisias.[2] In some depictions of Aphrodite holding Eros, her motherly role is underlined by showing her with mantled head.[3] The head from Antioch may also represent the goddess, or it may be an idealized portrait of a private individual as Aphrodite, one in which attributes reflecting different elements of her character are combined.

JMP

BIBLIOGRAPHY
Unpublished.

NOTES

1. Aphrodite of Capitoline and Medici types: *LIMC* 2:52–53, pls. 38–40, s.v. Aphrodite (A. Delivorrias). Cf. also the so-called Bartlett Head, in the Museum of Fine Arts, Boston, 03.743 (*LIMC* 2:107, pl. 107, no. 1061). For a topknot on a woman from a late-fourth-century funerary monument, see Vermeule 1981, 124, no. 95.
2. *LIMC* 2:151–54, pls. 154–56, s.v. Aphrodite (Aphrodisias) (R. Fleischer).
3. *LIMC* 2:119, pl. 124. In these cases, as in the cult image of Aphrodisias, Aphrodite does not wear her hair in a topknot.

51.

FRAGMENT OF A MASK

Perhaps late first or early second century A.D.
Provenance: Daphne-Harbie, sector 26/27-O (Pb52-S511);
acquired April 9, 1938
Material: fine-grained white marble
Dimensions: h. 12.5 cm., w. 7.0 cm., w. at knot 6.2 cm.,
d. 9.7 cm.
Gift of the Committee for the Excavation of Antioch to
Princeton University (2000-55)

CONDITION: *Fragment includes the top inner portion of the
left brow, the forehead and hair, half of the topknot, and a brief
continuation of the cranium behind. Behind and to the left of the
knot, the channel from a drill hole bisects the break. Rusty discol-
oration around the drill hole. Surface is weathered and discolored
by a brownish patina. A few small modern chips on the hair.*

This fragment, the upper left forehead and hair, orig-
inally formed part of a hollow figure. The concave
interior surface preserves rough gouges made by a
point. The skin and coiffure, in contrast, are carefully
finished, with a smooth, sharp brow beneath an un-
marked forehead. The hair is rendered in the "melon
coiffure," with sections of locks twisted and pulled
away from the brow line. At the center of the head,
a flat area remains uncarved and blank.[1] A topknot
of hair surmounts the crown. Shallow drilled holes
articulate the curly ends of the individual locks.
While those on the front are elaborate curlicues, on
the back they are more simply rendered, as triangular
locks. Behind the topknot, two parallel chisel marks
outline the position of a fillet. The hairstyle con-
tinues behind the band in two or three wavy but
perfunctory grooves.

The combination of the "melon coiffure" with a
topknot is a late development of a fourth-century B.C.
arrangement and does not appear on many sculp-
tures.[2] The hairstyle is, however, worn by the "Grey-
Haired Gossip" character, as described in Pollux's list
of New Comedy masks.[3] The Antiochean piece may
also have been a mask, used to decorate the interior
of one of the houses at Daphne. Hollowed marble
masks were found in Pompeii. These complete heads

measure ca. 25 cm. high, slightly double the preserved height of the fragment from Antioch. The Campanian examples feature drilled holes preserving iron hooks at the crowns of their heads, apparently used to suspend them between the columns of garden peristyles.[4] A similar rust-stained puncture is found behind the topknot of the Antioch fragment. The profile of the fragment suggests its use as a hanging object. The hair continues the upward vertical façade of the forehead, rather than angling gently back toward the crown of the head as is usually found in sculpture in the round.[5] Behind the topknot, the taenia and hair continue horizontally, nearly perpendicular to the front portion of the face. In addition, the space between the hairline and the topknot has been unnaturally compressed.

Archaeological context cannot help to establish a date for this piece.[6] Stylistic considerations, though, would place it in the Roman imperial period, perhaps in the late first or early second century A.D.[7]

MLL

BIBLIOGRAPHY
Unpublished.

NOTES

1. For similar treatment, see Karageorghis and Vermeule 1964, pl. 37, no. 1.
2. Thompson 1963, 43, with a single reference to a terracotta figurine from Priene.
3. Pollux 4.143–44 (no. 36); see Bernabò Brea 1981, 220.
4. Sogliano 1907, 590–93. For illustrations of the masks hanging in the peristyle, see 549, fig. 1, and 551–53, figs. 3–5.
5. For a similar type of "verticality," see the terracotta masks in Bernabò Brea 1981, 222, fig. 374.
6. The precise find-spot is not indicated in the excavation reports, which only note that the piece was found early in the season (Princeton Archive, inventory card, records the find on April 9, 1938). During this preliminary period, the excavators removed a dump located over area B-12 (Princeton Archive, *Antioch Field Notebook*, 1937–38, Daphne 26/27-0, Villa #5, 12/4/38). For the location of B-12, see the plan of Daphne 26/27-0 in Stillwell 1941, 259.
7. Compare, for instance, the hairstyle of a woman in the Capitoline Museum, Stanza degli Imperatori 23, inv. 441, dated to the late Trajanic period. The rendering of her curly front locks parallels the topknot, while the twisted sections in the rear match the Antioch fragment's "melon coiffure" (Fittschen and Zanker 1983–85, 3:52, no. 67, pl. 84).

52.

FEMALE HEAD

Probably Hadrianic, A.D. 117–138
Provenance: Daphne-Harbie, sector 20-N (theater),
May 20, 1934
Material: large-grained white marble
Dimensions: h. 24.3 cm., w. 17.8 cm., d. 22.7 cm.
Gift of the Committee for the Excavation of Antioch to
Princeton University (2000-51)

CONDITION: *Head broken off at chin. Lower features of the face broken in a flat area from the bridge of the nose to the jawbone. In the rear, the bun is broken off on the right side. Bottoms of earlobes both broken off. Extensive chipping along the brow line, cheeks, and throughout the coiffure. Weathering on sides of hair and face. Flat, finished areas flank the topknot. Surface is smooth and highly polished, perhaps resulting from modern acid cleaning.*

The woman's face is round and chunky, with half-closed, elliptical eyes. A shallow carved line separates the tear ducts from the eyeballs. The slightly drooping lids are sharply rendered, creating crisp transitions between the eyes, lids, and surrounding flesh. This hard, linear carving contrasts with the thick, frothy hair, which sits in a low mass on the woman's forehead.

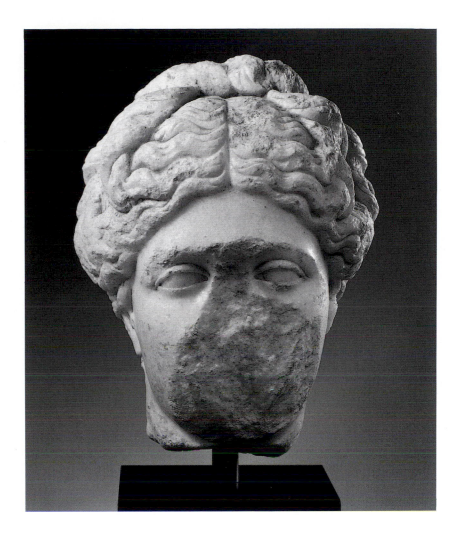

In the front section of the coiffure, drill work articulates heavy, wavy locks. These part in the middle, twist into two thick coils above the ears, and knot on the crown of the head. The loose ends, characteristic of this hairstyle, were apparently added onto finished oval platforms flanking the knot. While no traces of dowel holes remain, shallow drill marks ring the flat spaces, which could have facilitated adhesion of plaster or terracotta pigtails. Behind the topknot, a cursorily carved fillet circles the head and secures the coiffure. The rear segment of hair is elaborately braided, pulled straight back, and wound into a sketchily carved bun at the nape of the neck. Short tendrils of hair protrude at the temple and behind the ears; longer ones escape from the bun and curl down her neck. Remains of the neck indicate that the head sat straight upon the body. It is likely that the statue stood in a niche or against a wall, since the rear of the head is only roughly carved.

The topknot hairstyle became popular in late-fourth-century B.C. sculpture and was worn by a variety of female personae throughout antiquity.[1] It became particularly popular in the Roman period, when it was used on a number of different deities, both male and female. This version, in which the side wings are swept up from above the ears, is more unusual; generally the locks are gathered at the temples.[2] The idealized features and hairstyle indicate that this statue depicted a goddess, possibly Artemis or Aphrodite, who often wear this type of coiffure. The elaborate and specific coiffure, which does not match any known sculptural type, may indicate that the head depicted an individual in the guise of the goddess.[3] However, the preserved facial features are very idealized, and the damage to the lower portion of the face prevents further conjecture on this point.

The head was discovered in the theater at Daphne, in or near the west wall of the *scaenae frons*.[4] Fragments

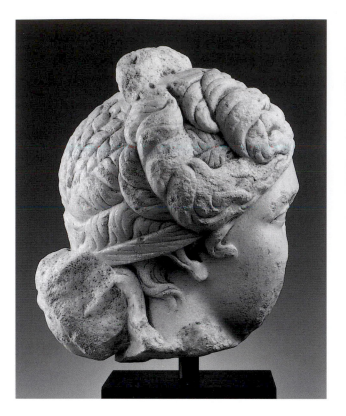

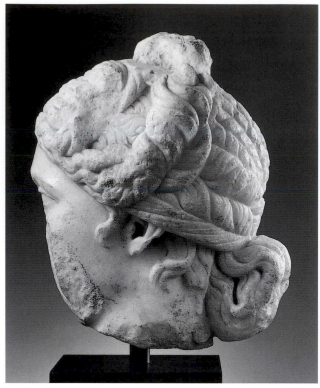

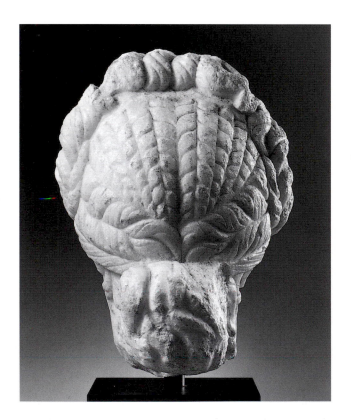

of additional sculptures were found in the same area.[5] The theater at Daphne was built in the fourth quarter of the first century A.D. A second phase of reconstruction followed the partial destruction of the building by an earthquake in A.D. 341.[6] Although the theater's unusually shallow stage and flat *scaenae frons* apparently lacked the niches traditionally used to display statuary,[7] many sculptures were found throughout the building.[8] Most of them, including this piece, were concentrated under the fourth-century paving, along with architectural elements destroyed by the earthquake.[9]

This sculpture probably belonged to the first construction although it was carved in the early second century. Stylistic and physical characteristics, including the rendering of the hair and the shape of the eyes, suggest a date in the Hadrianic period.[10] The heavy breakage on the lower portion of the face, along with the fragmentary state of the associated finds, indicates that it was among the pieces damaged in the seismic upheaval and subsequently discarded. It may have been found in an area of fill dated no earlier than the second century A.D. MLL

BIBLIOGRAPHY
Stillwell 1938, 172, pl. 9, no. 143 (4440-S201).

NOTES

1. Thompson 1963, 42–43.
2. Cf., for instance, the "Artemis Rospigliosi" in *LIMC* 2:646, pl. 468, no. 274, s.v. Artemis (L. Kahil).
3. For a discussion of this practice, see cat. no. 54 and Wrede 1981, passim.
4. Princeton University Archives: W. A. Campbell, F. O. Waage, J. Lassus and D. N. Wilber, *General Report on the Excavations at Antioch-on-the-Orontes for the Season of 1934,* p. 11; *Excavation Notebook, 1934,* Saturday, 19 May and Monday, 21 May, records that this piece was found in "trench T."
5. Sculptural fragments from trench T recorded in the *Excavation Notebook, 1934,* for Saturday, 19 May, and Monday, 21 May, include: the left arm and side of a draped torso (possibly 4447-S208; Stillwell 1938, 173, pl. 11, no. 151), a draped female torso (possibly 4442-S203; Stillwell 1938, 172, pl. 9, no. 145), a small hand holding an object (a foot?) (possibly 4454-S215; Stillwell 1938, 174, pl. 13, no. 168), a nude left shoulder with drapery (possibly 4448-S209; Stillwell 1938, 173, pl. 13, no. 152), a fragmentary head, and fragments of legs and drapery. While the torso of Artemis (6226-S345; Stillwell 1938, 173, pl. 12, no. 160) and a support for a statue of the Cnidian Aphrodite (4446-S207 [Princeton 2000-72; cat. no. 59]; Stillwell 1938, 173, pl. 11, no. 149) originated in the theater, they were not found in this trench, as indicated by Campbell et. al. (n. 4 above), 11.
6. For information on the theater, see Wilber 1938, 57–94.
7. Wilber 1938, 60.
8. Wilber 1938, 92.
9. Wilber 1938, 62. The fill under the theater does not date earlier than the second century A.D. (Stillwell 1938, 173).
10. The Antioch head compares well to a portrait from Perge, dated to this period: Inan and Alföldi-Rosenbaum 1979, 251, no. 229, pl. 163.2.

53.

FEMALE HEAD WITH DIADEM

Hadrianic, A.D. 117–138
Provenance: found at Yakto (near Antioch) and presented to the excavation, April 24, 1934
Material: medium-grained white marble
Dimensions: h. 19.9 cm., w. 19.8 cm., d. 18.1 cm.
Gift of the Committee for the Excavation of Antioch to Princeton University (2000-52)

CONDITION: *Broken at chin from mouth down. Right ear and drapery broken. Back of head is missing. Nose and eyebrows chipped. Left cheek is discolored, possibly due to bruising of the stone. Top of diadem on left broken and flattened; dowel hole drilled in flat area.*

This woman wears her wavy hair parted in the center, with the strands pulled loosely back from her face.

The individual strands of hair are separated by deep drilled channels. Twin wisps of hair escape from the mass of locks and adhere to her cheeks. A diadem secures a veil over her coiffure. This crown appears to have been fairly decorative, with a lower, pointed crest fronting the upper, rounded crescent. The diadem was repaired in antiquity, as indicated by a smooth, flattened area on its left side. A dowel hole

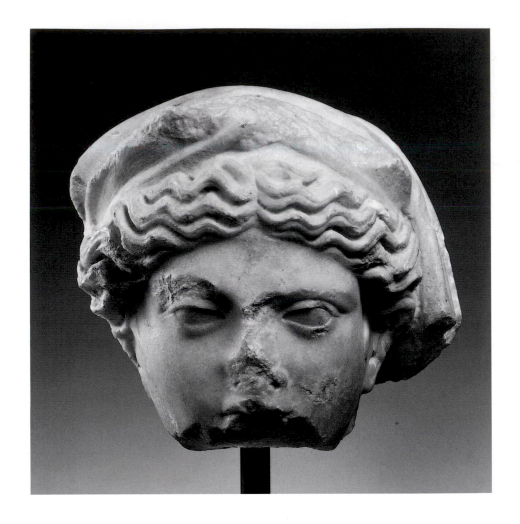

was drilled into the stone to secure a patch completing the headgear. A deep drilled furrow separates the diadem from the hair. The woman has narrow, ovate eyes. Careful attention has been paid to the eyelids, though the surface of the eye itself has not been articulated. Due to poor preservation, little can be said about the lower part of the face, except that it appears to have been rather narrow.

The idealized features indicate that this statue probably represented a goddess, possibly Hera or Demeter.[1] An identical, though more detailed, arrangement of locks is worn by a crowned (though unveiled) figure in the Academy of Art in Madrid.[2] The woman's hair is carved in wavy, tubelike strands which narrow to thin points around her forehead. The locks are separated by deep grooves. This treatment is seen on other Hadrianic statues, for instance,

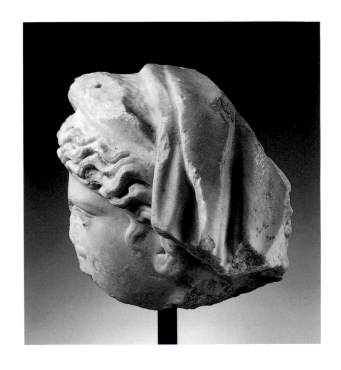

Caryatid no. 2236 from Hadrian's Villa at Tivoli.[3] The eyes of the Antioch sculpture, almond-shaped and crisp, recall those of a statue of Sabina from Perge.[4] These details suggest a date in the second quarter of the second century A.D. MLL

BIBLIOGRAPHY
Stillwell 1938, 178, pl. 22, no. 230 (3397-S119).

NOTES
1. Both goddesses are occasionally shown wearing the combination of a diadem with a veil. See, e.g., a painting of Hera from the House of the Tragic Poet at Pompeii (*LIMC* 4:684, pl. 416, no. 210, s.v. Hera [A. Kossatz-Deissmann]) or a statue of Demeter in the Ny Carlsberg Glyptotek, Copenhagen (inv. 703; *LIMC* 4:859, pl. 572, no. 143, s.v. Demeter [L. Beschi]).
2. *EA*, nos. 1781–82.
3. Schmidt 1973, pl. 9.
4. Inan and Rosenbaum 1966, 72, no. 36, pl. 22.

54.

COLOSSAL FEMALE HEAD

Late Antonine, late second century A.D.
Provenance: Seleuceia in Pieria; purchased July 7, 1938
Material: large-grained white marble
Dimensions: h. 36.8 cm., w. 27.5 cm., d. 27.4 cm.
Gift of the Committee for the Excavation of Antioch to Princeton University (2000-50)

CONDITION: *Head broken diagonally from neck across to left temple. Upper left side and back of head also broken. Nose, eyebrows, and lips badly chipped. Surface is badly weathered and discolored grayish brown. Discoloration is particularly prominent above forehead on left, and on the back of the sculpture. A large discolored crack runs diagonally across the right side of the forehead, extending into the hair. Similar cracks are seen on the right eye and along the left side of the nose.*

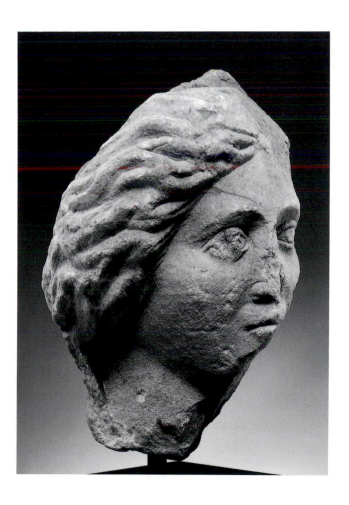

This colossal female head has a round, chubby face with small, protruding lips and bulging eyes. The eyes, surrounded by thick, fleshy lids, sit shallowly within semicircular arching eyebrows. Carved or drilled incisions indicate the iris and pupils. The woman's hair is rendered in clumpy, wavy locks separated by deeply recessed valleys. The coiffure is parted in the middle and drawn back away from the face. A running drill line delineates the border between the hair and flesh. This continues down both sides of the neck, suggesting that the hairstyle finished in a bun or ponytail. The poor preservation of most of the hair surface prevents a more detailed description.

The idealized features and loosely flowing hairstyle suggest that this woman represents a divinity

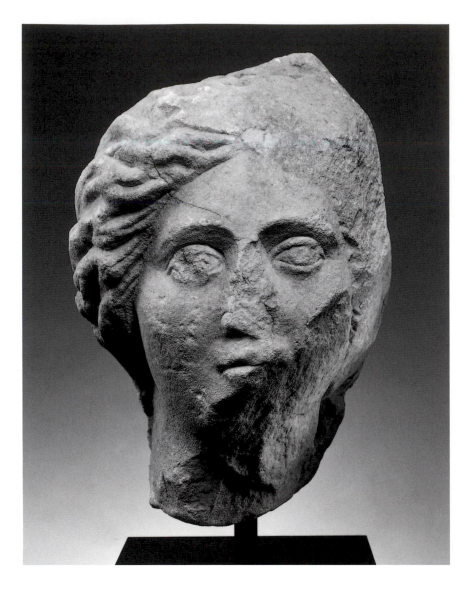

or personification. However, her drilled eyes and the treatment of her eyelids open the possibility that the head is a portrait depicting a woman as a goddess, perhaps Venus. A statue group from Ostia, now in the Museo Nazionale delle Terme, Rome, provides a parallel for the Antioch head, as well as a date.[1] A nude male figure, modeled on the Ares Borghese statue type, stands with a partially draped woman posed as the so-called Venus of Capua, who wears a diadem. The couple has been variously identified as Marcus Aurelius and Faustina the Younger, Commodus and Crispina, or private citizens who lived during the reign of Marcus Aurelius, ca. 175–180.[2] Statues of emperors and empresses in the guise of deities spurred private citizens to adopt this mode of representation, and depictions of common men

and women as Mars and Venus were especially popular during the Antonine period.[3] The head from Antioch may be one such representation. While the Antioch head lacks traces of a diadem, and her hair is more loosely bundled, her facial features echo those of the Venus from Ostia, suggesting a date in the late second century A.D. MLL

BIBLIOGRAPHY
Stillwell 1941, 122, pl. 8, no. 314 (Pb524-S549).

NOTES
1. Calza 1978, 19–20, pls. XI, XII.
2. See Wrede 1981, 133–34; Kleiner 1982, 281.
3. Wrede 1981, 133–36, 268–72, 306–23.

55.

FRAGMENT FROM A STATUE OF APHRODITE

*Hellenistic variant of the second or first century B.C. or a
Roman copy of the first or second century A.D.*
Provenance: purchased at Antioch, 1934
Material: medium-grained white marble, crystalline
*Dimensions: h. 33.5 cm., h. of base 5.4 cm., w. 24.3 cm.,
d. 16.5 cm., dowel hole 3.5 x 4 cm.*
*Gift of the Committee for the Excavation of Antioch to
Princeton University (2000-73)*

CONDITION: *Only the base and the lower legs of the figure
remain. The original curved edge of the base is visible on the left
side only. The right foot of the figure is broken away in the back
from the ankle to the bottom of the base. The big toe of the left foot
is missing. The nose and most of the left side of the dolphin from
its left eye to the tail are broken off. The surface is well polished;
most of the drapery folds, however, are chipped and worn.*

The fragment represents the lower legs of a draped
figure. The figure is standing with the weight on the
straight left leg while the right leg is bent slightly
and moved to the back. The drapery is pulled taut
across the right leg and gathered in the center, approx-
imately at hip height, thereby causing heavy folds to
fall vertically onto the base between the figure's feet.

The toes of the left foot are visible underneath the bottom edge of the drapery. Pressed against the left leg is a dolphin with its nose pointing down onto the base. A square dowel hole penetrates the back of the triangular support for the dolphin.

The fragment belongs to a known statue-type of Aphrodite, the half-dressed Aphrodite Pudica: the goddess gathers the drapery with her left hand in front to cover her lower body, while she holds her right hand in front of her breast. Numerous variants of the Pudica type are known, differing in such details as the side to which the goddess turns her head, the hand with which she holds the drapery, and the amount of drapery covering her. Three Roman copies, one in the Bardo Museum in Tunis, one in the Chevrier Collection, and one in Florence are similar to the Princeton piece.[1] In all copies and variants the dolphin seems to be the preferred strut, probably a reference to the goddess's birth from the sea. The date of the original is still debated and ranges from the second half of the fourth century to the second half of the second century B.C. It is also uncertain whether the original was the cult statue from the Temple of Aphrodite on Rhodes.[2] The Princeton piece, which possibly came from one of the many sanctuaries of Aphrodite in Daphne, could be a Hellenistic—second to first century B.C.—variant of the original or a Roman copy of the first century A.D. TN

BIBLIOGRAPHY
Stillwell 1938, 178, pl. 22, no. 233 (3781-35S)

NOTES
1. For the Aphrodite in Tunis, see *LIMC* 2:82, pl. 73, no. 737, s.v. Aphrodite (A. Delivorrias); Di Vita 1955, pl. 10.2. For the copy in the Chevrier collection, see Di Vita 1955, pl. 10.1. For the Vatican copy, see *EA*, no. 3713.
2. *LIMC* 2:82, s.v. Aphrodite.

56.

FRAGMENT OF EROS STANDING ON A DOLPHIN

First century A.D.
Provenance: Antioch, sector 16-P
Material: medium-grained white marble, crystalline
Dimensions: h. 5.1 cm., w. 1.8 cm., d. 3.2 cm.
Gift of the Committee for the Excavation of Antioch to
Princeton University (2000-66)

CONDITION: *Only the front of the left foot and the tip of the tail of the sea creature are preserved. The surface is slightly worn, with a few scratches on the left side, and bits of incrustation on the foot and inside the coiling tail.*

A left foot rests on the coiling, cleft tail of a sea creature.

 The tiny fragment may represent the foot of Eros standing on the tail of a dolphin. Both Eros and dolphins were associated with Aphrodite, and figures of Eros standing on or riding dolphins often functioned as struts for statues of the goddess.[1] The piece was found along with the cache of small arms and legs (cat. nos. 92 and 93) in a sculptor's workshop in sector 16-P of Antioch. The estimated destruction of the workshop in the second half of the first century A.D. provides a *terminus ante quem* for the fragment. TN

BIBLIOGRAPHY
Unpublished.

NOTE
 1. See for example *LIMC* 2:79 and 84, pls. 70, 74,
 and 75, nos. 697, 698, 749, 755, 757, s.v. Aphrodite
 (A. Delivorrias).

57.

Torso from a Statuette of Aphrodite Anadyomene

First—second century A.D.
Provenance: Daphne-Harbie, surface find, catalogued
April 10, 1937
Material: medium- to large-grained white marble
Dimensions: h. 13.0 cm., w. 14.5 cm., d. 8.1 cm.
Gift of the Committee for the Excavation of Antioch to
Princeton University (2000-76)

CONDITION: *This work is broken at the waist, the left shoulder, and the right breast. The head and the right arm, both now lost, originally were attached with dowels, sections of which survive in situ. A shallow hole has been worked on the left shoulder. Most surfaces show light scratching and abrasion. The stone is discolored, with a dull yellow patina. Further color is provided by a brown incrustation on the front, the back, and the bottom, as well as by rust stains around the two dowels.*

The piece depicts a nude adult female. Her left upper arm lay close by her side, while the right extended out horizontally from the shoulder. The torso bends slightly leftward in order to compensate for this outstretched limb. There is no evidence of any drapery or attributes. The figure appears somewhat heavy, with a thick chest and comparatively small breasts. Smooth, rounded lines dominate the carving, which is of fairly good quality.

The distinctive pose of the shoulders and arms identifies this sculpture as a variant of the Aphrodite Anadyomene type.[1] This composition, often associated with the famed painter Apelles, shows the goddess arranging her hair after first arising from the sea.[2] The Daphne-Harbie statuette, like most such figures, probably engaged both her hands in sorting a generous mass of tresses. None of the latter survive, although the small hole in the goddess's left shoulder suggests that at least some locks were added separately in bronze.[3]

The Anadyomene type itself originated in the Hellenistic age, an era of unprecedented interest in the artistic potential of the female nude. This particular example, however, comes from the later Roman

copy tradition. Although bereft of an exact archaeological context,[4] the general execution of the Daphne-Harbie torso, including a slightly simplified pose and the use of separately carved limbs, suggests a date somewhere in the early imperial period (first or second century A.D.). RJC

BIBLIOGRAPHY
Stillwell 1941, 123, no. 330, pl. 7 (Pa315-S396).

1. See *LIMC* 2: 54–56, pls. 40–43, s.v. Aphrodite, especially nos. 424 and 425. Further comparanda may be found in De Luca 1964, 213–25, pls. XLVIII–LV; and Dwyer 1982, 63–64, figs. 79, 189, 190.
2. Apelles is known to have painted a scene of Aphrodite emerging from the waves while wringing the sea foam from her hair. It is thought that this image provided the visual model which ultimately inspired sculptural compositions of this type. See Bieber 1961b, 21 and Robertson 1975, 493–94.
3. Professor B. S. Ridgway first proposed this explanation, after examining the shoulder of the piece.
4. The torso, first catalogued by the Antioch excavations on April 10, 1937, was a surface find from Daphne-Harbie.

58.

LOWER HALF OF A STATUE OF ISIS

Early second century A.D.
Provenance: Seleuceia in Pieria; found by a farmer in the area of trench 17/18-J
Material: medium- to large-grained white marble with gray veins, highly crystalline
Dimensions: h. 62.7 cm., w. at bottom 27.2 cm., w. at top 16 cm., d. at bottom 21.2 cm., d. at top (at central drapery fold) 14 cm., tenon hole 3.5 x 4 cm.
Gift of the Committee for the Excavation of Antioch to Princeton University (2000-81)

CONDITION: *Numerous scratches and abrasions from a plough or pickax cover the surface, especially on the left leg and along the top edge. Most of the folds of the garment are nicked and chipped. The bottom edge is rounded and smooth from wear. The front right surface is covered with gritty, sand-colored incrustations.*

The piece is the bottom half of a statue that was constructed in two parts; preserved are the lower torso and legs of a female figure. She stands with the weight on her right leg while the left leg is bent, a movement that has caused a slight thrust of her hip to the right. She wears a long chiton, the folds of which are barely visible through the shorter himation, worn on top. The himation has been gathered in a knot high on the now-missing upper torso, thus creating a straight, central fold that falls vertically from the figure's chest to her feet. Although this fold logically should end at the bottom of the himation,

it continues to the bottom of the statue as if incorporating the chiton as well. An overfold and two corners of the knotted himation are visible just below the top edge of the fragment. On the right, the himation extends slightly out from the side of the leg, as if being lifted up and away from the body. The top of the fragment is flat, with a square tenon hole in the center, for attachment of the upper part of the statue. The feet, now missing, were attached separately, as witnessed by the flat fittings underneath the folds of the drapery in front. The back is only perfunctorily carved, the drapery merely blocked out. The bottom of the base has been roughly flattened with a pointed chisel and parts of it are broken off, creating an unstable foundation, which once must have fit into a larger statue base.

The straight central folds that fall vertically from the female figure's chest to her feet indicate that the statue represented the Egyptian goddess Isis or a follower of her cult. Numerous statues, figurines, and relief sculpture representing Isis herself or women dressed in her image are known, with the himation draped over the right shoulder and tied in the characteristic Isis-knot between the breasts.[1] The stance of the type varies, as do the attributes. The Princeton variant, in which the goddess or her follower is standing with the weight on the right leg, the left slightly bent, and the hip pushed to the right, seems to have been quite popular, especially in relief.[2] Commonly the figure holds a *situla* in the left hand and a *sistrum* in the right; more rare are representations in which she lifts the himation with her right hand, thus creating an outer fold, as in the Princeton example.[3] The extremely regular, almost stylized, folds of the himation on the right side, similar to representations of Isis in Egypt, show the artist's attempt to "Egyptianize" the statue.[4] The flat, dough-like quality of the folds of the himation, through which the underlying drapery barely shows, are characteristic of Roman representations of Isis of the early second century A.D.[5]

Little is known about the cult of Isis at Antioch; thus far, no structure has been unearthed in the area of Antioch that can be identified as a sanctuary or temple to Isis. However, the discovery of several lamp attachments in the shape of busts of the goddess and

of mosaics depicting Isiac rituals suggests that she was as popular in Antioch as in the rest of the Roman empire.[6] Evidence that her cult may have existed in Antioch as early as the Hellenistic period is provided by literary sources, according to which Seleucus IV had an image of the Egyptian goddess brought from Memphis to Antioch.[7] TN

BIBLIOGRAPHY
Stillwell 1941, 121, pl. 2, no. 307 (a1005-S465bis).

NOTES

1. See, e.g., Eingartner 1991, figs. 9, 12, 13, 17, 20, 21, 24, 25, 30(1)-32, 34, 108, 110, 112, 114, 118, 119, and 121.

2. See, e.g. Arslan 1997, figs. III.6, VI.32; and Eingartner 1991, figs. 101, 103–4, 108.1–116.

3. Cf. a Hellenistic relief from Rhodes in the British Museum: Arslan 1997, fig. III.6; Eingartner 1991, fig. 7. The outer fold on the right is usually created by the overflow of the himation behind the figure's back: cf. Eingartner 1991, figs. 6, 11–13, 16–17, 20–23, 30.1, 31, 33.1, 34–36.

4. For Egyptian and "Egyptianizing" statues of Isis or Egyptian queens, see Dunand 1973, pls. 8.1–2, 9.1 and 13.1.

5. See, e.g., Eingartner 1991, figs. 11–12, 25, 31–34, and 147.

6. Waage 1934, 62. Eight busts of Isis and twelve of Serapis were discovered in the 1932 excavations, all dating to the end of the first and the beginning of the second century A.D. For the two mosaics from Antioch depicting Isiac rites, see Witt 1997, figs. 34 and 35.

7. Libanius, *Orationes* 11.114.

59.

Fragment of the Knidian Aphrodite

Roman copy (first or second century A.D.) of a Hellenistic variant
Provenance: Daphne-Harbie 20-N (theater); found in an aqueduct near the gutter of the orchestra with fill dating not later than the second century A.D., in May 1934.
Material: large-grained white marble, highly crystalline
Dimensions: h. 56.6 cm., h. of hydria 20 cm., w. at base 17.5 cm., w. at top 10.5 cm., d. at base 16.6 cm., d. at top 9.2 cm., distance from base to center of dowel hole 43 cm.
Gift of the Committee for the Excavation of Antioch to Princeton University (2000-72)

CONDITION: *The fragment is broken horizontally at the narrowest point of the top. The base has been broken away in front and on the right. Most drapery tips are chipped and worn; one large fold is missing in front above the hydria. The hydria is complete except for part of the base. A large dowel hole appears on the top right side where the fragment would have been attached to the statue itself. The surface is polished smooth.*

Long, perpendicular folds fall in overlapping sections over a plain, undecorated hydria, covering its top and sides. A corner of the cloth, adorned with a small round pendant, hangs in front of the vessel. The drapery on the back is smoothed out.

The drapery and the hydria once functioned as a strut for a replica of the famous fourth-century statue of the Knidian Aphrodite by Praxiteles. The naked figure of Aphrodite would have held the drapery in her left hand, having just disrobed for a bath, as suggested by the hydria. The long, straight folds of the drapery and the small size of the undecorated hydria are similar to copies of the Venus Belvedere type, traditionally considered a Hellenistic variant of the original, in the Vatican, in Rome (Museo Nazionale delle Terme), and in Munich.[1] In copies of this type, Aphrodite lifts the drapery close to her body instead of lowering it onto the hydria, a characteristic of the so-called Venus Colonna type.[2] As in the Princeton fragment, drapery folds in versions of the Venus Belvedere type consequently are longer and fall

straighter than in copies of the Venus Colonna type. The hydria in Princeton is stylistically closest to a well-preserved copy in the Museo Torlonia in Rome, while the drapery is similar to that of the Venus Belvedere in the Vatican, which has been dated to the second century A.D.[3]

Stillwell suggested that the drapery fragment belonged with a torso of Aphrodite, also found in trench 20-N in the theater in May 1934.[4] He realized, however, that no join could be made between the two and that the dowel hole in the hydria fragment had no corresponding cutting in the left leg of the torso.[5] The fragments therefore probably belonged to two separate statues. The discovery of a third copy of the bathing goddess in Daphne in 1937 is indicative of the popularity of the type in antiquity.[6] Its occurrence in Daphne seems especially appropriate, since the area was famous not only for its ample water supply, and consequently its public baths and luxurious villas with lush gardens and fountains, but also for its numerous sanctuaries of Aphrodite.

TN

BIBLIOGRAPHY
Stillwell 1938, 173, pl. II, no. 149 (4446-S207).

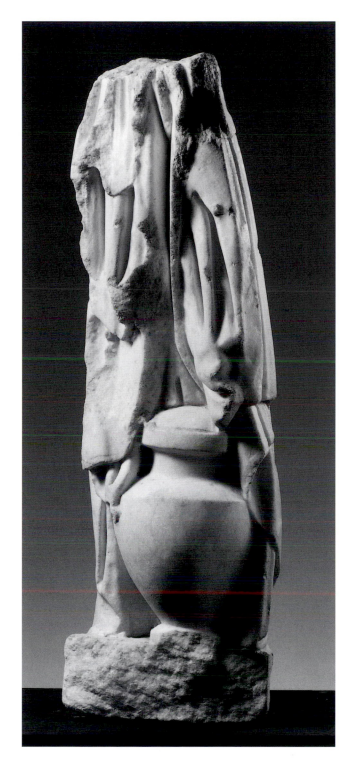
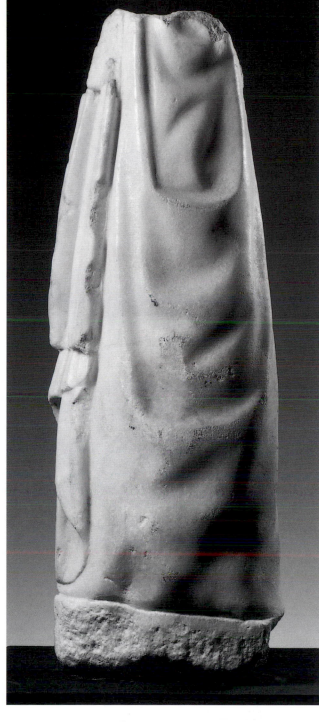

NOTES

1. Closuit 1978, nos. 6, 21, and 11. For a summary of the
 discussion on the original Praxitelean type and its
 variants, see *LIMC* 2:49–54, s.v. Aphrodite (A. Deli-
 vorrias), with bibliography.
2. The "Venus Colonna" type, named after a statue in
 the Vatican, has traditionally been considered the most
 reliable copy of the Praxitelean original (*LIMC* 2:50,

pl. 36, no. 391, s.v. Aphrodite). Against this theory is
 Pfrommer 1985, 173–80.
3. Closuit 1978, nos. 8 and 6; Blinkenberg 1933, 148–50,
 no. I 12; 131–41, no. I 3.
4. Stillwell 1938, 173, pl. 11, no. 148.
5. Stillwell 1938, 173, no. 149, note.
6. Stillwell 1941, 121, pl. 5, no. 299. For a list of extant
 examples of the Aphrodite, see Closuit 1978, 27–34.

60.

Lower Legs of a Draped Female Figure

Probably second—third century A.D.
Provenance: Antioch, sector 13-s (written on sculpture), April
1936 (P6239-S422)
Material: fine-grained white marble
Dimensions: h. 24.0 cm., h. of base 4.9 cm., w. at top
15.2 cm., d. 15.5 cm., d. at base 14.6 cm.
Gift of the Committee for the Excavation of Antioch to
Princeton University (2000-74)

CONDITION: *The fragment is broken just above the knees.*
Both feet, which would have been visible underneath the drapery,
are broken off. The edge of the circular or oval base is broken all
around except for a small section in the back. The surface is
chipped and worn throughout, with noticeable damage to the right
knee and the back of the himation. Weathering on the surface has
left the material a creamy tan color, the front mottled with dark
spots. A black stain on the back indicates that the figure was in
contact with fire or burnt soil.

The statuette represented a standing female draped
in a long chiton, the thin, deeply cut folds of which
are visible underneath the hem of a heavier himation.
She is posed with her weight on her left leg, while
her right leg is relaxed and flexed; the preserved right
heel shows that she was wearing thick-soled shoes.
The back of the figure is much less detailed, with
very shallow drapery folds.

Although the posture and the draping of the lower
body preserved by this fragment originate in the fifth
century B.C.,[1] this figure was rendered in a fourth-
century type. The folds of the himation that run
diagonally up from the right ankle, combined with
those of the lower left edge of the himation, suggest
that this female was draped in a manner similar to
that of Demokratia, the personification of democracy,
in a well-known document relief from the Athenian
Agora, datable to 337/6 B.C.[2] Numerous variations of

the type were produced in the Hellenistic and Roman periods.[3] This particular figure could have been standing alone or as part of a group.[4] NP

BIBLIOGRAPHY
Unpublished.

NOTES
1. E.g., Nemesis of Rhamnous by Agorakritos: see Stewart 1990, 2: pls. 403, 404.
2. See Boardman 1998, fig. 150.
3. Hellenistic: see Linfert 1976, T. 56, no. 299 (early third century B.C.). Roman: Rose 1997, pl. 60 (Antonia II, mother of Claudius). See also Filges 1997, figs. 7, 15, 108.
4. For example, Budde and Nicholls 1967, 44–45, no. 77 (pl. 23): a goddess with Eros.

61.

BUST OF ISIS

Second century A.D.
Provenance: Antioch; acquired in 1937 ("not from the excavations")
Material: dark gray marble
Dimensions: h. 13.4 cm., w. 95 cm., d. 6.5 cm.
Gift of the Committee for the Excavation of Antioch to Princeton University (2000-59)

CONDITION: *Only part of the neck, the left shoulder, and the left breast down to the waist are preserved. The surface is worn, scratched, and covered with a thin layer of light gray incrustation.*

The fragment represents a bust of a female figure. She is dressed in a thin chiton pulled taut over the breast by a belt or a drapery fold tied underneath. A himation is draped over the left shoulder. The ends of corkscrew curls falling onto the shoulders appear in front and back. The bust is rounded and hollowed out in the back. On top of the neck, a dowel hole for insertion of the now missing head is visible.

The corkscrew curls and the himation, which was draped over the left shoulder and tied underneath the breasts, identify this fragment as a bust of Isis. Busts of the Egyptian goddess, of varying materials, were popular throughout the Roman empire.[1] In Antioch alone, eight terracotta lamp attachments in the shape of Isis-busts were found.[2] Often discovered or depicted together with busts of Sarapis, these small busts were probably used in private household shrines or as traveling cult statues. Gray marble was often

used by sculptors to represent dark-skinned persons and not infrequently, especially in the second century A.D., employed to depict Egyptian gods, priests, or cult followers.[3] (Cat. nos. 94 and 95 from Antioch are of a similar gray marble, which may have been imported.) The rudimentary carving of the curls and the deep cutting of the himation folds indicate that the Princeton bust dates to the second century A.D.[4]

. TN

BIBLIOGRAPHY
Stillwell 1941, 122, pl. 7, no. 320 (Pa391-S401).

62.

FEMALE TORSO

Later second or third century A.D., probably after Greek prototypes from the second half of the fifth century B.C.
Provenance: Antioch, sector 14-R
Material: medium-grained white marble
Dimensions: h. 13.8 cm., w. 16.7 cm., d. 12.8 cm.
Gift of the Committee for the Excavation of Antioch to Princeton University (2000-77)

CONDITION: *A long break runs diagonally from the right shoulder to the left breast before turning up across the left biceps. The head and the tip of the left shoulder also are lost. There is moderate to heavy chipping along the right side and on the raised folds of drapery. The surface, which retains many tool marks, was never smoothed fully. It now shows moderate abrasion, as well as scattered accretions and iron stains (especially on the left arm). The stone is discolored and appears a brownish gray.*

The piece portrays the upper torso of a woman wearing a peplos. She seems to have held her left arm at her side, but the pose otherwise remains unclear. The proportions are buxom, with a stout chest paired to a relatively slender neck. Her garment generally has a strong linear structure but shows two quite contrasting textures. Its thick, heavy edges stand out in high relief and receive their own articulation with deep drill channels. The material over the breast, however, appears fairly thin and is molded around the curve of the body. The carving is of fair quality, but the work lacks flair. Its overall appearance seems heavy, with an emphasis on simplified forms.

The presence of the peplos suggests that this piece either copies or draws inspiration from an earlier Greek prototype. This garment was quite common in works of the high Classical period but fell out of general favor during Hellenistic times.[1] The stylistic qualities of this particular example (a formal linear structure contrasted with an increasingly thin and revealing fabric) point to a model made somewhere in the last half of the fifth century B.C.[2] Although the exact function of the piece remains unknown, it probably portrays an ideal or divine figure.

There is little information on the archaeological context of the torso,[3] but its execution certainly appears late. The thick, stylized borders and prominent drill channels on the peplos, for example, suggest a date somewhere in the later second or third century A.D.

RJC

NOTES
1. See Arslan 1997, figs. IV.5 (faience), V.122 (bronze), V.126 (terracotta lamp attachment), V.148 (alabaster), V.201 (bronze), VI.2 (bronze), VI.8 (bronze), VI.18 (bronze); and Eingartner 1991, figs. 74–79 (all of marble except fig. 76 [limestone] and fig. 77 [alabaster]).
2. Waage 1934, 62.
3. Anderson and Nista 1989, 67.
4. Compare with Eingartner 1991, fig. 77; and *LIMC* 5:768 and 775, pls. 504 and 512, nos. 58 and 197, s.v. Isis (T.T. Tinh). A second-century dating was kindly suggested to me by Professor B. S. Ridgway.

BIBLIOGRAPHY
Unpublished.

NOTES

1. See Stewart 1990, 77. Although not in general use, the peplos was employed in later times for a few specific subjects, such as images of the goddess Athena.

2. It was only in the later fifth century B.C. that the previously heavy and opaque peplos really began to show the underlying body (see Stewart 1990, 77). The Antioch torso appears to reflect this phase of transition because it preserves many of the earlier formal qualities while exploring the expressive potential of the new trend toward thinner, clinging fabrics. Useful comparanda include such noted works as the pedimental sculptures from the Parthenon, especially on the East façade (ca. 438–432 B.C.), for which see Stewart 1990, 152–54 (fig. 349), and the Maidens' Porch from the Erechtheion (ca. 420–415 B.C.), for which see Stewart 1990, 167–68 (figs. 431–32).

3. There is no find card or any other identifiable reference in the excavation archives at Princeton. The only information on the provenance of the torso comes from a cryptic painted label, which refers to excavation area "14-r."

63.

TORSO OF A DRAPED FEMALE FIGURE

First—second century A.D.
*Provenance: Seleuceia in Pieria; acquired July 18, 1937
("not from the excavations")*
Material: medium- to large-grained white marble
Dimensions: h. 17.9 cm., w. 19.1 cm., d. 8.6 cm.
*Gift of the Committee for the Excavation of Antioch to
Princeton University (2000-75)*

CONDITION: *The lower part of the figure is broken off just
below the abdomen, part of which is chipped off. The right arm
and shoulder, and the hand and lower forearm of the figure's left
arm are missing. The socket for the insertion of the head (now
missing) has irregular edges, parts of which display fresh breaks.
The back of the figure was roughly flattened with a pointed chisel.
Much of the surface is chipped and worn.*

The fragment is the torso of a female figure, clad in
a chiton that falls in slender folds from the shoulders
over the breasts. Below the breasts a belt creates an
overfold on the sides and causes the chiton to cling
tightly to the swelling breasts. The neckline of the
chiton in front provides a suitable edge for the socket
of the head. A himation, draped over the figure's left
shoulder, falls between her body and her left arm
in vertical and zigzag folds. The hips and the shoul-
ders are pushed slightly to the figure's left, creating a
curve that is delineated by the folds of the chiton on
the right side of the body. These folds are arranged
diagonally from the right toward the figure's left hip,
which indicates that they are pushed aside by a for-
ward movement of the right thigh. This movement,
together with the general curve of the body, signals
a standing posture for the figure, with the weight
given to her left leg while the right leg is relaxed. The
placement of the left arm indicates that the woman
may be supporting herself on a feature, the upper-
most contours of which are barely visible underneath
her left forearm.

The statuette is a small-scale replica of the so-
called Tiepolo type of Aphrodite.[1] It is thus to be
restored as a standing female with her weight on her

left leg and the right leg in a relaxed position. The
slight motion latent in this posture causes a tilt of
the hips, which is evident in the drapery of this figure
below the breasts. The left arm is bent with the left
hand (now missing) sensuously resting above the
hip. This type was reproduced in many replicas—
mostly statuettes—found in Rhodes and its vicinity.[2]
A. Linfert has suggested that they all copy a Rhodian
cult statue of Aphrodite dating to the first quarter of
the second century B.C.[3] That this statuette is a pre-
cise, though unassuming, replica of the main type is
suggested by the V-shaped fold between the breasts
and the patterned folds of the himation, features
shared by most replicas of this type. NP

BIBLIOGRAPHY
Stillwell 1941, 122, pl. 7, no. 321 (P1013-S463).

NOTES
1. Linfert 1976, 156–58, pl. 70, 383–85.
2. See Linfert 1976, 157, nn. 620–23; see also Laurenzi
 1939, 57–65 and Gualandi 1969, 233–72.
3. See Linfert 1976. Contra: Zagdoun (1978, 311–13), who
 posits a prototype of Athenian origin dating to ca. 300 B.C.

64.

FEMALE TORSO

Second–third century A.D.
Provenance: vicinity of Antioch/Seleuceia in Pieria; acquired
June 23, 1937
Material: medium-grained white marble (Thasian?)
Dimensions: h. 8.6 cm., w. 4.8 cm., d. 2.9 cm.
Gift of the Committee for the Excavation of Antioch to
Princeton University (2000-80)

CONDITION: *Flat break through the center of the body,*
preserving the left side of the torso from neck to waist. Sloping
horizontal break through waist. Left forearm missing. Scratches
and general wear; grayish patina.

Although it now lies flat, this small torso was appar-
ently broken from a statuette, for the missing left
forearm originally protruded in the round, and what
remains of the back, behind the left shoulder and
arm, is unworked, and would have been partially
visible in a relief. None of the woman's flesh is pre-
served, only drapery. She wears a chiton secured by a
broad belt decorated with two diagonal slashes that
run counter to the surrounding folds. The belt pulls
the garment tight over the left breast, the form of
which is correspondingly accentuated. Over the chi-
ton, the woman wears a bulky himation that hangs
over her left shoulder. The diagonal folds below the
neck must belong to the himation, but the equally
heavy folds beneath the belt cannot, since the tail of
the himation hangs down inside the left arm. The
belt is unusually wide for a chiton, but himatia are
not belted; were this not so, one might believe that
only a single garment is represented. JMP

BIBLIOGRAPHY
Unpublished.

65.

Pair of Fragments from a Draped Figure

Probably first century A.D.
Provenance: Daphne-Harbie; acquired in 1937
Material: medium-grained white marble with slight bluish cast
Dimensions: (a) h. 46.8 cm., w. 31.0 cm., d. 20.8 cm.
(b) h. 27.5 cm., w. 25.3 cm., d. 27.4 cm.
Gift of the Committee for the Excavation of Antioch to Princeton University (2000-82a-b)

CONDITION: *The larger fragment (a) has irregular breaks along its left side and bottom, the latter sloping sharply down to proper left. The flat break through the left arm is flush with the adjacent drapery; the even, rectangular break in the flat background above the arm follows its downward slope. The smaller fragment (b) has relatively flat breaks on the top, bottom, and proper right sides; part of the drapery is preserved on the upper left side, but below this is an irregular break. There are numerous chips and abrasions, ancient and modern, in the drapery folds on both fragments; all the major breaks are ancient and have the same yellowish brown incrustation as the carved surfaces. The back of the larger fragment is roughly picked and is more eroded and more heavily encrusted than the front. The quality of the carving is good, the deep drapery folds not merely drilled but carefully modeled and polished.*

Although these two fragments from draped figures do not join, their material, condition, and patina, along with certain carved details, suggest that they may derive from the same monumental statue. On the larger fragment (a) the folds of a himation hang from the upper part of a raised left arm; the lower arm is broken off at the point where it emerged from the drapery. The break just above and behind the arm shows that there was a flat, slablike background at this point, extending laterally to the elbow, where it terminated: its vertical edge is preserved down the left side, behind the pendant drapery.

The orientation of the drapery on the smaller fragment (b) is more difficult to reconstruct. Tension folds converge near the upper left corner, where they disappear beneath a lateral fold; one thinks of the bunched drapery beneath the arm of Asklepios in

representations going back to the fourth century B.C.[1] If the two fragments do indeed come from the same statue, then the parallel folds on the left side of the smaller piece may represent the continuation of the drapery that hangs down both sides of the arm above; the smaller fragment would therefore likely have originated in the area of the figure's left hip. Arguing against this interpretation is the larger fragment's combination of a background slab with a lower left arm carved in the round, a hybrid technique unsuitable for a standing figure but known from sculpted depictions of the enthroned Sarapis, in which the back of the throne extends above the god's shoulders and behind his head, while the left arm, raised to hold a scepter, is carved in the round.[2] The colossal scale of the fragments from Daphne points to a god or some other divine figure (e.g., an empress), and the evidence strongly suggests that this deity was seated on a throne. The lack of attributes, however, makes it impossible to establish even the sex, let alone his or her identity. JMP

BIBLIOGRAPHY
Stillwell 1941, 123, pl. 7, nos. 331–32 (Pa791-S441 and Pa792-442).

NOTES
1. E.g., St. Petersburg A 224; *LIMC* 2:870, pl. 634, no. 33, s.v. Asklepios (B. Holzmann).
2. For some examples, see *LIMC* 7:669, pl. 504, nos. 8c, 9, 10b, s.v. Sarapis (G. Clerc and L. Leclant).

66.

FEMALE SHOULDER

Possibly first century A.D.
Provenance: Seleuceia in Pieria, sector 19-J
Material: medium- to large-grained white marble
Dimensions: h. 7.9 cm., w. 17.6 cm., d. 14.1 cm.
Gift of the Committee for the Excavation of Antioch to
Princeton University (2000-78)

CONDITION: *The piece is broken unevenly along the bottom*
and the left side, leaving the fragment with a roughly triangular
profile. Some cracking is visible on the bottom face. The sculpture
appears weathered, with considerable wear and abrasion marking
its grainy surface. A beige patina covers the stone.

The fragment depicts the corner of a woman's right
shoulder. This figure wears an ionic chiton, whose
buttoned seam forms the dominant surviving feature.
Its appearance is delicate, with thin, clinging fabric
that divides into many fine folds. The shallow carv-
ing, although now somewhat battered, displays both
skill and sensitivity.

The precise subject of this piece remains obscure,
but its distinctive drapery indicates clearly the influ-
ence of Classical Greek prototypes. Such clinging,
diaphanous fabrics were characteristic of the so-called
rich style, which began in the late fifth century B.C.
Indeed, the style of this particular fragment com-
pares fairly well with other Roman works inspired
by that same period.[1]

Unfortunately, the very authenticity of this "copy"
makes its own origins all the more difficult to deter-
mine, especially in the absence of detailed archaeo-
logical data.[2] The fine modeling and lack of drill
work are suggestive of the earlier empire, but noth-
ing certain can be said without further evidence.

 RJC

BIBLIOGRAPHY
Unpublished.

NOTES
1. A Roman adaptation of one of the parapet slabs from
 the Temple of Athena Nike on the Athenian Acropo-
 lis (ca. 420–400 B.C.), for example, shows the goddess
 wearing an extremely similar garment; see Stewart
 1990, fig. 422. It must be noted, however, that while
 such general stylistic parallels can show the influence
 of Classical models on a piece, they, of themselves,
 cannot prove that it copies a specific Greek work.
2. No written record of this piece survives in the excava-
 tion archives. The sculpture itself, however, is marked
 with the general area and context of its discovery:
 "S[eleucia, quadrant] 19j, gate surface."

67.

PLASTER HEAD OF AN ATHLETE(?)

Hellenistic or early Roman, second century B.C.—
first century A.D.
Provenance: found in Seleuceia in Pieria, sector 19-K,
excavation 2, around the "Painted Floor," May 20, 1938
Material: gypsum plaster ("plaster of Paris")
Dimensions: h. 24.9 cm., w. 16.8 cm., d. 11.6 cm.
Gift of the Committee for the Excavation of Antioch to
Princeton University (2000-120)

CONDITION: *The head is broken at the neck. Its left side has melted away, and a concave depression hollows the lower section of this side of the neck. The right side is poorly preserved, with the hair and the right ear visible as soft masses of the skull. While the top of the forehead and the bottom of the chin have survived, the rest of the profile has been worn away. Numerous air holes pock the surface. Stillwell observed traces of red pigment on one of the locks of hair;[1] this coloring is no longer visible. There is a modern scratch along the cheek.*

Because of its delicate nature, few plaster sculptures in the round have survived. In antiquity, plaster was used primarily to provide three-dimensional versions of works of art from which to produce copies.[2] A plaster or wax mold would be taken from workshops, where a positive would be made in plaster. Using a pointing or triangulating technique, a sculptor would reproduce the contours of the original, modifying it as necessary. The models could be reused; only rarely were they distributed to the commissioners of the finished sculptures.[3] Workshops producing minor arts, such as worked or sculpted metal, used plaster molds and casts to record their designs—a type of three-dimensional pattern book.[4] As works of art in their own right, plaster casts were primarily restricted to death masks, which reproduced the features of the deceased in negative or positive. The surviving examples are often found in tombs or catacombs, although they may have been displayed in upper-class Roman households during the imperial period.[5] Archaeological evidence for decorative plaster sculpture in the round is slim, although the Roman satyrist Juvenal, writing around A.D. 100, condescendingly

speaks of uneducated men who cram their houses with plaster casts of philosophers.[6]

The Princeton head, which was found in a domestic context, may be an example of such decorative plaster sculpture. The man's short, curly hairstyle may identify him as an athlete, although gods and private individuals could appear with similar coiffeurs.[7] The piece probably would have been covered with a thin coat of finer plaster, which would have provided a smooth, detailed surface.[8] The indented area on the left side of the figure's neck, identified by Stillwell as the sweeping marks of the caster's fingers,[9] more likely resulted from the deterioration of the surface.

Other finds from the "Painted Floor," an area near the "House of Cilicia,"[10] include several Hellenistic coins and pottery fragments from the Hellenistic and early Roman period.[11] It would seem logical to assign this date to the plaster head. MLL

BIBLIOGRAPHY
Stillwell 1941, 122, no. 313 (b311-S538).

NOTES

1. Stillwell 1941, 122.
2. Two major troves of ancient plasterworks, found at Baia in Italy and Sabratha in Libya, appear to have served this purpose. See Landwhehr 1985 and Barone 1994.
3. Barone 1994, 9–16.
4. This seems to be the motivation behind a series of plaster reliefs and molds from Egypt found in Begram, Afghanistan; see Kurz 1954.
5. D'Alessandro and Persegati 1987, 47–60; the use of wax masks in the atria of Roman houses is described by Pliny (*Natural History* 35.2) and Polybius (*Histories* 6.53.1–54.2).
6. Juvenal, 2.4.
7. See, e.g., the Diskobolos attributed to the sculptor Naukydes (Paris, Louvre MA 89): Stewart 1990, fig. 442. The hairstyle is also worn by Hermes in the group of the god with the baby Dionysos, attributed to Praxiteles, in the Olympia Museum (Stewart 1990, fig. 607); and the youth on the funerary stele from Ilissos (Athens National Museum 869; Stewart 1990, fig. 517).
8. For a similar casting method, see Landwhehr 1985, 116, pls. 66, 67 a–c.
9. Stillwell 1941, 122.
10. References to the "Painted Floor" appear throughout the *Antioch Field Book, 1938*, although its location is never shown on a plan. The area was located on the acropolis of Seleuceia, and evidently was discovered after the excavation of the House of Cilicia, which appears in the excavation notebook as "excavation 1." The "Painted Floor" (excavation 2) seems to have been an interior room opening onto one of the north-south streets (Princeton University Archives, *Antioch Field Book, 1938*). For information on the House of Cilicia, see Stillwell 1941, 5 and Levi 1947, 57–58.
11. *Antioch Field Book, 1938*, Seleuceia, Finds, 6.

68.

HEAD OF A SATYR WITH THE HAND OF A HERMAPHRODITE

Roman copy (second-century A.D.) of a Hellenistic original
Provenance: Daphne-Harbie, sector 20-N (theater),
April 1935
Material: medium-grained white marble, highly crystalline
Dimensions: h. 23.6 cm., w. 18.4 cm., d. 18.3 cm.
Gift of the Committee for the Excavation of Antioch to
Princeton University (2000-49)

CONDITION: *The fragment was broken and mended with iron dowels in antiquity. It was found in six pieces in 1935 and reassembled in 1995. The preserved area includes parts of the hair and beard of the satyr, as well as part of the nape of his neck, his forehead, nose, and left eye. Of the hermaphrodite only the base of the hand, plus the ring and pinky finger remain. The preserved surface is well polished. Large, reddish brown rust stains appear on the skin and hair of the satyr, especially in the areas near the dowel holes.*

The fragment consists of the head of a bearded satyr against whose face a small hand is pressed. The satyr's wild locks of hair rise high from his forehead and are held with a band which is visible only on the right side of his head and in the back. Strands of his curly beard fall down his chin and overlap the dainty hand placed over his mouth and nose. Two small horns (one missing) appear in the satyr's hairline just above his frowning forehead. The hair of the satyr and the fingers of the hermaphrodite are separated by drilled grooves, while the individual locks, the fingernails, and the details of the eye are carefully carved. Three

dowel holes appear on top of the flat area onto which the top of the satyr's head would have been attached. Two other dowel holes are visible, one inside the head near the area of the now-missing right ear of the satyr, and one in the hairline for attachment of the right horn. While some of the dowels were used to attach pieces of marble to the main sculpture when it was first carved, the position of others indicates that the piece was repaired in antiquity.

Enough remains of the fragment to identify it as having belonged to a copy of a famous statue group that represented a *symplegma*, or entanglement, of a

seemingly between a nymph and a satyr, provided protection against the envious Evil Eye.[5] It thus represented a serious conflict rather than a playful one, which is how it is most often interpreted. An apotropaic function might explain the frequent setting of the group and other images of hermaphrodites in baths and gymnasia where naked human bodies were especially vulnerable to the Evil Eye.[6] The unusual circumstance that three of the twenty-seven known replicas of the group were found in Daphne, a relatively small suburb of Antioch, may indicate that there was a sanctuary of Hermaphroditos in the area.[7] Considering the large number of sanctuaries and temples of Aphrodite in Daphne, this is not unlikely.

TN

BIBLIOGRAPHY
Stillwell 1938, no. 163, pls. 13, 14 (5269-S291).
LIMC 5:297, no. 630, s.v. Hermaphroditos (A. Ajootian).
Ajootian 1997, 231, 233.

hermaphrodite and a satyr, the hermaphrodite rejecting the advances of the satyr by pushing his/her hand vigorously against his face. At least twenty-seven Roman replicas of this group are known, the most complete being a famous example in Dresden.[1] At Daphne alone, at least two copies, including this example, stood in the theater, and fragments of a third were found nearby by a surveying party.[2] It has been suggested that these were replicas of an original from Pergamon, executed by Kephisodotos, the son of Praxiteles. If true, the Princeton fragment offers a good example of Pliny's description of the group in Pergamon, which displayed, he wrote, the pressing of fingers into flesh.[3] While the now-lost original has been dated variously from the fourth to the second century B.C., the interchanging play between the delicate carving of the eye and of individual strands of hair of the satyr with the occasional deep, yet sensitive, drill work between the locks of hair dates the Princeton fragment to the second century A.D.[4]

A recent theory about the function of these copies is that the guardian quality of the deity Hermaphroditos is reflected in the group and that the surprise element of the erotic struggle, from most angles

NOTES
1. Dresden, Staatliche Kunstsammlung 155; *LIMC* 5:278, pl. 195, no. 63d, s.v. Hermaphroditos (A. Ajootian).
2. Stillwell 1938, 173–74, pl. 13, nos. 161–68; C. Vermeule, in Kondoleon 2000, 92–93, fig. 2. A fragment from a fourth group, once in a private collection at Antioch, said to be from the region of the theater at Daphne, is of a related but different type: see Stillwell 1938, 174 (under no. 161).
3. Pliny, *Natural History* 36.24. For a summary of the discussion on the identification and dating of the original, see Inan 1975, 124–25. For another good example of the realistic effect of "fingers pressing into flesh," see Ashmole 1929, pl. 21, no. 30.
4. A statue of Marsyas in Paris offers a good stylistic comparison for the head of the satyr in Princeton: Meyer 1987, pl. 15, fig. 24. Ajootian (1997, 233) suggests a third-century date for both fragmentary copies of the group from the theater in Daphne, but stylistically, the Princeton piece must be earlier than that.
5. Ajootian 1997, 230–35.
6. Ajootian 1997, 230–31.
7. Ajootian (1997, 229 and 241 n. 55) suggests that there were sanctuaries to Hermaphroditos on Kos and in Pergamon.

69.

HEAD OF DIONYSOS

Late second century A.D.
Provenance: Daphne-Harbie ("not from the excavations")
Material: medium-grained white marble
Dimensions: h. 15.8 cm., w. 9.9 cm., d. 12.7 cm.
Gift of the Committee for the Excavation of Antioch to
Princeton University (2000-56)

CONDITION: *Most of the left side of the head is preserved,*
including the left eye and cheek. The left eyebrow is slightly
chipped; the nose and mouth are missing. Much of the hair below
the ear is broken off; a large crack runs from the top of the skull
down to the point where the break in the hair begins. The surface
of the face is very smooth; the hair and wreath are more worn;
there are numerous scratches and abrasions on the back of the
head. A thin, yellowish beige incrustation coats every surface,
including the breaks.

The fragment preserves the left side of the head of
Dionysos, from a statue about two-thirds life-size.
The hair is parted in the middle and gathered in the
back, where it is coiled into a loop. The god wears a
garland of ivy with bunches of grapes, some of which
are still visible below his ears. At the top of the fore-
head a carved line running parallel to the edge of the
hair may denote a fillet worn across the brow. A shal-
low carving emphasizes the pupil of the eye.

The hairstyle, the wreath and attributes, and the
youthfulness of the face suggest that this fragment is
to be restored to a small statue of the Resting Dio-
nysos type, an adaptation of the late-fourth-century
type of Apollo Lykeios.[1] The small size of this fig-
ure, along with the pertinence of the theme, allows
us to conjecture its function as part of a table leg
(trapezophoron).[2] NP

BIBLIOGRAPHY
Stillwell 1941, 122, pl. 8, no. 322 (Pa817-S446).

NOTES
1. Schröder 1989; *LIMC* 3: nos. 119–28, s.v. Apollon
 (W. Lambrinudakis).
2. Dionysos alone or in the company of a small satyr
 is often depicted as part of the decoration of table
 legs. See Schröder 1989, nos. A14 (pl. IV), N8 (pl. XVI),
 N14 and N15 (pl. XVII).

70.

Head of a Barbarian

Probably 2nd century A.D.
Provenance: Seleuceia in Pieria; acquired August 14, 1937
Material: white marble
Dimensions: h. 5.8 cm., w. 4.4 cm., d. 5.0 cm.
Gift of the Committee for the Excavation of Antioch to
Princeton University (2000-58)

CONDITION: *A flat, diagonal break extends from the area of the right ear down through the right cheek, mouth, chin, and left shoulder, where it intersects an irregular break sloping back in the opposite direction. Surface very worn; light brown patina.*

The back of the head is uncarved, and on the sides there is only so much modeling as would complete a frontal view. The head therefore probably derives from a relief, although the breakage and wear make even this uncertain. The man's features are severely eroded, but he has rather deep-set eyes and a small nose, and there are distinct traces of a mustache and beard. His long, straight hair radiates from the apex of his domed cranium, framing his face and hanging in lank, sharply filed strands on his forehead.

The man's wild hair and droopy mustache suggest he is a barbarian, such as were often represented on battle sarcophagi of the second and third centuries.[1] This head is probably too small to be from such a sarcophagus, although it is not impossible. The object broken away to the left of the head was too thick and high to have been the man's own arm or drapery and may represent a second figure: not enough remains for meaningful speculation. JMP

BIBLIOGRAPHY
Unpublished.

NOTE
1. For battle sarcophagi, see Andreae 1956. For a summary of the various barbarians depicted in Roman art, see Bailey 1999, 79–82.

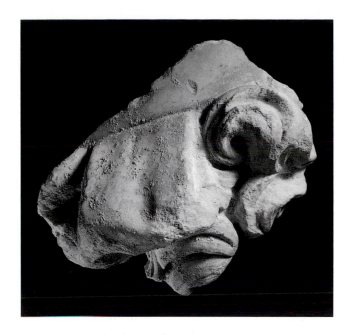 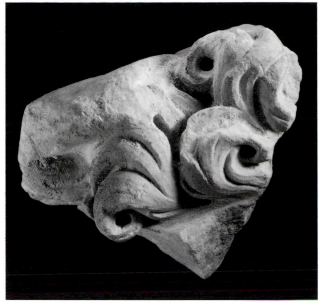

71.

Fragment from a Colossal Head

Second–third century A.D.
Provenance: Antioch; acquired May 13, 1937
Material: fine-grained white marble
Dimensions: h. 10.1 cm., w. 6.8 cm., d. 9.1 cm.
Gift of the Committee for the Excavation of Antioch to
Princeton University (2000-57)

Condition: *Flat break in back, along natural cleavage; concave break below; the break at right more irregular. The left-hand curl and lower right corner of the looped fold are broken away. Minor chipping and scratches; brown stains and light incrustation.*

The fragment preserves part of the hair and head-band from the right side of a colossal head. The sloping, transverse section of the headband, broad and slightly concave, is intersected at right angles by a looped fold, tucked beneath it, which emerges to hang loosely over the underlying curls. The latter are boldly rendered, with carved strands and drilled centers. Two curls are aligned in echelon at the lower right, where a distinct groove marks the beginning of the facial plane, a sliver of which remains. There is no trace of the ear, which, if represented, must have lain just beneath the curls abutting the looped fold.

The sex of the figure is uncertain, but the short, curly locks would be more at home on a male, as would the broad, cloth headband or fillet.[1] The latter, although fragmentary, cannot be confused with a helmet,[2] nor with a Phrygian cap, like that worn by Paris or Ganymede.[3] Its apparent softness and width, and especially the tucked fold on the side, suggest that it may be a *mitra*, a cloth headband that could be worn tightly wrapped, like a turban, or in looser

fashion, as a headband. In Attic vase-painting the *mitra* is worn by mortal komasts and by Dionysos; it recurs in some later sculptures of the god, but was more commonly associated with Priapus, usually in turban form.[4]

The inked notation "13-R" on the back of the fragment suggests that it was found at Antioch in sector 13-R, where a large building was partially excavated over three seasons, from 1934 to 1936.[5] An additional inscription, however, indicates that the piece was acquired in 1937, when no further excavation was undertaken in that sector. It therefore presumably was acquired as a gift or purchase, like so many of the sculptural fragments brought back to Princeton.

JMP

BIBLIOGRAPHY
Unpublished.

NOTES

1. Cf. the fillet on a Roman head of an athlete in the Early Classical style, in Boston, Museum of Fine Arts, 03.754: Comstock and Vermeule 1976, 86, no. 134.

2. In statues of the Athena Ince-Blundell type, the rolled leather earflaps of an oriental cap emerge from beneath the goddess's Corinthian helmet, which she wears pushed back on her head: see Ridgway et al. 1994, 53–56, no. 15.

3. The earflaps of a Phrygian cap, and of related oriental caps, such as the Persian *kidaris*, are broader and in one piece with the cap, not emerging from beneath the brim. For sculptures of Paris and Ganymede in such caps, see *LIMC* 1:497, pls. 374–75, s.v. Alexandros (R. Hampe); *LIMC* 4:154–69, pls. 75–96 (esp. pl. 84, no. 124), s.v. Ganymedes (H. Sichtermann).

4. For some examples in vase-painting, see Boardman 1989, figs. 146, 163, 180, 182, 204, 239. Sculptures of Dionysos wearing a *mitra* are less common; cf. the bronze herm from the Mahdia shipwreck and its parallels: Mattusch 1996, 168–90. For some examples of Priapus wearing a *mitra*, see *LIMC* 8:1035–41, pls. 685–94, s.v. Priapus (W.-R. Megow).

5. Stillwell 1938, 1–4.

72.

TORSO OF A YOUTH

Trajanic, A.D. 98–117
Provenance: Daphne-Harbie; purchased June 29, 1937
Material: medium-grained white marble
Dimensions: h. 50 cm., w. 22.2 cm., w. at hip 19.5 cm., d. 26 cm.
Gift of the Committee for the Excavation of Antioch to Princeton University (2000-39)

CONDITION: *Broken at chest level and at mid-thigh. On the back, above the buttocks, a semicircular shelf, measuring 13 x 7 cm. (d. 1.5 cm.), extends upward from the small of the back, while a second cutting extends downward along the surface of the broken upper margin. Rasp-smoothed borders about 1.5 cm. wide surround the rougher, broken interior surfaces of the cuts. On the upper buttocks, two pairs of dowel holes connected by a horizontal tunnel run under the surface of the sculpture. The bridge of stone between the two holes has broken away on the right side. A brownish deposit covers the left side of the statue. Several modern chips on thighs, torso, and genitals.*

The youth stood with his weight resting on his right leg. His left leg dangles slightly, and may have crossed over the weight-bearing limb at or below the knee. The boy leans gently forward at the waist, and his rib cage rotates sharply upward and to his right, perhaps pulled by his right arm, which may have reached upward and across his body. The torso is unmuscular, with fairly slight proportions; the soft belly protrudes slightly.

The crossed-leg pose was established by the fifth century B.C. in relief sculpture and the minor arts,[1]

218

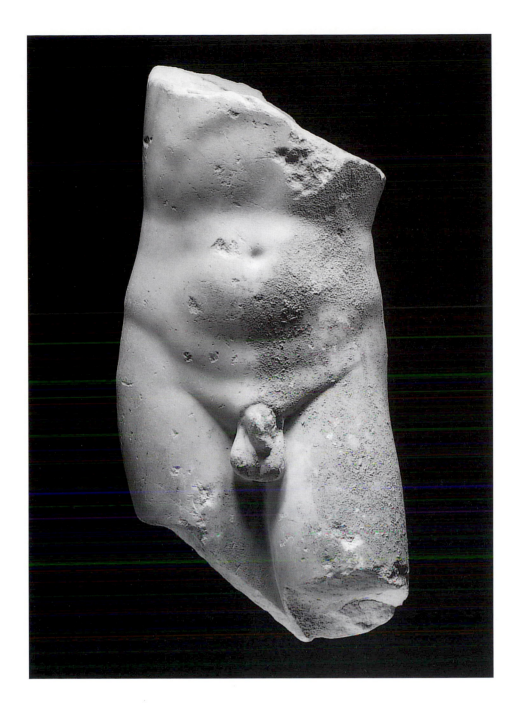

and became a popular motif in sculpture in the round in the late fourth century and throughout the Hellenistic and Roman periods. Deities (particularly Apollo and Dionysos) and mortals alike appeared in this position.[2] While no evidence survives to determine the identity of the Antioch youth, his original stance may have replicated that of a young *genius* holding a lowered and inverted torch in his left hand and reaching up and over his torso with his right.[3] The style of the carving suggests a date in the Trajanic period.

The semicircular cuttings on the figure's back suggest that the piece was damaged and patched in antiquity. At the time of this repair, the dowel holes may have been drilled through the figure's upper buttocks to fasten the figure to an external support.

MLL

BIBLIOGRAPHY
Stillwell 1941, 122, pl. 5, no. 318 (Pa867-S455).

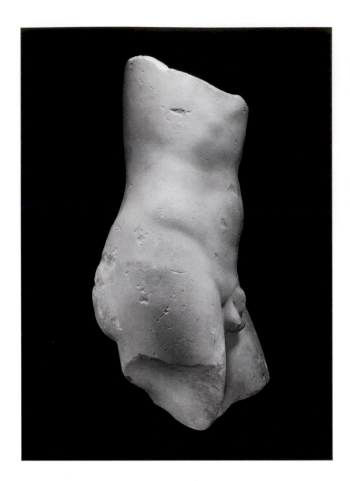

NOTES

1. Müller 1943, 171; cf., for instance, the figure of Eros on the east frieze of the Parthenon; the stance also appears on votive reliefs throughout the later fifth and fourth centuries; see Stewart 1990, figs. 520–22.

2. Vermeule and Comstock 1988, 56.

3. See, e.g., *RSGR* 4:259, no. 4; this figure reverses the pose of the Antioch piece.

73.

TORSO OF A YOUTH

Antonine, second century A.D.
Provenance: found in the villa at Daphne-Yakto,
sector 17/18-H/J, April 13, 1933
Material: medium-grained white marble
Dimensions: h. 60.1 cm., w. at chest 36.8 cm., d. 19.7 cm.
Gift of the Committee for the Excavation of Antioch to
Princeton University (2000-36)

CONDITION: *Right leg broken at upper thigh; left leg broken at groin. Both arms broken above the elbow. The head is missing. A puntello is visible below the left hip. A rough, broken area running vertically down the outside of the right leg indicates the original position of the right arm. Impurities in the stone have resulted in areas of accelerated weathering, particularly visible on the left arm. Surface otherwise is lightly polished and in excellent condition.*

The youth stands with his weight resting on his right leg, his left dangling slightly behind, rotating his pelvis slightly to the left and back. His right arm hangs at his side, pulling the right shoulder downward, while his left arm, bent at the elbow and cocked back and upward, lifted and twisted the left shoulder. A large square puntello indicates the point where this arm may have intersected with the youth's left hip. The strongly contracted muscles of the right shoulder indicate that the youth's head turned to this side.

The statue should be considered a variation on a Polykleitan theme. While not a copy of a specific statue type, the torso shares elements with many pieces connected to the fifth-century sculptor, most notably the *Diskophoros*, with which it shares the dynamic twisting contrapposto visible in the shoulders.[1] The position of the limbs gives the Antioch example a particularly taut and lively appearance, opposed to the languid curves of other Polykleitan copies and variants. The delicate musculature and the absence of pubic hair suggest the youthfulness of the subject, who was possibly an athlete, young god, or hero.[2]

The statue was found in Daphne-Yakto in a complex built in the third century A.D. and modified in the fifth century.[3] The torso was discovered in a service area connecting two sectors of the building, near the richly decorated "cruciform room."[4] The figure may have originally occupied a niche in the nymphaeum, along with a second statue also found nearby.[5] The "cruciform room" forms part of the original

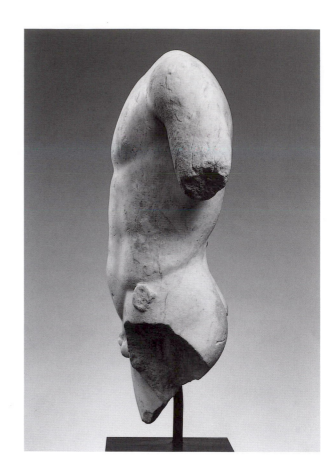

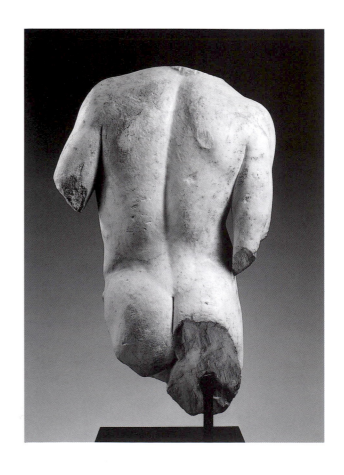

third-century villa and continued in use after the fifth-century remodeling, making it impossible to determine when the statues were originally placed.[6]

The soft modeling of the musculature suggests a date in the Antonine period.[7] The early date of its manufacture makes it unlikely that the statue was commissioned specifically for the nymphaeum.

MLL

BIBLIOGRAPHY
Lassus 1938, 121.
Stillwell 1938, 170, pl. 1, no. 100 (2537-S94).

NOTES
1. See Hallett 1995, pl. 8.11; Bol 1990b, 111–17 (P. Bol).
2. For this interpretation of a similar torso identified as a variant of the Meleager by Skopas, see Vermeule and Brauer 1990, 44, no. 29. While the Princeton torso resembles the piece in Cambridge, details such as the turn of the neck (to the right, versus the left), the twist of the shoulders, and the positioning of the arms preclude associating the two pieces.
3. Lassus 1938, 118–47, 223, plan IX.

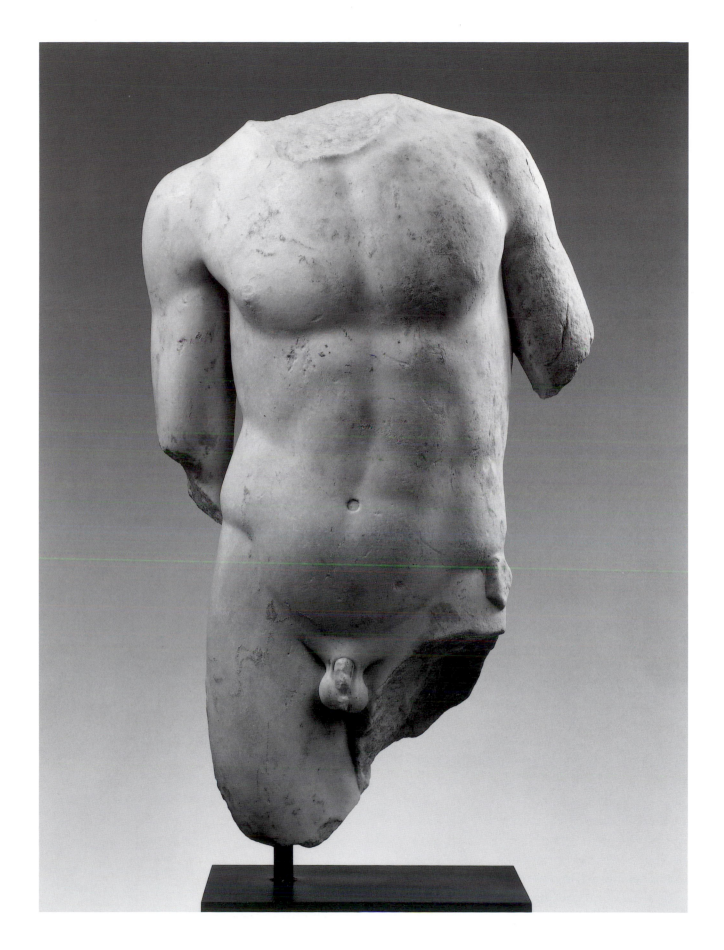

4. Lassus 1938, 121 (in area 13); Princeton University Archives, inventory card (between areas 11 and 14). These two sources suggest that W. A. Campbell mistakenly reported that the male torso was found among rubble in area 28, along with a copy of the so-called Spinario (Princeton University Archives, *General Report on the Excavations at Antioch on the Orontes for the Season of 1933*, 8; fig. 31; for the Spinario, see Stillwell 1938, 170, no. 104, pl. 2.

5. Campbell, in the archival report cited in the previous note (pp. 8–9), recorded that a second torso which may also have adorned the nymphaeum was found "in the corner room of the cruciform ensemble," associating this piece with the Apollo Sauroktonos type. Although typologically different, he may have been referring to the male torso catalogued in Stillwell 1938, 170, no. 101, pl. 1.

6. Lassus 1938, 118–121.

7. Lassus 1938, 121 ("II siècle"). Compare a variant of the Dresden Youth in the Palazzo dei Conservatori, Rome, dated A.D. 140–160 (Beck, Bol, and Bückling 1990, 638, no. 168).

74.

TORSO OF A BOY POURING WATER

Roman copy (first–second century A.D.) of a Hellenistic original

Provenance: presented to the Princeton excavation at Antioch by the Muktar of the village of Yakto, 1934; according to the excavation card, N1351, the fragment came from Daphne-Harbie

Material: medium- to large-grained white marble, crystalline

Dimensions: h. 52 cm., w. at level of navel 19.8 cm., w. at bottom 25.8 cm., w. at top 15.7 cm., d. 20.2 cm.

Gift of the Committee for the Excavation of Antioch to Princeton University (2000-38)

CONDITION: *Head, neck, shoulders and lower legs are missing. Genitals and a large part of the upper right side of the figure, front and back, have been chipped off. The surface is well polished but extremely worn and covered with numerous knicks, abrasions, and modern cuts (from the plow?). Remains of drapery on the back of the figure are chipped and worn. A small dowel hole is centered at the bottom of the drapery.*

The round, narrow chest, the pudgy hips and thighs, the protruding stomach, and the soft and childlike musculature indicate that the torso belonged to a young child. The right leg is moved slightly forward and outward in relation to the left, suggesting that the boy was standing still and not striding forward. The upward stretch of the left side of the chest and the position of the missing left arm indicate that the left arm was raised above the head. Simultaneously, the boy probably leaned his chin or right cheek on his right shoulder, as a thin ledge still remains above the right chest area. The elongated feature on the back of the figure, extending from the area between the shoulder blades to below the buttocks, and a now-missing feature below the boy's left shoulder in front are all that remains of drapery that hung over the left shoulder and down the back, where it was attached to the boy's backside by a dowel.

The fragmentary statue from Daphne represented a boy pouring water from a large hydria. Holding the heavy water vessel with both hands and supporting it on his left shoulder, the child's right cheek rested

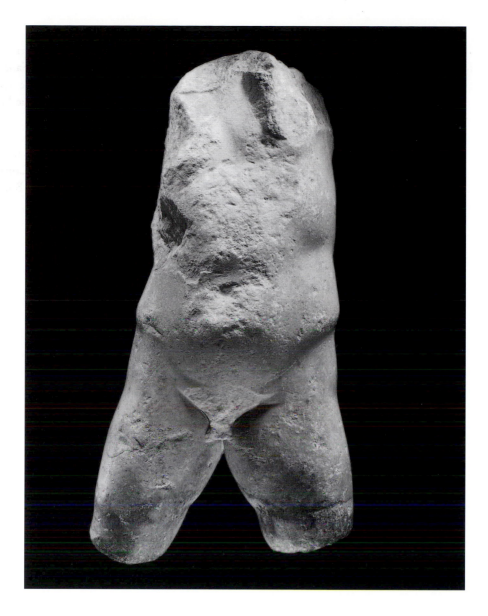

on his upper right chest area, his legs were bent and spread wide apart, and all the soft muscles in his little body were bulging under the strain. A folded mantle draped over his left shoulder provided a soft pillow on which the boy rested his burden. Of the numerous and similar Roman versions of this originally Hellenistic work, two copies in the Vatican provide particularly close parallels to the Princeton fragment.[1] A few copies display traces of wings on their back, which may indicate that the Hellenistic original was thought of as Eros.[2] In the Roman period, the type was popular as decoration in gardens and villas and was often converted into a fountain-head.[3] When the statue functioned as a fountain, the hydria became the actual vehicle for the flowing water.

The Princeton statue might have had a similar function since it supposedly came from the area of Daphne famous for its villas, gardens, and springs. The brown stains at the bottom of the legs, the many nicks and chips on its surface, and the fact that all extremities seem to have been chipped off consciously at a later date may indicate that the statue was placed upright in the soil for decades and perhaps was used as a field marker or boundary stone. TN

BIBLIOGRAPHY
Stillwell 1938, 178, pl. 22, no. 231 (3398-S120).

NOTES

1. See Andreae 1995, no. 700, pls. 736–37; Lippold 1956, no. 85, pl. 100.

2. O. Brendel, in *EA*, 40–41, no. 3977.

3. For a list of copies that were used as fountainheads, see Kapossy 1969, 41–42.

75.

TORSO OF A MAN IN A TUNIC

Probably second century A.D.
Provenance: Daphne-Harbie, 26-K/L, North; surface N.W.R.I.;
August 8, 1935
Material: fine-grained white marble
Dimensions: h. 34.2 cm., w. at top of thighs 20 cm., w. below
fold of tunic 18.4 cm., d. 15.8 cm.
Gift of the Committee for the Excavation of Antioch to
Princeton University (2000-40)

CONDITION: *The torso is broken just above the waist along a slanting plane that descends toward the back to about 3 cm. above the overfold of the tunic. The legs are missing from just below the knees. The drapery folds, especially on the right side, are worn and chipped. A square strut has been broken off the left hip. The surface is highly polished on the front and sides while merely smoothed on the back, where chisel marks are still visible in places. Dark gray incrustation covers the right front of the figure and half of the left leg.*

The fragment is of a male figure, dressed in a short tunic *(exomis)* which was tied over the left shoulder, exposing the right side of the upper body. Above the belt, which holds the garment together, the thin folds hang diagonally from the figure's (missing) left shoulder and over the belt, which they cover in front. The cloth lies flat across the figure's legs, pulled taut by the advancing left thigh, and hangs in slender, zigzag folds down the right side, where an opening

reveals the polished skin beneath. V-shaped folds are created in front by the forward movement of the figure's left leg and by the thrust of the hip to his right. To the proper left of the figure was a support, as evidenced by the broken strut on the hip.

The short tunic alone is not sufficient evidence for a secure identification of this fragment. This type of garment is worn by various figures such as Odysseus, Hephaistos, the Kabeiroi, Amazons, warriors, artisans, laborers, beggars, and rustic literati such as Diogenes. The slenderness of waist and limbs suggest a youthful figure. The leaning posture of this figure is matched by a male torso once in the Swiss art market, which has been identified as a wounded warrior.[1] This torso also parallels the Princeton fragment in the V-shaped folds between the thighs and the zigzag folds on the side of the figure.[2]

<div align="right">NP</div>

BIBLIOGRAPHY
Stillwell 1938, 175, pl. 17, no. 187 (6198-S341).

NOTES
1. Freyer-Schauenburg 1977, 192–93, figs 5–7; tentatively identified as Hephaistos by Brommer (1978, 97 and 240, no. 14, pl. 48.3).
2. See Freyer-Schauenburg 1977, 193, fig. 6 for a right profile view of the torso in Switzerland.

76.

STATUETTE OF ENDYMION

Second century A.D.
Provenance: Antioch, sector 17-O, May 26, 1937
Material: very fine-grained white marble
Dimensions: h. 22.0 cm., w. 17.1 cm., d. 9.0 cm.
Gift of the Committee for the Excavation of Antioch to
Princeton University (2000-47)

CONDITION: *The figure is fractured at the waist, and has also lost his left foot and his genitalia. The support on which he rests is broken on both the bottom and the right, although a small band of worked stone survives in the intervening angle. Remnants of a short spur project from the upper right-hand corner of this base. An adjacent figure has been effaced almost entirely, with only the left hand escaping destruction. The surface shows some abrasion, as well as chipping on raised features such as the outer edges of the garment. Much of the original finish, however, remains visible. There is only mild discoloration of the stone, along with a few scattered bits of grayish accretion.*

The piece depicts a half-draped male figure reclining upon an unidentified support. His back remains roughly blocked out, indicating that a frontal perspective was intended. The figure is observed from his left side, with the legs shown in silhouette while the lower torso turns out in a three-quarter profile. The left leg extends with only a slight bend, while the right has been drawn in at a ninety-degree angle. His proportions are powerful, with a muscular abdomen and sturdy thighs. A garment hangs across the latter, completely enveloping the limbs of the figure while leaving his genitals exposed. Although somewhat doughy in appearance, this drapery shows rather dynamic modeling. It clings closely to the left leg but otherwise falls into a dramatic series of thick folds and broad cavities. A disembodied left hand alights upon the right thigh. This appendage is executed in a much smaller scale, and looks childlike in comparison.

The figure rests upon a support of unusual shape and appearance. It stretches from his knees to his buttocks, and seems to portray a gently rising slope. A single line is engraved immediately beneath this

grade, while two additional lines, set in parallel, run horizontally across the front of the base.

The carving is of high quality but quite disparate character. The main figure has been executed in a very smooth style, which emphasizes well-rounded (if somewhat simplified) volumes. In contrast, the base is quite flat and relies upon line. A very fine polish was applied to the main frontal surfaces, although less prominent areas and features, such as the small hand, received more summary treatment.

Although the figure is robbed of any attributes, his unusual reclining pose is sufficient to identify him as Endymion, the sleeping shepherd whose beauty attracted the moon goddess Selene.[1] Indeed, this particular piece may have formed part of a larger composition—well known from sarcophagi—which depicted the goddess and her train descending upon the recumbent youth.[2] Such an interpretation is

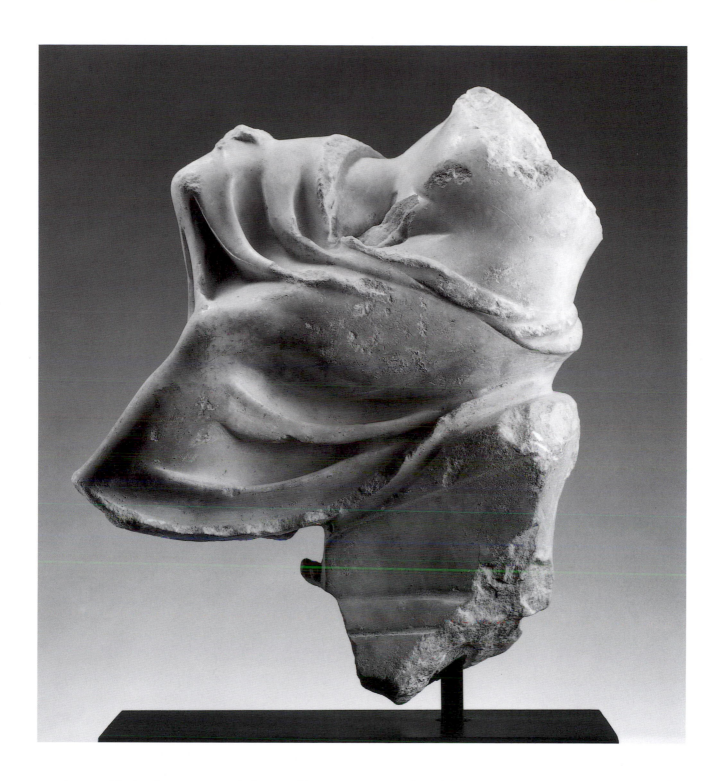

consistent with the figure type, and also would explain the presence of the mysterious little hand on Endymion's thigh: one of Selene's attendant erotes, who often are shown surrounding, and sometimes even disrobing, the shepherd.

Unfortunately, the context of this sculpture is considerably more obscure than its subject. Many examples of this composition are found on sarcophagus reliefs. The Antioch piece, however, is carved in the round (albeit with an unfinished back), has no obvious mounting points, and is set upon a rather curious base. Its original function remains unclear.

The sculpture was found in a disturbed level that encompassed a wide range of remains, from the

Hellenistic to the medieval.[3] In terms of style, the pose has its closest match in a sarcophagus of the second century A.D., whilst the broad, stylized folds of the drapery find parallels in contemporary Asia Minor.[4] The piece, therefore, should be assigned to the second century A.D., a period which witnessed a general revival of artistic interest in the myth of Endymion.

<div style="text-align: right">RJC</div>

BIBLIOGRAPHY
Stillwell 1941, 119, no. 279, pl. 7 (a729-S439).

NOTES
1. The iconography of Endymion is rather diverse, and a basic summary may be found in *LIMC* 3: 726–42, s.v. Endymion (H. Gabelmann). The best parallel is provided by a sarcophagus in Copenhagen; see *LIMC* 3: no. 52, pl. 555; Sichtermann 1992, 109, no. 35, pls. 26.4, 34.2. This piece shows the same reclining pose and positioning of the legs, although it faces in the opposite direction and has slightly different drapery.
2. See *LIMC* 3: nos. 13–85, pls. 552–9; and Sichtermann 1992, 103–63, nos. 27–137, pls. 26–114.
3. Excavation notes record the find on May 26, 1937, in Antioch sector 17-0, dig 3, room A. Although most of the surrounding material was Roman in origin, examples of medieval pottery were found mixed in, proving the archaeological context to be insecure and thus useless for dating the sculpture.
4. The aforementioned sarcophagus in Copenhagen (above n. 1) provides the best parallel for the pose. It is dated to ca. A.D. 150–170. The drapery may be compared with that on a second-century statuette of a river god from Ephesos; see Aurenhammer 1990, 102–3, no. 83, pl. 59a. This latter piece, although of lesser quality, shows the same tendency toward thick, smooth folds and broad cavities.

77.

LEGS OF A MALE STATUETTE

Second century A.D.
Provenance: Daphne-Harbie, sector 26-M/N
Material: medium- to large-grained white marble
Dimensions: h. 30.7 cm., h. of plinth 6.0 cm., w. of plinth 21.2 cm., d. of plinth 21.0 cm.
Gift of the Committee for the Excavation of Antioch to Princeton University (2000-45)

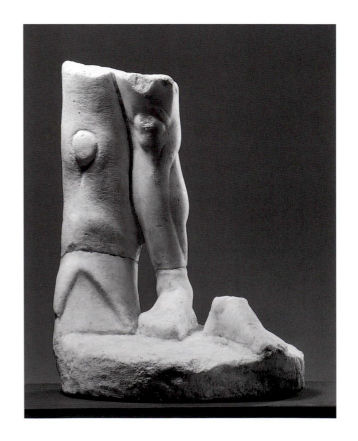

CONDITION: *The left leg is broken away at the ankle. The right leg and support are broken in a horizontal plane at the same height, across the thigh of the figure; an additional fracture just above the right ankle and adjacent support was mended in 1995. The kneecap, tip of the left big toe, and parts of the base in front and back are chipped, but otherwise the surface is well preserved. All breaks are worn around the edges. The bottom of the base was worked fairly smooth.*

The fragment preserves parts of the legs and feet of a standing figure on an oval base. The well-defined musculature of the legs indicates that the figure is male. A support in the shape of tree trunk abuts the right leg, only separated from it by a deeply drilled

groove. The figure stands with his weight on his right leg while the position of the left foot, which is in front and turned outward, indicates that the left leg was relaxed. The toes are not represented, and a faint swelling, barely visible, below the break above the right ankle, may be the top of a soft leather boot.

Boots are most commonly worn by Hephaistos and by rustic divinities, such as Silvanus.[1] From the third century onward boots are also worn by figures in the type of the Good Shepherd or Jonah Praying.[2] Without further attributes, it is difficult to decide on the identity of this figure. The fragment is paralleled in both the shape of the plinth and the position of the feet by a statuette of Silvanus in Berlin.[3] NP

BIBLIOGRAPHY
Stillwell 1941, 120, pl. 11, no. 292 (c97-S567; c217-S585).

NOTES
1. Hephaistos: Brommer 1978, T. 21.3 and T. 22.2. Silvanus: see *LIMC* 7: nos. 10–33 (A. M. Nagy).
2. Wixom 1967, 67–89, figs. 23 and 29.
3. Conze 1891, no. 282; *LIMC* 7: pl. 552, no. 31, s.v. Silvanus.

78.
TORSO OF EROS

Probably second century A.D.
Provenance: Daphne-Harbie; acquired in 1937 ("not from the excavations")
Material: large-grained white marble
Dimensions: h. 15.4 cm., w. 18.5 cm., d. 14.3 cm.
Gift of the Committee for the Excavation of Antioch to Princeton University (2000-42)

CONDITION: *The torso is broken horizontally at the navel and at the top of the shoulders. The right arm is completely missing, while the left shoulder and upper arm are preserved. Wings on the back are broken at the roots. The surface is worn, nicked, and covered in front with dark gray incrustation. Rust stains appear below wings in the back.*

The fragment represents the naked upper torso of a winged youth. The position of the shoulders and the curve of the torso suggest that the figure was standing with his weight on the left leg with the hips pushed to his left. A slight upward curve of the right shoulder and a dowel hole suggest that the right arm was lifted, while the left arm was positioned down, slightly away from the body, and behind the torso. The ends of long locks of hair appear above the shoulders in the back and especially above the left shoulder. The remains of two wings are visible on the upper back. A slightly protruding feature below the right arm toward the back may have been the place where the right wing was attached to the figure.

A small dowel hole appears in the center of the left arm stump; two larger holes are cut in the upper torso for attachment of the right shoulder and arm, and between the shoulders for placement of the head.

The small statue depicted a youthful, winged Eros. The curve of the torso, the position of the arms,

an arrow in the right. The protruding abdomen and soft musculature place the Princeton figure within a group of replicas that emphasized the childlike nature of Eros, while the Centocelle Eros itself, now in the Vatican, and a replica in Berlin, portray the developed chest musculature of a young man.[2] Some identify the original of the Centocelle type as a fourth-century Greek work by Praxiteles, others as a Roman creation of the Augustan period.[3] Although the fragmentary state of the Princeton piece hardly allows a dating based on style, the popularity of the type in the Antonine period provides a tentative date for the Princeton piece in the second century A.D.[4] TN

BIBLIOGRAPHY
Stillwell 1941, 122, pl. 7, no. 328 (Pa383-S391).

NOTES
1. Vermeule and Comstock 1988, 32–33, no. 20. For the Eros of Centocelle itself, and a list of fifteen replicas, see Zanker 1974, 108, pl. 81, figs. 1–6.
2. For a discussion on the different characteristics of the Centocelle type, see Zanker 1974, 109.
3. Vermeule and Comstock 1988, 32.
4. Zanker 1974, 109.

and the remains of long curls falling onto the shoulders identify the statue as a replica of the so-called Eros of Centocelle, the best preserved example of which is a small statuette in Boston.[1] The young god of love would have held a bow in his left hand and

79.
TORSO OF PRIAPUS *ANASYROMENOS*

First century B.C.–early second century A.D.
Provenance: Antioch 23/24-K (cemetery), April 28, 1934
Material: medium-grained white marble
Dimensions: h. 19.7 cm., w. 23.0 cm., d. 13.6 cm.
Gift of the Committee for the Excavation of Antioch to Princeton University (2000-41)

CONDITION: *Only the lower torso and upper thighs, some drapery, and part of a pedestal remain. The legs are broken horizontally along a plane that slopes from the upper thighs in front to the back of the knees. The upper part of the pedestal is damaged, and a large piece is chipped off its front. The surface of the piece is worn and covered by a grayish brown patina.*

The fragment depicts a nude male leaning on a tall, square pedestal to his left while holding a baby or pieces of fruit in a fold of his chiton. The slightly

higher position of his right hip suggests that he supported himself on the left leg in a contrapposto position. A dowel hole for attachment of an erect phallus is clearly visible above the genitals. The cloak hangs over the left arm and down the figure's left side in front of the pedestal. Marks along the right side of the hips and upper thighs suggest that the drapery hung down on this side as well. The back of the fragment is flat and roughly picked.

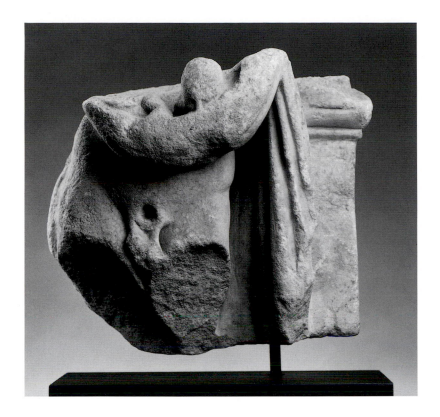

The act of lifting one's garments to display the genitals, generally referred to as the *anasyromenos* pose, is not uncommon in ancient art. The gesture is shared by female and male fertility deities alike and is often associated with Hermaphroditos and Priapus, as is the simultaneous cradling of fruit or infant putti in a fold of the raised garment.[1] The modeling of the hips and thighs, which are undoubtedly those of a male youth, and the presence of a dowel hole for a rather large, erect phallus suggest that the Princeton fragment depicted Priapus rather than Hermaphroditos, who is usually represented with a woman's body and small male genitals. The role of Priapus as guardian of fertility is stressed by the erect phallus and by the abundance of fruit or putti he carries in front of him.[2] The *anasyromenos* image of this potent deity was used for protective purposes against all evil in Greece, Rome, and the Near East in both private and public contexts from the early Hellenistic period to the end of the second century A.D.[3] While an exact equivalent for the Princeton piece is lacking, its small scale and roughly picked back may indicate that it came from a private context. If so, it was perhaps originally immured in the external wall of a house next to the entrance, where it would have served a prophylactic function similar to that of small marble plaques of Hermaphroditos *anasyromenos* and of Herakles of the second century B.C. from Delos, some of which were found in situ.[4] The fact that the Princeton fragment was found in a trench (23/24-K) within the area of an ancient cemetery in Antioch may demonstrate that the sculpture, probably reused, had protective powers in funerary contexts as well. The lack of deep drill work in the drapery of the fragment suggests a date of no later than the early second century A.D. ⎯ TN

BIBLIOGRAPHY
Stillwell 1938, 171, pl. 3, no. 120 (3396-S118).

NOTES
1. Ajootian 1997, 224–25; *LIMC* 5:274, s.v. Hermaphroditos (A. Ajootian); *LIMC* 8:1042–43, s.v. Priapos (W.-R. Megow).
2. For statues of Priapus *anasyromenos* holding fruit, see *LIMC* 8:1034–35, pl. 685, nos. 69, 76–77, 81, s.v. Priapus; *RSGR* 2.1:73, no. 6, and 74, nos. 2, 4–6. For examples of Priapus with putti, see *LIMC* 8:1035, pl. 686, nos. 78, 79, 83; *RSGR* 2.1:74, nos. 8–10.
3. *LIMC* 8:1029.
4. Ajootian 1997, 230–31.

80.

LOWER TORSO OF A BOY

Antonine, second century A.D.
Provenance: Antioch; purchased April 1936 (P6240-S423);
labeled as being from sector 14-S
Material: fine-grained white marble
Dimensions: h. 11.6 cm., w. 16.7 cm., d. 12.9 cm.
Gift of the Committee for the Excavation of Antioch to
Princeton University (2000-44)

CONDITION: *Broken at groin and above hips. An imperfection in the stone creates a gouge, which bisects the torso perpendicularly to the right of the belly button and continues across the upper and lower broken surfaces. Surface covered with a white calcareous deposit.*

The hip and buttocks indicate that the nude boy stood on his right leg, with his left leg positioned forward. Fatty rolls protrude over his navel and groin area. The position of the legs, the slope of the buttocks, and the folded flesh on the belly suggest that the child leaned forward and braced himself with his left leg.

A statue of a child in the Ny Carlsberg Glyptotek assumes a similar pose, although as a mirror image of the Antioch piece.[1] Genre sculptures of children became popular in the Hellenistic period. Previously, children and infants had been depicted as scaled-down adults, without their characteristic proportions and baby fat. However, a rising interest in the naturalistic rendition of the juvenile body led to the creation of images of children in a wide variety of media—from terracotta figurines, to reliefs, to bronze and marble sculptures in the round.[2] Statues of pudgy young boys with animals, such as snakes or geese, retained their popularity in the Roman period, and were often copied for wealthy patrons.[3] Although the Antioch figure is fragmentary, the position of the youth's legs suggests an association with this tradition. The deeply drilled channels, which separate the buttocks, the folds of flesh, and the joint between the left leg and torso, all point toward a date in the Antonine period.[4]

MLL

BIBLIOGRAPHY
Unpublished.

NOTES
1. Copenhagen, Ny Carlsberg Glyptotek. *Billedtavler til kataloget over antike Kunstvaerker* (Copenhagen 1907), pl. 13, no. 173a; see also *RSGR* 4:266, n. 3.
2. Rühfel 1984, 186–309.
3. Bieber 1961b, 136–38. One extremely popular piece, known in multiple copies and attributed by Pliny (*Natural History* 34.84) to the Hellenistic sculptor Boëthus, shows a toddler strangling a goose; see Rühfel 1984, 254–58, with prior bibliography.
4. The drill work compares well to the hip section of a fragmentary female torso from the theater at Leptis Magna: Caputo and Traversari 1976, 55–56, no. 34, pl. 48.

81.

Torso of a Youth Wearing an Animal Skin

Late second or early third century A.D.
Provenance: Antioch vicinity; purchased April 23, 1936
(P6243-S425)
Material: medium- to large-grained white marble
Dimensions: h. 15.6 cm., w. 16.7 cm., d. 12 cm.
Gift of the Committee for the Excavation of Antioch to
Princeton University (2000-43)

CONDITION: *Broken at hips and upper thighs. Surface weathered and covered with a dark deposit. Modern abrasions on edges of breaks and on surface of legs.*

The youth stands on his left leg, with his right leg positioned slightly forward and angled to the right. He wears an animal skin which angles downward in a fringe across his belly. The leg of the fawn skin hangs down his right thigh, with the animal's hoof visible just above the break.

Dionysos and members of his cortège, including erotes, Pan, and personifications of the Seasons, all wear a *nebris*, a fawn skin. It is impossible to determine whether this figure represents the god himself, as the figure is missing its upper body, which might have preserved traces of the god's characteristic long locks on its shoulders. The pose does not replicate any known sculptural type, and the youth's immaturity further complicates the identification. Dionysos, who generally appeared as a more mature male in the early Roman empire, became increasingly youthful in the mid-second and third centuries A.D.[1] If not the god of wine, the figure may depict a faun or similar woodland deity. The *nebris*, which sits unusually low on the torso, and the fringe along its bottom edge suggest a date in the late second or early third century A.D.[2]

MLL

BIBLIOGRAPHY
Unpublished.

NOTES
1. For instance, a table support decorated with a statue of Dionysos in the Museum of Fine Arts, Boston: Comstock and Vermeule 1976, 140, no. 219.
2. Cf. the animal skin worn by the personification of Summer on a sarcophagus in the Albright-Knox Gallery, Buffalo, dated to the 180s: Kranz 1984, 192–93, pl. 23, fig. 3. Cf. also, a torso of Dionysos from Ephesos, now in the British Museum, dated to the late Antonine period: Aurenhammer 1990, 63–64, pl. 29, no. 42.

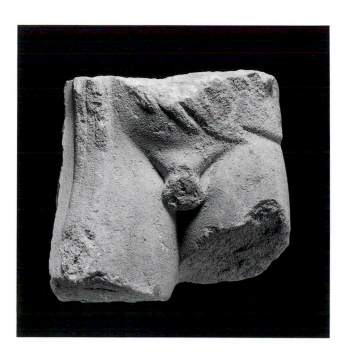

82.

FRAGMENT OF HERMES(?)

Second or third century A.D.
Provenance: Seleuceia in Pieria; purchased July 19, 1937
Material: large-grained white marble
Dimensions: h. 21.5 cm., w. 14.5 cm., d. 12 cm.
Gift of the Committee for the Excavation of Antioch to
Princeton University (2000-46)

CONDITION: *Only a part of an arm and elbow is preserved. The fragment is broken horizontally at top, diagonally at bottom, and vertically on its right side. The back is roughly finished. A curved feature attached to the arm is chipped and partially missing. The preserved surface in front is nicked, slightly scratched, and covered with a gray incrustation.*

The fragment represents parts of the upper left arm and elbow of a life-sized figure. A very small part of the naked(?) torso of the figure is still preserved, connected to the arm at the top of the fragment. A few folds of drapery are visible between the arm and the torso. A curved feature is attached to the upper part of the arm.

The piece apparently belonged to a statue of a nude youth whose chlamys was draped around and behind the shoulders, then brought forward under the left arm and thrown across the raised forearm.[1] Commonly considered a Roman variant of a Greek original of the fifth or the fourth century B.C.,[2] the schema of the nude youth with a chlamys was popular in the Roman period, when it was associated with gods or heroes such as the Dioskouroi, Meleager, or Hermes, and it was eventually appropriated by Roman generals and emperors.[3] The curved feature attached to the upper arm may be the remnants of a *caduceus*, held by the youth in his left hand, in which case he can be identified as Hermes.[4] Similar remains are visible on a late Antonine statue of Hermes from Side.[5] The very schematic rendering of the drapery folds and the employment of a drill indicate that the fragment dates to the second or third century A.D. TN

BIBLIOGRAPHY
Unpublished.

NOTES
1. For examples of nude youths carrying a chlamys, see Andreae 1995, 318–19, no. 260; Caputo and Traversari 1976, no. 5, pl. 4; Karageorghis and Vermeule 1964, pl. 16, fig. 2 and pl. 28, fig. 1; Inan 1975, no. 19, pls. 29–31.
2. For an original by Polykleitos or Praxiteles, see bibliography in *LIMC* 5:321, 363–64, 367–68, pls. 231, 272–73, 278, nos. 396, 915, 925, 950a-c, s.v. Hermes (G. Siebert); by Lysippos or Skopas, see *LIMC* 6:415, 423, pls. 208, 215, nos. 3 and 72, s.v. Meleagros (S. Woodford).
3. As Dioskouroi: Caputo and Traversari 1996, 25, no. 5; *LIMC* 3:572, 575, pls. 460, 464, nos. 48, 51, 90, s.v. Dioskouroi (A. Hermary); and *LIMC* 3:612–13, 615, pls. 489–91, nos. 1, 18, 32, s.v. Dioskouroi/Castores (F. Gury). As Meleager: Karageorghis and Vermeule 1964, 18–19, no. 8; *LIMC* 6 (as in n. 2 above). As Hermes: Inan 1975, 65–72, no. 19; *LIMC* 5 (as in n. 2 above). On the history of the chlamys motif, see Weber 1975, 33–35.
4. That the fragment might have belonged to a figure of Hermes holding a caduceus was kindly suggested to me by Professor Ridgway.
5. See Inan 1975, no. 19, pl. 31, fig. 2.

83.

SHOULDER FROM A CUIRASSED BUST

Probably third century A.D.
Provenance: Yakto (near Antioch)
Material: medium-grained white marble
Dimensions: h. 5.0 cm., w. 9.4 cm., d. 5.1 cm.
Gift of the Committee for the Excavation of Antioch to
Princeton University (2000-79)

CONDITION: *The piece is broken off on the right (inner) side,*
producing a roughly triangular profile. Its bottom remains flat
and smoothed but was never polished. The outer face shows mild
scratching and abrasion, although some of its old finish still
survives. The stone has become discolored and appears tan with
reddish highlights.

This fragment shows the tip of a draped left shoulder. The heavy garment conforms to the general line of the body but covers any underlying detail. It is divided into a few shallow overlapping segments, each articulated by a series of incised vertical lines. The design is repetitive and quite stylized. Its carving lacks true precision but proves perfectly adequate for such a relatively unambitious undertaking.

This piece originally formed part of an armored portrait bust. Although the garment appears superficially similar to conventional drapery, its segments actually are highly stylized representations of the thick leather straps that served as shoulder guards on Roman cuirasses. The presence of such equipment suggests that the sculpture portrayed a military officer, or, perhaps, an emperor.

It would be impossible to determine the individual without further evidence,[1] but stylistic analysis can provide an approximate date. The shallow and patterned rendering of the straps, for example, compares well with similar trends seen on a cuirass in Reggio di Calabria.[2] The latter is dated fairly precisely to ca. A.D. 250, although the Yakto shoulder should be attributed more generally to the third century A.D.

<div style="text-align:right">RJC</div>

BIBLIOGRAPHY
Unpublished.

NOTES
1. Such evidence, unfortunately, is not forthcoming from archaeological sources. Like so many other small fragments from Antioch, this shoulder remains unmentioned in the excavation records. Its place of origin, however, was painted on the side.
2. See Vermeule 1959, 71, pl. 22.69. This cuirass is of a slightly different type (based on Hellenistic rather than Roman models), but the leather straps in its skirt show the same basic stylistic developments as the Yakto shoulder.

84.
YOUTH WITH A DOWNTURNED TORCH

Third century A.D.
Provenance: Daphne-Harbie, sector 27-0, May 24, 1938
Material: fine-grained white marble
Dimensions: h. 46.5 cm., w. at shoulders 20.7 cm.,
w. at hips 18.4 cm., d. 12.4 cm.
Gift of the Committee for the Excavation of Antioch to
Princeton University (2000-37)

CONDITION: *Torso broken into two pieces (now repaired), with break running horizontally through the left arm and back, and angling downward to a break below the belly. Right arm, head, and both legs missing. The genitals are broken off. The front is smooth, flecked with small flaws or possibly puntelli. The surface is mottled and discolored, with traces of thin roots. Drilled troughs delineate the arms and legs. Surface on back of the figure and along lower left arm is rough, as though unfinished. At base of neck, between shoulders, an indented area carved with diagonal waves indicates that the piece was carved out of reused stone, possibly a draped figure. Square dowel holes on the bottom surface and lower side of left leg. Flaw in stone along knuckles of left hand. Modern chip on lower left side, and several modern abrasions.*

The nude youth stands on his left leg, with some weight shared by the right leg. His left arm hangs by his side, holding a downturned torch. The torch, composed of a bundle of summarily carved strips, is bound by a ring; the torch's lower half seems to have broken off. Break marks below the youth's right armpit and along his right leg indicate that his right arm also hung at his side. He may have carried an object in his right hand, which could explain the long vertical break extending down his leg. A slight protrusion of stone on the left shoulder may indicate that a lock of hair rested here. The boy's fleshiness and his small genital area attest to his youth.

Youthful figures with downturned torches, particularly erotes and personifications of Somnus or Thanatos, are often found in funerary contexts, both on sarcophagi and as sculptures in the round.[1] However, these figures generally lean on their torches, in poses evoking a juvenile Herakles Farnese. Other mythological contexts in which they appear include Bacchic and thiastic episodes.[2] The active gestures and contorted poses differentiate these figures from the decidedly frontal and static Antioch youth, as does the fact that the youth appears to have held a second

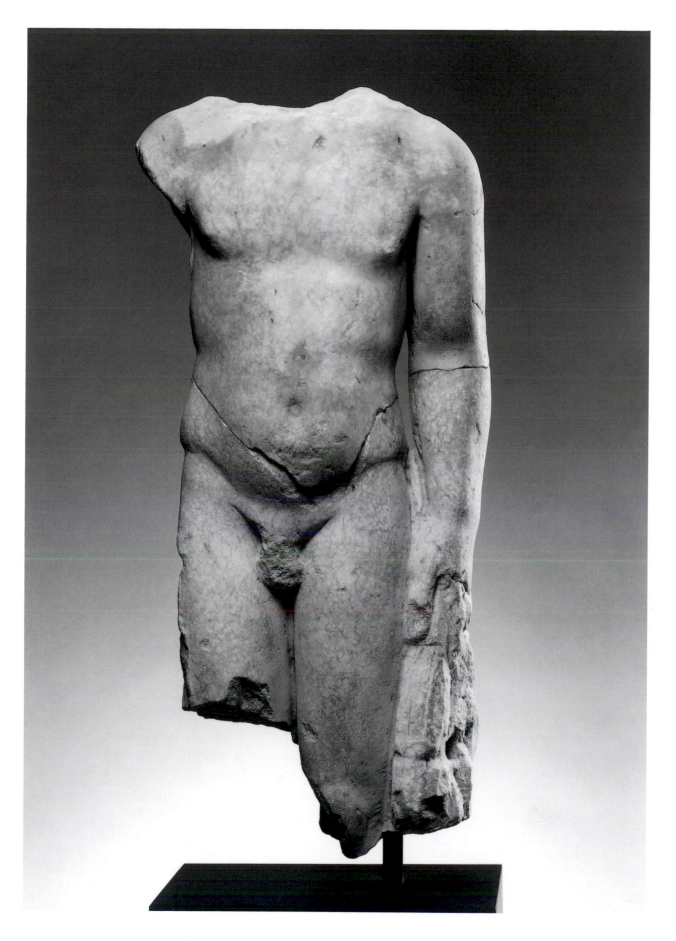

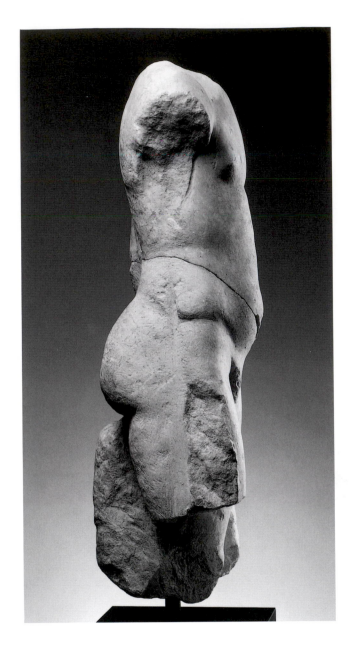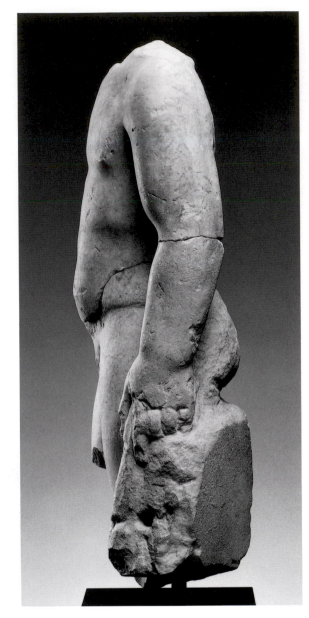

object in his right hand. No precise parallels can be found for the type.[3]

These anomalies may be explained by restrictions encountered by the artist, who sculpted the figure out of a previously carved block. A section of the original piece is preserved on the youth's upper back, and the flat surface of the large triangular support may also belong to the earlier composition. The sculptor appears to have encountered other technical problems. While the surface is generally smoothly finished, transitions between body masses are awkward: note particularly the heavy, low-sitting hip muscles. The artist has incorrectly rendered the responses of the pelvis to the action of the legs. While the youth stands on his left leg, his right hip is actually slightly higher. Finally, the rear portion of the lower right leg and buttock are narrower than the front plane of the statue. This difference is emphasized by a low shelf running up the figure's right side.

The torso was found in a late-fifth-century villa in Daphne-Harbie,[4] incorporated into either the northwest wall of the courtyard (room 6) or the south wall of the apsidal northwest peristyle bordering this courtyard (room 7a).[5] Several other fragments

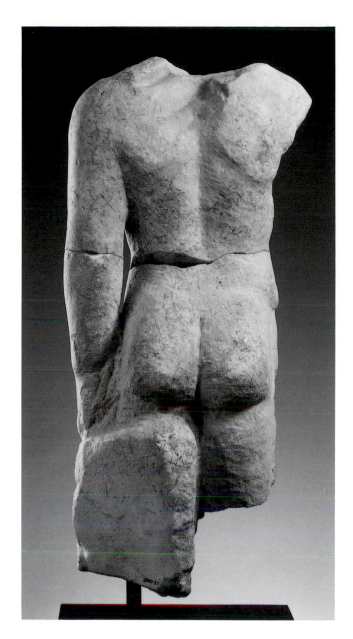

BIBLIOGRAPHY
Stillwell 1941, 121, pl. 3, no. 298 (b365-S543).

NOTES

1. *RE* 6:508, s.v. Eros; *LIMC* 6:591–93, s.v. Hypnos/ Somnus (G. Lochin).
2. *LIMC* 3:976–77, pls. 689–90, s.v. Eros/Amor, Cupido (N. Blanc and F. Gury).
3. For a statue of an Eros with crossed legs and a decided leftward lean, who holds a small object in his right hand and a downturned torch in his left, see *RSGR* 52:501, no. 3.
4. For the building and its date, see Stillwell 1941, 29–31, fig. 33.
5. Find-spot reports conflict: Princeton University Archive: F. O. Waage (*Antioch Excavation Diary, 1938,* 206–207) locates the find-spot in the wall of the courtyard, while the inventory card in the Princeton University Archives notes that it was discovered in the peristyle-side of the wall.
6. Stillwell 1941, 121, pl. 12, no. 300 (b324-S540); found under the mosaic floor of room B6 (Princeton University Archives, inventory card).
7. Stillwell 1941, 121, pl. 8, no. 302, (a1140-S481); found in a water channel in the northwest sector of room B6 (Princeton University Archives, inventory card).
8. Stillwell 1941, 121, pl. 8, no. 303 (a813-S445); found in the cut west of room B7 (Princeton University Archives, inventory card).
9. For the earlier groups of rooms, see Stillwell 1941, 27–29, fig. 32.

of sculpture were found in the same area. These included a lion's head,[6] the head of a female figure,[7] and a hand holding drapery.[8] The fifth-century complex replaced and partially covered at least three groups of rooms paved with mosaics, which seem to have been occupied for most of the third and fourth centuries.[9] The male torso and the other sculptures may have originally decorated the earlier structure. The youth's chubby flesh and the possible connection with the earlier structure at Daphne-Harbie suggest a date in the third century.

MLL

85.
RELIEF OF EROS(?)

Probably first—second century A.D.
Provenance: Seleuceia in Pieria; purchased July 29, 1937
Material: large-grained white marble
Dimensions: h. 16.7 cm., w. 23.3 cm., d. 11.8 cm.
*Gift of the Committee for the Excavation of Antioch to
Princeton University (2000-91)*

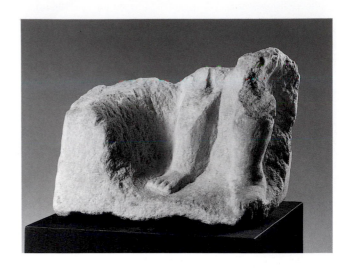

CONDITION: *The piece exhibits a rather poor state of preservation. Its slab is broken completely at both top and bottom, while only traces of a worked surface remain on the right side. The subject consequently is cut off at the level of the knees, and his left foot has lost its outer toes. An iron dowel in the figure's right leg and traces of another in his left provide evidence of an ancient repair. Other alterations include a groove across the top rear of the block and a large (w. 5.8 cm.) quarter-spherical cutting in the broken surface on its bottom. The stone is worn and discolored, with a grainy tan incrustation covering much of the piece.*

The relief shows a figure of indeterminate sex standing in a crudely worked recess, the right side of which has been lost. The walls and the floor of this space are uneven, and its surfaces remain rough. The figure, carved in very high relief, is positioned against the left wall of the recess. The left leg projects forward with a bent knee and an outward turn, while the right remains more or less straight. Faint sandal straps can be seen on the left ankle, but no other clothing or attributes are visible. Both legs appear rather short and pudgy. The workmanship is of poor quality, with clumsy rendering and minimal finish.

The damaged condition of this relief hampers considerably the identification of its subject. Stillwell suggested a depiction of Eros, presumably on the basis of the figure's stunted fleshy build.[1] Such an interpretation certainly seems plausible and would also explain the presence of sandals on what appears to be an otherwise nude figure of childlike dimensions. Nevertheless, this attribution must remain tentative, as the inferior quality of the carving does not permit any definite interpretation based solely on proportions.

Whatever its subject, the piece itself enjoyed a very active history in antiquity. The dowel holes in the knees, for example, demonstrate at least one ancient repair. Since such care was unlikely to be motivated purely by aesthetic appreciation, it may be surmised that the carving served in some role of continuing importance, perhaps commemorative, to a local constituency. This significance, however, eventually faded and the relief then seems to have been reused as building material. The channel on the back of the block and the cutting on its bottom almost certainly were made at this time.[2] Indeed, the block as a whole may have been trimmed significantly and reworked, a circumstance which would explain both the lopsided composition of the relief as well as the traces of a worked surface along its broken right side.

The dating of this particular piece poses something of a problem. Like many other works from Antioch, it was found outside a secure archaeological context.[3] Moreover, the poor execution of the carving leaves little room for precise stylistic analysis. The relief therefore can be attributed only on the basis of the most elementary style and composition, which are broadly consistent with the imperial period. The piece's history of ancient repair and reuse would argue against a very late date. RJC

BIBLIOGRAPHY
Stillwell 1941, 123, no. 353, pl. 15 (Pc 457-S618).

NOTES
1. Stillwell 1941, 123.
2. The channel seems to have been made in order to facilitate fitting the block into a larger construction.

The precise purpose of the quarter-spherical cutting on the bottom surface is more ambiguous. It may have been the incision for a building clamp, although the excavation records (card Pc457-S618) suggest a "lewis hole."
3. In this case, the relief was purchased by the excavation from local villagers on July 29, 1937.

86.

LEG OF A STATUETTE

Probably first–third century A.D.
Provenance: Antioch, sector 15-M, found September 11, 1939
Material: medium- to large-grained white marble
Dimensions: h. 15.4 cm., w. 6.6 cm., d. 7.6 cm.
Gift of the Committee for the Excavation of Antioch to Princeton University (2000-86)

CONDITION: *The leg is broken at both the top of the thigh and just below the knee. There is considerable chipping on the inner thigh, along with some lesser damage around the lower joint. Several large gouges mar the surface, which has seen much wear and abrasion. Many areas have become roughened, although the back retains tools marks and does not appear ever to have been smoothed fully. The stone is heavily discolored, and a brownish gray accretion lingers along the outer thigh.*

The piece portrays part of a male left leg, bent at approximately a 145-degree angle. There are no visible garments or attributes. The limb is of massive build, with a thick, powerful thigh. Its carving is of fair quality, and emphasizes simplified, molded volumes. The surface appears smooth and rounded, with little defined detail.

This fragment formed part of a larger work which showed a stocky male nude engaged in some sort of action. Although the figure cannot be identified with any certainty, such features might suggest a depiction of Herakles. Indeed, the limb bears a striking similarity, in both execution and build, to a statuette of that hero now in Selçuk.[1] There is insufficient evidence to date either of these two pieces precisely, although the pair may be attributed broadly to the imperial period.[2]

RJC

BIBLIOGRAPHY
Unpublished.

NOTES
1. See Aurenhammer 1990, 113–14, no. 93, pl. 65c.
2. The Antioch fragment was found on September 11, 1939, in excavation sector 15-M. This sector contained numerous remains, including those of two successive buildings with mosaic pavements, dated, respectively, to the third and fifth/sixth centuries A.D.; see Stillwell 1941, 11–12. The sculpture probably was associated with one of these structures, although it might well have predated both.

87.
LEFT THIGH

First or second century A.D.
Provenance: Antioch, sector 16-P
Material: medium-grained white marble
Dimensions: h. 16.1 cm., w. at center 9.0 cm., d. at center
9.6 cm.
Gift of the Committee for the Excavation of Antioch to
Princeton University (2000-87)

CONDITION: *The piece is broken at both top and bottom, with heavy chipping and wear on these edges. Moderate pitting and abrasion mar the once-polished surface. The stone is discolored and displays some light accretion on the inner thigh. Numerous root marks cover the outer thigh, in addition to several small iron stains along the front.*

The fragment depicts a slightly underlife-sized left thigh, apparently male. Traces of the upper knee survive, suggesting that the leg was held straight. The limb remains bare and without attributes. Its build is firm, with flaring musculature on the inner thigh. The carving is of good quality and favors well-modeled forms.

Such scant remains permit little reconstruction beyond the generic type of a muscular male nude. Given the dearth of archaeological data,[1] it would appear that the identity and context of this sculpture have been lost irretrievably. The general technique and workmanship of piece suggest a date somewhere in the early imperial period. RJC

BIBLIOGRAPHY
Unpublished.

NOTE
1. No information is available on the exact archaeological context of this piece. It is marked as having come from excavation sector 16-P but cannot be identified within any of the records.

88.

LEG OF A HORSE

First—second century A.D.
Provenance: Antioch, sector 13-R, found April 29, 1938
Material: medium-grained white marble
Dimensions: h. 13.1 cm., w. at base 6.7 cm., d. at base 9.4 cm.
Gift of the Committee for the Excavation of Antioch to
Princeton University (2000-88)

CONDITION: *The fragment is broken at both top and bottom. There is light wear and abrasion on all surfaces, in addition to several larger gouges. Remnants of a smooth finish survive on the rear face. The stone is discolored, with some grayish accretion and scattered root marks.*

The piece depicts the limb of an animal. It has a more or less oval section, the front of which is augmented by flaring sinews. The latter taper toward the bottom of the fragment, where, on the left rear, is the beginning of a joint. The carving is of high quality, with powerful modeling of the musculature and anatomy.

Although little remains of this limb, its build and size seem generally consistent with those of a horse.[1] Indeed, the narrow section, pronounced tendons, and rear articulation all suggest a lower (possibly left) ankle, just above the fetlock joint. The pose and the larger context of this beast remain unclear. It can be dated broadly, on the basis of workmanship and technique, to the early imperial period (first or second century A.D.).[2]

RJC

BIBLIOGRAPHY
Unpublished.

NOTES

1. For a discussion of equine anatomy see Thompson 1896, 50–54, pls. 28–34. By Thompson's criteria, this fragment is, in fact, somewhat larger than would be expected for an average horse from one of the lighter breeds. (The heavy breeds, such as Clydesdales, come from northern Europe, and are not known to have been used extensively by the Romans.) This divergence (of approximately 25 percent) may reflect either a slightly overlife-sized image or the strengthening of a weak structural area in the sculpture.

2. The fragment was found on April 29, 1938, in excavation sector 13-R. It had been built into a wall associated with an early Byzantine (A.D. 537/8) bath complex; for an account of the area, see Stillwell 1941, 8. Although this context provides an interesting *terminus ante quem*, it offers no useful information on the origin of the piece.

89.

FOOT ON A BASE

First–third century A.D.
Provenance: Daphne-Harbie (P6234-S428)
Material: fine-grained white marble
Dimensions: h. 12.4 cm., w. 9.6 cm., d. 19.1 cm.,
h. of base 7.8 cm.
Gift of the Committee for the Excavation of Antioch to
Princeton University (2000-84)

CONDITION: *Most of the instep, the outer heel, and four of the toes are broken off. All breaks are ancient and worn except those of the toes, which look very fresh. The surface of the foot is covered with nicks and fractures; the base is broken in a straight plane from big toe to heel. The bottom of the piece has been roughly flattened with a pointed chisel.*

The fragment consists of a right, bare foot on a statue base. The worn and chipped surface of the foot makes it impossible to conjecture whether it belonged to a male or a female figure. The fact that the foot is bare perhaps indicates that the figure to which it belonged was in the nude. TN

BIBLIOGRAPHY
Unpublished.

90.

COLOSSAL ARM

First–third century A.D.
Provenance: vicinity of Antioch/Seleuceia in Pieria
Material: fine-grained white marble
Dimensions: l. 43.5 cm., w. 14.5 cm., th. of wrist 9.7 cm.
Gift of the Committee for the Excavation of Antioch to
Princeton University (2000-85)

CONDITION: *The arm is broken at the wrist and at the elbow in uneven, diagonal breaks. Several fractures run the length of the arm. All breaks are worn, and the surface, especially in front, is covered with a grayish incrustation. A brown stain encircles the break around the wrist, as if this end had been placed in damp soil for a long period of time.*

The fragment is a large, naked forearm. The edge of a square tenon hole for attaching the fragment to the upper arm of a statue is visible in the break at the elbow.

The massive bulk of the arm suggests that it belonged to an overlife-sized statue that probably represented a god, a hero, or an emperor. The position of the tenon hole and the elbow indicate that the forearm was attached in a 45-degree angle to the upper arm. TN

BIBLIOGRAPHY
Unpublished.

248

91.

COLOSSAL HAND

First—second century A.D.
Provenance: Daphne-Harbie, 1937 ("not from the excavations")
Material: large-grained white marble
Dimensions: l. 18.3 cm., w. 14.8 cm., w. across knuckles
13.2 cm., d. 11.9 cm.
Gift of the Committee for the Excavation of Antioch to
Princeton University (2000-83)

This right hand from a colossal statue was not found
in the excavations at Daphne but acquired independ-
ently at the source. The middle, ring, and little fingers
curve diagonally around a cylindrical object while the
missing thumb and index finger were stretched out
along its length. There is no clue as to the identity
of the object, which could be any number of things:
staff, spear, thyrsos, torch, or scepter.[1] The work-
manship is good. JMP

CONDITION: *The break runs straight across the wrist and
the lower end of the cylinder. Thumb and index finger are broken
away in diagonal planes converging at the upper break in the
cylinder. There are ancient and modern breaks in the middle
finger and chips in the remaining knuckles and fingertips; the tip
of the ring finger is missing. A hard gray incrustation covers
much of surface, especially the back.*

BIBLIOGRAPHY
Stillwell 1941, 123, pl. 11, no. 329 (Pa 284-S392).

NOTE
1. T. Najbjerg notes (personal communication) that
 colossal statues of two Roman emperors (Hadrian
 and Titus?) were found near the theater in Daphne;
 see Chapot 1902, 162–64.

92.

GROUP OF TWENTY-EIGHT ARMS AND HANDS

First half of the first century A.D.
Provenance: Antioch, 1937; all from sector 16-P, except for a single elbow from sector 13-R; and one large elbow and forearm fragment found at Daphne-Harbie, sector 26-M/N
Material: fine- to large-grained white marble
Dimensions: l. of smallest piece 4 cm., l. of longest piece 11.4 cm.
Gift of the Committee for the Excavation of Antioch to Princeton University (2000-118.1-28)

CONDITION: *The surfaces of all pieces are chipped and worn. One hand is especially marred by scratches. Dowel holes have been drilled in all hands and arms. Where the ancient iron dowels are still embedded in the hole, they are usually surrounded by rusty brown stains.*

The cache consists of nine hands (one holding a round object), one hand with wrist and forearm, two hands of which only the fingers are visible, four individual fingers, nine arms with elbows, and three upper arms. All the arms are bare and show no traces of drapery. The traces of dowel holes in all fragments except the fingers indicate that these pieces were attached separately to the body of statuettes; two of the fingers are from life-sized sculptures. The muscles on the arm from Antioch 13-R (second row, third from left in photo) are very pronounced, and it probably belonged to a statuette of a male figure.

Twenty-five of these fragments were found in 1937 in the same sculptor's workshop at Antioch (sector 16-P) as the group of legs and feet in the following entry (cat. no. 93), along with several other statue fragments. The apparent destruction of the workshop in the second half of the first century A.D. provides a *terminus ante quem* for this group. TN

BIBLIOGRAPHY
Unpublished.

93.
GROUP OF TWELVE LEGS AND FEET

First half of the first century A.D.
Provenance: Antioch, sector 16-P
Material: fine- to large-grained white marble
Dimensions: l. of smallest piece 5.4 cm., l. of longest piece 11.5 cm.
Gift of the Committee for the Excavation of Antioch to
Princeton University (2000-119.1-12)

CONDITION: *Almost all pieces are scratched, worn, and covered with root incrustations.*

The cache consists of five lower legs, one thigh, three thighs with knees, one ankle and heel, one front part of foot, and a base with two feet. Most of the legs, lower and upper, are naked, with clearly defined musculature, and probably belonged to statuettes of male figures. One of the pieces retains the lower part of a garment, probably a short chiton. The dowel holes are still visible on two of the pieces.

The fragments were discovered at Antioch in 1937 together with the group of arms and hands in the preceding entry (cat. no. 92), along with several other statue fragments. This area, sector 16-P, yielded the most sculpture within the city itself. The excavation along the large main street in this sector of Antioch revealed a sculptor's workshop with two cement-lined basins and an oven that may have functioned as a limekiln. The fragments were found in the immediate area of the oven and may have been destined for destruction in the limekiln or for reuse by the sculptor. The nature of the objects makes it impossible to date them on a stylistic basis; however, the destruction of the workshop in the second half of the first century A.D. provides a *terminus ante quem* for the group. TN

BIBLIOGRAPHY
Unpublished.

94.

FRAGMENTARY HEAD OF A GOAT

Late second or early first century B.C.
Provenance: Daphne-Harbie; purchased April 25, 1935
(P4873-S255/615)
Material: fine-grained, dark gray marble
Dimensions: h. 27.8 cm., w. 18.2 cm., d. 14.8 cm.
Gift of the Committee for the Excavation of Antioch to
Princeton University (2000-60)

CONDITION: *Preserved from shoulders to cheek; includes the top of the head and the outer corner of the left eye. Both horns are missing, as are the ears, which were originally doweled to the sides of the head. Large dowel hole behind the horns on the upper neck. Surface weathered in some areas.*

This fragment has been variously identified as the mane of a horse, a dolphin or similar water animal, or as a bundle of human hair.[1] However, glands on the sides of its neck securely identify it as the neck of a goat. Long, shaggy locks of hair, carved in low relief and accentuated by parallel cuttings, cover the neck. At the poll, the locks become short and tousled; this also occurs under the cheek and near the chest area. Below the ears, these tufts fade into the smooth coat of very short hair which covers the face. The animal turns its head slightly to its right. The upright posture of the neck and the relatively calm hair suggest that the animal stood still or walked quietly.

The goat wears a bridle, which runs behind its (now-missing) ears. Small circles carved in relief bordered by raised edges decorate the leather. Farther below, a second strap encircles the neck above the animal's shoulders; this piece is less decorative, and secures a rectangular roll of material over the withers, apparently to prevent chafing. A complete example of this type of harness is seen on the relief decoration of a child's sarcophagus from Sinope.[2]

This animal probably formed part of a sculptural group, like that depicted on the child's sarcophagus mentioned above. The inward turn of the goat's head suggests that it was paired with a second beast. Goat-drawn carts reportedly participated in the Dionysiac procession staged by Ptolemy Philadelphus,[3] and they

appear in various artistic media during the Roman period, when they are generally associated with putti, Dionysiac characters, or children.[4] The dowel hole in the goat's upper neck could have provided an attachment point for a putto, who may have led the animals by the reins or driven the cart. While no sculptural parallels are found for this type of group, the translation of relief motifs into three-dimensional ensembles is not unknown.[5] The dark stone from which

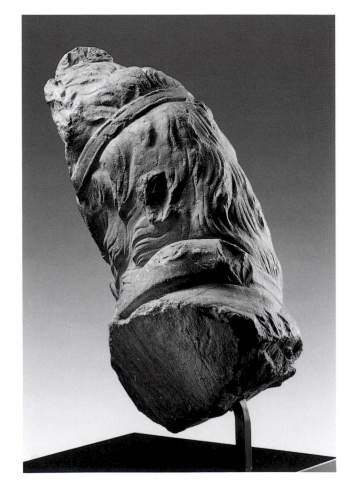

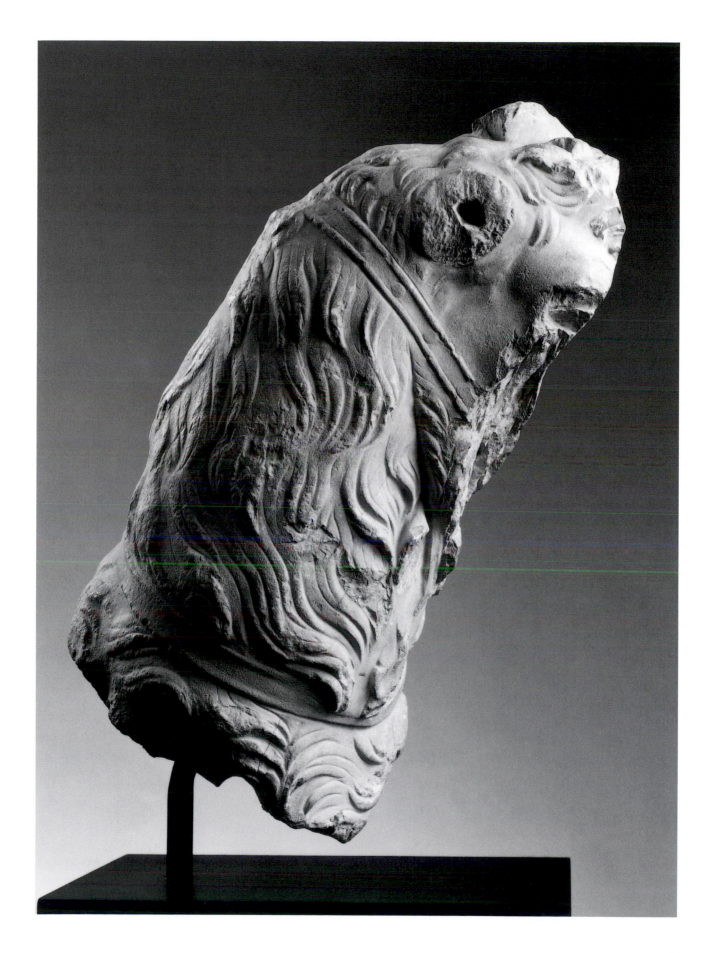

253

the goat is carved finds parallels in other pieces from Antioch.[6] In this case, the stone's decorative quality may have distinguished the animal from other members of the group, which might have been rendered in a white or contrasting colored marble.[7]

It is unlikely that this piece depicted the slightly more common sculptural group of the child Dionysos riding a goat.[8] The Antioch goat wears a bridle and harness, a detail rarely shared by the steeds of Bacchus. Nor does the animal preserve any traces of the infant rider, who might have grasped the mane or gripped the shoulders between his knees.

The lively and detailed characterization of the hair, combined with the rare dark stone, suggest that this piece was imported into Antioch. Stylistically, it probably dates to the late second or early first century B.C.[9]

MLL

BIBLIOGRAPHY
Unpublished.

NOTES
1. Princeton University Archives, inventory card.
2. Istanbul, Archaeological Museum, no. 1165; *LIMC* 3:930, pl. 664, no. 974, s.v. Eros (A. Hermary). The Antioch piece lacks the strap over the goat's forehead.
3. Athenaeus, *Deipnosophistae* 5.200; see also Toynbee 1973, 164–66.

4. Goat-drawn chariots driven by putti are painted in the house of C. Iulius Polybius at Pompeii (IX 13, 1); see Cerulli Irelli et. al 1991, pl. 101. A sarcophagus relief in the Louvre depicts a boy riding in a goat cart: Toynbee 1973, fig. 166. Goats pull a cart full of grapes in the Dionysiac cortège depicted on a gold patera from Rennes in the Cabinet des Médailles, Paris: Levi 1947, 23, fig. 5. Goat carts are also linked to the youthful personifications of the Seasons and appear on sarcophagi, where they are contrasted to chariots drawn by boars, lions, oxen, etc. These animals are not consistently driven by specific Seasons; see Kranz 1984, pl. 92, nos. 1, 2.
5. See, e.g., a marble group in the National Archaeological Museum, Naples (inv. no. 6218), depicting two men cooking a slaughtered pig. This tableau adapts a relief motif rendered on cameos, metalwork, ivory, and plaster: Hackin et al. 1954, figs. 397–404.
6. See, e.g., a fragment of a snake (cat. no. 95) and a fragmentary bust of Isis (cat. no. 61).
7. A nymphaeum from Silahtaraga, Istanbul, used similar polychromy to distinguish gods (in white marble) from giants (in gray limestone): Pasinli 1995, 117.
8. For a discussion of this type, see Hesberg 1979, 297–317, pls. 60–76.
9. Cf. the comparable treatment of the hair of another goat, in the Prado Museum, dated by Hesberg 1979, 302, pl. 69.1, to the late Republic. Cf. also the hair and beard of a portrait from Delphi, dated to the late second century B.C.: Bieber 1961b, figs. 692–93.

95.
BODY OF A SERPENT

Late second or early third century A.D.
Provenance: Antioch, sector 22-K
Material: fine-grained dark gray marble with white specks
Dimensions: h. 14.7 cm., w. at center 5.7 cm., d. at center 4.9 cm.
Gift of the Committee for the Excavation of Antioch to Princeton University (2000-61)

CONDITION: *The sculpture is broken, along roughly parallel lines, at both ends. A very large gouge of more recent date (without any incrustation) appears on the right side, near the smaller end. The entire surface shows moderate wear and abrasion, although the right side and the belly seem to have suffered most. There is a heavy brownish incrustation on the back, with lighter deposits almost everywhere else.*

pose. Such beasts were not uncommon in Roman art. They were associated closely with death and rebirth, and consequently accompanied various divinities of healing, fertility, and the so-called mystery cults.[1] It seems quite likely that this fragment functioned as such an attribute: possibly for Hygieia, although the use of this unusual dark stone might suggest a more exotic entity.[2]

Like so many of the minor finds from Antioch, this piece lacks meaningful documentation of its archaeological context.[3] Strong stylistic parallels, however, are available. An unusual statue of a snake from Constanta, for example, shows a very similar treatment of the body and the scales.[4] It appears to be contemporary with the Antioch fragment, which therefore should be attributed to the late second or early third century after Christ. RJC

BIBLIOGRAPHY
Unpublished.

NOTES
1. For a brief discussion on the place of serpents in Roman art, see Toynbee 1973, 223–36.
2. Professor B. S. Ridgway, for example, has suggested that the serpent may have come from an image of Isis, and that its use of dark stone was a deliberate allusion to Egyptian granite statuary (personal communication). The problem is an interesting one, since this piece is not an isolated anomaly. Another fragment in dark stone, showing part of a snake's body as well as a human left hand, was purchased in Daphne-Harbie; see Stillwell 1941, 122, pl. 12, no. 323 (Pc 71-S558). Although differences of provenance, carving style, and precise material separate the two pieces, this duplication does argue for an established local tradition of representing certain serpent-related deities in dark stone.
3. The piece is marked with an abbreviated find code, "22K s66" (sector 22-K, sculpture no. 66), but it is not mentioned in any of the site records.
4. See Toynbee 1973, 392, no. 84 (fig. 111); or *LIMC* 4: pl. 161, no. 1, s.v. Glykon (G. B. Battaglia).

This fragment shows the undulating body of a serpent. It comes from the front of the beast and narrows toward the head. The creature is covered on its back and sides by broad triangular scales with rounded points. These plates are carved deeply on the back, but become progressively more shallow near the ribbed belly. Rounded lines and edges predominate, accentuating the serpent's curves. The carving is of fair quality but lacks fine detail.

In the absence of more substantial remains, it proves difficult to reconstruct this sculpture with any precision. The only certainty is that it included an approximately life-sized serpent in a contorted

96.

FRAGMENT OF A STAFF WITH A BEARDED SERPENT

Possibly first—second century A.D.
Provenance: purchased in Jekmejeh, June 17, 1939
Material: medium- to large-grained white marble, highly crystalline
Dimensions: h. 7.2 cm., w. 4.8 cm., d. 3.6 cm.
Gift of the Committee for the Excavation of Antioch to Princeton University (2000-67)

CONDITION: *The fragment is broken in an even plane across the serpent's neck and the staff, and in front of its head. The surface is hardly worn but fairly encrusted. The nose and the beard of the serpent are chipped.*

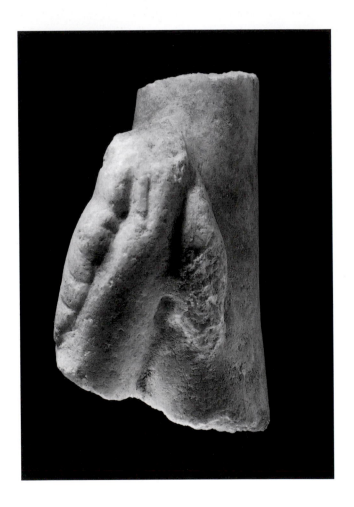

The piece represents the head of a bearded serpent and part of a knotted staff. The beard, one eye, and the mouth of the snake are visible. A line of scales extends behind the eye. A hole is drilled in the bulky part of the staff.

Serpents were commonly depicted on ancient representations of tree trunks that functioned as struts for statues of the gods Apollo, Athena, Hygieia, and Asklepios. The small size of this fragment, however, indicates that it represented a snake coiled around a staff rather than a tree trunk. The figure most often associated with a serpent staff is Asklepios, the god of healing.[1] Only rarely is the serpent bearded as in the Princeton fragment; a second-century Roman copy of Asklepios from Salamis is one of the few other examples that features a snake with a beard.[2]

TN

BIBLIOGRAPHY
Unpublished.

NOTES
1. See, e.g., Ashmole 1929, pl. 19, fig. 20; Inan 1975, no. 77, pl. 72, fig. 1. For a small figure of Asklepios with the serpent staff from Antioch, see Stillwell 1941, pl. 5, no. 317.
2. See Karageorghis and Vermeule 1964, 1: no. 5, pl. 13, fig. 1; and Karageorghis and Vermeule 1966, 2: no. 80, pl. 6, fig. 1.

97.

Chest and Forelegs of a Lion

First–third century A.D.
Provenance: Daphne-Harbie, sector 20-N (theater), May 1934
Material: large-grained white marble
Dimensions: h. 26.5 cm., w. 21.2 cm., d. 86 cm.
Gift of the Committee for the Excavation of Antioch to
Princeton University (2000-63)

CONDITION: *The piece is broken diagonally across the chest of the animal and across both forelegs. The left leg is broken horizontally; the right leg is broken diagonally. The surface is badly worn. The left leg is scarred by four horizontal, perpendicular cuts and two vertical cuts running along its side.*

The poorly preserved fragment represents the chest and part of the forelegs of an animal, probably a lion. Curly locks from a mane cascade down the chest, contrasting with the smooth skin of the forelegs. The back of the piece has been flattened with a rough chisel.

The lion was a popular subject in Greek and Roman plastic arts, both in relief and in the round. In Greece lions were associated with funerary monuments from the seventh century B.C. onward.[1] Symbolizing strength and courage, statues of lions were placed on graves as guardians, or the animal was featured in the relief decoration of grave stelai.[2] The popularity of the lion continued through Hellenistic and Roman times.[3] Lions carved in the round can be found in various positions—lying down, sitting, standing, or crouching.[4] The vertical position of the left leg of the Princeton example indicates that the lion to which the piece belonged was standing or seated. The diagonal break above the missing right leg suggests that the right foreleg was raised or moved forward.[5] This might indicate that the lion was standing or walking rather than sitting. If, as was argued by Stillwell, this fragment belongs with a second fragment, now missing, with part of a lion's mane, we may deduce from the latter's position that the lion also turned its head.[6]

Dating the piece is made extremely difficult by its worn and fragmentary condition. The detailed carving of the individual locks of hair and the irregular pattern

257

by which the strands interweave are reminiscent of the manes on lions of the fourth century B.C.[7] It is not unlikely, therefore, that the Princeton fragment is a Roman copy of such fourth-century monuments.

TN

BIBLIOGRAPHY

Stillwell 1938, 173, pl. 11, no. 158a (listed as 4493-S219a, but subsequently changed to P4391-S200).

NOTES

1. Vedder 1985, 115–16.
2. Vermeule 1972, 55.
3. Vermeule 1972, 52–53. See also Calvani 1979, 270; Koch 1988, 120, no. 45.
4. For the various positions of freestanding lions in antiquity, see the numerous examples in *RSGR* 2:710–722.
5. For a similar breakage pattern, cf. a statue from Sardis: Hanfmann and Ramage 1978, fig. 129. Although the Princeton lion would have been standing or seated, not lying down like the Sardis example, the breaking off of a raised, right foreleg would have created a similar cut in the Princeton fragment.
6. Stillwell 1938, 173, pl. 11, no. 158b. For a very similar piece of mane from a lion that turns its head, see Hanfmann and Ramage 1978, 62–63, no. 24, figs. 90–91. For six examples of freestanding lions that fit all the criteria mentioned, see *RSGR* 2:716, nos. 1–3, 5; 717, no. 3; 718, no. 5. The subsequent renumbering of the Princeton fragment suggests that the excavators eventually may have concluded that it did not belong with the other fragment after all.
7. For example, cf. the well-preserved lions from the Mausoleum of Halicarnassos and from the tumulus at Marathon (Vermeule 1972, figs. 10 and 4), both dating ca. 340 B.C.

98.

FRAGMENT OF A WING

Probably late second century A.D.
Provenance: Daphne-Harbie; acquired May 29, 1937
Material: fine-grained white marble
Dimensions: h. 12.8 cm., w. 14.4 cm., d. 8.3 cm.
Gift of the Committee for the Excavation of Antioch to Princeton University (2000-68)

CONDITION: *The piece is broken on the top, the bottom, and the inside (left) edge. There is some chipping, especially on raised angles. In general, the surface remains slightly rough, with moderate abrasion and a tan discoloration. The rear face, however, shows more serious wear and is covered by a dark brown incrustation.*

This fragment portrays part of a right wing. Its main plane remains flat, while the outer edge bends forward. Most of the wing is covered with large feathers arranged in a regular series of tufts. The latter are rendered abstractly and appear as pairs of closely superimposed ovals. A rough stippled pattern, however, occupies much of the rear surface, indicating that this area was not intended to be seen. The shallow

carving is quite stylized and takes on a heavy cast from the broad, featureless feathers.

The sheer scale of this fragment and its feathers suggests the depiction of a large mythological figure, such as a Victory. (Although one cannot exclude entirely an avian of monstrous proportions, such creatures remain relatively rare in Roman art.) The piece was clearly a substantial work and presumably occupied a position of some prominence.

The fragment was purchased from local villagers, and its original context therefore remains obscure.[1] There are, however, numerous parallels for its stylized system of plumage. A similar pattern of abstracted, composite tufts is found on a variety of different subjects, from Eros to the eagle of Zeus, and appears characteristic of the second century A.D.[2] The carving

on this particular piece, however, remains shallow and rather reduced, suggesting a comparatively late date within this period. RJC

BIBLIOGRAPHY
Unpublished.

NOTES
1. No record of the piece exists in excavation archives, although the date and place of its purchase have been painted on one side.
2. Related examples include a Hadrianic Eros in the İzmir museum, which can be found in Söldner 1986, 2:651–52, no. 101, fig. 110; and an Antonine group of Ganymede and the Eagle in the Vatican (*LIMC* 4: pl. 95, no. 251, s.v. Ganymedes [H. Sichtermann]).

99.

FRAGMENTARY RELIEF OF AN EAGLE

Third century A.D.
Provenance: Ain-Tavilé (near Antioch), catalogued March 31, 1936 (P6236-a249)
Material: medium-grained white marble
Dimensions: h. 15.6 cm., w. 10.9 cm., d. 4.8 cm.
Gift of the Committee for the Excavation of Antioch to Princeton University (2000-64)

CONDITION: *Broken on all edges, although some surfaces (the indentations on the top and the sides, as well as the two bottom corners) have been reworked. The head and the wings are lost completely. Extensive chipping has effaced the left foot, as well as the entire right side from mid-leg upward. The front of the relief appears rough, with heavy abrasion and numerous small marks. Its reverse, however, retains a smooth, flat finish, marred only by moderate scratching and a brownish discoloration. The rear surface also shows considerable wear around the edges of the reworked areas.*

This piece depicts an eagle standing upon spread legs. The pose is frontal, although the exact orientation of the head and wings remains unclear. The

bird has a broad, rounded breast, which creates a somewhat squat appearance. Its plumage varies tremendously in texture, with the feathers rendered as teardrops on the body, pointed ovals on the legs, and long arcs in the tail. The carving is somewhat stylized, with an emphasis on simple, curved lines. The execution is undistinguished.

In light of the relief's damaged condition, it is impossible to determine exactly what larger context the eagle may have occupied. Roman art generally employed such creatures, the companions of almighty Jupiter, as emblems of power and/or divinity.[1] They therefore are found frequently on official monuments (especially of a military nature) and in religious contexts. The relatively plain appearance of this particular piece might suggest the latter alternative, perhaps a private votive.

Whatever its original role, the relief was reused at least once in premodern times. The smooth rear surface (thereafter the primary face) and the recarved sections probably both date from this second phase. The newly reworked stone, essentially a flat slab with several holes cut through it, may have functioned as some manner of well or drain cover.[2] In any event, the heavy wear around the edges of these holes indicates that they were exposed frequently to friction, perhaps from hoisting ropes.

Any attempt to date this particular piece, subsequently reused as a builder's stone,[3] must rely entirely upon stylistic analysis. The rounded figure, the awkward pose, and the simplified lines all seem to be later characteristics, although the care to distinguish different types of plumage shows a continuing dialogue with classical precedents. Comparison with a similar (but less well-executed) eagle from Hama suggests an origin somewhere in the third century A.D.[4]

RJC

BIBLIOGRAPHY
Unpublished.

NOTES
1. For a concise discussion of eagles in Roman art, see Toynbee 1973, 240–43.
2. Professor B. S. Ridgway first suggested the reuse as a well cover (personal communication). This theory would explain both the basic form of the fragment as well as the curious wear patterns around its holes. The presence of so many closely spaced apertures, however, remains curious even in this context.
3. The relief was catalogued on March 31, 1936. No detailed account of its context could be found in the excavation archives, although the find card claims that it was discovered within a "double wall."
4. For the Hama piece, part of a votive altar, see Ploug 1985, 184–86, fig. 41b.

100.

FRAGMENT FROM AN ORPHEUS RELIEF

Middle of the third century A.D.
Provenance: Jekmejeh (near Antioch), Villa 1, June 30, 1939
Material: large-grained gray marble
Dimensions: h. 30.5 cm., w. 22.5 cm., d. 20.7 cm.
Gift of the Committee for the Excavation of Antioch to Princeton University (2000-62)

CONDITION: *The piece is broken on the top, the bottom, and the right side. An internal strut, located on the inner surface of the left wall, has been lost. The elephant remains largely intact, lacking only the lower parts of its legs and trunk. The neighboring deer is missing not only its lower legs but also the front of its head and most of its body. The surface of the relief shows heavy wear and abrasion, with some chipping on raised features such as* the foliage and the elephant's ear. There is strong discoloration of the stone, and a brownish incrustation lingers on the back, along the bottom, and in some crevices.

The relief shows a pair of animals set closely together under a horizontal band of foliage. An elephant occupies the left-hand corner of the composition, its head

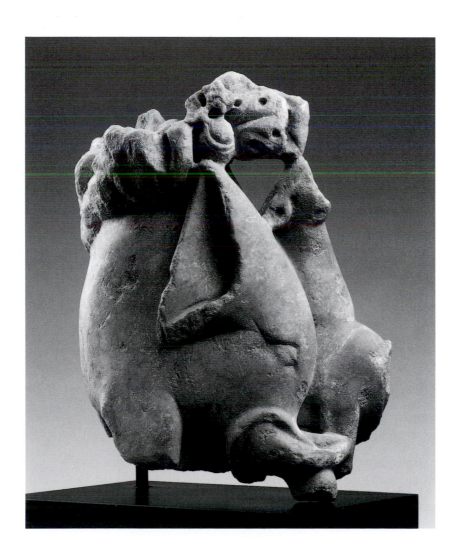

and forelegs resting in the main frontal plane while the rest of its body bends back sharply to form a short side wall. The beast appears to be standing calmly while gazing off toward the right. It has a rather blocky build, accented by a massive sloping forehead, thick tusks, and large, fan-shaped ears. The eye is set shallowly and appears almost triangular in profile.

Adjoining the elephant is the fragmentary figure of a doe, carved out of scale so as to be of equal height. This second creature clearly is meant to complement the first, its body being arranged so as to curve around the elephant's head. The doe, however, exhibits much more graceful proportions, including a very long slender neck which twists back gently as the animal stands staring up at something over its shoulder.

The piece as a whole is characterized by simplified physical forms and smooth, soft rendering, a combination that can lend an almost cartoonlike quality to the figures (particularly the elephant). These effects are highlighted by extensive use of drillwork and undercutting, especially in the foliage and the spaces between the figures. Indeed, the latter areas are cut through completely, providing dramatic contrasts of surface and shadow.

Although now quite worn, the front of the relief originally would have been well finished. Less visible areas, such as those hidden by overlaps or in undercuttings, received much more summary treatment. The back of the piece was hollowed out and left quite rough, indicating that this face was intended to be unseen.

Just as animals permeated the experience of everyday life in Roman times, so too did they embellish the visual arts of this period. Even exotic beasts like elephants appear in a variety of different artistic contexts.[1] In spite of this larger currency, however, the close compositional grouping of these two particular beasts, not normally paired, suggests one very specific scene: that of Orpheus charming the animals. This latter composition depicts the legendary bard surrounded by a ring of diverse creatures, who stand entranced by his music. Although perhaps best known from mosaic representations, this scene also survives in a number of sculpted fountain reliefs that offer strong parallels to the Jekmejeh piece.[2] All show a

similar densely packed arrangement of different creatures (in diverse scales) looking toward a central focus. One example, from Byblos, even provides a close parallel for the horizontal band of foliage, which served as a compositional device to separate the different tiers of animals.[3] A more telling similarity, however, is the position of the elephant. Each and every one of these reliefs shows this beast in exactly the same pose and exactly the same place (the lower left-hand corner). Given the distinctive nature of this composition, one cannot but conclude that they all depict the same scene.[4]

Nor do the parallels end there. The fountain reliefs help to illuminate not only the subject of the Jekmejeh piece, but also its function. Found in a vestibule to the courtyard of a large suburban villa, this small fragment originally was assumed to have come from a sculpted wall revetment.[5] Close comparison with the other Orpheus reliefs, however, suggests something different. Not only do all the pieces enjoy a common subject, they also share the same basic structure: a broad face and shallow sides; deeply carved figures on a "pierced" background; and a rear

wall which has been completely hollowed out except for a series of internal struts.[6] In light of these fundamental similarities, it seems quite probable that, at least initially, this fragment also formed part of one such fountain relief.

Being located so firmly within the larger tradition of Orpheus reliefs, it can be no surprise that these latter pieces also provide the best parallels for dating the Jekmejeh fragment. The example from Sabratha shows the strongest stylistic affinities, especially in the smooth rendering and the execution of the elephant's features.[7] When balanced against the presence of slightly later compositional elements (e.g., the band of foliage), these similarities suggest a date in the middle of the third century after Christ.

RJC

BIBLIOGRAPHY

Stillwell 1941, 119, no. 284, pl. 12 (c436-S611: A335).

NOTES

1. Toynbee (1973, 15–31) provides a good general introduction to the place of animals in Roman art. (The specific role of elephants is treated in the following chapter, 32–54).

2. A basic overview of the type, in all media, may be found in *LIMC* 7: pls. 66–74, nos. 89–163, s.v. Orpheus (M. Garezou). The fountain reliefs are catalogued as nos. 143a–c (pl. 71). Such association of Orphic imagery with fountains had a long tradition within Roman art. Indeed, an example in the capital, the so-called *Lacus Orphei*, even was mentioned as a landmark by Martial (*Epigrams* 10.19.6–9).

3. For the Byblos piece see *LIMC* 7: pl. 71, no. 143a, s.v. Orpheus; and Fauffray 1940, 7–36, pl. 5a.

4. The depiction of Orpheus charming the animals possesses fairly unique iconography, especially in its association of so many different beasts not normally grouped together. Only one other compositional type employs a comparable variety of creatures, the so-called "animal paradise," discussed by Toynbee (1973, 283–99). This latter subject, although itself dependent upon Orphic imagery, nevertheless possesses notable differences. The animals usually are neither so closely packed nor oriented toward a common focus. Thus, general composition alone makes it quite likely that the Jekmejeh relief comes from an Orphic context, while the repetition of specific details common to other known examples makes this attribution all but certain.

5. The piece was found on June 30, 1939, in Villa 1, room 2, at Jekmejeh, in the same location as an unusual apotropaic mosaic (see Stillwell 1941, 24–25). Excavation of the site was preceded by extensive looting, which seems to have obscured the context of the relief.

6. The remains of one such support are clearly visible on the interior of the Jekmejeh piece. This example compares extremely well with the system of struts found on the Sabratha relief, seen in Squarciapino 1941, 65, fig. 2.

7. For the Sabratha piece see *LIMC* 7: pl. 71, no. 143b; and Squarciapino 1941, 61–79, figs. 1–3

101.

FRAGMENT OF APOLLO KITHAROIDOS

Perhaps second century A.D.
Provenance: Daphne-Harbie; purchased June 3, 1937
Material: fine-grained white marble
Dimensions: h. 15.3 cm., w. 10.5 cm., d. 6.7 cm.
Gift of the Committee for the Excavation of Antioch to Princeton University (2000-48)

CONDITION: *Only the bottom of a lyre and the top of a tripod remain. The central curve of the lyre is chipped but otherwise intact, while the two side prongs have broken away completely. The bowl of the tripod is slightly chipped in front. The tripod legs are broken off at various heights; of the back leg only the attachment to the bowl is visible. The few parts of the snake visible underneath the bowl are worn and chipped. A hole drilled in the body of the snake in the lower front features a broken and rusty iron stud which has caused the fragment to crack. All breaks are worn and the surface in front is covered with a thin layer of grayish brown incrustation.*

The fragment represents the bottom part of a lyre (*kithara*) resting upon a tripod. The lower right edge of the lyre touches the front edge of the tripod in a slightly tilted position which indicates that it is being held by someone. The box of the lyre is intact and clearly visible in front. The bowl of the tripod is decorated with an incised band that imitates a twisted rope. The tripod legs consist of fluted columns between which the coils of a serpent are visible.

The combination of tripod, lyre, and serpent indicates that the fragment belonged to a small statue of Apollo holding a lyre. While several types of the Apollo Kitharoidos were known in antiquity, the Cyrene type, named after the cult statue in the Temple of Apollo in Cyrene, was especially popular in the Hellenistic East. Many replicas of this variant show Apollo resting his lyre on a tripod.[1] Whether the Princeton fragment belonged to a copy of the Cyrenaic cult statue or a different Kitharoidos type is uncertain; nevertheless, the popularity of the former in the East suggests that this piece does belong to the Cyrene type. Although its fragmentary state does not allow a dating based on style, the existence of so many Roman replicas of the Cyrene type from the second century A.D. may indicate that this statuette also dates from the same period. TN

BIBLIOGRAPHY
Unpublished.

NOTE
1. For an early Antonine replica of the Cyrene statue in the Capitoline Museum in Rome (inv. 628), see *LIMC* 2:384, pl. 304, no. 61k, s.v. Apollon/Apollo (E. Simon). Similar replicas are represented by a much restored statue in Palazzo Doria in Rome (*EA*, no. 2261), a statuette in Algier (Mus. Nat., Coll. Moret à Marengo, in *RSGR* 3:29, fig. 5), and by a relief figure in the Hadrianic tondo on the Arch of Constantine in Rome (see *LIMC* 2:410, pl. 324, no. 332, s.v. Apollon/Apollo).

102.
LION SKIN SUPPORT FOR A
STATUETTE OF HERAKLES

Third century A.D.
Provenance: Jekmejeh (near Antioch); catalogued June 26, 1939
(c425-S608)
Material: fine-grained white marble
Dimensions: h. 16.8 cm., w. 8.8 cm., depth 13.0 cm.
Gift of the Committee for the Excavation of Antioch to
Princeton University (2000-65)

CONDITION: *This piece is broken at both top and bottom.*
A large strut survives on the bottom right, while the beginning of
another appendage is visible just above the lion's right ear. Faint
traces of red coloring are present beneath the right jowl. Light
wear is evident on some raised features, but the overall surface
condition remains good, except for a grainy incrustation (tan
with black flecks) on the top and the front.

The lion skin hangs vertically over a lost support.
The left side of the face and hide are roughed out
only, indicating that the piece was meant to be seen
in a three-quarter right profile. Its mane was unusually

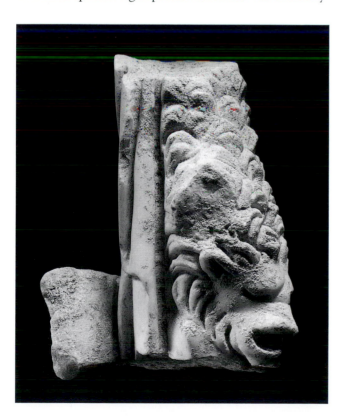

long and extended past the top break. The carving
here is somewhat stylized, with the curly tufts of the
beast rendered as an impressionistic mass of super-
imposed ovals with drilled highlights. The locks sur-
rounding the jaw have a more wavelike profile but
exhibit the same predominance of drill work. Facial
features are powerful, with a strong brow, deep-set
eyes, a broad snout, and a gaping mouth. The hide
has been rendered quite simply and is therefore essen-
tially indistinguishable from conventional drapery.
Its overall appearance is heavy, with a few smooth,
thick folds separated by deep vertical drill channels.
The small swelling just beneath the lion's right jaw
shows rather different treatment, and should be under-
stood as the start of a second feature emerging from
beneath the draped skin.

The presence of a lion skin immediately suggests
a depiction of Herakles, since such a pelt served as
one of his primary attributes. Although this skin fre-
quently is shown draped across the hero's shoulders,
many sculptures leave it hanging at his side in order
to camouflage structural supports.[1] The Jekmejeh
hide almost certainly functioned in this latter role.
Indeed, it may have come from a statuette of the
Copenhagen/Dresden or Farnese types, which depict
the hero leaning to his left upon a skin-covered club.[2]
Such an identification would explain not only the
orientation of the skin and struts, but also the nature
of the curious swelling beneath the lion's right jaw:
a knot on the club.[3]

Although discovered in the course of regular
excavations, the lion skin was a surface find,[4] and so
cannot be dated by archaeological context. In terms

of style, the simplified drapery and the heavy use of the drill both suggest a date in the later imperial period. A more precise date, however, may be obtained through comparison with a lion-headed image of Kronos in the Vatican,[5] on which the treatment of hair and ears is very similar to that of the Jekmejeh fragment. The latter therefore may be assigned to the third century A.D., a period of noted popularity for Herakles in Roman art. RJC

BIBLIOGRAPHY
Stillwell 1941, 119, no. 283, pl. 12 (c425-S608).

NOTES
1. Numerous examples of both compositional types may be found in *LIMC* 4, s.v. Herakles (J. Boardman et al.).
2. For the Copenhagen/Dresden type see *LIMC* 4: pls. 489–91, nos. 663–81; for the Herakles Farnese type see *LIMC* 4: pls. 491–95, nos. 681a-732.
3. The interpretation of this swelling as a knot on Herakles' club was suggested by Professor B. S. Ridgway. One possible alternative is that the feature represents part of a tree trunk beneath the pelt, a supporting element known from other images of the hero, such as the Herakles Chiaramonti (*LIMC* 4: pl. 475, no. 461). Such a small, ill-defined knot would be unusual for a tree trunk, however, while its like is often found on clubs.
4. A find card (no. c425-s608), dated June 26, 1939, survives in the excavation archives.
5. See Andreae 1995, 442–43, no. 567. This piece is assigned to the early third century A.D. The Jekmejeh fragment, however, is a bit more stylized, and therefore might be slightly later in date.

103.

CLUB FROM A STATUETTE

Probably second or third century A.D.
Provenance: Antioch, sector 25-H
Material: medium-grained white marble
Dimensions: length 5.7 cm., diameter 2.3 cm.
Gift of the Committee for the Excavation of Antioch to
Princeton University (2000-69)

CONDITION: *Broken at both top and bottom. There is heavy wear and discoloration along the entire surface, although one (lengthwise) half seems to have suffered more markedly. Some scattered rust stains also are present.*

This fragment consists of a slightly tapered cylinder marked by a series of six swellings. These are arranged in two evenly spaced but offset rings, and appear to represent wood knots. The proportions of the piece are relatively slender, and its overall workmanship seems fair.

 The many knots and the relatively narrow width of this work identify it as a fragment from a club.[1] Its

presence suggests a depiction of Herakles,[2] although, in the absence of further evidence, this attribution cannot be confirmed. The exact context of the original figure, in any case, remains unclear.[3] Dating it also proves difficult, especially in light of the fragment's worn condition and minimal features. The general style and workmanship, however, appear entirely consistent with the imperial period. RJC

BIBLIOGRAPHY
Unpublished.

NOTES
1. One also finds knots on tree trunks, but usually not with this density and regular spacing. Such stumps, moreover, tend to have broader proportions. The relative difference can be seen best in those sculptures that have both elements; for example, see *LIMC* 4: pl. 468, no. 354, s.v. Herakles (J. Boardman).
2. The club appears most often with Herakles (for whom it is a primary attribute), but other characters, such as Theseus, may also use it.
3. This sculpture has been marked with a find-spot, section 25H, but it is ignored by the excavation archives. Indeed, that area as a whole receives little attention in the official accounts.

104.

QUIVER

First—third century A.D.
Provenance: Daphne-Harbie, sector 26-M/N, June 6, 1939
Material: medium- to large-grained white marble
Dimensions: h. 32.1 cm., w. 11.2 cm., d. with sling 14.4 cm.
Gift of the Committee for the Excavation of Antioch to Princeton University (2000-71)

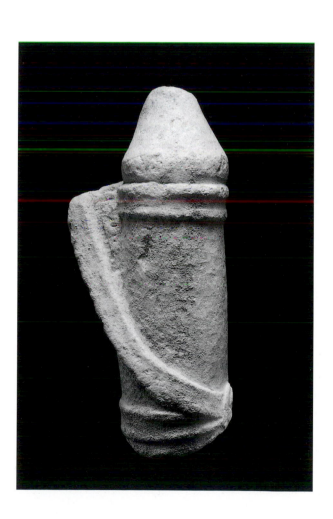

CONDITION: *The quiver is broken at the bottom, on the tip, and along the top of the harness. There are several large gouges and many minor chips, especially on the raised straps. The overall surface remains rough and grainy, suggesting that the piece was never finished. Its inner face is particularly unpolished and retains many tool marks. The stone is discolored slightly and bears bits of brownish accretion.*

The quiver has a cylindrical body and a cone-shaped cover. It is unornamented aside from an articulated neck. The harness consists of a single thick band (just above the bottom break) attached to a short shoulder strap. Its proportions appear squat, but the original height of the piece remains unknown. The carving is rough and blocky, with only a broad delineation of form.

The uniformly crude condition of this piece, combined with the lack of any apparent points for attachment, argues against the quiver ever having

been employed in a sculpture. Nonetheless, it can be seen to conform to a type quite common in Roman art. Longer versions are carried by a variety of different persons, although the present proportions, if original, would suggest strongly that this quiver was intended for an image of Eros/Cupid.[1]

The quiver itself was found amidst the ruins of a large villa in a wealthy residential area of Daphne-Harbie.[2] Although discovered in this late context, its exact origins remain unclear.[3] The workmanship and technique, certainly, are consistent with the imperial period, although the unfinished state of the piece precludes any more precise analysis. RJC

BIBLIOGRAPHY
Stillwell 1941, 121, no. 297, pl. 12 (c285-S594).

NOTES
1. Erotes sometimes are equipped with special stubby quivers, clearly designed to complement their own diminutive stature. Examples quite similar to the Daphne-Harbie piece may be seen in Söldner 1986, 2:617–18, nos. 39–40, figs. 45–47. Such proportions, however, remain exceptional. Even erotes often carry quivers of the more common slender variety; see, for example, *LIMC* 3: pl. 614, no. 78a, s.v. Eros.
2. A brief description of the villa and its surroundings, located in Daphne-Harbie, sector 26-N/M, may be found in Stillwell 1941, 7–8 and 25–27.
3. The find card, dated June 6, 1939, specifies that this piece (along with Stillwell 1941, 120, no. 290, c284-S593) was found above a layer of imperial-era mosaics. Unfortunately, the confused nature of this specific context (which also contained remains several centuries older than the underlying mosaics) renders such information useless for dating the quiver.

105.

PINECONE

First–early second century A.D.
Provenance: Antioch, sector 16-P, 1937
Material: medium-grained white marble
Dimensions: h. 7.9 cm., diam. 5.4 cm.
Gift of the Committee for the Excavation of Antioch to Princeton University (2000-70)

CONDITION: *Rather poor. The surface is very rough and abraded, and may never have been finished. Additional pitting also is visible. Much of the stone has been discolored and appears beige.*

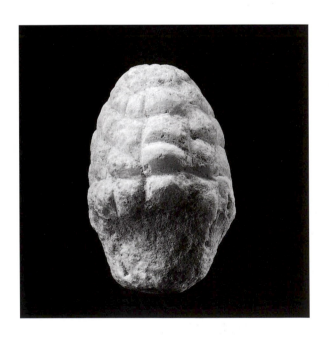

The piece is approximately egg-shaped and seems to portray a pinecone. Roughly squarish segments have been cut across most of the surface, although the bottom third remains smooth. This latter area also has been tapered, probably for insertion into a socket. The carving is awkward and irregular.

As evidenced by the tapered end, this piece almost certainly was intended as an addition to a larger sculpture. The exact context remains unclear, although it

might have been meant as the crown to a thyrsos, the Dionysiac staff, or perhaps as part of a cornucopia.[1]

The pinecone was discovered in central Antioch, near the site of a sculptor's workshop which was destroyed in the late first century A.D. It is tempting to interpret the piece as one of that establishment's many cast-offs, although it was not recorded until some months after the shop's excavation.[2] In any case, the sculpture must date before the mid-second century A.D., when the area was covered by an extension of the city's main monumental street.

RJC

BIBLIOGRAPHY
Unpublished.

NOTES

1. Thyrsoi regularly are topped with pinecones. An example similar to this sculpture may be seen in *LIMC* 3: pl. 448, no. 204, s.v. Dionysos/Bacchus. The cornucopia remains a viable alternative, especially since an example with a pinecone (misidentified as a pineapple, although that fruit was unknown to the Roman world) was found in the same area less than two weeks before: see Stillwell 1938, 176, no. 198 (6170-S330), pl. 18.

2. For a general overview of the area (excavation sector 16-P) and its contents see Stillwell 1941, 14–16. A more detailed discussion of the sculptor's shop may be found on pages 118–19. The latter was excavated in March 1937, but the pinecone was not recorded until June 23. A connection may still exist (the levels of the workshop, after all, had been disturbed by a number of later pipes), but it cannot be confirmed without additional information on the exact context and placement of the various pieces.

106.

CINERARY URN

Probably first century A.D.
Provenance: Antioch
Material: fine-grained white marble with gray veins
Dimensions: h. without lid 25.9 cm., h. with lid 37.7 cm., w. of rim 4.5 cm., diam. 31 cm., diam. of lid 28.5 cm.
Gift of the Committee for the Excavation of Antioch to Princeton University (2000-90)

CONDITION: *The urn and lid are complete; the lid is slightly chipped. The exteriors of both urn and lid are worn, and the relief decoration on the urn is now visible mostly in outline.*

The solid lid is conical in shape, tapering to a short knob. The cylindrical body of the urn is decorated in relief with a stylized garland suspended by four symmetrically placed bucrania. This decoration occupies a wide zone defined above by a carved line which circles the urn 4 cm. from the rim. The upper rim is square in section, with a flat outer edge (h. 1.5 cm.) and an upper surface that is slightly convex. The transition from the upper rim to the body of the urn is

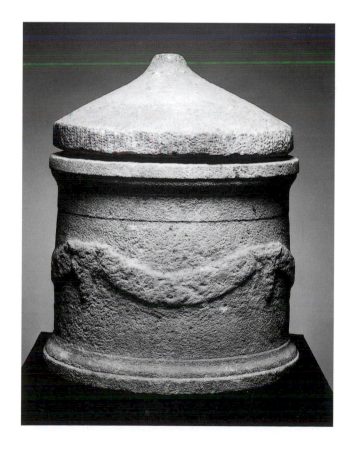

nicely rendered in the form of a cyma reversa molding. The foot is a mirror image of the rim. The interior of the urn and the bottom of the lid are roughly picked with a pointed chisel; a recessed flange around the edge of the lid secures its fastening on the urn. A square dowel hole (3 x 3 cm.) is centrally placed under the bottom of the urn.

This ash container is of a type common in Rome,[1] where it is best exemplified by two exquisitely sculpted urns from the tomb of P. Sulpicius Platorinus.[2] It resembles in form and decoration—but not in size— a type of round altar common in the East from the Hellenistic period onward.[3] It is possible that this

typically Roman funerary object was used to contain the ashes of a Roman in the Antioch area at some point during the first century A.D. N P

BIBLIOGRAPHY
Stillwell 1941, 124, pl. 12, no. 361 (Pa1381-S496).

NOTES
1. Toynbee 1971, 254.
2. Sinn 1987, nos. 25 and 51, pls. 10d and 18a; Koch and Sichtermann 1982, 46–47; they date to the mid-first century A.D.
3. Berges 1986.

107.
TWO SECTIONS FROM A GARLAND SARCOPHAGUS

Mid-second century A.D.
Provenance: Seleuceia in Pieria, 1937
Material: white marble
Dimensions: (a) h. 16.9 cm., l. 95.8 cm., d. 12.7 cm.
 (b) h. 16.4 cm., l. 62.3 cm., d. 14.1 cm.
Gift of the Committee for the Excavation of Antioch to Princeton University (2000-89a-b)

CONDITION: *(a) Damage to leg of putto; minor chipping (modern) along lower edge and elsewhere; surface eroded. (b) More eroded than (a), with consequent enlargement of drill holes and channels; some breakage among the fruits and leaves; mottled with black, organic incrustation.*

The two nonjoining fragments are probably from the same garland sarcophagus and preserve portions of the relief on the front of the coffin. Both pieces fractured into neat, horizontal "slivers" along natural lines of cleavage in the marble. In both cases, the upper break is flat while the lower one is slightly concave and slopes sharply upward. Narrow sections of the rough-picked inner wall of the coffin are preserved on the backs of both fragments, running their length and varying in width from 7.7 to 12.7 cm.

Both fragments preserve parts of heavy swags held up by naked little boys (putti), a type of decoration that characterizes the so-called garland sarcophagi of the second and third centuries A.D.[1] The chubby right leg of a putto is preserved on the right end of the larger piece (a); at the opposite end is a section of the ribbon that bound the ends of the swag. The fruits and foliage in the swags are typical of those on garland sarcophagi of the second century, consisting of grapes and acorns, oak and grape leaves, apples or quinces, pinecones, and ears of wheat. The areas above the swags would have been occupied by masks, Medusa heads, or small mythological reliefs. The heterogeneous mix of fruits, nuts, and wheat suggest that these swags were not symbolic of specific seasons, the cadence of which is represented

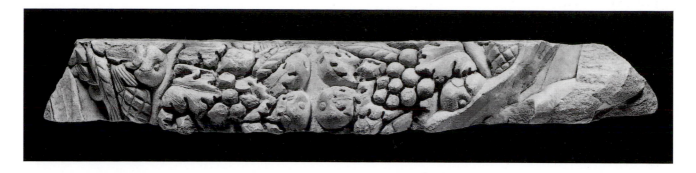

on some garland sarcophagi by succesive swags of seasonal fruits and florals.[2] The swags represent actual funerary offerings; they are also found on grave altars and in the friezes of larger funerary monuments, beginning in the first century B.C.[3] Garland sarcophagi first appear under Hadrian (117–138), but the extensive drill work on these examples suggests a date later in the second century A.D. They were found together in a rock-cut tomb at Seleuceia, along with fragments from at least two other sarcophagi, in a plundered necropolis south of the "Tunnel of Titus."[4]

<div style="text-align: right">JMP</div>

BIBLIOGRAPHY
Stillwell 1941, 123, pl. 13, no. 338 (a1120-S475a and b).

NOTES

1. For garland sarcophai, see Herdejürgen 1996; Toynbee 1934, 202–16, pls. 43–48; McCann 1978, 25–33.
2. E.g., Atlanta, Emory University 1999.11.7; Herdejürgen 1996, pl. 17, no. 44.A.
3. Two marble slabs decorated with swags, presumably from a funerary monument, were found at Antioch: Stillwell 1938, 178, pl. 21, nos. 227 and 228.
4. Stillwell 1941, 4, 123, pl. 13, nos. 336–39; for the position of the necropolis, see p. 255, plan 1, 17-E. For fragments from two other garland sarcophagi, one from Seleuceia, the other from Antioch, see Stillwell 1941, 123–24, pl. 13, nos. 341 and 360.

GRAVE STELAI
FROM ANTIOCH

Antiochene Grave Stelai in Princeton

Robert G. A. Weir

The twenty-six grave stelai in this catalogue all come from Antioch-on-the-Orontes or its environs. Since the Princeton team bought most pieces from the locals, the provenances can seldom be confirmed; nevertheless, almost all the stelai are so utterly consistent with other Antiochene examples as to raise no doubts.[1] The few unusual stelai are not likely to have traveled far from their place of origin and may safely be considered local products too, albeit possibly created under a different set of influences. Within the Roman province of Syria, the varieties of grave stelai were few and each was limited to specific geographic areas. Thus, all the examples in Princeton may be assigned to the northern coastal region on the basis of characteristic iconographies and styles. But stelai from the Antioch area also employ marble, not yellow limestone (as in the northern Euphrates valley[2]), nor volcanic basalt (as in the southern

Hauran[3]). The inscriptions upon Antiochene grave stelai are almost entirely in Greek, very rarely in Latin, but never in the Aramaic used in the regions of Urfa/Edessa or Palmyra[4] (see Table 1).

Before discussing further the stelai in Princeton and how they compare with the *corpus* of inscribed stelai from Antioch,[5] one needs to emphasize how they are distinct from others found elsewhere in ancient Syria.[6] Whereas Hellenistic grave stelai from Syria have been found only along its coast, three geographic groups may be distinguished in northern Syria of the Roman imperial period (first–third century A.D.). To the east of the coastal group centered on Antioch-on-the-Orontes is another located along the west bank of the Euphrates in Syria Kyrrhestike; to the north of the latter extends the third concentration of stelai, from Syria Kyrrhestike in the west into the kingdom of Osrhoene across the Euphrates in the east. These three groups are each homogeneous and all quite distinct from the better-known Palmyrene style to the south.[7]

Closest to Antioch is the large stelai group centered on Seleuceia in Pieria/Belkis that exhibits a homogeneity of figural composition, theme, stone type, and inscriptional characteristics and may fairly be attributed to a single workshop.[8] The group's geographic range includes Münbiç, Carablus, and Oğuzelī in Turkey, as well as the environs of Hierapolis-Bambyke/Membidj just over the border in modern Syria. Sufficient examples survive for one to trace the stylistic evolution of grave reliefs over time and see how a style particular to the area evolved in the presence of Roman imperial and Palmyrene influences.[9] Only those grave reliefs displaying human figures (rather than simply eagles, swags, and baskets[10]) may be assigned an approximate date on the basis of

Table 1: Language of Inscription

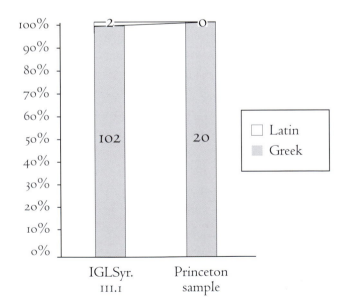

portrait style. Portrait style and the occasional Seleucid era date indicate that at Seleucia in Pieria/Belkis these reliefs were produced between the mid-first century A.D.[11] and the Tetrarchic period.[12] But most examples date between Trajan and Severus, with an especial concentration in the Antonine decades.[13] This is not surprising in light of the increased population and prosperity of the city in the second century A.D. that followed upon the pacification of eastern Asia Minor at that time.[14] The typical form of grave stelai from Seleuceia in Pieria/Belkis and the west bank of the Euphrates is that of a half-length figure within an arcuated niche.[15] One occasionally comes across full-length figures.[16] The inscriptions usually follow the formula of X, ἄλυπε χαῖρε. The only real variations are the occasional addition of a patronymic or the substitution of αωρε for ἄλυπε; and the spelling χερε is common. The language of most stelai inscriptions is Greek, but a large minority is in Latin, no doubt owing to the stationing of the Legio IIII Scythica just outside the city.[17]

The neighboring stelai group centered on Antioch is very different, yet equally homogeneous, and thus likely the work of a single workshop too. The use of marble for grave stelai is particular to the coastal region near Antioch,[18] which is not surprising when one realizes that the coarse-grained, grayish marble usually encountered there came by ship from Asia Minor.[19] In addition, the marble used for grave stelai at Antioch almost always comes in thin slabs, sometimes already smoothly polished on both sides. This is reminiscent of a known Egyptian practice of reusing revetment plaques as grave stelai, usually military ones; frequently, the original profiles are still visible on their—new—reverse faces.[20] How exactly marble was procured for the workshops of Antioch is still uncertain, but it is very clear that the supply of marble occasionally required reuse of ornamental slabs, as two grave stelai in Princeton demonstrate.[21] In other instances, the unsmoothed character of all surfaces but the front face might indicate the minimal processing of the rough slabs shipped to Antioch. The limited height of relief on the Antiochene grave stelai is a natural consequence of the slabs from which they were carved and yet another distinguishing characteristic. Their relative thinness sug-

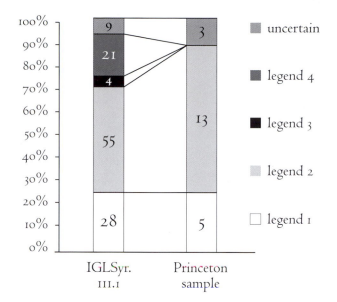

Table 2: Inscriptional Types

Legend 1: εὐψύχει + X
Legend 2: X + ἄλυπε χαῖρε
Legend 3: οὐδεὶς ἀθάνατος
Legend 4: other

gests that the Antioch stelai, more cogently than their thicker counterparts from the Euphrates valley[22] and Palmyra,[23] were also employed as *loculus* lids in subterranean chamber tombs. As in the Euphrates valley stelai, the sunken relief portions of the Antioch stelai are enclosed within a square or rectangular frame that sometimes supports a crude, triangular pediment. But unlike the inland stelai, the back of the relief plane on the Antioch stelai is flat and seldom concave, not even on the thicker stelai that would permit it. Below the relief panel, the lower portion of the frame is reserved at both Antioch and Seleuceia in Pieria/Belkis for the inscription that names the deceased and bids him or her farewell. The inscriptional formula of X, ἄλυπε χαῖρε is also the most common at Antioch; but occurring about half as often is the formula εὐψύχει, X that is peculiar to Antioch.[24] The *corpus* of inscribed stelai from Antioch and environs in *IGLSyr* III.1 is large and varied enough to include a number of more individual inscriptions.[25] The iconography of the Antiochene figures is also different from that of the Euphrates valley: there are no half-length busts, but instead a

variety of standing, seated, or reclining figures.[26] Letter styles, hairstyles, and a single archaeological context[27] suggest dates in the first and second centuries A.D. for the stelai in Princeton. This is further confirmed by the occurrence of a city-era date corresponding to A.D. 59 on *IGLSyr* III.1.927. Even the more wealthy and prominent citizens of Antioch were buried with relatively humble marble plaques such as these to mark their tombs.[28]

Table 3: Gender

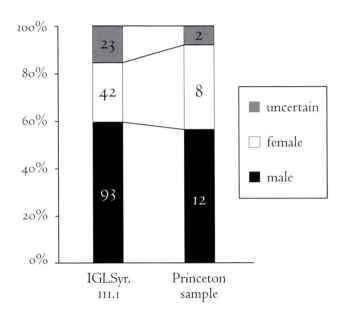

The sample of inscribed grave stelai in Princeton may be compared with the *IGLSyr* III.1 *corpus,* as regards both the proportion of men to women named among the deceased by the stele inscriptions and the sorts of legend that appear (see Table 2 and Table 3). What clearly emerges from these comparisons is that the sample of Princeton grave stelai is characteristic of all Antiochene grave stelai, once due allowance is made for its small size. The small Princeton sample certainly accounts for the absence of stelai with more unusual inscriptions; but one ought to recall that the more elaborate legends in *IGLSyr* III.1 tend to occur on the more elaborate stelai, which probably found their way into museums or private collections, rather than on the humble monuments that Stillwell and his colleagues bought from the inhabitants of Antioch and Daphne.

NOTES

1. The funerary stele of Aurelia Artemis on display at the Walters Art Gallery in Baltimore (marble 26.2) is said by its label to have been manufactured in third- or fourth-century A.D. Egypt from imported marble; however, its size, material, iconography, style of execution, legend, and letter style are all identical with examples discovered in Antioch that are described in this catalogue. The attributions on this label, should, I believe, be disregarded in favor of the archaeological and comparative material presented below.

2. Wagner 1976, 156.

3. Parlasca 1989, 542.

4. Non-Aramaic inscriptions are in fact rare at Palmyra (e.g., Museum of Fine Arts, Boston, 22.659; Comstock and Vermeuule 1976, 257, no. 401: ΑΘΘΑΙΑ ΑΛΥΠΕ ΧΑΙΡΕ).

5. *IGLSyr* III.1, nos. 885–988.

6. The portion of ancient Syria where grave stelai have been discovered corresponds to modern-day Turkey's southern border region, since very little in the way of such things—with the obvious exception of Palmyrene reliefs—has been found in modern Syria. For instance, only a single grave stele has been found in Dura-Europos (Parlasca 1981, pl. 19.1; Yale University Art Gallery inv. 1938.5356, found reused in the plasterwork of the Artemis temple). It has the usual aediculate niche with a triangular pediment type and contains a relief of the funeral banquet genre, though the inscription is Latin, not Greek. Parlasca believes that this iconography was borrowed by a Roman familiar with grave stelai in Antioch for a fellow countryman who died in Dura-Europos.

7. See Parlasca 1989, 544–51 for an introduction to the characteristics of Palmyrene sculpture. Over a thousand specimens of this distinctive sculpture are known today, including nine at Princeton (cat. nos. 150–58). The grave stelai range in date from the first half of the first century A.D. through 273, the year of Queen Zenobia's defeat by Emperor Aurelian (a date confirmed by the frequent occurrence of city-era dates on later stelai in the series). The iconography evolved over time from the merely epigraphic to relief borders and symbolic representations (such as a curtain: Parlasca 1989, fig. 200b), then to half-length busts, and, by the mid-second century A.D., a full-length standing figure of the deceased within a niche, which is not unlike contemporary examples from Antioch (p. 545). As at Antioch, most funerary reliefs were carved on plaques of marble meant to close *loculi* in subterranean *hypogeia,* though above-ground tomb-towers are also known to

have existed in this region. Other works concerned specifically with funerary sculpture from Palmyra are Sadurska 1976; Parlasca 1976; Parlasca 1984a.

8. Wagner 1976, 156. For an overview of the region's grave stelai, see Parlasca 1981, 9–14.

9. Wagner 1976, 156.

10. Wagner 1976, 173–273. Five broad types of local grave stelai are distinguished: *aedicula* (no. 1–71), *aedicula* with rounded pediment (no. 72), *aedicula* without architrave but a rounded niche (nos. 73–76), niche with architectural frame (nos. 77–87), and niche without architectural frame (nos. 88–131). The aediculate types almost always contain eagles, and often a swag too; many also exhibit a basket and swag, sometimes without the eagle; and very occasionally there is the ancillary type of two hands. The niche types almost always display half-length figures of the deceased, though a very few show full-length figures.

11. Parlasca (1981, 10) mentions a stele in the Seleuceia in Pieria/Belkis group in the Gaziantep museum (inv. 1961) that bears a date of 65/66 A.D., according to the Seleucid era, and is thus the oldest, absolutely dated stele from this region. The reassuringly first-century A.D. iconography of the figure's hairstyle bodes well for the dating of other stelai by this criterion.

12. Parlasca 1978a, 309. A relief known from a London auction may be dated to the later third century A.D. on the basis of hairstyle (Christie's London, December 5, 1973, lot 161, pl. 9). The same auction house also sold in 1973 two early Severan stelai from the same area (July 11, 1973, lot 177, pl. 18).

13. Wagner 1976, 161–65.

14. Wagner 1976, 283.

15. One funerary stele from Hierapolis-Bambyke/Membidj now in the national museum in Damascus (inv. 3495) shows a half-length facing male bust in a niche with the legend ΑΡΤΩΒΙΝΟΣ ΑΛΥΠΕ ΧΑΙΡΕ below (Parlasca 1989, 552). The stele of Daphnos, who is represented by a half-length bust within a niche, now resides in the Brooklyn Museum (acc. no. 69.34) and is thought to have come from the same site; and though this specimen clearly exhibits the stylistic influence of Palmyra, the Greek legend along the bottom of the frame (ΔΑΦΝΕ ΧΡΗΣΤΕ ΑΛΥΠΕ ΧΑΙΡΕ) safely locates it in northern Syria: see Parlasca 1969–70. Also at the center of funerary monuments of this sort was Seleuceia in Pieria, from which may come an example of early Antonine style in the J. Paul Getty Museum in Malibu (inv. 71.AA.282) that is unusual for its representation of two brothers: see Parlasca 1980.

16. Wagner 1976, 212–13, no. 69; 216–17, no. 75; 217–18, no. 76; 220–21, no. 83; 221–22, no. 84. Most interesting of these is the stele of Apollas (212–13, no. 69), the earliest dated stele from the region (see n. 11 above), though no. 76 probably also dates to the mid-first century A.D.

17. Wagner 1976, 173–273, 283. For information on the grave markers of Roman soldiers in northern Syria, see also Balty and van Rengen 1993.

18. Parlasca 1978a, 308. The use of yellow limestone in the Euphrates valley has already been noted.

19. Parlasca 1981, 17.

20. Parlasca 1981, 17. Examples of soldiers' and civilians' stelai are attested by G. Grimm (1978, nos. 169 and 170; Alexandria inv. 24489 and 24202) and H. Heinen (1980, pl. 3b, 4).

21. See below, P3784-I71 (cat. no. 119) and Pa289-S393 (cat. no. 130).

22. Parlasca 1978a, 308.

23. Parlasca 1989, 546.

24. *IGLSyr* III.1, nos. 885–988.

25. *IGLSyr* III.1, no. 912 (iambic trimeters), nos. 915 and 944 (both elegiac distich), 926.

26. Within the Syrian context, the funeral banquet genre is characteristic of the Antioch area (Parlasca 1981, 18), though a single example is known from Dura-Europos (see above n. 6). A few such examples are in Princeton, but the best-quality one is to be found in the Louvre (Parlasca 1981, pl. 19.2, 18n.182: inv. MND 408, 60 x 36 cm.). Its stylish and carefully rendered beard and hairstyle date the deceased to the early Antonine period, about the second quarter of the second century A.D. Of further interest is the inscription: ΠΕΡΣΕΟΥ [sic] ΑΛΥΠΕ ΧΑΙΡΕ ΚΑΤΑΛΕΙΠΩΝ ΔΑΦΝΕΙΤΑΙΣ ΤΑ ΚΑΤΑ ΕΘΟΣ ΚΙΡΚΗΣΙΑ ΓΕΝΟΜΕΝΑ ΘΕΩΡΕΙΝ (*IGLSyr* III.1.965), which indicates that Perseas was a man of sufficient wealth to leave to the people of Daphne funds sufficient for a celebration of the local Olympic Games (Parlasca 1981, 17–18). Banquet-type stelai (in all their variations) are very common and the subject of much study: Pfuhl and Möbius (1979, 353–68) survey the genre; see also Thönges-Stringaris 1964; and Fıratlı 1964, 18–22.

27. Stele P2209-I123:S91 (cat. no. 116) was discovered in room 54 of Antioch's Bath A, reused in a wall of *opus mixtum* that the archaeologist dated to before ca. A.D. 200 (Elderkin 1934, 4–7, especially pl. III).

28. See the stele of Perseas, n. 26 above.

108.

GRAVE STELE OF LEONIDE

First century A.D.
Provenance: purchased in Seleuceia in Pieria, August 14, 1937
*Material: coarse-grained whitish marble with long, dark
gray streaks*
*Dimensions: h. 27.6 cm., w. 16.6 cm., th. 6.8–7.1 cm.,
letter h. 1.4–1.6 cm., interlinear space 2.4 cm.*
*Gift of the Committee for the Excavation of Antioch to
Princeton University (2000-97)*

CONDITION: *The left edge of the stele is intact and smoothly
polished. The original bottom edge seems not to be preserved, but
rather it is cut off and fitted with a tenon to attach it to a base.
The original right edge is likewise missing; however, the inscrip-
tion indicates that most of the stele's width is preserved. The relief
figure is intact except for her head, which is missing where the top
of the stele is broken off. The stele's back face has been smoothed
only roughly with a point and now shows incipient flaking.*

Within a frame with a wide bottom surface is repre-
sented a woman seated to right atop a cross-legged
stool. Her lower body and proper right arm are seen
in profile, but her torso is three-quarters facing to
the viewer. Her right arm is bent at the elbow and
holds something over her lap. Her left arm is con-
cealed behind the right one(?). Her invisible left foot
(indicated by drapery folds near the knees) is drawn
behind her right one. She is clad in a himation over a
chiton. She seems to be wearing footwear of some
sort. Below the relief panel is a two-line inscription
in letters neatly, yet shallowly, inscribed:

ΛΕΩΝΙΔΗ []
ΑΛΥΠΕ [χαῖρε]

Farewell, griefless Leonide . . .

The catalogue of Pfuhl and Möbius provides two
possible comparanda for the type of a woman, fully
draped, sitting on a chair to right with no figure to
balance her in the right field.[1] In this case, a good
parallel would be a stele in the Musée Rodin, Paris;
it was once thought to have come from Sidon but has
been reattributed to Antioch.[2] But if the incomplete

inscription is any indication, this stele would have
been wide enough to accommodate a small standing
figure in the right field, which is the much more
usual iconography (see cat. no. 122). One good com-
parandum of the early imperial period was found in
Eresos on Lesbos and has the small figure of a ser-
vant girl standing to the right of the deceased.[3] Not
only was it executed on the same scale as the
Princeton fragment,[4] but the garments, drapery pat-
terns, and positions of the legs and right arm are also
very close; it also has a tenon on its bottom edge.
Although the two pieces have minor iconographic
differences, both may have sprung from a common
prototype. By analogy with the Eresos stele, the
Princeton stele would have possessed a pediment
and been freestanding rather than a *loculus* lid, which
would also set it apart from the other Antiochene
grave stelai at Princeton. RGAW

BIBLIOGRAPHY
Stillwell 1941, 105, no. 218 (Pa1382-I256: S497).

NOTES
1. Pfuhl and Möbius 1979, 234, pl. 133, no. 903 (Istanbul
 Arch. Mus., inv. 4142) and no. 946 (243, pl. 142: Brit-
 ish Museum: Smith 1904, no. 2253). Both examples are
 of unknown provenance. The Istanbul stele is of hard,
 pock-marked limestone with a triangular pediment
 and three akroteria. Below the pediment, two rosettes
 flank a wreath. Below those is a sunken rectangular area
 with the bas-relief of woman seated to right on a stool,
 arms folded across her belly. Below that is inscribed
 Μύττα Δαμοτέλη γυνή. Pfuhl calls it primitive work
 of the second century B.C.; but Möbius attributes this

too high date to the stele's shape and maintains a late imperial date for the relief and a distant origin for the stone. The London comparandum is a pedimented stele of yellow, coarse-grained marble with a single, large akroterion. In the almost square relief area, a woman is seated to right on a draped stool. There is a very low footstool under her feet. Her head is bare. She leans forward on her elbows in an attitude of mourning. Her left hand holds the edge of a mantle that may swaddle her. Below the relief is inscribed,/...χρ]ηστὴ χαῖρε. Pfuhl calls it inferior Hellenistic work, possibly early; but Möbius says that it is no earlier than third-century B.C. Rhodian. The pose of neither figure, however, is a match for that of the Princeton fragment.

2. Musée Rodin nouv. inv. 80; 38.5 x 16 x 2.5 cm.; Parlasca 1981, 17, pl. 18.5 (no parallels cited in n. 171, but see nn. 173, 174): the grave stele of Klaudia Salamathe (ΚΛΑΥΔΙΑ ΜΑΓΝΟΥ ΘΥΓᴬ ΣΑΛΑΜΑΘΗ ΑΛΥΠΕ ΧΑΙΡΕ), who is shown seated to right, fully draped

with velification, on a chair of uncertain type; notable in this stele (and other examples of its type) is its asymmetrical use of space since there is no second figure standing to the right of the seated woman.

3. Pfuhl and Möbius 1979, 238, pl. 138, no. 919 (Eresos museum, inv. 133). This stele of white marble in high relief is intact but for a chipped-off right foot. At top is a pediment with an akroterion at its apex. Below this, along the top edge of the relief frame, is inscribed ᾿Ισει ᾿Αρτέμωνες χρηστὴ χεῖρε. Upon a draped stool is seated to the right a woman clothed in a chiton worn under a cloak that swathes most of her body. Her legs are seen in profile, but her torso is three-quarter turned toward the viewer. Her right arm rests upon her lap. Her left arm is bent at the elbow, and the hand holds a corner of the mantle up by her face. To her right stands a small servant girl clad in a chiton who holds up a cylindrical box in her right hand.

4. Without the tenon, its dimensions are 55 x 35 x 8 cm.

109.

STELE OF DEMETRIOS, SON OF TIMOKLES

Probably first century A.D.
Provenance: purchased in Seleuceia in Pieria
Material: gray marble with lighter portions
Dimensions: h. 48.7 cm., w. 28.6 cm., th. 12.6 cm.,
h. of inscribed panel 9.0 cm., letter h. 1.5 cm.
Gift of the Committee for the Excavation of Antioch to
Princeton University (2000-114)

CONDITION: *Almost the whole stele is preserved, aside from a large chip at the top left corner, which does not affect the figural decoration, and another large chip at the bottom right corner, which has carried off the final two or three letters of each line of the inscribed text. Except for his head, which has been carefully and deliberately removed, and some damage in the region of his proper right hand, the figure of Demetrios is well preserved. There is relatively little lime incrustation and little wear to blur the details of the stele.*

The togate figure of Demetrios stands facing the viewer against a recessed relief plane with no frame along its top or sides. A hem of the toga runs from his right wrist up and over his right shoulder. His proper right arm crosses his chest obliquely and its hand may have protruded from under the toga's hem somewhat. His left arm hangs straight down and is covered by the toga, as is his closed hand. Although the upper half of the figure is very static and frontal, the positioning of Demetrios's legs follows a contrapposto stance after the Classical Greek paradigm, in this case with the figure's left leg as the weight-bearing one and his right as the free one. His left leg does not press at all against the toga's heavy drapery and must therefore be locked in a straight position, a supposition which the near-frontal orientation of his left foot confirms. But his right thigh and knee do press against the toga, enough to smooth out its folds; the shin below is invisible through the drapery but must be drawn backward in a resting position in order to attach to his more sharply-angled right foot. The bottom edge of the toga extends to the top of his booted feet. The figure of Demetrios stands atop an

incised panel with the following two-line inscription carelessly cut between incised guide lines:

ΔΗΜΗΤΡΙΕ ΤΙΜΟΚΛΕΟ[υϛ]
ΑΛΥΠΕ ΧΑ[ῖρε]

Demetrios, (son) of Timokles, griefless, farewell!

The iconography of Demetrios's stele is largely similar to Pfuhl and Möbius's common *Mann im Normaltypus* genre, missing only the requisite scroll in the figure's left hand.[1] Although the dates of *Normaltypus* stelai range from the second century B.C. through the third century A.D., the shapes and uniform sizes of the letters are most at home in the first century A.D.; and such carelessness of execution as they exhibit can be paralleled in any century. On the other hand, the flatness of the drapery folds argues against a date as early as that of cat. no. 110, with its somewhat more voluminous and naturalistic drapery. The artistic quality of the figure is higher than the quality of the inscription would have led one to believe. The distinct possibility exists that monuments of this common sort were usually prefabricated and lacked only their inscriptions when relatives of the deceased paid a visit to the workshop. In such a scenario, the inscription may have been cut under pressure of time and by another, less skilled sculptor than the one who carved the relief. The absence of Demetrios's head is remarkable, considering the state of the rest of the stele, and gives every appearance of being a deliberate act of ancient vandalism.　　RGAW

BIBLIOGRAPHY
Stillwell 1941, 124, pl. 15, no. 357 (Pa114-I245: S472).

NOTE
1. Pfuhl and Möbius 1979, 90–107, nos. 156–249. Compare the similar Pa289 cat. no. 130.

110.

STELE OF A WOMAN

Probably first century A.D.
Provenance: Antioch; purchased May 18, 1938
Material: dark gray marble with white streaks, not
coarse-grained
Dimensions: h. 29.4 cm., w. 38.5 cm., th. 14.3 cm.,
w. of relief panel 25.1 cm., d. of relief plane 1.5 cm.,
letter h. 2.0–2.1 cm., interlinear space 1.1–1.2 cm.
Gift of the Committee for the Excavation of Antioch to
Princeton University (2000-116)

CONDITION: *This is the lower half of a stele whose full width is preserved. Both female figures are preserved as high as the chest. The right and left sides have been dressed—to which the traces of a toothed chisel at the bottom of the left edge attest—whereas the bottom edge and back have been only roughly picked. The transitions between the front face and both left and right edges are not perpendicular; rather, an obliquely set band (w. 4–4.5 cm.) connects the front face to the edge. The inscribed lower border is complete at the left but broken away at the right edge; much of the inscribed surface has flaked off. The lower border is also missing its lower left portion; and slightly to the left of its center is a deep, irregularly shaped gap that interrupts both lines of the inscription. In the middle of the right-hand portion of the inscription's first line is a deep hole that has destroyed one or two letters. A thick lime deposit obscures much of the relief and inscription.*

The preserved stele comprises a recessed panel, enclosed within unadorned borders to the right, left, and below. In relief on the plain background of the panel are the legs, lower torsoes, and lower left arms of two draped women, who stand to face the viewer. Both women are clad in a heavier himation over a longer chiton that reaches to the ground. The figure on the left stands with her weight on her proper left foot, her right leg bent at the knee and its foot drawn back and turned slightly outward. Her left arm hangs down, and the hand seems to grasp some of the cloak material. Her right arm may rest obliquely across her chest. The right-hand figure stands with her weight on her proper right foot, her left leg bent at the knee and its foot drawn back and turned slightly outward.

Her left arm hangs down, and the hand grasps some of the cloak material. Her right arm rests across her chest. The two-line inscription on the lower border is cut well:

ΛΑΔΟΥΗΚΑ[..³⁻⁴..]ΑΛΚΑΙΟΥΕ̣
[..³⁻⁴..] Α̣Λ̣[υπε] ΧΑΙΡΕ

*Griefless, Ladoueka(?)[...],
(daughter) of Alkaios, [...] farewell!*

This stele is similar to the *Frau im Normaltypus* genre that consists of a woman, clad in a himation over a chiton, who stands and faces the viewer,[1] except in this instance there are two figures instead of one. Although a second woman's name may reasonably be expected to hide in the lacunae noted above, there are no traces to indicate that the hortative verb was anything other than singular. There is an evident symmetry and balance in their contrapposto stances: the woman standing on the left puts her weight on her left leg, the woman on the right, on her right leg; and the drapery folds of their himatia run up to the hip of the leg in question. But the similar pose of both left arms varies the symmetry and causes each figure to stand out as an individual. The closest parallels for the schema of the left-hand figure date from the late

Hellenistic period;[2] but the best matches for the figure on the right date somewhat later, to the imperial period.[3] The letter forms of the inscription are characteristic of the early Roman imperial period. In addition, the treatment of the drapery makes more use of volume than is seen on most Antiochene examples at Princeton. A date in the first century A.D. therefore seems most probable.

Despite a thickness and weight that lead one to believe that it could not have been a *loculus* lid, the stele's unsmoothed back face is an indication that it was not freestanding, but rather built into something.

RGAW

BIBLIOGRAPHY
Stillwell 1941, 123, pl. 15, no. 350 (Pb290-I279: S534).

NOTES
1. Pfuhl and Möbius 1979, 148–53, nos. 452–82.
2. Pfuhl and Möbius 1979, 135, no. 399 (present location unknown, though once in Rokeby Hall, Yorkshire; second century B.C.); 135, no. 400 (Istanbul Arch. Mus. 4134; first century B.C.). Later examples with a similar pose extend into the third century A.D. (nos. 401, 402).
3. Pfuhl and Möbius 1979, 132, no. 388 (Nisyros museum; Roman imperial period). This particular schema is known as the *Große Herkulanerin.*

III.
STELE OF ANTYLOS

First century A.D.
Provenance: Daphne-Harbie; purchased April 22, 1934
Material: light gray limestone
Dimensions: h. 61.0 cm., w. 31.5 cm., th. 13.7 cm., h. of inscribed panel 30.8 cm., w. of inscribed panel 21.8 cm., letter h. 2.5–3.5 cm.
Gift of the Committee for the Excavation of Antioch to Princeton University (2000-115)

CONDITION: *The stele is intact, other than a large chip out of the lower left edge which does not affect the design. The front face is weathered, which obscures the details of the portrait bust, but not so much as to efface the very many claw chisel marks within the inscribed panel. Long exposure to the elements is also suggested by the lack of apparent paint traces within the crevices of the deeply cut inscription. The lowest portion of the stele beneath the panel has a rougher surface and may never have been finished.*

ΑΝΤΥΛΕ
ΑΛΥΠΕ
ΧΕΡΕ

Farewell, griefless Antylos

The even spacing between letters, the small variation in letter sizes, and, in particular, the shapes of such diagnostic letters as *epsilon* all point to a relatively early date for this inscription. The inscription names the deceased with the Greek transcription for Latin *cognomina* such as Antulus, Antullus, or Antullius.[1] The portrayal of the deceased as a frontal, chest-length bust within a recessed space and with an inscription below is also consistent with his Roman citizenship since it immediately brings to mind one of the standard iconographies for freedmen and their families. But its concessions to Antiochene conventions make this stele clearly a hybrid: Antylos is not apparently wearing a toga; and the inscription, besides being in Greek, follows the most prevalent of local formulas rather than some more Roman expression of the deceased's status. Despite such variations, the inspiration for a facing portrait of this sort is more Western than Palmyrene, since the half-length busts are not attested there as early as the first century A.D.[2] Reliefs of a similar bust-type within an architectural frame are known from nearby Seleuceia from the mid-first century A.D. on, where the presence of the Legio IIII Scythica may have exerted some influence on choice of iconography.[3] Possibly this Antylos was one of the thousands of veterans who settled in Syria upon discharge from one of the three or four legions based in that province in the first century A.D.

For the variant spelling of χαῖρε see cat. no. 116 (P2209). R G A W

BIBLIOGRAPHY
Stillwell 1938, 162, no. 97 (P3782-I69: S241).

NOTES
1. Stillwell 1938, 162, no. 97.
2. Parlasca 1989, 545.
3. Wagner 1976, 160–65, 173–273 (nos. 77–87), 283.

A shallowly recessed, rectangular panel is vertically centered on the stele's front face and occupies about half its area. A rectangular frame, which on each side takes the form of an Ionic pilaster without a base, borders the panel. A chest-length, frontal bust is set midway along the top edge of the rectangular frame and is enclosed within the shallow space created by the semicircular arcosolium above it. The figure is clad from the neck down in what appears to be a long-sleeved chiton. Whereas his left arm rests on the top edge of the rectangular frame, his right arm extends into the frame, as if gesturing at the inscription below. The inscription, which is restricted to the panel's upper half, is composed of deep and carefully cut letters:

112.

STELE OF EPIGONOS AND SEKONDA

Probably first century A.D.
Provenance: purchased in Antioch; from sector 24-L, surface;
April 13, 1935
Material: coarse-grained white marble
Dimensions: h. 32.0 cm., w. 26.5 cm., th. 10.4 cm.,
h. of inscribed panel 7.0 cm., letter h. 1.2–1.6 cm.
Gift of the Committee for the Excavation of Antioch to
Princeton University (2000-95)

CONDITION: *Although the stele's top is broken away, its
original bottom and two sides remain, albeit in a battered and
worn state. The deeply set relief panel is largely effaced, there is
damage to the relief frame's lower edge, and the two bottom
corners of the stele are broken away. The inscription in its own
recessed panel is legible except at the edges of the stele, where chips
have broken away. Lime incrustation degrades the amount of
visible detail on the stele. Two dowel holes in the base indicate a
secondary use for this stele, which surely contributed significantly
to its current, worn state of preservation.*

The damaged relief panel still bears near its right
edge clear traces of the traditional banqueter's couch
(*kline*), though in this instance there is no trace of the
small side table which sometimes accompanies such
representations. Any sign of one or more human
figures has also been obliterated. The transition from
the relief plane to the frame is sharply articulated,
almost perpendicular, along all three preserved edges.
The three-line inscription is cut well and without
benefit of incised guide lines:

ΕΠΙΓΟΝΟΣ ΕΙΣΟΔΟΤΟΥ
ΣΕΚΟΝΔΑ ΕΠΙΓΑ []
[ἄ]ΛΥΠΟΙ ΧΑΙΡΕΤΕ

*Epigonos, son of Eisodotos, (and) Sekonda,
daughter of Epiga [...], (both) griefless, farewell!*

The inscription's letter shapes and uniform sizes
are characteristic of the early Roman imperial period.
This was evidently the grave monument of a married

couple and probably represented the husband reclin-
ing to right on the *kline* and looking back at his wife,
who was seated on a stool facing him from the left
(cf. cat no. 113). RGAW

BIBLIOGRAPHY
Stillwell 1938, 162, no. 96 (P4754-I131: S241).

113.

STELE OF DIONYSODOROS AND DIPHILA

Probably first century A.D.
Provenance: purchased in Seleuceia in Pieria (Pc460-1312)
Material: coarse-grained, light gray marble
Dimensions: h. 19.1 cm., w. 39.3 cm., th. 8.0 cm.,
letter h. (in lines 1–3) 1.2 cm. and (in line 4) 1.5 cm.
Gift of the Committee for the Excavation of Antioch to
Princeton University (2000-113)

CONDITION: *The lower third to half of the stele is preserved to its full width. Hardly anything survives of the relief panel and its scene; but the inscribed text is largely intact and lacks only a few letters at the extremities of lines owing to chips in the stone. Some of the letters have been blurred by lime deposit and, in the case of the first three lines on the flat relief frame, by wear. Traces of a post or tenon project downward from the central third or so of the stele's bottom edge.*

The only extant traces of the relief scene are the leg of a kline at the right edge and a low, rectangular base to its left. The extant, lower right-hand side of the relief frame is wider than a small portion that is preserved on the left and is broad enough to accommodate the first three lines of the inscription. The letters in the last line of text are taller than the others and are cut into a concave molding. All the lettering is cut carefully and without benefit of incised guide lines:

[Δι]ΟΝΥΣΟΔΩΡΕ ΔΙΟΝΥΣΟΔΩ[ρου]
ΚΑΙ ΔΙΦΙΛΑ ΗΡΑΚΛΕΙΤΟΥ ΤΟΥ Ε̣[πι-]
ΚΑΛΟΥΜΕΝΟΥ ΘΕΟΔΟΤΟΥ

ΑΛΥΠΟΙ ΧΑΙΡΕΤΕ

Dionysodoros, (son) of Dionysodoros, and Diphila, (daughter) of Herakleitos, the one surnamed Theodotos, (both) griefless, farewell!

The inscription's letter shapes and uniform sizes are characteristic of the early Roman imperial period.

This was evidently the grave monument of a married couple and probably represented the husband reclining to right on the *kline* and looking back at his wife, who was seated on a stool facing him from the left (cf. cat. no. 112). RGAW

BIBLIOGRAPHY
Unpublished.

114.

STELE OF EUDAIMON

Probably first century A.D.
Provenance: Antioch; purchased September 7, 1934
Material: grayish marble
Dimensions: h. 20.7 cm., w. 18.8 cm., th. (top) 1.8 cm. and
(bottom) 2.2 cm., letter h. 1.1–1.2 cm.
Gift of the Committee for the Excavation of Antioch to
Princeton University (2000-93)

CONDITION: *About half of the stele is preserved, including all of its right end and most of the inscription incised into the frame along its bottom edge. The extant right edge and surviving portions of the top and bottom edges are only roughly worked. The reclining figure is missing only his right forearm and his legs. Traces of red pigment remain in the first three letters of the inscription.*

The relief panel is set within a rectangular frame with pediment that is typical of the funeral banquet genre. A male figure is shown reclining upon a low, padded *kline* and propping himself up on his left elbow. His head and torso are turned to face the viewer; likewise, his extended right arm gestures in

some way to the viewer. In his left hand he holds a cup. His face is clean-shaven; and his hair has a simple, uncurled coiffure characteristic of the first and the earlier second century A.D. He is clad in a long, unbelted chiton with full sleeves; the drapery folds across his torso and legs are very straight and flat. The bunched folds of a heavier garment can be seen crossing in front of his thighs and looping over his left shoulder. In front of the kline is a mixing bowl standing on three short legs. The single-line inscription is crudely incised into the lower border of the relief frame and reads:

Εὐ] ΔΑΙΜωΝ ΕΥΨΥΧΕΙ

Eudaimon, be of good cheer!

The funeral banquet genre commonly encountered upon ancient grave stelai includes some examples with iconography similar to this one, with its

solitary male figure reclining to the right, his head turned to face the viewer, and his right arm raised in greeting or to hold something small.[1]

The not-uncommon name of Eudaimon is here particularly *à propos* to the standard invocation, which might account for his enthusiastic gesture and the presence of a wine bowl in lieu of the more usual table with foodstuffs.

RGAW

BIBLIOGRAPHY
Stillwell 1938, 163, pl. 19, no. 106 (P3783-I70).
Kondoleon 2000, 141, no. 31.

NOTE
1. Of similar iconography are Pfuhl and Möbius 1979, 369, no. 1489 (Istanbul Arch. Mus., no. 2797; late Hellenistic date; uncertain, small object in raised right hand); and 370, no. 1497 (formerly in a private collection in Istanbul; uncertain Roman imperial date; wreath in raised right hand).

115.
STELE OF PREISKIL[LOS?]

First—second century A.D.
Provenance: Antioch; purchased March 31, 1938
Material: coarse-grained, gray marble
Dimensions: h. 13.6 cm., w. 14.6 cm., th. 3.1 cm., w. of border (left) 3.0 cm. and (bottom) 0 .8 cm., h. of relief 0.3 cm., letter h. 1.0–1.3 cm., interlinear space 0.2–0.3 cm.
Gift of the Committee for the Excavation of Antioch to Princeton University (2000-108)

CONDITION: *This stele fragment preserves the lower left corner and portions of the original bottom and left edges. Along its bottom edge, the stele is preserved to about two-thirds of its original width, since only three letters are missing from each of the inscription's two lines. Of the relief, only about half the* kline *and the feet of the deceased are extant. The two extant edges are perpendicular to the front face and smoothly polished. The back face is likewise smoothly polished. The surface of the marble is clean, without lime incrustation (but only a few spots of rust), and it never suffered much weathering.*

288

Unlike a number of other stelai, this example has a very low relief frame that is not conspicuous. The depth of the relief plane behind the frame is only 0.3 cm., to which the transition from the frame is oblique, not perpendicular. The relief comes to the same height as the frame. Of the figure of the deceased, all that can be seen is a long chiton-like garment with many deep, parallel folds that comes down to the top of a slippered foot lying on the couch. The legend is neatly cut into the relief plane under the couch and between its legs, not on the narrow frame. The lettering in the second line is a little wider and sloppier than that in the first line:

ΠΡΕΙϹΚΙΛ [λε? ἄ]
ΛΥΠΕ ΧΑ [ῖρε]

Farewell, griefless Preiskil(los?)!

Despite the exiguous amount of preserved relief, it is very probable that another example of the funeral banquet genre is here presented.[1] The only other option would be the *prothesis* genre,[2] which is so rarely found as to be very unlikely in this case.

The name of the deceased may be restored as either Preiskillos or Preiskilla (both of which have the same number of letters in the vocative). The vocative

ἄλυπε is of no help in determining gender since it is α-privative and thus does not distinguish masculine from feminine endings. Since men predominate in scenes of the funeral banquet genre on grave stelai, Preiskillos is slightly to be preferred.[3] The use of ει, rather than ι, in the transcription of the Latin name is common at this period[4] and also indicates that by Roman times the two sounds already had the same phonetic value (as they do in modern Greek).

RGAW

BIBLIOGRAPHY
Stillwell 1941, 101, no. 198 (Pb21-I259: S500).

NOTES
1. Pfuhl and Möbius 1979, nos. 1488–2066 cover all the varieties of the funeral banquet genre.
2. Pfuhl and Möbius 1979, nos. 2067 and 2068. In these two examples, four mourners stand behind the *kline* that bears the body of the deceased; the small amount of relief here preserved does not by itself preclude the presence of other such figures.
3. However, cat. no. 128 (Pb75-I268: S514) is a rare example of funerary banquet iconography for a woman.
4. The substitution of ει for ι frequently appears in inscriptions of the Roman imperial period at Delphi; see, e.g., the indices of names in Pouilloux et al. 1985.

116.

STELE OF AN UNKNOWN BANQUETER

First–second century A.D.
Provenance: Antioch, sector 10 -LNW (Bath A), north wall of room 54; excavated March 22, 1933
Material: dark gray marble
Dimensions: h. 26.6 cm., w. 9.3 cm., th. 6.2 cm., w. of frame (bottom) 3.0 cm., d. of relief 2.5 cm. (top) and 0.3 cm. (bottom), letter h. 1.8 cm.
Gift of the Committee for the Excavation of Antioch to Princeton University (2000-102)

CONDITION: *Only a vertical sliver is preserved from a much larger stele of the funerary banquet type. What remains of the relief decoration is somewhat worn. A short portion of the bottom edge survives; the relief frame along the bottom is smoothly polished and makes a rounded transition to the bottom edge. The bottom edge is smoothly finished at the front for 2 cm., but the rest gives way to rough-picked work. The back face is only roughly worked.*

[ὁ δεῖνα, ἄλυ]ΠΕ ΧΕ[ρε]

…, griefless farewell!

The size of this stele, its greater thickness, its relief decoration, and the fineness of its detailing indicate a much larger and better quality funeral monument than usually encountered at Antioch; however, the iconography is still consistent with other examples of the funeral banquet genre.[1] The position of the surviving letters under the relief indicates that the inscription was no longer than the standard three words of the more modest stelai. The variant spelling of χαῖρε is well attested during the Roman period in Antioch[2] (and elsewhere) and shows that the phonetic equivalence of ε and αι current in modern Greek was already present in Roman times.

This example and cat. no. 133 are the only two stelai fragments not to have been bought by the Princeton team. The exact provenance of the other fragment is unrecorded, but this one was found re-used in a later wall: the *opus mixtum* that encased it was dated by the excavators to before ca. A.D. 200,[3] which provides a convenient *terminus ante quem* for this type of stele at Antioch.

RGAW

BIBLIOGRAPHY
Stillwell 1938, 148, no. 13 (P2209-I23: S91).

NOTES
1. Pfuhl and Möbius 1979, nos. 1488–98, are the most similar to the other Antioch grave stelai in Princeton: a single man reclining to right upon a *kline* with no other figures present. In this case, it is quite possible that one or two slaves, or a spouse, were also represented in the relief, of which numerous varieties are recorded by Pfuhl and Möbius (nos. 1499–2066).
2. *IGLSyr* III.1, no. 946, among several others from the selection of inscribed grave stelai found in and around Antioch (nos. 885–988).
3. Elderkin 1934, 4–7, especially pl. III.

The preserved portion of the relief is exiguous but readily identifiable: it shows the lower part of the torso and some of the right arm of a draped figure of uncertain gender reclining upon a *kline*. The extended proper right arm rests upon the side of the body. The garment seems to be long and loose-fitting (probably an unbelted chiton). Before the *kline* stands part of a low, three-legged table laden with objects that represent food. The execution of the relief is a little above average on this type of stele: the drapery is well executed and shows some attempt at modeling; also, the table's legs are detailed enough to indicate their ornamentation with animal heads. Below this, on the raised border, is part of an inscription. The letters are roughly scratched, not tooled:

117.

STELE OF EUBOLAS

Later first–early second century A.D.
Provenance: Antioch; purchased April 6, 1938
Material: somewhat coarse-grained, light gray marble
Dimensions: h. 20.2 cm., w. 29.4 cm., th. 1.8 cm.,
letter h. 1.5–2.1 cm.
Gift of the Committee for the Excavation of Antioch to
Princeton University (2000-92)

CONDITION: *Although at one time broken into six fragments, this stele has been repaired and is intact except for a small piece missing from near its center. The more or less smooth bottom edge runs back at a slightly oblique angle. The other edges are very rough and seem either to run straight back (left and right edges) or obliquely (aediculate top edge). The front face was smoothed down with some coarse abrasive or tool that left numerous, usually parallel, scratches before the relief decoration was cut. The background of the relief has been left rough-picked. The back face is smoothly polished but bears a coating of lime accretion.*

The stele has the pediment shape typical of the funeral banquet genre. The scene comprises a male figure reclining to the right and propped up on his proper left elbow upon a padded couch. His head is held upright and faces the viewer. His hair is short-cropped and his face smooth-shaven. His left forearm extends toward the viewer and is so foreshortened that one sees only the hand. His extended right arm lies across his belly and its hand comes to rest by his crotch. His left leg lies extended upon the couch; but his right leg (behind it) is bent at the knee. The figure seems to be wearing a short-sleeved tunic (visible on the right forearm) under a long, heavier garment that envelops his left arm and whose loose folds of drapery lie across his waist. Some sort of shoe or slipper may be indicated on the proper left foot (the only one visible). In front of the couch

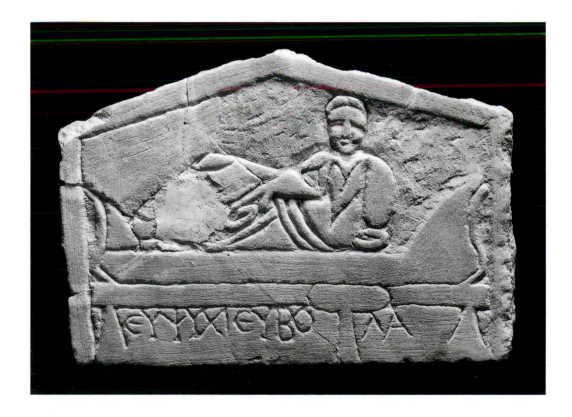

is a low single-footed table. The relief technique is unlike that used on any of the other Antioch stelai in Princeton. The couch and the male figure are rather crudely incised and not in true relief. The field around the figure's head and torso and at either end of the couch has been cut back by a millimeter or two to suggest some depth—though not deeply enough to remove the figure's incised outline—but is elsewhere level with the rest of the front face. The single-line inscription runs between the two legs of the couch and is interrupted by the table:

ΕΥΨΥΧΙ ΕΥΒΟΛΑ

Be of good cheer, Eubolas!

This is a fine example of both the funerary banquet genre as usually represented at Antioch and also of the use of marble revetment slabs for grave stelai with very shallow relief decoration. The simplicity of the representation on this almost intact example would suggest that the other Antiochene examples too had a relatively plain iconography. Banquet-type stelai (in all their variations) are very common and themselves the object of careful study.[1] Almost all the relevant examples in Pfuhl and Möbius's catalogue come either from East Greek islands such as

Kos or from western Asian cities such as Kyzikos, Pergamon, Prusa, and Byzantium.

The schematic execution of the figure's clean-shaven face precludes the absolute certainty of a pre-Hadrianic dating, but the lettering of the inscription (though admittedly of rough execution) is not so elongated as became common in the course of the second century A.D. Likewise, the straight cross-bar of the *A* is earlier rather than later in date. On the other hand, the smaller size of *epsilons* (that are rounded) and of *omicrons* relative to the other letters is characteristic of later rather than earlier inscriptions. Thus a date in the later first or early second century A.D. is suggested.

RGAW

BIBLIOGRAPHY
Stillwell 1941, 123, pl. 14, no. 347 (Pb42-I264: S508).
IGLSyr III.1, pp. 508–9, no. 931.
Kondoleon 2000, 140–41, no. 30.

NOTES

1. Pfuhl and Möbius 1979, nos. 1488–1502 exemplify this particular iconography in the much wider genre (for which, see their introduction, 353–68). For the funeral banquet genre, see also Thönges-Stringaris 1964 and Fıratlı 1964, 18–22.

118.

STELE OF []ENOS

Probably later first–early second century A.D.
Provenance: Antioch, 1933
Material: somewhat coarse-grained, light gray marble
Dimensions: h. 10.2 cm., w. 12.8 cm., th. 3.6 cm.
Gift of the Committee for the Excavation of Antioch to Princeton University (2000-101)

CONDITION: *This fragment preserves only the lower right corner of the complete stele and represents one-quarter, or possibly less, of the original object. A large chip along the bottom edge has removed the actual corner and much of the last three letters of the inscription. The extant portions of the right and bottom edges are roughly finished. The back face is smooth, as is the front face, except where it has been crudely gouged to form the relief decoration.*

Although little survives, it is clear that this fragment originally belonged to a pedimented stele of the funeral banquet genre and would have closely resembled the stele of Eubolas (cat. no. 117). The scene would have comprised a male figure reclining to the right on a padded couch, his head turned to face the viewer, and his body propped up by his proper left elbow. What does survive of the relief in this case is the right leg of the dining couch and the usual small table beside it. Three gashes on the table's top surface schematically suggest the foodstuffs atop it. Below, the single-line inscription runs along the lower edge of the relief frame in roughly cut and shallow letters:

[]ENE EYΨỴX̣Ị

[]enos, be of good cheer!

For discussion of the funerary banquet genre, see the very similar cat. no. 117. Although the lettering of the present stele (cat. no. 118) is more carelessly carved, it resembles that of the preceding stele and may thus be of similar date. This stele is also another example of a marble revetment plaque reused as a grave marker. Its one distinction is its reversal of the epigraphic formula of first name, then exhortation; this is without parallel among the Princeton stelai from Antioch. Although too little survives of the rest of the stele to show definitively whether or not the reversed inscription was just one of several variants, the reversal seems more a careless lapse than indicative of a profound digression from the banqueter type.

<div align="right">RGAW</div>

BIBLIOGRAPHY
Stillwell 1938, 150, no. 18 (P3278-I29).

119.
STELE OF HELENE

First–second century A.D.
Provenance: Antioch, sector 22-F (ancient cemetery just WSW *of modern town); purchased September 10, 1934*
Material: coarse-grained gray marble
Dimensions: h. 17.1 cm., w. 18.8 cm., th. 5.5 cm., h. of inscribed border 4.8 cm., letter h. 1.3–1.5 cm., interlinear space 0.2–0.3 cm.
Gift of the Committee for the Excavation of Antioch to Princeton University (2000-106)

CONDITION: *The stele's full width and half its height are preserved; of the figure itself, the lower part survives, broken off at about navel level. The frame, back of the relief plane, and back face are all polished smooth. The back of the relief plane is at right angles to the frame and does not curve to meet it. The bottom edge once had a smooth surface, but this was broken up in the course of its reuse as a grave stele. The left and right edges have a broken surface that runs straight back (for 1.7 cm. and 2.2 cm. respectively) before each becomes a polished plane that then runs*

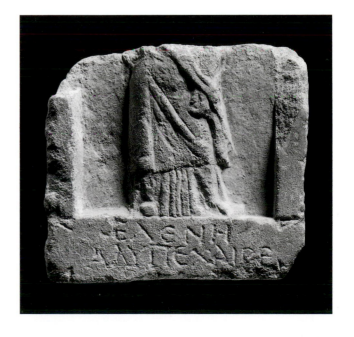

obliquely (for 4.9 cm. on both edges) to the back face. On the lower part of each edge's sloping plane lies a piece of molding (4.2 cm. high and 3.6 cm. deep) that was truncated when this stone was recut as a grave stele.

Standing within the center of the sunken panel that is surrounded by a plain, raised border are the facing legs, partial torso, and proper left arm of a draped female figure. The figure is set atop a low wedge that is angled toward the viewer. Her right leg is straight and bears most of her weight; her left leg is bent at the knee and drawn back somewhat so that the foot angles outward. She is clad in a chiton, a himation, and some sort of footwear. Her left arm hangs down and rests on her left thigh; it is swathed in the himation as far as the wrist; and its clenched hand perhaps holds a piece of garment. Traces of what is probably her right elbow suggest that her right arm rested across her chest. The inscribed portion of the stele is represented as a recessed *tabula ansata* and reads:

ΕΛΕΝΗ
ΑΛΥΠΕ ΧΑΙΡΕ
Farewell, griefless Helene!

The stele of Helene is a good example of the *Frau im Normaltypus* genre that consists of a woman, clad in a himation over a chiton, who stands and faces the viewer.[1] Quite often, no ancillary figures are represented. This is a widespread schema that appears in many different regions and qualities of execution. Its dates range from the late third century B.C. up to the third century A.D. The frames surrounding the sunken relief panel are often given architectural detailing and arranged to represent *aediculae.*

<div align="right">RGAW</div>

BIBLIOGRAPHY
Stillwell 1938, 161–62, pl. 19, no. 95 (P3784-I71).

NOTES
1. Pfuhl and Möbius 1979, 148–53, nos. 452–82.

120.
STELE OF DIONYSIOS

Later first–second century A.D.
Provenance: Antioch; purchased April 5, 1938
Material: coarse-grained white marble
Dimensions: h. 16.3 cm., w. 14.3 cm., th. 3.1 cm., letter h. 1.1–1.6 cm., interlinear space 0.5–0.7 cm., h. of border (lower) 3.8 cm., w. of border (right) 1.6 cm., d. of relief plane 0.7 cm.
Gift of the Committee for the Excavation of Antioch to Princeton University (2000-109)

CONDITION: *Horizontally, this stele is almost complete, since its inscription lacks only one letter to the left of the break in each of its two lines. Vertically, it is more than half preserved, since the figure is broken off just below chest height. The relief has suffered very little wear or abrasion. The extant portion of the smooth right edge bears a curious incised line down its center. The bottom edge and back face are only roughly striated with a point. At the top of the back face, one can see where smoothing with a chisel*

was begun (stele here only 1.9 cm. thick). The marble has been discolored by burning on its lower border and edges; elsewhere, there is an occasional thin deposit of lime.

Within the relief frame, a male figure stands facing, barefoot, and clad in an unbelted chiton. Its folds are shallow and almost straight but the flutter of chiton edge against the back field of the relief is well rendered. The man's left elbow is visible and indicates that this arm was folded across his chest. His hanging right arm holds a stylized bunch of grapes or (less likely) a basket. His legs below the edge of the chiton and his feet are bare. The legs are rendered as prisms, not cylinders. No toolmarks have been left in the back field. On the frame below the figure is a two-line inscription:

[Δ]ΙΟΝΥCΙ
[Ε]ΕΥΨΥΧΕΙ

Dionysios, be of good cheer!

For this iconography there are no parallels in the Pfuhl and Möbius catalogue of grave stelai. However, the bareness of his feet and the unbelted chiton he wears suggest that Dionysios was a child, not an adult, when he died. The bunch of grapes is surely an allusion to his name. Furthermore, Dionysiac allusions are not inappropriate on funeral monuments, as the popularity of stelai with banquet scenes attests. RGAW

BIBLIOGRAPHY
Stillwell 1941, 123, pl. 14, no. 346 (Pb30-I260: S503).

121.

STELE OF SEVERA

First–second century A.D.
Provenance: Antioch; purchased June 4, 1939
Material: coarse-grained gray marble
Dimensions: h. 14.4 cm., w. 14.9 cm., th. 43 cm., h. of bottom border 4.3 cm., w. of side border (top) 2.1 cm. and (bottom) 3.1 cm., d. of relief 1.0 cm., h. of figure 5.8 cm., w. of figure 5.9 cm., letter h. 1.6–1.7 cm.
Gift of the Committee for the Excavation of Antioch to Princeton University (2000-96)

CONDITION: *Approximately one-third of the entire stele is preserved as a triangular fragment that includes its lower left corner and about half its width and height. Of the relief figure, only the lower portion of the two legs below the knees is preserved. The last letter of the Greek inscription is on a tiny fragment glued back onto the relief frame after the latter suffered a fresh break, which also obscures the figure's left foot. The back face was originally left rough with a number of conspicuous point marks, but weathering has now smoothed this surface a great deal. Lime deposit is present here and there on the marble.*

Although very little of her figure is preserved, the representation of Severa clearly follows a type already seen on other Antioch stelai. She wears a slightly shorter himation over a long chiton that comes down to her slippers. The fold patterns in her garments indicate that her proper left leg is straight and bears most of her weight, whereas her right leg is bent slightly at the knee and her right foot is thus drawn back and angled slightly outward. On the left edge, the forward portion (0.9 cm. wide) is perpendicular to the front face of the stele, but the rest (4.1 cm.) runs obliquely to the back face. The well-preserved left side of the relief frame (2 cm. wide) runs obliquely to the relief plane, whereas this same transition from the bottom edge of the relief frame (width of 3.2 cm. smoothly polished, then 0.8–0.9 cm. unfinished) is at right angles. The depth of the relief plane is usually 1.3 cm. behind the relief frame, but it increases to 1.7 cm. just around the relief figure. The inscription is more carefully and neatly cut on this example than on most others from Antioch and reads:

ϹΕΥΗΡΑ ΑΛΥ[πε χαῖρε]

Griefless Severa, (farewell)

The stele of Severa is another example of the *Frau im Normaltypus* genre that consists of a woman, clad in a himation over a chiton, who stands and faces the viewer.[1] Quite often, no ancillary figures are represented. This is a widespread schema that appears in many different regions and qualities of execution. Its dates range from late third century B.C. up to the third century A.D. The frames surrounding the recessed relief panel are often composed of architectural members so as to resemble *aediculae*.　　　RGAW

BIBLIOGRAPHY
Stillwell 1941, p. 101, no. 199 (Pc370-I308).

NOTE
1. Pfuhl and Möbius 1979, 148–53, nos. 452–82.

122.
STELE OF AITETE

Second century A.D.
Provenance: vicinity of Antioch; purchased
Material: coarse-grained white marble
Dimensions: h. 22.2 cm., w. 11.8 cm., th. 4.1 cm.,
letter h. 1.0 cm.
Gift of the Committee for the Excavation of Antioch to Princeton University (2000-98)

CONDITION: *The lower left corner of the stele is preserved. Its details are somewhat obscured by lime deposit but exhibit very little actual wear or abrasion. The seated figure is largely intact, missing only her proper left arm, left leg, and part of her right foot. To judge from what remains, the full height of the stele was probably 25–30 cm. The extant portions of the inscription suggest that slightly more than half of the stele's original width is preserved.*

The relief panel represents a woman seated three-quarters to right atop a cross-legged stool, which is shown in profile. It is uncertain from the extant traces if her legs were also rendered three-quarters to right or in profile. Her proper right arm is extended, and its hand rests on her right knee. Nothing is to be seen in her right hand. Her left arm is apparently raised, for nothing is visible beyond the edge of her torso along the preserved right edge of the stele. She is clad from the neck down in a long-sleeved chiton, which is covered by a himation that hangs from her left shoulder and bunches up in loose, horizontal folds across her lap. Whereas the relief plane curves

gradually to meet the left edge of the relief frame, the transition to the relief plane is more nearly perpendicular along the frame's bottom edge. Below the relief panel is a two-line inscription in a rather squat script:

AITHTEI [ἄλυπε,]
XA[îρε]

Griefless Aitete, farewell

The incomplete, yet formulaic, inscription along the bottom of this stele indicates that it would have been wide enough to accommodate a second figure standing in the right field. Two-figure reliefs of this sort were common under the Roman empire. One good comparandum of the early imperial period was found in Eresos on Lesbos and has the small figure of a servant girl standing to the right of the deceased (cf. cat. no. 108).[1] The name Aitete has second-century A.D. parallels in Egypt and Syria, including another grave relief discovered by the Princeton expedition.[2] RGAW

BIBLIOGRAPHY
Stillwell 1941, 109, no. 241 (Pb94-I271).

NOTES
1. See above, cat. no. 108, n. 3.
2. Stillwell 1941, 109, no. 241.

123.

STELE OF AN UNKNOWN BANQUETER

Antonine period, second century A.D.
Provenance: Antioch; purchased April 21, 1937
Material: fine-grained white marble
Dimensions: h. 18.3 cm., w. 12.4 cm., th. 5.5 cm.,
d. of relief 0 .6 cm., w. of border (right) 1.6–3.0 cm.
Gift of the Committee for the Excavation of Antioch to
Princeton University (2000-104)

CONDITION: *The upper right third of this pedimented stele survives. The fragment's left edge is quite smooth and has a very straight line (surely an indication of spoliation), whereas its bottom is concave and obviously a natural fracture. Portions of the stele's original right and top edges are preserved and run obliquely to the back face; traces clearly indicate that some sort of metal point or drove was used to form these very rough edges. The back face is smoothly polished. Lime deposit covers most of the fragment.*

A male figure reclines to the right, propped up on his left elbow; his extended right arm lies on the side of his body; his head is held upright and faces the viewer. It is not clear whether he is holding anything in his left hand. The hairstyle is a somewhat voluminous mass of tightly curled locks; a short, trimmed beard occupies the area on and near the chin. He is clad in a light garment with sleeves (probably a chiton); folds of a heavier garment envelop his left arm.

Missing from the relief scene is the couch upon which the deceased is reclining, though one end of it may be suggested by a widening of the aediculate frame along the right side of the stele. Otherwise, this is clearly a typical example of the funeral banquet genre.[1]

The figure's head on this relief is sufficiently detailed and well preserved to allow a reliable dating to the Antonine period on the basis of his coiffure.

<div align="right">RGAW</div>

BIBLIOGRAPHY
Stillwell 1941, 123, pl. 14, no. 343 (Pa392-S402).

NOTE
1. See Pfuhl and Möbius 1979, nos. 1488–98 for this particular variety with the single male figure and no (apparent) attendants.

124.

STELE OF HADRIANOS

Antonine period, second half of the second century A.D.
Provenance: Antioch; purchased April 26, 1938
Material: coarse-grained, light gray marble
Dimensions: h. 18.8 cm., w. 34.3 cm., th. 3.7 cm.,
h. of inscribed border 4.5 cm., letter h. 2.7–3.1 cm.
(growing taller to the right; initial ∈ 1.9 cm).
Gift of the Committee for the Excavation of Antioch to
Princeton University (2000-105)

CONDITION: *The stele is fully preserved in width and two-thirds in height. It is mended from three pieces. Of the reclining figure only his head, proper right forearm, and a portion of his feet are missing. The inscription survives intact. A large chip is missing from the lower right-hand corner of the frame. The relief frame has been smoothly polished, as have the forward portions (1.2–1.5 cm.) of the left and right edges. The rest of these two edges has been left very rough and runs obliquely to the smoothly polished back face. The bottom edge has also been left very rough and likewise runs obliquely to the back face. The lime deposit remarked on this stele when it was first recorded is no longer visible.*

The relief panel shows a male figure reclining upon a low, padded *kline,* propped up on his left elbow and turned to face the viewer. In his left hand he seems to hold a cup. His right arm lies extended upon his body. He is clad in a long, unbelted chiton that extends as far as his feet and elbows. A thick roll of drapery from a heavier garment lies draped across his waist, crosses his left forearm, and runs up and over his left shoulder. In front of the couch stands a low, circular, monopodium table bearing unidentifiable items of food. A single-line inscription is incised

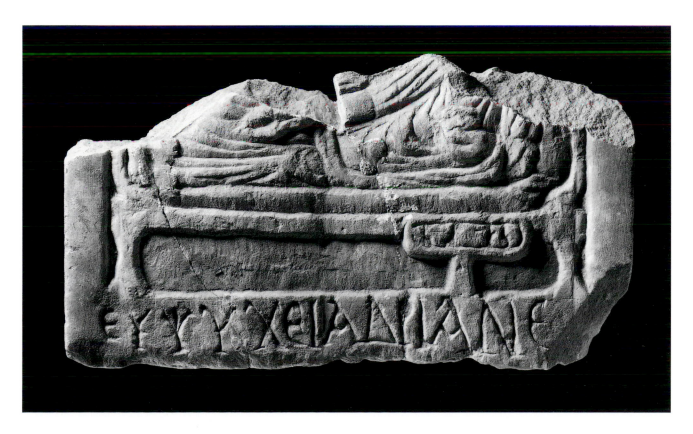

on the lower border of the stele in rather carelessly executed letters:

EYΨYXEI AΔPIANE

Be of good cheer, Hadrianos!

Funerary banquet representations (in all their variations) are very common and themselves the object of careful study.[1] Almost all the relevant examples in Pfuhl and Möbius's catalogue come either from East Greek islands such as Kos or from western Asian cities such as Kyzikos, Pergamon, Prusias, and Byzantium.

This particular example is not so well preserved as the stele of Eubolas (cat. no. 117), but it is more detailed, more carefully executed, and wider. The style of the drapery's execution is doughy and heavy. Although

the head (and thus coiffure) of the deceased is missing from this stele, the elongated letter forms and the letters' mannered serifs indicate a date after the first century A.D. In addition, the name Hadrianos probably places this stele in the second half of the second century A.D. RGAW

BIBLIOGRAPHY
Stillwell 1941, 123, pl. 15, no. 349 (Pb143-I275: S519).

NOTE
1. Pfuhl and Möbius 1979, nos. 1488–1502 exemplify this particular iconography in the much wider genre (for which see their introduction, 353–68). For the funeral banquet genre, see also Thönges-Stringaris 1964; and Fıratlı 1964, 18–22.

125.

STELE OF AN UNKNOWN BANQUETER

Probably second century A.D.
Provenance: Daphne-Harbie; gift presented March 20, 1935
(P4456-S217)
Material: almost white marble, not coarse-grained
Dimensions: h. 18.3 cm., w. 24.6 cm., th. 5.6 cm.,
th. at edge (right) 4.9 cm., d. of relief 3.0 cm., w. of border
(right) 2.5–2.8 cm.
Gift of the Committee for the Excavation of Antioch to
Princeton University (2000-110)

CONDITION: *There remains somewhat less than half of the stele, which includes a lower portion of its right edge but none of the other edges. The extant right edge is only roughly finished and runs obliquely to the unworked back face. A break at the top right has taken with it the figure's head. At the bottom, the fragment is broken off in a more or less straight line along the bottom of the couch, thus excluding whatever inscription there might have been. There is an oblique break across the left side of the fragment, right at shin level. Along the top of the fragment, a long break runs parallel to the reclining body of the figure. The surviving portion of the relief is in good condition and exhibits very little wear.*

The relief panel shows the greater part of a figure of uncertain sex reclining upon a padded *kline*, supported on its left elbow, and turned to face the viewer. The figure's left hand holds a cup or small bowl. Its right arm is extended along the right side of the torso; and the right hand rests upon the right thigh, where it grasps an uncertain object (possibly a piece of food). The left leg is extended and straight, but the right leg is bent at the knee. The garments on this example are particularly clear. The figure wears a long, flowing chiton that runs (probably) from ankles to neck; it

has sleeves that extend to below the elbow (as far as the left wrist, where it ends in a cuff, but apparently only as far as the forearm of the right arm). The body's pose produces numerous flat folds of drapery about the legs and torso. Running across the waist, then behind the proper left hand, and finally over the proper left shoulder is a ropey cable of heavier material. In front of the thickly padded couch are traces of an incised outline, which probably represented the low table bearing foodstuffs that is usually found in such representations. Since the fragment shows little wear in this area, the details seem to have been painted on, not sculpted.

Since there is neither an inscription nor a head from this fragmentary stele, the figure's gender is uncertain. Most funeral banquet stelai are for men; considering this, and if the apparent lack of breasts may be used as a criterion, this figure is likely male. Numerous examples of the genre may be found in the catalogue of Pfuhl and Möbius, though the precise iconography of this specimen is not represented there.[1]

RGAW

BIBLIOGRAPHY
Unpublished.

NOTE

1. The genre is exemplified by Pfuhl and Möbius 1979, nos. 1488–1502 and a few other nonsequential examples. Banquet-type stelai (in all their variations) are very common and the subject of much study (353–68 survey the genre; see also Thönges-Stringaris 1964; and Fıratlı 1964, 18–22). However, none of the examples in the Pfuhl and Möbius catalogue is quite as plain as what one can make out from the Antioch stelai in Princeton. For instance, no. 1491 (370, pl. 216: Istanbul Arch. Mus., inv. 212; see also Fıratlı no. 212, pl. 59) resembles the Antioch examples in size, execution, and most particulars of iconography, except that a shelf carrying two apotropaic hands is indicated along the back of the relief plane. Pfuhl calls this stele inferior work of the mid-imperial period. Also, no. 1498 (371, pl. 217: from the Pergamon excavations, now in the Bergama agora-depot) is very like the Antioch stelai in size, material, quality of execution, and flatness of relief; however, it shows an olive tree at the right edge of the stele, growing over the head of the deceased. Pfuhl calls it inferior work of the early imperial period.

126.

STELE OF AN UNKNOWN MAN

Second century B.C.—third century A.D.
Provenance: Daphne-Harbie; catalogued April 28, 1934
Material: coarse-grained white marble, with some gray inclusions
Dimensions: h. 10.1 cm., w. 14.6 cm., th. 4.1 cm.
Gift of the Committee for the Excavation of Antioch to
Princeton University (2000-100)

CONDITION: *About a quarter of the whole grave stele is preserved, including a portion of its right edge only. A portion of the relief frame on the right has been chipped away, but some of the right edge, running obliquely to the back face, is visible behind the damaged area. The back face is smoothly polished.*

Preserved are a facing draped torso, a proper left arm, and a portion of the right arm of what is likely a standing male figure. He is clad in a toga with the characteristic heavier roll of drapery over his left shoulder. His left arm is bent at the elbow and its hand grasps a short scroll *(rotulus).* The right arm does not lie across the chest but seems to hang down along the side of his body. One side of the relief frame once ran immediately to the right of the figure.

Although this stele is unusual among the other examples for not representing the proper right arm crossing the chest, the drapery patterns and book scroll are typical of the *Mann im Normaltypus* genre.[1] This is a simple representation of the deceased, togate and standing to face the viewer. His left hand holds a *rotulus* (which in combination with the toga serves to designate him as a man with business in the public sphere of the forum or agora). He is usually alone in the relief, though a smaller-scale slave or two frequently appear standing by his right leg. The dates of *Normaltypus* stelai range from the second century B.C. through the third century A.D.; they are found in all the major cities of Asia Minor and the southeast Balkans. RGAW

BIBLIOGRAPHY
Stillwell 1938, 176, no. 206 (P3395-S117).
Stillwell 1941, pl. 14, no. 342 (mistakenly identified as Pa289).

NOTE
1. Pfuhl and Möbius 1979, 90–107, nos. 156–249.

127.

STELE OF AN UNKNOWN BANQUETER

Probably second century A.D.
Provenance: Seleuceia in Pieria; purchased August 14, 1937
Material: coarse-grained white marble
Dimensions: h. 19.7 cm., w. 17.8 cm., th. 6.0 cm.
*Gift of the Committee for the Excavation of Antioch to
Princeton University (2000-111)*

CONDITION: *Approximately half of the stele seems to be
preserved and retains its original top and left edges; both have
been smoothly finished. The top edge contains a rectangular clamp
hole (3.3 x 2.2 cm. and 3.5 cm. deep). Since the original surface
of the relief's frame is worn or has been broken off, its degree of
finish is unknown. The back face is smoothly polished. Wear,
abrasion, and a copious lime deposit obscure many of the details.*

The traces of the relief frame along the top edge of
the fragment indicate that the relief panel was rec-
tangular and did not have the pediment shape typical
of the funeral banquet genre. A heavily worn figure
of indeterminate gender reclines to the right upon a
padded *kline* with torso and head turned to face the
viewer. The weight of the figure's reclining body may
have been supported by the elbow of the left arm
that is not represented on this fragment. The figure
seems to be clad in a sleeved chiton that leaves the
proper right forearm bare. A cable of seemingly
thicker drapery descends from the proper right shoul-
der. The proper right upper arm rests along the side
of the body then bends at the elbow to hang down
in front of the belly. Shown behind the figure and to
the left are a vertical bar and attached horizontal
panel of uncertain significance: they may form part
of an architectural backdrop to the banqueting scene,
perhaps a canopy, or a doorway.

It is distinctly possible that this stele was more
elaborate than most from Antioch in that it included
representations of multiple banqueters. Its size and
thickness are certainly greater than most others of

the funeral banquet genre in Princeton. Pfuhl and
Möbius show no parallels for the iconography of
this stele with the same architectural backdrop,[1]
which renders its precise identification impossible.

The relief's severe abrasion and the insertion
of a dowel hole suggest that the grave stele was
later reused.
 RGAW

BIBLIOGRAPHY
Stillwell 1941, 123, pl. 15, no. 352 (Pc451-S614).

NOTE
1. Pfuhl and Möbius 1979, no. 1537 presents a vertical
 architectonic intrusion that is somewhat similar (378,
 pl. 221: from Odessos, now in the Varna museum, first
 half of the second century A.D.); but the particular
 depiction of a doorway, or of a post and canopy,
 found on cat. no. 127 is unparalleled.

128.

GRAVE STELE OF HELENE

Probably second century A.D.
Provenance: Daphne-Harbie; purchased April 15, 1938
Material: light gray marble with medium-sized crystals and
some dark gray inclusions
Dimensions: h. 12.6 cm., w. 10.1 cm., th. 2.9 cm.,
h. of inscribed band 4.5 cm., w. of border (right) 1.3 cm.,
letter h. (line 1) 1.5–1.6 cm. and (line 2) 1.1–1.3 cm.,
interlinear space 0.1–0.2 cm.
Gift of the Committee for the Excavation of Antioch to
Princeton University (2000-94)

CONDITION: *The stele is preserved to perhaps half its height and about two-thirds of its original width (to judge from how much of the inscription is missing). The extant portion includes the lower right quadrant, though the actual corner has been chipped away. The partially preserved right edge of the stele was never polished smooth and runs back perpendicularly to the back face. The bottom part of the stele is broken off without an even plane and may well be the original bottom edge that never was straightened or smoothed (especially if the stele had been reused from a revetment plaque). Although some two-thirds of the inscription is preserved, only the food table, one end of the* kline, *and a tiny portion of the deceased are visible. A thin layer of lime deposit now coats some of the stele.*

The stele was originally centered on a recessed, rectangular area (0.4–0.6 cm. deep) whose back plane was never smoothed. Within it survives part of a readily identifiable scene of the funeral banquet genre. In the foreground stands a three-legged table on whose legs animal protomes are schematically suggested; a set of cross-struts runs between all three legs at their midpoint. Behind the table is represented a *kline* whose wooden leg with its lathe-turned decorations may be seen to the right of the table. Of the deceased atop the *kline*, only a scrap of some clothed limb survives, along with a single incised line that might possibly denote her resting arm (upon analogy with other figures in this genre). Below the relief panel is a two-line inscription in letters neatly, yet shallowly, inscribed. There is a pair of incised guide lines 1.6 cm. apart for the first line of text but not for the smaller and less carefully executed second line.

[Ἑλ]ΕΝΗ ΑΛΥ
[πε] ΧAIPE
Griefless Helene, farewell!

This stele is a welcome confirmation that the grave monument of a woman (alone, without her husband) might also be of the funeral banquet genre. Although the small amount of relief is inconclusive on this point, the inscription leaves no doubt that only

a single person—a woman—was to be commemorated by this stele. Despite the genre's many variations and a careful assembly of their exemplars,[1] there are very few comparanda for this particular iconography in the standard catalogue by Pfuhl and Möbius.[2]

The restoration of the deceased's name as Helene is the only probable option in view of the available space.[3] RGAW

BIBLIOGRAPHY
Stillwell 1941, 102–3, no. 207 (Pb75-I268: S514).
Kondoleon 2000, 141, no. 32.

NOTES
1. Pfuhl and Möbius 1979, nos. 1488–1502 exemplify this particular iconography in the much wider genre (for which, see their introduction, 353–68). For the funeral banquet genre, see also Thönges-Stringaris 1964 and Fıratlı 1964, 18–22.
2. Pfuhl and Möbius 1979, no. 553b (486, pl. 87, late imperial: Rhodes); no. 2018 (485–86, pl. 292, late imperial: Bursa museum, inv. 1026); and perhaps no. 2021 (486, of uncertain date: Chios; see also Le Bas and Waddington 1870, no. 1166).
3. Stillwell himself also came up with this restoration (Stillwell 1941, 103, no. 207).

129.

STELE OF PHILPIKOS

Probably second century A.D.
Provenance: Seleuceia in Pieria; purchased June 12, 1936
Material: coarse-grained grayish marble
Dimensions: h. 38.8 cm., w. 23.0 cm., th. 9.8 cm., letter
h. 2.2–3.8 cm., interlinear space 0.5–0.7 cm.
Gift of the Committee for the Excavation of Antioch to
Princeton University (2000-112)

CONDITION: *The stele is almost intact; missing are the top and left edges. The right edge is beveled, with a smooth, forward-facing portion and a wider, point-smoothed portion running obliquely to the back face. A few gashes were cut across the top of the right edge at some later point. The bottom edge is very smoothly finished. The back has been left rough and the marks of tools are quite clear. The actual lower right corner is missing.*

A male figure clad in a toga(?) stands facing the viewer atop a small, circular plinth that is set into a low, curved base. His proper left arm may hang by his side; and his right arm may have crossed his chest.[1] His lower legs are bare; and his feet wear schematic "slippers." Most of the visible drapery runs in crudely rendered catenary folds from lower left to upper right. Despite the relief's low quality, it has been simply and clearly executed. The figure may have stood

inside a pedimented *aedicula*. The back field of the relief is strongly concave. Below the relief frame, a recessed *tabula ansata* contains a three-line inscription:

ΦΙΛΠΙΚΕ ΑΛ
ΥΠΕ ΧΑΙ
ΡΕ

Philpikos, griefless, farewell!

Since the inscription is complete, one may reasonably suppose along with Stillwell that Φιλπικός is a contracted form of Φιλιππικός. The representation of a base indicates that one is viewing a statue of the deceased rather than Philpikos himself. Since this figure is centered over the inscription and the concave curve of the relief plane corroborates its centrality within the relief field, it is unlikely that sufficient space would have remained in the missing, left field for any additional attributes or figures. A few examples from Pfuhl and Möbius show a figure of the de-

ceased atop a statue base,[2] but there are no examples of a circular statue base as carved on this stele.

RGAW

BIBLIOGRAPHY
Stillwell 1938, 163, no. 104 (P6225-I209: S429).

NOTES
1. Cf. Stillwell 1941, pl. 15, no. 357.
2. Pfuhl and Möbius 1979, 94, pl. 38, no. 173 (Istanbul, Arch. Mus., inv. 1122): originally from Amisos, this early-second-century A.D. stele exhibits a high and uninscribed base; no. 184 (96, pl. 39: Rijksmuseum, Leiden, inv. L.K.A. 1144) is a Trajanic stele purchased in Izmir that exhibits a low and inscribed base; no. 187 (96, pl. 39: now in a Swiss private collection) is a third-century A.D. stele that also has a low and uninscribed base but came either from north Lydia or from west or northwest Phrygia.

130.
STELE OF AN UNKNOWN MAN

Mid–late second century A.D.
Provenance: Kharab area, near Antioch; surface find
April 7, 1937
Material: white marble, only slightly gray and not coarse-grained
Dimensions: h. 7.4 cm., w. 11.6 cm., th. 2.8–4.1 cm., w. of frame 2.3–2.4 cm., d. of relief 1.6 cm.
Gift of the Committee for the Excavation of Antioch to Princeton University (2000-103)

CONDITION: *Only a small portion, perhaps one-fifth, of the whole stele is preserved; and the only extant piece of edge is at the right. This small portion of edge is not smoothly finished and runs straight back, not obliquely. The back face bears a scrap of vegetal relief with no intact edges.*

The figure of the deceased standing and facing the viewer is preserved only from the belly up. The figure is obviously male because a short beard can be discerned that covers only the chin and jaw line in a fashion similar to that of Hadrian. His hair is somewhat voluminous with tight curls. He wears a toga, under which a lighter garment may be seen at an open V in front of his neck. A hem of the toga runs from his right wrist up and over his right shoulder. His proper right arm crosses his chest obliquely and its hand protrudes from under the toga's hem to clasp a wide fold of its drapery near his left shoulder. His left arm hangs down straight and is covered by the toga at least as far as the elbow. Of the vegetal relief on the other face, there are visible a tendril

with a fleshy leaf, a bud, and (at the tip) an opening flower attached to it; above these is an uncertain object with an undulating outline.

The vegetal relief apparently belongs to the original use of this marble, since the extant right edge of the grave stele does not correspond to a similar break in the vegetal frieze panel but was made later, either when the vegetal frieze lay disused and already broken, or when it was chopped up to serve as the material for grave stelai. Reuse of marble for grave stelai is not unknown in the Princeton collection.[1]

The toga and pose of the deceased strongly suggest that the iconographic genre of the intact relief was Pfuhl and Möbius's *Mann im Normaltypus*.[2] This genre is a simple representation of the deceased, togate and standing to face the viewer. His left hand holds a small scroll (which in combination with the toga serves to designate him as a man with business in the public sphere of the forum or agora). He is usually alone in the relief, though a smaller-scale slave or two frequently appear standing by his right leg. The dates of *Normaltypus* stelai range from the second century B.C. through the third century A.D.; and they are found in all the major cities of Asia Minor and the southeast Balkans. RGAW

BIBLIOGRAPHY
Stillwell 1941, 123, no. 342 (Pa289-S393) (but not illustrated on pl. 13, no. 342, which is in fact P3395 [cat. no. 126]).

NOTES
1. See the stele of Helene (cat. no. 119), which was recut from a revetment slab.
2. Pfuhl and Möbius 1979, 90–107, nos. 156-249.

131.

STELE OF ANTONIN[A?]

Late second–third century A.D.
Provenance: vicinity of Antioch; purchased
Material: coarse-grained white marble
Dimensions: h. 11.8 cm., w. 10.9 cm., th. 5.5 cm.,
letter h. 1.7 cm.
Gift of the Committee for the Excavation of Antioch to
Princeton University (2000-99)

CONDITION: *Only the lower left corner of the stele is preserved. Of the figural decoration, a portion of one leg of a folding chair remains, but the lower part of the pilaster preserved along the stele's left edge exhibits only a moderate amount of wear. The extant portion of the relief frame is smoothly polished and shows no major edge chips. The smoothly finished relief plane exhibits a long, oblique incision, which seems more likely deliberate than accidental damage. The transition from the rather deep relief plane to the frame is crisp and perpendicular.*

The most probable restoration of the legend would require a width of about 30 cm. for the stele when it was complete, since it seems clear that there is not enough vertical space on the lower frame to accommodate a second line of text. An estimate of its

original height is more tentative, but a comparison with the similar but better-preserved stele of Aitete (cat. no. 122) suggests that 25–30 cm. would not be unrealistic.

This stele, despite the slightness of its preserved sculpture, very likely showed a figure seated on a folding chair within an *aedicula*. Although the surviving legend is noncommittal about gender, the iconographically similar stelai of Aitete (cat. no. 122) and of Leonide (cat. no. 108) suggest by analogy that the deceased was female. The architectural nature of the *aedicula* is more explicitly defined here than on any other of the Princeton stelai through the use of incised grooves and slight modeling to represent the pilaster's decorative molding and its base. Along the lower edge of the relief frame runs the one-line inscription in rather deep and well-cut letters.

ANTⲰNIN[α ἄλυπε χαῖρε]
Farewell, griefless Antonina!

Stillwell is wrong to see the right foot of a standing figure on this stele,[1] since the extant traces neither look human nor resemble any of the feet of standing figures on other stelai (e.g., cat. nos. 119 and 121). The restoration of Antonina, rather than Antoninos, is suggested by these comparanda.

RGAW

BIBLIOGRAPHY
Stillwell 1941, 109, no. 239 (Pb50-I266).

NOTE
1. Stillwell 1941, 109, no. 239.

132.

STELE OF ANTONINOS

Later second—earlier third century A.D.
Provenance: from Daphne-Harbie; catalogued April 28,
1934 (P3399-I44)
Material: light gray marble, not coarse-grained
Dimensions: h. 10.9 cm., w. 30.8 cm., th. 2.9 cm.,
h. of inscribed surface 7.0 cm., letter h. 1.6–2.2 cm.
Gift of the Committee for the Excavation of Antioch
to Princeton University (2000-117a, b)

CONDITION: *The extant grave relief is comprised of two*
joining fragments that preserve the full width of the stele. Verti-
cally, the lower part of the relief frame and a narrow strip of the
relief panel itself are preserved. The only damage to the lower
part of the relief frame is a chip at the lower left corner. The
edges and the surface of the relief frame are all smoothly finished.
There is no appreciable lime incrustation on the stele; and the
extensive traces of red coloring in the lettering of the inscription
testify to an absence of heavy weathering since antiquity.

The extant traces of the relief scene are limited to
the two feet of a standing, facing figure. Both the lack
of hanging drapery between the feet and the known
male gender of the recipient lead one to imagine a
togate man similar to Demetrios, son of Timokles
(cf. cat. no. 109). The extant, lower side of the relief
frame is much wider than the small portions that are
preserved on either side. The lettering of the inscrip-
tion is deeply and rather carefully cut, though with-
out benefit of incised guide lines:

<div align="center">

ΑΝΤωΝΕΙΝΕ ΑΛΥΠΕ
ΧΑΙΡΕ

Antoninos, griefless, farewell!

</div>

The inscription's letter shapes and variations in
letter sizes suggest a date no earlier than the second
century A.D., which is consistent in this case with the
great popularity in the eastern provinces of the name
Antoninos from the mid-second century A.D. on.[1] The
probable iconographic similarity between this stele
and that of the togate Demetrios, son of Timokles,
which are separated by a century or more, is indica-
tive of the prestige attached to Roman citizenship
right up to the time of Caracalla's decree of universal
enfranchisement in A.D. 212. RGAW

BIBLIOGRAPHY
Unpublished.

NOTE
1. The name is common enough to occur, in its feminine
 form, on another in the Princeton group, cat. no. 131 (Pb50).

133.
GRAVE STELE OF A BOY(?)

First—third century A.D.
Provenance: Daphne-Harbie, sector 20-N[1]
Material: coarse-grained gray marble
Dimensions: h. 12.3 cm., w. 10.2 cm., th. 4.9 cm., d. of relief
plane 3.2 cm., h. of foot 3.2 cm., w. of foot 4.3 cm.
Gift of the Committee for the Excavation of Antioch to
Princeton University (2000-107)

CONDITION: *Only a small portion of the stele's bottom
edge is preserved. Of the relief itself, only a proper right foot
is preserved.*

The bottom edge is divided into two quite different
bands, of which the very roughly finished one may
not have been visible originally; the other band is in
fact the frame of the relief and smoothly polished.
There is no inscription upon the relief frame. The
single extant foot is a bare, proper right foot whose
length cannot be ascertained since the heel lies be-
hind the relief plane. The foot is angled forward,
almost as if the subject were standing on tiptoes. The
smoothly polished back face is only 1–1.5 cm. behind
the relief plane, which bellies out slightly at the
bottom of the relief.

The stele from which this fragment came was
obviously much larger (and possibly more elaborate)
than most found at Antioch. The nature of the stele's
bottom edge is paralleled in the Princeton group
only by Pc460 (cat. no. 113) and suggests that it was
slotted into a base rather than being a *loculus* cover in
the fashion of most Antiochene examples.[2] The rep-
resentation of the deceased as if standing on tiptoes
is also atypical of Antioch stelai in general. On the
other hand, the marble type is consistent with what
was used in and around Antioch but not elsewhere in
Syria;[3] likewise, this reuse of a marble revetment slab
as a grave stele was extremely common in Antioch of
the Roman imperial period,[4] as other Princeton ex-
amples show. The likeliest solution is an Antiochene
manufacture under the influence of iconography from
the Euphrates valley of northern Syria. The unshod
foot suggests that the deceased was a child.[5]

This stele fragment and cat. no. 116 (P2209) are the
only two from Antioch actually to have been found
in an archaeological context, rather than bought. But
in this case, the expedition records give no indication
about the circumstances of discovery; a surface find or
a recovery from the spoil heap are the two most likely
possibilities. The same area yielded numerous other
fragments of marble architectural fragments, especially
Corinthian column capitals and cornice pieces.[6]

RGAW

BIBLIOGRAPHY
Unpublished.

NOTES
1. This stele bears no identifying numbers, only DH-20-N
 (which is merely the find location); nor does this item
 appear in any of Stillwell's notes.
2. Parlasca 1978a, 308.
3. Parlasca 1978a, 308.
4. Parlasca 1981, 17. *Loculus* covers were also the usual form
 of grave stele in the Palmyra area (Parlasca 1989, 546).
5. See the stele of Dionysios (cat. no. 120).
6. See Stillwell 1938, 86–92, for cornice fragments,
 Corinthian capitals, and other, uncertain architec-
 tural fragments.

HAURANITE SCULPTURE

Hauranite Sculpture

Robert Wenning

Regional styles are typical for Syrian art of the Roman period. In addition to a few Palmyrene examples (cat. nos. 150–58),[1] The Art Museum possesses an important collection of Hauranite sculpture from southern Syria.[2] The material of choice is local Hauranite basalt, a hard volcanic stone, difficult to work, which looks almost black in ambient light but more brownish if a spotlight falls on it.

Most of the sixteen Hauranite pieces at The Art Museum were recovered by the Princeton University Archaeological Expeditions to Syria in 1904–5 and 1909 under the direction of Howard Crosby Butler, and those few not securely documented in excavation records are almost certainly from the same source. The documents and photographs from this expedition are preserved at Princeton in the Research Photograph Collection and Archives of the Department of Art and Archaeology, a source for documentary photographs in several studies.[3] For some of the sculptures, the provenance Seeia is indicated in the inventory book, and for a few (cat. nos. 135–37), this is confirmed by their publication in Butler's expedition reports. From his publications, additional pieces in the collection can be attributed to Seeia (cat. nos. 134, 139, 140), and for some others this provenance seems to be likely (cat. nos. 138, 141–43). For the remaining six sculptures (cat. nos. 144–49), a clear provenance cannot be established; the Hauran seems probable because of the material, and the same location is suggested by stylistic features at least for nos. 144–46, 148. The exact find spot and the architectural context are given for six of the sculptures: nos. 134–37 are from the so-called Entrance to Theatron, the gate to the temenos of Ba'al Shamīn. One fragment, no. 139, is part of a statue found in front of the so-called Temple of Dūsharā, and no. 140 is said to be from the

so-called Roman gate. Other sculptures (cat. nos. 138, 144, 145) could belong to votives set up in the temenoi (temple precincts). No. 142 belongs to a figured capital from Qanawāt, Seeia, or another site in the region. Of special importance are the three heads catalogued here as nos. 145, 148, and 149, because only a limited number of portraits are known from Syria.[4] These and the head of a goddess (cat. no. 147) are of better quality than most of the other Hauranite sculptures. In the catalogue the works are organized into two groups according to their provenance: nos. 134–40 comprise sculptures from Seeia, and nos. 141–49 are the works probably from the Hauran.

For a long time Seeia was a very important sanctuary in the Hauran region. It was founded by local Arab tribes or clans who wrote their inscriptions in Nabataean. Whether or not these clans were actually Nabataean is much debated because they differ from the Nabataeans of Arabia Petraea. Their differences might be explained by influences of Hellenistic Syrian culture and, to a great extent, of older Syrian Aramaic traditions, as J.-M. Dentzer demonstrated in a recent lecture.[5] Nevertheless, the sculptures should be termed Hauranite rather than Nabataean. The sanctuary itself was built on a high ridge on three terraces. The oldest temple at Seeia, that of Ba'al Shamīn, is dated by an inscription to 33/32-2/1 B.C.[6] The so-called Entrance to Theatron provides admittance to the temenos of Ba'al Shamīn; this gate is reconstructed in the Pergamum Museum at Berlin but without the tympanum figures.[7] Another reconstruction (or a cast from the Berlin one) was once exhibited at the Princeton University library.[8] The portico in front of the temple of Ba'al Shamīn is called "theatron" in inscription *CIS* II 163. The temple, the theatron (upper temenos), the gate, and part of

the middle temenos belong to the first building phase. The well-dated sculptures of this phase, especially those from the Entrance to Theatron, provide the foundation for the classification of all Hauranite sculpture. A second inscription, *CIS* II 164, may refer to an enlargement (upper storey) of the temple; if it does, the dating of the sculptures would be affected.[9] There are at least two slightly later temples in the sanctuary on the lower terraces (see below). The site was excavated by H. C. Butler in the early years of the twentieth century and again, much later, by J.-M. Dentzer.[10]

The arched tympanum (3.00 x 1.30 m.) of the so-called Entrance to Theatron featured sculptures in high relief. The keystone of the arch bears the bust of Baʿal Shamīn with sunrays.[11] Butler reconstructed the tympanum scene as a group consisting of a victorious man heralded by two riders with trumpets, with two horses facing in opposite directions, and a standing figure between them.[12] This reconstruction should be viewed with great caution. Fragments L–O,[13] from the great heap of building materials from the gate (fallen "in hopeless confusion"), which Butler used for his reconstruction, are now at Princeton, but there are at least three other male heads in the Suweida Museum whose style and measurements strongly suggest that they belong either to this tympanum or to that of the Temple of Baʿal Shamīn.[14] These three heads are unpublished and the attribution needs to be proved.

One slab (ca. 105 x 73 cm.) of the tympanum was drawn by M. de Vogüé in the nineteenth century and depicts a bridled horse facing left.[15] At the bottom of the saddle a socket is shown for the figure of the rider. This drawing corresponds in its measurements to the dimensions of the tympanum and to cat. no. 137, but it is not integrated into Butler's reconstruction. A second relief of the same height (w. ca. 26 cm.), published by de Vogüé, portrays a standing man in a tunic,[16] but the man seems too small against the size of the horses to be attributed to the tympanum figures (he cannot be combined with fragment O). Moreover, the bottom of this slab differs from the slab with the horse. Another possibility would be to attribute both slabs to the tympanum of the Temple of Baʿal Shamīn itself, which was Butler's tentative solution.[17]

At the moment, however, it still seems impossible to attempt a new reconstruction of the tympanum reliefs. Such an undertaking would require further detailed investigation of the entire sculptural complex, and even then, the evidence might be insufficient to allow an authoritative reconstruction. Nevertheless, the Hauranite collection of The Art Museum is certainly of greater importance for Classical and Near Eastern archaeologists than the number and character of the items seem to indicate: they are the basis for the study of the local Hauranite art in the Roman period.[18]

BIBLIOGRAPHY AND FURTHER READING ON HAURANITE SCULPTURE

M. Dunand, *Le Musée de Soueïda: inscriptions et monuments figurés.* BAH 20 (Paris 1934).

A. Abel, "La statuaire hawranienne," *AnnArchBrux* 49 (1956): 7–15.

S. Diebner, "Bosra: Die Skulpturen im Hof der Zitadelle," *RdA* 6 (1982): 52–71.

I. Skupinska-Løvset, *Funerary Portraiture of Roman Palestine. An Analysis of the Production in Its Culture-Historical Context,* SIMA Pocket-Book 2 (Gothenburg 1983), 311–20.

G. Bolelli, "La ronde-bosse de caractère indigène en Syrie du Sud," in Dentzer 1986, 311–72.

J. Dentzer-Feydy, "Bosra et le Hauran," in Caubet 1990, 57–71.

G. Bolelli, "La sculpture au Musée de Suweida," in Dentzer and Dentzer-Feydy 1991, 63–80.

J. Dentzer-Feydy, "Au musée de Suweidā: les linteaux sculptés de figures divines," *AAS* 41 (1997): 39–48.

A. Abou Assaf, *Gabal Hauran und seine Denkmäler* (Damascus 1998).

NOTES

1. Cat. nos. 152, 156, and 158 (from Palmyra) entered The Art Museum's collection at the same time as did the Hauranite basalt sculptures from H. C. Butler's expedition (below). Butler may have acquired the Palmyrene pieces, possibly through purchase, and brought them to Princeton along with the material he excavated.

2. For bibliography on Hauranite sculpture, see the list above, at the end of the introduction to this section.

3. E.g., C. L. MacAdams, in H. I. MacAdams 1986, 244–49, 311–69; and Kennedy 1995.

4. Cf. Parlasca 1985, 343–45; Skupinska-Løvset 1999, 208–30.

5. Cologne, February 12, 2000.
6. *CIS* II 163.
7. Schmitt-Korte 1976, fig. 43.
8. See Butler 1916, fig. 332.
9. Parlasca 1967, 558.
10. Butler 1916, 365–402; Dentzer 1985, 65–83; Dentzer 1990.
11. Butler 1916, fig. 331 (fragment G, now Damascus, Nat. Mus. 46, partly damaged).
12. Butler 1916, 385, fig. 329.
13. Butler 1916, fig. 334. For fragments L–O (cat. nos. 134–37, not in order), see Butler 1916, 382, 384–85, 398, fig. 334; E. Littmann and D. Magie, Jr., in Butler 1916, 367 (frag. N; cat. no. 136); Bossert 1951, 35 no. 515, fig. (frag. O; cat. no. 134); Parlasca 1967, 557; Bolelli 1986, 325, nos. 1–4, 326 no. 5, pl. XVIII a–d (assuming the sculptures got lost); Bolelli 1991, 72; Haider, Hutter, and Kreuzer 1996, 181.
14. Suweida Museum, inv. 332 (h. 16.5 cm., w. 13.4 cm., d. 7.5 cm.); inv. 761, from Seeia (h. 16.5 cm., w. 15.5 cm., d. 16.5 cm.); inv. 895, from Seeia (data kindly submitted by H. Laxander).
15. De Vogüé 1865–77, 36, pl. 2.4; see also Butler 1903, 416; Bolelli 1986, 325 n. 39, 328, pl. XVIIc.
16. De Vogüé 1865–77, pl 2.5.
17. Butler 1916, 377, fig. 325c.
18. I owe Michael Padgett a debt of gratitude for allowing me to publish these sculptures, for his kind support during my visits to The Art Museum, and for his valuable help in editing this part of the catalogue.

134.

Upper Part of a Man in High Relief

Hauranite, last part of first building phase of Temple of
Baʿal Shamīn, Seeia, 33/32-2/1 B.C.
Provenance: central figure in the tympanum of Entrance to
Theatron at Seeia; fragment O
Material: brownish basalt
Dimensions: h. 33 cm., h. of head 19.1 cm., w. 34.3 cm.,
w. of head 17.8 cm., d. 20.6 cm.
Princeton University Archaeological Expeditions to Syria,
1904–5 and 1909 (y1930-449)

CONDITION: *Preserved are the head and shoulders of an*
underlife-sized standing man carved in very high relief. The
dimensions and the lack of arms with attributes in front of the
breast clearly indicate a full standing figure rather than a pilaster

bust.[1] The top of the head is flattened to meld with a pillarlike
block at the back of the head and neck; the surface of the flattened
top slopes toward the ground of the tympanum, and there is
no evidence that anything was originally placed upon the head.
At the back of the block, behind the right ear, is a dowel hole for
attaching the statue to the tympanum. When placed high in the
tympanum and viewed from below, the head would have appeared
more voluminous and majestic than in its modern installation.
The surface is carefully smoothed but the stone contains many
small pores. The bridge of the nose and tip of the chin are broken
off, and the upper part of the body is irregularly broken off below
the armpits. The back of the bust was partially hollowed out in
modern times, probably to reduce the weight.

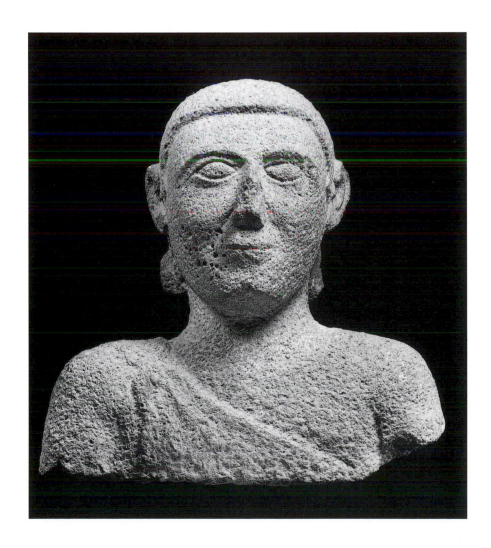

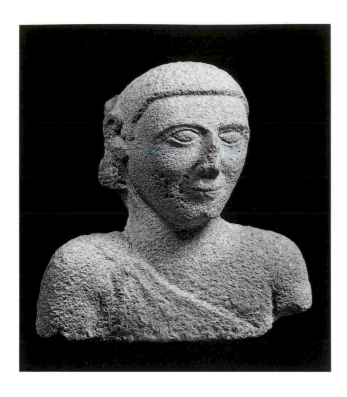

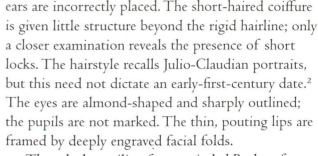

ears are incorrectly placed. The short-haired coiffure is given little structure beyond the rigid hairline; only a closer examination reveals the presence of short locks. The hairstyle recalls Julio-Claudian portraits, but this need not dictate an early-first-century date.[2] The eyes are almond-shaped and sharply outlined; the pupils are not marked. The thin, pouting lips are framed by deeply engraved facial folds.

Though the smiling face reminded Butler of an archaic statue, the expression is typical for Hauranite sculptures of that phase.[3] The face is not expressionless, especially when seen from below; despite some masklike stiffness, the features are made vivid by plump cheeks that contrast nicely with other more emphatically glyptic elements. The style is comparable to that of other sculptures from Seeia and nearby Qanawāt.[4] However, the figure differs from standard representations of Baʿal Shamīn. A firm identification remains unknown. The context, as part of the tympanum with the riders, and the inscription that defines one of the latter as "Triton trumpeter" (see cat. no. 136) suggest, as Butler wrote, that the statue depicts one of the temple's benefactors.[5] This then could be Maleikat, the son of Ausū, the son of Moʿaierū, shown as donor and guardian of the sanctuary he built. Above him, Baʿal Shamīn was shown in a larger bust in the center of the arch. RW

The statue depicts a man wearing a long tunic fixed on his right shoulder with a round fibula, leaving his left shoulder and arms uncovered. The way the man is dressed is unusual and may contribute to discerning his status, function, and identification. Though the drapery folds are indicated, the bust remains quite flat; the collarbones are hardly visible and the

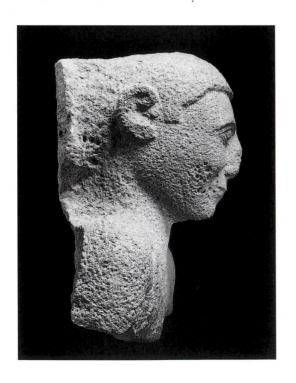

BIBLIOGRAPHY
Butler 1916, 384–85, fig. 334, fragment O.
Bossert 1951, 159, no. 515 (illus.).

NOTES

1. For a pilaster bust from the temple, see Bolelli 1986, pl. XVIIa.
2. Cf. a head of Tiberius in the Museum of Fine Arts, Boston (inv. 1971.393): Comstock and Vermeule 1976, no. 331.
3. Cf. the "sub-Ptolemaic smile" associated with some Egyptian mummy masks: Parlasca 1967, 557; Grimm 1974, 47, 104.
4. Cf. the head of Baʿal Shamīn in a relief from the temple of Baʿal Shamīn at Seeia, now Paris, Louvre AO 4997: J.-M. Dentzer, in Homès-Fredericq 1980, 102, no. 73; Hellenkemper-Salies 1981, pl. 71; Caubet 1990, no. 16. This head proves the close relation between the temple and the gate sculptures. These two heads might have been worked by the same artist. Also comparable is the bust of a figured capital, Damascus, Nat. Mus. 5040, from the so-called Temple of Dūsharā at Seeia (unpubl.); cf. another capital, possibly from Qanawāt, Suweida Mus. 295: Negev 1976, fig. 79; Dentzer and Dentzer-Feydy 1991, cat. 4.15, pl. 1. Cf. further a seated man from Qanawāt, Suweida Mus. 609: Dentzer and Dentzer-Feydy 1991, cat. 4.28, pl. 4; and another seated man of unknown provenance: Dunand 1934, no. 66, pl. 20.
5. Cf. the monumental votive group of Allat and a Babylonian-Jewish hero or the Jewish king as rider set up in the temenos of the temple at Saḥr, which has been discovered and reconstructed by T. Weber (publication in preparation).

135.

MALE HEAD IN HIGH RELIEF

Hauranite, last part of first building phase of Temple of Baʿal Shamīn, Seeia, 33/32–2/1 B.C.
Provenance: tympanum of Entrance to Theatron at Seeia; fragment M
Material: brownish basalt
Dimensions: h. 17.0 cm., w. 15.3 cm., d. 6.8 cm.
Princeton University Archaeological Expeditions to Syria, 1904–5 and 1909 (y1930-443)

CONDITION: *The head in relief is broken off under the chin. Part of the right side of the head is irregularly broken off, following a line from the outer corner of the right eye to the corner of the mouth and the middle of the chin. The latter break is more or less in a single plane and allows the head to lie close to the original ground of the relief. The top of the head is chipped around the dowel holes.*

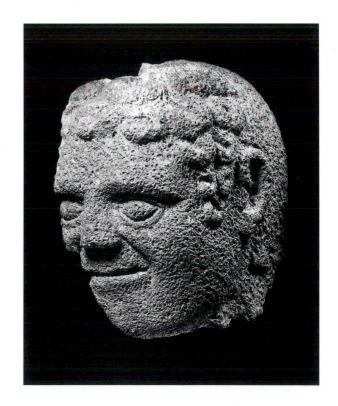

Preserved is the head of a man in a three-quarter view to the left. The back of the head, behind the left ear, is uncarved and tapers into a block that was fixed to the tympanum, apparently by means of metal pins, as evidenced by two large, parallel dowel holes (l. 1.8 cm.) on top of the head. The structure

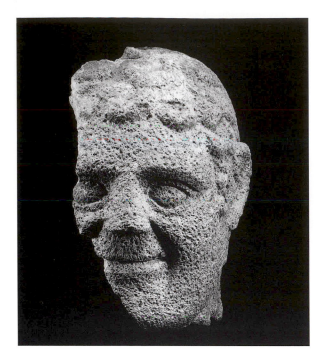 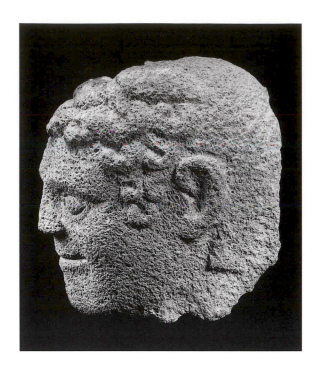

of the face is comparable to that of the standing man (cat. no. 134) but smaller, stockier, and rounder; he has a similar smile but a shorter nose, and the eyeballs are slightly more protuberant. The hair, too, is different, with short, tight curls arranged in somewhat clumpy fashion.

The block at the back of the head determines the position approximately, with the face turned to a complete three-quarter view. The dowel holes at the top point to a position high in the relief, just below the arch. Such placement, as well the similarity in dimensions to the trumpeting rider (cat. no. 136), suggests that this man is also to be reconstructed as a rider, though neither this nor the assumption that the man was also a trumpeter can be proved (unlike the trumpeter, he holds no instrument to his lips).[1] This means the composition in the tympanum relief as reconstructed by Butler—with two identical riding trumpeters represented in mirror image—is not correct. The man, looking slightly to his right, that is, to the back wall and a little toward the top, would seem to have had a relationship (eye contact) with the Ba'al Shamīn on the arch.

In style, this head may be compared with the bust of Ba'al Shamīn at the keystone of the arch,[2] with three unpublished relief heads at the Suweida Museum, possibly belonging to the tympanum figures of the gate or the temple, with some other heads from Suweida,[3] and with the busts of figured capitals from Seeia.[4] RW

BIBLIOGRAPHY
Butler 1916, 384–85, fig. 334, fragment M.

NOTES
1. Butler (1916, 384) alternately suggested a reconstruction with a standing man between the right-hand rider and the central figure (cat. no. 134).
2. Butler 1916, fig. 331, fragment G, now Damascus, Nat. Mus. 46; Bolelli 1986, 325 no. 1; J. Dentzer-Feydy, in Dentzer 1986, 269, pl. III b 1.
3. Dunand 1934, no. 106, 112, pl. 25; Bolelli 1986, nos. 31–32, pl. IX.
4. Damascus, Nat. Mus. 44 and 45 (from the so-called Temple of Dūsharā at Seeia): Butler 1916, fig. 337a; Mercklin 1962, 23–24, nos. 71–72, figs. 94–95; Negev 1976, fig. 78 (incorrectly captioned as Suweida Museum); Dentzer-Feydy, in Dentzer 1986, 269 pl. IXb. Cf. also a figured capital from Qanawāt, Suweida Mus. 409: Dunand 1934, 64 no. 122 pl. 28; Mercklin 1962, 24, no. 74, fig. 99; Dentzer and Dentzer-Feydy 1991, cat. 4.14. These busts are to be compared especially for the stocky features. In addition, cf. "The Marble Statue" from Dura-Europos: Downey 1977, 85–87, pl. 19. For a Roman relief, cf. the tomb stele Hamburg Museum, inv. no. 1928.97: Parlasca 1978b, 117, pl. 34.

136.

HEAD OF A TRUMPETER IN HIGH RELIEF

Hauranite, last part of first building phase of Temple of Ba'al Shamīn, Seeia, 33/32–2/1 B.C.
Provenance: tympanum of Entrance to Theatron at Seeia; fragment N
Material: brownish basalt
Dimensions: h. 12.0 cm., w. 10.1 cm., d. 4.2 cm.
Princeton University Archaeological Expeditions to Syria, 1904–5 and 1909 (y1930-444)

Conditon: The fragment of a head from a relief is broken all around, so that only the face with part of the hair on the forehead remains (one row of curls and two curls of a second row). Part of the right side of the head is broken off but not as close to the eye, mouth and chin as on fragment M (cat. no. 135), which is better preserved. This irregular break runs more or less straight down, while the break at the left more closely follows the shape of the face. There is no block preserved at the back of the head. The face ends at the chin in a horizontal cut, while at the mouth and chin a great piece is knocked off where the trumpet touched the lips. The surface is porous. There is a large dowel hole (*l. 2.6 cm.*) *at the top of the head, extending all the way back into the break. Here the back is diagonally cut, while the lower two-thirds are more or less planar.*

Preserved is the head of a man in a three-quarter view to the right. The features are close to those of the heads on fragments M and O, and the same parallels may be cited,[1] but this head appears broader, with larger eyes. The nose is conspicuously short again, while the mouth and its adjacent facial folds are enlarged. The relatively broad area above the

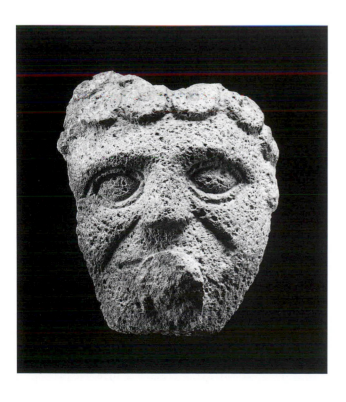

upper lip is typical for these heads. The curly hair seems to be less vivid than the similar coiffure of fragment M (cat. no. 135), with the few great curls falling onto the forehead in a formulaic manner.

The man holds a trumpet at his lips.[2] A piece of the tube with oval cross section (diam. 2.8 cm., l. 1.8 cm.) remains at the break; the lower part is knocked off.[3] The trumpet originally continued downward rather than upward. The wide mouth and enlarged cheeks perhaps indicate the blowing of the trumpet. Behind the trumpet, the details of the mouth and facial folds are not fully modeled on the left side of the face, suggesting that the head was to be seen in three-quarter view. As with fragment M (cat. no. 135), the dowel hole and the three-quarter view indicate a similar position in the left half of the tympanum. Butler's suggestion that the head belonged to the left-hand rider is probably correct: behind the saddle and the body of the rider there is a short Greek inscription, which reads "Triton, trumpeter."[4] For the horse, see cat. no. 137, below.

RW

BIBLIOGRAPHY
Butler 1916, 384–85, fig. 334, fragment N.

NOTES

1. For the large eyes and their framing elements, cf. the head Paris, Louvre AO 4996: F. Baratte, in Homès-Fredericq 1980, 103, no. 75; Hellenkemper-Salies 1981, pl. 221; Caubet 1990, no. 15. It is assumed that this head is from a statue which could have been set up in front of the temple of Baʿal Shamīn.

2. For the trumpet(er), cf. various Roman historical reliefs, e.g., the Arch of Titus in Rome, Roman battle sarcophagi, and the shorter trumpets on coins of Bar Kokhba (Yarden 1991, 101–6). The long trumpet seems to have been an instrument of great official occasions, especially triumphs, and possibly a Hellenistic-Roman element in Syrian regional art. The Nabataeans seem to have been more familiar with the double flutes (auloi); see I. Parlasca 1990, 159–60, pl. 27.1 (Nabataean terracotta figurines). Trumpets are not common in the ancient Near East before the Roman period, but in Greece the war trumpet (salpinx) was mentioned by Homer. Other trumpets were employed in sanctuaries to assemble the congregation or to announce cultic acts, sunset, or holy periods: cf. the inscription for the trumpeter at the temple of Jerusalem: Demsky 1986, 50–52.

3. The round mouthpiece is not always depicted.

4. E. Littmann and D. Magie, Jr., in Butler 1916, 367, no. 772 (a reading disproved such earlier suggestions as "Kreiton" and "Breiton/Britto"); Bolelli 1986, 344. The slab with the inscription was given to the Princeton University Library but could not be located in 1994.

137.

HEAD OF A HORSE IN HIGH RELIEF

Hauranite, last part of first building phase of Temple of Baʿal Shamīn, Seeia, 33/32–2/1 B.C.
Provenance: tympanum of Entrance to Theatron at Seeia; fragment L
Material: brownish basalt
Dimensions: h. of head 23.3 cm., h. at neck 1.48 cm., w. 13.5 cm., d. 21.5 cm.
Princeton University Archaeological Expeditions to Syria, 1904–5 and 1909 (y1930-440)

CONDITION: *The head is broken off at the neck. The tip of the horse's right ear, the greater part of its left ear, and a piece of basalt between the mane and left ear are broken off. The left rein is chipped. There is a whitish discoloration on the basalt from the left ear to the neck and bridle; it is less pronounced on the opposite side below the mane, which itself has a reddish discoloration. There is a dowel hole behind the left ear and possibly a second, broken dowel hole at the end of the mane. The underside of the head has somewhat fewer details because of the bowed head.*

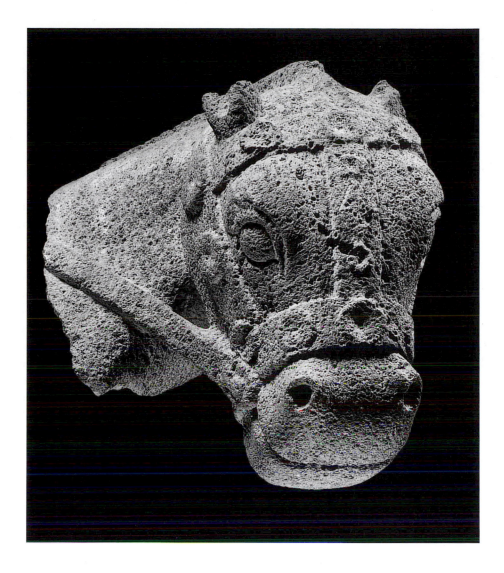

The head is from a relief of a bridled horse, stand-
ing to the right, the head itself bowed and turned
sharply out toward the front, so that both sides are
fully worked like a sculpture in the round. Details of
both horse and bridle are accurately portrayed. The
mane is cut short, with a tuft combed forward onto
the forehead. The eyes are hooded beneath heavy
lids.[1] The nostrils are slightly flared; there are four
slight notches upon the mouth. The bridle consists
of a trapezoidal halter with a middle strap and a
snaffle. The reins are tightened by the rider. The
snaffle-bit is fixed with rivets to the reins. Each halter-
strap is decorated with three round disks or rosettes,
while the middle strap features a rhombus between
two smaller discs.

Butler described the slab with the plain outlines
of this horse.[2] The horse was saddled and there was

a socket in the saddle into which the body of the
rider once was fitted with a peg. It is this rider that
Butler, aided by the inscription on the slab above,
identified with the fragmentary head of a trumpeter
(cat. no. 136). An idea of the horse with its harness
and saddle can be had from the drawing of the right-
hand horse made by de Vogüé.[3]

Sculpted riders are a common motif in local
Hauranite sanctuaries;[4] sometimes they appear with
representations of gods, more often with those of
donors. The inscription on this relief ("Triton,
trumpeter") allows the rider to be identified as a
companion of the central figure (cat. no. 134) or
as a priest of the sanctuary.[5] RW

BIBLIOGRAPHY
Butler 1916, 384–85, fig. 334, fragment L.

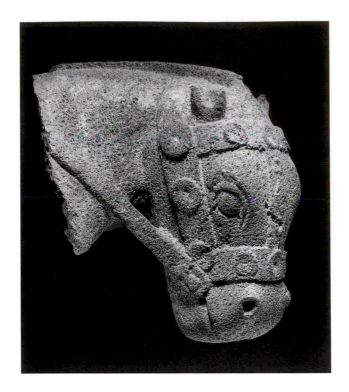
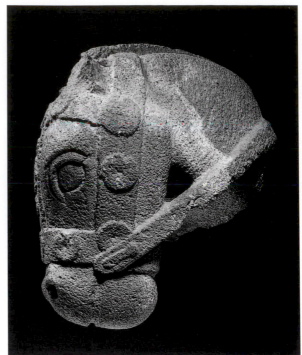

NOTES

1. Cf. the head in Dunand 1934, no. 112, pl. 25 (already compared with head cat. no. 135), and the head in Bolelli 1986, 350, no. 36, pl. x.
2. Butler 1916, 384.
3. De Vogüé 1865–77, 36, pl. 2.4. See also the discussion in the introduction to this section.
4. Especially the sanctuaries at Qanawāt, Saḥr, and Seeia. More than 20 sculptures of riders/horses are known:

see Diebner 1982, 62, nos. 28–30, figs. 31–34; Bolelli 1986, 321, 324, 328, 343–44, 349, 352–53, nos. 20–22, 70–75, pls. VII, XVII, XVIII; Bolelli 1991, 71–72; Weber 1995, 203–11, pls. 29–30 (possibly the caravan gods Azizos and Monimos). For (the different) Nabataean terracotta figurines of riders and horses, see I. Parlasca, in Lindner and Zeitler 1991, 121–24, figs. 37–50 and in Weber and Wenning 1997, 130, fig. 146b, 147.
5. Cf. Bolelli 1986, 344.

138.

HEAD OF A MAN

Hauranite, late first century B.C.—early first century A.D.
Provenance: Syria, probably Hauran (Seeia?)
Material: dark brownish basalt
Dimensions: h. 17 cm., w. 14 cm., d. 17 cm.
Princeton University Archaeological Expeditions to Syria, 1904–5 and 1909 (y1930-442)

CONDITION: *Diagonally broken off at the neck (7 x 14 cm. in diam.), from which a modern iron dowel extends (previously restored with a plaster bust). A protrusion in the back may be some kind of hair knot, but it cannot be excluded that this is a support to fix the figure to a background; there is otherwise no indication that the head derives from a relief. The surface is generally worn and knocked about. Chips have flaked off at the brows, the left eyeball, the nose, and the chin.*

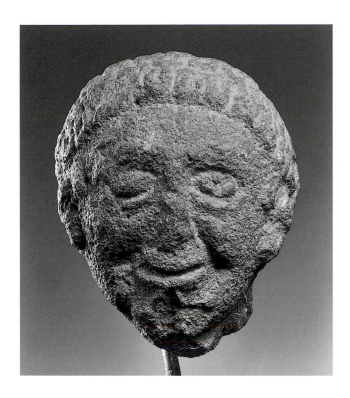

and the eyeballs protuberant (pupils not drilled). The forehead is arched, the nose wedge-shaped, the chin pointed. The frontal view seems to be the principal one, but it remains possible that the head was originally to be seen in three-quarter view. The short hair is arranged in a manner recalling the female "melon coiffure," framing the forehead in a broad strip of two rows of curls while at the back the curly hair is less voluminous but still neatly arranged. There are ringlets in front of the ears; the larger curls behind the left ear are at some variance with the rest of the hairdo. The smile and the ornamental construction of the head are typical of early Hauranite figures, especially heads from Seeia,[1] which therefore seems the most likely provenance. RW

The underlife-sized head of a man is nearly in the round, with bold features and a strong neck. Sharp, curved lines were preferred in the composition of the mouth, the naso-labial lines, the eyelids, and the hairline. The cheeks and brows are somewhat swollen

BIBLIOGRAPHY
Unpublished.

NOTE
1. Cf. the Seeia group in this catalogue (nos. 134–37 above), and other heads, such as Dunand 1934, nos. 106, 112, pl. 25; Bolelli 1986, nos. 31–32, pl. IX. Especially comparable is a head in London, British Museum WA 125 699: Bolelli 1986, no. 25, pl. VIII.

139.

Female Face in Relief: Personification of the Land of the Hauran, from the Base of a Statue of Seeia

Hauranite, first half of the first century A.D.
Provenance: from debris in front of the so-called Temple of Dūsharā at Seeia; fragment P
Material: dark brownish basalt
Dimensions: h. 15.9 cm., w. 13.3 cm., d. 5.2 cm.
Princeton University Archaeological Expeditions to Syria, 1904–5 and 1909 (y1930–448)

CONDITION: *The face of a figure, broken all around: diagonally above the eyes (upper part of the left eye chipped off), in front of both ears, and through the neck. The broad break in the back is relatively straight, so that the face seems to have been cleanly cloven from its parent head. The nose is lost and the tip of the chin is damaged. Of the hair, only a single curl remains in front of the left ear. There is a large, light discolored patch on the right cheek, and similar but smaller patches are found below the chin and around the outer corner of the left eye. Otherwise the color of the basalt's porous surface is irregularly shaded from lighter to darker brown. Sprinkled spots of mica are visible in the breaks.*

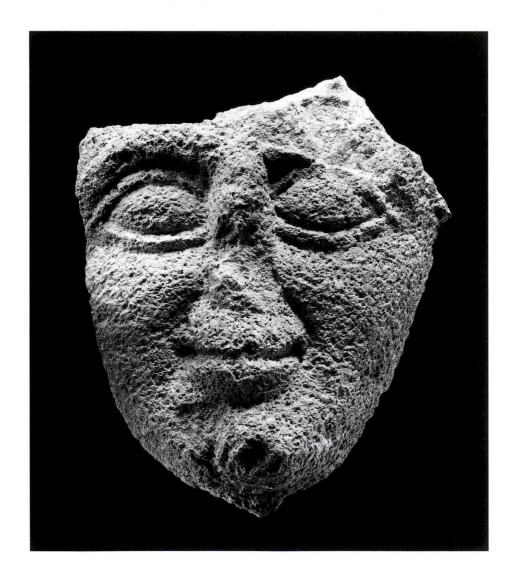

The fragmentary base of a statue of Seeia that yielded this face remained at the site and was brought to the Suweida Museum around 1980; this single fragment is the only piece taken away to Princeton. The face is shown in a frontal view. In comparison with the heads from the Entrance to Theatron, this head is distinctively broader and flatter,[1] much more even than the head cat. no. 134. The flat cheeks and round, projecting chin contribute much to this impression and make the face seem a bit masklike, an effect opposed by the smile, by the soft modeling, and by certain asymmetries in the features. By contrast, some features, especially the treatment of the large eyes, compare well with heads such as cat. no. 135. The more naturalistic and, despite the somewhat broad presentation, more vivid composition of the face when compared to those from the Entrance to Theatron indicates that there had been some intervening development, a conclusion that fits the contextual evidence suggesting a later date for the statue of Seeia (see below).

The face was found by Butler knocked off from the sculptural base of a statue.[2] The damaged base was found in the debris in front of so-called Temple of Dūsharā.[3] According to a bilingual Greek-Nabataean inscription,[4] the statue could be identified as that of Seeia, the personification of the site.[5] The flat slab with the inscription was set against the podium of the temple (h. 1.4 m.), just below the middle of the space between the left-hand column and the adjoining half-column of the façade.[6] This argues for the possibility that the statue was erected together with the temple and that it can be assigned a similar date.

The so-called Temple of Dūsharā is situated at the west corner of the middle temenos with its front toward the paved courtyard, which forms another theatron. Butler's reconstructed plan of the temple has now been corrected by the excavations of J.-M. Dentzer,[7] who also established the stratigraphy of the complex. The temple is later than the façade of the upper theatron, for the façade was partly cut down to build the temple. This seems to have been an act of connection rather than one of destruction. Dentzer suggested a dating into the second half of the first century A.D., but an altar for the statue of Galis, found in front of the temple, is dated to A.D. 29/30 (*RepES* 2117) and offers a *terminus ante quem*.[8] For stylistic reasons there can be no great

distance between the statue of Seeia and the sculptures from the Entrance to Theatron. A date in the first third of the first century A.D. therefore seems to be likely for the statue as well.

It is not known to whom the temple was dedicated: Dūsharā was suggested only because of his rank among Nabataean gods. Dūsharā is not mentioned in any of the inscriptions from the site, and there are many other possible deities to whom the temple might have been dedicated. Butler thought the statue of Seeia represented Dūsharā, perhaps influenced by the tendrils with grapevines at the base. Considering where the statue was erected, it could hardly have been the cult statue of this temple or a representation of the temple's owner, as Dentzer speculated.[9]

Although the base of the statue is broken off above the feet, rich folds of a long chiton indicate that Seeia was shown in a manner following Hellenistic tradition but transferred into local style. In the Hauran, this drapery is very often associated with statues of Nike. Seeia as the personification of the site corresponds to the rank of a city-goddess or Tyche, as rightly pointed out by Dentzer and C. Augé. Since the creation of the famous Tyche of Antioch in the third century B.C., many of the Eastern Tyche types followed her manner of drapery (cf. cat. no. 146).

Seeia stands upon a rocky hill identified with the djebel al-ʿArab, the Hauranite mountains. Her feet (with sandals) rest upon a thick tendril of shoots with grapes and leaves. Contrary to Butler, Seeia is not shown pressing grapes: the stem of a vine completely surrounds the base. Grapes were one of the main products of this hilly country, as they still are today.[10] Between the feet of Seeia and below the folds of her chiton, a female bust emerges below the shoots (see fig. 1). The head is slightly turned to the right and a little bit bowed so it could face the visitor to the temple. Butler's description and drawing are somewhat misleading but are corrected by Dentzer. Much of the upper left part of the head is cleanly broken off in the same manner as the face and was already missing when the base was found by Butler; perhaps it will be rediscovered at the site. The head is covered by the stem and leaves of the vine, but the wavy hair beneath is visible. Below the left ear a curl remains at the edge of the break; possibly it fits

with the single curl on the face. Above the left shoulder of the figure, Butler indicated wavy lines in his drawing; these are identified by Dentzer as long curls typical of personifications of fertility.[11] Possibly she is correct, but when I studied the base these lines seemed to me rather to be parts of leaves and petals. That would point to another coiffure with wavy hair, thick strands, and the neck more free of curls, as typical of another group of personifications of fertility and charm.[12] Indeed, two thick, twisted strands are visible in the same shady corner below the ears, covered by leaves above the shoulders. The breast and shoulders are covered with leaves;[13] the shoulders are indicated by modeling and the forms of the leaves are simply rendered. Contrary to Butler, there is no medallion or necklace upon the breast.

The Dionysiac motif of the base is employed to indicate the fertility of the "land of the Hauran," which, according to the inscription, is represented by the bust. Vine tendrils with grapes can be found in architectural decorations of the Temple of Baʿal Shamīn as well, but not in that of the so-called Temple of Dūsharā. The motif is very common in decorations of temple architecture in the Hauran. Among these, the one from the main portal of the Temple of Baʿal Shamīn is the closest, and Butler's description may stand for the grapevine on the base of Seeia as well: "The carving is very realistic, the leaves are much convoluted and veined, the stems of the vine follow graceful and natural curves, the tendrils are delicate and the fruit is represented in naturalistic form."[14] Butler suggested that the main portal might

Figure. 1. Base of the statue of Seeia

be later than the inner portal, whose carved tendrils are cruder and stiffer in composition. If he is right, the date of the inscription *CIS* II 164 should be considered.[15] That would explain why the statue and the jambs of the outer portal are treated in the same style. But more research is necessary to establish the chronology of Hauranite tendrils.

Although there is no need to assume a cult of Dūsharā as the god of wine because of this base or other decorations with grapevines, nevertheless Dūsharā and Dionysos were both venerated in the region.[16] The identification of Dūsharā with Dionysos as the god of wine seems to be a later development. The fertility of the Hauran was ascribed to the main god of the site or the region, and that was Baʿal Shamīn; it was not produced by Seeia, but was simply embodied in what was surely a votive offering and not a cult statue. An altar with the bust of a god above grapevines like those on the base of the Seeia statue was also found in the sanctuary at Seeia.[17] Iconographically that bust is identified with the juvenile Dūsharā,[18] but according to the inscription, the altar is dedicated to Zeus Kyrios, an epithet of Baʿal Shamīn.[19]
RW

BIBLIOGRAPHY

Butler and Littmann 1905, 407–8.
Butler 1909, 82–83, 89–90, pl. II.
Butler 1916, 384–85, fig. 334, fragment P (face); 390, fig. 337b, d (base); cf. reconstruction of the temple in fig. 335.
Parlasca 1967, 557, 558 n. 46.
Dentzer 1979, 325–32, figs. on 328.
Dentzer and Dentzer-Feydy 1991, 115, cat. 3.13, pl. 17.622 (base only).
LIMC 7: 704–5 (base only), s.v. Seeia (C. Augé) [1994].
P. W. Haider, in Haider, Hutter, and Kreuzer 1996, 182–83 (still interpreted as Dionysos).
Freyberger 1998, 50, pl. 32a–b (base only).

NOTES

1. Unlike the impression one might have from the drawing and the three-quarter views by Butler 1916, figs. 334P, 336–37.
2. See bibliography above, esp. Butler 1916, 390, 398, figs. 336–37. The knocked off face was affixed to the dam-

aged base to make the photograph in fig. 337. The base (h. 53 cm., w. 62 cm., d. 52 cm.) is exhibited in the Suweida Mus., inv. 622 [794]: Sourdel 1952, 63–64; Negev 1976, 52; J. Dentzer 1979, 325–32, figs. pp. 329–30; F. Villeneuve, in Dentzer 1986, 72; C. Augé, in Zayadine 1990, 133 fig. 11a, b ; Dentzer and Dentzer-Feydy 1991, 115 (cat. 3.13), pl. 17; *LIMC* 7:704, s.v. Seeia (C. Augé); Freyberger 1998, pl. 32a, b. I would like to thank both J. Dentzer-Feydy, for her generosity in sending me some new photographs of the base and permitting its publication in this volume, and H. Hatoum, the director of the Suweida Museum, for his kind permission to study the base and other sculptures in the museum.

3. Or "more precisely," within the doorway of the temple. But according to the clearing of J.-M. Dentzer, the entrance to the temple is still an unsolved problem (see Dentzer 1990).

4. E. Littmann, in Butler 1909, 375–78, no. I, fig. 1; *RepES* 1092; E. Littmann, in *PPUAES* IV A (1914), 81–83, no. 103, fig. 13; Littmann and Magie, Jr., in Butler 1916, 364–65, no. 767; Cantineau 1932, 14–15, no. 3; MacAdam 1986, 350 pl. 11b. The inscription reads in Nabataean: dʾ ṣlmtʾ/dy šʿyʾw: *This is the statue of Seʿīʿ*; in Greek: ΣΕΕΙΑ ΚΑΤΑΓΗΝΑΥΡΑ/ΝΕΙΤΙΝ ΕΣΤΗΚΥΙΑ: *Seeia standing above the land of the Hauran.*

5. Seʿīʿ in Aramaic means a leveled (holy) space. Cf. *IGRR* III 1230. This corresponds with the terraces of the sanctuary as noted by Littmann. It is worth considering whether this understanding is mixed with the character of the Roman deity: Seeia took care of the seeds in the soil.

6. Cf. Butler 1916, fig. 335.

7. Butler 1909, 81–91, pls. I–II; Butler 1916, 385–90, figs. 335–37; Negev 1976, 52; J. Dentzer-Feydy, in Dentzer 1986, 270, 277, pl. VIII; Dentzer 1990, 364–67, figs. 1–2, pl. 53.3. For further stylistic classification and an early dating, see Freyberger 1991, 10, 20–21, 25–26, 28, 31; Freyberger 1998, 50, Beilage 14b.

8. Another Greek inscription from the façade of the temple (Littmann and Magie, Jr., in Butler 1916, 359–64, no. 766) itself is related to Emperor Claudius (A.D. 41–54), but it is discussed as being a secondary votive inscription that cannot itself date the temple.

9. The assumption of J. Dentzer was accepted by D. F. Graf (*JRA* 5 [1992]: 451), by me (Wenning 1987, 34, 37; Wenning, in Kuhnen 1990, 390); and by Freyberger 1998, 50. Further research of various sanctuaries gives reason to be less optimistic and to understand the sculpture rather as a votive statue.

10. F. Villeneuve, in Dentzer 1986, 121–25.

11. Glueck 1965, pls. 11, 14, 31.

12. Glueck 1965, pl. 1, 25, 46, 53, and others.

13. As typical for sea creatures and figures *"im Blätterkelch"*; cf. (Nabataean examples are cited only) P. J. Parr, *ADAJ* 4/5 (1960): pl. 15; Glueck 1965, pl. 31; Maurer and Maurer 1980, fig. 64.3; Roche 1990, 391, no. 8, fig. 10. Unlike sea creatures, the leaves do not cover the face of this figure.

14. Cf. Butler 1916, 378, fig. 327.5. Another unpublished fragment can be seen still on the site.

15. See the introduction, above.

16. Sourdel 1952, 63–64, 83–84.

17. Dunand 1934, 20–21, no. 15, pl. 9; Dentzer 1979, 332; Dentzer and Dentzer-Feydy 1991, cat. 5.23, with references.

18. This is our modern imaginative understanding of the type. But compared with the various juvenile Helios types representing Baʿal Shamīn, especially the one from the Entrance to Theatron (Butler 1916, fig. 331G), there is no reason why this bust should not be a representation of Baʿal Shamīn.

19. The opposite situation is found in the metope with a bust of Helios from the Qasr al-Bint at Petra, possibly the Temple of Dūsharā. While names and types of representations are secondary compared with the rank and function of the gods, there is no difference between Baʿal Shamīn and Dūsharā on the level of function as the god of heaven. Names of Nabataean gods are largely interchangeable. This phenomenon is described by E. A. Knauf, in Lindner 1986, 78. Cf. also Merklein and Wenning 1997; and Wenning 2001.

140.

Keystone with Nike in High Relief

Hauranite, late Antonine/early Severan, late second–early third century A.D.
Provenance: Roman gate at Seeia[1]
Material: brownish basalt
Dimensions: h. 43 cm., w. 26 cm., w. at thighs 20.5 cm., d. 23.8 cm.
Princeton University Archaeological Expeditions to Syria, 1904–5 and 1909 (y1930–36)

CONDITION: *Only the body of the Nike from the face of a keystone remains. Broken off and missing are: the head (clean break through the neck, diam. 9.5 cm.); the right arm at the armpit, where a dowel hole (d. 2.5 cm.) shows that the arm was separately attached; the left arm at the elbow; the right leg at the knee; the lower left leg; and both wings. The legs may possibly have continued on the undersides of the keystone.[2] The break behind the right thigh is largely hollowed out, but there is no indication of an attachment. On the outside of the left thigh, a part toward the back is broken off. Of the right wing, only a shapeless stump remains behind the right shoulder. Only a little more of the left wing remains, a wedge-shaped fragment that retains its upward orientation. At the back of the figure a flattened piece (l. 16.5 cm., d. 5.5 cm.) continues down to the hollow of the left knee. The surface is porous, with larger pores in front of the left upper arm and in the folds on the right side. Otherwise, it is in good condition. The body is modeled even toward the back, but the sides are largely lacking in details.*

A Nike was shown on the face of a keystone and seemed to fly down to bring good news. Her wings were spread diagonally upward; the right arm was outstretched. The left arm was bent with the left hand coming forward. The objects once in her hands are lost. The left leg advanced, with the right leg trailing. Nike's chiton is molded against her body by the swift

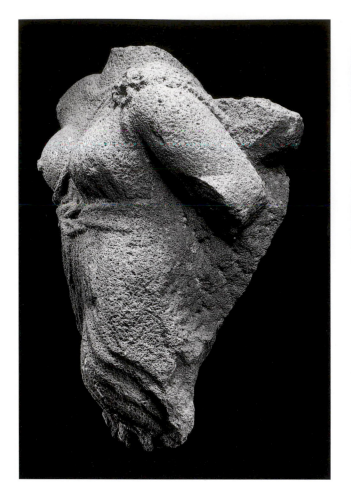

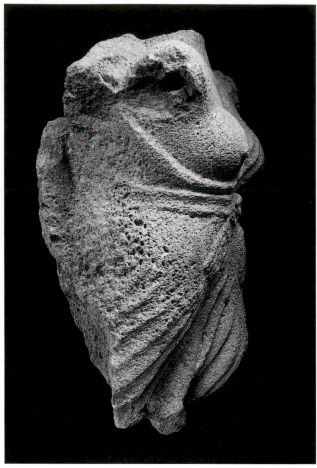

forward movement, leaving the arms and the right breast bare. The chiton is knotted just below her breast and fastened with a fibula on her left shoulder; there is no overfold and no mantle. The fibula forms a kind of a rosette with six attached spirals; six parallel folds descend from it to both sides. The high-cinched belt with its characteristic "Herakles" knot follows a Hellenistic fashion. The ends of the belt fall diagonally downward from the knot in unusually broad form, corresponding nicely to the folds of the chiton. The latter are limited to some deep pleats running mainly from the left shoulder down to the right knee. A single, straight fold separates the diverging folds on the thighs. The selvedge of the chiton frames the right breast in a strong curve from the fibula at the left shoulder, below the breast, then diagonally up to the back.

The protruding right breast is hemispherical, with a distinctly plastic nipple. The left breast under the chiton is hardly less emphasized, and this modeling complements the strong movement of the figure. The collarbones form an arched line clearly contrasting with the neck. The stomach is hidden under the ends of the belt and is not swollen, as in many other Nikai; instead more emphasis is placed on the thighs.

A Hellenistic prototype seems likely for the figure, but the subject goes back as least as far as the Nike of Paionios at Olympia.[3] The Nike type was very common in the Hauran.[4] This Nike adorned the keystone of the eastern face of the middle arch of the so-called Roman gate at Seeia.[5] It is difficult to establish the chronology of the gate using stylistic comparisons because the decorations were published only by Butler and shown either in sketchy drawings or in small dark photographs. The reeded quarter-columns, the pilaster reliefs with an oval-shaped acanthus rinceau, and the other panels with an interlacing grapevine pattern, where the tendrils frame two elements like a grape and a leaf, are very close in their conception to those from the western temple at

330

Atīl, which dates to A.D. 151. Butler, however, pointed to other aspects more typical of the end of the second century A.D. and compared the Tychaion at aṣ-Ṣanamaïn, dated to A.D. 191.[6] All in all, a date in the late Antonine/early Severan period best fits the evidence. RW

BIBLIOGRAPHY
Butler, *PAAES* 1903, 417 with 2 figs.
Butler 1916, 397.

NOTES
1. Found without inventory number by curator Frances Jones, who assigned it the unused accession number y1930–36 so that it would be close to the pieces y1930–440 through y1930–456, a group to which it obviously belongs.
2. Cf. the keystone from Dāmet el-ʿAlyā: Butler 1919, fig. 378. Cf. also the keystone(?) with Nike at Bostra: Diebner 1982, 57 no. 5, figs. 6–7; the keystone with Nike from ʿIrā: Dentzer and Dentzer-Feydy 1991, cat. 8.31; and a pilaster with Nike from Seeia: Dentzer and Dentzer-Feydy 1991, cat. 8.17.
3. Fuchs 1969, 201–4 fig. 218.
4. Abel 1956, 3–4; Diebner 1982, 53–59 nos. 2–13, with further references; Bolelli 1986, 323, 341–42; Bolleli, in Dentzer and Dentzer-Feydy 1991, 78–79. Bolelli estimates that various types of Nikai account for about 20 percent of all sculptural subjects in the Hauran.
5. Cf. Butler, in *PAAES* 1903, 361–65, fig. 127; Butler 1916, 395–98, fig. 342; Dentzer 1985, 69; Dentzer-Feydy, in Dentzer 1986, 297; P. W. Haider, in Haider, Hutter, and Kreuzer 1996, 183 (dated ca. A.D. 200). For the Ionian capital cf. Dentzer-Feydy 1990, 143–81. Inscription no. 431 from a jamb reads: "By provision of Iulios Heraklitos to Zeus were built these gates and the wall about them." Inscription no. 432 from the architrave seems to refer to the same donor and donation but is preserved only in fragmentary form. See Prentice 1908, 329–30, nos. 431–32. The Iulius Heraclitus listed by G. W. Bowersock (1983, 163) among the equestrian *praesides* of Arabia from the third quarter of the third century A.D. is possibly a different individual.
6. Cf. Freyberger 1989, 87–103; Freyberger 1998, 47.

141.

THREE ACORNS FROM A GARLAND RELIEF(?)

Hauranite, Augustan period, 31 B.C.–A.D. 14
Provenance: Syria, probably Hauran (Seeia?)
Material: basalt
Dimensions: h. 13.6 cm., w. 18.4 cm., d. 11.6 cm.
Princeton University Archaeological Expeditions to Syria,
1904–5 and 1909 (y1930-446)

CONDITION: *Broken elliptically across the top; the break in back is essentially flat except for a broad concavity at the top. The tip of the acorn on the right is damaged.*

Three acorns are shown hanging in a bundle, the hulls enclosing two-thirds of the seeds and nicely decorated like quilted rhombuses. Above them are parts of two semicircular twigs, the left one with an inner twig or disk. The base is flat, and the fragment may well have belonged to the corner of an architectural decoration.

Acorns are not common in Hauranite ornament, where the vine is dominant. The oak is the holy tree of Zeus and might be that of Baʿal Shamīn as well. Acorns are mainly used to feed pigs, but in Arabia, especially, oil was extracted from acorns;[1] it therefore

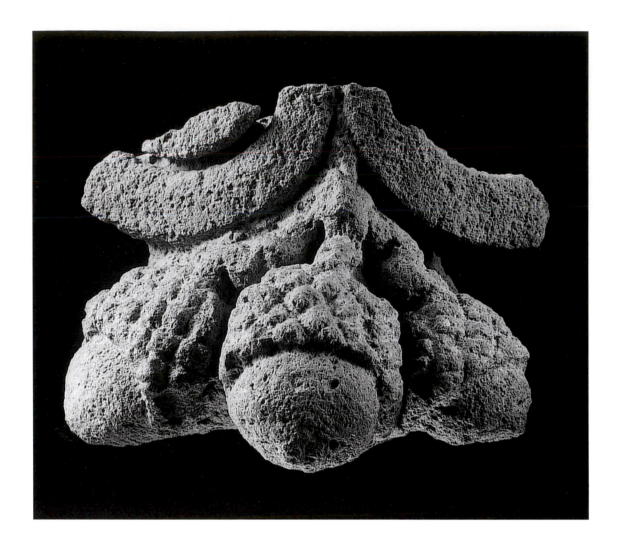

is possible that acorns were a symbol of fertility owed to Baʿal Shamīn, or to other gods. Indeed, acorns are found in combination with other fruits in sculpted garlands, like that in a frieze with erotes at Petra,[2] and in a frieze at the temple at Slīm in the Hauran,[3] both dating to the late first century B.C. At the temple at Slīm, which seems to be dedicated to Baʿal Shamīn, three acorns are shown grouped together. These Syrian acorns from the Augustan period were perhaps influenced by decorations from the Roman West. While the Petra frieze is close to Augustan prototypes, the frieze at Slīm is executed in a regional style.

It is not clear that the fragment with three acorns was part of such a garland, but probably it is from that period and from the Hauran. To my knowledge, there have been no decorations with acorns found at Seeia, but much material from that site remains unpublished. Considering the style and the provenances of the other sculptures given by the Princeton expedition to The Art Museum and the possibility that acorns could refer to Baʿal Shamīn, it cannot excluded that this small fragment also was found in the god's sanctuary at Seeia. RW

BIBLIOGRAPHY
Unpublished.

NOTES
1. Cf. *RE* 5.2:2064–73.
2. Schmidt-Colinet 1980, 190, fig. 2 (compared with the Ara Pacis); R. Fellmann Brogli and R. A. Stucky, in Stucky, Fellmann Brogli and Schmid 1993, 29, figs. 47–49.
3. Freyberger 1991, 22–24, 38, pl. 9c, 10b. He interprets the acorns and oak leaves as signs of sacral dignity and piety.

142.

HANDS OF A BUST FROM A FIGURED CAPITAL

Hauranite, first half of the first century A.D.
Provenance: unknown, probably Syria/Hauran
Material: basalt
Dimensions: h. 10.5 cm., w. 15 cm., d. 6.3 cm.
Princeton University Archaeological Expeditions to Syria,
1904–5 and 1909 (2000-147)

CONDITION: *Parts of right and left hands holding a leaf.*
The right hand is broken off at the back of the hand; the thumb
is lost. A break runs diagonally through the fingers of that hand.
Of the left hand, only the tip of the index finger remains. The
surface is pockmarked and has brown incrustation, as is often
the case with basalt sculptures from the Hauran.

A figure is grasping with both hands the upper mid-
dle acanthus leaf of a Corinthian capital. The type is
well known in Hauranite figured capitals from col-
umns and pilasters.[1] In these, a young figure of ideal
type is represented in bust form, naked or dressed,
sometimes with smiling features.[2] As he grasps the
leaf, his thumbs are horizontally splayed out, the
index fingers outstretched, and the other fingers bent.
The way the figure rises from the acanthus leaves sym-
bolizes the blessing of the temple deity but is not a
representation of the deity itself.

Among the figured capitals, a group of three
seem closest to the Princeton fragment,[3] especially
if one compares the fingers and the relatively large
leaf. Considering the findspot of one of these capi-
tals, it can be assumed that all three come from a
temple at Qanawāt, where other Hauranite sculp-
tures have been found.[4] These capitals are dated to
the first half of the first century A.D. by comparison
with figured capitals from the so-called Temple of
Dūsharā at Seeia. It is unknown if the Princeton
fragment derives from a figured capital from Seeia
or Qanawāt, but it should be noted that the index
fingers seem to rest higher upon the leaf than in
all other known examples. RW

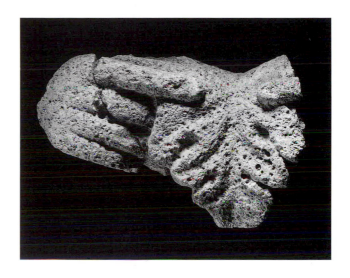

BIBLIOGRAPHY
Unpublished.

NOTES
1. Mercklin 1962, 23–26, nos. 70–80, figs. 94–107.
2. Bolelli 1986, pl. XVIIa (pilaster capital from the Baʿal
 Shamīn at Seeia, now British Mus. WA 125 696).
3. Suweida Mus. 409 from Qanawāt (Mercklin 1962,
 fig. 99; Negev 1976, fig. 79); ʿIrā, house of the Sheikh,
 without clear provenance (J. Dentzer-Feydy, in
 Dentzer 1986, pl. IXd); Suweida Mus. 295 (Dentzer
 and Dentzer-Feydy 1991, 117, pl. I; from Seeia?).
4. Cf. Bolelli 1986, 348–53 (those from the "Nabataean"
 building).

143.

RIGHT ARM OF A STATUE

Hauranite, first century B.C.—first centuy A.D.
Provenance: Syria, probably Hauran (Seeia?)
Material: basalt
Dimensions: l. 16.9 cm., w. of arm 5.6 cm., w. of hand 5.0 cm.
Princeton University Archaeological Expeditions to Syria,
1904–5 and 1909 (y1930-445)

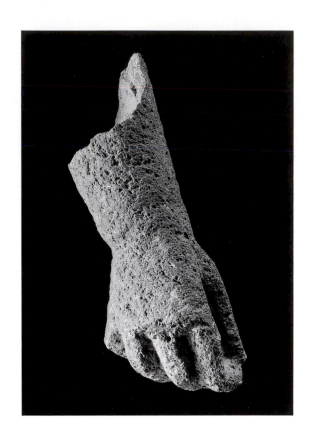

CONDITION: *Broken off below the elbow. The bottom of the arm is flat, with almost a right angle at the juncture with its inner plane. The break is deeply concave. There is a break at the end of the fingertips.*

Fragment of forearm with right hand. The hand is empty but once rested upon something as indicated by the break in the fingertips. This fragment probably belongs to the same group as cat. nos. 134–140, but it is not mentioned in the expedition records.

<div align="right">RW</div>

BIBLIOGRAPHY
Unpublished.

144.

RECLINING LION IN HIGH RELIEF

Hauranite, first century B.C.—first century A.D.
Provenance: Syria, probably the Hauran
Material: brownish basalt
Dimensions: h. 21 cm., w. 39.5 cm., d. 17.5 cm.
Princeton University Archaeological Expeditions to Syria,
1904–5 and 1909 (y1930-452)

CONDITION: *From a relief of a large animal, preserving the lower body and the folded legs. Broken off at the bottom, the break irregular but more or less level. Broken also close behind the tail and diagonally from the shoulder to the left foreleg. Head missing, tip of right paw broken off; body and paws chipped. The surface of the basalt is somewhat porous. There is a notch cut between the rump and tail. The ground between the legs is roughly chiseled. Behind the left hind leg is the stump of an unidentifiable extension.*

The animal reclining and facing right is probably a lion, as indicated by the shape of the body and (inordinately) long paws. Above the forelegs some shaggy hair remains at the breast. The paws rest on the sloping ground as the body leans backward slightly. All four bent legs are visible in the front, but the left legs are only summarily sketched. Both of the right legs are vigorously sculpted, with sharp contours,[1] a noticeable contrast with the rounded

body. The tail is brought under the body between the hind legs and then wound around the right hind leg. On the strong cylindrical body, five carved ridges indicate the rib cage.[2]

Lions are common in Hauranite art, both crouching and reclining.[3] Following old traditions, they are either the guardians of the sanctuaries or the constant companions of particular goddesses, especially Allat.[4] The worked details of this lion's legs are visible only when seen a little from above, which excludes the possibility that the figure functioned as an acroterion; rather, it could have stood as a guardian at the base of a wall near an entrance. The lion cannot be attributed to one of the sanctuary façades at Seeia or the other major Hauranite sites, and it more probably belongs among the many votives set up in those sanctuaries. RW

BIBLIOGRAPHY
Unpublished.

NOTES

1. Cf. the lions in Dunand 1934, nos. 123, 124, pl. 27.
2. Cf. the lion in Dunand 1934, no. 126, pl. 30. The cylindrical body is typical in Hauranite sculpture and can be found even for horses (cf. Bolelli 1986, pl. XVI, no. 75).
3. Cf. Bolelli 1986, 320, 327, 339, 344, 352, nos. 63–69, pls. XIV–XV. There are some others not listed by Bolelli, and, in addition, various reliefs with lions. At Seeia, lion protomes are shown at the base of the upper storey of the Temple of Baʿal Shamīn (Butler 1916, 378, fig. 325. 326.8; Butler, *RBibl* 1905, pl. opposite page 96, no. 3; Bolelli 1986, 325, no. 5, pl. XVIIIe). Cf. *LIMC* 1:564–70, pls. 424–25, 430, s.v. Allath (J. Starcky).

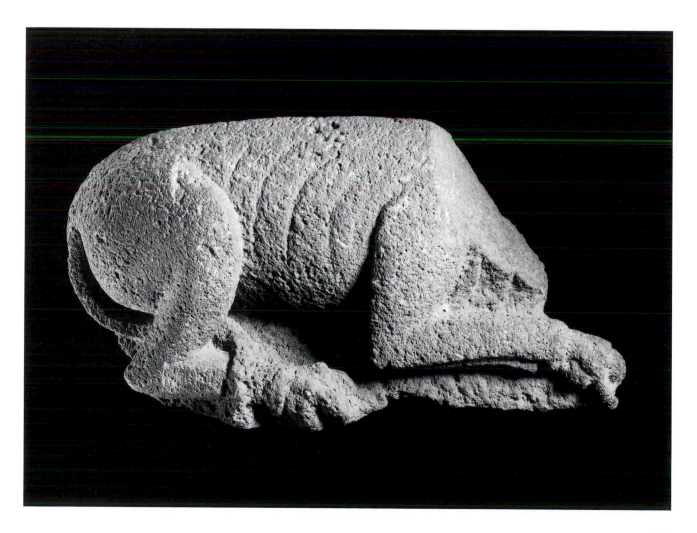

145.

HEAD OF A YOUNG MAN

Hauranite, first century A.D.
Provenance: Syria, probably the Hauran
Material: dark brownish basalt
Dimensions: h. 21 cm., w. 15 cm., d. 19.6 cm.
Princeton University Archaeological Expeditions to Syria,
1904–5 and 1909 (y1930-454)

CONDITION: *Cleanly broken off at the neck, from which extends a modern iron dowel. Large chip in the chin; ridge of the nose and some leaves of the wreath broken off. At the back of the head is a broken support. The surface is porous, with noticeably larger holes extending from the corner of the left eye to the cheek. Otherwise well preserved.*

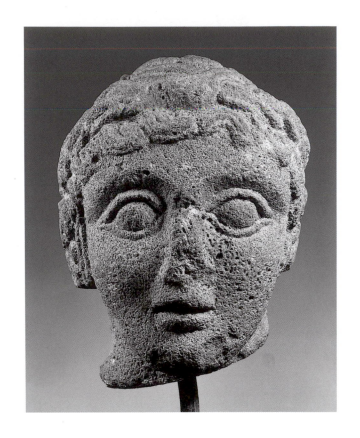

A head of a young man is crowned with a laurel wreath. There are some asymmetrical features, particularly the hair. The head is slightly tilted; a three-quarter view is preferable. The face is softly but vividly modeled, dominated by the eyes and mouth. The eyes are large and framed by thick lids, the outer ends of which extend a bit too much. The pupils are not represented. Sensual lips frame the

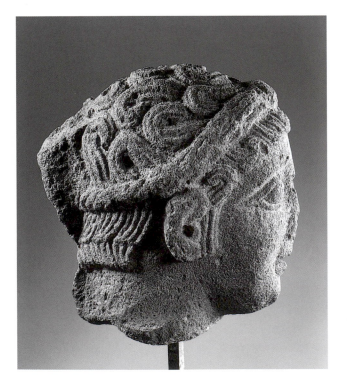

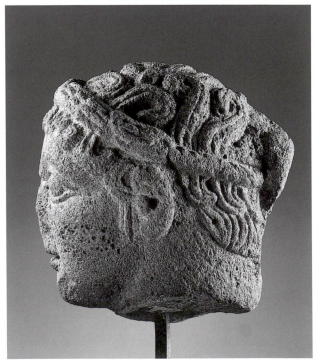

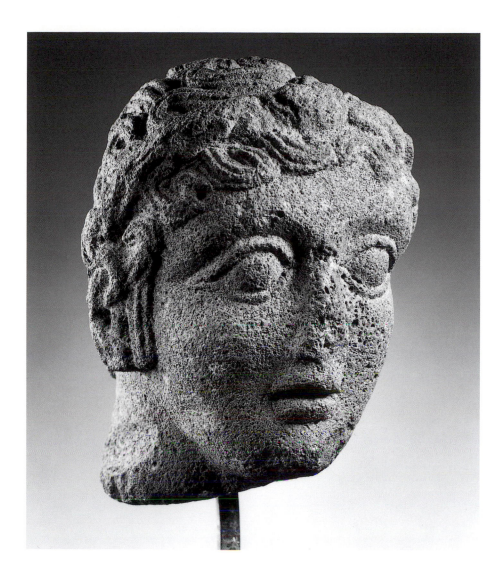

open mouth. The chin is pointed, the ears carefully sculpted. The hair, a mixture of large doughy curls and incised strands, is fully sculpted in the back. Thin strands hang in front of the ears. The laurel wreath consists of two parallel rows of overlapping leaves and seems to have a medallion at the center.[1] Behind the ears the wreath continues as a twisted cord, pressing down the hair; at the back a strand overlaps the knot. Below the cord, the hair at the neck is carved in two opposed rows of crescents.

The head may have belonged to a portrait statue. Its somewhat pathetic features give it an idealized air that derives from the Hellenistic tradition. The shape of the eyes, in particular, suggests Hauranite art of the first century A.D. K. Parlasca compared a head from the art market in New York which is close in conception but different in other respects.[2] Nevertheless, this head and others from Syria discussed by Parlasca in various articles support this dating.

RW

BIBLIOGRAPHY
Parlasca 1967, 557–59, fig. 9.

NOTES
1. For crowned heads with an emblem marking them as priests, see Parlasca 1988, 221.
2. Parlasca 1967, 544, 549–50, 556–60, figs. 2–3.

146.

KEYSTONE WITH BUST OF TYCHE IN HIGH RELIEF

Hauranite, early second century A.D.
Provenance: Syria, probably the Hauran
Material: light brownish basalt, darker in the breaks
Dimensions: lateral h. of keystone 30 cm., h. in the middle
34.6 cm., w. at bottom 33 cm., w. at top 40 cm.,
d. of keystone 7 cm., d. with bust 31 cm.
Princeton University Archaeological Expeditions to Syria,
1904–5 and 1909 (y1930-456)

CONDITION: *The figure is well preserved, with only slight damage to the nose and chin and a short gash in the right shoulder. Large parts of the polos are broken off. Two dowel holes at the back and one at the right side apparently stem from an earlier modern installation; small chips at the edges also may have resulted from such an installation. Dark traces of burning(?) are visible on the fruits of the cornucopia and the cornice above. There are no traces of plaster, as was suggested by F. F. Jones.*

A trapezoidal keystone with cornice is sculpted with the bust of Tyche, who cradles a cornucopia in her left hand and arm. Her projecting head leans back against the middle of the cornice, so that she seems to thrust toward the visitor below the promise of all the goods within her horn. The relief ground is carefully smoothed. Between the head of Tyche and the fruits of the cornucopia the ground is not as much deepened as in the other parts. The flattened bottom of the keystone is slightly curved (difference of 5 cm. from the middle to the sides), while the lateral cuts are straight. To create a curved line at the top of the cornice, the edges of the horizontal band have been

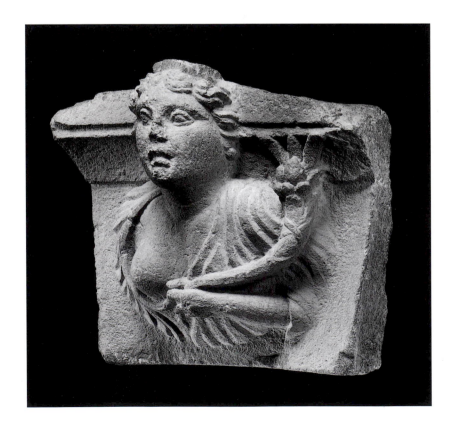

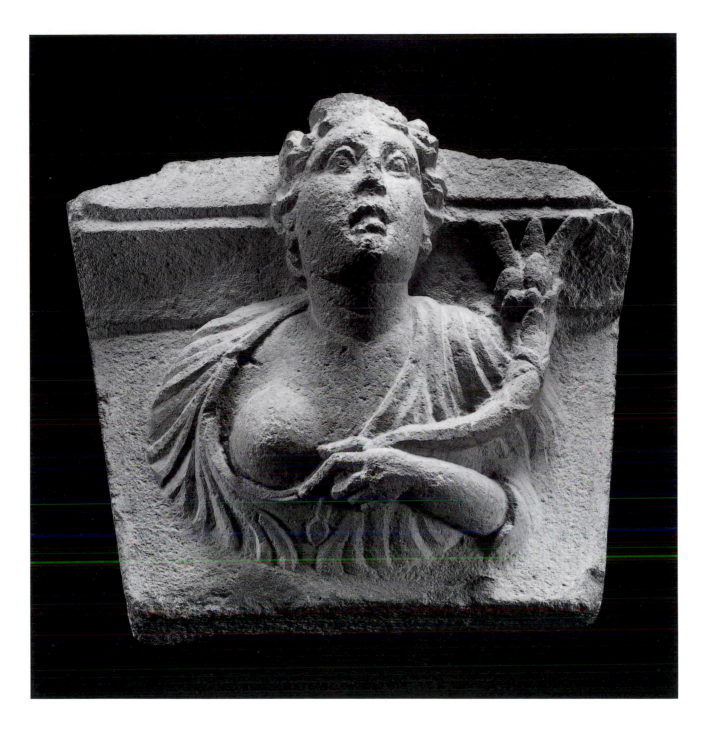

roughly cut. The slab was made lighter by hollowing the stone at the back. The profile of the cornice slab consists of a cavetto with a horizontal band at the top, created by cutting a notch into the ground of the relief below and leaving a narrow fascia above it. The bust is outlined like an oval. To get this form, the left elbow needed to disappear into the ground of the relief and the right arm was not depicted. The chiton covers both shoulders with thick folds but leaves the right breast nude, framed by the diagonal oval of the selvedge. The nipple on the hemispherical breast is only faintly indicated.

The crisp carving of the folds contrasts nicely with the soft modeling of the face. The small eyes with undrilled pupils, the full face, the opened mouth, and the small pointed chin contribute much to this impression, as does the slight turning of the head itself. The Venus rings in her neck were considered a sign of beauty. Tyche's wavy hair, parted in the center with plaits and large curls at the sides, is crowned by

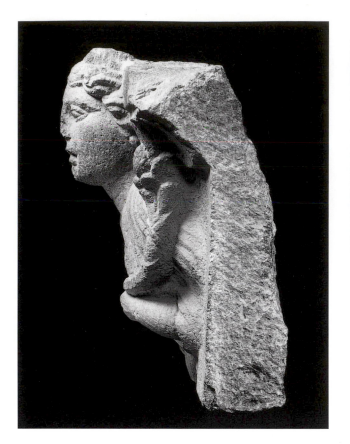

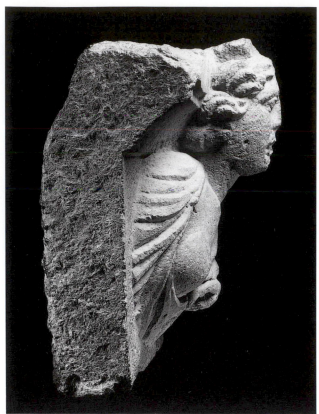

a small *polos* (not recognizable as a mural crown, which one would expect).

Collarbone and breastbone are indicated by subtle profiles and a notch. This is a typical feature among Hauranite sculptures. The nude left forearm is placed horizontally in front of the body with the hand below the middle of the breast. The lower end of the horn is between the index and the middle finger, and below it is the lower end of a ribbon with a knob or a leaf. The base of the cornucopia is roughly carved with a small flat face while the upper part is adorned with the crossed ends of the ribbon. Inside the mouth, three leaves support the fruits, which are represented as three small balls and three larger ones (the latter may be pinecones). At the top, three large fleshy leaves that look like a lotus flower lean against the cavetto.

The Semitic world has a long tradition of belief in a personal tutelary god or goddess of fate and in a god or goddess of fate, like Gad. The Hellenistic Tyche met all conditions for such a deity and became especially popular in the Roman East.[1] Although it has not been possible to connect this keystone with a particular site, it fits very well with the realm of Hauranite art. The shape of the bust and comparisons with a votive relief at Beirut,[2] dated to A.D. 108, allow us to suggest a date in the Trajanic period for the keystone. RW

BIBLIOGRAPHY
Jones 1960, 66–67 (illus.).
Matheson 1994, 113 no. 37 (illus.).

NOTES
1. For Tyche in the Hauran, see Sourdel 1952, 49–52. For the Tyche of Palmyra, see Parlasca 1984b, 167–76.
2. Seyrig 1965, 32–33, fig. 4; Seyrig 1966, 148, fig. 4. Cf. also the busts from an altar from Seeia, Suweida Mus. 29: Dunand 1934, no. 29, pl. 10, esp. pl. 10c; the Nike from Derʿā at Istanbul, Mus. Arch. 2408 (K 1399): Parlasca 1989, 542, fig. 199b; and a small head of Nike in Paris, Louvre AO 26598: F. Baratte, in Homès-Fredericq 1980, 105, no. 79.

147.
HEAD OF A GODDESS

Hauranite, first half of the second century A.D.
Provenance: Syria, probably the Hauran
Material: dark basalt
Dimensions: h. 27.3 cm., w. 18.4 cm., d. 19.3 cm.
Princeton University Archaeological Expeditions to Syria,
1904–5 and 1909 (y1930-453)

CONDITION: *Clean diagonal break at the neck, from which extends a modern iron dowel. Three large dowel holes at the neck below the wreath could be modern. Surface partly worn. Damage to her right eye, left cheek close to the nose, ridge of the nose, part of the hair at the neck, center of the wreath.*

The head of a crowned goddess is turned slightly to her right. The head is broken off from a statue. The conventional features are typical for Roman-period idealized sculpture. The full face has a strongly modeled nose and sharply cut mouth. The forehead, cheeks, and chin are firmly modeled but not over-emphasized. The eyes seem to be relatively large because the great arch of the brows exaggerates their apparent size. Hanging semicircles overlapped by the upper lid indicate the pupils; it is not clear whether or not the center of the pupil was drilled. The corners of the mouth are drilled, pulling them down

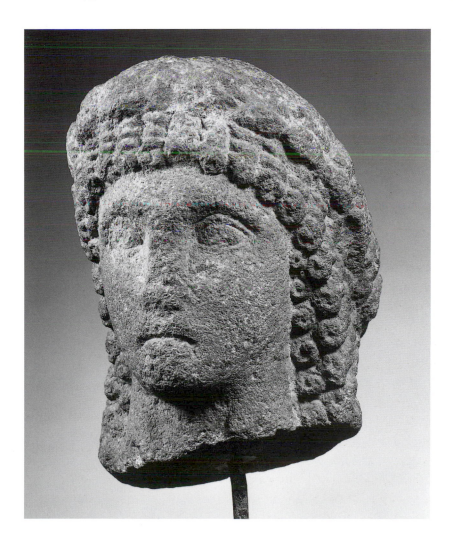

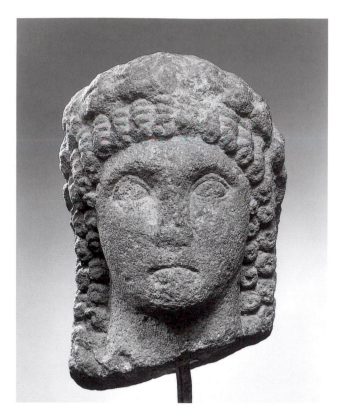

and giving the face a sad expression. The upper lip is slightly indicated.

The somewhat bulky face corresponds with the hairdo, with its thick frame of triple twisted curls around the forehead and down onto the shoulders. The tips of the curls are spiral-shaped and look like jewelry (rosettes), especially where two rows hang side by side. The hair is crowned with a laurel wreath of three parallel leaves; at the back the wreath is tied with overlapping double fillets and wrapped in a cloth(?). Below this wrapping are spiral curls like those at the sides. The roundish back of the head within the circle of the wreath is not incised with curls.

The hairstyle, the so-called *Buckellockenfrisur*, was common in the Neronian-Flavian period but continued longer in the East than in the West.[1] Among later Hauranite sculptures examples are found at Bostra[2] and in the Suweida Museum.[3] The best parallel is a crowned head of a goddess from Goutta, near Damascus, also in basalt.[4] The Princeton head is closer to Roman prototypes and can be dated to the first half of the second century A.D.
RW

BIBLIOGRAPHY
Unpublished.

NOTES
1. Parlasca 1967, 564.
2. Diebner 1982, 61, 64–65, nos. 26, 37, figs. 28–29 (head of a bearded god) and 46 (tomb stele of Tobaia). Cf. earlier examples of *Buckellocken*—in a different style—on bearded heads from Seeia and Qanawāt: see Bolelli, in Dentzer 1986, nos. 16, 25, 27–28, 30–33, 36, 39, and pl. xviia.
3. Dunand 1934, no. 104, pl. 26 (as female head); Dentzer and Dentzer-Feydy 1991, cat. 8.13 (as Nike?) and cat. 8.01, pl. 13 (bust of a god from a lintel). The latter's hairstyle is close to various representations of Palmyrene gods.
4. Damascus, Nat. Mus. 1944 (4199): Abdul-Hak 1951, 74, no. 2, pl. 38.2a [reversed]; K. Parlasca 1982, 214, no. 197.

148.
HEAD OF A WOMAN

Hauranite, first half of the second century A.D.
Provenance: Syria, probably the Hauran
Material: dark brownish basalt
Dimensions: h. 26.8 cm., w. 17 cm., d. 17.8 cm.
Princeton University Archaeological Expeditions to Syria, 1904–5 and 1909 (y1930-450)

CONDITION: *Broken at the neck, from which extends a modern iron dowel. A large triangular piece is missing from the left side of the neck. Damage to the chin and left eye. The upper lip and ridge of the nose are broken off, and also the middle part of the crown. Various small chips and scratches. The hair in back is worn. The surface is porous, with some larger pores and fine cracks.*

The head of a young woman turns a bit to her left and looks upward. The head possibly belonged to a portrait statue, for the modeling is lively. The forehead is low and sloping. The deep-set eyes have heavy upper lids and relatively flat eyeballs, the pupils indicated by engraved, hanging semicircles. The right eye is a little smaller than the left one. The nose seems to be strongly modeled, but the break makes it look excessively broad. The mouth is parted slightly. The oval-shape of the head, the small rounded chin, and the unusually long slender neck contribute to the effect of a thin face. The ears are covered by hair.

The curly hair is combed back without a central part and arranged in large flamelike curls that frame the face. Behind these are traces of a chaplet of plaited

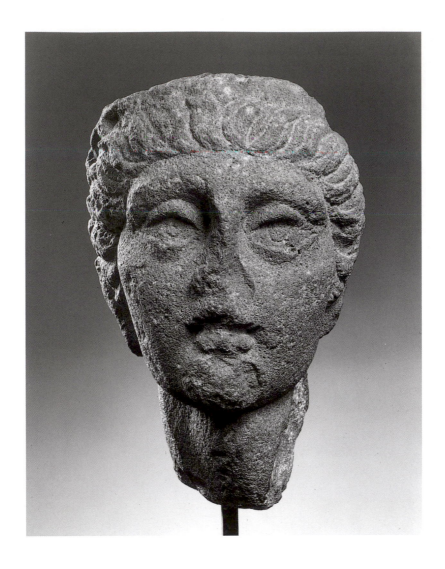

hair rather than a fillet, or possibly a wreath of leaves. Inside the circle described by this chaplet the hair is sketched only. The hair falls in twisted curls at the sides and down the long neck, where it is collected in a small knot.

The hairstyle with a wavy fringe has a long history from the Classical period onward. It can be found on some other heads from the Hauran,[1] but more often the hair on these has a part.[2] These examples alone would allow us to identify the Princeton head as a Hauranite sculpture, but other regional centers in Syria might be possible as well. The comparisons set the head in the Trajanic-Hadrianic period.[3]

RW

BIBLIOGRAPHY
Unpublished.

NOTES
1. Cf. a head in Paris, Louvre AO 3747: F. Baratte, in Homès-Fredericq 1980, no. 78; and a tomb relief at Damascus, Nat. Mus. 7622: Parlasca 1981, 19, pl. 21,1. For other Syrian regions, see Parlasca 1981, 13, pl. 13,3; Skupińska-Løvset 1999, 90, pl. II.
2. Cf. a head from Suweida: Dunand 1934, 117, no. 117, pl. 26; and the head Suweida Mus. 252: Dentzer and Dentzer-Feydy 1991, cat. no. 8.24, pl. 18.
3. Cf. a male head in London, British Museum WAA 125 697: Skupińska-Løvset 1983, 242, pl. 112. The hairstyle can be found with some variations from Livia to Crispina. While a date in the middle of the second century A.D. still seems possible, the way the pupils are engraved argues against a late Antonine date.

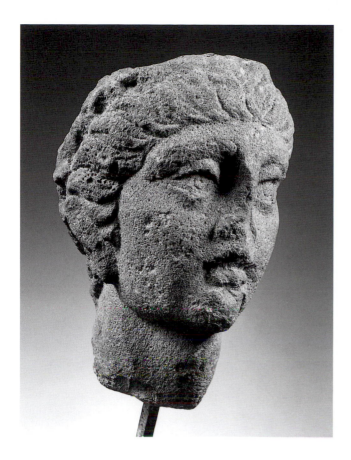

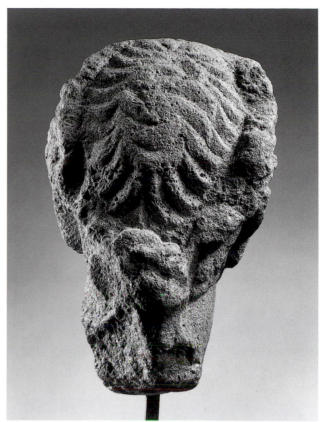

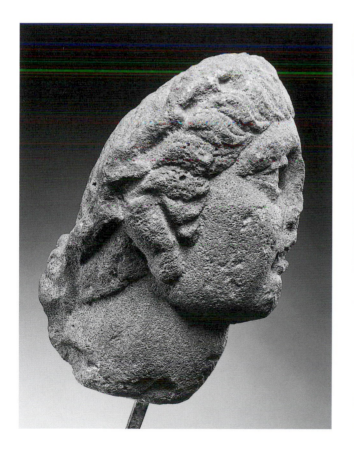

149.

HEAD OF A MAN

Hauranite(?), ca. A.D. 150
Provenance: Syria, probably the Hauran
Material: brownish basalt
Dimensions: h. 25.6 cm., w. 19.7 cm., d. 19.1 cm.
Princeton University Archaeological Expeditions to Syria,
1904–5 and 1909 (y1930-451)

CONDITION: *An irregular break runs through the neck under the chin; a modern iron dowel is in the neck. There is damage to chin, lips, nose, right cheek, left eye and brow, and hair. The surface is porous, with some large pores (inner corner of right eye, right temple, hair on the left side).*

The beardless head of a man[1] is turned to his left and slightly upward; a three-quarter view must have been preferred. The head obviously belonged to a portrait statue. The sloping forehead is covered by pendant locks, which fall almost to the brows. The face is oval with vivid modeling and prominent brows. The eyes are not enlarged; the pupils are engraved as hanging three-quarter circles (overlapped by the upper lid), with central drill holes. The mouth has deep corners and a small lower lip.

The curly, asymmetrical hair is arranged in a thick fringe around the head and held back by a fillet. At least five large locks fall on the middle of the forehead. Deeply drilled parts and pronounced undercuts contribute to the effect of volume and movement. The hairdo makes up one-third of the height of the head. At the sides, below the fringe, are three voluminous spiral curls, and smaller curls in front of the ears, which are covered by hair. Below the ears, on the cheeks, are two small spiral curls. On the back of the head, within the circle of the spiral curls, are three concentric rows of thick, sickle-shaped curls. Continuing down in back, below the broad fillet and its knot are a few twisted curls. Because of the break, it remains unclear if the hair on the nape was in a knot.

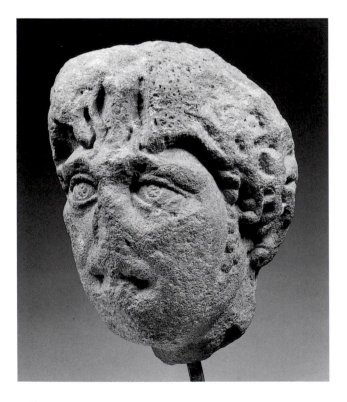

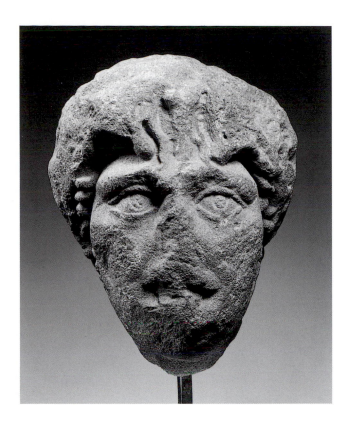

The hairstyle and the way in which the pupils are engraved and drilled point to a date in the Late Hadrianic to Antonine period.[2] There are no known parallels among Hauranite sculptures nor any from other Syrian basalt regions.[3] The quality of the head goes beyond that of most of the sculptures in these areas.

RW

BIBLIOGRAPHY
Unpublished.

NOTES
1. Understood in the inventory book as a head of a woman. This cannot be excluded, but the hairstyle, especially the locks at the forehead, favor a man.
2. Parlasca 1981, pl. 8.2. Cf. also a head of a priest in St. Petersburg: Vostchinina 1974, 159–60, no. 32, pls. 50–57; Parlasca 1985, 344.
3. If the head listed as cat. no. 148 really can be attributed to the Hauran, the same provenance should be considered for this head because the material is very similar.

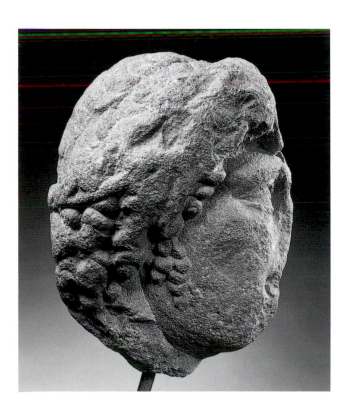

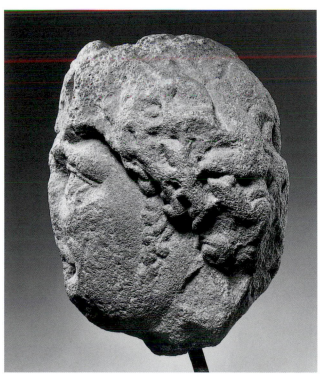

PALMYRENE SCULPTURE

150.

FUNERARY BUST OF A
BANQUETING YOUTH

First half of the second century A.D.
Provenance: Palmyra
Material: grayish local limestone
Dimensions: h. 53.3 cm., w. 37.3 cm., d. 18.5 cm.
Gift of Elias S. David (y1962-92)

CONDITION: *Nearly complete; the rounded cut at the lower left was probably intentional. The head was broken and has been reset with plaster, perhaps incorrectly.*

The figure is detached on the sides and stands on a flat lower surface, which is much deeper to the right, nearly triangular. The sculpture represents the upper body of a man reclining on a dinner couch, his left elbow resting on a pillow of which only the upper part is shown. The right arm was probably never represented. The man wears a tunic with sleeves and a himation draped around his left arm and shoulder. His right hand holds a kantharos, a large drinking vessel on a godrooned foot, rather clumsily rendered in this case; it should have two handles, but the one on the left, which is free and visible, is only a low

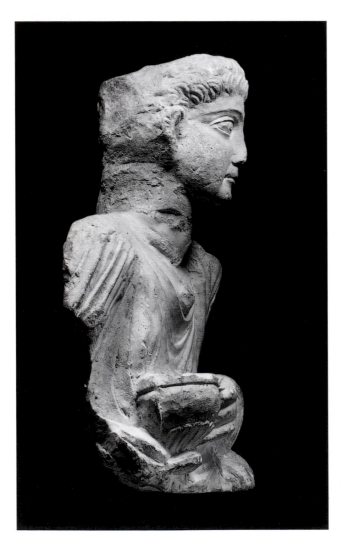 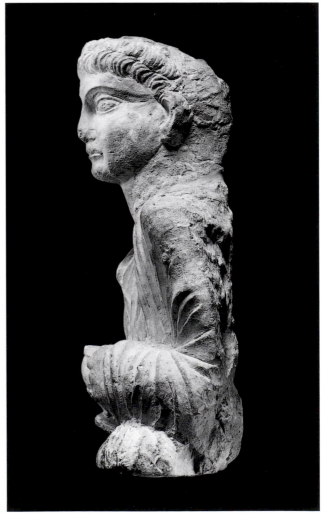

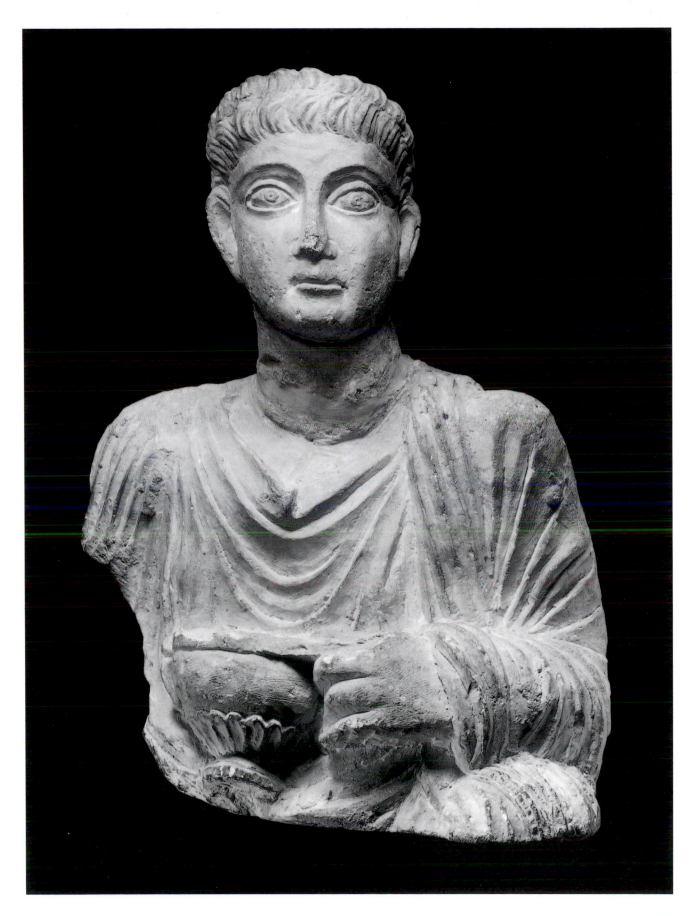

ledge with no hold for fingers. The young man is clean-shaven, his hair arranged in rows of short, wavy tufts. The nose is straight and marked with sharp vertical ridges that extend upward and arch to the sides to form eyebrows. The eyes are almond-shaped, the eyeballs indicated with two concentric circles. The ear lobes are sketchy and flat.

This sculpture is an example of the "economy version" of huge slabs representing one or more banqueters surrounded by family. Such slabs were set on the outer edge of sarcophagi whose front imitated a dinner couch complete with mattresses and pillows. In this case, the bust would have rested on a sarcophagus, toward its right corner, and would have been accompanied on the left by another, similar sculpture whose outline is mirrored by the rounded cut where the right arm of this figure should have been.

The banquet motif is frequent in the funerary art of Palmyra. Only men recline and drink from hand-held cups, while women sitting on chairs accompany them and children stand behind. It is not clear whether the scene epitomized the promise of the afterlife or looked back to the happy family life left behind.

MG

BIBLIOGRAPHY
Unpublished.

151.

FUNERARY SLAB WITH MALE BUST IN HIGH RELIEF

First half of the second century A.D.
Provenance: Palmyra
Material: soft yellow local limestone
Dimensions: h. 43.5 cm., w. 33.0 cm., d. 19.6 cm.
Unrecorded acquisition (y205)

CONDITION: *Both right corners are missing; numerous chips, including the tip of the nose. The man's right shoulder and elbow were never sculpted, the arm being cut even with the edge of the slab.*

The bust depicts a clean-shaven man wearing a tunic and a himation. The left hand holds an olive branch. The folds of both garments are flattened, rendered practically in the same way as the fingers and the nose ridge; the ear lobes are not detached behind. The hair is rendered as two horizontal bands of short striations. The eyes, marked with two concentric circles, are set deep under protruding brows, which join the sharp vertical edges of the nose.

Traces of ancient plaster on the right edge and above the head on right and left testify to the way of fixing the sculpture in the tomb slot after the funeral, rather negligently in this case. The inscription over the man's left shoulder is a nineteenth-century illiterate fake, intended to enhance the commercial value of the piece.

MG

BIBLIOGRAPHY
G. E. Post, *Palestine Exploration Fund Quarterly Statement,* 1891, 37.
Ingholt 1928, 103, n. 1.

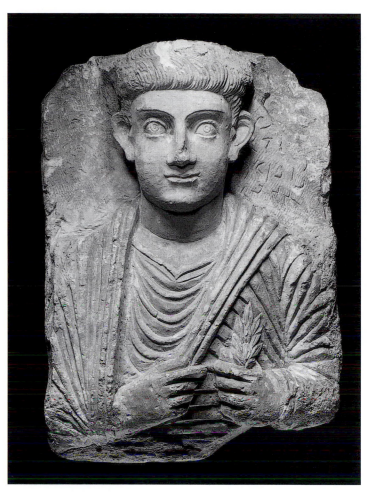

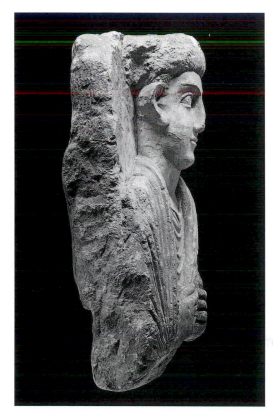

152.

HEAD OF A WOMAN

Early second century A.D.
Provenance: Palmyra
Material: hard white local limestone
Dimensions: h. 24.0 cm., w. 19.5 cm., d. 17.8 cm.
Unrecorded acquisition, before 1922[1] (y1930-455)

CONDITION: *Broken at neck; much-weathered surface, exposing nummular voids inside the stone. Many chips, including the tip of the nose and the left temple with a part of the eye gone.*

The head was protruding above a funerary slab on which the torso had been represented in high relief. The face is almost square, with prominent cheekbones, a slightly pouting mouth, and a fleshy nose. The large eyes are marked with two concentric circles, sheltered under sharp, ridged eyebrows. The woman wore on her hair the usual attire consisting of a frontal band marked with vertical lines, a turban made of tightly twisted cloth rolled around the head, and a veil at the back. The hair appears only as two locks on each temple, partly covering the ears and brought to the back under the veil. The tips of the

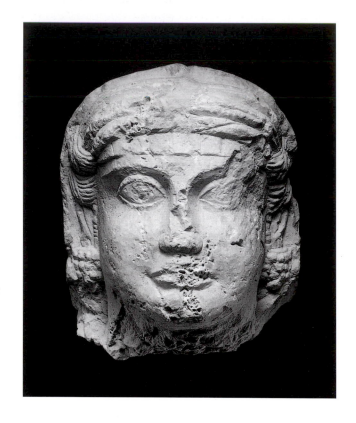

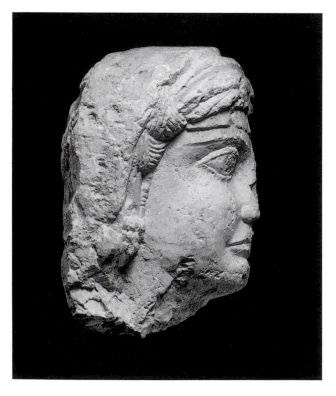

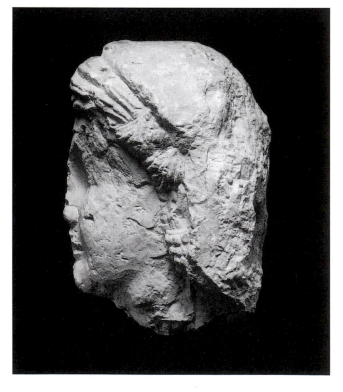

ears are adorned with earrings taking the form of grapes, and strings of beads are hanging in front of each ear, possibly attached to the grapelike pendants.

Full-length representations show that in real life the veil reached to the ankles and was used to cover the whole figure when the woman appeared in public. In funerary portraiture, however, the face is always exposed. The grape earrings are typical of jewelry produced in the first half of the second century. As a recently found specimen has demonstrated,[2] they were made of pearls fixed on a silver core. Palmyra was en-gaged in active commercial relations with the Gulf region, the main source of pearls in antiquity. The wearing of beads in front of the ears is a rare feature; the "beads" might even be pearls. MG

BIBLIOGRAPHY
Unpublished.

NOTES
1. See p. 313, n. 1.
2. Witecka 1994, 73–74.

153.

HEAD OF A PRIEST

Mid-second century A.D.
Provenance: Palmyra
Material: hard white local limestone
Dimensions: h. 23.6 cm., w. 13.6 cm., d. 9.3 cm.
Gift of Edward Sampson, Class of 1914, for the Alden Sampson Collection (y1962-141)

CONDITION: *The fragment preserves the face, nearly complete, and part of the headgear. Chopped from the flat background, it is broken at the neck. The nose and the left ear are missing; chips on eyes and mouth.*

The head was probably part of a half-figure similar to cat. no. 150 above. An oval, clean-shaven face features a full mouth and elongated eyes under incised eyebrows. The pupils may have been marked with single circles. The preserved ear is almost square, rather crudely modeled in front, with a rough clump of stone behind. The head wears a cylindrical hat (*modius*) with the rim of an underlying cap shown above the forehead. Two vertical lines marked the front of the headgear, and a crown of olive leaves was attached to it, adorned with a central medallion, now chipped off.

The *modius*, so-called because of its resemblance to the Roman receptacle for measuring grain, charac-terizes the man as a priest.[1] The actual priestly hats

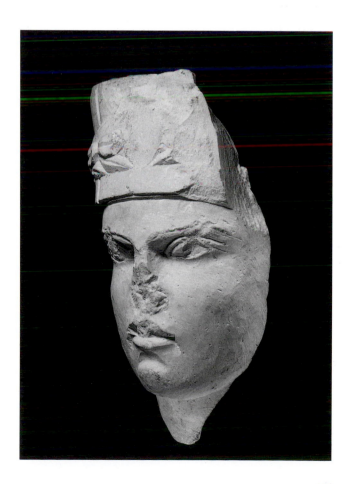

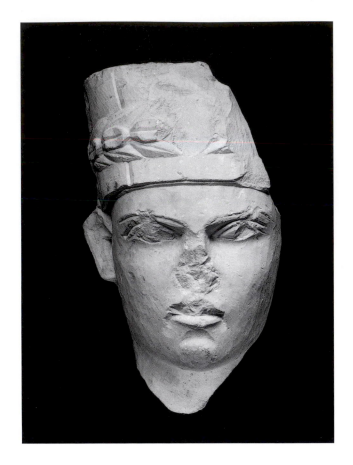 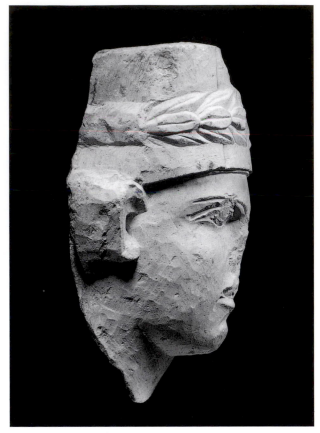

were probably made of felt or leather and worn on a skullcap. The olive wreath was of metal, possibly gold, and attached with a cloth strap behind, as shown also on this head. The wearers were always entirely clean-shaven, including the scalp. Some of them wore an un-ornamented *modius,* while those wearing a crown on it presumably enjoyed some more distinguished rank within the priestly order, though the exact meaning of the adornment is unknown. MG

BIBLIOGRAPHY
Unpublished.

NOTE
1. On Palmyrene priests, see Stucky 1973, 163–80.

154.

FRAGMENTARY HEAD OF A PRIEST

Second half of the second century A.D.
Provenance: Palmyra
Material: hard white local limestone
Dimensions: h. 17.3 cm., w. 14.3 cm., d. 11.4 cm.
Gift of Edward Sampson, Class of 1914, for the Alden
Sampson Collection (y1962-142)

CONDITION: *The piece is broken diagonally from the left temple to the tip of the nose, which is chipped off; the lower part of the face is missing entirely. The headgear is nearly complete, but the figure in the wreath is badly broken. The back surface is chopped off from a slab.*

The head was part of a funerary half-figure of the usual type (see cat. no. 150). The eyeballs are marked with two concentric circles, a feature that does not occur after ca. A.D. 150. The brows are set off as sharp ridges, and a horizontal wrinkle just below the priestly hat spans the forehead. The headgear has the usual two vertical grooves and is banded with a wreath of leaves meeting in front at a small draped bust, bareheaded, whose face is entirely broken away.

MG

BIBLIOGRAPHY
Unpublished.

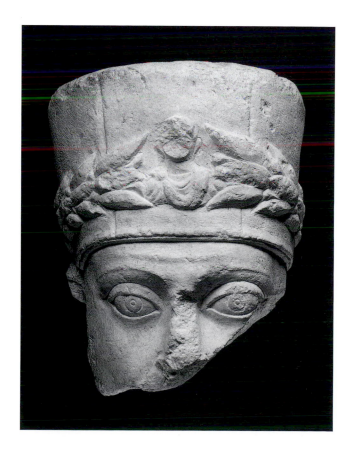
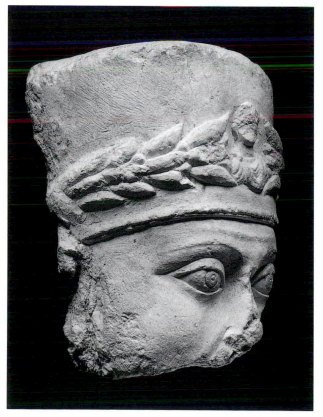

155.

HEADDRESS OF A PRIEST

Second–third century A.D.
Provenance: Palmyra
Material: hard grayish local limestone
Dimensions: h. 15.9 cm., w. 19.5 cm., d. 20.8 cm.
Gift of Edward Sampson, Class of 1914, for the Alden
Sampson Collection (y1962-140)

CONDITION: *Broken bottom surface, complete around. Top and back surface unworked; visible chisel marks. Head of the small bust attached separately (probably modern repair).*

The fragment displays the usual features of the priestly headgear (see cat. nos. 153 and 154 above). The olive wreath is rendered with particular precision. A small bust is placed in the center; the man represented is bareheaded and wears a tunic and himation with carefully rendered folds.

The *modius* is too large to have been part of a funerary half-figure. The head of its owner was probably projected above a huge slab representing a banquet scene, set on a sarcophagus in the form of a dining couch, of which many have survived in situ in underground tombs of Palmyra. We have no clues regarding the identity of the small figures on the *modius*; in some cases they wear a *modius* themselves. They might represent the wearer's ancestor or predecessor in office.

MG

BIBLIOGRAPHY
Unpublished.

156.

HEAD OF A BANQUET ATTENDANT

Late second—third century A.D.
Provenance: Palmyra
Material: hard white local limestone
Dimensions: h. 15.0 cm., w. 11.3 cm., d. 16.5 cm.
Unrecorded acquisition, before 1922[1] (y1930-441)

CONDITION: *Originally protruding in high relief on the front wall of a sarcophagus, intentionally broken around, at neck and on the left. The tip of the nose is broken off; chips on the chin.*

This head of a young man is clean-shaven, with the hair arranged in three rows of "snail curls" around the face. The eyes are elongated, the eyeballs not marked (perhaps once painted).

The class of banquet relief to which this fragment belongs stood on sarcophagi that were provided with furniture legs at their corners and a mattress on top to imitate dining couches. The central panel of such sarcophagi often presents, somewhat incongruously, standing figures of young servants who usually hold the drinking utensils but who could also be preparing for a ritual sacrifice or a hunting party. This head belonged to such an attendant. MG

BIBLIOGRAPHY
Unpublished.

NOTE
1. See p. 313, n. 1.

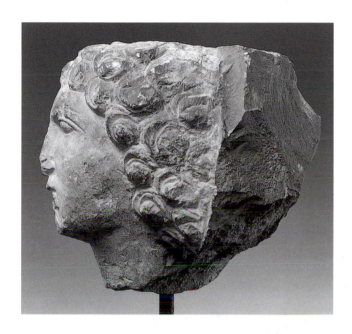

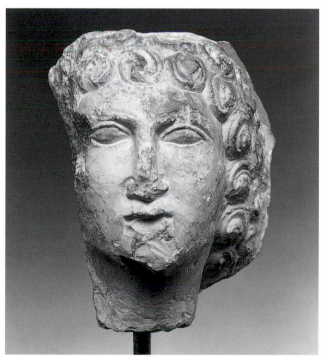

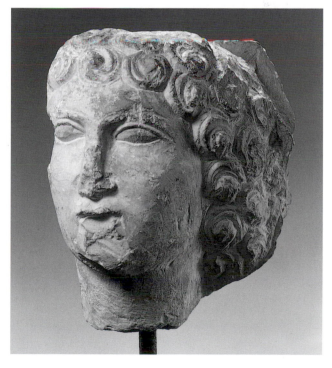

157.

FUNERARY SLAB WITH MALE BUST IN HIGH RELIEF

First half of the third century A.D.
Provenance: Palmyra
Material: hard white local limestone
Dimensions: h. 48.5 cm., w. 41.4 cm., d. 21.3 cm.
*Gift of Mrs. W. Lester Glenney and her sister, Mrs. Field
(y1946-109).*

CONDITION: *Minor breaks on edges, lower left corner of the background missing. The sculpture is complete except for the tip of the nose and some chips. On the surface to the left of the head, patches of modern plaster indicate possible modern reuse as a building stone.*

A frontal bust of a man, turned very slightly to his left, is nearly detached on the flat surface of the slab.

Behind the figure a piece of hanging cloth is represented, fixed with two rosette-headed nails, each also securing a palm branch. To the right, an engraved inscription in Aramaic (letters 1.5 cm. high):

ydyʿbl br / mzbnʾ / brwqʾ / hbl

[*Yediʿbel, son of Mezabbana (son of) Barôqa. Alas!*]

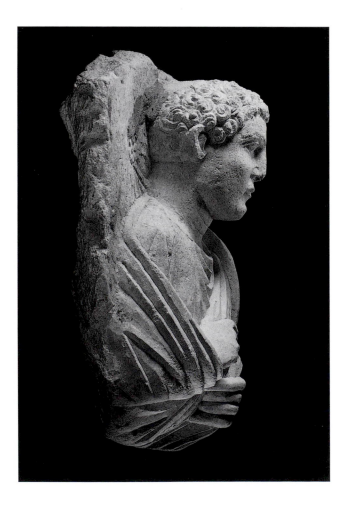 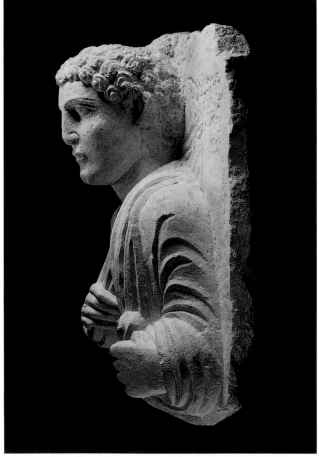

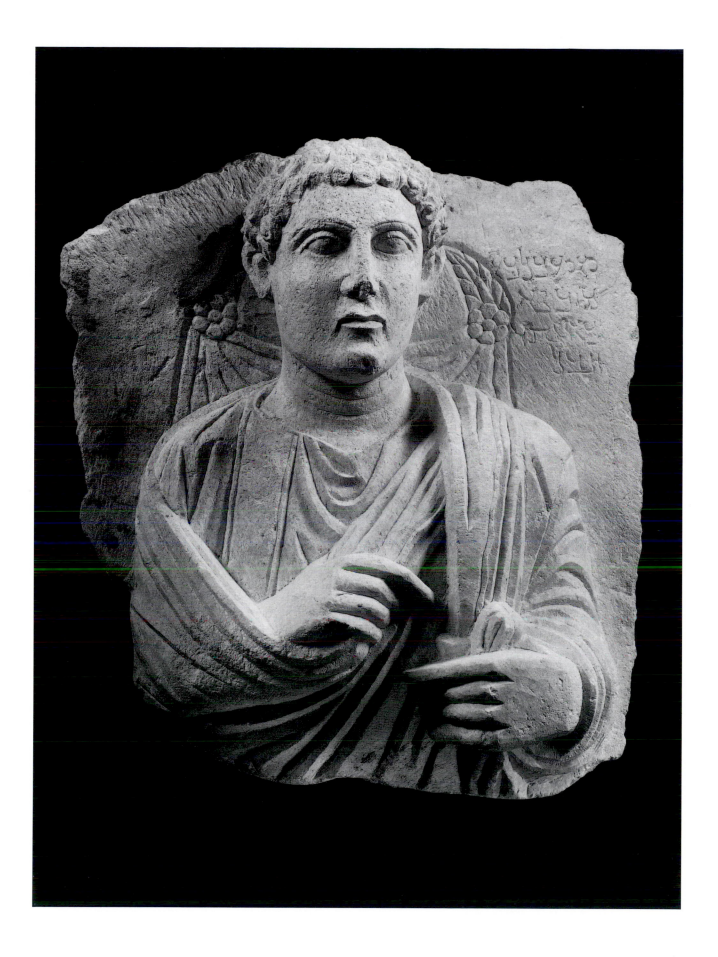

The man's name, which means "(the god) Bel knows," is relatively common in Palmyra. The veil stretched behind him indicates that he is portrayed here as a dead person, the circumstance expressed also by the exclamation closing the text.

Yedi'bel wears a tunic provided with a wide vertical band with marked borders on the right of his chest, which represents an applied piece of embroidery; the latter was probably once painted with a pattern or intended to be so. He is draped in a himation covering both arms but off the right shoulder. His left hand is grasping the loose end of the drapery, his right emerges from the folds of the cloak which pass diagonally across the chest. The folds of both garments are sharp and V-shaped, except for a wavy vertical line falling from the left shoulder, which marks the brim of the cloak.

The full, round face, clean-shaven, is surrounded by curly hair arranged in several rows of tight "snail" locks. The chin protrudes, flattened on the tip; the mouth is small and pinched, the nose straight, even with the forehead. The eyes are almond-shaped, with pupils marked with small circles, once painted. Slightly arched grooves mark the brows.

This is a funerary monument typical of Palmyra from the end of the first century A.D. to the end of Palmyrene art, marked by the sack of A.D. 272. Such slabs were used to close burial slots in the walls of family tombs, either dug underground or built in the form of towers (until ca. A.D. 120) and elaborate mausolea during the second and third centuries. When the tomb chambers were entirely filled, half-figures of the deceased would have been closely packed in vertical rows of five or more slabs, one above the other in each row. The tombs were in principle intended for large families and many generations, but in practice parts of them, especially underground, were often sold to relatives or even strangers. Even so, few tombs were ever filled, and most were subsequently robbed.

Placed as they were on a crossroads between East and West, the Palmyrenes used simple draped clothes of the Classical world just as often as trousers and richly embroidered tunics fashionable in Mesopotamia and Iran. In this case, the Greek mantle covers a garment that could have been decorated with quite elaborate patterns. Scraps of such were actually found in some tombs.

Few Palmyrene funerary busts show individual traits that would allow them to be described as portraits in the usual sense. Most, like this one, represent only a conventional type: a young man or old, a lady, a boy. What was generally sought was not the likeness of the deceased but a material abode for his soul, believed to inhabit the stone. Such at least were the beliefs to which the earliest inscriptions bear witness, though they might have become only dimly felt by the time the tombstone of Yedi'bel son of Mezabbana had been carved. MG

BIBLIOGRAPHY
CIS II 4312, pl. LIII (inscription).
Hillers and Cussini 1995, no. 669.

158.

HEAD OF A MAN

Third century A.D.
Provenance: Palmyra
Material: hard white local limestone
Dimensions: h. 8.6 cm., w. 7.5 cm., d. 8.8 cm.
Unrecorded acquisition, before 1922[1] (y1930-447).

CONDITION: *The head is broken at the neck; the top and the right forehead are missing; and the tip of the nose is chipped off. A fragment of flat background and a trace of a raised border remain to the proper left of the head.*

The man has a full beard and mustache, sharply separated from the cheeks and marked with short chisel strokes on a slightly raised surface. The hair is arranged in three rows of curls around the forehead. The eyes are elongated, with lids running as two parallel bars toward the ears, which are deeply pierced with a drill. The eyeballs are marked with a single circle each, the brows grooved.

This fragment is detached from a funerary slab, which, instead of bearing a half-figure in high relief, represented the deceased within an ornamental border, reclining on a couch and being served by a cup bearer.[2] The figures were necessarily rather small, but the features do not differ significantly from those of the more frequent funerary busts, and like most of the latter, they represent a type rather than an individual.

MG

BIBLIOGRAPHY
Unpublished.

NOTES
1. See p. 313, n. 1.
2. For parallels see Colledge 1976, 78–79, pl. 109; Ruprechtsberger 1987, 25.

ETRUSCAN SCULPTURE

159.

HEAD OF A LION

Third quarter of the sixth century B.C.
Provenance: unknown
Material: brown volcanic stone (nenfro)
Dimensions: h. 32.7 cm., w. 22.0 cm., d. 38.6 cm.
Museum purchase, John Maclean Magie and Gertrude Magie
Fund (y1994-58)

CONDITION: *Broken through the mane and neck to just below the jaw. Large chip in mane below right ear; slight damage to left side of chin, tip of right ear, and sides of tongue. Minor scratches, pitting, and abrasion.*

The volcanic stone contains numerous mineral inclusions, both dark and light; although pitted, the material is dense and hard. The lion's head is broken from a complete sculpture. The beast's mouth is open in a roar, the tongue lolling between the lower canines. The fleshy lips hang in scalloped folds on either side. The muzzle is short and square, with a nose shaped like an ivy leaf. Converging, parallel grooves on either side of the muzzle extend from the nose to beyond the eyes, which are large, with steeply arched sockets and outlined lids. The crest of the mane frames the

face like a hood. The pointed ears are small and lie flat on the mane, the surface of which is smooth and unmodeled. There are distinct traces of red paint on the tongue, lips, and eyes.

Sculpted lions of this type were placed in pairs at the entrances of rock-cut tombs in central and southern Etruria. Their function as tomb guardians is inferred from their exclusively funerary use, but their exact meaning is unknown. In addition to lions, other guardian animals were in the form of sphinxes (the most numerous class), leopards, rams, dogs, griffins, winged horses, hippocamps (some with riders), horsemen, and at least one centaur.[1] The stone guardians might flank the entrance to the dromos outside the tomb, be just inside the dromos flanking the entrance, or stand at the lower end of the dromos, flanking the

entrance to the burial chamber; they might also stand on the roof or over the lintel.[2] Those from Chiusi/Clusium and other inland sites are carved in soft limestone, but at most other sites the favored material was volcanic stone: tufa, peperino, or nenfro, the latter particularly associated with Vulci. Most lion guardians are seated and are usually winged; couchant lions are less common and normally lack wings.[3] Both types have similar heads, and it is uncertain from which type this head derives. The earliest examples, inspired by Near Eastern and East Greek prototypes, date to the second quarter of the sixth century B.C., but the confident handling and mature style of the Princeton lion suggest a slightly later date.

JMP

BIBLIOGRAPHY
Record 54.1 (1995): 68, 69 (illus.).

NOTES

1. The only comprehensive study of Etruscan stone tomb guardians is Hus 1961, which is now out of date but includes drawings of many pieces excavated at Vulci in the nineteenth century and now lost. The best analysis of lion guardians is still Brown 1960, 62–72, pls. 23–25. See also Kohler 1960; Vermeule 1961b; Vermeule 1964b; Hoffmann 1970, 1–4, no. 1; Del Chiaro 1977; Del Chiaro 1982; De Ruyt 1983; Brijder 1984; Jucker 1991, 290–91, no. 387; Spivey 1997, 119–23, figs. 102–7.

2. For a reconstruction of a tomb at Veii with guardian sphinxes, see Lulof and Kars 1994, 61.

3. For both types of lions, see Brown 1960, pls. 23–24, 25b–d. A third type neither sits nor reclines, but is represented walking: only two examples are known, one in the Museo Archeologico, Florence, 75963 (Brown 1960, pl. 25), another in the New York art market (unpublished).

160.

ASH URN (*Cinerarium*) WITH RELIEF OF PELOPS AND HIPPODAMEIA

Second half of the second century B.C.
Provenance: said, improbably, to have been found at Sybaris[1]
Material: alabaster
Dimensions: h. 52.7 cm., w. 70.0 cm., d. 28.5 cm.
Gift of David G. Carter, Class of 1945, in memory of Charles Rufus Morey (y1986-68)

CONDITION: *The lower half has suffered severe water erosion, particularly affecting the figures of Myrtilos, Oinomaos, the Triton, and the male demon, as well as the legs and lower bodies of the horses. Water also has badly eroded both of the lower front corners and the Doric frieze connecting them, and the right side of the urn body, which was broken in pieces and repaired with cement (the rest of the urn body is unbroken). Missing elements—some not eroded, but broken away—include the right leg and hand of Myrtilos, the left hand of Hippodameia, part of the chariot wheel, Pelops's left arm, three of the horses' raised forelegs, the Triton's left forearm, the left arm and leg of the male demon, and the face of the figure behind Myrtilos. There are cracks in the left side of the urn, two deep breaks in the upper moldings and another in the back rim. A circular hole (diam. 2.5 cm.) in the top of the forward rim is filled with a plug of white alabaster; a smaller hole farther left is filled with plaster. There are three large, horizontal drill holes in the sides of both the upper and lower left corners. The alabaster has a yellow patina and a surface texture varying from grainy to polished.*

The interior of the rectangular ash urn is roughly picked, the back and sides smoothly polished. The missing lid would have been crowned by a carved figure of a reclining banqueter—male or female, depending on the sex of the deceased—whose name might have been written on the edge in Etruscan letters. The front of the urn features a carved relief framed above and below by moldings and ornamental friezes. The upper moldings, from top to bottom, consist of an ovolo with egg-and-dart, a beaded fillet, dentils, twin fasciae, and a frieze of alternating rosettes and palmettes, the latter intruded upon by figures in the relief. Below the relief is a Doric frieze, framed by beaded fillets, with alternating triglyphs and rosette-metopes.

The relief tells the story of the myth of Pelops and Hippodameia. According to Apollodorus (*Epitome* 2.3–7), Pelops, the son of Tantalus, was given a team of swift horses by his lover Poseidon.

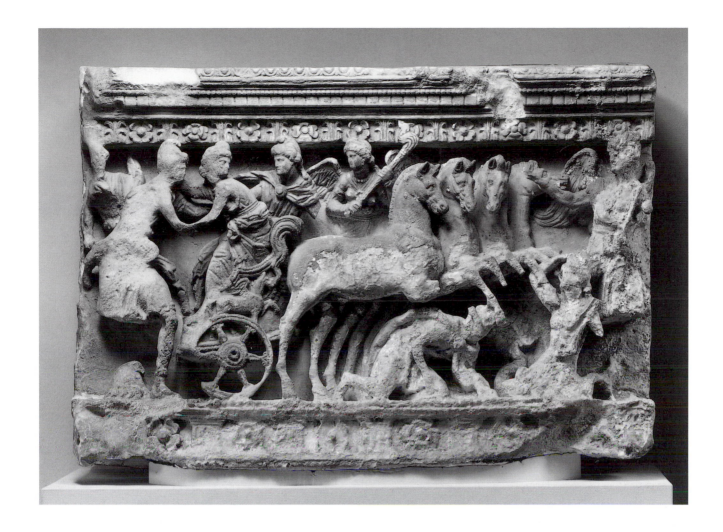

When he reached manhood, he fell in love with Hippodameia, the daughter of King Oinomaos of Pisa, in the Peloponnese. A prophecy had warned the king that his daughter's husband would kill him—or, in some other versions, he lusted after her himself—so he made it a condition of her wedding that he might pursue her and any potential spouse in his chariot and, should he catch them, spear her suitor to death. Oinomaos killed several suitors this way, but Pelops bribed the king's charioteer, Myrtilos, to remove the linchpins of his master's chariot before the race, causing him to be thrown and killed. The tale formed the principal foundation myth of the Olympic Games and was immortalized in the east pediment of the Temple of Zeus at Olympia.

In this relief, different episodes are condensed into a single, synoptic image that highlights the most important elements of the story while ignoring their separation in time. Oinomaos has already fallen and is being trampled by the four horses drawing Pelops's chariot, all eight of their forelegs raised in unison. The king, who wears a cloak, tunic, and Phrygian cap, rests a hand on the ground as he looks back at the treacherous Myrtilos, whom he is said to have cursed with his dying breath. To the king's right, also beneath the horses, is a Triton, a male sea-creature with a nude, human torso and a bifurcated, serpentine lower body, whose scaly fish tales writhe upon the ground. The Triton cradles a broken rudder in his left arm and raises his right hand to his winged head. His presence may allude to the fact that the horses were a gift from Poseidon, whose altar at the Isthmus of Corinth is said in one source to have been the objective of the race (Diodorus Siculus 4.73).[2] Behind and to the right of the Triton, a winged male demon advances to the right but reaches back toward the horses, as though urging them on. He, too, has a

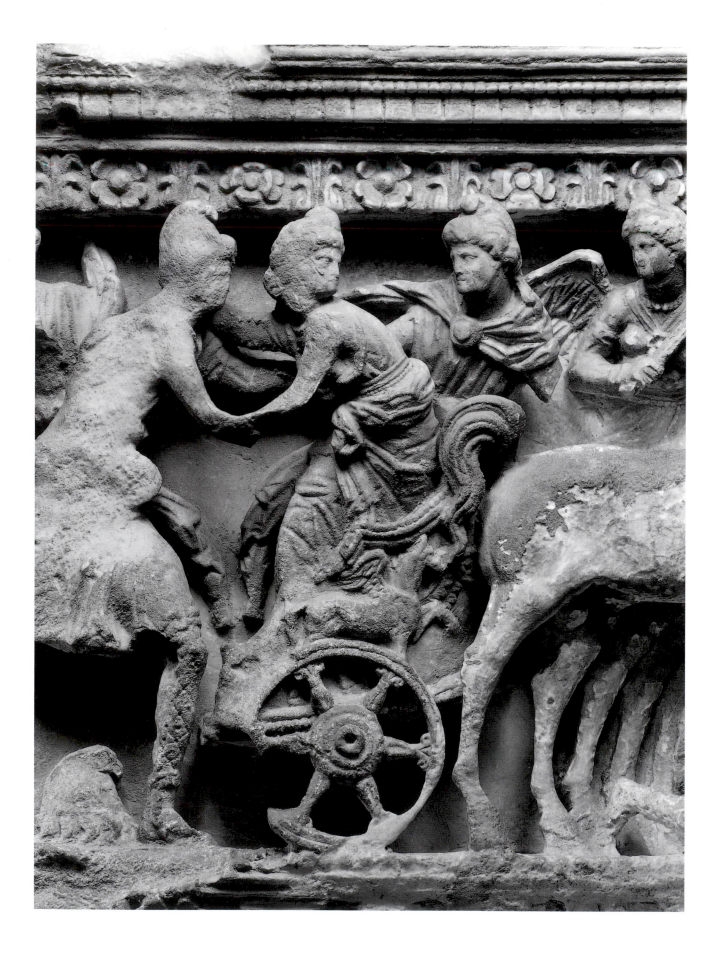

winged head, and wears a short chiton and carries a staff or torch.

In the left half of the scene, a young male, probably Myrtilos, stands on the ground and helps Hippodameia debark from the chariot. He wears a Phrygian cap and a long gown (chiton), which is tucked high up under his belt. A Phrygian cap lies on the ground between his feet. In the space behind him, in the upper left corner, is the damaged torso of another male in similar attire. Myrtilos strides avidly forward, taking Hippodameia by the left arm as she rests her right hand on his shoulder. She, however, turns away from him and looks back at a second youthful male, who stands in the box alongside her. This is undoubtedly her lover Pelops, who meets her gaze and reaches back to her with his right arm. He wears a gown and cap like those of Myrtilos, but also a cloak (chlamys), secured at his throat by a circular pin. His missing left arm was extended to control the team, but there is no trace of reins or harness. A winged female flies to the right, emerging from the flat background above the horses. She carries a torch and is dressed in a skirt, necklace, armlets, and crossed bandoleers with a central rosette between her bare breasts. A relief of a griffin decorates the box of the chariot, the wheel of which has six voluted spokes.

The winged female is certainly a Vanth, an Etruscan version of the Greek Fury, who normally is attired in just this fashion and usually carries a torch. We might think she is here to symbolize the punishment of Oinomaos's hubris or as a reminder of the curse that follows Pelops as the son of Tantalus, but Vanths turn up in a variety of Etruscan funerary contexts, many more benign than this. On an alabaster urn in Volterra, for example, she appears in this same position above a team of chariot horses, who are not trampling a mythical king but merely pulling the car of a local magistrate, the latter recently deceased but decidedly unheroic.[3]

Decorated ash urns were produced at several sites in northern Etruria, where cremation was traditionally favored over inhumation. These were often fashioned from volcanic stone or terracotta, but at Volterra the urns were carved in alabaster from local deposits, still exploited today. Hundreds survive, but most do not depict mythological stories. Among the few parallels to the relief on the Princeton urn, the closest one is in Florence, which also has identical ornamental moldings; the principal differences are the absence of Triton, replaced by a small dog, and of the figure behind Myrtilos.[4]

JMP

BIBLIOGRAPHY
Sotheby Parke-Bernet, New York, Cranbrook Collections, May 4, 1972, lot 332, illus. facing p. 131.
Record 46.1 (1987): 44, 47 (illus.).

NOTES
1. The cinerarium was formerly in the collection of Jacob Hirsch, from whom it was acquired in 1929 by the Cranbrook Academy, Bloomfield Hills, Illinois. It was bought by the donor at Sotheby Parke-Bernet, New York, May 4, 1972.
2. On another alabaster urn, however, a similar Triton appears in the same place, beneath the legs of galloping chariot horses, but the subject is completely different: Museo Guarnacci, Volterra, inv. no. 400; Cristofani et al. 1975, 50–51, no. 54.
3. Museo Guarnacci, Volterra, inv. no. 168; LIMC 8:177, pl. 125, no. 39, s.v. Vanth (C. Weber-Lehmann). The griffin on the magistrate's chariot is also identical to the one in Princeton, a warning that we would be unwise to overinterpret it in the context of the Pelops myth.
4. Museo Archeologico Nazionale, Florence, inv. no. 78495; Cristofani et al. 1975, 98–99, no. 138; LIMC 5:438, pl. 313, no. 31, s.v. Hippodameia I (M. Pipili). A. Maggiani (in Cristofani et al. 1975) identifies the man standing on the ground as Pelops and the charioteer as Myrtilos, but Pipili and others are surely correct that Pelops is driving the chariot accompanied by Hippodameia. A second urn, in Volterra, is very similar, but with egg-and-dart instead of a Doric frieze: Museo Guarnacci, Volterra, inv. no. 178; Laviosa 1964, 146–49, no. 30. For other examples, see Cristofani et al. 1975, nos. 73–74, and 308; Brunn and Körte 1890, 2:121–29, pls. 49–52.

ADDENDUM: GREEK SCULPTURE

161.

ATTIC RELIEF WITH HORSEMAN AND BEARDED MAN

Beginning of the fourth century B.C.
Provenance: unknown
Material: Pentelic marble
Dimensions: h. 40.5 cm., w. 33.2 cm., d. 7.6 cm.,
th. of slab 6.1–6.5 cm.
Museum purchase, Carl Otto von Kienbusch, Jr.,
Memorial Collection Fund (1996-66)

CONDITION: *The ancient break along the right side is irregular and encrusted, extending through the horse's body behind the neck and across the rider's left thigh. There is only minor chipping along the left and upper edges, but the shallow molding at the bottom is more damaged: there is an ancient break between the feet of the horse and man, while the damage farther right, taking the horse's left hoof, is more recent. The damage to the rider's left foot is ancient, but not that to the adjacent calf, nor to the horse's breast and right knee, the man's right shoulder, and the pendant folds of the himation. A fresh gash extends across the horse's mane and eye, following the line of a calcite vein. The preserved surfaces are worn, with considerable loss of detail. There are two modern dowel holes in the underside of the slab. The shallow, reddish brown incrustation that tints much of the surface is speckled black in places, especially on the back.*

The fragment preserves the left half of a rectangular stele with a shallow relief of a bearded man facing a horse and rider, the latter lost except for his left leg and right foot. The man stands to the right, his weight on his right leg, his left foot drawn back. His legs and head are in profile, his bare chest in three-quarter view. His face is quite worn, but he has full lips, deep-set eyes, and a straight nose. The crease in his short hair shows it is bound with a fillet. His himation is wrapped around his left shoulder and under his right arm, exposing his chest. He leans forward slightly, resting his weight on his walking stick, which he props against a pad of drapery wadded under his left arm. His right hand is raised, not in gesture, but to rest on the pad of drapery, while the back of his lowered left hand is touched by the raised right hoof of the horse, which comes prancing in

from the right. The horse holds its head high, but not higher than that of the man, who is distinctly taller. The front of the horse's clipped mane terminates in a short, nodding crest. The animal's anatomy is carefully rendered, the rippling muscles of its breast and shoulder contrasted with the loose folds of skin on the neck.

On the back of the stele, along the right edge, are two square dowel holes with slender channels extending from them; a third one of identical shape is cut into the top of the upper right corner. These show that the relief was repaired in antiquity with metal pins, now lost. A subsequent reuse, possibly as a paving stone, may account for the even wear on the back surface, which was rough-picked with a pointed chisel. On the top and left sides of the slab, the fore-edges are flat and recessed, while the rest of the surface is higher, although nearly as flat. The resulting ledge is bolder on the left side than on the top, and in both cases it tapers away before reaching the upper left corner. This treatment is peculiar, being the opposite of *anathyrosis*, in which the central area of a side edge is left recessed to facilitate articulation with an adjacent block.[1]

Both style and material point to an Attic origin for the stele. The absence of lateral or upper moldings is somewhat unusual, as is the absence of an inscription, although this could have been lost in the damage to the lower molding. There was no lengthy, multiline inscription below, for part of the lower edge of the slab is preserved. Some fourth-century Attic votive stelai show mounted heroes approaching mortal worshipers, but the latter are always represented

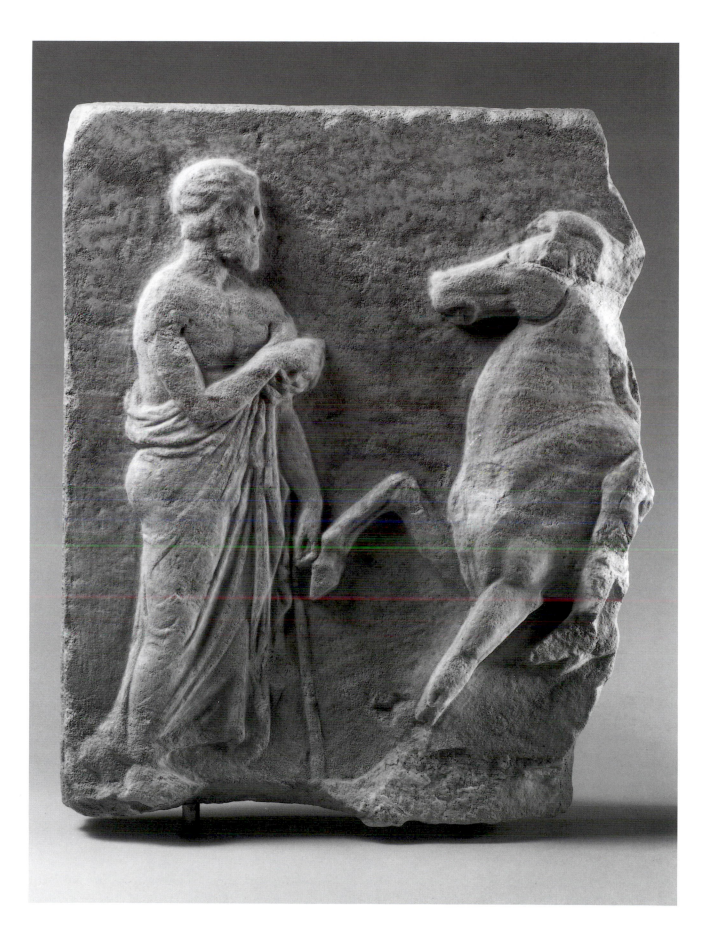

as significantly smaller than the heroes and their mounts.[2] Being taller than the horse, this man must be a deity or a personification. Support for this is found in a relief from Rhodes, now in London, dating to the beginning of the fourth century B.C., in which a mounted hero approaches an appropriately diminutive mortal votary, before whom stands an interceding goddess or heroine.[3] The goddess looms a head taller than the horse, and her hand touches its upraised hoof. A few fourth-century Athenian document reliefs show a bearded, middle-aged man who leans on a stick under his left arm; he has been identified as Demos, the personification of the People of Athens. In one example, securely dated to 398/397 B.C., Demos is shown shaking hands with Athena, and his leaning posture and the carving of his himation are nearly identical to those of the man in Princeton.[4] If the Princeton relief depicts Demos, it may be a victory monument honoring an equestrian victory of some kind, or possibly it crowned a separately carved honorary decree, with the horse and rider referring to the honoree's victory in an equestrian event.[5] The gentle contact between Demos's hand and the horse's hoof, however, suggests a more intimate, divine affinity, like that between the goddess and the mounted hero on the London relief. It corresponds to the handshake between Demos and Athena on the relief in Athens, an intimate gesture that underlined the sacred bonds uniting the People of Athens, their patron goddess, and the deified heroes of Attica.

JMP

BIBLIOGRAPHY
Record 56.1-2 (1997): 105 (illus.), 107.

NOTES
1. C. L. Lawton (1995, 11 n. 26) mentions a similar raised edge on a relief in Athens, which she says argues against its restoration over the alliance of 433/432 between Athens and Leontinoi.
2. See Mitropoulou 1977, no. 37, fig. 59; nos. 57–58, figs. 93–94; no. 130, fig. 188.
3. London, British Museum inv. no. 753; *LIMC* 6:1043, pl. 695, no. 346, s.v. Heros Equitans (A. Ceramanovic-Kuzmanovic et al.).
4. Athens, National Archaeological Museum inv. no. 1479; *LIMC* 3:379, pl. 274, no. 44, s.v. Demos (O. Alexandri-Tzahou); Lawton 1995, 89–90, pl. 8, no. 14. Lawton disagrees with Alexandri-Tzahou's identification of the man as Demos and instead identifies him as the mythical Athenian king Erechtheus. Lawton further notes that both figures on the Athens relief "have the rounded, doughy quality of the drapery of the Erechtheion frieze," a comparison also raised by Homer Thompson in speaking about the Princeton relief (personal communication). The Erechtheion frieze was carved between 409 and 406 B.C. (Boardman 1985, 148).
5. For examples of such reliefs, with mounted or dismounted horsemen, see Lawton 1995, pl. 16, no. 30; pl. 30, no. 58; pl. 53, no. 100; pl. 65, no. 122.

162.

FRAGMENTARY PORTRAIT OF A GREEK KING

Hellenistic, ca. 275–250 B.C.
Provenance: unknown
Material: bronze
Dimensions: h. 19.5 cm., w. 20 cm., d. 25 cm.
Museum purchase, Fowler McCormick, Class of 1921, Fund, and partial gift of Claude Dunbar Hankes-Drielsma (1996-183)

CONDITION: *The face is missing from the eyebrows down, but both temples are preserved. There is a crack in the left temple. On the back of the head below the diadem a big piece of hair is missing. In the head of hair there are a dozen holes, some of which were caused by fastening pins required during the casting process; others are the result of too thin a flow of the molten bronze. The surface is in excellent condition and has a smooth, dark green patina.*

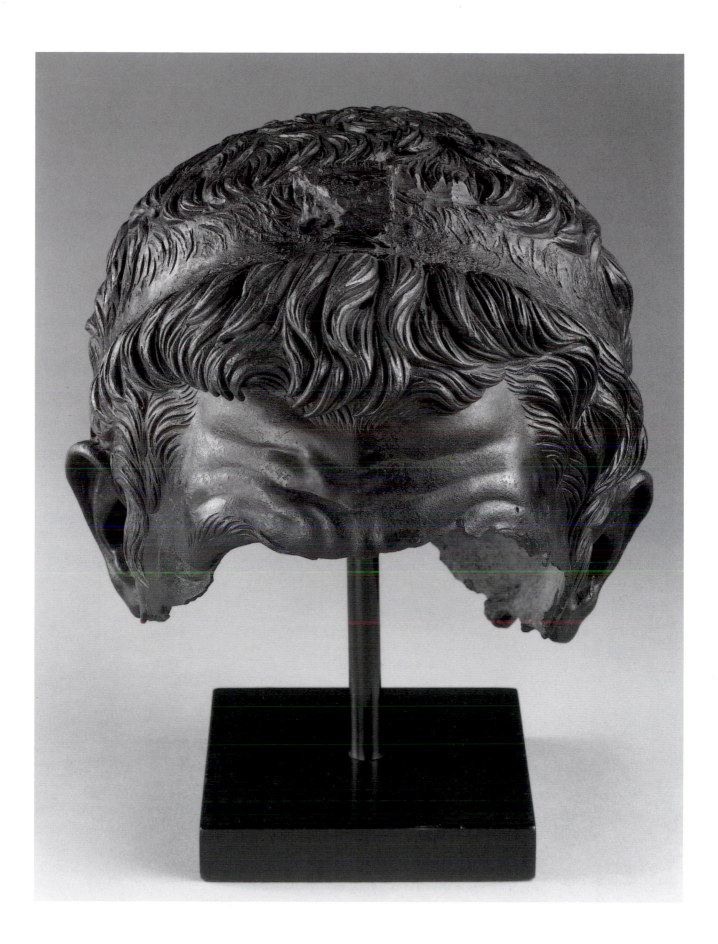

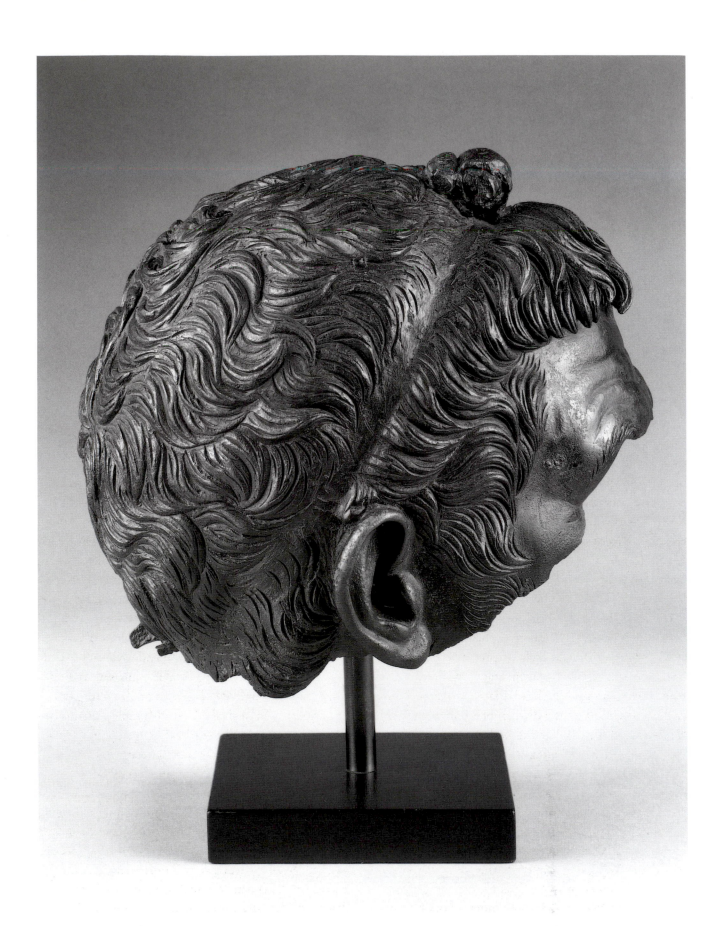

378

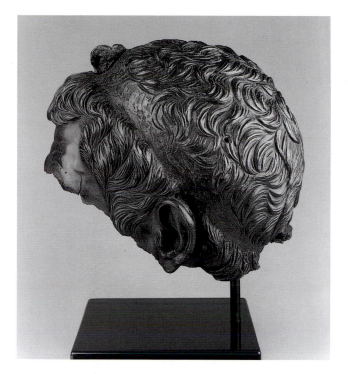
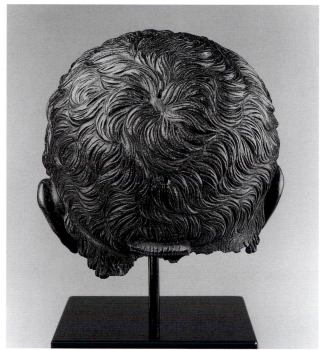

Size and diadem leave no doubt that the head depicts Hellenistic royalty. The coiffure of wiry and undulating short locks hints at a practical and very energetic personality. That is especially true of the hair above the forehead with its central cowlick, the so-called *anastolé* motif.[1] The dynamic impression is enhanced by a formation of locks that literally spill down from the crown of the head, partly masking the *anastolé*. The king's energy and capability to give commands and make decisions also show in the furrowed forehead and the raised eyebrows.

The king's diadem, likely of precious metal, had been wrought separately, as indicated by the depression running around the head. Placed at half distance within the circuit of the diadem bedding, above the forehead and the nape of the neck, are two short, tubular or rolled appliqués, which were cast separately and are held in place by clasps. The upper rolls are the more slender and have striations that seem to imitate either hair or the fabric of a woven diadem (see below). The form of these appliqués at first may seem to indicate that the diadem was not a flat band, but of the tubular variety. However, the width and depth of the bedding are not consistent throughout its course. Above the forehead, the indentations are remarkably deep and wide, while in the right profile

they fade out rather quickly and are not continued beyond the ear, where the workmanship in general betrays less diligence than in the other views. In the left profile, the bedding becomes shallow from the temple on and tapers as it approaches the backward contraption. The latter marks the spot where the ends of a *flat* diadem were tied in a knot and allowed to fall down on the neck and shoulders. The deep and conspicuous depressions to the sides of the frontal contraption must therefore have served another purpose than just accommodating the ribbon-shaped diadem.

In the rendition of forehead and eyebrows—that is to say, stylistically—the bronze compares well with third-century portraits like those of Epikouros, an anonymous dynast in the Getty Museum, Demosthenes, and, most of all, the so-called Demokritos from Herculaneum, in Naples.[2] The latter's affinity to the Demosthenes, whose portrait was erected at Athens in 278/277 B.C., as well as the other comparisons suggests a date for the Princeton head within or close to the second quarter of the third century B.C. There are interesting similarities between the Princeton piece as a purely Greek work and a larger-than-life diorite head from Egypt in Munich, that likewise wears a diadem.[3] The latter, too, has wild, undulating locks issuing from underneath the diadem which "spill"

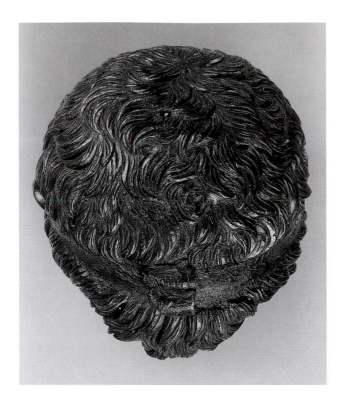

same man. If so, a Greek king is sought who, in the middle of the third century, played a role in Egypt without being himself a Ptolemy, the iconography of the Ptolemies being well-enough known to exclude that the Princeton head represents one of them. This seems to leave only one possibility: Antiochus II Theos, king of Syria between 261 and 246 B.C., who after generations of war between Seleucids and Ptolemies had not only concluded peace with Egypt, but also married Berenike "Syra," a daughter of Ptolemy II, in 251/250 B.C. The couple resided at Antioch, where Ptolemy sent shiploads of Nile water which was believed to enhance female fertility.[7] The king's effort to forge closer ties between the rivaling houses was understandable because internal strife made additional theaters of war undesirable. Antiochus unquestionably felt the same, for the vast provinces of Parthia and Bactria had defected from the empire and needed, at least in the long run, to be reconquered.

The Munich diorite head helps to solve the problems of the sizable indentations on either side of the paired rolls on the front of the Princeton head. To its fillet a set of small wings is attached which identify the sitter with Hermes-Thoth, the god of talk and diplomacy. In coinage, Antiochus II often is shown with a wing attached to his flat diadem.[8] It follows, therefore, that the Princeton head originally also possessed Hermes wings, which were held in place by the surviving appliqué. As the indications of hair that invade the depressions show, the wings fit only loosely into the molds.

So far, the similarities between the Munich and Princeton heads have been emphasized, but it is also necessary to note the differences. These concern primarily the right profile views. While in the Munich head the hair is combed from the center of the forehead to the temple, upon which it forms a tousled mass,[9] there is in the Princeton bronze a monotonously even sequence of comma-shaped locks that stretches from the ear to the center of the brow.[10] The only parallel for this is found in posthumous coin portraits of Antiochus's father, Antiochus I Soter,[11] who had been a sworn enemy of the Ptolemies. Second, the forehead of the Munich figure protrudes slightly; in that respect, and in its overall

onto the more organized sequence of hair strands seaming the upper forehead; in the left profile, a row of comma-shaped locks originating from the center of the brow forms a "pincer" with another set of locks that is growing out of the upper temple. The same features occur on the Princeton head. In both instances, moreover, the tufts of hair covering the temple proper and the area in front of the ear are almost identically organized. The wrinkly forehead and the flaring eyebrows are likewise comparable, especially if one takes into account the diminished malleability of the extremely hard Egyptian stone.[4]

Although the forcefulness, immediacy, and essential Greekness of the Munich diorite have been repeatedly underscored, scholars have tended to assign it a late date, in the second or first century B.C. However, it compares well with the portrait of Menander[5] and some late Egyptian heads, which J. A. Josephson in his recent study of so-called late-period sculpture has dated to the decades before 246 B.C.[6] Thus, the stylistic dates for both the Munich and the Princeton head coincide. Consequently, given the typological similarities (to which may be added that both heads sport downy beards: cf. the Princeton head's right profile), it seems possible that both images depict the

profile, it agrees with the portrait of Antiochus II in the king's standard coin emissions.[12] In the Princeton head, however, the lower forehead bulges out in exactly the same way as it does on posthumous coin portraits of Seleucus I, the founder of the dynasty.[13] How to account for these differences?

If the Egyptian version of Antiochus's portrait suppresses the reminiscence of Seleucus I, that is only too understandable, because an illegitimate son of Ptolemy I, Ptolemy Keraunos, had first insinuated himself into the Seleucid's good graces and then stabbed him from behind. From the Egyptian point of view, this unpleasant incident need not have been brought up again under happier circumstances, and the same was true of the other iconographical peculiarity of Antiochus's portrait as represented by the Princeton bronze. The king's father, Antiochus I, had opened the series of "Syrian Wars" between the Seleucids and Egypt, which would turn out to be literally endless, and that, surely, was something the Ptolemies were not eager to remember. The differences can thus be rationally explained and present no obstacle to the identification of both the Princeton and Munich heads as Antiochus II Theos. Ptolemy's shipments of Nile water had proven conducive to the conception of one child when, in 246 B.C., the marriage between Antiochus II and Berenike broke up. The former abandoned the Egyptian princess, as "prophesied" by Daniel,[14] to rejoin his ex-wife Laodike at Ephesos. Laodike had him poisoned and also had Berenike and her daughter killed. Seleuco-Egyptian affairs thus went back to where they had been before the accord between Antiochus II and Ptolemy II.

The Princeton bronze—and, for that matter, the Princeton-Munich type—is of importance in yet another respect: it improves our understanding of the portraiture of Pompey the Great (106–48 B.C.), the renowned Roman Republican general. The Copenhagen type of his images combines his familiar down-to-earth physiognomy with an *anastolé* hairstyle. In the literature, that has often been viewed as a contradiction in terms:[15] the "messages" of face and hairstyle were deemed incompatible and gave rise to the assumption that different areas of the head addressed different constituencies within the Roman populace.[16]

What aggravated the problem was that no direct parallel to Pompey's *anastolé* could be pointed out. It consists of a cowlick above the center of the forehead upon which "disorganized" hair spills from above. In other words, Pompey's hairstyle resembles that of the Princeton-Munich Antiochus II. The Republican general's referral to Seleucid iconography makes good sense, for it was he who in 64 B.C. dissolved the Seleucid empire by transforming it into the Roman province of Syria. H M

BIBLIOGRAPHY

Sotheby's, London, July 5, 1982, no. 393 (illus.).
Record 56.1–2 (1997): 106 (illus.), 107.
Meyer 2000b, 9–36, figs. 1, 7, 14–16, 42.

NOTES

1. For the term, see Plutarch, *Pompey* 2.
2. Epikouros: Kruse-Berdoldt 1975, 3–50; Richter 1965, 2:194–200; Schefold 1943, 118; Meyer 1987, 15 and 27, n. 15. Anonymous dynast: Herrmann 1993, 29–42; Meyer 1996, 174–77, figs. 50, 52, and 54. Demosthenes: Richter 1965, 2:215–23; Meyer 1987, 27, n. 95. Demokritos: Schefold 1943, 124, no. 2; Buschor 1971, 27, no. 104; Meyer 1996, 174 and 176, fig. 51.
3. Meyer 2000b, 11–13, figs. 2, 10, 13, 17, 18; cf. Grimm 1975, 1–8.
4. Meyer 2000b, 15–18.
5. Meyer 2000b, 12, fig. 19. Richter 1965, 2:224–36.
6. Josephson 1997, 42–45, pls. 13.2, 14.1; Meyer 2000b, 28 with additional comparisons. See also Kaiser 1999, 248, pl. 39a, d; cf. Meyer 2000b, 28, figs. 20, 21.
7. Bevan 1985, 1:179; *CAH* 8² (1984), 419 (H. Heinen). M. Pfrommer (1992, 36–38, pls. 5.7, 6.2) sees a portrait of Berenike "Syra" in the woman in the frieze who is holding a shield, but this is not accepted by M. Fuchs (1998), 96, fig. 3.
8. Meyer 2000b, 23–24 figs. 12 and 36.
9. Meyer 2000b, 16–18; 22–23 fig. 10.
10. Meyer 2000b, fig. 7.
11. Meyer 2000b, fig. 8.
12. Meyer 2000b, figs. 10–12.
13. Meyer 2000b, figs. 7 and 9.
14. Daniel 11.6.
15. Cf. Meyer 2000b, 24–27.
16. Giuliani 1986; Curtius 1931, 236–38. Important for a better understanding of Pompey's portraits are Trunk 1994, 473–87 and Fuchs 1999b, 131–35; Meyer 2000b, 24–27.

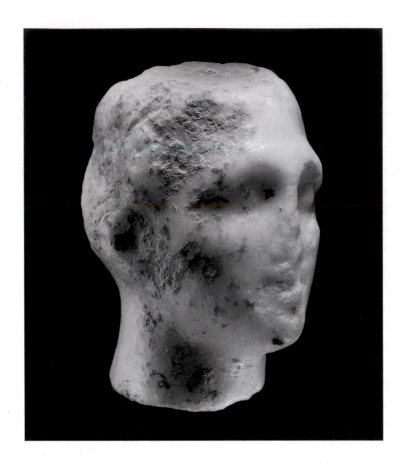

163.

HEAD OF AN ATHLETE

Ptolemaic, first half of the second century B.C.
Provenance: unknown
Material: fine-grained, grayish white marble
Dimensions: h. 5.9 cm., w. 4.5 cm., d. 4.4 cm.
Gift of Edward Sampson, Class of 1914, for the Alden
Sampson Collection (y1964-139)

CONDITION: *A break with jagged edges runs through the neck. The top of the head is partly flattened and shows a slanted surface (not a break). The better part of the nose is missing, the mouth battered. The ears and the back of the head are only roughed out. Incisions above the nape of the neck indicate a wreath. Above the left ear there are traces of three fingers placed horizontally and with the palm facing outward against the temple. The tip of the topmost finger was freestanding and has broken off. Three drilled holes serve to create a distance between fingers and hair. Discolorations and thick incrustations are mostly on the right half of the head as well as on the surface of the break through the neck. The face, the left profile, and the back of the head have undergone cleaning.*

In spite of the head's small size, the piece of marble at the sculptor's disposal was not sufficient to make attachments superfluous: a slice of marble had to be glued onto the top of the head to allow for a complete impression. Size and patchwork technique hint at an Egyptian provenance, for the land on the Nile is devoid of marble. The image's style of workmanship points in the same direction. At first glance, there may be Scopaic reminiscences,[1] but the deep-set eyes under the sharply arched eyebrows, along with the tilted, bony forehead point to the Hellenistic period. The portrait of Menander and the head of the Getty bronze athlete come to mind.[2] A most

interesting comparison, however, is provided by a filleted male head formerly in the Bergsten collection. It is known to have been acquired around 1930 from the Giza Museum at Cairo.[3] The expressions of the Princeton and Bergsten pieces are sufficiently similar to assign both of them to the same general period, the creative centuries of the Hellenistic age, but the head from Giza may belong to the second century.[4] The Princeton head is firmer and has a more immediate presence. It finds a close comparison in a female head from the altar of Asklepios in Kos, which originated, as M. Bieber has shown, in the workshop of the sons of Praxiteles, who also worked in Egypt (early third century B.C.).[5]

The sketchily incised wreath on the back of the head and the fingers by the left temple identify the man portrayed in the Princeton head as an athlete. The preserved fingers are from bottom to top: the index finger, the middle finger, and the ring finger. That is to say that the wreath, which has slid into place, had been held between thumb and index finger. The theme of an athlete wreathing himself makes it likely that the Princeton head belonged to a full-length statuette. Figures like the Getty bronze and the Mahdia Agon give an idea of how the figurine may have looked in its entirety.[6] It must have stood some 30 cm., about the same height as the famous statuette of Socrates from Alexandria, in London.[7] Whether the athlete was at the same time intended to represent a royal portrait is hard to establish, but perhaps possible: Ptolemaic kings have been convincingly identified in miniature groups of mythical wrestlers who triumph over fiendish opponents.[8]

HM

BIBLIOGRAPHY
Unpublished.

NOTES

1. Cf. Stewart 1977, pl. 41b; Arias 1952, pl. XIV, 47; Lehmann 1973, pl. 38.
2. Menander: Richter 1965, 2:224–36; Meyer 1996, 105, figs. 13 and 17. Bronze athlete: Frel 1982.
3. Christie's, London, April 21, 1999, 93, no. 91.
4. Cf. Bieber 1961b, 108–9, figs. 420, 428.
5. Bieber 1923–24, 255–56, pl. VI.
6. Frel 1982; W. Fuchs 1963, 12–14; G. M. Söldner, in Hellenkemper-Salies 1994, 399–429.
7. Meyer 1986a, 26–27, figs. 11–12; Scheibler 1989, 50, fig. 7.6.
8. Kyrieleis 1973, 133–47, pls. 45–48.

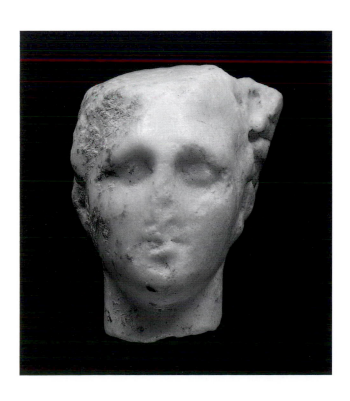

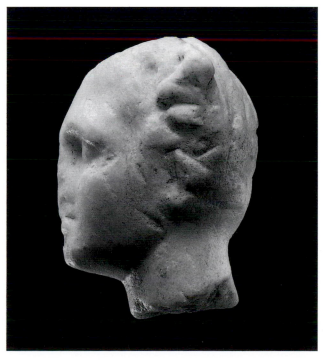

Concordance of Accession Numbers to Catalogue Numbers

Accession Number	Catalogue Number	Accession Number	Catalogue Number
y9	44	y1958-1	15
y180	22	y1962-92	150
y205	151	y1962-137	26
y342	33	y1962-140	155
y1929-62	43	y1962-141	153
y1930-36	140	y1962-142	154
y1930-440	137	y1963-30	5
y1930-441	156	y1963-44	28
y1930-442	138	y1964-139	163
y1930-443	135	y1964-140	35
y1930-444	136	y1970-1	19
y1930-445	143	y1980-10	9
y1930-446	141	y1980-34	8
y1930-447	158	y1981-34	18
y1930-448	139	y1984-2	7
y1930-449	134	y1984-15	14
y1930-450	148	y1984-77	1
y1930-451	149	y1985-34	11
y1930-452	144	y1986-68	160
y1930-453	147	y1987-1	25
y1930-454	145	y1988-10	31
y1930-455	152	y1989-24	24
y1930-456	146	y1989-26	16
y1938-6	37	y1989-41	12
y1938-10	36	y1989-55	3
y1940-326	40	y1990-3	13
y1943-90	20	y1991-21	32
y1945-247	34	y1991-43	21
y1946-109	157	y1993-38	45
y1948-58	23	y1994-1	47
y1949-110	42	y1994-32	27
y1952-63	4	y1994-33	39
y1952-169	48	y1994-58	159
y1953-25	6	y1994-140	29
y1954-146	38	y1994-141	30
y1955-3228	17	1995-124	46

Accession Number	Catalogue Number	Accession Number	Catalogue Number
1996-10	41	2000-69	103
1996-66	161	2000-70	105
1996-183	162	2000-71	104
2000-36	73	2000-72	59
2000-37	84	2000-73	55
2000-38	74	2000-74	60
2000-39	72	2000-75	63
2000-40	75	2000-76	57
2000-41	79	2000-77	62
2000-42	78	2000-78	66
2000-43	81	2000-79	83
2000-44	80	2000-80	64
2000-45	77	2000-81	58
2000-46	82	2000-82a-b	65
2000-47	76	2000-83	91
2000-48	101	2000-84	89
2000-49	68	2000-85	90
2000-50	54	2000-86	86
2000-51	52	2000-87	87
2000-52	53	2000-88	88
2000-53	50	2000-89a–b	107
2000-54	49	2000-90	106
2000-55	51	2000-91	85
2000-56	69	2000-92	117
2000-57	71	2000-93	114
2000-58	70	2000-94	128
2000-59	61	2000-95	112
2000-60	94	2000-96	121
2000-61	95	2000-97	108
2000-62	100	2000-98	122
2000-63	97	2000-99	131
2000-64	99	2000-100	126
2000-65	102	2000-101	118
2000-66	56	2000-102	116
2000-67	96	2000-103	130
2000-68	98	2000-104	123

Accession Number	Catalogue Number	Accession Number	Catalogue Number
2000-105	124	2000-114	109
2000-106	119	2000-115	111
2000-107	133	2000-116	110
2000-108	115	2000-117a–b	132
2000-109	120	2000-118.1-28	92
2000-110	125	2000-119.1-12	93
2000-111	127	2000-120	67
2000-112	129	2000-147	142
2000-113	113	2000-308	2

Concordance of Antioch Sculpture

The Stillwell number is given in the format of volume year, object number.
1938 = R. Stillwell, ed., *Antioch on-the-Orontes II: The Excavations 1933–1936* (Princeton 1938).
1941 = R. Stillwell, ed., *Antioch on-the-Orontes III: The Excavations 1937–1939* (Princeton 1941).
Stillwell numbers followed by "(Downey)" indicate objects found in the respective volumes within the sections written by Glanville Downey titled "Greek and Latin Inscriptions." All other Stillwell numbers here listed indicate objects found in the respective volumes within the sections titled "Catalogue of Sculpture."

Objects with a Stillwell number but without a catalogue number are those sculptures indicated in the Stillwell volumes as being in The Art Museum, but which in fact are not in its collection.

Objects in the catalogue that lack a Stillwell number comprise the Antioch sculptures in Princeton that were never published by Stillwell.

Stillwell number	Catalogue number	Antioch number
1938, 13 (Downey)	116	P2209-I23: S91
1938, 18 (Downey)	118	P3278-I29
1938, 95 (Downey)	119	P3784-I71
1938, 96 (Downey)	112	P4754-I131: S241
1938, 97 (Downey)	111	P3782-I69: S241
1938, 100	73	2537-S94
1938, 101	not in Princeton	2729-S97
1938, 104 (Downey)	129	P6225-I209: S429
1938, 106 (Downey)	114	P3783-I70
1938, 120	79	3396-S118
1938, 121	not in Princeton	4318-S185
1938, 123	not in Princeton	4320-S187
1938, 143	52	4440-S201
1938, 149	59	4446-S207
1938, 158a	97	4493-S219a
1938, 163	68	5269-S291
1938, 187	75	6198-S341
1938, 206	126	P3395-S117
1938, 230	53	3397-S119
1938, 231	74	3398-S120
1938, 233	55	3781-35S
1941, 198 (Downey)	115	Pb21-I259: S500
1941, 199 (Downey)	121	Pc370-I308
1941, 207 (Downey)	128	Pb75-I268: S514
1941, 218 (Downey)	108	Pa1382-I256: S497
1941, 239 (Downey)	131	Pb50-I266

Stillwell number	Catalogue number	Antioch number
1941, 241 (Downey)	122	Pb94-I271: S516
1941, 249	not in Princeton	c557-S657
1941, 260	not in Princeton	a180-S372
1941, 279	76	a729-S439
1941, 283	102	c425-S608
1941, 284	100	c436-S611: A335
1941, 285	49	c89-S563
1941, 292	77	c217-S585; c97-S567
1941, 294	not in Princeton	c110-S570
1941, 297	104	c285-S594
1941, 298	84	b365-S543
1941, 301	not in Princeton	b325-S541
1941, 307	58	a1005-S465bis
1941, 313	67	b311-S538
1941, 314	54	Pb524-S549
1941, 317	not in Princeton	Pb253-S427
1941, 318	72	Pa867-S455
1941, 320	61	Pa391-S401
1941, 321	63	Pa1013-S463
1941, 322	69	Pa817-S446
1941, 328	78	Pa383-S391
1941, 329	91	Pa284-S392
1941, 330	57	Pa315-S396
1941, 331	65	Pa791-S441
1941, 332	65	Pa792-S442
1941, 338	107	a1120-S475a–b
1941, 342	130	Pa289-S393
1941, 343	123	Pa392-S402
1941, 346	120	Pb30-S503: I260
1941, 347	117	Pb42-S508: I264
1941, 349	124	Pb143-S519: I275
1941, 350	110	Pb290-S534: I279
1941, 352	127	Pc451-S614
1941, 353	85	Pc457-S618
1941, 355	not in Princeton	Pc576-S673
1941, 356	not in Princeton	Pc577-S674
1941, 357	109	Pa1114-S472: I245
1941, 361	106	Pa1381-S496
	50	Pa663-S438
	51	Pb52-S511

Stillwell number	Catalogue number	Antioch number
1941, 361	56	no number
	60	P6239-S422
	62	no number
	64	no number
	66	no number
	70	no number
	71	no number
	80	P6240-S423
	81	P6243-S425
	82	no number
	83	no number
	86	no number
	87	no number
	88	no number
	89	P6234-S428
	90	no number
	94	P4873-S255/615
	95	no number
	96	no number
	98	no number
	99	P6236-a249
	101	no number
	103	no number
	105	no number
	113	Pc460-I312
	125	P4456-S217
	132	P3393-I44
	133	no number

Bibliography of Works Cited

Abdul-Hak 1951
Abdul-Hak, S., and A. Abdul-Hak. *Catalogue illustré, du Départment des antiquités greco-romaines au Musée de Damas.* Vol. 1. Damascus 1951.

Abel 1956
Abel, A. "La statuaire hawranienne." *AnnArchBrux* 49 (1956): 7–15.

Abou Assaf 1998
Abou Assaf, A. *Gabal Hauran und seine Denkmäler.* Damascus 1998.

Adriani 1938
Adriani, A. "Minturno." *NSc* 1938, 159–226.

Ajootian 1997
Ajootian, A. "The Only Happy Couple." In *Naked Truths. Women, Sexuality, and Gender in Classical Art and Archaeology,* ed. A. O. Koloski-Ostrow and C. L. Lyons, 220–42. London and New York 1997.

Albizzati 1921
Albizzati, C. "Ritratto femminile dell'età di Traiano." *DissPontAcc* 15, ser. 2 (1921): 291–307.

Alexiou 1974
Alexiou, M. *The Ritual Lament in Greek Tradition.* Cambridge 1974.

Altmann 1905
Altmann, W. *Die römischen Grabaltäre der Kaiserzeit.* Berlin 1905.

Amedick 1991
Amedick, R. "Die Kinder des Kaisers Claudius." *RM* 98 (1991): 373–95.

Amelung 1895
Amelung, W. *Die Basis des Praxiteles aus Mantinea.* Munich 1895.

Amelung 1903–56
Amelung, W. *Die Sculpturen des Vaticanischen Museums.* Berlin 1903–56.

Amelung 1925
Amelung, W. "Studien zur Kunstgeschichte Unteritaliens und Siziliens." *RM* 40 (1925): 181–212.

Anderson and Nista 1988
Anderson, M. L., and L. Nista. *Roman Portraits in Context. Imperial and Private Likenesses from the Museo Nazionale Romano.* Exhib. cat., Emory University, Atlanta. Rome 1988.

Anderson and Nista 1989
Anderson, M. L., and L. Nista, eds. *Radiance in Stone. Sculptures in Colored Marble from the Museo Nazionale Romano.* Exhib. cat., Emory University, Atlanta. Rome 1989.

Andreae 1956
Andreae, B. *Motivgeschichtliche Untersuchungen zu den römischen Schlachtsarkophagen.* Berlin 1956.

Andreae 1971
Andreae, B. "Die Entwicklung der römischen Löwenjagdsarko-phage." *AA* 1971, 119–22.

Andreae 1980
Andreae, B. *Die Sarkophage mit Darstellungen aus dem Menschenleben: Die römischen Jagdsarkophage.* ASR 1.2. Berlin 1980.

Andreae 1985
Andreae, B. *Die Symbolik der Löwenjagd.* Opladen 1985.

Andreae 1992
Andreae, B. "Vom Pergamonaltar bis Raffael: Vorbilder, Eigenart und Wirkung der römischen Sarkophage." *AntW* 23.1 (1992): 41–64.

Andreae 1995
Andreae, B., ed. *Bildkatalog der Skulpturen des Vatikanischen Museums.* Vol. 1, *Museo Chiaramonti.* Berlin and New York 1995.

Andreae and Jung 1977
Andreae, B., and H. Jung. "Vorläufige tabellarische Übersicht über die Zeitstellung und Werkstattzugehörigkeit von 250 römischen Prunksarkophagen des 3. Jhs. n. Chr." *AA* 1977, 432–36.

Andreae and Kyrieleis 1975
Andreae, B., and H. Kyrieleis, eds. *Neue Forschungen in Pompeji.* Recklinghuasen 1975.

Angelicoussis 1992
Angelicoussis, E. *The Woburn Abbey Collection of Classical Antiquities.* Mainz 1992.

Antiquités égyptiennes
Antiquités égyptiennes, grecques et romaines appartenant à P. Philip. Auction cat., Paris, Feb. 10–14, 1905.

Antonaccio 1992
Antonaccio, C. M. "Style, Reuse, and Context in a Roman Portrait at Princeton." *AA* 1992, 441–52.

Arias 1952
Arias, P. E. *Skopas.* Rome 1952.

Arndt 1912
Arndt, P. *La Glyptothèque Ny Carlsberg.* Munich 1912.

Arnold 1969
Arnold, D. *Die Polykletnachfolge.* JdI Ergh. 25. Berlin 1969.

Arslan 1997
Arslan, E. A., ed. *Iside. Il mito, il mistero, la magia.* Milan 1997.

Art of the Late Antique **1968**
Art of the Late Antique from American Collections. Exhib. cat., Rose Art Museum, Brandeis University. Waltham, Mass. 1968.

Ashmole 1929
Ashmole, B. *A Catalogue of the Ancient Marbles at Ince Blundell Hall.* Oxford 1929.

Aurenhammer 1990
Aurenhammer, M. *Die Skulpturen von Ephesos. Bildwerke aus Stein. Idealplastik,* vol. 1. Forschungen in Ephesos X.1. Vienna 1990.

Bailey 1999
Bailey, D. M. "A Chalcedony Barbarian." In *Classicism to Neo-Classicism. Essays Dedicated to Gertrud Seidmann,* ed. M. Henig and D. Plantzos, 79–82. London 1999.

Balty 1980
Balty, J. "Trébonien Galle et Volusien." In *Eikones. Festschrift Hans Jucker,* 49–56. Bern 1980.

Balty 1993
Balty, J. C. *Porträt und Gesellschaft in der römischen Welt.* TrWPr 13 (1993).

Balty and van Rengen 1993
Balty, J. C., and W. van Rengen. *Apamée de Syrie. Quartiers d'hiver de la 11^e Légion parthique. Monuments funéraires de la nécropole militaire.* Brussels 1993.

Baratte and Metzger 1985
Baratte, F., and C. Metzger. *Catalogue des sarcophages en pierre d'époque romaine et paléochrétienne.* Paris 1985.

Barone 1994
Barone, G. *Gessi del Museo di Sabratha.* Rome 1994.

Bartman 1999
Bartman, E. *Portraits of Livia.* Cambridge and New York 1999.

Bartman 2001
Bartman, E. "Hair and the Artifice of Roman Female Adornment." *AJA* 105 (2001): 1–25.

Bastet and Brunsting 1982
Bastet, F. L., and H. Brunsting. *Catalogus van het klassieke beeldhouwwerk in het Rijksmuseum van Oudheden te Leiden.* Vols. 1 and 2. Zutphen 1982.

Becatti 1954
Becatti, G. *Scavi di Ostia.* Vol. 2, *I mitrei.* Rome 1954.

Becatti 1968
Becatti, G. "Una statua di Eracle con cornucopia." *BdA* 53 (1968): 1–11.

Beck and Bol 1993
Beck, H., and P. C. Bol, eds. *Polykletforschungen.* Berlin 1993.

Beck, Bol, and Bückling 1990
Beck, H., P. C. Bol, and M. Bückling, eds. *Polyklet. Der Bildhauer der griechischen Klassik.* Mainz 1990.

Bérard 1982
Bérard, C. "Pénalité et religion à Athènes: un témoignage de l'imagerie." *RA* 1982, 137–50.

Berge 1989
Berge, L. "Recent Acquisitions in the Classical Collection at the Art Institute of Chicago." In *Daidalikon, Studies in Memory of Raymond B. Schoder,* ed. R. F. Sutton, 41–52. Wauconda, Ill. 1989.

Berger 1978
Berger, E. "Zum von Pliny [N.H. 34.55] überlieferten *'nudus talo incessens'* des Polyklet." *AntK* 21 (1978): 55–62.

Berger 1980
Berger, E. "Ein Vorläufer Pompejus' des Grossen in Basel." In *Eikones. Festschrift Hans Jucker,* 64–75. Bern 1980.

Berges 1986
Berges, D. *Hellenistische Rundaltäre Kleinasiens.* Freiburg 1986.

Bergmann 1977
Bergmann, M. *Studien zum römischen Porträt des 3. Jhs. n. Chr.* Bonn 1977.

Bergmann 1978
Bergmann, M. *Marc Aurel.* Liebieghaus Monographie 2. Frankfurt 1978.

Bergmann 1982
Bergmann, M. "Zeittypen in Kaiserporträt?" In *Römisches Porträt. Wissenschaftliche Konferenz, 12–15 Mai 1981,* 143–47. Berlin 1982.

Bergmann and Zanker 1981
Bergmann, M., and P. Zanker. "Damnatio Memoriae." *JdI* 96 (1981): 317–412.

Bernabò Brea 1981
Bernabò Brea, L. *Menandro e il teatro greco nelle terrecotte liparese.* Genoa 1981.

Bettini et al. 1998
Bettini, A. et al. *Marmi antichi delle raccolte civiche genovesi.* Genoa 1998.

Bevan 1985
Bevan, E. R. *The House of Seleucus.* London 1902. Reprint Chicago 1985.

Bianchi Bandinelli 1954
Bianchi Bandinelli, R. "Sarcofago da Acilia con la designazione di Gordiano III." *BdA* 39 (1954): 200–220.

Bieber 1917
Bieber, M. "Die Herkunft des tragischen Kostüms." *JdI* 32 (1917): 15–104.

Bieber 1923–24
Bieber, M. "Die Söhne des Praxiteles." *JdI* 38–39 (1923–24): 242–75.

Bieber 1961a
Bieber, M. *The History of the Greek and Roman Theater.* Rev. ed. Princeton 1961.

Bieber 1961b
Bieber, M. *The Sculpture of the Hellenistic Age.* Rev. ed. New York 1961.

Bieber 1977
Bieber, M. *Ancient Copies.* New York 1977.

Blanc and Nercessian 1992
Blanc, N., and A. Nercessian. *La cuisine romaine antique.* Grenoble 1992.

Blinkenberg 1933
Blinkenberg, C. *Knidia. Beiträge zur Kenntnis der praxitelischen Aphrodite.* Copenhagen 1933.

Blome 1978
Blome, P. "Zur Umgestaltung griechisches Mythen in der römischen Sepulkralkunst." *RM* 85 (1978): 435–57.

Blome 1983
Blome, P. "Der Tod des Apsyrtos auf einem römischen Sarkophagdeckel." *RM* 90 (1983): 201–9.

Blome 1992
Blome, P. "Funerärsymbolische Collagen auf mythologischen Sarkophagreliefs." In *Giornate Pisane. Atti del IX Congresso della F.I.E.C., 24–30 agosto 1989. StIt* 10, ser. 3 (1992): 2:1061–73.

Blümel 1933
Blümel, C. *Staatliche Museen zu Berlin. Katalog der Sammlung antiker Skulpturen. Römische Bildnisse.* Berlin 1933.

Boardman 1985
Boardman, J. *Greek Sculpture: The Classical Period.* London 1985.

Boardman 1989
Boardman, J. *Athenian Red Figure Vases: The Classical Period.* London 1989.

Boardman 1998
Boardman, J. *Greek Sculpture: The Late Classical Period.* London 1998.

Bocci Pacini and Nocentini Sbolci 1983
Bocci Pacini, P., and S. Nocentini Sbolci. *Museo Nazionale Archeologico di Arezzo. Catalogo delle sculture romane.* Rome 1983.

Bockelberg 1979
Bockelberg, S. von. "Der Friese des Hephaisteion." *AntP* 18 (1979): 23–48.

Bodel and Tracy 1997
Bodel, J., and S. Tracy, eds. *Greek and Latin Inscriptions in the U.S.A.: A Checklist.* Rome 1997.

Bol 1990a
Bol, P. C., ed. *Forschungen zur Villa Albani. Katalog der antiken Bildwerke.* Vol. 2. Berlin 1990.

Bol 1990b
Bol, P. C. "Diskophoros." In Beck, Bol, and Bückling 1990, 111–17.

Bol 1992
Bol, P. C., ed. *Forschungen zur Villa Albani: Katalog der antiken Bildwerke.* Vol. 3. Berlin 1992.

Bol 1994
Bol, P. C., ed. *Forschungen zur Villa Albani: Katalog der antiken Bildwerke.* Vol. 4. Berlin 1994.

Bol 1984
Bol, R. *Das Statuenprogramm des Herodes-Atticus-Nymphäums.* Berlin 1984.

Bolelli 1986
Bolelli, G. "La ronde-bosse de caractère indigène en Syrie du Sud." In Dentzer 1986, 311–72.

Bolelli 1991
Bolelli, G. "La sculpture au Musée de Suweida." In Dentzer and Dentzer-Feydy 1991, 63–80.

Bollmann 1998
Bollmann, B. *Römische Vereinshäuser: Untersuchungen zu den Scholae der römischen Berufs-, Kult- und Augustalen-Kollegien in Italien.* Mainz 1998.

Bonanno 1976
Bonanno, A. *Portraits and Other Heads on Roman Historical Relief up to the Age of Septimius Severus.* Oxford 1976.

Bonanno 1977
Bonanno, A. "Un gruppo di ermette decorative a Malta." *ArchCl* 29 (1977): 399–410.

Bonanno 1988
Bonanno, A. "Imperial and Private Portraiture." In *Ritratto ufficiale e ritratto privato. Atti della II conferenza internazionale sul ritratto romano, Roma 1984,* ed. N. Bonacasa and G. Rizzo, 157–64. Rome 1988.

Borbein 1982
Borbein, A. H. "Polyklet." *GGA* 234 (1982): 184–241.

Borbein 1996
Borbein, A. H. "Polykleitos." In Palagia and Pollitt 1996, 66–90.

Boschung 1986
Boschung, D. "Überlegungen zum Liciniergrab." *JdI* 101 (1986): 257–87.

Boschung 1987
Boschung, D. *Antike Grabaltäre aus den Nekropolen Roms.* Bern 1987.

Boschung 1993a
Boschung, D. *Die Bildnisse des Augustus. Das römische Herrscherbild I.2.* Berlin 1993.

Boschung 1993b
Boschung, D. "Die Bildnistypen der iulisch-claudischen Kaiserfamilie." *JRA* 6 (1993): 39–79.

Boschung, Hesberg, and Linfert 1997
Boschung, D., H. von Hesberg, and A. Linfert. *Die antiken Skulpturen in Chatsworth. CSIR Great Britain*, vol. 3, fasc. 8. Mainz 1997.

Bossert 1951
Bossert, H. T. *Altsyrien.* Tübingen 1951.

Bothmer 1990
Bothmer, D. von, ed. *Glories of the Past: Ancient Art from the Shelby White and Leon Levy Collection.* New York 1990.

Bowerman 1913
Bowerman, H. C. *Roman Sacrificial Altars.* Bryn Mawr 1913.

Bowersock 1983
Bowersock, G. W. *Roman Arabia.* Cambridge and London 1983.

Boyce 1937
Boyce, G. *Corpus of the Lararia of Pompeii. MAAR* 14 (1937).

Brandenburg 1967
Brandenburg, H. "Meerwesensarkophage und Clipeusmotiv." *JdI* 82 (1967): 195–245.

Brijder 1984
Brijder, H. A. G. "Two Etruscan Centaurs." *BABesch* 59 (1984): 113–16.

Brilliant 1992
Brilliant, R. "Roman Myth/Greek Myth: Prosperity and Appropriation on a Roman Sarcophagus in Berlin." In *Giornate Pisane. Atti del IX Congresso della F.I.E.C., 24–30 agosto 1989. StIt* 10, ser. 3 (1992): 2:1030–45.

Brommer 1967
Brommer, F. *Die Metopen der Parthenon.* Mainz 1967.

Brommer 1978
Brommer, F. *Hephaistus: Der Schmiedegott in der antiken Kunst.* Mainz 1978.

Brommer 1984
Brommer, F. *Herakles II: Die unkanonischen Taten des Helden.* Darmstadt 1984.

Brouillet 1994
Brouillet, M. S., ed. *From Hannibal to Saint Augustine: Ancient Art of North Africa from the Musée du Louvre.* Exhib. cat., Michael C. Carlos Museum, Emory University. Atlanta 1994.

Brown 1960
Brown, W. L. *The Etruscan Lion.* Oxford 1960.

Brunn 1887
Brunn, H. *Beschreibung der Glyptothek König Ludwig's I.* 5th ed. Munich 1887.

Brunn and Körte 1890
Brunn, H., and G. Körte. *I rilievi delle urne etrusche.* Vol. 2. Berlin 1890.

Bücheler 1895
Bücheler, F. *Carmina latina epigraphica.* Vol. 1. Leipzig 1895.

Budde and Nicholls 1967
Budde, L., and R. Nicholls. *A Catalogue of the Greek and Roman Sculpture in the Fitzwilliam Museum, Cambridge.* Cambridge 1967.

Budischovsky 1977
Budischovsky, M.-C. *La diffusion des cultes isiaques autour de la mer adriatique.* Vol. 1. Leiden 1977.

Buranelli 1991
Buranelli, F. *Gli scavi a Vulci della società Vincenzo Campanari-Governo Pontificio: 1835–1837.* Rome 1991.

Buschor 1971
Buschor, E. *Das hellenistische Bildnis.* 2d ed. Munich 1971.

Butler 1903
Butler, H. C. *Architecture and Other Arts. PAAES* 2. New York 1903.

Butler 1909
Butler, H. C. "The Temple of Dūsharā at Sîʿ in the Haurân." In *Florilegium Melchior de Vogüé*, 79–95. Paris 1909.

Butler 1916
Butler, H. C. "Sîʿ (Seeia)." In *Ancient Architecture in Syria. PPUAES* 2.A-6, 365–402. Leiden 1916.

Butler 1919
Butler, H. C. "The Ledjā." In *Ancient Architecture in Syria. PPUAES* 2.A-7, 403–46. Leiden 1919.

Butler and Littmann 1905
Butler, H. C., and E. Littmann. "Explorations at Sîʿ." *RA* 1905, 1:404–12.

Cagiano de Azevedo 1951
Cagiano de Azevedo, M. *Le antichità di Villa Medici*. Rome 1951.

Cain 1993
Cain, P. *Männerbildnisse neronisch-flavischer Zeit. Tuduv-Studien: Reihe Archäologie 2*. Munich 1993.

Calkins 1968
Calkins, R. C. *A Medieval Treasury*. Exhib. cat., Andrew Dickson White Museum of Art, Cornell University. Ithaca 1968.

Calvani 1979
Calvani, M. M. "Leoni funerari romani in Italia." In *Acta of the 11th International Congress of Classical Archaeology, London 1978*, 270–1. 1979.

Calza et al. 1977
Calza, R. et al., eds. *Antichità di Villa Doria Pamphilj*. Rome 1977.

Calza 1978
Calza, R. *Scavi di Ostia*. Vol. 9, *I ritratti*. Rome 1978.

Calza and Nash 1959
Calza, R., and E. Nash. *Ostia*. Florence 1959.

Cambi 1984
Cambi, N. "Zwei Vespasians-Porträts aus Dalmatien." *Boreas* 7 (1984): 82–88.

Candida 1979
Candida, B. *Altari e cippi nel Museo Nazionale Romano*. Rome 1979.

Cantineau 1932
Cantineau, J. *Le Nabatéen*. Vol. 2. Paris 1932.

Capecchi et al. 1979
Capecchi, G. et al., eds. *La Villa del Poggio Imperiale*. Rome 1979.

Capecchi et al. 1980
Capecchi, G. et al., eds. *Collezioni fiorentine di antichità*. Vol. 2, *Palazzo Peruzzi, Palazzo Rinuccini*. Rome 1980.

Caputo and Traversari 1976
Caputo, G., and G. Traversari. *Le sculture del teatro di Leptis Magna*. Rome 1976.

Carli and Arias 1937
Carli, E., and P. E. Arias. *Il Camposanto di Pisa*. Rome 1937.

Caubet 1990
Caubet, A., ed. *Aux sources du monde arabe. L'Arabie avant l'Islam. Collections du Musée du Louvre*. Paris 1990.

Cerulli Irelli 1961–62
Cerulli Irelli, G. "Una base dedicata a Silvano dallo scultore." *BullCom* 73 (1961–62): 103–11.

Cerulli Irelli et al. 1991
Cerulli Irelli, G. et. al. *Pompejanische Wandmalerei*. Stuttgart and Zürich 1991.

Chamay and Maier 1989
Chamay, J., and J.-L. Maier. *Art romain. Sculpture en pierre du Musée de Genève*. 2 vols. Mainz 1989.

Champlin 1998
Champlin, E. "God and Man in the Golden House." In *Horti Romani. Atti del convegno internazionale, Roma, 4–6 maggio 1995*, ed. M. Cima and E. La Rocca, 333–44. Rome 1998.

Charbonneaux 1963
Charbonneaux, J. *La sculpture grecque et romaine aus Musée du Louvre*. Paris 1963.

Chiarlo 1983
Chiarlo, C. R. "'Donato l'à lodate per chose buone': il riempiego dei sarcofagi da Lucca a Firenze." In *Colloquio sul reimpiego dei sarcofagi romani nel medioevo*, 121–32. *MarbWPr* 1983.

Chioffi 1999
Chioffi, L. *Caro: il mercato della carne nell'occidente romano. Reflessi epigrafici ed iconografici*. Rome 1999.

Clauss 1990
Clauss, M. *Mithras: Kult und Mysterien*. Munich 1990.

Clauss 1992
Clauss, M. *Cultores Mithrae. Die Anhängerschaft des Mithras-Kultes*. Stuttgart 1992.

Closuit 1978
Closuit, L. *L'Aphrodite de Cnide*. Martigny 1978.

Coarelli 1978
Coarelli, F. "Praeneste." In *Studi su Praeneste*, ed. F. Coarelli, i–ix. Perugia 1978.

Colledge 1976
Colledge, M.A.R. *The Art of Palmyra*. London 1976.

Collingwood 1974
Collingwood, R. *The Technique of Sprang*. London 1974.

Collins 1970
Collins, J. L. "The Marble Sculpture from Cosa." Ph.D. diss., Columbia University, New York 1970.

Comella 1982
Comella, A. *Il deposito votivo presso l'Ara della Regina*. Rome 1982.

Comstock 1953
Comstock, H. "The Connoisseur in America." *The Connoisseur* 131 (1953): 68–69.

Comstock and Vermeule 1976
Comstock, M. B., and C. C. Vermeule. *Sculpture in Stone: The Greek, Roman, and Etruscan Collections of the Museum of Fine Arts, Boston.* Boston 1976.

Conlin 1997
Conlin, D. A. *The Artists of the Ara Pacis.* Chapel Hill 1997.

Conze 1891
Conze, A. *Berlin Königliche Museen-Beschreibung der antiken Skulpturen.* Berlin 1891.

Copies 1974
Copies as Originals: Translations in Media and Techniques. Exhib. cat., The Art Museum, Princeton University. Princeton 1974.

Corso 1988
Corso, A. *Prassitele: fonti epigrafiche e letterarie. Vita e opere 1. Xenia Quaderni* 10. Rome 1988.

Costantini 1995
Costantini S. *Il deposito votivo del santuario campestre di Tessennano.* Rome 1995.

Cristofani et al. 1975
Cristofani, M. et al. *Corpus delle urne etrusche di età ellenistica.* Vol. 1, *Urne Volterrane.* Part 1, *I complessi tombali.* Florence 1975.

Cumont 1942
Cumont, F. *Recherches sur le symbolisme funéraire des romains.* Paris 1942.

Ćurčić and St. Clair 1986
Ćurčić, S., and A. St. Clair, eds. *Byzantium at Princeton: Byzantine Art and Archaeology at Princeton University.* Princeton 1986.

Curtius 1931
Curtius, L. "Physiognomik des römischen Porträts." *Die Antike* 7 (1931): 226–54.

Curtius 1932
Curtius, L. "Ikonographische Beiträge." *RM* 47 (1932): 202–68.

Curtius 1944–45
Curtius, L. "Falsche Kameen." *AA* 1944–45, 1–24.

Curtius 1946
Curtius, L. "Dionysischer Sarkophag." *ÖJh* 36 (1946): 62–76.

Curto 1972
Curto, S. "Statua di Eracle con cornucopia." *BdA* 57 (1972): 255.

Dacos, Giuliani, and Pannuti 1973
Dacos, N., A. Giuliani, and U. Pannuti, eds. *Il tesoro di Lorenzo il Magnifico.* Vol. 1, *Le gemme.* Florence 1973.

D'Alessandro and Persegati 1987
D'Alessandro, L., and F. Persegati. *Scultura e calchi in gesso. Storia, tecnica e conservazione.* Rome 1987.

Daltrop 1958
Daltrop, G. *Die stadtrömischen männlichen Privatbildnisse Trajanischer und Hadrianischer Zeit.* Münster 1958.

Daltrop, Hausmann, and Wegner 1966
Daltrop, G., U. Hausmann, and M. Wegner. *Die Flavier. Das römische Herrscherbild* II.1. Berlin 1966.

Datsouli-Stavridi 1985
Datsouli-Stavridi, A. *Romaïka portraita sto Ethniko Archaiologiko Mouseio tis Athinas.* Athens 1985.

Datsouli-Stavridi 1987
Datsouli-Stavridi, A. *Romaïka portraita sto mouseio tis Spartis.* Athens 1987.

Datsouli-Stavridi 1989
Datsouli-Stavridi, A. "Antoninische Porträts in Dimitsana, Arkadien." *Boreas* 12 (1989): 135–36.

De Angeli 1992
De Angeli, S. *Templum Divi Vespasiani.* Rome 1992.

De Caro 1987
De Caro, S. "The Sculptures of the Villa of Poppaea at Oplontis: A Preliminary Report." In *Ancient Roman Villa Gardens,* ed. E. B. MacDougall, 77–133. Washington, D.C. 1987.

De Caro 1994
De Caro, S. *La villa rustica in località Villa Regina a Boscoreale.* Rome 1994.

De Franciscis 1972
De Franciscis, A. "Due ritratti di M. Aurelio." *RM* 79 (1972): 331–36.

Deichmann, Bovini, and Brandenburg 1967
Deichmann F. W., G. Bovini, and H. Brandenburg. *Repertorium der christlich-antiken Sarkophage.* Vol. 1, *Rom und Ostia.* Wiesbaden 1967.

De Koehne 1853
De Koehne, B. *Musée de sculpture antique de Mr. de Montferrand.* St. Petersburg 1853.

Delbrueck 1933
Delbrueck, R. *Spätantike Kaiserporträts von Konstantinus Magnus bis zum Ende des Westreichs.* Leipzig 1933.

Del Chiaro 1977
Del Chiaro, M. "Archaic Etruscan Stone Sculpture." *GettyMusJ* 5 (1977): 45–54.

Del Chiaro 1982
Del Chiaro, M. "Etruscan Stone Winged Lion." *GettyMusJ* 10 (1982): 123–26.

Delivorrias 1993
Delivorrias, A. "Lakoniká Anthémia." In *Sculpture from Arcadia and Laconia. Proceedings of an International Conference, Athens 1992*, 205–16. Oxford 1993.

Della Corte 1914
Della Corte, M. "Continuazione degli scavi sulla Via dell'Abbondanza."" *NSc* 1914, 103–12.

De Luca 1964
De Luca, G. "Piccolo torso femminile a Genova." *ArchCl* 16 (1964): 213–25.

De Luca 1976
De Luca, G. *I monumenti antichi di Palazzo Corsini in Roma*. Rome 1976.

Demsky 1986
Demsky, A. "When the Priests Trumpeted the Onset of the Sabbath." *Biblical Archaeology Review* 12.6 (1986): 50–52, 73–74.

Dentzer 1979
Dentzer, J.-M. "A propos du temple dit de 'Dusarès' à Sî'." *Syria* 56 (1979): 325–32.

Dentzer 1985
Dentzer, J.-M. "Six campagnes de fouilles à Sî': développement et culture indigène en Syrie méridionale." *DM* 2 (1985): 65–85.

Dentzer 1986
Dentzer, J.-M., ed. *Hauran I. Recherches archéologiques sur la Syrie du Sud à l'époque hellénistique et romaine. Deuxième partie*. Paris 1986.

Dentzer 1990
Dentzer, J.-M. "Neue Ausgrabungen in Sî' (Qanawât) und Bosra (1985–1987): Zwei einheimische Heiligtümer der vorkaiserzeitlichen Periode." In *Akten des XIII. Internationalen Kongresses für Klassische Archäologie, Berlin 1988*, 364–70. Mainz 1990.

Dentzer and Dentzer-Feydy 1991
Dentzer, J.-M., and J. Dentzer-Feydy, eds. *Le djebel al-'Arab. Histoire et patrimoine au Musée de Suweida*. Paris 1991.

Dentzer and Orthmann 1989
Dentzer, J.-M., and W. Orthmann, eds. *Archéologie et histoire de la Syrie*. Vol. 2, *La Syrie de l'époque achéménide à l'avènement de l'Islam*. Saarbrücken 1989.

Dentzer-Feydy 1990
Dentzer-Feydy, J. "Les chapiteaux ioniques de Syrie méridionale." *Syria* 67 (1990): 143–81.

Dentzer-Feydy 1997
Dentzer-Feydy, J. "Au Musée de Suweida: les linteaux sculptés de figures divines." *AAS* 41 (1997): 39–48.

De Ruyt 1983
De Ruyt, F. "L'originalité de la sculpture étrusque à Castro au VIe siècle avant J.-C." *AntCl* 52 (1983): 70–83.

Devijver and van Wontgerhem 1990
Devijver, H., and F. van Wontgerhem. "The Funerary Monuments of Equestrian Officers of the Late Republic and Early Empire in Italy, 50 B.C.–100 A.D." *AncSoc* 21 (1990): 59–98.

De Vogüé 1865–77
De Vogüé, M. *Syrie centrale. Architecture civile et religieuse du Ier au VIIe siècle*. Paris 1865–77.

Di Castro and Fox 1983
Di Castro, D., and S. P. Fox. *Disegni dell'antico dei secoli XVI e XVII. Xenia Quaderni 3*. Rome 1983.

Diebner 1982
Diebner, S. "Bosra: Die Skulpturen im Hof der Zitadelle." *RdA* 6 (1982): 52–71.

Dimas 1998
Dimas, S. *Untersuchungen zur Themenwahl und Bildgestaltung auf römischen Kindersarkophagen*. Münster 1998.

Dintsis 1986
Dintsis, P. *Hellenistische Helme*. Rome 1986.

Di Vita 1955
Di Vita, A. "L'Afrodite Pudica da Punta delle Sabbie ed il tipo della Pudica drappeggiata." *ArchCl* 7 (1955): 9–23.

Dolci 1980
Dolci, E. *Carrara: cave antiche*. Viareggio 1980.

Dolci 1988
Dolci, E. "Marmora Lunensia: Quarrying Geochemistry, Technology, Trade." In *Classical Marble: Geochemistry, Technology, Trade*, ed. N. Herz and M. Waelkens, 77–84. Dordrecht 1988.

Dontas 1966
Dontas, G. "Metapolemika tina gluptika prosktemata ton mouseion Rodou kai Ko." *ArchDelt* 21 (1966): 84–101.

Dorcey 1988
Dorcey, P. F. "A Reconsideration of the Silvanus Tondo on the Arch of Constantine in Rome." *AncW* 18 (1988): 107–20.

Dorcey 1992
Dorcey, P. F. *The Cult of Silvanus: A Study in Roman Folk Religion.* Leiden 1992.

Downey 1977
Downey, S. B. *The Stone and Plaster Sculpture. Excavations at Doura-Europos, Final Report III.1 and 2.* Los Angeles 1977.

Dragendorff 1895/96
Dragendorff, H. "Terra sigillata. Ein Betrag zur Geschichte der griechischen und römischen Keramik." *BJb* 96/97 (1895/96): 18–155.

Dragendorff and Watzinger 1948
Dragendorff, H., and C. Watzinger. *Arretinische Reliefkeramik.* Reutlingen 1948.

Dräger 1994
Dräger, O. *Religionem significare. Studien zu reich verzierten römischen Altären und Basen aus Marmor.* Mainz 1994.

Drerup 1980
Drerup, H. "Totenmaske und Ahnenbild bei den Römern." *RM* 87 (1980): 81–129.

Dresken-Weiland 1998
Dresken-Weiland, J., ed. *Repertorium der christlich-antiken Sarkophage.* Vol. 2, *Italien. Mit einem Nachtrag Rom und Ostia, Dalmatien, Museen der Welt.* Mainz 1998.

Dunand 1973
Dunand, F. *Le culte d'Isis dans le bassin oriental de la Méditerranée.* Vol. 1. Leiden 1973.

Dunand 1934
Dunand, M. *Le Musée de Soueida: inscriptions et monuments figurés. BAH* 20. Paris 1934.

Dütschke 1875
Dütschke, H. *Antike Bildwerken in Oberitalien.* Vol. 2, *Zerstreute antike Bildwerke in Florenz.* Leipzig 1875.

Dworakowska 1983
Dworakowska, A. *Quarries in Roman Provinces.* Wroclaw 1983.

Dwyer 1982
Dwyer, E. J. *Pompeian Domestic Sculpture: A Study of Five Pompeian Houses and Their Contents.* Rome 1982.

Eingartner 1991
Eingartner, J. *Isis und ihre Dienerinnen in der Kunst der römischen Kaiserzeit.* Leiden 1991.

Elderkin 1925
Elderkin, G. W. "The Museum of Historic Art. The Classical Collections: Sculpture." *Art and Archaeology* 20 (1925): 115–18.

Elderkin 1934
Elderkin, G. W., ed. *Antioch-on-the-Orontes.* Vol. 1, *The Excavations of 1932.* Princeton 1934.

Elderkin 1938
Elderkin, G. W. "Shield and Mandorla." *AJA* 42 (1938): 227–36.

Engemann 1973
Engemann, H. J. *Untersuchungen zur Sepulkralsymbolik der späteren römischen Kaiserzeit. Jahrbuch für Antike und Christentum,* Ergh. 2. Munich 1973.

Equini Schneider 1979
Equini Schneider, E. *Catalogo delle sculture romane del Museo Nazionale "G. A. Sanna" di Sassari e del comune di Porto Torres.* Sassari 1979.

Erhart Mottahedeh 1984
Erhart Mottahedeh, P. "The Princeton Bronze Portrait of a Woman with Reticulum." In *Studies in Honor of Leo Mildenberg,* ed. A. Houghton et al., 193–210. Wetteren 1984.

Evers 1994
Evers, C. *Les portraits d'Hadrien: typologie et ateliers.* Brussels 1994.

Fauffray 1940
Fauffray, J. "Une fouille au pied de l'acropolie de Byblos." *BMusBeyrouth* 4 (1940): 7–36.

Felletti Maj 1953
Felletti Maj, B. M. *Museo Nazionale Romano. I ritratti.* Rome 1953.

Ferrari 1966
Ferrari, G. *Il commercio dei sarcofagi asiatici.* Rome 1966.

Filges 1997
Filges, A. *Standbilder jugendlicher Göttinen: Klassische und frühhellenistische Gewandstatuen mit Brustwulst und ihre Kaiserzeitliche Rezeption.* Cologne 1997.

Fiorelli 1879
Fiorelli, G. "Pompei." *NSc* 1879, 240–43.

Fıratlı 1964
Fıratlı, N. *Les stèles funéraires de Byzance gréco-romaine.* Paris 1964.

Fittschen 1969a
Fittschen, K. "Bemerkungen zu den Porträts des 3. Jahrhunderts n. Chr." *JdI* 84 (1969): 206–11.

Fittschen 1969b
Fittschen, K. *Untersuchungen zum Beginn der Sagendarstellungen bei den Griechen.* Berlin 1969.

Fittschen 1971
Fittschen, K. "Zum angeblichen Bildnis des Lucius Verus im Thermen-Museum." *JdI* 86 (1971): 214–52.

Fittschen 1973
Fittschen, K. Review of Inan and Rosenbaum 1966. *GGA* 225 (1973): 46–67.

Fittschen 1976
Fittschen, K. "Zur Panzerstatue von Cherchel." *JdI* 91 (1976): 175–210.

Fittschen 1977a
Fittschen, K. *Katalog der antiken Skulpturen in Schloß Erbach. AF* 3. 1977.

Fittschen 1977b
Fittschen, K. Review of C. Saletti, *I ritratti antonini di Palazzo Pitti* (Florence 1974). *Gnomon* 49 (1977): 221–23.

Fittschen 1977c
Fittschen, K. "Antik oder nicht-antik?" In *Festschrift für Frank Brommer*, 93–99. Mainz 1977.

Fittschen 1979
Fittschen, K. "Sarkophage römischer Kaiser oder vom Nutzen der Porträtforschung." *JdI* 94 (1979): 578–93.

Fittschen 1982
Fittschen, K. *Die Bildnistypen der Faustina minor und die Fecunditas Augustae.* Göttingen 1982.

Fittschen 1991
Fittschen, K. "Zur Datierung des Mädchenbildnisses vom Palatin und einiger anderer Kinderporträts der mittleren Kaiserzeit." *JdI* 106 (1991): 297–309.

Fittschen 1992
Fittschen, K. "Der Tod der Kreusa und der Niobiden. Überlegungen zur Deutung griechischer Mythen auf römischen Sarkophagen. In *Giornate Pisane. Atti del IX Congresso della F.I.E.C., 24–30 agosto 1989. StIt* 10, ser. 3 (1992): 2:1046–60.

Fittschen 1993
Fittschen, K. "Das Bildnis des Kaisers Gallien aus Milreu. Zum Problem der Bildnistypologie." *MM* 34 (1993): 210–27.

Fittschen 1999
Fittschen, K. *Prinzenbildnisse antoninischer Zeit.* Mainz 1999.

Fittschen and Zanker 1983–85
Fittschen, K., and P. Zanker. *Katalog der römischen Porträts in den Capitolinischen Museen und den anderen kommunalen Sammlungen der Stadt Rom.* Vols. 1 and 3. Mainz 1983–85.

Flasch 1901
Flasch, A. "Die sog. Spinnerin." In *Festschrift seiner Königlichen Hoheit dem Prinzregenten Luitpold von Bayern zum 80sten Geburtstage.* Erlangen 1901.

Fless 1995
Fless, F. *Opferdiener und Kultmusiker auf stadtrömischen historischen Reliefs.* Mainz 1995.

Flower 2000
Flower, H. "*Damnatio memoriae* and Epigraphy." In Varner 2000, 58–69.

Fraser 1972
Fraser, P. M. *Ptolemaic Alexandria.* Oxford 1972.

Freke and Gandy 1999
Freke, T., and P. Gandy. *The Jesus Mysteries: Was the "Original Jesus" a Pagan God?* London 1999 and New York 2000.

Frel 1967
Frel, J. "ΔΙΟΝΥΣΟΣ ΛΗΝΑΙΟΣ." *AA* 1967, 28–34.

Frel 1982
Frel, J. *The Getty Bronze.* Malibu 1982.

Freyberger 1989
Freyberger, K. S. "Das Tychaïon von aṣ-Ṣanamaïn. Ein Vorbericht." *DM* 4 (1989): 87–108.

Freyberger 1991
Freyberger, K. S. "Der Tempel in Slīm: Ein Bericht." *DM* 5 (1991): 9–38.

Freyberger 1998
Freyberger, K. S. *Die frühkaiserzeitlichen Heiligtümer der Karawanenstationen im hellenisierten Osten. Damaszener Forschungen* 6. Mainz 1998.

Freyer-Schauenburg 1977
Freyer-Schauenburg, B. "Vulcanus oder Kabeiros." *BJb* 177 (1977): 185–97.

Friesen 1993
Friesen, S. J. *Twice Neokoros: Ephesus, Asia and the Cult of the Flavian Imperial Family.* New York 1993.

Fröhner 1878
Fröhner, W. *Notice de la sculpture antique du Musée National du Louvre.* 4th ed. Paris 1878.

Fuchs 1987
Fuchs, M. *Untersuchungen zur Ausstattung römischer Theater in Italien und den Westprovinzen des Imperium Romanum.* Mainz 1987.

Fuchs 1989
Fuchs, M. "Le sculture dello scavo Calabresi (1840)" and "Le sculture dello scavo Regolini (1846)." In Fuchs, Liverani, and Santoro 1989, 53–88 and 89–115.

Fuchs 1992
Fuchs, M. *Römische Idealplastik. Glyptothek München, Katalog der Skulpturen.* Vol. 6. Munich 1992.

Fuchs 1997
Fuchs, M. "Besser als sein Ruf: Neue Beobachtungen zum Nachleben des Kaisers Nero in Spätantike und Renaissance." *Boreas* 20 (1997): 83–96.

Fuchs 1998
Fuchs, M. "Aurea aetas: ein glückverheißendes Sibyllinum im großen Oecus der Villa von Boscoreale." *JdI* 113 (1998): 91–108.

Fuchs 1999a
Fuchs, M. *In hoc etiam genere graeciae nihil cedamus. Studien zur Romanisierung des späthellenistischen kunst im 1. Jh. v. Chr.* Mainz 1999.

Fuchs 1999b
Fuchs, M. "Hoffnungsträger der res publica: Zur Authentizität des Pompeius, Typus Kopenhagen 597." In Steuben 1999, 131–35.

Fuchs 2001
Fuchs, M. *Römische Reliefwerke. Glyptothek München, Katalog der Skulpturen.* Vol. 7. Munich 2001.

Fuchs, Liverani, and Santoro 1989
Fuchs, M., P. Liverani, and P. Santoro. *Caere 2: Il teatro e il ciclo statuario giulio-claudio,* ed. P. Santoro. Rome 1989.

Fuchs 1963
Fuchs, W. *Der Schiffsfund von Mahdia.* Tübingen 1963.

Fuchs 1969
Fuchs, W. *Die Skulptur der Griechen.* Munich 1969.

Fullerton 1990
Fullerton, M. D. *The Archaistic Style in Roman Statuary.* Leiden and New York 1990.

Furtwängler 1903
Furtwängler, A. *Einhundert Tafeln nach Bildwerken der Kgl. Glyptothek zu München.* Munich 1903.

Furtwängler and Wolters 1910
Furtwängler, A., and P. Wolters. *Beschreibung der Glyptothek König Ludwig's I.* 2d ed. Munich 1910.

Galliazzo 1976
Galliazzo, V. *Sculture greche e romane del Museo Civico di Vicenza.* Treviso 1976.

García y Bellido 1949
García y Bellido, A. *Esculturas romanas de España y Portugal.* Madrid 1949.

Gassner 1985
Gassner, V. "Tabernen im Sepulkralbereich." In *Lebendige Altertumswissenschaft. Festgabe zur Vollendung des 70. Lebensjahres von H. Vetters,* 165–69. Vienna 1985.

Gauer 1998
Gauer, W. *Kwartalnik Historii Kultury Materialnej* 1–2 (1998).

Geist and Pfohl 1976
Geist, H., and G. Pfohl. *Römische Grabinschriften.* 2d ed. Munich 1976.

Geppert 1996
Geppert, S. *Castor und Pollux.* Münster 1996.

Gercke 1968
Gercke, W. B. *Untersuchungen zum römischen Kinderporträt.* Hamburg 1968.

Gergel 1986
Gergel, R. A. "An Allegory of Imperial Victory on a Cuirassed Statue of Domitian." *Record* 45.1 (1986): 2–15.

Gergel 1987
Gergel, R. A. "A Julio-Claudian Torso in the Walters Art Gallery." *JWalt* 45 (1987): 19–31.

Gerke 1940
Gerke, F. *Die christlichen Sarkophage der vorkonstantinischen Zeit.* Berlin 1940.

Ghedini 1980
Ghedini, F. *Sculture greche e romane del Museo Civico di Padova.* Rome 1980.

Ghiandoni 1995
Ghiandoni, O. "Il sarcofago asiatico di Melfi: ricerche mitologiche, iconografiche, e stilistiche." *BdA* 89–90 (1995): 1–58.

Giuliani 1986
Giuliani, L. *Bildnis und Botschaft.* Munich 1986.

Giuliano 1957
Giuliano, A. *Museo Profano Lateranense. Catalogo dei ritratti romani.* Vatican City 1957.

Giuliano 1979
Giuliano, A., ed. *Museo Nazionale Romano. Le sculture.* Vol. 1, pt. 1. Rome 1979.

Giuliano 1982
Giuliano, A., ed. *Museo Nazionale Romano. Le sculture.* Vol. 1, pt. 3. Rome 1982.

Giuliano 1985a
Giuliano, A. "Un quarto rilievo della serie Grimani." *Xenia* 9 (1985): 41–46.

Giuliano 1985b
Giuliano, A., ed. *Museo Nazionale Romano. Le sculture.* Vol. 1, pt. 8. Rome 1985.

Giuliano 1986
Giuliano, A., ed. *Museo Nazionale Romano. Le sculture.* Vol. 1, pt. 6. Rome 1986.

Giumlia 1983
Giumlia, A. *Die neuattischen Doppelhermen.* Vienna 1983.

Glueck 1965
Glueck, N. *Deities and Dolphins. The Story of the Nabataeans.* New York 1965.

Goethert 1972

Goethert, F. W. *Katalog der Antikensammlung des Prinzen Carl v. Preussen im Schloss zu Klein-Glienicke bei Potsdam.* Mainz 1972.

Goethert 1992

Goethert, K.-P. "Leihgaben und Neuerwerbungen der Original- und Abguss-Sammlung in den Jahren 1989–1991." In Pfrommer 1992, 91–102.

Golvin and Landes 1990

Golvin, J.-C., and C. Landes. *Amphitheatres et gladiateurs.* Paris 1990.

Graf 1992

Graf, D. F. "The Syrian Hauran." *JRA* 5 (1992): 450–66.

Graindor 1938

Graindor, P. *Bustes et statues-portraits d'Égypte romaine.* Cairo ca. 1938.

Gregori 1987/88

Gregori, G. L. "Horti sepulchrales e cepotaphia nelle iscrizioni urbane." *BullCom* 92 (1987/88): 172–88.

Griffin 1984

Griffin, M. *Nero: The End of a Dynasty.* London 1984.

Griffo 1987

Griffo, P. *Il Museo Regionale Archeologico di Agrigento.* Rome 1987.

Grimm 1974

Grimm, G. *Die römischen Mumienmasken aus Ägypten.* Wiesbaden 1974.

Grimm 1975

Grimm, G. *Kunst der Ptolemäer- und Römerzeit im Ägyptischen Museum Kairo.* Mainz 1975.

Grimm 1976

Grimm, G. "Ein neues Bildnis Vespasians aus Ägypten." In *Festschrift für G. Kleiner,* 101–3. Tübingen 1976.

Grimm 1978

Grimm, G. *Götter und Pharaonen, Ausstellung Katalog Essen– München–Hildesheim 1978/79.* Mainz 1978.

Grimm 1989

Grimm, G. "Die Porträts der Triumvirn C. Octavius, M. Antonius und M. Aemilius Lepidus." *RM* 96 (1989): 347–64.

Gross 1940

Gross, W. H. *Bildnisse Trajans.* Berlin 1940.

Gualandi 1969

Gualandi, G. "Artemis-Hekate. Un problema di typologia nella sculptura ellenistica." *RA* 1969, 233–72.

Gütschow 1938

Gütschow, M. *Das Museum der Prätextat-Katakombe.* MemPontAcc 4. 2. Vatican City 1938.

Habicht 1982

Habicht, C. "Eine Liste von Hieraopoioi aus dem Jahre des Archons Andreas." *AM* 97 (1982): 178–84.

Hackländer 1996

Hackländer, N. *Der archaistische Dionysos: Eine archäologische Untersuchung zur Bedeutung archaistischer Kunst in hellenistischer und römischer Zeit.* Frankfurt 1996.

Hacklin et al. 1954

Hacklin, J. et al. *Nouvelles recherches archéologiques à Begram. Mémoirs de la délégation archéologique française en Afghanistan.* Vol. 11. Paris 1954.

Hafner 1961

Hafner, G. *Ein Apollon-Kopf in Frankfurt und die Niobiden– Gruppe des 5. Jahrhunderts.* Baden-Baden 1961.

Haider, Hutter, and Kreuzer 1996

Haider, P. W., M. Hutter, and S. Kreuzer, eds. *Religionsgeschichte Syriens.* Stuttgart, Berlin, and Cologne 1996.

Hallett 1995

Hallett, C. H. "Kopienkritik and the Works of Polykleitos." In Moon 1995, 121–60.

Hamiaux 1992

Hamiaux, M. *Musée du Louvre. Les sculptures grecques.* Vol. 1. Paris 1992.

Hamiaux 1998

Hamiaux, M. *Musée du Louvre. Les sculptures grecques.* Vol. 2. Paris 1998.

Hanfmann 1966

Hanfmann, G. M. A. "A Hellenistic Landscape Relief." *AJA* 70 (1966): 371–73.

Hanfmann 1975

Hanfmann, G.M.A. *Roman Art.* New York and London 1975.

Hanfmann and Ramage 1978

Hanfmann, G. M. A., and N. H. Ramage. *Sculpture from Sardis: The Finds through 1975. Archaeological Exploration of Sardis,* Report 2. Cambridge, Mass. 1978.

Häuber 1986

Häuber, C. "I nuovi ritrovamenti." In *Le tranquille dimore degli dei,* ed. M. Cima and E. La Rocca, 173–200. Exhib. cat., Palazzo dei Conservatori. Rome 1986.

Häuber 1990

Häuber, C. "Zur Topographie der Horti Maecenatis und der Horti Lamiani auf dem Esquilin in Rom." *KölnJb* 23 (1990): 11–107.

Häuber 1991

Häuber, C. *Horti Romani. Die Horti Maecenatis und die Horti Lamiani auf dem Esquilin. Geschichte, Topographie, Statuenfunde.* Cologne 1991.

Haynes 1985
Haynes, S. *Etruscan Bronzes*. New York 1985.

Heiderich 1966
Heiderich, G. *Asklepios*. Giessen 1966.

Heinen 1980
Heinen, H. "Zwei neue römische Soldatengrabsteine aus Ägypten." *ZPE* 38 (1980): 115–24.

Hekler 1909
Hekler, A. "Römische weibliche Gewandstatuen." In *Münchener archäologische Studien dem andenken A. Furtwänglers gewidmet*, 109–248. Munich 1909.

Held 1959
Held, J. S. *Rubens: Selected Drawings*. London 1959.

Hellenkemper-Salies 1981
Hellenkemper-Salies, G., ed. *Die Nabatäer*. Exhib. cat., Rheinisches Landesmuseum. Bonn 1981.

Hepding 1907
Hepding, H. "Die Arbeiten zu Pergamon 1904–1905, III: Die Einzelfunde." *AM* 32 (1907): 378–414.

Herdejürgen 1995
Herdejürgen, H. "Ein Sarkophagfragment im Palazzo Corsetti in Rom." *RM* 102 (1995): 387–90.

Herdejürgen 1996
Herdejürgen, H. *Die antiken Sarkophagreliefs*. Vol. 6, pt. 2, fasc. 1, *Stadtrömische und italische Girlandensarkophage*. Berlin 1996.

Hermary 1983
Hermary, A. "Deux têtes en marbre trouvées à Amathonte." *BCH* 107 (1983): 292–99.

Herrmann 1993
Herrmann, A. "A Hellenistic Portrait Head." *GettyMusJ* 21 (1993): 29–42.

Herrmann 1925
Herrmann, P. *Verzeichnis der antiken Originalbildwerke der staatlichen Skulpturensammlung zu Dresden*. 2d ed. Dresden 1925.

Hesberg 1979
Hesberg, H. von. "Einige Statuen mit bukolischer Bedeutung in Rom." *RM* 86 (1979): 297–317.

Hesberg 1992
Hesberg, H. von. *Römische Grabbauten*. Darmstadt 1992.

Hettner 1881
Hettner, H. *Die Bildwerke der Kgl. Antikensammlung zu Dresden*. 4th ed. Dresden 1881.

Hiesinger 1975
Hiesinger, U. W. "The Portraits of Nero." *AJA* 79 (1975): 113–24.

Hillers and Cussini 1995
Hillers, D. R., and E. Cussini. *Palmyrene Aramaic Texts*. Baltimore 1995.

Himmelmann 1973
Himmelmann, N. *Typologische Untersuchungen an römischen Sarkophagreliefs des 3. und 4. Jhs. n. Chr.* Mainz 1973.

Himmelmann 1980
Himmelmann, N. *Über Hirten–Genre in der antiken Kunst*. Abhandlungen der Rheinisch–Westfälischen Akademie der Wissenschaften 65. Opladen 1980.

Himmelmann 1986
Himmelmann, N. "Eine frühhellenistische Dionysos-Statuette aus Attika." In *Studien zur Klassischen Archäologie. Friedrich Hiller zu seinem 60. Geburtstag*, 43–54. Saarbrücken 1986.

Himmelmann 1989
Himmelmann, N. *Herrscher und Athlet*. Exhib. cat., Universität Bonn, Akademisches Kunstmuseum. Bonn 1989.

Himmelmann 1998
Himmelmann, N. "The Stance of the Polykleitan Diadoumenos." In *Reading Greek Art. Essays by Nikolaus Himmelmann*, ed. W. Childs, 156–86. Princeton 1998.

Hoffmann 1969
Hoffmann, H. "Erwerbungsbericht des Museums für Kunst und Gewerbe Hamburg 1963–1969." *AA* 1969, 318–77.

Hoffmann 1970
Hoffmann, H. *Ten Centuries That Shaped the West*. Exhib. cat., Rice University, Institute for the Arts. Houston 1970.

Hofkes-Brukker and Mallwitz 1975
Hofkes-Brukker, C., and A. Mallwitz. *Der Bassae Fries*. Munich 1975.

Hofter 1988
Hofter, M. "Porträt." In *Kaiser Augustus und die verlorene Republik*, 291–343. Exhib. cat., Martin-Gropius-Bau. Berlin 1988.

Holmes 1965
Holmes, J. *Chichester: The Roman Town*. Chichester 1965.

Hölscher 1967
Hölscher, T. *Victoria Romana*. Mainz 1967.

Homès-Fredericq 1980
Homès-Fredericq, D., ed. *Inoubliable Petra. Le royaume nabatéen aux confins du désert*. Exhib. cat., Musées Royaux d'Art et d'Histoire. Brussels 1980.

Horn 1931
Horn, R. *Stehende weibliche Gewandstatuen in der hellenistischen Plastik.* RM Ergh. 2. Munich 1931.

Humphrey 1986
Humphrey, J. *Roman Circuses: Arenas for Chariot Racing.* London 1986.

Hus 1961
Hus, A. *Recherches sur les statuaires en pierre étrusque archaïque.* Paris 1961.

Huskinson 1996
Huskinson, J. *Roman Children's Sarcophagi: Their Decoration and Its Social Significance.* Oxford 1996.

Inan 1975
Inan, J. *Roman Sculpture in Side.* Ankara 1975.

Inan and Rosenbaum 1966
Inan, J., and E. Rosenbaum. *Roman and Early Byzantine Portrait Sculpture in Asia Minor.* London 1966.

Inan and Alföldi-Rosenbaum 1979
Inan, J., and E. Alföldi-Rosenbaum. *Römische und frühbyzantinische Porträtplastik aus der Türkei: Neue Funde.* Mainz 1979.

Ingholt 1928
Ingholt, H. *Studier over palmyrensk Skulptur.* Copenhagen 1928.

Ingholt 1935
Ingholt, H. "Five Dated Tombs from Palmyra." *Berytus* 2 (1935): 57–120.

Janson 1957/1963
Janson, H. W. *The Sculpture of Donatello.* Princeton 1957. Rev. ed. 1963.

Jashemski 1979
Jashemski, W. F. *The Gardens of Pompeii, Herculanum, and the Villas Destroyed by Vesuvius.* New Rochelle 1979.

Jashemski 1993
Jashemski, W. F. *The Gardens of Pompeii, Herculaneum, and the Villas Destroyed by Vesuvius.* Vol. 2, *Appendices.* New Rochelle 1993.

Jenkins and Williams 1985
Jenkins, I., and D. Williams. "Sprang Hair Nets." *AJA* 89 (1985): 411–18.

Jenkins and Williams 1987
Jenkins, I., and D. Williams. "A Bronze Portrait Head and Its Hair Net." *Record* 46.2 (1987): 9–19.

Johansen 1994
Johansen, F. *Roman Portraits I: Ny Carlsberg Glyptotek.* Copenhagen 1994.

Johansen 1995
Johansen, F. *Roman Portraits II: Ny Carlsberg Glyptotek.* Copenhagen 1995.

Jones 1954a
Jones, F. F. "Welcome Back, William." *Record* 13.2 (1954): 22–23.

Jones 1954b
Jones, F. F. "The Princeton Art Museum: Antiquities Received in Recent Years." *Archaeology* 7 (1954): 237–43.

Jones 1960
Jones, F. F. *Ancient Art in The Art Museum, Princeton University.* Princeton 1960.

Jones, Martindale, and Morris 1971
Jones, A. H. M., J. R. Martindale, and J. Morris. *The Prosopography of the Later Roman Empire.* Vol. 1, A.D. 260–395. Cambridge 1971.

Jongste 1992
Jongste, P. *The Twelve Labours of Hercules on Roman Sarcophagi.* Rome 1992.

Josephson 1997
Josephson, J. A. *Egyptian Royal Sculpture of the Late Period.* Mainz 1997.

Jucker 1961
Jucker, H. *Das Bildnis im Blätterkelch.* Basel 1961.

Jucker 1981a
Jucker, H. "Römische Herrscherbildnisse aus Ägypten." *ANRW* II 12.2 (1981): 667–724.

Jucker 1981b
Jucker, H. "Iulisch-Claudische Kaiser- und Prinzenporträts als 'Palimpseste.'" *JdI* 96 (1981): 236–316.

Jucker 1983
Jucker, H. "Marmorporträts aus dem römischen Ägypten: Beobachtungen, Vorschläge und Fragen." In *Das römisch-byzantinische Ägypten. Akten des internationalen Symposions, Trier 1978,* 139–49. Mainz 1983.

Jucker 1991
Jucker, I. *Italy of the Etruscans.* Exhib. cat., The Israel Museum, Jerusalem. Mainz 1991.

Jung 1986
Jung, H. "Die Reliefbasis Athen Nationalmuseum 1463. Spätklassisch oder neuattisch?" *MarbWPr* 1986, 16–28.

Kabus-Jahn 1962
Kabus-Jahn, R. *Studien zu Frauenfiguren des vierten Jahrhunderts v. Chr.* Darmstadt 1962.

Kabus-Jahn 1975
Kabus-Jahn, R. "Statuettengruppe aus dem Demeterheiligtum bei Kyparissi auf Kos." *AntP* 15 (1975): 31–64.

Kaiser 1999
Kaiser, W. "Zur Datierung realistischer Rundbildnisse ptolemäisch-römischer Zeit." *MDIK* 55 (1999): 237–63.

Kapossy 1969
Kapossy, B. *Brunnenfiguren der hellenistischen und römischen Zeit.* Zürich 1969.

Karageorghis and Vermeule 1964
Karageorghis, V., and C. Vermeule. *Sculpture from Salamis.* Vol. 1. Nicosia 1964.

Karageorghis and Vermeule 1966
Karageorghis, V., and C. Vermeule. *Sculpture from Salamis.* Vol. 2. Nicosia 1966.

Kelleher 1963
Kelleher, P. J. "College Museum Notes." *The Art Journal* 23.1 (1963): 46.

Kennedy 1995
Kennedy, D. "The Publications of the Princeton University Archaeological Expeditions to Syria in 1904–5 and 1909 Relating to Syria." *PEQ* 127 (1995): 21–32.

Kent, Overbeck, and Stylow 1973
Kent, J. P. C., B. Overbeck, and A. U. Stylow. *Die römische Münze.* Munich 1973.

Kerényi 1976
Kerényi, C. *Dionysos: Archetypal Image of Indestructible Life.* Princeton 1976.

Kersauson 1986
Kersauson, K. de. *Musée du Louvre. Catalogue des portraits romains.* Vol. 1. Paris 1986.

Kersauson 1996
Kersauson, K. de. *Musée du Louvre, Catalogue des portraits romains.* Vol. 2. Paris 1996.

Kienast 1982
Kienast, D. *Augustus: Prinzeps und Monarch.* Darmstadt 1982.

Kinney 1997
Kinney, D. "*Spolia, damnatio* and *renovatio memoriae.*" *MAAR* 42 (1997): 117–48.

Kiss 1984
Kiss, Z. *Études sur le portrait romain en Égypte.* Warsaw 1984.

Klauser 1966
Klauser, T. *Frühchristliche Sarkophage in Bild und Wort.* AntK-BH 3. Olten 1966.

Klein 1898
Klein, W. *Praxiteles.* Leipzig 1898.

Klein 1921
Klein, W. *Vom antiken Rokoko.* Vienna 1921.

Kleiner 1987
Kleiner, D. E. E. *Roman Imperial Funerary Altars with Portraits.* Rome 1987.

Kleiner 1992
Kleiner, D. E. E. *Roman Sculpture.* New Haven 1992.

Kleiner and Matheson 1996
Kleiner, D. E. E., and S. B. Matheson, eds. *I Claudia: Women in Ancient Rome.* Exhib. cat., Yale University Art Gallery. New Haven 1996.

Kleiner 1942
Kleiner, G. *Tanagrafiguren.* JdI Ergh. 15. Berlin 1942.

Kluge and Lehmann-Hartleben 1927
Kluge, K., and K. Lehmann-Hartleben. *Die antiken Großbronzen.* Vol. 1. Berlin and Leipzig 1927.

Koch 1988
Koch, G. *Roman Funerary Sculpture: Catalogue of the Collections. The J. Paul Getty Museum.* Malibu 1988.

Koch 1993
Koch, G., ed. *Grabeskunst der römischen Kaiserzeit.* Mainz 1993.

Koch 1997
Koch, G. "Zu einigen Sarkophagen vorkonstantinischer Zeit in Rom." In *Vom Orient bis an den Rhein. Begegnungen mit der christlichen Archäologie. Festschrift Peter Poscharsky,* ed. U. Lange and R. Sörries, 191–206. Dettelbach 1997.

Koch and Sichtermann 1982
Koch, G., and H. Sichtermann. *Römische Sarkophage.* Munich 1982.

Kockel 1993
Kockel, V. *Porträtreliefs stadtrömischer Grabbauten.* Mainz 1993.

Koeppel 1985
Koeppel, G. "Die historischen Reliefs der römischen Kaiserzeit, III. Stadtrömische Denkmäler unbekannter Bauzugehörigkeit aus trajanischen Zeit." *BJb* 185 (1985): 143–213.

Kohler 1960
Kohler, E. "An Etruscan Tomb Guardian." *Expedition* 2.2 (1960): 25–27.

Kondoleon 2000
Kondoleon, C., ed. *Antioch: The Lost Ancient City.* Exhib. cat., Worcester Art Museum. Princeton 2000.

Konstantinopoulos 1977
Konstantinopoulos, G. *Die Museen von Rhodos 1: Das Archäologische Museum.* Athens 1977.

Koortbojian 1995
Koortbojian, M. *Myth, Meaning, and Memory on Roman Sarcophagi.* Berkeley 1995.

Kranz 1984
Kranz, P. *Jahreszeiten-Sarkophage.* Berlin 1984.

Kreeb 1988
Kreeb, M. *Untersuchungen zur figürlichen Ausstattung delischer Privathäuser.* Chicago 1988.

Kreikenbom 1990
Kreikenbom, D. *Bildwerke nach Polyklet.* Berlin 1990.

Krug 1968
Krug, A. *Binden in der griechischen Kunst.* Hösel 1968.

Krull 1985
Krull, D. *Der Herakles vom Typus Farnese.* Frankfurt and New York 1985.

Kruse 1975
Kruse, H. J. *Römische weibliche Gewandstatuen des zweiten Jahrhunderts v. Chr.* Göttingen 1975.

Kruse-Berdoldt 1975
Kruse-Berdoldt, V. *Kopienkritische Untersuchungen zu den Porträts des Epikur, Metrodor und Hermarch.* Ph.D. diss., Göttingen 1975.

Kuhnen 1990
Kuhnen, H.-P. *Palästina in griechisch-römischer Zeit.* Munich 1990.

Künzl 1975
Künzl, E. "Eine Silberkanne mit Kentauromachie aus Pompeji." *JRGZM* 22 (1975): 62–80.

Kurz 1954
Kurz, O. "Begram et l'occidente gréco-romain," in Hacklin et al. 1954, 89–150.

Kyrieleis 1973
Kyrieleis, H. "Kathaper Hermes kai Horos." *AntP* 12 (1973): 133–47.

Kyrieleis 1975
Kyrieleis, H. *Bildnisse der Ptolemäer.* Berlin 1975.

Kyrieleis 1986
Kyrieleis, H. "Theoi Horatoi. Zur Sternsymbolik hellenistische Herrscherbilness." In *Studien zur Klassischen Archäologie: F. Hiller zu seinem 60. Geburtstag am 12. März 1986,* 55–72. Saarbrucken 1986.

Lanciani, Hermanin, and Paribeni 1919
Lanciani, R., F. Hermanin, and R. Paribeni. "Sull'autenticità di una testa di bronzo." *Ausonia* 9 (1919): 123–38.

Land des Baal 1982
Land des Baal. Syrien—Forum der Völker und Kulturen. Katalog Museum für Vor- und Frühgeschichte Berlin. Mainz 1982.

Landes 1990
Landes, C. *Le cirque et les courses de chars, Rome-Byzance.* Aix-en-Provence 1990.

Landwhehr 1985
Landwhehr, C. *Die antiken Gipsabgüsse aus Baiae. Greichische Bronzestatuen in Abgüssen römischer Zeit.* Berlin 1985.

Lange 1996
Lange, U. *Ikonographisches Register für das Repertorium der christlich–antiken Sarkophage.* Vol. 1, *Rom und Ostia.* Dettelsbach 1996.

La Rocca 1983
La Rocca, E. *Ara Pacis Augustae: in occasione del restauro della fronte orientale.* Rome 1983.

La Rocca 1990
La Rocca, E. "Linguaggio artistico e ideologia politica a Roma in età repubblicana." In Pugliese Carratelli 1990, 289–495.

La Rocca 1994
La Rocca, E. "Arcus et arae Claudii." In Strocka 1994, 273–78.

Lassus 1938
Lassus, J. "Une villa de plaisance à Daphné-Yakto." In Stillwell 1938, 95–147.

Lattimore 1962
Lattimore, R. *Themes in Greek and Latin Epitaphs.* Urbana 1962.

Laubscher 1982
Laubscher, H.P. *Fischer und Landleute.* Mainz 1982.

Laurenzi 1939
Laurenzi, L. "Rilievi e statue d'arte rodia." *RM* 54 (1939): 42–65.

Laviosa 1964
Laviosa, C. *Scultura tardo-etrusca di Volterra.* Exhib. cat. Florence 1964.

Lawrence 1928
Lawrence, M. "A Sarcophagus at Lanuvium." *AJA* 32 (1928): 421–34.

Lawrence 1951
Lawrence, M. "Additional Asiatic Sarcophagi." *MAAR* 20 (1951): 115–66.

Lawton 1995
Lawton, C.L. *Attic Document Reliefs: Art and Politics in ancient Athens.* Oxford 1995.

Le Bas and Waddington 1870
Le Bas, P., and W. H. Waddington. *Inscriptions grecques et latines recueillies en Asie Mineure II. Textes en minuscules et explications. Voyage archéologique en Grèce et Asie Mineure.* Paris 1870.

Le Corsu 1977
Le Corsu, F. *Isis: Mythe et mystère.* Paris 1977.

Lehmann 1973
Lehmann, P. W. *Skopas in Samothrace.* Northampton, Mass. 1973.

Levi 1944
Levi, D. "A Chalk Bust from Chichester." *Record* 3.2 (1944): 9–18.

Levi 1947
Levi, D. *Antioch Mosaic Pavements.* Princeton 1947.

Lindner 1986
Lindner, M., ed. *Petra. Neue Ausgrabungen und Entdeckungen.* Munich and Bad Windsheim 1986.

Lindner and Zeitler 1991
Lindner, M., and J. P. Zeitler, eds. *Petra. Königin der Weihrauchstrasse.* Fürth 1991.

Linfert 1973
Linfert, A. "Der Torso von Milet." *AntP* 12 (1973): 81–90.

Linfert 1976
Linfert, A. *Kunstzentren hellenistischer Zeit. Studien an weiblichen Gewandfiguren.* Wiesbaden 1976.

Linfert 1992
Linfert, A. *Die antiken Skulpturen des Musée Municipal von Château–Gontier.* Mainz 1992.

Linfert 1993
Linfert, A. "Aus Anlaß neuer Repliken des Westmacottschen Epheben und des Dresdener Knaben." In Beck and Bol 1993, 141–92.

Linfert-Reich 1971
Linfert-Reich, I. *Musen- und Dichterinnenfiguren des vierten und frühen dritten Jahrhunderts.* Cologne 1971.

Lippold 1923
Lippold, G. *Kopien und Umbildungen griechischer Statuen.* Munich 1923.

Lippold 1950
Lippold, G. *Die griechische Plastik.* Munich 1950.

Lippold 1956
Lippold, G. *Die Skulpturen des Vaticanischen Museums.* Vol. 3, pt. 2. Berlin 1956.

Liverani 1993
Liverani, P. "Il Doriforo del Braccio Nuovo e l'Efebo tipo Westmacott di Castel Gandolfo." In Beck and Bol 1993, 117–40.

Loeschke 1880
Loeschke, G. "Die Catagusa des Praxiteles." *AZ* 38 (1880): 102.

Lorenz 1972
Lorenz, T. *Polyklet.* Wiesbaden 1972.

Lorenz 1993
Lorenz, T. "Annäherung an des Werk Polyklets." *StädelJb* 14 (1993): 7–18.

Lulof and Kars 1994
Lulof, P. S., and H. Kars. "Early Etruscan Stone Sculpture." *BABesch* 69 (1994): 49–61.

Lützow 1869
Lützow, K. von. *Münchner Antiken.* Munich 1869.

MacAdam 1986
MacAdam, H. I. *Studies in the History of the Roman Province of Arabia: The Northern Sector. BAR-IS* 295. Oxford 1986.

Macridy 1912
Macridy, T. "Un hiéron d'Artemis Polo à Thasos." *JdI* 27 (1912): 1–19.

Maderna-Lauter 1990
Maderna-Lauter, C. "Polyklet in Rom." In Beck, Bol, and Bückling 1990, 328–92.

Manodori 1982
Manodori, A. *Anfiteatri, circhi, e stadi di Roma.* Rome 1982.

Mansuelli 1958
Mansuelli, G. A. *Galleria degli Uffizi. Le Sculture.* Vols. 1 and 2. Rome 1958.

Mari 1991
Mari, Z. *Forma Italiae 35. Tibur 4.* Florence 1991.

Marquardt 1995
Marquardt, N. *Pan in der hellenistischen und kaiserzeitlichen Plastik.* Bonn 1995.

Martin 1987
Martin, H. G. *Römische Tempelkultbilder.* Rome 1987.

Martin 1969
Martin, J. R. *Rubens: The Antwerp Altarpieces.* New York 1969.

Massner 1988
Massner, A.-K. "Corona civica." *AM* 103 (1988): 239–50.

Mastrocinque 1998
Mastrocinque, A. *Studi sul mitraismo: il mitraismo e la magia.* Rome 1998.

Matheson 1994
Matheson, S. B. *An Obsession with Fortune: Tyche in Greek and Roman Art. Yale Unversity Art Gallery Bulletin.* New Haven 1994.

Matheson 1996
Matheson, S. *Polygnotos and Vase Painting in Classical Athens.* Madison 1996.

Mattingly and Sydenham 1923
Mattingly, H., and E. A. Sydenham. *The Roman Imperial Coinage I: Augustus to Vitellius.* London 1923.

Mattusch 1996
Mattusch, C. C. *The Fire of Hephaistos: Large Classical Bronzes from North American Collections.* Exhib. cat., Harvard University Art Museums. Cambridge 1996.

Matz 1891
Matz, F. *Antike Bildwerke in Rom mit Ausschluß der größeren Sammlungen.* Ed. F. von Duhn. Leipzig 1891.

Matz 1963
Matz, F. *Archäologische Untersuchungen zum Dionysoskult in hellenistischer und römischer Zeit. Abhandlungen des Geistes- und Sozialwissenschaftlichen Klasse, Akademie der Wissenschaften und der Literatur in Mainz 15.* Wiesbaden 1963.

Matz 1968
Matz, F. *Die Dionysischen Sarkophage. ASR* iv.1, 2. Berlin 1968.

Matz 1969
Matz, F. *Die Dionysischen Sarkophage. ASR* iv.3. *Die Denkmäler 162–245.* Berlin 1969.

Matz 1975
Matz, F. *Die Dionysischen Sarkophage. ASR* iv.4. *Die Denkmäler 246–285, Nachträge.* Berlin 1975.

Maurer and Maurer 1980
Maurer, J.-P., and G. Maurer. *Petra. Frühe Felsarchitektur in Jordanien.* 2d ed. Hannover 1980.

McCann 1978
McCann, A. M. *Roman Sarcophagi in the Metropolitan Museum of Art.* New York 1978.

Meischner 1984
Meischner, J. "Privatporträts aus den Regierungsjahren des Elagabal und Severus Alexander (218–235)." *JdI* 99 (1984): 319–51.

Mercklin 1962
Mercklin, E. von. *Antike Figuralkapitelle.* Berlin 1962.

Merkelbach 1984
Merkelbach, R. *Mithras.* Königstein/Ts. 1984.

Merker 1973
Merker, G. S. *The Hellenistic Sculpture of Rhodos.* Goteborg 1973.

Merklein and Wenning 1997
Merklein, H., and R. Wenning. "Die Götter in der Welt der Nabatäer." In Weber and Wenning 1997, 105–10.

Meyer 1985
Meyer, H. "Vibullius Polydeukion: ein archäologisch-epigraphischer Problemfall." *AM* 100 (1985): 393–404.

Meyer 1986a
Meyer, H. "Der Berg Athos als Alexander." *RdA* 10 (1986): 22–30.

Meyer 1986b
Meyer, H. "Zu römischen Umbestattungen. (Noch eine Behauptung des Balbinus.)" *BollMC* 91.2 (1986) 279–90.

Meyer 1987
Meyer, H. *Der weiße und der rote Marsyas.* Munich 1987.

Meyer 1989
Meyer, H. "Zu Polydeukion, dem Archon Dionysios und W. Amelung in Boreas 11, 1988, 62 ff." *Boreas* 12 (1989): 119–22.

Meyer 1991
Meyer, H. *Antinoos. Die archäologischen Denkmäler unter Einbeziehung des numismatischen und epigraphischen Materials sowie der literarischen Nachrichten.* Munich 1991.

Meyer 1993
Meyer, H. "A Cycle of One? On the Meaning of a Puzzling Figure on the Princeton Dionysiac Sarcophagus." *RdA* 17 (1993): 51–53.

Meyer 1995
Meyer, H. "A Roman Masterpiece: The Minneapolis Doryphoros." In Moon 1995, 65–115.

Meyer 1996a
Meyer, H. "The Terme Ruler. An Understudied Masterpiece and the School of Lysippos." *BullCom* 97 (1996): 125–48.

Meyer 1996b
Meyer, H. "The Hanging Marsyas Reconsidered." *BullCom* 97 (1996): 89–124.

Meyer 1996c
Meyer, H. "The Levy Bronze." *BullCom* 97 (1996): 149–96.

Meyer 2000a
Meyer, H. *Prunkkameen und Staatsdenkmäler römischer Kaiser.* Munich 2000.

Meyer 2000b
Meyer, H. *Ein Seleukide in Ägypten. R.A.M.S.E.S.* 2. Munich 2000.

Meyer forthcoming
Meyer, H. "Vom Herold Odios und der schönwangigen Diomede." *Nikephoros* (forthcoming).

Meyers 1990
Meyers, P. "The Use of Scientific Techniques in Provenance Studies of Ancient Bronzes." In *Small Bronze Sculpture from the Ancient World: Papers Delivered at a Symposium Organized by the Department of Antiquities J. Paul Getty Museum, 1989*, ed. M. True and J. Podany, 237–52. Malibu 1990.

Michaelis 1882
Michaelis, A. *Ancient Marbles in Great Britain*. Cambridge 1882.

Mielsch 1985
Mielsch, H. *Buntmarmore aus Rom im Antikenmuseum Berlin*. Berlin 1985.

Mikocki 1999
Mikocki, T. *Les sculptures mythologiques et décoratives dans les collections polonaises*. CSIR Poland, vol. 3, fasc. 2. Warsaw 1999.

Milkovich 1961
Milkovich, M. *Roman Portraits: A Loan Exhibition of Roman Sculpture from the First Century B.C. through the Fourth Century A.D.* Exhib. cat., Worcester Museum of Art. Worcester, Mass. 1961.

Mingazzini and Pfister 1946
Mingazzini, P., and F. Pfister. *Forma Italiae*. Vol. 1, pt. 2, *Surrentum*. Florence 1946.

Mitropoulou 1977
Mitropoulou, E. *Attic Votive Reliefs of the 6th and 5th Centuries B.C.* Athens 1977.

Mitten and Doeringer 1968
Mitten, D. G., and S. F. Doeringer. *Master Bronzes from the Classical World*. Exhib. cat., The Fogg Art Museum, Harvard University. Mainz 1968.

Mlasowsky 1992
Mlasowsky, A. *Herrscher und Mensch*. Exhib. cat., Kestner-Museum. Hannover 1992.

Moon 1995
Moon, W. G., ed. *Polykleitos, the Doryphoros, and Tradition*. Madison 1995.

Moreno 1975–76
Moreno, P. "Formazione della raccolta di antichità nel Museo e Galleria Borghese." *Colloqui del Sodalizio* 5, ser. 2 (1975–76): 129–43.

Moreno 1978–80
Moreno, P. "Il bronzo Getty ed una statuetta di Eracle ai Musei Vaticani." *RendPontAcc* 51–52 (1978–80): 69–89.

Moss 1988
Moss, C. *Roman Marble Tables*. Ph.D. diss., Princeton University, Princeton 1988. University Microfilms International no. AAT-88-19205.

Müller 1943
Müller, W. "Zum 'Pothos' des Skopas." *JdI* 58 (1943): 154–82.

Mustilli 1937
Mustilli D. "Testa di caprone." *NSc* 13 (1937): 66.

Negev 1976
Negev, A. Die Nabatäer. *Sondernummer AntW* 7 (1976).

Neudecker 1988
Neudecker, R. *Die Skulpturenausstattung römischer Villen in Italien*. Mainz 1988.

Niccolini and Niccolini 1896
Niccolini, F., and F. Niccolini. *Le case ed i monumenti di Pompei*. Vol. 4, supplemento 2. Naples 1896.

Nieddu 1986
Nieddu, G. "Un'erma di Sileno da S. Antonio (Ruinas-Oristano)." *Nuovo bullettino archeologico sardo* 3 (1986): 161–65.

Nista 1994
Nista, L. ed. *Castores. L'immagine dei dioscuri a Roma*. Rome 1994.

Nock 1932
Nock, A. D. "Cremation and Burial in the Roman Empire." *HTR* 25 (1932): 321–59.

Oberleitner 1973
Oberleitner, W. "Zwei spätantike Kaiserköpfe aus Ephesos." *Jahrbuch der Kunsthistorischen Sammlungen in Wien* 69 (1973): 127–40.

Ohly 1970
Ohly, D. "Römischer Relief-Sarkophag mit Löwenjagd." *MüJb* 21 (1970): 188–92.

Ohly 1971
Ohly, D. "Neuerwerbungen: Bildnis eines Römers." *MüJb* 22 (1971): 227–29.

Ohly 1972
Ohly, D. *Glyptothek München. Griechische und römische Skulpturen*. Munich 1972.

Ohly-Dumm 1973
Ohly-Dumm, M. "Bruchstück eines römischen Relief-sarkophags." *MüJb* 24 (1973): 239–40.

Orto and Varone 1990
Orto, L. Franchi d', and A. Varone, eds. *Rediscovering Pompeii*. Rome 1990.

Özgan 1979
Özgan, R. "Eine Mädchenstatue in Fethiye." *MarbWPr* 1979, 39–45.

Özgan 1995
Özgan, R. *Die griechischen und römischen Skulpturen aus Tralleis*. Bonn 1995.

Palagia 1980
Palagia, O. *Euphranor.* Leiden 1980.

Palagia and Pollitt 1996
Palagia, O., and J. J. Pollitt, eds. *Personal Styles in Greek Sculpture.* Cambridge 1996.

Palma 1976
Palma, B. "Il rilievo tipo 'Grimani' da Palestrina." *Prospettiva* 6 (1976): 46–49.

Palma Venetucci 1992
Palma Venetucci, B., ed. *Uomini illustri dell'antichità.* Vol. 1, pt. 2, *Le erme tiburtine e gli scavi del settecento.* Rome 1992.

Paribeni 1934
Paribeni, R. *Il ritratto nell'arte antica.* Milan 1934.

Paribeni 1959
Paribeni, E. *Catalogo delle sculture di Cirene.* Rome 1959.

I. Parlasca 1990
Parlasca, I. "Seltene Typen nabatäischer Terrakotten. Östliche Motive in der späteren Provincia Arabia." In *Das antike Rom und der Osten. Festschrift K. Parlasca,* ed. C. Börker and M. Donderer, 157–74. Erlangen 1990.

Parlasca 1966
Parlasca, K. *Mumienporträts und verwandte Denkmäler.* Wiesbaden 1966.

Parlasca 1967
Parlasca, K. "Zur syrischen Kunst der frühen Kaiserzeit." *AA* (1967): 547–68.

Parlasca 1969–70
Parlasca, K. "A New Grave Relief from Syria." *Brooklyn Museum Annual* 11 (1969–70): 168–85.

Parlasca 1976
Parlasca, K. "Probleme Palmyrenischer Grabreliefs— Chronologie und Interpretation." In *Palmyre. Bilan et perspectives. Colloque de Strasbourg, 18–20 octobre 1973,* 33–43. *Travaux du Centre de Recherche sur le Proche-Orient et la Grèce antiques* 3. Strasbourg 1976.

Parlasca 1978a
Parlasca, K. "Römische Grabreliefs aus der Südosttürkei." In *Proceedings of the Tenth International Congress of Classical Archaeology. Ankara-Izmir 23–30/IX/1973,* vol. 1, ed. E. Akurgal, 305–9. Ankara 1978.

Parlasca 1978b
Parlasca, K. "Der Übergang von der spätrömischen zur frühkoptischen Kunst im Lichte der Grabreliefs von Oxyrhynchos." *Enchoria* 8 Sonderband (1978): 115–20.

Parlasca 1980
Parlasca, K. "Zur syrischen Plastik in römischen Kaiserzeit." *GettyMusJ* (1980): 141–46.

Parlasca 1981
Parlasca, K. *Syrische Grabreliefs hellenistischer und römischer Zeit. Fundgruppen und Probleme.* Mainz 1981.

Parlasca 1984a
Parlasca, K. "Probleme der palmyrenischen Sarkophage." *MarbWPr* 1984, 183–296.

Parlasca 1984b
Parlasca, K. "Die Stadtgöttin Palmyras." *BJb* 184 (1984): 167–76.

Parlasca 1985
Parlasca, K. "Das Verhältnis der palmyrenischen Grabplastik zur römischen Porträtkunst." *RM* 92 (1985): 343–56.

Parlasca 1988
Parlasca, K. "Ikonographische Probleme palmyrenischer Grabreliefs." *DM* 3 (1988): 215–21.

Parlasca 1989
Parlasca, K. "La sculpture grecque et la sculpture de l'époque impériale en Syrie." In Dentzer and Orthmann 1989, 537–56.

Parr 1960
Parr, P. J. "Nabatean Sculpture from Khirbet Brak." *ADAJ* 4/5 (1960): 134–36.

Parra 1978
Parra, M. C. "A proposito di un relievo con statua di Silvano [Leptis Magna]." *MÉFRA* 90 (1978): 807–28.

Pasinli 1995
Pasinli, A. *Istanbul Archaeological Museum.* Istanbul 1995.

Pedley 1990
Pedley, J. G. *Paestum.* London 1990.

Pensabene 1989
Pensabene, P. *Il teatro romano di Ferento: architettura e decorazione scultorea.* Rome 1989.

Perry 1936
Perry, B. E. *Studies in the Text History of the Life and Fables of Aesop.* Haverford, Pa. 1936.

Pfisterer-Haas 1991
Pfisterer-Haas, S. "Zur 'Kopfbedeckung' des Bronzetänzers von Mahdia." *AA* 1991, 99–110.

Pfrommer 1985
Pfrommer, M. "Zur Venus Colonna." *IstMitt* 35 (1985): 173–80.

Pfrommer 1992
Pfrommer, M. *Göttliche Fürsten in Boscoreale. Der Festsaal in der Villa des P. Fannius Synistor. TrWPr* 12 (1992).

Pfuhl and Möbius 1979
Pfuhl, E., and H. Möbius. *Die ostgriechischen Grabreliefs*. Vol. 2. Mainz 1979.

Pisani Sartorio et al. 1990
Pisani Sartorio, G., et al. *Lo sport nel mondo antico*. Rome 1990.

Ploug 1985
Ploug, G. *The Graeco-Roman Town: Hama. Fouilles et recherches de la Fondation Carlsberg 1931–38*. Vol. 3, pt. 1. Copenhagen 1985.

Polaschek 1972
Polaschek, K. "Studien zu einem Frauenkopf im Landesmuseum Trier und zur weiblichen Haartracht der iulisch-claudischen Zeit." *TrZ* 35 (1972): 141–210.

Pollini 1987
Pollini, J. *The Portraits of Gaius and Lucius Caesar*. New York 1987.

Pollini 1995
Pollini, J. "The Augustus from Prima Porta and the Transformation of the Polykleitan Heroic Ideal." In Moon 1995, 262–82.

Pollini 1999
Pollini, J. Review article of Boschung 1993. *Art Bulletin* 81 (1999): 723–35.

Pollitt 1986
Pollitt, J. J. *Art in the Hellenistic Age*. Cambridge 1986.

Pompei 1999
Pompei: Pitture e mosaici. Vol. 9, *Regio IX*, pt. 2. Rome 1999.

Pouilloux et al. 1985
Pouilloux, J. et al. *Fouilles de Delphes*. Vol. 3, *Épigraphie*. Fasc. 4, *Les inscriptions de la terrasse du temple et de la région nord du sanctuaire. Index*. Paris 1985.

Poulsen 1951
Poulsen, F. *Catalogue of Ancient Sculpture in the Ny Carlsberg Glyptotek*. Copenhagen 1951.

Poulsen 1962–74
Poulsen, V. *Glyptotèque Ny Carlsberg. Les portraits romains*. 2 vols. Copenhagen 1962–74.

Prentice 1908
Prentice W. K. *Inscriptions of the Djebel Haurân. Greek Inscriptions. PAAES* 8. New York 1908.

Price 1984
Price, S. R. F. *Rituals and Power: The Roman Imperial Cult in Asia Minor*. Cambridge 1984.

Pryce 1937
Pryce, F. N. "A Hellenistic Portrait." *BMQ* 11.2 (1937): 57–58.

Pugliese Carratelli 1990
Pugliese Carratelli, G., ed. *Roma e l'Italia: radices imperii*. Milan 1990.

Quartino 1987
Quartino, L. "Frammento di sarcofago con thiasos marino." *Xenia* 14 (1987): 51–58.

Raeder 1983
Raeder, J. *Die statuarische Ausstattung der Villa Hadriana bei Tivoli*. Frankfurt 1983.

Ramage 1983
Ramage, E. S. "Denigration of Predecessor under Claudius, Galba, and Vespasian." *Historia* 32 (1983): 201–14.

Reinsberg 1995
Reinsberg, C. "Senatorensarkophage." *RM* 102 (1995): 360–70.

Ricard 1923
Ricard, R. *Marbres antiques du Musée du Prado*. Paris 1923.

Richter 1965
Richter, G. M. A. *The Portraits of the Greeks*. Vol. 2. London 1965.

Richter 1984
Richter, G. M. A. *The Portraits of the Greeks*. 2d ed. Rev. by R. R. R. Smith. Ithaca 1984.

Ridgway et al. 1994
Ridgway, B. S. et al. *Greek Sculpture in The Art Museum, Princeton University: Greek Originals, Roman Copies, and Variants*. Princeton 1994.

Rizzo 1932
Rizzo, G. E. *Prassitele*. Milan and Rome 1932.

Robert 1897
Robert, K. *Einzelmythen. ASR* III.1. Berlin 1897.

Robert 1930
Robert, L. "Nouvelles remarques sur 'l'Édit d'Ériza'." *BCH* 54 (1930): 262–67.

Robertson 1975
Robertson, M. *A History of Greek Art*. Vol. 2. Cambridge 1975.

Roche 1990
Roche, M.-J. ""Bustes fragmentaires trouvés à Pétra." *Syria* 67 (1990): 377–95.

Röder 1971
Röder, J. "Marmor Phrygium: Die antiken Marmorbrüche von Iscehisar in Westanatolien." *JdI* 86 (1971): 253–312.

Rodriguez Oliva 1988
Rodriguez Oliva, P. "Una herma decorativa del Museo Municipal de San Roque (Cadiz) y algunas consideraciones sobre este tipo de esculturillas romanas." *Baetica* 11 (1988): 215–29.

Roncalli 1973
Roncalli, F. *Il "Marte" di Todi. MemPontAcc* 11.2. Vatican City 1973.

Rose 1997
Rose, C. *Dynastic Commemoration and Imperial Portraiture in the Julio-Claudian Period.* Cambridge 1997.

Rosenbaum 1960
Rosenbaum, E. *A Catalogue of Cyrenaican Portrait Sculpture.* London 1960.

Röwer 1987
Röwer, R. "Eklektischer Jünglingskopf aus Casalciprano." *DialArch* 9–10 (1976–77): 497–503.

Rühfel 1984
Rühfel, H. *Das Kind in der griechischen Kunst.* Mainz 1984.

Rumpf 1939
Rumpf, A. Die *Meerwesen auf den antiken Sarkophagreliefs. ASR* v.1. Berlin 1939.

Rumscheid 2000
Rumscheid, J. *Kranz und Krone. Istanbuler Forschungen* 43. Tübingen 2000.

Ruprechtsberger 1987
Ruprechtsberger, E., ed. *Palmyra. Geschichte, Kunst und Kultur der syrischen Oasenstadt.* Linz 1987.

Rutschowscaya 1990
Rutschowscaya, M.-H. *Coptic Fabrics.* Paris 1990.

Sadurska 1976
Sadurska, A. "Nouvelles recherches dans la nécropole Ouest de Palmyre." In *Palmyre. Bilan et perspectives. Colloque de Strasbourg, 18–20 octobre 1973,* 11–32. *Travaux du Centre de Recherche sur le Proche-Orient et la Grèce antiques* 3. Strasbourg 1976.

Saladino 1998
Saladino, V. "Centauri restrictis ad terga manibus: un'upotesi sul torso Gaddi." In *In Memoria di Enrico Paribeni,* ed. G. Capecchi et al., 379–95. Rome 1998.

Sammlung Wallmoden 1979
Die Skulpturen der Sammlung Wallmoden. Göttingen 1979.

San Severo 1989
Il Museo Civico di San Severo: Catalogo ragionato di reperti archeologici. San Severo 1989.

Schädler 1998
Schädler, U. "Repertorio dei rinvenimenti scultorei." In *La Villa dei Quintili: fonti scritte e fonti figurate,* ed. A. Ricci, 81–146. Rome 1998.

Schauenburg 1976/77
Schauenburg, K. "Unteritalische Kentaurenbilder." *ÖJh* 51 (1976/77): 2–44.

Schefold 1943
Schefold, K. *Die Bildnisse der antiken Dichter, Redner, und Denker.* Basel 1943.

Schefold 1981
Schefold, K. *Die Göttersage in der klassischen und hellenistischen Kunst.* Munich 1981.

Scheibler 1989
Scheibler, I. *Sokrates in der griechischen Bildniskunst.* Exhib. cat., Staatliche Antikensammlungen und Glyptothek, Munich. Munich 1989.

Schiffler 1976
Schiffler, G. *Die Typologie des Kentauren in der antiken Kunst von 10. bis zum Ende des 4. Jh. v. Chr.* Frankfurt 1976.

Schmidt 1966
Schmidt, E. *Die Kasseler Apoll und seine Repliken. AntP* 5. Berlin 1966.

Schmidt 1973
Schmidt, E. *Die Kopien der Erechtheionkoren. AntP* 13. Berlin 1973.

Schmidt-Colinet 1980
Schmidt-Colinet, A. " Nabatäische Felsarchitektur." *BJb* 180 (1980): 189–230.

Schmitt-Korte 1976
Schmitt-Korte, K. *Die Nabatäer. Spuren einer arabischen Kultur der Antike.* Hannover 1976.

Scholz 1992
Scholz, B. I. *Untersuchungen zur Tracht der römischen Matrona.* Cologne 1992.

Schöne 1878
Schöne, R. *Le antichità del Museo Bocchi di Adria.* Rome 1878.

Schraudolph 1993
Schraudolph, E. *Römische Götterweihungen mit Reliefschmuck aus Italien: Altäre, Basen und Reliefs.* Heidelberg 1993.

Schröder 1989
Schröder, S. F. *Römische Bacchusbilder in der Tradition des Apollon Lykeios.* Rome 1989.

Schröder 1993
Schröder, St. F. *Katalog der antiken Skulpturen des Museo del Prado in Madrid.* Vol. 1, *Die Porträts.* Mainz 1993.

Scrinari 1953–55
Scrinari, V. "Le donne dei Severi nella monetazione dell'epoca." *BullCom* 75 (1953–55): 117–35.

Seiler 1969
Seiler, S. *Beobachtungen an Doppelhermen.* Hamburg 1969.

Seiler 1992
Seiler, F. *Casa degli Amorini dorati (VI 16,7,38). Häuser in Pompeji,* vol. 5. Munich 1992.

Sestieri 1940
Sestieri, P. C. "Tre ritratti del Museo Nazionale di Napoli." *Critica d'Arte* 5.1 (1940): 92–97.

Seyrig 1965
Seyrig, H. "Antiquités syriennes." *Syria* 42 (1965): 25–34.

Seyrig 1966
Seyrig, H. *Antiquités syriennes.* Vol. 6. Paris 1966.

Sgubini Moretti 1982–84
Sgubini Moretti, A. M. "Statue e ritratti onorari da Lucus Feroniae." *RendPontAcc* 55/56 (1982–84): 71–109.

Sheard 1978
Sheard, W. S. *Antiquity in the Renaissance: Catalogue of the Exhibition Held April 6–June 6, 1978.* Northampton, Mass. 1978.

Sichtermann 1970a
Sichtermann, H. "Deutung und Interpretation der Meerwesensarkophage." *JdI* 85 (1970): 224–38.

Sichtermann 1970b
Sichtermann, H. "Beiträge zu den Meerwesensarkophagen." *AA* 85 (1970): 214–41.

Sichtermann 1992
Sichtermann, H. *Die Mythologischen Sarkophage II. ASR* XII. Berlin 1992.

Sichtermann and Koch 1975
Sichtermann, H., and G. Koch. *Griechische Mythen auf römischen Sarkophagen.* Tübingen 1975.

Simon 1961
Simon, E. "Zum Fries der Mysterienvilla bei Pompeji." *JdI* 76 (1961): 117–72.

Simon 1962
Simon, E. "Dionysischer Sarkophag in Princeton." *RM* 69 (1962): 136–58.

Simon 1967
Simon, E. *Ara Pacis Augustae.* Tübingen 1967.

Simon 1979
Simon, E. "Die Götter am Trajansbogen zu Benevent." *TrWPr* 1 (1979): 1–15.

Sinn 1987
Sinn, F. *Stadtrömische Marmorurnen.* Mainz 1987.

Sinn 1991
Sinn, F. *Vatican Museums, Museo Gregoriano Profano ex Lateranense. Die Grabdenkmäler 1: Reliefs, Altäre, Urnen.* Mainz 1991.

Sinn and Freyberger 1996
Sinn, F., and K. S. Freyberger. *Vatikanische Museen, Katalog der Skulpturen: Museo Gregoriano Profano ex Lateranense.* Vol. 1, *Die Grabdenkmäler.* Pt. 2, *Die Ausstattung des Hateriergrabes.* Mainz 1996.

Sivan 1993
Sivan, H. *Ausonius of Bordeaux: Genesis of a Gallic Aristocracy.* London 1993.

Skupinska-Løvset 1983
Skupinska-Løvset, I. *Funerary Portraiture of Roman Palestine. An Analysis of the Production in Its Culture-Historical Context.* SIMA Pocket-Book 2. Gothenburg 1983.

Skupinska-Løvset 1999
Skupinska-Løvset, I. *Portraiture in Roman Syria.* Lodz 1999.

Smith 1904
Smith, A. H. *British Museum. A Catalogue of Sculpture in the Department of Greek and Roman Antiquities.* Vol. 3. London 1904.

Sogliano 1907
Sogliano, A. "Campania. VI. Pompei. Relazione degli scavi fatti dal dicembre 1902 a tutto marzo 1905. Casa degli Amorini dorati (Isola XVI, Reg. IV, n. 7)." *NSc* 1907, 549–93.

Söldner 1986
Söldner, M. *Untersuchungen zu liegenden Eroten in der hellenistischen und römischen Kunst.* Frankfurt and New York 1986.

Söldner 1994
Söldner, G. M. "Der soggennante Agon." In *Das Wrack: Der antike Schiffsfund von Mahdia,* ed. G. Hellenkemper Salies, 399–429. Exhib. cat., Rheinisches Landesmuseum. Bonn 1994.

Solin 1971
Solin, H. *Beiträge zur Kenntnis der griechischen Personennamen in Rom.* Vol. 1. Helsinki 1971.

Solin 1972
Solin, H. "Analecta Epigraphica." *Arctos* 7 (1972): 163–205.

Solin 1982
Solin, H. *Die griechischen Personennamen in Rom. Ein Namenbuch.* Vol. 2. Berlin 1982.

Solin 1996
Solin, H. *Die stadtrömischen Sklavennamen. Ein Namenbuch.* Vol. 2. Stuttgart 1996.

Sourdel 1952
Sourdel, D. *Les cultes du Hauran à l'époque romaine. BAH* 53. Paris 1952.

Southern 1998
Southern, P. *Augustus*. London 1998.

Spinazzola 1928
Spinazzola, V. *Le arti decorative in Pompei e nel Museo Nazionale di Napoli*. Milan 1928.

Spivey 1997
Spivey, N. *Etruscan Art*. London 1997.

Squarciapino 1941
Squarciapino, M. "Un gruppo di Orfeo tra la fiere del Museo di Sabratha." *BullCom* 69 (1941): 61–79.

Stemmer 1978
Stemmer, K. *Untersuchungen zur Typologie, Chronologie, und Ikonographie der Panzerstatuen*. Berlin 1978.

Steuben 1973
Steuben, H. von. *Der Kanon des Polyklet. Doryphoros und Amazone*. Tübingen 1973.

Steuben 1990
Steuben, H. von. "Der Doryphoros." In Beck, Boling, and Bückling 1990, 185–98.

Steuben 1999
Steuben, H. von, ed. *Antike Porträts. Zum Gedächtnis von Helga von Heintze*. Möhnesee 1999.

Steuben and Zanker 1966
Steuben, H. von, and P. Zanker. "Wagenlenker und Omphalosapollon." *AA* 1966, 68–75.

Stewart 1977
Stewart, A. *Skopas of Paros*. Park Ridge 1977.

Stewart 1990
Stewart, A. *Greek Sculpture: An Exploration*. New Haven 1990.

Stillwell 1938
Stillwell, R., ed. *Antioch-on-the-Orontes II. The Excavations 1933–1936*. Princeton 1938.

Stillwell 1941
Stillwell, R., ed. *Antioch-on-the-Orontes III. The Excavations 1937–1939*. Princeton 1941.

Strocka 1965
Strocka, V. M. "Die Brunnenreliefs Grimani." *AntP* 4 (1965): 87–102.

Strocka 1967
Strocka, V. M. "Aphroditekopf in Brescia," *JdI* 82 (1967): 110–56.

Strocka 1971
Strocka, V. M. "Kleinasiatische Klinensarkophag-deckel." *AA* 1971, 62–86.

Strocka 1984
Strocka, V. M. *Casa del Principe di Napoli (VI 15,7.8)*. Tübingen 1984.

Strocka 1994
Strocka, V. M., ed. *Die Regierungszeit des Kaisers Claudius (41–54 n. Chr.): Internationales Symposion, Freiburg i.Br. 1991*. Mainz 1994.

Strong 1908
Strong, S. A. "Antiques in the Collection of Sir Frederick Cook, Bart., at Doughty House, Richmond." *JHS* 28 (1908): 1–45.

Stuart Jones 1912
Stuart Jones, H., ed. *A Catalogue of the Ancient Sculptures Preserved in the Municipal Collections of Rome. The Sculptures of the Museo Capitolino*. Oxford 1912.

Stucky 1973
Stucky, R. A. "Prêtres syriens I. Palymre." *Syria* 50 (1973): 163–80.

Stucky 1987
Stucky, R. A. "Das Mithrasrelief Rom, Thermenmuseum 164688/Karlsruhe 76/121." *Hefte des archäologischen Seminars der Universität Bern* 12 (1987): 17–19.

Stucky, Fellmann Brogli, and Schmid 1993
Stucky, R. A., R. Fellmann Brogli, and St. G. Schmid, eds. *Petra und die Weihrauchstrasse*. Exhib. cat., Galerie "le point," Schweizerische Kreditanstalt. Zürich 1993.

Sturgeon 1977
Sturgeon, M. C. "The Relief on the Theatre of Dionysus in Athens." *AJA* 81 (1977): 31–53.

Stuveras 1969
Stuveras, R. *Le putto dans l'art romain. CollLatomus* 99. Brussels 1969.

Syme 1979
Syme, R. "Ummidius Quadratus, capax imperii." *HSCP* 83 (1979): 287–310.

Tabanelli 1962
Tabanelli, M. *Gli ex–voto polivisaceri etruschi e romani*. Florence 1962.

Thompson 1963
Thompson, D. Burr. *Troy: The Terracotta Figurines of the Hellenistic Period. Troy: Supplementary Monograph* 3. Princeton 1963.

Thompson 1896
Thompson, E. *Studies in the Art Anatomy of Animals*. London 1896.

Thönges-Stringaris 1964
Thönges-Stringaris, R. *Das griechische Totenmahl*. Bonn 1964.

Tolle-Kastenbein 1986
Tölle-Kastenbein, R. *Frühklassische Peplosfiguren. AntP* 20 (1986).

Toynbee 1934
Toynbee, J. M. C. *The Hadrianic School*. Cambridge 1934.

413

Toynbee 1944
Toynbee, J. M. C. *Roman Medallions*. New York 1944.

Toynbee 1971
Toynbee, J. M. C. *Death and Burial in the Roman World*. London 1971.

Toynbee 1973
Toynbee, J. M. C. *Animals in Roman Life and Art*. London 1973.

Toynbee 1978
Toynbee, J. M. C. *Roman Historical Portraits*. Ithaca 1978.

Tran Tam Tinh 1975
Tran Tam Tinh, V. "Les problèmes du culte de Cybele et d'Attis à Pompei." In Andreae and Kyrieleis 1975, 279–90.

Treggiari 1969
Treggiari, S. *Roman Freedmen during the Late Republic*. Oxford 1969.

Trillmich 1982
Trillmich, W. "'Ausländer-Porträts' in der mittleren Kaiserzeit." In *Römisches Porträt, Festschrift L. Alscher. WissZBerlin* 31.2/3 (1982): 297–300.

Trillmich et al. 1993
Trillmich, W. et al. *Denkmäler der Römerzeit*. Mainz 1993.

Trunk 1994
Trunk, M. "Pompeius Magnus. Zur Überlieferung und 'Zwiespältigkeit' seines Porträts." *AA* 1994, 473–87.

Turcan 1965
Turcan, R. "Du nouveau sur l'initiation dionysiaque." *Latomus* 24 (1965): 101–19.

Turcan 1966
Turcan, R. *Les sarcophages romains à représentations dionysiaques: essai de chronologie et d'histoire religieuse*. BÉFAR 210. Paris 1966.

Turcan 1972
Turcan, R. *Les religions de l'Asie dans la vallée du Rhône*. Leiden 1972.

Turcan 1993
Turcan, R. *Mithra et le mithraisme*. Paris 1993.

Unge Sörling 1994
Unge Sörling, S. "A Collection of Votive Terracottas from Tessennano (Vulci)." *MedMusB* 29 (1994): 47–54.

Van Hoorn 1951
Van Hoorn, G. *Choes and Anthesteria*. Leiden 1951.

Varner 2000
Varner, E. R., ed. *From Caligula to Constantine: Tyranny and Transformation in Roman Portraiture*. Exhib. cat., Michael C. Carlos Museum, Emory University. Atlanta 2000.

Vaughan 1959
Vaughan, M. "The Connoisseur in America." *The Connoisseur* 144 (1959): 134–38.

Vedder 1985
Vedder, U. *Untersuchungen zur plastischen Ausstattung attischer Grabanlagen des 4. Jhs. v. Chr.* Frankfurt 1985.

Vermaseren 1956
Vermaseren, M. J. *Corpus inscriptionum et monumentorum religionis mithriacae*. Vol. 1. The Hague 1956.

Vermaseren 1965
Vermaseren, M. J. *Mithras, Geschichte und Kult*. Leiden 1965.

Vermaseren 1978
Vermaseren, M. J. *Corpus Cultus Cybelae Attidisque*. Vol. 4, *Italia, Aliae Provinciae*. Leiden 1978.

Vermeule 1955
Vermeule, C. C. Review of *Opuscula Romana*, vol. 1 (Lund 1954). *AJA* 59 (1955): 349–51.

Vermeule 1957
Vermeule, C. C. "Herakles Crowning Himself." *JHS* 77 (1957): 283–99.

Vermeule 1959–78
Vermeule, C. C. "Hellenistic and Roman Cuirassed Statues." *Berytus* 13 (1959): 1–82; 15 (1964): 95–110; 16 (1966): 49–59; 23 (1974): 5–26; 26 (1978): 85–123.

Vermeule 1961a
Vermeule, C. C. "A Greco-Roman Portrait of the Third Century A.D." *Dumbarton Oaks Papers* 15 (1961): 3–22.

Vermeule 1961b
Vermeule C. C. "Etruscan Leopards and Lions." *BMFA* 59 (1961): 13–21.

Vermeule 1962
Vermeule, C. C. "Roman Sarcophagi in America: A Short Inventory." In *Festschrift für Friedrich Matz*, ed. N. Himmelmann-Wildschütz and H. Biesantz, 98–109. Mainz 1962.

Vermeule 1964a
Vermeule, C. C. "Greek and Roman Portraits in North American Collections Open to the Public." *PAPS* 108.2 (1964): 99–134.

Vermeule 1964b
Vermeule, C. C. "An Etruscan Zoo Revisited." *BMFA* 62 (1964): 103–13.

Vermeule 1972
Vermeule, C. C. "Greek Funerary Animals, 450–300 B.C." *AJA* 76 (1972): 49–59.

Vermeule 1981
Vermeule, C. C. *Greek and Roman Sculpture in America.* Malibu and Berkeley 1981.

Vermeule 1986
Vermeule, C. C. "Figural Pillars: From Asia Minor to Corinth to Rome." In *Corinthiaca: Studies in Honor of Darrell A. Amyx,* ed. M. A. Del Chiaro, 71–80. Columbia, Missouri 1986.

Vermeule 1990
Vermeule, C. C. "Roman Portraits in Egyptian Colored Stones." *JMFA* 2 (1990): 39–48.

Vermeule and Bothmer 1959
Vermeule, C. C., and D. von Bothmer. "Notes on a New Edition of Michaelis: Ancient Marbles in Great Britain, Part Three, 2." *AJA* 63 (1959): 329–48.

Vermeule and Brauer 1990
Vermeule, C. C., and A. Brauer. *Stone Sculptures: The Greek, Roman, and Etruscan Collections of the Harvard University Art Museums.* Cambridge, Mass. 1990.

Vermeule and Comstock 1988
Vermeule, C. C., and M. B. Comstock. *Sculpture in Stone and Bronze in the Museum of Fine Arts, Boston: Additions to the Collections of Greek, Etruscan, and Roman Art, 1971–1988.* Boston 1988.

Visconti 1884
Visconti, C. L. *Les monuments de sculpture antique du Musée Tor-lonia.* Rome 1884.

Vittinghoff 1936
Vittinghoff, F. *Der Staatsfeind in der römischen Kaiserzeit: Unter-suchungen zur 'damnatio memoriae'.* Berlin 1936.

Vorster 1983
Vorster, C. *Griechische Kinderstatuen.* Cologne 1983.

Vorster 1993
Vorster, C. *Vatikanische Museen, Katalog der Skulpturen: Museo Gregoriano Profano ex Lateranense.* Vol. 2, *Römische Skulpturen des späten Hellenismus und Kaiserzeit.* Pt. 1, *Werke nach Vorlagen und Bildformeln des 5. und 4. Jarhunderts v. Chr.* Mainz 1993.

Vorster 1998
Vorster, C. *Die Skulpturen von Fianello Sabino: Zum Beginn der Skulpturenausstattung in römischen Villen.* Wiesbaden 1998.

Vostchinina 1974
Vostchinina, A. I. *Musée de l'Ermitage. Le portrait romain.* Leningrad 1974.

Waage 1934
Waage, F. O. "Lamps, Pottery, Metal and Glass Ware." In Elderkin 1934, 58–67.

Waelkens 1982
Waelkens, M. *Dokimeion: Die Werkstatt der repräsentativen kleinasiatischen Sarkophage. Chronologie und Typologie ihrer Produktion.* AF 11. Berlin 1982.

Waelkens 1986
Waelkens, M. "Marmi e sarcofagi frigi." *Annali della Scuola normale superiore di Pisa* 16.3 (1986): 661–78.

Wagner 1976
Wagner, J. *Seleukia am Euphrat/Zeugma.* Wiesbaden 1976.

Waldhauer 1928
Waldhauer, O. *Die antiken Skulpturen der Ermitage.* Pt. 1. Berlin and Leipzig 1928.

Walker 1990
Walker, S. *Catalogue of Roman Sarcophagi in the British Museum.* CSIR Great Britain, vol. 2, fasc. 2. London 1990.

Walters 1974
Walters, V. J. *The Cult of Mithras in the Roman Provinces of Gaul.* Leiden 1974.

Ward-Perkins and Claridge 1978
Ward-Perkins, J., and A. Claridge. *Pompeii A.D. 79: Treasures from the National Archaeological Museum, Naples, and the Pompeii Antiquarium.* Pt. 2, *The Objects Described.* Boston 1978.

Watt 1897
Watt, J. *Examples of Greek and Pompeian Decorative Work.* London 1897.

Weber 1975
Weber, H. "Zu einem 'Römerbildnis' in Basel." *AntK* 18 (1975): 28–35.

Weber 1995
Weber, T. "Karawanengötter in der Dekapolis." *DM* 8 (1995): 203–11.

Weber and Wenning 1997
Weber, T., and R. Wenning, eds. *Petra: Antike Felsstadt zwischen arabischer Tradition und griechischer Norm.* Mainz 1997.

Wegner 1939
Wegner, M. *Die Herrscherbildnisse in antoninischer Zeit. Das römische Herrscherbild* 11.4. Berlin 1939.

Wegner 1956
Wegner, M. *Hadrian, Marciana, Matidia, Sabina. Das römische Herrscherbild* 11.3. Berlin 1956.

Wegner 1966a
Wegner, M. "Vespasian." In Daltrop, Hausmann, and Wegner 1966, 9–17.

Wegner 1966b
Wegner, M. *Die Musensarkophage. ASR* v.3. Berlin 1966.

Wegner 1979a
Wegner, M. *Gordianus III. bis Carinus. Das römische Herrscherbild* III.3. Berlin 1979.

Wegner 1979b
Wegner, M. "Nachträge zum römischen Herrscherbild im 2. Jh. n. Chr. 1. Teil." *Boreas* 2 (1979): 87–181.

Weichers 1961
Weichers, A. *Aesop in Delphi.* Meisenheim 1961.

Weitzmann 1977
Weitzmann, K., ed. *Age of Spirituality.* Exhib. cat., Metropolitan Museum of Art. New York 1977.

Wenning 1987
Wenning, R. *Die Nabatäer. Denkmäler und Geschichte.* Freiburg and Göttingen 1987.

Wenning 2001
Wenning, R. "Die Religion der Nabatäer." *Welt und Umwelt der Bibel* 19 (2001): 19–26.

White 1967
White, K. D. *Agricultural Implements of the Roman World.* Cambridge 1967.

White 1987
White, C. *Peter Paul Rubens: Man and Artist.* New Haven 1987.

Wiegartz 1965
Wiegartz, H. *Kleinasiatische Säulensarkophage: Untersuchungen zum Sarkophagtypus und zu den figürlichen Darstellungen.* Berlin 1965.

Wiggers and Wegner 1971
Wiggers, H. B., and M. Wegner. *Caracalla, Geta, Plautilla. Das römische Herrscherbild* III.1. Berlin 1971.

Wilber 1938
Wilber, D. N. "The Theater at Daphne. Daphne-Harbie 2oN." In Stillwell 1938, 57–94.

Wilpert 1929
Wilpert, J. *I sarcofagi cristiani antichi.* Vol. 1. Rome 1929.

Wilpert 1932
Wilpert, J. *I sarcofagi cristiani antichi.* Vol. 2. Rome 1932.

Winkes 1969
Winkes, R. *Clipeata Imago: Studien zu einer römischen Bildnisform.* Bonn 1969.

Winkes 1985
Winkes, R. *Love for Antiquity: Selections from the Joukowsky Collection.* Louvain-la-Neuve 1985.

Winkes 1988
Winkes, R. "Bildnistypen der Livia." In *Ritratto ufficiale e ritratto privato. Atti della II conferenza internazionale sul ritratto romano, Rome 1984,* ed. N. Bonacasa and G. Rizzo, 555–61. Rome 1988.

Winkes 1995
Winkes, R. *Livia, Octavia, Iulia. Archaeologia Transatlantica* 13. Providence and Louvain-la-Neuve 1995.

Winter 1908
Winter, F. *Die Skulpturen. AvP* 8, pt. 2. Berlin 1908.

Witecka 1994
Witecka, A. "Catalogue of Jewellery Found in the Tower-tomb of Atenatan in Palmyra." *Studia palmyrenskie* 9 (1994): 71–91.

Witt 1997
Witt, R. E. *Isis in the Ancient World.* Baltimore 1997.

Wixom 1967
Wixom, W. D. "Early Christian Sculptures at Cleveland." *BClevMus* 54 (1967): 67–89.

Wojcik 1986
Wojcik, M. R. *La Villa dei Papiri ad Ercolano.* Rome 1986.

Wood 1986
Wood, S. *Roman Portrait Sculpture, 217–260 A.D.: The Transformation of an Artistic Tradition.* Leiden 1986.

Wrede 1976
Wrede, H. "Lebenssymbole und Bildnisse zwischen Meerwesen." In *Festschrift für Gerhard Kleiner,* ed. H. Keller and J. Kleine, 147–78. Tübingen 1976.

Wrede 1978
Wrede, H. "Die Ausstattung stadtrömischer Grabtempel und der Übergang zur Körperbestattung." *RM* 85 (1978): 411–33.

Wrede 1981
Wrede, H. *Consecratio in formam deorum: Vergöttlichte Privatpersonen in der römischen Kaiserzeit.* Mainz 1981.

Wrede 1986
Wrede, H. *Die antike Herme.* Mainz 1986.

Wünsche 1998
Wünsche, R. *Der Torso.* Exhib. cat., Staatliche Antikensammlungen und Glyptothek. Munich 1998.

Yarden 1991
Yarden, L. *The Spoils of Jerusalem on the Arch of Titus. A Re-investigation. AIRRS* 16. Stockholm 1991.

Yuen 1997
Yuen, T. "Glyptic Sources of Renaissance Art." In *Engraved Gems: Survivals and Revivals*, ed. C. M. Brown, 137–57. Hanover, N.H., and London 1997.

Zanker 1974
Zanker, P. *Klassizistische Statuen.* Mainz 1974.

Zanker 1975
Zanker, P. "Grabreliefs römischer Freigelassener." *JdI* 90 (1975): 267–315.

Zanker 1980
Zanker, P. "Ein hoher Offizier Trajans." In *Eikones. Festschrift Hans Jucker*, 196–202. Bern 1980.

Zanker 1982
Zanker, P. "Herrscherbild und Zeitgesicht." In *Römisches Porträt, Festschrift L. Alscher. WissZBerlin* 31.2/3 (1982): 307–12.

Zanker 1988
Zanker, P. *The Power of Images in the Age of Augustus.* Ann Arbor 1988.

Zanker 1998
Zanker, P. *Pompeii: Public and Private Life.* Cambridge, Mass. 1998.

Zayadine 1990
Zayadine, F., ed. *Petra and the Caravan Cities.* Amman 1990.

Zevi 1976
Zevi, F. "Proposta per un'interpretazione dei rilievi Grimani." *Prospettiva* 7 (1976): 38–41.

Zevi 1979
Zevi, F. "Il santuario della Fortuna Primigenia a Palestrina." *Prospettiva* 16 (1979): 2–22.

Zimmer 1982
Zimmer, G. *Römische Berufsdarstellungen.* Berlin 1982.

Index

heads (*continued*): 343–45, 347n.3; Head of a Woman, cat. no. 152, 313n.1, 354–55; Head of a Woman, Recarved from an Earlier Head, cat. no. 3, 11–14; Head of a Young Man, cat. no. 145, 312, 336–37; Head of a Youth, cat. no. 21, 84–87; Male Head from an Historical Relief, cat. no. 25, 100–102; Male Head in High Relief, cat. no. 135, 312, 317–20; Plaster Head of an Athlete(?), cat. no. 67, 211–12

Helene, Stele of, cat. no. 119, 293–94; 307n.1

Helene, Stele of, cat. no. 128, 304–5

Helios, 328nn. 18 and 19

helmets, 14, 30, 134–35, 217, 218n.2

Hephaistos, 228n.1, 229, 233

Hera, 174, 190; painting, Pompeii, 191n.1

Herakles, 98, 128–32, 140–47, 245, 265–67, 330; Chiaramonti, 266n.3; Child's Sarcophagus with Herakles and Centaurs, cat. no. 41; Copenhagen/Dresden type, 265; Farnese type, 90, 240, 265; head in a double herm, Leiden, 131–32; Head of Herakles with Vine Wreath, cat. no. 37, 130–32; Lion Skin Support for a Statuette of Herakles, cat. no. 102; oinochoe with centaurs drawing chariot of Herakles, Paris, 147n.13; plaques, from Delos, 235; Small Head of Herakles, cat. no. 36, 128–30; statue, Ashmolean Museum, Oxford, 99n.7; statue, Copenhagen, 99n.7; statue, Munich, 99n.7, 130; statue, Dresden, 99n.7; statue, with a cornucopia, Museo Nazionale Romano, Rome, 130; statuette, Selçuk, 245; Twelve Labors of, 145, 147n.7

hermaphrodite: Head of a Satyr with the Hand of a Hermaphrodite, cat. no. 68, 179, 212–14; *symplegma* with a satyr, 213–14

Hermaphroditos, 214; *anasyromenos*, 235

Hermes, 98, 99n.7, 125–26, 238; Fragment of Hermes(?), cat. no. 82, 238; Group of Hermes and Ram, cat. no. 34, 125–26; Hermes-Thoth, 380; with infant Dionysos, from Rhodes, Archaeological Museum, 113; with infant Dionysos, Olympia Museum, 212n.7; Polykleitos or Praxiteles, sculptue, 238n.2; statue, Museo Nuovo Capitolino, 99n.16; statue, from Side, 238; torso, Museo Nazionale Romano, Rome, 99n.7

herms: double, 103–5, 131; — Fragmentary Double Herm with Heads of Old and Young Dionysos, cat. no. 26, 103–5; — with head of Herakles, Leiden, 131–32; herm busts, 103–11, 148; — Herm Bust of Pan, cat. no. 28, 108–11; — of Pan, from Pompeii, 111n.5; Herm Bust of Silenos, cat. no. 27, 106–7

Herod I, king of Judaea, 176

himations, 60, 112, 164, 166, 197–98, 202–4, 206–8, 278, 282–83, 294, 296, 296, 350, 352, 358, 362, 376

Hippodameia: Ash Urn with Relief of Pelops and Hippodameia, cat. no. 160, 368–71

Holconius Rufus, statue of, Pompeii, 33n.18

holes, 92–94, 114–16, 126; clamp holes, 141, 303; dowel holes, 27, 33, 47, 88, 95, 117, 182, 189–90, 200, 203, 213, 218–19, 224, 233–35, 244, 250–52, 285, 303, 315, 317–20, 338, 341; drain holes, 140; lewis hole, 245n.2; lid sockets, 161; mounting holes, 80, 131; pinholes, 47; tenon holes, 198, 248

horsemen, 313, 316, 318, 320–21, 366, 374–76; Attic Relief with Horseman and Bearded Man, cat. no. 161, 374–76

horses, 52–55, 116, 247, 252, 313, 320, 335n.2, 368–71, 374–76; Head of a Horse in High Relief, cat. no. 137, 312–13, 317–18, 320–22; Leg of a Horse, cat. no. 88, 247; winged, 366

Huskinson, J., 149

Hygieia, 255–56; statue from Antioch, Worcester Art Museum, 180

Io, 174

Iolaus, 147n.9

Isis, 126–28, 198, 255n.2; Bust of Isis, cat. no. 61, 203–4; busts as lamp attachments, from Antioch, 198, 203; cult of, 180, 198; Head of Isis, cat. no. 35, 126–28; Isis-Aphrodite, figure of, 180; Isis-knot, 198; Lower Half of a Statue of Isis, cat. no. 58, 180, 197–99; mosaics of Isiac rituals, from Antioch, 198; priestesses of, 72

Istanbul, Archaeological Museum: Nike from Der'ā, 340n.2; stele with figure on a base, 306n.2; stele with seated woman, 278n.1

Istanbul, Silahtaraga, nymphaeum, 254n.7

ivy, 88; berries, 103, 106, 109; garlands, 141, 144, 146n.3, 215; leaves, 31, 103–4, 106, 109

İzmir museum, statue of Eros, 259n.2

Jekmejeh, 261–62, 263n.5, 256, 265

jewelry: earrings, 355; fibula, 316, 329; pins, 27, 371; rings, 39n.9

Jonah, 165–67; Jonah Praying, 233

Josephson, J. A., 380

Jucker, H., 46

Jupiter: eagles of, 260; Jupiter Capitolinus, 58; Temple of Jupiter Capitolinus, Antioch, 176

Justinian, emperor, 178–79

Kabeiroi, 229

Kephisodotos, satyr and hermaphrodite, 214

Kharab, 306

Klejman, J. J., 164

kline: and funerary busts, 350–52; on grave stelai, 285–93, 298–301, 303–4; *kline*-shaped sarcophagi, 350–52, 358–59; on sarcophagus lids, 155–56

Koch, G., 134

Kronos, lion-headed image, Vatican, 265

Laberia Alexandria, 158; sarcophagus of, cat. no. 44, 157–60

Laodicea, 174, 178

Laodike, mother of Seleucus II, 175, 381

Lassus, J., 179

Lassus, M. Jean, 179

Lateran, wrestling boy, 17n.7

laurel: twigs, 151–52; wreaths, 70–71, 100, 114–16, 336–37, 341–43

legs: Left Thigh, cat. no. 87. 246; Leg of a Statuette, cat. no. 86, 245; Legs and Feet, Group of Twelve, cat. no. 93, 180, 195, 251; Legs of a Male Statuette, cat. no. 77, 180, 232–33; Lower Legs of a Draped Female Figure, cat. no. 60, 202–3

Leiden, double herm, 131–32

Leonide, Grave Stele of, cat. no. 108, 278–79, 308

Lesbos, Eresos museum, grave stele, 278, 279n.3, 297

Libanius, 174–75, 180

Linfert, A., 206

lions, 146, 156, 254n.4 257–58, 266, 334–35, 366–68; Chest and Forelegs of a Lion, cat. no. 97, 179, 257–58; Head of a Lion, cat. no. 159, 366–68; hunts, 162–63; — lion-hunt sarcophagi, 162–63; lionesses, 144, 146; lion-headed image of Kronos, Vatican, 265; from Mausoleum of Halicarnassos, 258n.7; pelts of, 98, 265–66; pelts of, Nemean lion/Herakles', 98, 130, 140–43, 265; — Lion Skin Support for a Statuette of Herakles, cat. no. 102, 265–66; Reclining Lion in High Relief, cat. no. 144, 312, 334–35; sarcophagus with centaurs fighting lions, Thessaloniki, 147n.17; from tumulus at Marathon, 258n.7

Livia Drusilla, wife of Augustus: basalt head, Villa Albani, 5n.2; head, Bonn, 5n.2; head, Copenhagen, 4, 5n.2; portraits of, 4, 87n.9, 344n.3

Lloyd, Malcolm, 178

London, British Museum: grave stele with seated woman, 278–79n.1; Hauranite heads, 323n.1, 344n.3; pilaster capital from Seeia, 333n.3; portrait, 183; portrait

head of a man, 20n.1; relief from Rhodes, 199n.3; relief with horseman, 376; standing Silenos, 113; statuette of Socrates, 383; torso of Dionysos, 237n.2

Lora del Rio, head of Augustus, 10, 11n.16

Lucilla Augusta, 62–63; portrait, Palazzo dei Conservatori, Rome, 62

Lucius Verus, emperor, 62, 64, 66

Lysippos, 90, 175

Madrid, Academy of Art, figure of a woman, 190

Madrid, Prado Museum, goat, 254n.9

Magie, David, 178

Magnus Maximus, emperor, 82

Malibu, J. Paul Getty Museum: grave stele of two brothers, 277n.15; head of an athlete, 382; portrait of Epikouros, 379

Manisa museum, columnar sarcophagi, 156n.9

mantles, 18, 33–34, 38, 44, 134, 184, 224, 279n.1, 279n.3; cloaks, 30, 117–20, 122–23, 369; paludamentum, 27–28, 50, 56, 59; see also himations

Mantua, head of Octavian/Augustus, 9–10, 11nn. 10 and 16

Marcus Aurelius, emperor, 62–64, 177, 192; head, Cyrene, 132; head, Frankfurt, 132; Portrait of Marcus Aurelius, cat. no. 15, 63–66; bronze medallion, 147n.11; portraits of, 62–66, 68, 58, 130, 132, 192

Mars, 14n.1, 135; Borghese Ares type, 192

Marseilles, sarcophagus with muse, 164n.3

masks, 212n.5, 270; death masks, 40, 43n.11, 211; Fragment of a Mask, cat. no. 51, 180, 185–86; of Grey-Haired Gossip, 185

Matz, F., 152

Maxentius, emperor, 124

McCormick, Cyrus H., 178

Medusa. See Gorgon Medusa

Meleager, 98, 99n.11, 238; Skopas, sculpture, 222n.2

Melfi, Museo Archeologico Nazionale, columnar sarcophagus, 156

Menander, portrait of, 380, 382

Mercury, 125–26

Minerva, 14n.1

Mithras Slaying the Bull, cat. no. 33, 122–25

Möbius, Hans, 278, 280, 292, 295, 300–301, 303, 305–7

mortises, 10n.3, 12, 103

Munich, Staatliches Museum Ägyptischer Kunst, diorite head, 379–81

Munich, Staatliche Antikensammlungen und Glyptothek: Aphrodite, Knidian, 200; caryatids, 134; fragment from lion-hunt sarcophagus, 162–63; portrait of Nero, 21n.10; silver jug, 145; Spinner,

bronze, 34, 38n.3, 39nn. 14 and 15; statue of Herakles, 99n.7, 130; Statue of Silenos, 91n.2

Musées Nationaux de France, 178–79

Muses, 164

Myrtilos, 368–71

Nabataean inscriptions, 312, 325, 327n.4

Namia Pudentilla, 82n.7

Naples, National Archaeological Museum: herm bust of Pan, 111n.5; marble group, men cooking a pig, 254n.5; portrait, 87n.7; portrait of Demokritos, 379; portrait of Plautilla, 73n.3; sarcophagus with a satyr, 154n.28

Narbonne, Musée Archeologique, Statue of Silenos, 92n.2

Narcissus, Polykleitan statue, 99n.6

narthex, 149

Naukydes, Diskobolos, 212n.7

Nemesis: Agorakritos, sculpture of Nemesis of Rhamnous, 203n.1; shrine of, Daphne, 178;

Nereids, 158, 160n.14

Nero, emperor, 177; headless cuirassed figure, 32; portrait, Munich, 21n.10; portrait, Worcester, 21n.10; Portrait of a Man, Recarved from a Portrait of Nero, cat. no. 5, 14, 18–21; portraits of, 17n.5, 25, 31–32, 100, 102n.9

Nerva, emperor, 59

Nike: Athena Nike, Temple of, Acropolis, 210n.1 Hauranite images of, 326, 328, 330, 340n.2; head of Nike, Paris; Keystone with Nike in High Relief, cat. no. 140, 312, 328–31; Nike of Paionios, at Olympia, 330

nymphs, 149, 153n.5, 154n.16, 214; Temple of the Nymphs, Daphne, 177

oak trees, 141–43, 331; acorns, 270, 331–32

Oceanus, 159–60

Octavia Minor, portrait on an aureus, 4

Odysseus, 229

Oinomaos, 368–71

olive trees, 301n.1, 352; leaves, 355–58

Orpheus, 262; fountain relief, charming the animals, from Byblos, 262; fountain relief, charming the animals, from Sabratha, 263, 263n.6; Lacus Orphei, 263n.2; Orpheus Relief, Fragment from, cat. no. 100, 261–63

Ostia: bust of a man, 76; portrait of Antinous, 59n.3; sarcophagi with sea creatures, 160

Otacilia Severa, wife of Philip the Arab, 76

Otho, emperor, 33n.18

Oxford, Ashmolean Museum, statue of Herakles, 99n.7

Padua, relief of satyr, 121n.10

palm trees, 52, 54; branches, 360

Palmyra, 178, 340n.1; grave stelai of, 274–75, 276nn. 6 and 7, 277n.15, 284, 310n.4; sculpture from, 276n.7, 312, 313n.1, 343n.3, 350–63; tombs of, 59, 358

Palmyrene sculpture: Fragmentary Head of a Priest, cat. no. 154, 357; funerary slab, inscription from, 360–62; Funerary Bust of a Banqueting Youth, cat. no. 150, 350–52, 355, 357; Funerary Slab with Male Bust in High Relief, cat. no. 151, 352–53; Funerary Slab with Male Bust in High Relief, cat. no. 157, 360–62; Headdress of a Priest, cat. no. 155, 358; Head of a Banquet Attendant, cat. no. 156, 313n.1, 359; Head of a Man, cat. no. 158, 313n.1, 363; Head of a Priest, cat. no. 153, 355–56; Head of a Woman, cat. no. 152, 313n.1, 354–55

Pan, 109, 149, 152, 237; head, Cyrene, 111n.3; herms, 108–11; — herm bust, Museo Archeologico Nazionale, 110; — Herm Bust of Pan, cat. no. 28, 108–11; Leiden Pan, 90; temple of, Antioch, 176

panthers, 95, 156; pelts of, 95–98, 143

Paris, Cabinet des Médailles, Dionysiac cortège on gold patera, 254n.4

Paris, Louvre: Amazonomachy sarcophagus, 136n.2; banquet-style grave stele, 277n.26; figural pillar with a barbarian, 60n.12; Hauranite heads, 320n.1, 344n.1; head of Ba'al Shamīn, 317n.4; head of Nike, 340n.2; head of Octavian/Augustus, 9; oinochoe, centaurs harnessed to chariot of Herakles, 147n.13; portrait of a man, 21n.13; sarcophagus relief, boy riding in a goat cart, 254n.4; statue, Westmacott Ephebe type, 99n.11; statue associated with Messalina, 17n.3; Statue of Silenos, 92n.2

Paris, Musée Rodin, grave stele, 278

Paris, statue of Marsyas, 214n.4

Parlasca, K., 337

Pasiteles, School of, 84, 87n.5; Pylades, 84–86

Patten, Henry J., 178

pediments, 31, 56, 168; of grave stelai, 47, 278, 279nn. 1 and 3, 287, 291, 293, 298, 303; pedimented aedicula, 306; rounded, 277n.10; triangular, 275, 276n.6, 278n.1

Pelops: Ash Urn with Relief of Pelops and Hippodameia, cat. no. 160, 368–71